HOGARTH

VOLUME 3
ART AND POLITICS

1750–1764

———

Who but a bigot, even to the antiques, will say that he has
not seen faces and necks, hands and arms in living women,
that even the Grecian Venus doth but coarsely imitate.

—*Hogarth*, THE ANALYSIS OF BEAUTY, 82

RONALD PAULSON

RUTGERS UNIVERSITY PRESS

NEW BRUNSWICK, NEW JERSEY

Library of Congress Cataloging-in-Publication Data
(Revised for volume 3)

Paulson, Ronald.
 Hogarth.

 CONTENTS: v. 1. The "modern moral subject," 1697–1732 — [etc.] — v. 3.
Art and politics, 1750–1764.
 Includes bibliographical references and indexes.
 1. Hogarth, William, 1697–1754. 2. Artists—England—
Biography. I. Title.
N6797.H6P38 1991 760'.092 [B] 90-24569
ISBN 0-8135-1694-3 (v. 1)
ISBN 0-8135-1696-X (v. 2)
ISBN 0-8135-1698-6 (v. 3)
ISBN 0-8135-1699-4 (v. 3 : pbk.)

P-324

CONTENTS

ILLUSTRATIONS

Unless otherwise indicated, the illustration is an etching-engraving.

LIST OF ILLUSTRATIONS

LIST OF ILLUSTRATIONS

PREFACE

This final volume takes Hogarth from his fifty-third year to his death at sixty-seven. Little more than a decade, the period opens with Hogarth at the height of his powers, having followed his biblical history paintings of *Moses Brought to Pharaoh's Daughter* and *Paul before Felix* with his "modern" history painting of *The March to Finchley;* at the center of London's art world, a figure of influence with the literary generation of Richardson and Fielding, he was known to an unprecedented spectrum of English men and women. At this point, he chose to philosophize about art, extending his successful practice into aesthetic theory, in *The Analysis of Beauty* (1753)—partly in reaction to the agitation for an art academy based on the French model, partly out of the conviction that his art required verbal validation, and partly (some contemporaries felt) out of hubris. And at the same moment the fabric of his hard-won reputation began to unravel. A new generation had arisen—some friendly and interested in building on Hogarth's achievement, but some determined to supersede what seemed to be, in England of the 1750s, too insular a figure to represent English art and culture to the world. Joshua Reynolds, just returned from Italy, was the epitome and spokesman of this next phase of English art. The rumblings began with the first proposal for a state academy; the satiric jibes of Smollett in *Peregrine Pickle* suggested that there was a vulnerable side to Hogarth, and this was picked up by Paul Sandby in his witty but ad hominum (and painful) caricatures following upon the publication of the *Analysis*.

The consequences—given his own doggedness and the shifting allegiances of former friends—were tumultuous and darkened the last years of Hogarth's life, pushing him to extremes of theory, practice, and self-justification. For the first time in his career he found himself

apparently out of step with his times—isolated and obsolescent. Although these cannot be called happy years, they elicited from Hogarth some of his most brilliant and audacious works, in writing as well as painting and engraving. In many ways he had already by 1750 anticipated the Reynolds generation, pointing the way into the Promised Land, but disagreeing with these younger artists over the nature of that promise.

Art and Politics focuses on the interplay of Hogarth's aesthetic theory and his politics vis-à-vis both the artistic community and the English governing elite, with imperialism a common term: the first group as it changed from Hogarth's St. Martin's Lane Academy to a hypothetical royal academy based on the French model, which would materialize only four years after his death; and the second as it changed from the isolationist electoral politics of Sir Robert Walpole to the "popular" expansionist politics of William Pitt.

The word "art" in the title refers to both the making of paintings and engravings *and* the new philosophy known as "aesthetics," created at the beginning of the century by Lockean thinkers, primarily Shaftesbury and Addison. The art treatises (of Alberti, Lomazzo, Lairesse, de Piles, and Dufresnoy) had been primarily addressed to artists. The third earl of Shaftesbury wrote both an art treatise (his *Judgment of Hercules,* 1713) and aesthetic treatises (gathered in his *Characteristics,* 1709)—the one instructing the artist rationally how to make a painting, and the other instructing the spectator in his or her irrational response to it. In Shaftesbury's words, the spectators, "feeling only by the effect whilst ignorant of the cause, term the *je ne sçay quoy,* the unintelligible or the I know not what, and suppose [it] to be a kind of charm or enchantment of which the artist himself can give no account."[1] These treatises turned attention from the maker, the painter or architect, in effect the producer, to the consumer. Aesthetic discourse was thus allied (recalling the terms of our discussion in volume 2) to a discourse of consumption in a consumer society. But these treatises focused specifically on a "Man of Taste," the gentleman connoisseur and collector—something an ordinary untrained, ungentlemanly person cannot be—and categorized the art object itself in terms of this gentleman's response.

In *The Analysis of Beauty* Hogarth came at aesthetics in a charac-

teristically reactive way: not "art" but "nature"; not the rules of the art treatises *or* the Man of Taste but the response of the ordinary person; not theory or reason but perception, sensation, and enjoyment. The name "aesthetics" (applied in the 1730s by the German philosopher Alexander Gottlieb Baumgarten) derived from the Greek *aisthetikos,* of sense perception.[2] The Greek *aisthesis,* as Terry Eagleton has noted, implies "the whole region of human perception and sensation, in contrast to the more rarefied domain of conceptual thought. It is thus the first stirrings of a primitive materialism— of the body's long inarticulate rebellion against the tyranny of the theoretical."[3] Hogarth does not turn (with Shaftesbury and Francis Hutcheson) to feelings of virtue, benevolence, and social contract but to the sensations aroused by the body—and not by a man's but a woman's body. And when he writes in the *Analysis* of the spectator's preferring the real woman over the antique Grecian Venus in stone, he is speaking, in the original sense of the term, as an aesthetician.

If the rise of aesthetics in England coincided with the rise of empiricism, one way of accounting for the phenomenon is as a rewriting of religion: religious faith, minus reason or the evidence of the senses, finds a new home in, is secularized into, aesthetics. Michael McKeon has argued that an aesthetic discourse comes to replace both religious discourse, brought under question by empiricism, and empirical discourse as well. The part that was "incapable of rational defense," that "contracted any of one's outward senses," was available to aestheticization.[4]

One such revision of both orthodox Christianity and Lockean empiricism was the Deist writings of Shaftesbury, whose aesthetics replaced God the creator (and by analogy the poet too) with man the perceiver; Old and New Testament subjects with classical and pagan subjects; and an immanent (as opposed to transcendent) God with Nature. Shaftesbury sought to replace God's personal revelation with a Platonic harmony and unity he called Beauty. Hogarth as well as Shaftesbury had Deist inclinations; but if Shaftesbury replaced God with an ideal Greek sculpture, Hogarth more radically—but in line with his "modern moral subjects"—replaced both with a living contemporary woman.

Hogarth's graphic demystification (we saw in vols. 1 and 2) began with Shaftesbury's recommendation to painters of the classical Hercules (Heroic Virtue, Hercules at the Crossroads), a replacement

for the New Testament Christ. But Hogarth superimposed—shifted attention from the classical to—a Christian gestalt, not the Life of Christ but of the Virgin; and then replaced the New Testament figures with recognizable living Londoners. In the Deist sense, once the classical myth has been compromised by juxtaposition with the Christian, the Christian itself must be submitted to reason, which meant (in the terms of Deist ridicule) *be made contemporary*. The metaphorical unveiling of Nature (shown in the subscription ticket for *A Harlot's Progress*) exposes the reality beneath the New Testament miracles, which assumes the significant vehicle of a beautiful woman. The demystification Hogarth called a "modern moral subject" was thus only a way station toward a *re*mystification as an allegory of beauty.

Another locus for Hogarth's aesthetics was Addison's formulation (in his "Pleasures of the Imagination") of the aesthetic object and experience as Beautiful or Great (or Sublime), with between these extremes a third category, the Novel or Uncommon (later called the Picturesque). The aesthetic alternatives in the first half of the century were essentially the Beautiful and the Sublime, with the middle term ignored. Hogarth's contribution in his *Analysis of Beauty* was to subsume the Novel under the Beautiful. He removed the detachment or disinterestedness (which Shaftesbury thought necessary of the Man of Taste) from Beauty, focusing instead on sexual attraction and exploration, but retaining the name. In the context of the new form that came to be called *the* novel, he turned Fielding's middle terms in the preface to *Joseph Andrews* and the "mixed character" of *Tom Jones* into a composite aesthetics that encompasses both his own "modern moral subject" and Fielding's "comic epic in prose"—and that anticipates in important ways the "Picturesque" that would be formulated by William Gilpin, Uvedale Price, and Richard Payne Knight in the 1780s and 1790s, only focusing on the human form rather than landscape.

Much of what I have said of an emergent aesthetics can be said of politics as well. Both represented a change from an art of the maker to one of the perceiver and responder: in the first case the Man of Taste, augmented by the ordinary spectator, and in the second the elector augmented by the disfranchised public. In the 1750s, as witnessed by Hogarth, the Walpolian electoral politics of manipulation appeared to be superseded by the "popular" politics of the charismatic

Pitt, who swayed crowds, and by his audience, a great, irrational, and threatening mass of people seeking authority through sheer numbers.

Clearly this was a conflicted situation for an artist who had himself constructed a "general public" for his art, whose aesthetics elevated along with the ordinary perceiver and the living woman the common smokejack, candlestick, and corset. Among other things, the *Analysis* was a defense of his own originality, his own "modern moral subject," and his own audience. His aesthetics also supported his idea of a democratic academy; his living English woman epitomized the native-based original art he advocated instead of a French-derived art of copying. If Pitt and the incipient royal academicians were equally Roman imperialist in oratory and orientation, Hogarth sought a point of origin for his art in ancient English signboards and graffiti.

Hogarth's art had been political from the start. His first significant insight was that sublime history painting, the premier artistic genre of his time, was giving cultural expression to a set of socially and economically determined values—largely by denying, mystifying, and displacing the hard facts of life into fantasies of heroism based on classical or biblical stories. History painting was the mode that read "harmony" and heroic virtue as a compensation for and screening off of the actual violence, oppression, and poverty perpetrated by the gods, heroes, and kings on ordinary people. Hogarth produced a counterart which not only showed the reality that was being repressed but included the delusive fictions of heroic virtue and the narrative of their production and consumption.

It was even clearer to Hogarth that the aesthetic theory promulgated by Shaftesbury and his followers carried political assumptions that called for a corrective parallel to that of his paintings/engravings on the tradition of history painting. This corrective—the deepest intention behind its writing—was *The Analysis of Beauty*. In Hogarth's skeptical view the Glorious Revolution (the work of both Shaftesburys, in politics *and* art) was a step toward oligarchy, not liberty. Until the unmistakable image of *The Times, Plate 1,* however, his political messages were coded as aesthetics and conveyed in double meanings that could easily be overlooked or repressed (and continued to be in the tradition of commentary that reached from Trusler's pious to Antal's Marxist moralizing).

It will be evident that I educe, in the course of this volume, a nar-

rative that supplements the narrative of civic humanist aesthetics outlined by John Barrell in *The Political Theory of Painting*[5] and the narrative of aesthetics which essentially limits it to the Sublime, originally constructed by Burke (and augmented in our time by Harold Bloom, Thomas Weiskel, and their followers). A narrative of the Beautiful as Hogarth defined it is, it seems to me, a corrective long overdue.[6]

The political myth of the civic humanist oligarchy was supplemented in the 1730s by the Opposition myth developed by the *Craftsman,* which in Bolingbroke's *Idea of a Patriot King* (1740, 1749) fueled the rhetoric of the Leicester House party, the earl of Bute, and the future George III. This myth, dating the birth of Liberty in Gothic times and not at the Revolution of 1688, opposed to a Walpolian corruption associated with Roman decadence a lost pastoral ideal of northern liberty, bold Anglo-Saxons, and the Ancient Constitution. Most significant for Englishmen like Hogarth, it projected a myth "about their own beginnings that at once set England outside the historical cycle of Graeco-Roman decline and yet connected its history with that of the Mediterranean world on which the conquering hordes of the North had descended when luxury and internal corruption had done their work."[7] Thus aesthetically as well as politically Rome was discredited and English artists urged to return (as Hogarth had urged as early as 1731) to their "ancient mother." In the 1750s, ably assisted by his young friend Bonnell Thornton, Hogarth adapted this aspect of Opposition ideology as the rationale for a true British art, summed up in the Sign Painters' Exhibition of 1762.

Politically, this primitivist myth bridged the Walpole and the Bute-George III eras, one seen negatively as corruption, the other positively as the recovery of a political ideal; and this overarching narrative helps to explain the basic continuity of Hogarth's politics, at least in its positive aspect. In its negative aspect, it reminds us that his career took off in the 1720s–1730s from the great public dialogue between an Opposition (the satire of Swift, Pope, and Bolingbroke) and a supposedly corrupt government, and that he never deviated thereafter from this counter-discourse and the necessarily oblique methods of Opposition satire, even when ostensibly supporting a party.

HOGARTH
ART AND POLITICS

1.

Hogarth's Reputation and the Idea of an Academy

Just two years after Hogarth's engraving of *The Gate of Calais* appeared, Tobias Smollett published his second novel, *The Adventures of Peregrine Pickle* (Feb. 1751), well seasoned with recognizable caricatures of his current enemies.[1] George Lyttelton as Gosling Scrag and his friend Henry Fielding as Mr. Spondy were only the most scurrilous, because most personal, of a rogues' gallery that also included Quin, Chesterfield, and Garrick. The physician-poet whom Peregrine meets in Paris in the Palais Royal (chap. 46) was recognized as Mark Akenside.

In 1751 Smollett was a peppery young Scot of barely thirty who had come down to London in 1739 to make his way in the literary world, and had been thwarted (he felt) by the theatrical coteries. Quick to respond to an affront, real or fancied, Smollett replied to the theatrical folk in *Roderick Random* (1741) and to the literary in *Peregrine Pickle*. In general he aimed his satire at his seniors, the famous and accepted leaders of the London literary establishment. Fielding had made a great splash with *Tom Jones*, Garrick was the foremost actor of the age, and Akenside, though exactly Smollett's age, was already famous as the author of *The Pleasures of Imagination* (1744), though perhaps his particular offense was a reference in his "Ode to the Earl of Huntingdon" (1748) to "the barbarous Host" of Scotsmen.[2]

The physician-poet's (Akenside's) companion in Paris is a painter named Pallet. While the doctor is a young man, a lover of the ancients dressed in sober black, Pallet is a modern who, "though seemingly turned of fifty, strutted in a gay summer dress of the Parisian cut, with a bag to his own grey hair, and a red feather in his hat."

He is "a painter from London, who had stole a fortnight from his occupation, in order to visit the remarkable paintings of France and Flanders." He is "extremely talkative," he "pronounce[s] judgment upon every picture in the palace" (the Palais Royal), and reveals with every word his pomposity as well as his ignorance of art, French, and Latin. When a Swiss connoisseur cries *magnifique!* at a picture, Pallet replies "with great vivacity,"

> *Manufac,* you mean, and a very indifferent piece of manufacture it is; pray gentleman take notice, there is no keeping in those heads upon the back ground, nor no relief in the principal figure: then you'll observe the shadings are harsh to the last degree; and come a little closer this way—don't you perceive that the fore-shortening of that arm is monstrous—agad, sir! there is an absolute fracture in the limb—doctor, you understand anatomy, don't you think that muscle evidently misplaced.[3]

Hogarth was by far the most famous artist in London at this time, and he had "just turned fifty" in 1747. He was well known for his jaunty dress, and George Vertue and others have recorded how he loved to hold forth, belittling "all other professors of Painting, got into great Reputation & esteem of the Lovers of Art," including Kneller, Lely, and Van Dyck.[4] By this time he had begun to talk about his Line of Beauty and other theoretical matters concerned with art. The name Pallet would support the identification. In 1749 Hogarth had issued his engraved self-portrait, portentously entitled *Gulielmus Hogarth,* which showed him with his dog Trump and a large, prominently displayed palette inscribed with the intentionally tantalizing Line of Beauty (see fig. 105). An artist's palette was already a Hogarth trademark, appearing as his seal affixed to the subscription tickets for his engravings.[5]

As an immediate source for his parody, Smollett made use of Hogarth's recent abortive trip to France and the print publicizing it, which both presented the artist and lampooned the French. Here was a target indeed for the bilious Scottish satirist. Pallet's Francophobic speech to Jolter (chap. 47) elaborates the contrast developed in *The Gate of Calais* between the starved but foppish French and the plain, roast beef-fed English: "there's a freshness in the English complexion, a *ginseekeye,* I think you call it, so inviting to a hungry French-

man, that I have caught several in the very act of viewing me with an eye of extreme appetite as I passed."[6] Smollett recalls Hogarth's whole unhappy trip by giving Pallet an analogous fiasco in chapters 49 and 50: he is imprisoned in the Bastille as a result of disguising himself as a woman (another case of mistaken identity), and later released on the condition that he and Peregrine leave Paris in three days. The story of Hogarth's getting into trouble through his sketching appears in chapter 67, where Pallet sketches an old Capuchin preaching in Antwerp Cathedral and is nearly mobbed by the congregation. (Smollett may be recalling the Franciscan, said to be a portrait of Hogarth's friend John Pine, who appears prominently in *The Gate of Calais*.)[7]

The caricature of Hogarth in *Peregrine Pickle* can be attributed in part to guilt by association and in part to the fact of Hogarth's prominence. His friendship with Fielding and Garrick had been manifested in painting and print (Richard III was a role censured by Smollett in the novel); worse, he was a close personal friend of both. Smollett does not, however, bring Pallet together with Spondy, and while his treatment of Fielding is grossly personal, he shows Hogarth in his public image, expressing his public views; the only private incidents alluded to are ones that Hogarth himself publicized (and he was, judging by Vertue, regarded by some of his contemporaries as a self-publicist). His career in general was extraordinarily public: from his proposals for his progresses, to his advocacy of the Engravers' Act, to his defenses of his art and his attacks on the art of rivals. He was not only the best-known English artist of the period, but also potentially the best comic butt; Smollett was one of the first to utilize this potential, in print at least.

But already Smollett differentiates, as would most of Hogarth's later attackers, between the great comic moralist and the poor, pretentious, silly painter and aesthetician who attempts abortive flights toward the sublime. Pallet is presented as a history painter, a creator of only the most serious works.

Elsewhere, like almost every novelist of the time, Smollett often invokes Hogarth's work to stress the comedy of a scene. In *Roderick Random* he notes that "It would require the pencil of Hogarth to express . . ." (chap. 47), and in *Peregrine Pickle* itself: "It would be a difficult task for the inimitable Hogarth himself to exhibit the ludicrous expression of the commodore's countenance . . ." (chap. 14).

It is the enthusiast for "the sublime parts of painting" who appears as Pallet, the Hogarth of *Moses Brought to Pharaoh's Daughter* and *Paul before Felix*—paintings that roughly correspond to the efforts of which Pallet is so proud. *Moses,* on display in the Foundling Hospital since 1747, may be recalled in Pallet's work-in-progress, another Egyptian subject, Cleopatra (chap. 61): an unkind critic might have seen Cleopatra in the sensuous lounging figure of Pharaoh's daughter, which clearly draws attention away from the young Moses. The Cleopatra is especially interesting because she is said to be a portrait of Pallet's wife and raises the question: Is this the origin of the later stories about Hogarth's painting his wife Jane as Sigismunda (1759, fig. 54)? Or was Pharaoh's Daughter (the equivalent of Cleopatra) also rumored to be a portrait of Jane? Pallet's "Judgment of Solo-mon" (chap. 46) might also be a parody of Moses's choice between his two mothers, but I suppose Smollett is alluding to *Paul before Felix,* with Felix choosing between Paul and Tertullus, which was by this time on display in Lincoln's Inn. The sketch that later gets Pallet into trouble depicts an old Capuchin, who he thinks will make "an excellent Paul preaching at Athens." The allusion, of course, is to the figure in Raphael's Cartoon which Hogarth used as the model for his Paul in *Paul before Felix* and had introduced in his *Characters and Caricaturas* of 1743. "Egad! friend Raphael," Pallet continues, "we shall see whether you or I have got the best knack at trumping up an Apostle" (chap. 67). This double disrespect, to the Capuchin and to Raphael, is what rouses the congregation's ire.

Smollett is the first person to publicly attack Hogarth's attempts at sublime history, and to draw the unkind inference that by using Raphaelesque motifs he is trying to outdo the Italian. Pallet's "Judgment of Solomon" may, indeed, recall more specifically the burlesque Judgment of Solomon that hangs on the wall of the bagnio in the fifth plate of *Marriage A-la-mode.* Perhaps Smollett is suggesting that Hogarth's history painting cannot in fact be distinguished from his burlesques of the genre. In Antwerp, Pallet admires Rubens's *Descent from the Cross,* but he cannot restrain his pleasure at seeing Dutch genre paintings that depict lice, a hog, and flies on a dog's carcass. His own paintings, like Hogarth's, turn out looking like these, "for he had exhibited the image of a certain object so like to nature, that the bare sight of it set a whole hogstye in an uproar" (chap. 67).

The final characteristic of Hogarth remarked by Smollett (and by

Vertue as well) was his nose for business. When Pallet reappears in London (chap. 96), spouting disdain for the connoisseurs, he has arranged a picture lottery for "Cleopatra," with subscription and proposals, and he offers to sell Peregrine a chance for "such a trifle as half a guinea." Hogarth's dislike for connoisseurs, his picture auctions, his published proposals for them, and the eccentric way in which he carried them out, were well known. Smollett, however, recalls here the more recent lottery for the painting of *The March to Finchley,* 30 April 1750, which coincides with Pallet's down to the detail of the price, half a guinea. Vertue, who describes this lottery, might not have agreed with Peregrine's opinion that it was "a begging shift to dispose of a paultry piece, that he could not otherwise have sold for twenty shillings," but he does conclude that "such fortunate successes are the effect of cunning artfull contrivances!" (3: 153).

Smollett's satire contains all the assumptions on which later attacks were based: from the superiority of Italian art to the particular flaws noted in the painter, contrasted with the talent of the comic moralist, and the implication that he was just another comedian who wanted to play Hamlet. Perhaps because the time was not yet ripe, contemporaries appear not to have played up Hogarth's portrait in Pallet.[8] The nickname that caught on in the 1750s, though taken from the same print, was not Pallet but Painter Pugg. The stimulus may have been *The Scandalizade* (1750, by William Kenrick?), a shotgun blast at contemporaries, in its way not unlike *Peregrine Pickle.* The author stands before a printshop window containing *Gulielmus Hogarth* and wonders why the dog is standing next to his master instead of running at his heels. But no,

> (Quoth a sage in the crowd) for I'd have you to know, Sir,
> 'Tis Hogarth himself and his honest friend Towser,
> Inseparate companions! and therefore you see
> Cheek by jowl they are drawn in familiar degree;
> Both striking the eye with an equal eclat,
> The biped *This* here, and the quadruped *That*—
> You mean—the great Dog and the Man, I suppose,
> Or the Man and the Dog—be't just as you chuse.—

You correct yourself rightly—when much to be blam'd,
For the worthiest person you first should have nam'd.
Great Dog! why *great Man* methinks you should say.
Split the difference, my friend, they're both great in their way.
Is't he then so famous for drawing a punk,
A Harlot, a Rake, and a Parson so drunk,
Whom *Trotplaid* delivers to praise as his Friend?
Thus a Jacknapes a Lion would fain recommend.—
The very self-same—how boldly they strike,
And I can't forbear thinking they're somewhat alike.—
Oh fie! to a Dog would you Hogarth compare?—
Not so—I say only they're alike as it were,
A respectable pair! all spectators allow,
And that they deserve a description below
In capital letters, *Behold we are Two.*

"Trotplaid" is a reference to Fielding (his pseudonym in the *Jacobite's Journal*), ridiculing his praise of Hogarth in *Tom Jones* as that of a jackanapes trying to ingratiate himself into the favor of a lion. Fielding, less circumspect politically, had been violently attacked from the beginning of his career; Hogarth hardly ever. In the 1750s, however, perhaps as the result of their mutual back-patting, their reputations began to converge. Orthodox critics tended to equate them, especially after Fielding in 1751 published *Amelia,* which could be regarded as his attempt at the sublime mode. The essential line taken against both was that used in 1748 to denigrate Fielding's *Jacobite's Journal:*

> *Low Humour,* like *his own,* he once exprest,
> In *Footman, Country Wench,* and *Country Priest:*
> But all who read, must *pity,* or must snore;
> When TROTT-PLAID's *humble Genius* aims at *more.*

Thomas Edwards, a friend of Samuel Richardson, wrote characteristically to the Reverend Mr. Lawry on 12 February 1752: "This winter has been a very barren one. . . . I have seen nothing but Amelia, and that I did not half like. His Heroes are generally good-natured fellows, but not honest men; and indeed I think, if Hogarth and he knew their own talents, they should keep to the Dutch manner of painting, and be contented to make people laugh, since what is really

great seems to be above their powers." Then he goes on to praise Richardson.[9]

There is no real point in time when the hostility toward Hogarth shown in Smollett's caricature can be said to have originated; it may have been latent among his artist contemporaries, who agreed with his defense of English art but regarded it as self-praise, to some extent at least. Most obviously, it followed his efforts to paint and engrave sublime histories. But it may also have been given an impetus in the late 1740s by the changing ideas in France, where the impatience with mythological subjects in history painting that Hogarth had shown in the 1730s came to the surface, launched by La Font de Saint-Yenne in his *Réflexions sur quelques causes de l'état présent de la peinture en France* (1747). La Font, and many others after him, attacked the rococo of Boucher and his followers, the erotic scenes and pretty little portraits. But unlike Hogarth, they unequivocally demanded a return to the dignity of true history painting—to noble themes and compositions in the grand manner. Naturally the attack fell upon small genre scenes and landscapes as well; works with no higher aim than imitation of nature were considered trivial and tending to undermine the taste for serious historical subjects.[10]

The alternative of moral scenes by a Greuze had not yet been raised by Diderot, and Hogarth's solution to the problem of decadent mythological painting had been modern moral subjects in an essentially rococo style. Therefore, the demand for seriousness of subject, classical and historical in tone, must have touched him at a sensitive point. As usual, he both reacted against such demands and felt their influence; he had, in fact, already responded with the simplified forms of *Garrick as Richard III* and *Moses*.

The Abbé Jean-Bernard Le Blanc was one of the originators of the movement back to seriousness with his *Lettre sur l'exposition des ouvrages de peinture* (1747), but it was his *Letters on the English and French Nations,* translated and published in England in the same year, that left its mark on English artists and connoisseurs. Letter 23, entitled "On the State of Painting and Sculpture in England," is based on a visit to England in the late 1730s. The gist of the argument is that while English connoisseurs strip the Continent of its greatest art treasures, England itself produces no painters of its own. There are many great poets, "and yet England has not hitherto bred one painter." Great foreign artists have visited England, "but in vain are

the seeds of art imported hither, the soil seems not to be proper for them"; he adds that Paris, of course, has the advantage of its Academy of Painting, which teaches its artists how to draw.[11]

Although the reverberations of this statement were to be profound in England, the more immediately galling assertions concern native history painters. Thornhill, the only Englishman who had attempted this high genre, is scornfully dismissed; all the rest have aspired no higher than portraits—and then for money rather than reputation. Kneller, the abbé says, launching into his attack on English portraiture, could only have made his reputation among the English. He makes the conventional distinction "in painting, as in poetry," between the two extremes, the sublime and burlesque: Raphael's burlesque equivalent is Callot, and Virgil's is Scarron. "The genius of the English painters," he says, "has not only found itself too weak to rise to the majesty of the first kind; they have not been happier whenever they attempted to descend into all the oddities of the second, which indeed is what they have practised most."

The letter ends with Le Blanc's remarks on Hogarth himself, which seem to have had some effect in the years that followed:

To conclude, those of them who have the talent to paint nature in burlesque, ennoble it by the use they make of it: they employ it to give a disrelish to vice.

The Luxembourg gallery by Rubens, or the battles of Alexander by Le Brun never had a greater run in our country, than a set of prints actually have in England, engraved lately from pictures of a man of genius in this way, but who is as bad a painter, as he is a good subject. They have made the graver's fortune who sells them; and the whole nation has been infected by them, as one of the most happy productions of the age. I have not seen a house of note without these moral prints, which represent in a grotesque manner the Rake's Progress in all the scenes of ridicule and disgrace, which vice draws after it; sometimes even in those circumstances, the reality of which, if tolerably expressed, raises horror: and the English genius spares nothing that can inspire it. Thus the ancients were of opinion, that nothing could give such an aversion for intemperance, as the very sight of a person labouring under the effects of it. I verily believe that such pictures make a deeper impression on a people like this, who delight in strong representations, than the most sensible reflections, or the most pathetic discourses. What do I say? The human kind are the same every

where: whatever end is proposed, it is surer and easier to make an impression on the senses, than to convince the understanding.[12]

This passage contains almost all the negative assumptions about Hogarth that held until long after his death. He is, whatever he may say himself, a burlesque painter, "a man of genius *in this way*," but as bad a painter as he is a good moralist. He remains something of a sport, and yet quintessentially English, in his limited and provincial emphasis on the grotesque—on "strong representations" rather than (the French contribution) "sensible reflections" and "pathetic discourses."

Most important, Le Blanc's strictures, like Smollett's caricature of Hogarth in *Peregrine Pickle,* reflect the beginning of the agitation in England for an academy along the French lines. This controversy first caused detractors to publicize Hogarth's hubris in attempting to rise from drolls to the biblical paintings in the Foundling Hospital and Lincoln's Inn. The center of the controversy was, ironically, Hogarth's St. Martin's Lane Academy. He had created it and brought about the developments that opened new outlets for artists—the general public, the pleasure gardens, the hospitals, and other public buildings. These effectively offered alternatives to personal patronage, increasing both the artist's independence and his status. One reaction, which Hogarth shared with the rest of the St. Martin's group, was expanded criticism of aristocratic patrons and silly connoisseurs. A second reaction, less strongly shared, was a growing agitation for a state academy.

Behind much of the theory of art in the eighteenth century was the example of France. In 1737 a daily paper, copied by the *Gentleman's Magazine,* had commented: "About two hundred paintings, and other prize pieces, of the Academy of Painters at Paris, are daily visited by the curious of all nations at the Louvre. What a discouragement . . . is it to the ingenious Men of *Great Britain* that we have no yearly Prizes to reward their Pains and Application!"[13] About the same time Thomas Atkinson published his *Conference between a Painter and Engraver,* in which he wrote: "If some Maecenas, some publick spirit, would set the design [of an academy] on foot, and get it confirmed by a government charter, as 'tis in France, . . . thou great English genius, to what heights wouldst thou tower!"[14]

In 1747 Le Blanc's criticism had appeared, and Hogarth's friend

Dr. James Parsons in his treatise on physiognomy promptly replied, pointing to the great works in St. Paul's, St. Bartholomew's, the Foundling, and Greenwich Hospital. But he admits that there is little encouragement in England for "any Branch but little Portraits," and goes on:

> And if we were bless'd with the same academical Endowments that other Nations can boast of, we should undoubtedly have as great Proficients in the Arts of Painting and Sculpture as any Nation: For it is notorious, that our Youth have made as good a Figure in foreign Academies as any that were educated at them; and we have even had some, who, by dint of Genius, have born away the Prizes from those of every other Nation.[15]

Partly to answer Le Blanc, John Gwynn published two years later *An Essay on Design: Including Proposals for Erecting a Public Academy to be Supported by Voluntary Subscription (Till a Royal Foundation can be obtain'd) For Educating the British Youth in Drawing, and the several Arts depending thereon.* Beginning with Le Blanc's assertion that the English, while a wise people, lack taste: "Tho' in our Writings we abound with good Matter," Gwynn writes, "we know not, according to him, how to make a good Book: That is, we are deficient in Rule, Judgment, and Method." Thus what is needed is an academy. English artists "have wanted, while young, the Assistance of an *Academy,* which should lead them on from the first Principles of Geometry and Perspective, thro' all the Rules of correct Drawing, and make them conceive a true Standard of Excellence before they attempt to excell." His chief argument in favor of an academy is the honor of the nation: "What, shall we be ever obliged to foreign Workmen for all that is beautiful and masterly in our Churches and Palaces?" England's art should reflect her triumphs on the sea, in trade, and elsewhere. But there would also be great pecuniary advantage: "If we had more regular Artists, and in great Number, not only much Money, which is now sent to *France* and *Italy,* might be saved, but a very profitable Exportation might be made of those Works that were not purchased by our own Connoisseurs." At present, he says, the balance of trade is against England. With an English academy, men of taste would visit England as Englishmen now visit Italy.[16]

Gwynn even projects some rules for his academy: that subscribers

appoint a committee of themselves to make the rules, that they appoint a secretary and treasurer, that they apply part of the fund to the purchase of a building, and that "a certain Number of the principal Painters, Sculptors, and Architects, of the greatest Reputation, be appointed Officers of the said Academy, with a Head." Finally, that these judges admit or reject pupils, and "That the Officers have proper Salaries for their Care in the Instruction of Pupils" (83). All of his arguments are based on his assumption of the merits of the French Academy; he emphasizes the importance of status and hierarchy, making it sound more like a group of politicians or state functionaries than artists.

Academies were in the air. In July 1749, Vertue records a conversation with Frederick, Prince of Wales, in which the latter "spoke much concerning the settlement of an Accademy for drawing & painting." This may have been the time when Vertue drew up his own plans for an academy: clearly many were doing so (1: 10). An academy, going back to the Renaissance concept, was a place where old and young could meet to draw the works that formed somebody's collection: the essentials were the works themselves and the desire to copy them. In contrast to the apprenticeship format, older and younger artists practiced together, originally "to enjoy in a sociable way drawing under one another's eyes and discussions on the theory and practice of art."[17] This was essentially the academy as Hogarth carried it on, with Thornhill's "collection" of casts, in St. Martin's Lane.

The academies that led to the French Académie Royale (founded in 1648) began with the rise of mannerism in Italy. "Mannerist artists, and that is what Mannerism means literally," as Nikolaus Pevsner notes, "try to adhere to the 'maniere,' set by the masters of the Golden Age." Thus copying became the principal activity of the French Academy. Professional artists who wished to become members had to submit "reception pieces," but amateurs could also be elected to membership. The academy emphasized precise laws as to procedure and the election of an elaborate system of functionaries. It was an absolutist organization in absolutist France, as Pevsner has commented, "passionately pursuing reason, system and order."[18] All of this was supposed to raise the artist above membership in a craft guild to the rank of a scientist or scholar and, above all, a gentleman.

Although the artists saw the academy in terms of social status,

royal favor, annual exhibitions, and the like, contemporaries thought of it as a school of art: "to train students—and to train them in one particular style of drawing and modelling, the style of the King and the Court"—as Hogarth implied when he wrote that "Lewis the 14 got more hon[r] by establishing a pompous parading [academy] at paris than the academician[s]." And, Hogarth adds, citing Voltaire as his authority, "after that establishment no work of genius appeard for says he they all became imitators and mannerists."[19]

As early as 1749 Gwynn had some of the St. Martin's Lane people on his side. His frontispiece was made by Samuel Wale and engraved by Charles Grignion; it showed Mercury introducing Minerva or some other figure representative of the arts (a putto holds a painting, and a palette, bust, lyre, and such emblems are gathered at her feet) to Britannia. In the background is a pillar with a medallion head of George II, above him crossed orb and sword with cap of liberty over the point, and above this the crown.

The essence of Hogarth's academy was its informal and democratic structure, but in the late 1740s this was being undermined from within and without. The artists' committee at the Foundling Hospital had brought artists into the public eye as never before, and it also had fragmented into factions. Rouquet's account of the difficulty the artists had gaining recognition and their attempt to prove their importance at the Foundling is juxtaposed, perhaps significantly, with his remark, "And indeed, the artists themselves have contributed to this injustice, by running one another down, as they usually do." The next paragraph turns to Hogarth's "new kind of pictures."[20] The implication, I think, is that the Foundling artists attacked each other's pictures, then and later, and that Hogarth, the most prominent of the artists, came in for his share of abuse.

Hogarth had withdrawn from any administrative function in the academy by the end of the 1730s. Vertue chronicles John Ellys as "manager" in 1741–1742, James Wills in 1743; in 1744–1745 Ellys, Hayman, Gravelot, and Wills (6: 171, 3: 123). In 1745–1746 a meeting was advertised for Saturday evening, 28 July (or October, depending on which was regarded as the seventh month), at the Half Moon Tavern in the Strand, to take subscriptions for the winter. Here Hayman is designated for history painting, Gravelot for design, Louis François Roubiliac for statuary, Richard Yeo for seal engraving, Wills for portraiture, and George Michael Moser for chasing (3: 127). There is no mention of Hogarth.

Moser, a Swiss enameler and draughtsman, had in the 1740s merged his drawing school in Salisbury Court with the St. Martin's Lane Academy. Although his daughter, remembering the events many years later, makes it sound earlier, the transaction cannot have been before the 1744–1745 season: "The report of this little Academy," she recalled, "drew the attention of Hogarth & several other English artists who visited and approving the Plan, proposed to Moser & the other foreigners to unite with them in forming one upon a more extensive scale."[21] Moser, a secretive, plotting sort of man, evidently wished to promote the concept of a Continental academy. In 1752 Hogarth's old friend Hayman, who had accompanied him to France four years earlier, made a more extended trip to Italy with Hudson and Roubiliac, and they may have found (or demonstrated) support in this symbolic journey for the idea of such an academy.

It was clear, however, that no support was going to come from George II, that notoriously uncultivated king. Since Hogarth's dedication of *The March to Finchley* to the king of Prussia as a "Patron of the Arts" is attacked in at least one of Sandby's satires (fig. 32), it seems likely (in view of Gwynn's emblematic image of George II) that Hogarth was referring ironically to some artists' attempts to get support from the king. But in 1751, with the death of Prince Frederick, people became aware of the king's age: and the new Prince of Wales, the first Hanoverian to be born and educated in England, seemed much more promising than his father. The artists began to look toward the next reign. Hogarth's own comment on how the project got started was that "his present majesty's inclination to those arts set those that now belong to it a maddning," which led to the meetings at the Turk's Head in 1753.[22] Considering that Hogarth wrote this around 1760, it seems quite likely that he was referring to George III as "his present majesty," and the attention Hogarth himself paid to the prince—introducing him into *The First Stage of Cruelty* in 1751 and later into Plate 2 of *The Analysis of Beauty*—suggests that he was perhaps showing interest in the arts (see figs. 4, 81).

Hogarth's opposition derived from both public and private sources. Before him was the example of the French Academy, which was to prove prophetic of the English: from the search for official standards on which to organize art down to the "Conférences" held by Le Brun, which set the precedent for Reynolds's discourses. He would also have remembered the endless arguments between the colorists

and the linear proponents, which the academy attempted to neutral-ize by having Louis Testelin draw up synoptic tables of Rules for Great Art (*Table de Préceptes,* published in 1675). Then another com-pilation followed, by de Piles, of tables alloting comparative marks to the great artists on the basis of 20 marks for perfection: thus Titian got 18 for color but only 6 for expression and 12 for composition; Michelangelo got 17 for drawing but only 4 for color and 8 for ex-pression and composition. Hogarth's thinking on the founding of an academy was modern: he recognized, as historians do today looking at the Royal Academy, that a national academy of art is a contradic-tion in terms. His opinion of course presupposes an organic and changing conception of art that was counter to his times and to the feeling that the best in style could be fixed and passed on as a tradition.

There were no doubt personal reasons as well—his own success story being one. As Dobson put it, "In his own walk he had suc-ceeded by a course of training which would have baffled nineteen men out of twenty; and he consequently undervalued the instruction of all academies whatsoever." "I know of no such thing as genius," Hogarth said to Gilbert Cooper; "genius is nothing but labour and diligence."[23] Something like this must have been a favorite saying of his in the 1750s (it crops up in his notes on the Society of Arts), but stressing the image of the self-made man, it missed the point that few others could have carried through with his own idiosyncratic training.

Hurt pride was undoubtedly another reason, for he must have re-garded the St. Martin's Lane Academy with the fondness of a father. This organization had belonged to him and his father-in-law, and he insists repeatedly that for thirty years it had functioned efficiently and accomplished as much as any state academy could, while avoiding its inherent dangers and inequalities. This would have been one mo-tive apparent to his colleagues who heard his arguments against a French-style academy, but they do not bring it up in their attacks. They emphasize rather his pride and fear that in a state academy, not of his own running, he would lose prestige. And they also see him as a dog in the manger: for, although he opened the way for other artists at the Foundling, the only subsequent commissions for his-tory painting were his own. No one could approach him in the sale of prints; Robert Strange, Vertue, and others could carry on with greater safety and profits in the reproductive line, but their profits

were not comparable to Hogarth's. John Pye was close to the truth, at least as seen by Hogarth's colleagues, when he wrote that he "stood alone, the sole occupant of the field of patronage created by his own genius, and dependent upon the million."[24]

From Hogarth's remarks, it is clear that the undemocratic organization was what he most disliked about the proposal. They were, he notes, in favor of "having salary as in france for telling as they do there the younger ones when a leg or an arm was too long or too short."[25] His own academy, essentially a life class, supported "with great order, and even with success to their pupils," as Rouquet put it a few years later in *The State of the Arts in England* (1755), "a model of each sex, by the annual and voluntary subscription of those who come there to learn." His testimonial might have been inspired by Hogarth himself: "This institution is admirably adapted to the genius of the English: each man pays alike; each is his own master; there is no dependance; even the youngest pupils with reluctance pay a regard to the lessons of the masters of the art, who assist there continually with an amazing assiduity."[26]

Some of the members, according to Rouquet's account, "with a view of rendering the arts more respectable, and at the same time of establishing a public free school," began to seek out ways of incorporating themselves into an academy.

> They imagined that as soon as they had chosen the professors and the other officers, and established a great many laws, for which the English are famous, they had erected an academy. And what was very droll, lest they should give offence to any of the business, by excluding them from a nomination to the professorship, they named almost as many professors as there were artists. But they forgot to observe that this sort of establishment can never subsist without some subordination, either voluntary or forced; and that every true born Englishman is a sworn enemy to all such subordination, except he finds it strongly his interest. Be that as it may, the project of an academy did not take place, either because it was ill planned, or because its inutility must have naturally produced its ruin (24–25).

A partisan of the artists who wanted a state academy, Robert Strange, remembered that time differently:

> Many attempts were made, about that time to enlarge the plan of this [the St. Martin's Lane] academy, but they as frequently proved abor-

tive: they failed through the intrigues of several amongst the artists themselves; who, satisfied with their own performances, and the moderate degree of abilities they possessed, wished, I believe, for nothing more than to remain, as they then were, masters of the field.[27]

Hogarth is probably the object of this sarcasm.

2.

POPULAR AND POLITE PRINTS, 1751–1752

POPULAR PRINTS

In mid-January 1750/51, as *Peregrine Pickle* was being printed off, Henry Fielding published *An Enquiry into the Causes of the Late Increase of Robbers,* and just one month later, in the *London Evening Post* of 14–16 February, Hogarth announced:

> *This Day are publish'd, Price 1 s. each.*
> Two large Prints, design'd and etch'd by Mr. Hogarth call'd
> BEER-STREET and GIN-LANE
> A Number will be printed in a better Manner for the Curious, at 1s. 6d. each.
> And on Thursday following will be publish'd four Prints on the Subject of Cruelty, Price and Size the same.
> N.B. As the Subjects of these Prints are calculated to reform some reigning Vices peculiar to the lower Class of People, in hopes to render them of more extensive use, the Author has publish'd them in the cheapest Manner possible.
> To be had at the Golden Head in Leicester-Fields, Where may be had all his other Works.[1]

As Luke Sullivan completed the engraving of *The March to Finchley* Hogarth must have been working on his graphic supplement to his friend's *Enquiry* (figs. 1–10). One can imagine Fielding, with the great sense of urgency he expresses in the *Enquiry,* seeking Hogarth's assistance. It seems most likely that they concerted a campaign in which the graphic augmented the verbal. Since Hogarth's prints ad-

dress the "reigning Vices peculiar to the lower Class of People" and represent, almost point for point, the issues of Fielding's *Enquiry,* he must have read the manuscript and begun his plates by the time it was published.

In the winter of 1748–1749 Fielding had been appointed a Westminster magistrate. *Tom Jones,* which he was still writing as he took up his duties, was published at the end of the year. By then he was devoting himself wholeheartedly to the business of presiding over the Bow Street police court and dealing with the shockingly high crime rate in central London. By then Fielding the magistrate, official spokesman for order, had replaced the rakish, freethinking Harry Fielding—grinning at Hogarth in *Characters and Caricaturas*—who had been attorney for the defense in *Tom Jones.*[2]

Fielding faced criminals daily in his courtroom. Hogarth's personal contact with the encroachments of poverty, crime, and violence in the metropolis was less direct. He lived in a respectable and elegant square. Newspapers described the physical improvements inhabitants were making in their park. The *Penny Post* for 3–5 August 1748 announced that "The Inhabitants of Leicester-square have ordered the Statue of his Majesty king George I. lately put up there, to be gilt with all Expedition." Some idea of the progress of crime in Leicester Fields can be gauged from the *London Evening Post* for 25–28 May 1751. The preceding Friday, 24 May, between 11 and midnight,

> Mr. Howard, an'eminent Peruke-maker, in Castle-Street, Leicester-Fields, was knock'd down near his own Door by a Ruffian; but recovering himself, he immediately seiz'd the Fellow by the Collar, and calling the Watch, the Villain thought proper to make off, leaving Mr. Howard in Possession of the Fore Part of his Coat, which was torn off in the Scuffle from the Neck to the Bottom. Mr. Howard was desperately wounded in the fore Part of his Head by the Violence of the Blow.

In general Londoners saw these "ruffians" as threats to their property and safety who deserved to be hanged or transported. There is no evidence that Hogarth disagreed, except that in his graphic works from *A Committee of the House of Commons* to *Paul before Felix* he tended to see the magistrate from the point of view of the accused. St. Paul—or Hogarth's father, Richard—was not, of course, the same as the ruffian who attacked your neighbor.

In May 1749 Fielding, in his first year as magistrate, was chosen chairman of the Quarter Sessions of the Peace, and so on 29 June delivered the annual charge (delivered frequently in the 1730s by Sir John Gonson), which was published three weeks later. Full of precedents and legal references, it was as much a charge to the citizens of Middlesex as to the law enforcement officers. Trying to anticipate crime at its source, he spent much time on minor offenses, and, like Gonson, found its roots in the brothels and dance halls, "where idle Persons of both Sexes meet in a very disorderly Manner, often at improper Hours, and sometimes in disguised Habits."[3] The key word "idleness," in this and Fielding's subsequent pamphlets, would have recalled, among other sources, Hogarth's print series of 1747, but Fielding shows none of Hogarth's ambivalence: he had a practical problem and sought practical solutions.

In his *Charge to the Grand Jury* he had distinguished between the poor and the rich: it is the poor who lose most through gambling, he argues, whereas "for the Rich and Great, the Consequence is generally no other than the Exchange of Property from the Hands of a Fool into those of a Sharper, who is, perhaps, the more worthy of the two to enjoy it."[4] The emulation of the "great" becomes in the *Enquiry* the basic cause of crime in London. Each rank in society, Fielding says, is now emulating the expensive pleasures of the next rank above. He is not, however, much disturbed by the nobleman who "will emulate the Grandeur of a Prince" or by the gentleman who "will aspire to the proper State of the Nobleman"; but there is reason for concern when

> the Tradesman steps from behind his Counter into the vacant Place of the Gentleman. Nor does the Confusion end here; it reaches the very Dregs of the People who aspiring still to a Degree beyond that which belongs to them, and not being able by the Fruits of honest Labour to support the State which they affect, they disdain the Wages to which their Industry would entitle them; and abandoning themselves to Idleness, the more simple and poor-spirited betake themselves to a State of Starving and Beggary, while those of more Art and Courage become Thieves, Sharpers, and Robbers.[5]

Practically speaking, Fielding has turned his attention on "the lower Order of People," but the *Enquiry* does not imply that the rich are without vice. Its point is that they can afford their vices, unlike those who are ruined through emulating them—and there is legally

nothing to be done. In his farce *Rape upon Rape* (1730) Fielding had included the speech: "Well, Sir, if you cannot pay for your transgressions like the rich, you must suffer for them like the poor." "Let the Great therefore answer for the Employment of their Time to themselves," he says in the *Enquiry,* "or to their spiritual Governors" (83). The poor, who threaten our daily existence, can and must be dealt with, and so his subject is the poor fools who, like Hogarth's Moll Hackabout and Tom Rakewell, try to emulate their superiors. His aim, Fielding says in his preface, is "to rouse the Civil Power from its present lethargic State" by focusing on practical measures that might conceivably alleviate the problem of crime among the emulative poor.

If his first chapter (as in *Joseph Andrews*) is on emulation, his second is on the poor's primary way of escaping from the burdens of productive labor, a "New Kind of Drunkenness . . . which, if not put a stop to, will infallibly destroy a great Part of the inferiour People"—that is, gin drinking, which he has "great reason to think, is the principal Sustenance (if it may be so called) of more than a hundred thousand People in this Metropolis" (88–89). Giving examples of the consequences of this "diabolical Liquor," he sounds as if he is recalling the gin-seller's baby in *The March to Finchley,* emaciated and evidently nourished only on its mother's wares: "What must become of the Infant who is conceived in *Gin?* with the poisonous Distillations of which it is nourished both in the Womb and at the Breast" (176). In *Gin Lane* Hogarth shows one mother pouring gin into her baby's mouth and another (the central figure) with exposed breasts that suggest she has been feeding her child, who is falling from her relaxed grip to its death (in a later state Hogarth gave the child a gin-ravaged face).

Fielding shows that one of the causes of the poor's thievery lies with the church wardens and overseers of the poor (discussed in his fourth section) who "are too apt to consider their Office as a Matter of private Emolument, to waste Part of the Money raised for the Use of the Poor in Feasting and Riot"—a point illustrated in Hogarth's *Gin Lane* and *First Stage of Cruelty* by the parish insignia on the arms of two young girls drinking gin and of the young Tom Nero and by the conspicuous absence of the parish officers who should be looking after them.[6] But of what does "looking after" consist? In the terms of Fielding's *Enquiry* it is just one thing, and that is keeping them

employed and out of mischief.[7] Fielding's chief recommendations are
for finding ways "to force the Poor to Industry," and so for stopping
the supply of cheap gin in order "to put a Stop to the Luxury of the
lower People," that is, their idleness (171).

However much he damns the various strata of the governing class,
Fielding is offering small comfort to—and certainly not reasoning
with—the governed. He is, after all, with his genteel ironic tone,
writing to the superior sort, not the inferior. Reading the pamphlet
is beyond their scope, as its cost is beyond their means. And so he
must employ his irony to get at the rich while proposing stronger
laws for limiting the potentials for mischief in the poor, who *can* be
affected by legislation. The laws must prevent the poor's excessive
gin drinking and make them settle down to safe, industrious be-
havior.

While Fielding does not omit the horrible consequences to the
gin drinkers, he emphasizes the consequences to others—the thefts
and murders the gin "emboldens them to commit." In *Gin Lane,*
however, there are no signs of crime, only terrible accidents and self-
destruction. The architectural and human decline is plainly the con-
sequence of drinking gin, but if we look around to see what led to
the gin drinking, we find (besides the distiller) only the pawnbroker
who permits, indeed encourages, these people to drink themselves
to death. The only sign of a parish officer is a man holding a staff
who is assisting in the burial of a woman killed by gin. The only
other hint is the distant church spire, which indicates an absence
rather than an active cause (like the remote dome of St. Paul's in *The
South Sea Scheme,* ill., vol. 1). Whereas in *Industry and Idleness* Tom
Idle rejected the church (Pl. 3), in *Gin Lane* the church has apparently
rejected these people: Hogarth has darkened the picture of society he
projected in 1747. He has chosen St. George's Bloomsbury, the one
London church with a monarch on its steeple (George I, whose
statue was also now in Leicester Fields), and has substituted by a false
perspective the pawnbroker's sign in the foreground for the cross.[8]
This fortuitous grouping (which recalls the absence of *Dieu* from
Dieu et mon droit in *The Sleeping Congregation*) materializes a sign of
the conjoined authority of church, state, and pawnbroker. The three
balls imply that they are a parodic Trinity, beneath which is the cen-
tral group, equally parodic, a Madonna and Child. She, with ex-
posed breasts and syphilitic sores on her legs, is the one example

Hogarth gives to support Fielding's thesis of lower-class affectation: she drops her baby in order to take—elegantly, with a refined gesture—a pinch of snuff. (One wonders whether it was a coincidence that all accounts of Fielding's physical appearance emphasize his excessive snuff taking.)

With this single exception, the poor depicted by Hogarth do not emulate the next class higher but are simply exploited or ignored by that class, which should oversee and (Hogarth's implication) protect them. This was what in effect he had shown happening to the poor from the *Harlot* onward, but now without the old theme of emulative consumption, for these are people who can only afford a pennyworth of gin.[9] Paintings no longer appear in the poor rooms depicted—indeed the scenes have moved outdoors, where property is less well defined. The signs are public—pawnbrokers' signs and church steeples—which indicate society's shirked responsibility for the poor. From the beginning what emulation came down to for Hogarth, man and artist, was a simple contrast between *them* and *us,* and the danger of allowing ourselves to imitate *them* (reflected also in his distrust of academic copying).

Responding, I believe, to Fielding's association of emulation, affectation, and poverty in the preface to *Joseph Andrews* (see vol. 2, 201–2), he had created Tom Idle, who is needy and desperate but not (in Fielding's terms) affected—not ridiculous. By placing him in conjunction with the successful rise in status of Goodchild, Hogarth was daringly testing Fielding's (or probably, more likely, as in *The Distressed Poet,* Pope's) aristocratic definition of the comic—demonstrating that the poor are *not* comic, that indeed it is Goodchild who imitates his master and may be regarded as comic. In Plate 1 he has the examples of Dick Whittington and *The Prentice's Guide* above his loom; in 2 he is in church with his master's daughter, whom he has married by 6; in 4 he joins his master, literally "a step up," in the countinghouse; and in 6 he has his name next to his master's above his door. Idle, the iconoclastic *contra*-emulator, destroys his *Prentice's Guide* and discards his indentures; his only model is the ballad of *Moll Flanders,* which he has tacked to his weaver's frame (and presumably other idle types like himself, people on his own level).[10] In fact, contrasted with the demonstration of *Marriage A-la-mode* that not only merchants but aristocrats themselves affect the poses of the next higher rank, *Industry and Idleness* shows that the one class that does not engage in affectation, that cannot aspire to rise, is the poor.

In the pendant, *Beer Street,* a church steeple is closer and more prominent, its flag indicating George II's birthday (30 Oct.), and he is also manifested front and center in his printed *Address to Parliament,* which is being read by fat, prosperous tradesmen. The king's *Address* offers plans for the "Advancement of our Commerce," which in terms of the metaphor of fat/beer versus thin/gin means making the denizens of Beer Street fatter, physically and economically. The two prints are as much about the absence or presence of royal/ecclesiastical patronage as about the drinking of beer or gin.

If the Trinity of *Gin Lane* was church, state, and pawnbroker, in *Beer Street* the central figures are a butcher, a blacksmith (or cooper), and a pavior, the last holding his phallic tool in close conjunction to his fondling of a pretty young woman—very different from the old hag in *Gin Lane.* But there is another group, the fishwives, who have come all the way from Billingsgate to Westminster in order to sell their fish, and they are *reading* the king's speech. Surely this is Hogarth's memory of Fielding's picture of affectation in *Joseph Andrews* based on literacy: these women in prosperous Beer Street are carrying out an act of affectation parallel to that of the gin-sodden woman in Gin Lane. And adjacent to them (i.e., Billingsgate women in Westminster, *reading*) is the pile of "scholarship" that is destined for a "trunk-maker." The joke can be read either against these Slipslops or against Fielding, who created Slipslop.

The fact is that the government encouraged distillation and sales of gin to support the landed interest (i.e., to encourage the production of spirits distilled from homegrown cereals) and provide itself with revenues. As one historian of gin has concluded, "the rise and decline of gin drinking can be related directly to taxation and legislation."[11] In 1743 Parliament repealed the 1736 Gin Act and adopted a more moderate one, drafted by a prominent distiller of the time. Lord Bathurst's argument was that since it was impossible to prevent the retailing of spirits, it would be better to license it instead, as this would reduce usage by increasing expense and also provide money for England's European wars. The new law, known as the Tippling Act, increased the price of gin, granted licenses only to alehouse license holders, and forbade distillers to retail. But in 1747 the distillers petitioned for the right to retail, and the act was modified accordingly. Once this right was restored to the distillers, gin consumption, which had waned slightly since 1743, rose markedly; drunkenness increased, population declined, and in 1750 a commission reported

that in some parts of London one in every five houses was a gin shop. Whether or not Hogarth had this information, he assumes some such situation when he includes the spire of St. George's in *Gin Lane* and juxtaposes with this print of the emaciated gin drinkers the prosperity of the fat merchants and the royal urge to greater commerce in *Beer Street*. The basic cause-and-effect relationship would be understood by the poor: not that beer drinking leads to prosperity and gin drinking to want, but the reverse. Rather, beer drinking is a product of prosperity and gin drinking of want.

Hogarth begins with the graphic tradition of contrasting views, especially Bruegel's *Maigre* and *Grasse Cuisine,* with a comically neat balancing of fat and lean: the same sort of contrast he had employed between industry and idleness (which goes back to the proverbial figures of Nobody and Somebody).[12] Again a pair of contrasting details is relevant. In the background of *Beer Street* a fat, encumbered upper-class woman is being crushed in her too-tight sedan chair (related to the fat beer drinkers in the foreground),[13] and in *Gin Lane* a poor, emaciated dead woman lies in her coffin. Each woman has two attendants and a box to hold her. (A woman lying in a wheelbarrow being fed gin makes a second parallel to the fat woman in her sedan chair.) Such details may have been overlooked by the audience of responsible citizens to which Fielding addressed himself, but the poor would have seen them straightaway. And once the women are seen as (with the two prints) a pair, left and right, with the logic of Hogarthian reading the fat one asks to be seen as a *cause* of the emaciated, dead one, and so also the fat, beer-drinking purveyors of essential commodities in the foreground. To the prosperous middle class, it is good *versus* evil; but to the poor, this *produces* that. The weight of the fat woman causes the sedan chairmen to pause and drink beer, as the crowd of bulky lawyers causes the hackney coach to collapse in *Cruelty* 2. Corpulence, overeating, and oppression are connected as they were in the City feast of *Industry and Idleness* 8.

The plates convey an implied contrast *and* causality between the state's paternalist duty to regulate on the old mercantilist basis and the new ideal of supply and demand in a free market ("advance our commerce," as the king's *Address* says) which wishes to regulate itself and determine its own level of profit and cost. "Whereas the first appeals to a moral norm—what *ought* to be men's reciprocal duties—the second appears to say: 'This is the way things work, or

would work if the State did not interfere.' " [14] From the point of view of eighteenth-century bread rioters, the second is the man (here the pawnbroker, but any merchant) who seeks private gain at the expense of his own neighbors, who accordingly can only riot or sink into gin and crime. For the poor man of this period, as Francis Place wrote, "none but the animal sensations are left; to these his enjoyments are limited, and even these are frequently reduced to two—namely sexual intercourse and drinking. . . . Of the two . . . drunkenness is by far the most desired" since it provides a longer period of escape and costs only a penny. [15]

Fielding's point about industry is illustrated in Gin Lane by the carpenter who pawns his saw, the housewife who pawns her kettle, saucepan, and fire tongs, to buy gin. Significantly, however, the prosperous folk of Beer Street are shown no more laboring than the dregs of Gin Lane. Hogarth has chosen the moment when they are relaxing with their mugs of beer *following* labor, as those of Gin Lane "relax" with their gin *in place of* labor. Even the workmen repairing the building have climbed up on the roof to rest. Only the painter (whom we shall examine later) and two of the three tailors in the adjacent building, high above Beer Street, are actually working. One of the tailors holds a beer mug while the other two sew: a detail that refers to "those wretched emblems of death and hunger, the Journeymen Taylors," [16] and more specifically reflects the troubles between the master tailors and their journeymen (some seven thousand of them in London) over wages and working conditions, which finally went into arbitration at the July 1751 Quarter Sessions. (Fielding was one of the magistrates who decided in favor of raising the journeymen's wages.) The beer drinking in this case distinguishes the master from his journeymen, whose oppressive working conditions, long hours, and miserably low wages (from 6 A.M. to 8 P.M., with half an hour for lunch and an hour for dinner, at less than 2s a day) may suggest that journeymen labor while their masters drink.

While Fielding's address reaches down as far as the middling sort of people, Hogarth's extends to the inferior sort, the poor wage earners if not the indigent poor—the journeymen and apprentices and indeed the gin drinkers themselves, the denizens of Gin Lane. Fielding questions only an occasional particularly brutal law, but Hogarth's visual images undermine the structure of authority itself. This is partly because there is in visual forms a greater potential for dou-

bleness—or openness—of interpretation. Fielding must address only an audience of the superior sort, and verbal irony is his only weapon against them (or method for instructing them). Hogarth can reach both groups directly, the poor as well as their betters. Both audiences can go to the visual image and take away the aspects they see through their particular preconceptions. But what the rich will see as peripheral irony, the poor will see as central.

There is, of course, the question of how many members of Hogarth's extended audience actually saw his "popular" prints. From *Industry and Idleness* through the prints of 1751 he reduced his price from 3 or 4 shillings to 1 shilling. A shilling was still a sizable sum for the poor, but Hogarth's gesture widened his audience to include the small artisans and journeymen if not apprentices.[17] Moreover, his prints were displayed in taverns, coffeehouses, and other public places, so that for each purchaser dozens of others who could not afford to buy the prints saw them. *Beer Street* and *Gin Lane* were presumably hung in taverns without offending the clientele or reducing the proprietor's sales. In that particular context it would have been most evident that not gin drinking per se but the oppression of the governing class as a *cause* of gin drinking was the real subject of the prints.

Hogarth pointedly announced in his advertisements for the prints that he "publish'd them in the cheapest Manner possible," referring to the light paper and the broad execution. He went so far as to employ John Bell to make woodcuts—the most "popular" print medium—of two of the *Stages of Cruelty* (figs. 7, 10), but the project had to be abandoned because in practice it proved more expensive than copper engraving.

CRUELTY

The most controversial terms of Fielding's *Enquiry* center around "cruelty" and capital punishment. He piously refuses to accept "the general Charge against the People of *England*" of a "natural inbred Cruelty":

> that we are cruel to one another is not, I believe, the common, I am sure it is not the true Opinion. Can a general Neglect of the Poor

be justly charged on a Nation in which the Poor are provided for
by a Tax frequently equal to what is called the Land-Tax, and where
there are such numerous Instances of private Donations, such Num-
bers of Hospitals, Alms-houses, and charitable Provisions of all
Kinds? (98–99)

But cruelty and neglect are emphatically the subject of Hogarth's six
prints. In *Gin Lane* the cruelty is the result of gin drinking, but in
the *Stages of Cruelty* it originates in the neglect of Tom Nero, who
(in Fielding's terms) without work to keep him busy sets the cycle in
motion which ends with his own "cruel" end. Cruelty is what de-
fines not just Nero but "the People of England." Indeed, Fielding
may have been acknowledging Hogarth's prints a year later in the
Covent-Garden Journal of 7 March 1751/52 ("Modern History"): "*If
something be not done to prevent it, cruelty will become the Characteristic of
this Nation.*"[18]

In Book 2 of Gay's *Trivia,* one of Hogarth's seminal texts, the
scenario for the *Stages of Cruelty,* especially Plate 2, had been fore-
shadowed:

> Here laden Carts with thundring Waggons meet,
> Wheels clash with Wheels, and bar the narrow Street;
> The lashing whip resounds, the Horses strain,
> And Blood in Anguish bursts the swelling Vein.
> O barb'rous Men, your cruel Breasts assuage,
> Why vent ye on the gen'rous Steed your Rage? (2.229–34)

And Gay envisions the cruel coachman in another incarnation revers-
ing roles with his horse, as happens to Nero in Plate 4:

> Severe shall be the brutal Coachman's Change,
> Doom'd, in a Hackney Horse, the Town to range:
> Carmen, transform'd, the groaning Load shall draw,
> Whom other Tyrants, with the Lash, shall awe. (239–42)

If the first *Stage of Cruelty* is defined by the absence of the St. Giles
Parish officers, the second is defined by the very bulky presence of
the lawyers whose weight is in fact responsible for the collapse of the
horse Nero is beating. They have crowded in to save a fare (the Thav-
ies Inn sign indicates the farthest shilling fare from Westminster Hall,

the lawyers' destination), and their size inevitably recalls the effect of the fat woman on the sedan carriers in *Beer Street,* and the weight of the prosperous beer drinkers as well. Thus we proceed to the grimly threatening constabulary of *Cruelty in Perfection* and the surgeon-magistrate of *The Reward of Cruelty,* those representatives of the law, the forces from above for whom Nero—as is finally made explicit in his "reward"—serves merely as someone who is not (to use Fielding's phrase) "beyond the reach of . . . capital laws."

However simple in appearance, the four *Stages of Cruelty* are densely interwoven: the "good man" (the Samaritan in his latest incarnation) appears in each plate (though almost lost among the other "good men" in 3); the rill of viscera from the victim in Plates 1, 2, and 3 becomes the length of entrail being extracted from Nero in 4; and the dog who is tortured in 1 returns to lick Nero's heart in 4, while the bird's eye being burnt out with a wire becomes Nero's eye being gouged out by his dissector. The rope is still around Nero's neck, recalling the rope around the dog's neck in 1, and even the bones that serve as legs of the cauldron in which his bones will be boiled recall the bone tied to a second dog's tail. In each plate the movement or gesture of the weapons is from the upper left down toward the lower right of the plate, reinforced by the downward slant of the shadow in 1, the collapsed coach in 2, the pointing arms in 3, and the pointer and disgorging entrails in 4. And if the eye follows this line, at the lower right corner in each case it finds an emblem, the equivalent of the chicks and the pond in *The March to Finchley:* a dog having a bone tied to his tail, a dead sheep, the dead girl, and the bucket of guts, with the dog going at the victim's heart. If the dogs as victim and revenger are connected as the beginning and end of a cycle, the lamb and the girl are juxtaposed in the center of this chiastic structure, as the most innocent and so most vulnerable of creatures.

For the structure is circular. In 4 the "good man" reappears pointing to the skeleton of James Field the highwayman (to indicate the instructive end to which Tom Nero's body will be put), and Field in turn is pointing toward the skeleton of another highwayman, James Macleane, who points back, returning the viewer's eye to the "good man." This diminished circle reflects the larger circle created by the entire series, suggested by the closed but rounded wall of the dissecting theater. In the first three plates a spectator might have hoped

to escape down the roads and alleys that lead into the distance. But we progress through the plates only to end where we began, in a closed circular movement, trapped in a circular room, with the same dramatis personae, the same gestures, the same rill of viscera.

The Reward of Cruelty, by all odds Hogarth's most horrifying image of the law, is an example of the way in which his popular audience would have understood what his more elevated audience only dimly sensed. The popular taboos surrounding human dissection that reverberate in this plate include the possibility of the man's surviving (or being resuscitated following) the hanging, the magically therapeutic powers of a malefactor's corpse, and the ability of the spirit of the dead to return to the living. The Tyburn Riots of the years leading up to 1752, as Peter Linebaugh has shown, were essentially aimed at rescuing the victim's body from the dissectors—a concerted extralegal action by small groups of his friends, relatives, or fellow apprentices.[19] These represented a kind of class solidarity, a set of beliefs, unwritten and of the underclass but as reasonable as those of the "better sort" with which we are more familiar, who thought in terms of the legal system and believed in the medical utility and the penal retribution involved in the dissection of malefactors.

Hogarth makes his statement by representing the chief surgeon in the pose of a magistrate presiding over a condemned malefactor.[20] The Company of Surgeons has made off with Tom Nero's body from the gallows. Only a year later, in March 1752, the law settled the matter by making dissection a part of the official penalty the judge could impose upon certain, though not all, criminals. This law, the "Murder Act," was framed as an immediate response to the Penlez Riots of 1749 (in which Fielding as Bow Street Magistrate played an important role). It is not without significance that the dissector in Hogarth's picture has been traditionally identified as Dr. John Freke, the surgeon who was prevented from dissecting Penlez's body in the cause célèbre that followed his execution—and who did dissect many other criminals.[21]

The happy effect of Fielding's and Hogarth's campaign was the passage of the Gin Act of 1751 (*24 Geo. II,* cap. 40) which, in a relatively short time, reduced the annual consumption of gin in England from eleven million to less than two million gallons.[22] But there was an-

other aspect to Fielding's *Enquiry*, the argument for increasingly severe laws. In Section 10, which presents the case against royal "Pardons," Fielding derides the efficacy of "mercy": "To speak out fairly and honestly, tho' Mercy may appear more amiable in a Magistrate, Severity is a more wholesome Virtue; nay Severity to an Individual may, perhaps, be in the End the greatest Mercy . . ." (164). He is referring to the exemplary nature of punishment—what he calls "the Dread of a sudden and violent Death" without any hope of a pardon that would encourage criminals to commit more crimes. In Section II he turns to the "terrors" of the execution, which, for maximum effect on the prisoner but especially on the public, should be carried out without delay and witnessed only by the magistrates who condemned him—without a public spectacle of the sort Hogarth represented in *Industry and Idleness* 11.[23] But if not spectacular, Fielding's execution *is* theatrical, based on the offstage murder of Duncan in Shakespeare's *Macbeth* (an Englishman's play about dynastic problems which could allude to the Forty-Five) acted by Garrick.[24]

Hogarth sets up *The Reward of Cruelty* as if it were a theatrical performance. But he has shifted his emphasis from Nero to the Overseers of the Poor and to government in general, which not only permits Nero to commit his first act of cruelty but clearly enjoys this final drama of *lex talionis*.[25] There is no other conclusion to be drawn than that Hogarth is submitting Fielding's terms—"mercy," and the Aristotelian "pity" and "terror"—to analysis, asking us to regard them not in Fielding's legal context but in the context of contemporary literary works (also in the shadow of the Forty-Five) such as Collins's odes to Mercy, Pity, and Fear, and of Fielding's own earlier literary works and of all Hogarth's graphic works.[26] Hogarth is criticizing the idea of capital punishment as vengeance but also as salutary admonition, as advocated in all its theatricality by Fielding.

Fielding was widely regarded by contemporaries as a stern magistrate, quite at odds with the advocate of good nature and forgiveness who wrote *Tom Jones*. The caricatures of him as magistrate, as Martin Battestin notes, included "his stern and arrogant demeanor on the bench, his habit of declaiming with his jaws crammed with tobacco, his way of favoring the rich and great while bullying the lower classes."[27] If we are to accept Battestin's identification of a profile in pencil and red chalk (fig. 12) as Fielding at this time (and the resem-

blance to Hogarth's authentic portrait of the young Fielding, fig. 11), we must note the close resemblance between its features and those of Hogarth's chief surgeon, whom he presents in the position and pose of a magistrate: the same long overhanging nose, the same receding, probably toothless mouth and protruding jaw.[28] James Field, a pugilist and ex-sailor, whose name appears above one of the displayed dissected skeletons in *The Reward of Cruelty,* had been examined by Fielding before being tried, convicted, and hanged for robbery.[29] And his skeleton—like Macleane's—could be construed as pointing to the surgeon-magistrate.

There is also the contemporary evidence of Samuel Johnson's response to Fielding's *Enquiry* in *Rambler* No. 114 (20 Apr. 1751), though characteristically without naming names. He is referring to Fielding when he says that "some are inclined to accelerate the executions; some to discourage pardons; and all seem to think that lenity has given confidence to wickedness, and that we can only be rescued from the talons of robbery by inflexible rigour, and sanguinary justice" (243–44). Johnson's argument is for mercy in the particular sense that crimes of theft and murder should not equally deserve capital punishment. But the characteristic Johnsonian sentiment comes in his reference to Herman Boerhaave's remark that "he never saw a criminal dragged to execution without asking himself, 'Who knows whether this man is not less culpable than me?' On the days when the prisons of this city are emptied into the grave, let every spectator of the dreadful procession put the same question to his own heart" (242).

Although Hogarth does have Nero (unlike Idle) commit murder as well as theft, it is presumably to focus on capital punishment while avoiding the added issue of murder-or-theft. He is nevertheless closer to Johnson, whose wisdom he was praising in the 1750s, than to his old colleague Fielding.[30] And in this sense, his engraving of *Paul before Felix,* announced in May, could be seen as a seventh plate following *Beer Street, Gin Lane,* and *The Four Stages of Cruelty:* here the magistrate is wicked, the accused is innocent, and the accusers are corrupt. The story of Paul and Felix was conventionally used to show the tables turned on the magistrate as the innocent defendant (here charged, interestingly, with another Fielding bête noire, inciting to riot) directs the accusation against his judge. The magistrate will reappear in 1753 in the first plate of *The Analysis of Beauty,* joining the severity of capital punishment with stupid judgments of taste,

embodied in the "square," both a symbol of correct form and a gallows (fig. 22).

There is no indication of friction between the two friends. Fielding continues to cite Hogarth. In *Amelia* Dr. Harrison, who has never "read a word of" either Dryden or Pope, knows and reveres Hogarth's graphic works. But Harrison's significant remark is that Hogarth's prints are worth more than *The Whole Duty of Man* (which recalls Edward Young's remark that *Clarissa* is "The Whole Duty of Woman"): Fielding now reads Hogarth's prints as graphic *Amelias*, anticipating the solemnity of Trusler's *Hogarth Moralised*. In any case, friendly remarks continue to appear in the *Covent-Garden Journal* (1752) and Fielding's final work, *The Journal of a Voyage to Lisbon* (1754). If Hogarth's six prints were in some sense a critique of Fielding, it was of Fielding the "magistrate," only one aspect of the "man" (Fielding's own term) who wrote *Amelia*. And if the stern visage of the presiding surgeon was meant to suggest Justice Fielding, Hogarth's ultimate image of his old friend was the younger, smiling face in the frontispiece to Fielding's *Works* of 1762 (fig. 11).

Hogarth, it is important to remember, expressed his radicalism only in images, never in words. In words, he spoke the language of the magistrates and the moralists. When he wrote of *Beer Street* and *Gin Lane* in his "Autobiographical Notes," he said they were presented as a contrast "where the invigorating liquor [beer] is recommended in order to drive the other [gin] out of vogue." In Beer Street "all is joyous and thriving. Industry and Jollity go hand in hand." At the same time he explained that the *Stages of Cruelty* was made specifically "in hopes of preventing in some degree that cruel treatment of poor Animals which makes the streets of London more disagreeable to the human mind, than any thing whatever, the very describing of which gives pain."[31]

He says he would rather have been the author of the *Stages of Cruelty* than the Raphael Cartoons, "unless I lived in a roman Catholic country." But when he repeats the statement on another page he adds significantly that "[I] speak as a man not as an artist."[32] What he means, of course, is that his kind of Protestant country calls for a different kind of "history painting"—one without superstition, which must be based on the public's benevolence, charity, and the virtue of works. The facts that while these six engravings were printed "in the cheapest Manner possible," some were "printed in a

better manner for the Curious" and on a better grade of paper (at 6*d*
more), and that Hogarth was at the same time working on the en-
gravings of the sublime history paintings of *Moses* and *Paul,* draw
our attention to the aesthetic dimension of these popular prints.

If he was not a moralist, his works the equivalent of *The Whole
Duty of Man,* then what was he? The answer lies in the treatise he
was now planning, *The Analysis of Beauty,* where he describes the
aesthetic purpose of the artist, as well as the aesthetic response of the
spectator, which can be summed up in the word "play." For Hogarth
aesthetics represents a step beyond the "modern moral subject"
which also explains retrospectively how in fact those earlier works
operated and the particular sense of morality they embodied.

In Beer Street, the microcosm of prosperous and respectable Lon-
don, the one thin shabby person besides the pawnbroker is the artist.
(Hogarth may have replaced the cadaverous Frenchman, being lifted
into the air by the fat Beer Streeter, with a leg of beef because he did
not want to confuse the issue of the underfed artist with an underfed
Frenchman [fig. 1].) He is observing that the artist remains outside
the national prosperity, however great, and can earn money only by
painting shop signs. No one in Beer Street can paint; an artist has to
be imported from Gin Lane. He is employed only to paint a sign ad-
vertising beer; he is so poor that he has only a gin bottle as a model;
and he is completely ignored by the Beer Streeters. As opposed to
the corpulent burghers drinking beer, whose shapes will reappear as
examples of the grotesque and ugly in *The Analysis of Beauty,* the
artist, though thin and ragged, as he leans back to admire his work,
makes a Hogarth Line of Beauty and holds up an artist's palette of
the sort Hogarth has by this time made his trademark. He is in fact
(besides the two journeymen tailors) the only person actually en-
gaged in work.

Hogarth is joking about the conflict, which was central to the
Shaftesburian discourse of civic humanist aesthetics in the period,
between art and commerce. The painter, in the midst of prosperous
commerce and commodity exchange, is the case of Shaftesbury's la-
borious "mechanic," not a true "artist." The presence of the schol-
arly detritus is explained by the basic commercial law of supply and
demand. On the positive side, Lockman's *New Ballad on the Herring
Fishery,* a proposal for fostering national fisheries, can be related to
the English artist returning to his roots by painting signboards of

English rural life; on the other hand, the books being carted away as junk by the people of Beer Street deserve their fate. George Turnbull's *Treatise upon Ancient Painting* (1740), a book that has been described as a summary of Shaftesburian aesthetics, had extended Old Masterism into a whole new area, the paintings of the Greeks and Romans themselves, of which, however, so little survived, and in such ruinous condition, that Turnbull's argument rested on the descriptions of ancient writers.[33] According to Turnbull there were two great ages of painting—of Apelles and of Raphael, though of course no paintings by Apelles survived. Apelles, Turnbull argued, was excelled as a colorist by Zeuxis as Titian excelled Raphael, and he systematically paralleled Apollodorus and Giorgione, Parrhasius and Correggio, and so on. There was no chance, Hogarth would have noted, to *look at* the ancient paintings, which only appeared in engraved reconstructions at the back of the book, with in some cases hypothetical colors indicated by numbers and a key underneath.

"Hill on Royal Societies," "Modern Tragedies," and "Politicks vol. 999" are other examples of uselessness that link art and politics.[34] But the presence of William Lauder's *Essay on Milton's Use and Imitation of the Moderns in His "Paradise Lost"* (1750) requires a fuller explanation. Lauder had claimed that Milton in *Paradise Lost* had plagiarized neo-Latin, that is, "ancient" writers; whereas, as was presently revealed by John Douglas, Lauder himself had taken these quotations from a Latin translation of *Paradise Lost* and pretended they were Latin poems that temporally preceded Milton. Lauder's *Essay* is as utterly useless a book as Turnbull's *Ancient Painting,* and with a similar thesis preferring the ancients to the moderns. The originality of the native English poet Milton, despite his detractors, is probably the main function of the reference to Lauder's *Essay.*[35]

Beer Street, however responsible for the evils of Gin Lane, is nevertheless (Hogarth is saying) all that English artists and writers have to work with, and the future lies in national fisheries and projects that link art and commerce, which indeed he will himself explore in the succeeding years, and not in an attempt to recover classical art and its manner.

The six plates must be regarded as another phase of Hogarth's search for a kind of contemporary history, this time in popular, folklore roots (emblematized within the set as a signboard), and in a stark simplicity and monumentality that none of his earlier prints achieved. In

Cruelty in Perfection (fig. 6) the girl's wounds resemble "poor, dumb mouthes" crying for justice—a providence that invokes John Reynolds's *Triumph of God's Revenge against the Crying and Execrable Sin of Murther* (ca. 1621) and anticipates Fielding's *Examples of the Interposition of Providence in the Detection and Punishment of Murder,* published in 1752.[36] These tracts show the powerful effect of simplification and expressive form that leads to the large woodcut Hogarth commissioned from Bell (fig. 7), for which he changed proportions from the engraving, enlarging and simplifying parts (the bat, the lantern), removing the man's head on the left, the face immediately to the left of Tom Nero, and the topiary tree at the far right.

The expressivity of popular art does not end with the artist's shop sign; it descends (or, if regarded magically, or as a popular idiom, ascends) to the graffiti of Plate 1 which desires and projects the hanging of Nero. In the *Stages of Cruelty* the popular prints have come into their own as modern history, complementing the conventional *Moses* and *Paul* prints published later in the same year.

The Reward of Cruelty is, in these terms, a reprise of the image of unveiling in *Boys Peeping at Nature,* which ushered in *A Harlot's Progress.* Fielding had, in fact, introduced this image into his recommendations for private executions; they should be solemn but *veiled*—unseen by the public: "Those [Priests] of *Egypt* in particular, where the sacred Mysteries were first devised, well knew the Use of hiding from the Eyes of the vulgar, what they intended should inspire them with the greatest Awe and Dread."[37] Isis was, of course, the Egyptian version of Ephesian Diana, the many-breasted figure of Nature used by Hogarth. But presented in *The Reward of Cruelty* as a final, rather than introductory image, the lifting of a skirt to see the female pudenda has become the more radical dissection of a body, no longer female but male. (The mediating woman is recalled only by the faithful lover whom Tom Nero murders.) This aesthetic of dissection, perhaps inspired by the strangely aesthetic terminology Fielding employs in his section on the "terror" of executions, was materialized a year later when in *The Analysis of Beauty* Hogarth refers to "the case of intestines, none of them having the least beauty, as to form, except the *heart;* which noble part, and indeed kind of first mover, is a simple and well-varied figure."[38] There Hogarth returns to Isis and Egypt (also Cleopatra) and, beginning with the word "penetrating" (recalling Addison's readers "of greater penetration"), he shows

much concern with clothing and the body under the clothes, the muscles and bones under the skin, and the implicit (and once explicit, 56) notion of the artist as anatomist.

Indeed, Hogarth's strange theory based on the model of a shell for the human body recapitulates the dissection of *The Reward of Cruelty.* He is probably recalling Addison's account of a dome and a square pillar in *Spectator* No. 415 (one of the "Pleasures of the Imagination" essays): "Look upon the Outside of a Dome, your Eye half surrounds it; look up into the Inside, and at one Glance you have all the prospect of it." This is essentially Hogarth's way of visualizing a whole figure from a single side or part of it; but his vocabulary is of "scooping out," in effect eviscerating or anatomizing what Addison referred to as "Figures of Bodies." Of course, it was Swift's "Last Week I saw a Woman *flay'd,* and you will hardly believe, how much it altered her Person for the worse" that ultimately inspired *The Reward of Cruelty,* whose power derives from the dilemma of whether to strip away or plaster over, analyze or conceal, reason or retire into the mercy of happy illusions.[39]

THE REMBRANDT HOAX

In the world of high art, the rage for Italian paintings had picked up after the Treaty of Aix-la-Chapelle in 1748, once again at the expense of English artists. A satiric notice printed in the *London Evening Post* sounds like Hogarth or one of his friends (16–18 Apr. 1751):

A Painter who had been kept in the House of Mr. H. Furnese for some Time, for the meanest Purposes, and paid by the Day for his Labour, took it into his Head, a few Weeks since, that he could do something like what other Painters had been famous for. He sat down to copy the Liberality and Modesty of Guido, in that Gentleman's Possession, and has produced what the Connoisseurs all allow to be an amazingly great Picture. One of the Figures is very little inferior to Guido's own; the other, which he did first, is somewhat less perfect; but even that might pass for a Guido at a modern Auction. In France, one Proof of Merit like this would make a Man happy for Life; we hope it will prove so, on this Occasion, in England.

Henry Furnese owned Guido's *Liberality and Modesty,* and indeed at about this time the young Robert Strange did copy it, announcing an engraving in 1754 and publishing it a year later.[40]

There is also the story (which must refer to 1749) about a caricature Hogarth circulated on the death of his friend, the painter Joseph van Aken (who had accompanied him on his trip to the Continent the year before). This design, which has not survived, is said to have represented van Aken's funeral procession, "composed of all the portrait painters of the metropolis as mourners, and overwhelmed with the deepest distress."[41] His death deprived at least Hudson and Ramsay of the skilled craftsman who supplied all but the heads and general compositions of their portraits.

The most celebrated of the satires on artists and connoisseurs in which Hogarth took part was in progress in the spring of 1751. While Italy was the prized source of paintings of the sublime sort, there was also a strong market for Rembrandt's etchings. Already eagerly sought after in the 1730s, when Pond was so devoted a collector that he took Dutch lessons and attempted in 1747 to etch a portrait of Dr. Mead in the Rembrandt manner, the demand had grown to large proportions by 1750.[42] They had become (to quote Vertue) "much esteemed and collected at any price. some particularly sold at sales very extraordinary"; and collectors fought for "the wild scrabbles skratches &c. done by him or thought to be done by him" (3: 159). In 1751 the first catalogue of Rembrandt's etchings appeared (compiled by Gersaint), and in 1752 an English translation followed.[43]

Benjamin Wilson, one of the St. Martin's Lane artists, reminiscing some years later, recalled that he was himself "an enthusiastic admirer of Rembrandt's works and a successful student of his style and manner."[44] At a sale he bid up to £10 for a Rembrandt drawing, which however went to Thomas Hudson (a student of Jonathan Richardson, another Rembrandt admirer), who afterward "expressed himself *very uncourteously*" to Wilson for having forced him to pay more than he had intended. (Since 1750 he and Hudson had been neighbors in Great Queen Street.) Wilson "restrained his resentment, but determined on taking a pleasant revenge." This retaliation, Wilson later recalled, telling the story to Benjamin West, stemmed from his knowledge that "Hudson upon all occasions maintained, that no one could etch like Rembrandt,—here he was right—that no one

could deceive him, and that he could always discover an imitation of Rembrandt directly he saw it." [45]

Thus Wilson began by copying a rare etching called "Companion to the Coach," then attributed to Rembrandt but now to Philips de Koninck or some other (fig. 13). He claimed to have copied it from memory, but he spent a great deal of labor on duplicating the India paper used by Rembrandt, which he discovered was made by pasting together and pressing more than one sheet. He later embroidered this story by asserting that "one evening" he "scratched a landscape, and took a dirty impression of it." He wrote the title "Companion to the Coach" on it in Dutch and included it in a portfolio with some genuine Rembrandt etchings that were shown Hudson by a Dutchman:

> Mr. Hudson immediately purchased it for 6s. and told Mr. Herring, nephew to the Archbishop of Canterbury, and others, that it was 'the best piece of perspective,' and 'the finest light and shade that he had ever seen by Rembrandt.'
>
> Wilson communicated the success of his scheme to his friend Hogarth, 'who,' he says, 'loves a little mischief.' Hogarth persuaded him to repeat the experiment and try its effect with Harding the famous printseller, who had the reputation of being a first-rate connoisseur.

This sounds like Hogarth, shifting the satire from a painter to a dealer. Wilson then etched an old man's head, which he dispatched by the same Dutch go-between to Harding. After a short examination, Harding paid the 2 guineas and threw in a bottle of wine, urging the Dutchman if he came upon any more to let him have first choice. The pair took a few others into their confidence and proceeded to gull such notables as Lord Duncannon (afterward Lord Bessborough, also a Hogarth collector), Arthur Pond, and Dr. Charles Chauncey—"all supposed connoisseurs of Rembrandt's works."

In Wilson's account of the story to Benjamin West, he says that when he discussed the gulling of Hudson with Hogarth, "D—n it," said Hogarth, "let us expose the fat-headed fellow." Wilson took the hint, spent the money he had obtained by his fraud on a supper to which he invited ("without telling any one what I meant to do") twenty-three artists, including Hogarth, Scott, Lambert, Joshua Kirby, and of course Hudson, telling them it was to be an "English roast" (i.e., a piece of meat and a satiric exposure):

Hogarth sat on his right, Hudson on his left. The chief dish at table
was a large sirloin of beef; 'decorated,' he says, 'not with greens or
with horseradish, but covered all over with the same kind of prints,'
which he had sold.

When the cold sirloin was first viewed, Scott, who came in behind
Hudson sang out, "A sail! a sail!"

Mr. Hudson would not at first believe that he had been taken in; but
'Hogarth stuck his fork into one of the engravings, and handed it to
him.' Wilson also produced his portfolio full of the engravings in vari-
ous stages of progress.

"What did Hogarth say, Sir?" asked Benjamin West, when he heard
the story. "He! an impudent dog! he did nothing but laugh with
Kirby [a crony from Ipswich of whom we shall be hearing more] the
whole evening.—Hudson never forgave him for it."

It had been expected that Hudson would see the joke and join the
crowd, but he "took serious offence, and again expressed himself
uncourteously." Wilson responded by telling him that he was therefore
determined to publish the prints and publicize the folly of both Hud-
son and Harding, painter and dealer. Accordingly the *General Adver-
tiser* for 7 May carried Wilson's advertisement:

> *On Saturday next* [i.e. 11 May] *will be published,*
> TWO PRINTS, in Imitation of Rembrandt, designed and etched
> by B. Wilson, which were purchased by two very great Connoisseurs,
> as curious and genuine Prints of that Master, and at a considerable
> Price.
> Soon will be published some others, taken from Mr. Wilson's own
> Paintings, and etched in the same manner.
> ☞ Those Gentlemen who are curious, and would be glad of
> Variations, and upon India Paper, may have them by applying to
> Mr. Wilson, at his House in great Queen-street, near Lincoln's-Inn-
> Fields.

The landscape sold for 6*d* and the head for a shilling, and "so great
was the demand that both plates were almost entirely worn away by
frequent printing."

Hogarth had evidently taken stock and used Wilson's hoax as an

opportunity to make his own statement on the subject of the Dutch style, the rage for dark prints, and at the same time usher in the publication of his own history paintings of the last few years—seen in situ by many Londoners and, he calculated, worth further disseminating in engraved copies. He must have planned this as soon as the hoax began (it is possible that his plan prompted the hoax), because only two days after Wilson's advertisement, on 9 May, there appeared in the same paper:

> MR. HOGARTH proposes to publish by Subscription, Two Large PRINTS, One representing *Moses* brought to *Pharaoh's Daughter;* the other, *Paul* before *Felix;* engraved after the Pictures of his Painting, which are now hung up in the Foundling-Hospital and Lincoln's Inn Hall. Five Shillings to be paid at the Time of Subscribing, and five more on the Delivery of the said Prints.

Then he adds, alluding to all that has gone before:

> For the first Payment a Receipt will be given, which Receipt will contain a new Print (in the true Dutch Taste) of *Paul* before *Felix.*
> N.B. The above two Prints will be 7s. 6d. each after the Subscription is over, and the Receipt Print will be sold at a very extraordinary Price.

He is referring to his brilliant Rembrandt parody (fig. 14), a print that probably brought in many subscriptions. It was so popular that by 1 June he had changed the wording to "will not be sold for less than One Guinea each." As his patrons recognized, here was something much more delicious "in its way" than the solemn engravings that were in progress. He goes far beyond Wilson's careful imitation to a general burlesque of the Rembrandt style—with dark mezzotint tone, wonderfully scratchy lines, and a blowsy female representing Justice. He may have had Rembrandt's *Christ before Pilate: The Large Plate* specifically in mind, but he comes closer to the spirit of his source than any of the more pious imitations of his day.[46] The low Rembrandtesque content (a dog relieving himself in *The Return of the Prodigal Son,* a boy in *The Rape of Ganymede*) is objectified in "Felix trembled" by showing the governor soiling himself in terror at Paul's words.

The scatological humor and discomforts of the body were also to be found in Smollett's "satiric" embellishments in *Peregrine Pickle*. As a satirist, he "disgraced" (one of his favorite words) Hogarth/Pallet by describing the physical consequences of his cowardice, seasickness, and so on. These, along with Pallet's secret love for depictions of dung, comprised Smollett's way of exposing Hogarth's "artistic pretensions." But then Hogarth, who was probably already planning to engrave versions of those history paintings, followed in May (three months after *Peregrine Pickle* was published) by parodying the Dutch taste, by which he meant Rembrandt in art and Smollett in literature. Thus he places a Felix who bears a resemblance to contemporary portraits of Smollett in a context of body functions to introduce his retellings of the *Paul before Felix* and *Moses before Pharaoh's Daughter* stories, which Smollett had alluded to as stories of Cleopatra and Solomon.[47] The artist and novelist were, in the long run, similar in many ways, from their northern origins to their popular imagery and sardonic satire. This was, of course, true of Hogarth and Rembrandt as well, and the purpose of the print was to prevent anyone from mistaking his style for that of his Dutch precursor.

POLITE PRINTS: REPRODUCING HISTORY PAINTINGS

Paul before Felix Burlesqued, independently a high point in Hogarth's oeuvre, nevertheless was made to fit into a sequence: (1) The original painting of *Paul before Felix* (ill., vol. 2, fig. 132), completed in 1748, was Raphaelesque in composition and execution, but in elaboration and detail it recalled Rembrandt. This is the painting that now hangs in the Great Hall of Lincoln's Inn. Sometime between 1748 and 1751 Hogarth must have completed at least a pencil copy (Pierpont Morgan Library) before the painting was turned over to Lincoln's Inn, and at some later date made (2) his own engraving (fig. 15). At a council held on 13 February 1748/49 it was "Ordered that Mr Hogarth be desired to send home the picture, and that it be placed in the Council Room till further Order."[48] The author of the *Student's Guide* writes that it was not hung in its permanent position in the Great Hall until 1750.[49]

The main change in his engraving was to omit the SPQR banner and the pillar that stands in the painting behind Tertullus, filling in this area with a deep perspective and more figures. The pillar had probably been part of the original composition in order to anchor the left side; but when Hogarth engraved it, and so reversed the composition, he found that it worked better to let the distance recede behind Tertullus's back and so subordinate the whole scene to the figure of Paul looming front-left. The undertaking of the engraving may have exposed the Rembrandt elements in the painting: without the delicate coloring they would have become more apparent. This discovery then may have led Hogarth to keep the engraving to record his work, while revising the painting itself.

(3) At a council of 26 February 1751 it was "Ordered that Mr Hogarth be at liberty to take the picture and retouch it, if he think proper, before it be framed." And in the margin, but undated: "Retouched accordingly." It is not clear whether there had been some difficulty about the framing. The retouching, however, was extensive: Hogarth eliminated figures and filled space with large areas of architecture in order to narrow the action to the main performers (ill., vol. 2, fig. 133).[50] The effort was toward a more austere and classical composition based on many prominent Lines of Beauty. (This was the painting as seen at Lincoln's Inn until it was overzealously cleaned in 1970).[51]

Rembrandt's history paintings (as opposed to his etchings and his portraits) had little impact on English artists with the ambivalent exception of Hogarth—from *The Pool of Bethesda* to *The March to Finchley*.[52] An undated caricature shows Hogarth making formal obeisance to Raphael while his real allegiance is to Rembrandt. An ape is painting "Moses striking the Rock," a Rembrandtesque picture, and exclaims, "A marvelous effect by G-d." Nearby is a book, "A Journal of my travels from Rome to Rotterdam I had the supreme happiness of touching Raphael SCULL that divine SCULL."[53] The juxtaposition of the Rembrandt, Hogarth, and Raphael versions of *Paul* seems to have been Hogarth's aim in the series of engravings he projected.

(4) In May 1751 he took the further step of issuing his burlesque ticket which inaugurated his subscription for the engravings of the sublime histories of *Paul* and *Moses*. The burlesque makes clear what he regarded (or felt he should regard) as excesses in history painting of the Rembrandt school, and implicitly in his original painting (1)

of *Paul before Felix* as it appeared to him by this time and in his engraving of it.

The burlesque was so popular that by December 1751 he was selling it independently and had replaced it as subscription ticket yet once more with (5) *Boys Peeping at Nature* (fig. 17), which he had used each time he broached a new area of subject matter for his art. First he had used it for the *Harlot's Progress,* a "modern moral subject" or "comic history-painting," second for the pastoral-georgic mode in *The Four Times of the Day,* and now for the sublime histories based on religious subjects. In this third case he significantly revised the design itself, erasing his inscriptions from Horace and Virgil, giving Nature a straighter, more classical headdress, and removing the faun lifting her shift. The first of a series of such revisions of earlier prints in which the erasure is the point (the earlier version will, of course, also appear in the collector's Hogarth folio), this print proclaimed that he was no longer concerned with gross contemporary reality, but with aesthetic as well as moral affairs, pointing toward *The Analysis of Beauty.* Whereas the modest putto had previously been restraining the faun, he is now alone—without any alteration in his pose—and supports a panel showing Nature's head and shoulders only (unlike the Isis–Diana, her breasts are chastely covered), sketched in an oval with a few curving lines. Simplicity, abstractness, and timelessness are the qualities expressed in the panel. The new subscription ticket says in a different way what the burlesque ticket said: this will be a history treated with modesty (*pudenter*).

(6) The revised painting of *Paul before Felix* was engraved not by Hogarth himself but by Luke Sullivan, who employed a smoother, more simplified and classicized style than he had used when engraving *The March to Finchley.* In this version Hogarth went so far as to omit the figure of Drusilla altogether (fig. 16). Her deletion was not only to censor a Rembrandt detail (Paul's hand covering her pubic area) but to further simplify and classicize the design into the best approximation to the Raphael ideal of history painting as Hogarth seems to have understood it. As in the engravings of *Marriage A-la-mode,* where the style was to be French, he left the hypothetical projection to another engraver.

One impression of Hogarth's own version of the engraving carried his manuscript inscription, "A print of the plate that was set aside as insufficient. Engraved by W.H."[54]—suggesting that this composition

represents an earlier unsatisfactory stage of the design compared to Sullivan's. There is no mention of his own engraving in the advertisements for the subscription, which presumably distributed only Sullivan's. The first mention of the alternative version as for sale was in an advertisement for *The Cockpit* of 1 December 1759 (*London Chronicle*), when Hogarth replied to Joseph Warton's remarks on his use of Rembrandtesque devices in his history paintings by engraving Warton's slighting and erroneous words on the bottom of *both* plates and issuing them as a study in comparison. The advertisement announces "another Print, Price 5s. of PAUL before FELIX . . . different in Composition, but of the same Size with the former [Sullivan's], and engraved by WILLIAM HOGARTH."

It is important to indicate the careful steps Hogarth took—characteristic of him—in order to demonstrate his transition from less to more classical and simplified forms, in effect from Rembrandt to Raphael, but also from comedy to tragedy, analogous to the transition he had demonstrated on the popular level in the six prints of February 1750/51. He has produced a new kind of serial progression, significantly different from the "progresses" of the 1730s and 1740s: alternative versions or retellings of the same story, the way Raphael or Rembrandt would have told it, which make aesthetic rather than moral points. The principle of variations in this series would be further evident in the variations of states Hogarth included in the folio collections of his prints (apparently extending to minuscule variations for avid collectors).[55]

The difference between the histories of the 1740s–1750s and the St. Bartholomew's Hospital paintings of the 1730s lies less in the paradigms of action or composition than in the reduction of detail and the simplification of the reading structure. Hogarth would have known two of Serlio's plates, stage sets for Tragedy and Comedy: one is a symmetrical and subordinated structure, an ideal classical town; the other is an irregular collection of buildings, some with Gothic or rustic details. In the latter lies an answer to why Hogarth's earlier works are not tightly unified, why they are in some sense incoherent: they are, by that convention, comic works. When he made the St. Bartholomew's Hospital pictures he was not yet willing to accept this decorum, but by the late 1740s and 1750s he was producing a relatively simplified composition in *Garrick as Richard III* followed by *Moses Brought to Pharaoh's Daughter* (fig. 18). *Paul before*

Felix, in its various versions, dramatizes the transition to *Sigismunda* (fig. 54); indeed Hogarth was attempting to convert a comic scene into a scene of tragedy or, in different terms, a complex rococo structure into simple classicizing forms.

To judge by Vertue's notation that Hogarth "got a good subscription" for his "two prints from paintings" (3: 156), there was no falling off in his popularity, and it is plain that the burlesque ticket was a great success. But the conjunction of Hogarth's and Fielding's reputations at this time, if it had no immediate effect, was to have a significant one a few years later. What had intervened between the subscription and delivery of the *Paul* and *Moses* prints (spring 1751, spring 1752) was the publication of *Amelia* on 19 December. The failure of *Amelia* undoubtedly affected the reputation of Hogarth as well. Fielding was seen, even by sympathetic readers, as having ventured beyond his proper preserve into foreign territory. His reputation was at its highest after *Tom Jones;* but, coupled with Lucian, Cervantes, Erasmus, and Swift, he was "the *humourous* Mr. Fielding" or "one of the greatest Genius's *in his Way,* that this, or perhaps any, Age or Nation have produced" (emphasis added).[56] In 1750 this was fairly much the reputation of both Fielding and Hogarth. Then came *Amelia,* which Fielding himself referred to as "my damned book (for so it is)."[57] The criticism was of not only its sentimental vein, its attempt to rise to the serious if not sublime, but also its dealing with low subjects with an unaccustomed frankness, and its socio-political commentary: all aspects that could have been detected by an unsympathetic critic in *Moses* and the earlier versions of *Paul.*

One of the criticisms of *Amelia* was of its obviously autobiographical association of Booth with Fielding and of Amelia with his late wife Charlotte. We have seen a similar tendency in Hogarth's *Industry and Idleness* of 1747, followed by *The Gate of Calais* in the next year. In *Paul before Felix* the protagonist—the prisoner, St. Paul—is implicitly William Hogarth the artist, who by this time seems to be regarding himself, or the English Artist, as the Saul/Paul of English society, carrying his message of conversion as he attacks the idolatrous and avaricious. The conversion has to do with the role of the artist freeing English painting from "ancient" art and the Continental tradition. The satire on avaricious idolators, the moral half, has picked up an aesthetic significance: the judge is now the connoisseur or critic of art to whom Hogarth was by this time addressing himself in *The*

Analysis of Beauty. In the *Paul before Felix* series of engravings Hogarth was offering his subscribers a judgment—an easy one between his *Paul before Felix* and the Dutch "scratches" he parodied in his etched "Burlesque" of Rembrandt, and a more difficult one between his own engraving of *Paul before Felix* and the chaste, neoclassical version he had prepared and had engraved by Luke Sullivan. Paul, the patron saint of London, is of course only the final summation of Hogarth the true English artist ("Anglus"), seen earlier as a dog, child, prisoner, harlot, or other outcast. *Moses* as well as *Paul* shows a judgment, but while the victim is helpless in the first, he is powerful and victorious in the second—victorious through his rhetoric and moral strength (with no assistance of divine intervention).

Hogarth had by this time opened virtually every possible form of history painting to his fellow English artists. A few, like Hayman, had pursued the historical illustration with some success. Hayman, indeed, is usually described in contemporary accounts as the paramount English history painter, presumably for his large pictures at Vauxhall, which continued to appear regularly through the 1750s, and were capped in 1760 with his four huge scenes from the Seven Years' War hung in the "new music room" adjoining the Rotunda. Hogarth had opened up the Foundling Hospital and kept the tradition going himself through all the lean years. When he engraved his *Paul* and *Moses* he was on the verge of the great age (in terms of quantity if not quality) of English history painting.

In 1758 Gavin Hamilton's *Andromache Mourning the Dead Hector* was commissioned, demonstrating another way of securing patronage for this kind of painting. Working in Rome, Hamilton realized that "only at Rome, under the influence of the temporary enthusiasm for Antiquity produced by the Grand Tour, would the traveling British patron be likely to commission the sort of picture he wanted to paint." He furthered this idea by making package deals with English connoisseurs who were buying antiquities from him: included in the bargain would be one of his own history paintings, which served as large mementoes of antique reliefs.[58] But Hamilton's first characteristic histories were begun in 1753, after a visit to London when he could have seen both the originals and the engravings of Hogarth's *Paul* and *Moses*. His stylized Homeric paintings, dependent on linear, planar compositions with heavy emphasis on horizontals and perpendiculars, established the official neoclassical line of descent from

Nicolas Poussin to Jacques Louis David. And this was appropriately accomplished by their Hogarthian distribution in engravings.

THE SALE OF THE *MARRIAGE A-LA-MODE* PAINTINGS

Times were changing and some things were coming to an end. The great burst of the comic histories was over, and the period of the sublime histories was being memorialized in engraved copies. Now the paintings of the last and most ambitious of the comic histories were to be sold. The announcement of the subscription for *Moses* and *Paul* had a last paragraph which, beginning with the cut-off date of the subscription, went on to announce a new auction:

> Subscriptions will be taken till the 6th of June next, and no longer, at the Golden Head in Leicester-fields, where the Drawings may be seen, as likewise the Author's six Pictures of *Marriage A-la-Mode,* which are to be disposed of within the said Time, by a new Method, to the best Bidder.

During the last half-dozen years the fate of the *Marriage A-la-mode* paintings had been shrouded in silence. At the time of the first auction of paintings, Hogarth had said he would sell the series as soon as he had finished with the engravings. But no buyer seems to have materialized. His friend Christopher Cock exhibited it in his auction rooms for some time—perhaps up to the time of his death on 10 December 1748.[59]

It is clear that Hogarth had some difficulty disposing of what he no doubt considered his masterpiece "in this way," and was feeling defensive about it, blaming the situation once again on the connoisseurs, auctioneers, and Old Masters. In the *Daily Advertiser* for 28 May 1751 he elaborated on his plan of sale:

> That each Bidder sign a Note, with the Sum he intends to give.
> That such Notes be deposited in the Drawers of a Cabinet, which Cabinet shall be constantly kept lock'd by the said William Hogarth. And as the Cabinet hath a Glass Door, the Sums bid will be seen on

the Face of the Drawers, but the Names of the Bidders may be con-
ceal'd till the Time of bidding shall be expired.

That each Bidder may, by a fresh Note, advance a further Sum, if
he is out-bid, of which Notice shall be sent him.

That the Sum so advanced shall not be less than three Guineas
each time.

That the Time of Bidding shall continue 'till Twelve o'clock the 6th
Instant, and no longer [i.e., 6 June].

That on Friday the 7th Instant, the Notes shall be taken out of the
Drawers, in the Presence of as many of the Bidders as please to attend;
when it will appear who shall bid the most Money for the Pictures, to
whom they shall be deliver'd, on paying the Money.[60]

That no Dealer in Pictures will be admitted a Bidder. As (accord-
ing to the Standard of Judgment, so righteously and laudably estab-
lish'd by Picture-Dealers, Picture-Cleaners, Picture-Frame-Makers,
and other Connoisseurs) the Works of a Painter are to be esteem'd
more or less valuable, as they are more or less scarce, and as the living
Painter is most of all affected by the Inferences resulting from this and
other Considerations, equally candid and edifying, Mr. Hogarth, by
way of Precaution, not Puff, begs Leave to urge, that, probably, this
[i.e., *Marriage A-la-mode*] will be the last Suite or Series of Pictures he
may ever exhibit, because of the Difficulty of vending such a Number
at once to any tolerable Advantage; and that the whole Number he has
already exhibited of this historical or humorous kind, does not exceed
fifty, of which the three Sets, call'd, *the Harlot's Progress, the Rake's
Progress,* and that now to be sold, make twenty; so that whoever has a
Taste of his own to rely on, not too squeamish for the Production of
a Modern, and Courage enough to avow it, by daring to give them a
Place in his Collection (till Time, the suppos'd Finisher, but real De-
stroyer of Paintings, has render'd them fit for those more sacred Re-
positories, where Schools, Names, Hands, Masters, &c. attain their
last Stage of Preferment), may from hence be convinced, that Multi-
plicity at least of his (Mr. Hogarth's) Pieces, will be no Diminution of
their Value.

This manifesto, repeated once in whole and later in part, sets the
stage for the fiasco that took place on 6 June. On that day, a Thurs-
day, the *General Advertiser* announced: "This Morning Mr. HO-
GARTH's Pictures of the MARRIAGE A-LA-MODE will be sold
to the best Bidder; and the Subscription of his two new Prints, will
be closed according to his Proposals, at his House Leicester-Fields."

Poor Hogarth was putting all his eggs in this one basket, and the result was foredoomed.

Vertue's account of the day starts off with the generalization that Hogarth "is often projecting scheems to promote his business in some extraordinary manner," and continues with the remark that he had some time ago made the *Marriage A-la-mode* paintings and issued prints, which "sold very well to a large subscription."

> lately a new scheem proposed in all the news papers to sell them by a new way of drawing lots that persons who woud buy them shoud. write down the summ they would give for them. and leave that written paper for others to make advances. still more & more as they pleased till a certain day & hour then the drawer to be openned. the highest bidder to be the proprietor of these pictures. as he thought the publick was so very fond of his works. & had showd often such great forwardness to pay him. very high prices. he puffd this in news papers for a long time before hand. but alass when the time came—to open this mighty secret he found himself neglected. for instead of 500. or 600 pounds he expected. there was but one person had got to bid. without any advance. the only sum of 120 pounds. by which he saw the publick regard they had for his works—but this so mortified his high spirits & ambition that threw him into a rage cursd and damned the publick. and swore that they had all combind together to oppose him—. (3. 156)

His six paintings did indeed sell for £21 apiece, from which the cost of "elegant Carlo Maratt frames" at 4 guineas each must be deducted. John Lane of Hillingdon, the purchaser, wrote an account of the affair and speculated on what had gone wrong with Hogarth's "scheem," as Vertue called it: "This *nouvelle* method of sale probably disobliged the Town; and there seemed to be at that time a combination against poor Hogarth, who, perhaps from the extraordinary and frequent approbation of his Works, might have imbibed some degree of vanity, which the Town in general, friends and foes, seemed determined to mortify." He may, of course, have been echoing Hogarth's own view. Another account, an anonymous letter to the *St. James's Chronicle* in 1781,[61] recalling the advertisement that forbade picture dealers from bidding, adds that Hogarth also "called on his friends, requesting them not to appear at the sale, as his house was small and the room might be overcrowded. They obeyed the

injunction. Early on this mortifying day he dressed himself, put on his tye-wig, strutted away one hour, and fretted away two more"— and no bidder appeared. About 11 A.M. Mr. Lane dropped in, "when, to his great surprise, expecting (what he had been a witness to in 1745, when Hogarth disposed of many of his Pictures) to have found his Painting-room full of noble and great personages, he only found the Painter and his ingenious friend Dr. Parson[s], Secretary to the Royal Society. These gentlemen sat in the Painting-room, talking together, expecting a number of spectators at least, if not of bidders."

When Hogarth opened the box, he found only one piece of paper, dated 15 May:

Dear S[r]

I was this day inform'd by a friend of mine in the City that Seventy five pounds only, was bid for your Pictures of Marriage Alamode; and this I hope will excuse my bidding you so small a Sum as One hundred and Twenty pounds for them; so much they are worth of my Money, with a promise never to sell them to any Picture Trader or Connoisseur-monger, so long as you or I shall live.

If in this foolish and grossly impos'd on generation, there shd not be found one wiser than myself, and until there is, I must insist on having this biding deposited in your cabbinet.

I am dear S[r] y[r] most obed[t] ser[t]

Chas. Perry.[62]

Lane continues his narrative:

Nobody coming in, about ten minutes before twelve by the decisive clock in the room, Mr. Lane told Mr. Hogarth he would make the pounds guineas. The clock struck twelve; and Hogarth wished Mr. Lane joy of his purchase, hoping it was an agreeable one. Mr. Lane answered, Perfectly so. Now followed a scene of disturbance from Hogarth's friend the Doctor; and, what more affected Mr. Lane, a great appearance of disappointment in poor Hogarth, and truly very reasonably so. The Doctor told Hogarth, he had hurt himself greatly by fixing the determination of the sale at so early an hour, when, he said, the people at that part of the town were hardly up. Hogarth, in a tone that could not but be observed, said, Perhaps it might be so. Mr. Lane, after some little time, said he was of the Doctor's mind,

adding that he was of opinion he was very ill paid for his labour; and
that, if Hogarth thought it would be of service to him, he would give
him till three o'clock to find a better purchaser. Hogarth warmly ac-
cepted the offer, and expressed his acknowledgements for the gen-
erosity of it. It received great encomiums from the Doctor, who
proposed to make it public; which was peremptorily forbid by
Mr. Lane, but which was ever remembered and acknowledged by Ho-
garth to the time of his death.

About one o'clock, two hours sooner than Mr. Lane had given him,
Hogarth said, he would no longer trespass on his generous offer; and
that, if he was pleased with his purchase, he was abundantly so with
his purchaser. He then desired Mr. Lane to promise him he would not
dispose of the Pictures without acquainting him with his intention:
and that he would never let any person, by way of cleaning, meddle
with them, as he always desired to take care of them himself.

A day or two later a gentleman approached Lane at a coffeehouse and
offered him £200 and more for the paintings, and "a gentleman in
public life once offered him three hundred guineas for them." When-
ever he and Hogarth met, the latter always asked him the same ques-
tion, to which Lane always answered, "He intended to keep them as
long as he lived. The last time he ever saw Mr. Hogarth he put the
same question to him, adding it was by desire of a *great and good
friend,* who authorized him to say, that he should set his own price,
and have it. Mr. Lane's answer to this was as it had always been."[63]

Vertue's last words on Hogarth's disastrous sale of *Marriage A-la-
mode* were that "by this his haughty carriage or contempt of other
artists may now be his mortification," and he added above the line:
"and that day following in a pet. he took down the Golden head
that staid over his door—" (3: 156). Vertue paints a vivid picture of
Hogarth's disappointment, his rage at the public, and his removal
of his own sign, the Van Dyck's Head; implicit too is the response of
those "other artists" for whom he had shown contempt.

Some idea of Hogarth in 1751—his position and reputation (at least
to the layman), his operating procedure, and his thoughts on the
business of art in London—can be garnered from a series of letters
written to Humphrey Senhouse, a wealthy landowner of Netherhall,
Cumberland.[64] Senhouse's second son, George, wanted to be an art-

ist, and as Senhouse assumed that one must enter all trades and professions through the time-honored system of apprenticeship, he cast about for a famous painter to whom he could apprentice his son. A Mr. William Thynne checked about London for him and reported (on 5 Nov. 1751): "I have spoke to some Gentlemen who are better Judges of Painting and Painters than I am, and their opinion is that Hogarth would be the fittest man, for tho' he deals much in the Grotesque way, he is allowed to be one of the best general Painters in Town." Notice that there was apparently no connection with Hogarth's Westmorland lineage, and that the cognoscenti, though dubious about his grotesque painting, still acknowledged him a very competent artist. Thynne was instructed to contact Hogarth, and in his next letter, dated 28 November, he writes:

> I have seen Mr. Hogarth and talked with him upon your Son's Affair but he is neither inclinable to take an Apprentice or a pupil: he tells me that in his Profession, young lads are seldom bound as Apprentice but go as Pupils by the year.
> I then asked him (since he did not incline to take any himself) who he would recommend as a proper Master and he told me one Mr. Knapton who is chiefly a Portrait Painter and who is at present employed in Drawing the Princess of Wales and all her children in one grand Picture.

Thynne called upon Knapton, who "says he will take him and give him his Bed, Board and Instruction, as a pupil at £50 a year. I asked him if in case the Boy's Genius leand more towards Grotesque or History, than towards Portrait whether he would chuse to instruct him in those Branches; his answer was—that it was equal to him; but that he chiefly followed Portrait, because he found it most Lucrative and in greatest demand." Thynne was not sure "whether this man will be a fit Master for your son," but he added that "Both Mr. Hogarth and Mr. Knapton made an objection to your son's age [he was 13]. They say that Boys (at their entry to that Profession) ought to be older, that they may have acquired a Strength of Judgment the better to enable them to distinguish the Proportions of Objects and the difference of Lights and Shades." Thynne allowed this as a just objection but informed them that his young friend had a natural turn of genius. Thynne seems also to have canvased, and Sen-

house corresponded with, a Mr. Clementson and Arthur Devis, both of whom were eager to take George as an apprentice.

Then John Brown, later the author of *An Estimate of the Manners and Principles of the Times* (1757),[65] who had been a minor canon of the cathedral at Carlisle, spent a week in London checking around, visiting "with all the eminent Painters in Town at present, and likewise with Mr. Hoare of Bath who is as eminent as any of them." His report is dated 7 March 1752:

> Mr. Hogarth takes neither Pupils nor Apprentices, having lately refused to take even a Friend's son. . . .[66]
>
> I breakfasted with Mr. Hogarth the other morning, and he said that tho' he took no Pupils himself, he wou'd tell me his Sentiments as a Friend upon the whole matter. He says that Painters are now grown so numerous, that it is become an uncertain Profession: and till a Man has distinguished himself, he is in some Danger of wasting such Employment as any Friend to him wou'd wish. The Engraving is more certain, tho' not attended with the same good chances as the other. An Engraver of any Capacity being sure of a Guinea and a half a week, besides his Entertainment, as soon as he is out of his Apprenticeship. Besides this, he says, shou'd your son ever become eminent in History-Painting, his being able to Engrave his own Designs (as Mr. Hogarth does himself) will more than double his Profit. He therefore thinks it wou'd be the surest way, to put your Son to a good Engraver: this wou'd naturally teach him the Principles of Painting; and after this he might study as a Pupil for two years under Mr. Knapton or any other eminent Painter, which wou'd qualify him to go abroad, or set up for himself, as shou'd be thought proper.

Young George was apparently as little satisfied with the idea of an apprenticeship to an engraver as Hogarth himself was when young: "I did imagine that Mr. Hogarth's Scheme wou'd not satisfy my little Friend," Brown writes in his next letter; "and besides this I find many with whom I have talked, thought it wou'd be a Danger of Cramping his Genius." George was apprenticed to Devis, and in one of his letters home (4 June 1752), he describes the sights he has been visiting in London. After St. Paul's, he went to the Foundling Hospital, "where I was very agreably entertain'd with some very fine History paintings done by the most celebrated hands this age can afford." Unfortunately, George was never to prove his genius; he died in 1753 of smallpox.

Another event that seems to have disturbed Hogarth in the period before the publication of *The Analysis of Beauty* was the test case for the Engravers' Act. The first prosecution under the statute did not occur until 24 July 1750, fifteen years after enactment;[67] this case was successfully concluded for the plaintiff, but the next one, three years later, exposed a loophole in the act. Thomas Jefferys, a printseller specializing in maps and charts at the corner of St. Martin's Lane, brought suit against Richard Baldwin, a bookseller of St. Paul's Churchyard, who had copied "A View of the British Fishery off the S° Coast of Shetland" for the *London Magazine*. The print had originally been made for Jefferys, who paid the artist and "took an assignment of the right to the property in it accruing to the Artist by the Act of Parliament." John Hawkins, who tells the story, was at the hearing before Lord Hardwicke on 22 March 1753 in the Court of Chancery—presumably in the hall of Lincoln's Inn, where the business of the Court of Chancery was frequently transacted, and where Hogarth's *Paul before Felix* hung, looking accusingly down on the proceedings.[68] Lord Hardwicke, pointing out that no printseller claiming under an assignment from the original inventor could take any benefit from the print, found for Baldwin. Although this only affected printsellers and in no way interfered with the artist's own interest, Hogarth expressed his displeasure to Hawkins afterward. "He lamented to me that he had employed Huggins to draw up the Act, adding, that, when he first projected it, he hoped it would be such an encouragement to engraving and printselling, that printsellers' would soon become as numerous as bakers' shops." One wonders if, when he said this, Hogarth remembered a notice in the *General Advertiser,* 8 June 1752: "The Inhabitants of the Publick Houses of ill Fame in Drury-Lane and about Covent-Garden in order to avoid the Prosecution of the Justices by the late Act, have turn'd Printsellers, and let out their Lodgings ready furnish'd." In 1755, Rouquet, perhaps prompted by Hogarth, notes that before the act "there were only two print shops in London; but since this act, they suddenly increased to some hundreds."[69]

Hogarth apparently thought Hardwicke's decision a serious enough setback to circulate among his friends a caricature of the chancellor as a spider in the center of a tangled web spotted with his victims. Although the only source for this story is Wilkes (*North Briton* No. 17), a decade later when he was using any weapon at his disposal

to attack Hogarth, it seems likely that it is distorted only in under-playing the very private nature of Hogarth's outburst. If the story has any truth, it must be connected with Henry Fox's speech of 29 May 1753 attacking the Clandestine Marriage Act and its chief ad-vocate Lord Hardwicke, comparing his Court of Chancery and its proceedings to a great spider.[70] The dates are so close, that it seems quite likely that Hogarth did pick up Fox's simile; perhaps the draw-ing was made for Fox himself—a year later he was an early subscriber to the *Election* prints. Nevertheless, only a year after Hardwicke's decision, Hogarth brought out his print celebrating the success of the Engravers' Act as subscription ticket for his *Election* prints (figs. 42, 43).

Hogarth still regarded the act as his own responsibility. He saw him-self, and was seen by many, as the guardian of English art, the sym-bol of the English artist. By the 1750s his name was almost prover-bial for a kind of comic-moral picture and for a commonsense, nationalistic attitude toward art. His profile in tricorn hat, busily sketching, was copied from *The Gate of Calais* onto numerous print-sellers' shop cards and signboards. Comic prints of all kinds were being sold at John Smith's "Hogarth's Head" in Cheapside and Ryall and Withy's "Hogarth's Head and Dial" in Fleet Street. His own folio of prints was a standard item in the libraries of all classes who could afford it, and individual prints decorated the walls of private and public houses throughout the land.[71] Steevens noted that a merchant named Purce left Hogarth a legacy of £100 "as a trifling acknowl-edgement for the pleasure and information the testator has received from his Works."[72] This particular fame was not to be shaken by subsequent events.

3.

AESTHETICS, EROTICS, AND POLITICS

The Analysis of Beauty, 1752–1753 (I): The Text

THE WRITING OF THE *ANALYSIS*

At the end of February 1751/52 Hogarth announced the completion of the two prints after his history paintings, *Paul before Felix* and *Moses Brought to Pharaoh's Daughter,*[1] and on 24 March he inserted a notice in Fielding's current periodical, *The Covent-Garden Journal:*

> M^r HOGARTH *Proposes to Publish, by* SUBSCRIPTION,
> A short Tract in Quarto, called THE ANALYSIS OF BEAUTY. Wherein Objects are considered in a new Light, both as to Colour and Form.
> (Written with a View to fix the fluctuating Ideas of Taste)
> To which will be added
> Two Explanatory Prints, serious and comical engraved on large Copper-Plates, fit to frame for Furniture.
> Five Shillings to be paid at the Time of Subscribing, and five Shillings more on the Delivery of the Book and Prints. The Price will be raised after the Subscription is over.
> Subscriptions are taken at his House in Leicester-Fields, where may be had all his other Works bound or otherways.
> N.B. The Two Prints, one Moses brought to Pharaoh's Daughter, the other Paul before Felix, are ready to be delivered to the Subscribers.

Proposed in March 1752, the book and plates were not completed and delivered until the end of 1753, twenty-one months later. Considering the length of time he took to finish the book, and the drafts that have survived, Hogarth can have had only a rough draft at this time which outlined the main ideas he later developed and elaborated.

In the preface he explains that his treatise evolved out of arguments about what he called the Line of Beauty. He recalls the Line's first public appearance on the palette in his emblematic self-portrait *Gulielmus Hogarth* (see fig. 105), made as frontispiece to the folios of his prints. He writes that he intended the enigmatic S curve as a "bait," and the "bait soon took." A remark of Vertue's in 1745 indicates that the Line of Beauty was at that time a frequent topic of Hogarth's conversation (3: 126). The bemused responses of his friends are evident as early as July 1746 when Garrick remarked, recalling the happy visit with Hogarth at Old Alresford: "I have been lately allarm'd with some Encroachments of my Belly upon the Line of Grace & Beauty, in short I am growing very fat."[2]

We can imagine Hogarth during the years 1745–1753 strolling around London, observing as always expressions and movements, the way light plays on a surface, the form shadows take as he passes beside a wall—collecting aspects of Nature, but now looking more selectively, seeking examples to fit his thesis. He mentions the "ordinary undulating motion of the body in common walking (as may be plainly seen by the waving line, which the shadow a man's head makes against a wall as he is walking between it and the afternoon sun)."[3] He provides acute commentary on physiognomy and curious speculation on epidermal structure, even advice on the way to keep children from bashfully lowering their chins and thus forcing their bodies into ugly lines: fasten "a ribbon to a quantity of plaited hair, or to the cap, so as it may be kept fast in its place, and the other end to the back of the coat . . . of such a length as may prevent them drawing their chins into their necks; which ribbon will always leave the head at liberty to move in any direction but this aukward one they are so apt to fall into" (154–55). As usual the word "liberty" ("to move in any direction") relates his personal observation to the theory he is projecting. He was a close observer, he had a naturally inquiring mind, and he loved to instruct. It is difficult to imagine his not passing on his observations about form to his friends and colleagues and, perhaps, anyone who would listen.

His colleagues at the St. Martin's Lane Academy and Slaughter's Coffee House badgered him about his theory. Argument grew, and the paranoid strain of his self-representations began to reemerge: he observed "that the torrent generally ran against me; and that several of my opponents had turn'd my arguments into ridicule, yet were daily availing themselves of their use, and venting them even to my face as their own; I began to wish the publication of something on this subject" (19). He falls into line with the old story of his father harried by the booksellers and himself by the printsellers and pirates.

And so in his subscription ticket (fig. 19), issued in March 1751/52 at the time of his advertisement, he puts Columbus into an abbreviated Last Supper composition in the position of Christ. The St. Paul of *Paul before Felix* has become Columbus—another half-jocular Hogarth stand-in. Everyone had laughed at Columbus's theory, but when he returned from his discovery of the New World (the Line of Beauty), jealous courtiers insisted that anybody could have done it. Columbus responded by asking who among them could stand an egg on end, and when none could, he simply smashed the end of the egg and stood it up. The ticket implies that it takes a Columbus—or a Hogarth—to demonstrate the obvious, what was always present in nature waiting to be formulated. The Line of Beauty itself is *naturally* present, for example, in the eels on Columbus's plate.

Self-justification was an important part, but only a part, of Hogarth's reason for writing a treatise on beauty. It would appear that he needed to allow the verbal side of his character a chance for expression once and for all, something he could manage only by actually writing a treatise. This was partly because the artist (according to all the art treatises), in order to be a master of the liberal arts, was supposed to write as well as paint. All of his verbalizing, from the *Analysis* through the writings composed up to the time of his death, was acknowledgment of the need to keep his art within the tradition of literature.

It is also possible that if earlier in his career engraving had proved insufficient to convey his ideas, leading him to develop the possibilities of color and texture, perhaps he had now come to feel that only the written word could adequately express them. He had commented on the subject of art in his early prints and subscription tickets with reference to genres, the doctrines of art treatises, rather than the wider question of beauty. The first plate he made for the *Analysis,*

with its sculpture yard, is still of a piece with the art-filled interiors of *Taste in High Life* and *Marriage A-la-mode.* His artist satires that began with *The Distressed Poet* of 1737 questioned both the status of the collector vis-à-vis a broader audience and the traditional picture of the artist as gentleman, master of the liberal arts. All of these laid the groundwork for the *Analysis.*

But his ultimate reason may have been quite simply that he wanted to carry out something his father had failed to do: his *Analysis* represented the scholarly work Richard Hogarth never got into print because of the treacherous booksellers. The negative reaction from some quarters was to have, accordingly, a greater effect on Hogarth than it might otherwise have had.

He insists that he wanted someone else to write the treatise for him but ended, much as he was accustomed to do with his engravers, by doing it himself with the help of his literary friends (19). Who were these friends? Fielding had encouraged Hogarth's theorizing about art but evidently played no part in the *Analysis;* a sick man, he was devoting the last ounce of his energy to the war against crime in London. Benjamin Hoadly and James Ralph, old friends, the one a physician and amateur playwright and scholar, the other a journalistic jack-of-all-trades, did offer him advice and a sympathetic sounding board for his ideas. The Reverends Thomas Morell and James Townley, both scholars, were admirers to the point of idolatry, and their enthusiastic encouragement must have been a refreshing contrast to the skepticism of the St. Martin's Lane artists.

Morell (b. 1703) was a clergyman and classicist, a graduate of Cambridge who lived in Turnham Green, not far from Hogarth, and had married (in 1738) a Chiswick woman, Anne Barker. He is reported to have been "a warm friend and a cheerful companion, who loved a jest, told a good story, and sang a good song. He was careless of his own interests and dressed ill, and his improvidence kept him always poor and in debt." He might well have reminded Hogarth of his father, but with the difference that his magnum opus, his *Thesaurus Graecae* Ποεσεως, a lexicon of Greek prosody, was eventually published. It appeared in 1762 with a frontispiece based on a portrait specially drawn by Hogarth (fig. 78). At the time of the *Analysis*'s composition, however, Morell was best known as the librettist for a number of Handel's oratorios. The most recent was *Jephtha,* the best lines of which were (ironically, considering that Hogarth was later

accused of depending on Morell for help with the *Analysis*) pilfered from Milton, Shakespeare, and Pope.[4]

James Townley (b. 1714) was at this time third undermaster at the Merchant Taylors' School; in 1753 he went to Christ's Hospital to become grammar master. (In 1760 he returned to Merchant Taylors' as headmaster.) A witty man much interested in the theater, Townley was "known among his friends for his neat gift of impromptu epigram," and a few years later he produced the successful stage comedy *High Life below Stairs* (1759).[5] Townley's feelings about Hogarth are expressed in a letter of February 1750 (the following year he produced the verses that accompanied the *Stages of Cruelty*). He says he "treasures" Hogarth's works "as a family book, or rather as one of the classics, from which I shall regularly instruct my children, just in the same manner as I should out of Homer, or Virgil." He goes on:

> You are one of the first great men I ever was acquainted with, and the first great man I desire to be acquainted with, because you have neither insolence nor vanity. Your character has been sketched in different pieces, by different authors, and great encomiums bestowed on you here and there in English, French, Latin, and Greek; but I want to see a full portrait of you. I wish I were as intimate with you, and as well qualified for the purpose, as your friend Fielding,—I would undertake it.

He has attempted such a portrayal in a Latin epitaph, which he hopes someday to see on a monument in Westminster Abbey, "in the corner, near Shakespeare."[6]

Joshua Kirby, though he did not assist Hogarth with the *Analysis,* was working along the same theoretical lines, and communication with him may have had an effect on Hogarth (Kirby appears among the other "disciples" in Sandby's satires). Nineteen years Hogarth's junior, Kirby had been apprenticed as a youth to a widow in Ipswich as a house and sign painter, setting up his own business around 1738. One story has it that Hogarth saw the sign of a rose he had painted, and was so impressed that he persuaded him to "persevere in the arts." By the late 1740s, at any rate, Kirby was Hogarth's agent in Ipswich for selling his prints—a sideline to his painting business. By 1748, he was also publishing views of ruins and churches in Suffolk;[7] four years later he was deep in theoretical problems of perspective,

based on the work of Brook Taylor, and had secured a promise from Hogarth for a frontispiece to the book he was writing, *Dr. Brook Taylor's Method of Perspective Made Easy, Both in Theory and Practice,* "In One Volume, Quarto, with a Frontispiece design'd by Mr Hogarth," and dedicated to that artist. The "*Frontispiece*" (engraved by Sullivan, fig. 20) was a satire on false perspective, characteristically both a comment on untutored perspective and an example of the theory Hogarth was putting forward in *The Analysis of Beauty.*

The perspective box—the foundation stone of Renaissance art—served the purpose of locating the privileged spectator (in the Whitehall Banqueting House, the monarch himself [vol. 1, 125–26]) in the one spot before the picture which made it intelligible (his property so to speak) according to the rules of perspective. The false—sometimes we might think shaky—perspective of Hogarth's "modern moral subjects" in fact plays with this sense of spectator identification, and his *Satire on False Perspective* proffers the rationale: in a serious picture, a painting in the Renaissance tradition of high art, these errors of perspective are ludicrous; but in a comic print they can be useful, creating, as when the young man's sword *seems* to stab the cuckolded Jew (*Harlot* 2) or the cow's horns *seem* to be sprouting from the unhappy husband's head (*Evening*), visual metaphors. The overly steep walls of *Harlot* 4 and *Rake* 8 suggest the temporally endless channel of the protagonist into a hopeless future. Hogarth's faux naïf perspective accomplishes two ends that will be the subject of *The Analysis of Beauty.* It emphasizes the dominance of his human characters; as on a contemporary stage, their relationship to each other is more coherent and meaningful than to their pasteboard setting, with which they are always slightly at odds. And the sort of punning brought about by naïve perspective in effect replaces the Renaissance Man as the proper spectator with the "common observation" of the ordinary viewer.

As early as 1751, and again in November and December 1753, when the academy dispute was raging, Kirby had advertised the subscription for his treatise in the newspapers. When the book was eventually published in 1754, the Hogarth frontispiece was followed by a dedication to the artist, which mentions "the great Obligations which I am under for your Friendship and Favour," and notes that Hogarth "first encouraged me to write upon the Subject" of this book. The design, promised in 1751, was not actually delivered until 1753,

when (on 3 May) Kirby replied with effusive thanks on the one hand, and a request for an essay to end his book on the other:

> for then I shall have you both in my Front, & Rear, & shall not be afraid even of yᵉ D—l himself when I am so Guarded: If the little Witlings despise yᵉ Study of Perspective, I'll give 'em a Thrust with my Frontispiece, which they cannot parry: & if there be any that are too tenacious of Mathematical Rules, I'll give them a Cross-buttock with yʳ Dissertation, & crush 'em into as ill-shaped Figures as those they would Draw by adhering too strictly to yᵉ Rules of Perspective.

He did not get the essay out of Hogarth, who was doubtless too busy writing his own treatise at the time. But, as he indicates, he was dealing with another aspect of Hogarth's system, the reliance on the eye rather than mathematical rules for perspective. "The whole design'd," as his advertisement said, "not only for the Use of Painters, and other Persons concern'd in the Arts of Drawing and Designing, but also for Gentlemen, whose Inclinations may lead them to this polite Amusement."[8]

Although not mentioned by Hogarth, or by Nichols or Ireland, one other name should be added to the list of those who in one way or another influenced the conception of the *Analysis*. This was Benjamin Wilson, a young man (born in 1721) who was as interested in science as in painting. He communicated his experiments with electricity to Martin Folkes and others at the Royal Society, Folkes characteristically advising him on both his experiments and his paintings. In the 1740s he traveled back and forth between England and Ireland, settling in London in 1750 and publishing his treatise on electricity. He took a house in Great Queen Street, Lincoln's Inn Fields (the one formerly occupied by Kneller), and set up as a portraitist (painting Folkes, Lord Orrery, and other scientific enthusiasts, as well as such actors as Garrick and Samuel Foote). He even attempted the genre Hogarth and Hayman were practicing, portraying Garrick and Miss Bellamy as Romeo and Juliet in the tomb scene (Yale Center for British Art); and, following Hogarth's example, he had his painting engraved and published by subscription. It was announced as ready for subscribers on 1 April 1753: "The Size of the Print is the same with Mr. Hogarth's Garrick in Richard."[9] By this time Wilson and Hogarth had perpetrated the Rembrandt hoax on Hudson. Wilson, with

his broad scientific interests, his connections with the Royal Society (to whom Hogarth sent a copy of the *Analysis,* possibly in hopes of being himself elected a member), and his inquiring mind, may have supplied the most powerful stimulus of all Hogarth's friends toward the formulating of his ideas in abstract terms. He may also be responsible for the spurious scientific precision that Hogarth sometimes injects into his argument.[10]

There is no record of Wilson's direct influence on the *Analysis,* but not long after it was published, in the spring or summer of 1754, he wrote Hogarth that he intended to show "farther advantages which I have gather'd from your excellent Analysis" when Hogarth returned to London from Chiswick. He seems to be collecting instances of Hogarth's "invariable principles being true" and also puzzles to amuse the theorist: "A parallellogram viewed obliquely at a given distance forms a different representation when seen through a telescope, than it does when viewed with the naked eye. In the one case the remote end of the parallgm appears larger than the near end whilst in the other case it appears smaller than the near end."[11]

These were the men who helped Hogarth and to some extent shaped the *Analysis:* scholars, scientists, artists, men of the theater, journalists, admirers of his engravings, and presumably good and sympathetic companions.

Manuscripts of the first three drafts of the *Analysis* have survived largely because, after the attacks following publication, Hogarth wanted to make sure that there was no doubt as to what he himself had written. If the first accusation made against him was that he stole his idea from Lomazzo, the second was that his treatise was written by his literary friends. The manuscripts prove that he was the sole author: only with the third draft, transcribed by an amanuensis, does Morell's hand become evident making corrections of style, though never of sense.

According to the early drafts of his preface, Hogarth approached one friend, apparently Hoadly, and discussed the project: should he verbally communicate his theory to Hoadly, who then would write it down? No ready answer provided itself—indeed, considering the complex of intentions involved, there was none—so Hogarth determined to do it himself.[12] Once he set to work, his method of composition seems to have roughly paralleled that of his paintings. He started with a conceptualized idea; then, with his imagination acti-

vated, illustrations, elaboration, and further ideas tumbled out, filling the margins and backs of pages, and covering additional scraps of paper. The difference was that in the discursive medium of the *Analysis* he never found a really satisfactory line of argument, equivalent to the narrative line of his progresses, on which to arrange his ideas. As Joseph Burke puts it, after his careful study of the manuscripts, "He had plenty of ideas, and a gift for telling phrase, but the general impression left by the drafts is one of intermittent accretion and painful replanning."[13] Passages are constantly being moved about from one place to another. The theory of comedy, for example, is not in the first draft at all. It began with a marginal comment beside the words "Quantity add Greatness to Grace": "When Improper or Incompatible excesses meet they generally excite our laughter especially when the forms of those excesses are Inelegant that is when they are composed of unvaried lines" (172). This set him thinking, and ideas flowed, mostly illustrations, until he had filled the margin and the opposite blank page. In the second draft the thought developed into a thorough "analysis of the ridiculous" parallel to the "analysis of beauty," which may owe something to Akenside's third book of his *Pleasures of Imagination.*

Having "thrown" his thoughts "into the form of a book" he recalls, "I submitted it to the judgment of such friends whose sincerity and abilities I could best rely on, determining on their approbation or dislike to publish or destroy it."[14] The first reader was again Hoadly (Nichols is the informant here, but his word is supported by the cartoons lampooning the project).[15] From the looks of the manuscript, it seems evident that the first draft, perhaps even the second, was composed before it was shown to Hoadly. All along, however, it must be supposed that Hogarth's conversations with Hoadly, and with his other friends, Morell, Townley, Ralph, and probably Wilson, contributed illustrations, learned references, and the like, as well as serving to clarify his own thoughts. Nor did he fail to utilize the St. Martin's Lane friends when possible: Roubiliac, who returned from Italy in 1752 with information on the *Apollo Belvedere* and other matters, may have served as Hogarth's telescope in the same way Jonathan Richardson, Jr., had served Richardson Sr.[16]

Of the finished manuscript, Hoadly evidently corrected a third (up to chap. 9) for the press—this would be the lost fourth draft—but was prevented by illness from continuing. Hogarth then turned to

Ralph, but by the time they had finished one sheet they were so at odds that they could not continue, though the incident did not affect their friendship. Hogarth's third recruit was Morell, who corrected the rest, except for the preface, which was corrected by Townley.[17] The last fact may explain why certain aberrations that appear nowhere else in the treatise were allowed to remain in the preface. Townley's son told John Ireland that when his father read the first sheet Hogarth showed him "he found *a plentiful crop of errors;* the second and third, were less incorrect; and the fourth, much more accurate than the preceding. Such is the power of genius," Ireland adds, "whatever its direction."[18]

One of the fugitive verses Hogarth wrote from time to time seems to date from the composition of the *Analysis:*

> "What!—a book, and by Hogarth!—then twenty to ten,
> All he gain'd by the *pencil,* he'll lose by the pen."
> "Perhaps it may be so,—howe'er, miss or hit,
> He will publish,—*here goes—it's double or quit.*"[19]

Having challenged Raphael with *Paul before Felix,* he was now going to challenge Alberti, Lomazzo, Shaftesbury, Richardson, and the rest on their own ground—but less to prove himself a Renaissance Man than to correct what he took to be the critics' stultifying effect on contemporary art. Throughout his career he had carried on a dialogue with them, adjusting all his movements to their doctrines, modifying here and subverting there but never stepping outside their frame of reference. Now, when their assumptions were threatening his St. Martin's Lane Academy, he did so with a vengeance.

AN ANTIACADEMIC TREATISE

In the first draft of his preface, which is a sharper, more illuminating document in many ways than the published version ("polished" by his friends), he introduces a parody of Plato's myth of the cave, telling "how one brought up from Infancy in a coal Pit, may find such pleasure and amusement there, as to disrelish, day light, and open air; and being Ignorant of the beautys above ground, grow uneasy,

and disatisfied, till he descends again into his Gloomy cavern." His concern is with "the Power of habit and custom," and he explicates his parable of the cave accordingly:

> so I have known the brilliant beauties of nature, disreguarded, for even the imperfections of art, occationd by running into too great an attention to, and imbibing false oppinions, in favour of pictures, and statues, and thus by losing sight of nature, they blindly descend, by such kind of prejudices, into the coal pit of conoiseiurship; where the cunning dealers in obscure works, lie in wait, to make dupes of those, who thus turn their backs, on the perfections of Nature. (190)

The Platonic foundation of authority in the art treatises, and the "dark pictures" of the Old Masters, make this a particularly appropriate image with which to begin the *Analysis*.

His intention to correct "the Power of habit and custom" is closely connected to his subtitle, "Written with a view of fixing the fluctuating Ideas of Taste" (emphasized also in all the advertisements). He passes immediately from "habit and custom" to the writers who have attempted to "dispell these clouds of uncertainty, and error, with design to fix some true Ideas of taste, upon a surer basis," scoring first "the natural philosophers," presumably Shaftesbury and Francis Hutcheson,

> who by their extended contemplations, on universal beauty, as to the harmony and order of things, were naturally led, into *the wide Roads,* of uniformity, and regularity; which they unexpectedly found *cros'd, and interupted,* by many other openings Relating to a kind of beauty, differing, from those they were so well acquainted with, they then, for a while travers'd these, seeming to them, *contradictory paths,* till they found themselves bewilder'd in *the Labarinth of variety.* (190; emphasis added)

Here Hogarth introduces a second parody, of Shaftesbury's own model for the artist to follow if he wishes to be a history painter: Hercules at the Crossroads. Shaftesbury and Hutcheson, attempting to follow the straight road Hercules is urged to follow by Virtue, find themselves instead in the "labyrinth" of variety that is not confined to the limitations of "harmony and order":

> Thus wandering a while in the maze of uncertainty, without gaining ground; they then to extricate themselves out of these difficultys; suddenly ascend the mount [possibly "mound"] of moral Beauty, contiguous with the open field of Divinity, where ranging at large, they seem to lose all remembrance of their first pursuit.

Hogarth is contrasting the broad road of moral order (that equates beauty with virtue and subordinates variety to uniformity) leading up to the Palace of Wisdom with the labyrinthine paths "of sportiveness, and Fancy . . . which differ so greatly from her other beauties, of order, and usefulness"—which he will privilege in *The Analysis of Beauty* as "the love [*or* pleasure *or* joy] of pursuit."

In the published treatise the long and elaborately developed metaphor of the road (up out of the coal pit of custom) is reduced (perhaps by the collaborators) to the bald statement that the "ingenious gentlemen who have lately published treatises" upon beauty, unable to discover the principle of the Line of Beauty, "have been bewilder'd in their accounts of [beauty], and obliged so suddenly to turn into the broad, and more beaten path of moral beauty" (3–4). Even so the finished preface begins with an aggressively iconoclastic assertion, that this thesis is "so entirely new" that "it will naturally *encounter with*, and perhaps may *overthrow*, several long received and thorough establish'd opinions" and with particular reference to the artist who is "*fetter'd* with his own impracticable rules of proportion" (3, 9; emphasis added).

The unfettering, comparable to the veil lifting in *Boys Peeping at Nature,* applies first to the spectator. "To see objects truly" is the reiterated aim of Hogarth's treatise. "I know not how further to prove this matter than by appealing to the reader's eye, and common observation," he writes (102). Thus the need "to see with our own eyes" was aimed at the common man or woman without preconceptions, who can be counted on to do so, for example, with the illustrative plates appended to the text (22–23, 25). On a continuum with the popular prints he had made between 1747 and 1751, Hogarth explicitly designates the audience of the *Analysis* as not the Shaftesbury–Richardson gentlemen, not those "who have already had a more fashionable introduction into the mysteries of the arts of painting and sculpture," but "those whose judgements are unprejudiced" (22). Accordingly he applies his theory to the humble examples of

chairs and stays, candlesticks and the movements of a dance, as well as to traditional works of art.

Unfettering applies, in the second place, to the painter who, not knowing about the Line of Beauty, has no grace in his pictures "more than what the *life chanced* to bring before" his eyes (10). But the Line is *in nature,* by which Hogarth means "chance" as well as "life." *The Enraged Musician* (ill., vol. 2, fig. 48) can now be read as a fable of the artist who *should* be inspired by the plebeian noisemakers outside his window, but through the mediation of the pretty milkmaid, a young woman who embodies the Line of Beauty. Any artist who follows nature or observation unfettered by the formulas, taste, and custom of the treatises, will produce *some* Beauty. Once aware of the sinuous milkmaid, he will discover the rest.

If he rejects Shaftesbury, Hogarth takes off, beginning with his echo of Addison's "intirely new," from the *Spectator* papers on the "Pleasures of the Imagination." We saw in volume 1 (131–34) that Hogarth regarded the *Spectator* as a sort of secular bible. Primarily, of course, he carried with him the two Addisonian assumptions: "Our Sight is the most perfect and most delightful of all our Senses" (No. 411, 3: 535) and "If we consider the Works of *Nature* and *Art,* as they are qualified to entertain the Imagination, *we shall find the last very defective, in Comparison of the former*" (No. 414, 3: 548; emphasis added).

Addison's terminology in No. 412—the Beautiful, Great, and Novel or Uncommon—was crucial, replacing as it did the hierarchy of the genres. Hogarth follows quite closely Addison's Novel, describing the same elements: "an agreeable Surprise" and "an Idea of which it was not before possest"; Addison's "Pursuit of Knowledge" becomes Hogarth's "pleasure [*or* love] of pursuit"; "Curiosity" is the crucial motive (though, while he discussed it in his drafts, he omitted the word from the published treatise). But primarily Addison's Novel "makes even the Imperfections of Nature please us"—it deals with contingencies, including the grotesque, and focuses on the crucial term "Variety": "It is this [the Novel] that recommends Variety, where the Mind is every Instant called off to something new, and the Attention not suffered to dwell too long, and waste it self on any particular Object" (3: 541). While Addison had noted that the Novel "gratifies" the soul's "Curiosity," here he suggests that the search is not finally gratified, does not come to rest. Further, as he describes

the Novel, "It is this, likewise, that *improves what is great or beautiful, and makes it afford the Mind a double Entertainment*" (emphasis added). Beauty as well "gives a finishing to any thing that is Great or Uncommon." There is clear precedent here for a theory of the Novel that in fact supersedes or includes both Great and Beautiful.

Hogarth's departures are, however, also striking: he designates the Novel the Beautiful while treating it as Addison did as a term that subsumes both Great and Beautiful. This was only a matter of terminology and, moreover, did not catch on; the next generation coined the term Picturesque and narrowed the Novel to landscape. But Hogarth's other departure was fundamental: Addison's "Pleasures" are of the "Imagination," which are "not so gross as those of Sense, nor so refined as those of the Understanding." Hogarth's pleasures are of the senses. But he is following Addison's distinction between sense and imagination as primary and secondary experiences—a distinction he manifested in the closed room of his "modern moral subject." The memory alone furnishes, wrote Addison,

> those Images, which we have once received, into all the varieties of Picture and Vision that are *most agreeable to the Imagination;* for by this Faculty *a Man in a Dungeon* is capable of entertaining himself with Scenes and Landscapes *more beautiful* than any that can be found in *the whole Compass of Nature.* (No. 411, 3: 537; emphasis added)

And in No. 413 Addison added the fable of the "Enchanted Hero of a Romance" who is lost in the "pleasing Delusion" of secondary qualities of objects until, the spell broken, "the disconsolate Knight finds himself on a barren Heath, or in a solitary Desart" of primary qualities: the colors of his imagination are replaced by the actual monochrome of the objects in the world, which was the world of Hogarth's prints (as opposed to his paintings).

Addison's term "liberty," the enemy of restraint and confinement (No. 412, 3: 540), also anticipates those closed rooms which cramped and stifled human beings. He was politically a Shaftesburian, but his theory permitted a more democratic reading. Taste is a kind of genius (not limited to class) given to some men and improved by contact with other similarly endowed men (No. 409). (He does side with Shaftesbury in No. 411 when he contrasts the "Man of a Polite Imagination" with "the Vulgar," whose pleasures are fewer and

more restricted; but then it was his contrast in No. 315 between "Men of greater Penetration" and the "ordinary Reader" upon which Hogarth based his reading structure.)

For Hogarth "liberty" is democratic—an area in which "the Eye has Room to range abroad," outside the closed room, as in his "stroles" around London (see vol. 1, 42–47), where he would "lose" himself "amidst the Variety of Objects that offer themselves to Observation"—both "Variety" and "Objects" carrying a large sanction for him.

Addison's "Pleasures of the Imagination" essays were particularly useful for Hogarth because they replaced the genres with the Great, Beautiful, and Novel. Without genres, the hierarchy and "rules"— those conditions under which a work was traditionally thought to achieve beauty—are no longer necessary. As Hogarth suggests in his preface, he is, among other things, using aesthetics to criticize the limitations of art treatises and the academicism they perpetuated. His break with tradition is evident at once in his chapter headings: Fitness, Variety, Uniformity, Simplicity, Intricacy, Quantity, and Lines.[20] Only toward the end, when these "principles" are firmly established, does he get around to the traditional categories of Proportion, Color and Light, Attitude and Action, which are then viewed from his own unorthodox standpoint.

If genre is the first dogma of the art treatises which Hogarth ignores, the second (and a primary issue in the art academy controversy), which he utterly rejects, is the importance of copying. Richardson, in a key passage of his *Essay on the Theory of Painting,* had asserted:

> Supposing two men perfectly equal in all other respects, only, that one is conversant with the works of the best masters . . . and the other not; the former shall, necessarily, gain the ascendant, and have nobler ideas, more love to his country, more moral virtue, more piety and devotion than the other; he shall be a more ingenious, and a better man.[21]

Hogarth not only does not recommend the copying of art, he replaces it with the "principle" of the serpentine line, which renders it irrelevant. His object, he says, is to show "what the principles are *in nature,* by which we are directed to call the forms of some bodies

beautiful, others ugly." Previous art treatises had only encumbered the mind with artists' manners and lives and ignored "the ideas . . . of the objects themselves *in nature*" (21, 24; emphasis added). Like Addison, he asserts the primacy of nature over pictures and sculptures and criticizes those who have spent so much time on style and manner that they have lost touch with nature itself; and for this reason, he is constantly urging his reader "to see objects truly," "to *see with our own eyes*" (25, 21). This problem of "how much prejudice and self-opinion perverts our sight" was of course the theme of his "modern moral subjects," of which in that sense the *Analysis* is a logical extension.

His conviction that we should turn from paintings to nature explains why he is concerned with form rather than Shaftesburian morality in the *Analysis*. The whole tradition of the art treatises was Platonic, based on the two underlying assumptions that beauty is virtue and that beauty is order.[22] That moral good was beautiful, evil ugly, made a strong case for idealized history painting as the highest genre, for the picture-poem analogy, and much else. But this is a notion most particularly associated with Shaftesbury: it has been said that "it is questionable whether any thinker has been more explicitly identified with the equation of the morally good with the aesthetically attractive than Shaftesbury."[23] Hogarth asserts that on the contrary *nature* is beautiful; morality (or Hercules's "wisdom") has no place in his argument, or in his opposition of nature to the unnatural, beauty to ugliness, variety to conformity and rigidity.

The tradition of the art treatises was also Platonic in that it defined beauty as unity. Alberti described beauty as "a kind of harmony and concord of all the parts to form a whole which is constructed according to a fixed number, and a certain relation and order, as symmetry, the highest and most perfect law of nature, demands."[24] J. P. de Crousaz's *Traité du Beau* (1715) defined beauty as consisting in "la relation de toutes les parties à un seul but." Most pertinently, Hutcheson in his *Inquiry concerning Beauty, Order, Harmony, and Design* (1725) defined it as uniformity in variety. Hogarth rejects the idea that mathematical proportion, let alone unity, is a source of beauty. As he wrote in his manuscript notes, continuing his earlier metaphor of a journey, "the Mathematical road is quite out of the way of this Enquiry" (169). His key term, "Variety," is hardly mathematical;

Hutcheson's examples were, significantly, geometrical figures: thus in rising order of beauty for Hutcheson were the triangle, the square, the hexagon, the octagon, and the duodecagon.

As opposed to unvarying geometrical shapes like straight lines and circles, "Variety" is symbolized in the *Analysis* by the wavy line in two dimensions and the serpentine in three. The serpentine line that Lomazzo had noted in art is, Hogarth untiringly demonstrates, everywhere in nature: in "elegant" movements on the stage or in the ballroom, but also in boxing and horse racing, in cooking and interior decoration, in the bones, muscles, and skin of the human body, and in the forms of flowers and plants (and the eels on Columbus's plate).

UNITY AND VARIETY—THE ONE AND THE MANY

Hogarth's term "Variety" applies to the two overlapping aspects of Beauty, the object itself and the aesthetic experience of the perceiver.

The aesthetic issue begins for him with Hutcheson's definition of beauty as the spectator's pleasure of discovering or recognizing the "Uniformity amidst Variety," or beauty as unity that subordinates variety. But Hogarth greatly increases Hutcheson's emphasis on discovery—that is, on active process as part of the aesthetic experience—and he reverses Hutcheson's order of priority: it is the pleasure of discovering not uniformity but variety ("infinite Variety"). He calls this "a composed variety" ("for variety uncomposed, and without design, is confusion and deformity" [35]) but adds that the more variety there is, the more beauty.

As a beautiful object he offers the example of a bell in terms reminiscent of Hutcheson's ratios: "here you see the variety of the space within is equal to the beauty of its form without, and if the space, or contents, were to be more varied, the outward form would have still more beauty." "We should therefore endeavour," he says of a section of human ribs, "to vary them every way in our power, without losing entirely the true idea of the parts themselves" (57, 79). In his chapter "Of Intricacy" he speaks of "*the beauty of a composed intricacy of form,*" because, he explains, too much variety in dress is tawdry,

and so "simplicity is call'd in to restrain its superfluities" (45, 52). But a typical formulation finds that "simplicity, without variety, is wholly insipid, and at best does only not displease; but when variety is join'd to it, then it pleases, because it enhances the pleasure of variety, by giving the eye the power of enjoying it with ease" (39). St. Paul's Cathedral, though a series of composed varieties, nevertheless demonstrates "the utmost variety without confusion, simplicity without nakedness, richness without tawdriness, distinctness without hardness, and quantity without excess." The emphasis, as usual, falls on the "utmost" variety (63).[25]

In Hogarth's graphic works leading up to the *Analysis,* although geometrical forms exercise control within the picture space, variety remains the operative element. In that pivotal work *The March to Finchley* (1750, ill., vol. 2), the crowd is outdoors and the buildings on either side of them by no means contain their shapes and motions. The architectural verticals and horizontals only regulate but do not subordinate the serpentine and irregular lines that lead the eye here and there, from object to object, never quite allowing it to rest. For Hogarth it is a principle of the most basic sort that geometrical structures should not finally subordinate the vital Lines of Beauty of life.

An example extended over twelve plates is *Industry and Idleness* (1747, ill., vol. 2). In one of the drafts of the *Analysis* Hogarth argues that "Fitness excites a pleasure equal or similar to that of truth and justice, uniformity, and regularity, are pleasures of contentment," in other words the sort of balanced, clear-cut morality of *Industry and Idleness,* the good apprentice and the bad. "Variety," on the other hand, "excites the lively feeling of wantonness and play," and "Intricacy" excites "the joy of pursuit." These qualities are opposed to "Simplicity and distinctness," which are "like the pleasure of easy attainment" (170–71). Thus, as defined by *The March to Finchley* and *Industry and Idleness,* Hogarth's method is essentially the discovery of variety in apparent uniformity.

This is not to say that the art treatises did not also sometimes stress variety,[26] but Hogarth (as in *Finchley*) extends the aesthetic concept of variety into the political concept of liberty, challenging the politics underlying the Shaftesburian aesthetics. The relationship of the whole and its parts, of unity and diversity, in art reflected the philosophical problem of the One and the Many, which itself reflected, perhaps from its origin, the more practical political problem of the relation-

ship of the ruler and the ruled, the monarch and his subjects, the state and the individuals who make it up. A traditional, unstated parallel, developed by both politicians and artists, was between the state and the work of art. And another parallel, more emphatic in the Whiggish aesthetic of Shaftesbury, was between the one Man of Taste and the many ordinary spectators. For Shaftesbury had shifted attention from the divine analogy that linked those supposed "makers," the deity, the monarch, and the artist, to the oligarchy that had deposed James II and replaced him with the "Revolutionary Settlement." In the monarchical ideal of the Stuart dynasty, order or providential design had been (in Howard Caygill's words) "mediated either through the works of art or through the legislation of the state"—and the former included the moral strictures of sermons and tracts and such poetic genres as satire and the georgic with their shared topos of *concordia discors.*[27] The theorists of the Revolutionary Settlement substituted for this "tyranny" "an immediate 'taste' or 'moral sense' valid apart from the rules of art or the direct agency of the state" (42), which bespoke the "liberty" of the subject based on irrational (but providential) "senses" of virtue, property, and contract, as well as art. In practice, this depended on the internalizing of the old laws by the people, governed by the "taste" of their disinterested betters.

Disinterestedness for Shaftesbury referred to the absence (or elision) of (1) ambition, (2) possession, and (3) consumption in the gentleman's response to the aesthetic object:

[1] Imagine then, good Philocles, if being taken with the beauty of the ocean, which you see yonder at a distance, it should come into your head to seek how to command it, and like some mighty admiral, ride master of the sea, would not the fancy be a little absurd? . . . [2] Suppose (my Philocles) that, viewing such a tract of country as this delicious vale we see beneath us, you should, for the enjoyment of the prospect, require the property or possession of the land.

The covetous fancy, replied I, would be as absurd altogether as that other ambitious one.

[3] O Philocles! said he, may I bring this yet a little nearer, and will you follow me once more? Suppose that, being charmed as you seem to be with the beauty of those trees under whose shade we rest, you should long for nothing so much as to taste some delicious fruit of theirs.[28]

Thus control, possession, and consumption are distinguished by Shaftesbury from a "rational and refined contemplation" of beauty. But Shaftesbury is of course assuming the equation of beauty and virtue—qualities that are not bodily and material, sensuous and (to use his term) "luxurious," but of utility to the *polis*. For, being of the property-owning class in the civic humanist scheme of things *is* to be disinterested. Being above interest one has no selfish stake, and that is why the ruling oligarchy must consist of disinterested people.[29]

Hogarth dismisses all three of Shaftesbury's negatives in his notion of the beautiful: ambition and control are implicit in the collecting and possessing of sculptures and paintings. Indeed, in practice art *was* used as an instrument of power by such as Shaftesbury, fetishized, regarded as property, and collected by the Men of Taste. Hogarth's examples of candlesticks, stays, and smokejacks are the most democratic of possessions, utilized by ordinary citizens. And his central example is the woman who is sexually desired by men. The difference between this and his earlier critique of Shaftesbury in the *Harlot* and *Rake* is that while there he undermined the assumption of *virtù* by revealing the underlying desire, in the *Analysis* he suggests that beauty *requires* desire as part of the experience he is trying to define.[30]

Bernard Mandeville's attack on Shaftesbury in the 1724 *Fable of the Bees* would have been the text that for Hogarth most realistically related politics, economics, and art; it may also have offered him the basic position he took vis-à-vis Shaftesbury and Hutcheson, which grew over the years into the full-fledged alternative of *The Analysis of Beauty*. Hogarth follows Mandeville's political confutation of Shaftesbury which parodied Unified Variety as

> Thus every Part was full of Vice,
> Yet the whole Mass a Paradise. . . .
> The Whole of which each Part complain'd:
> This, as in Musick Harmony,
> Made Jarrings in the main agree . . .

As Mandeville put it in his preface: "Those very Vices of every particular Person by skilful Management, were made subservient to the Grandeur and worldly Happiness of the whole."[31] Whereas for Shaftesbury the coincidence of public and private good was due to

an enlightened benevolence on the part of a Whig aristocracy, to Mandeville it was the result of private self-seeking—and this is the subtext of desire Hogarth reveals beneath the two illustrative plates of the *Analysis*.[32]

THE "PLEASURE OF THE PURSUIT"

If the chapter "Of Variety" is about the beautiful object, the chapter "Of Intricacy" is about the perception of it. Hogarth's "intricacy" involves difficulty and a slowing of process, while the Shaftesbury–Hutcheson sense of beauty and virtue was perceived immediately. Another point of difference with Hutcheson's *Inquiry* is that his pleasure of discovery becomes, for Hogarth, the "pleasure of the pursuit" (45).[33] Hogarth invokes Locke's metaphor of the chase from the beginning of the *Essay concerning Human Understanding:* the mind's "searches after truth are a sort of hawking and hunting, wherein the very pursuit makes a great part of the pleasure."[34] "Pursuing is the business of our lives," Hogarth writes:

> This love of pursuit, merely as pursuit, is implanted in our natures, and design'd, no doubt, for necessary, and useful purposes. . . . It is a pleasing labour of the mind to solve the most difficult problems; allegories and riddles, trifling as they are, afford the mind amusement. (41–42)[35]

The implicit term, which appears in a draft of the chapter "Of Intricacy," is "curiosity":

> Curiosity is implanted in all our minds ⟨we are naturaly inquisitif⟩, and ⟨have⟩ a propensity to searching after, pursuing and surmounting, difficultys, by which means most things useful and necessary are and have been attaind and the difficulty, of obtaining often enhaunces the pleasures of the pursuit and makes it become a sport. (171)

There follows (in both versions) first the metaphor of the hunt, "even . . . a delight in pursuing and sometimes suffer[ing] their prey

to eschape for the pleasure of chasing it again"; then, "it is a pleasing labour of the mind to unfold mystery Allegory and Riddles"; and finally, perhaps recalling *Tom Jones,* Fielding's version of pursuit in which the reader is continually invited to search out motive and causality, Hogarth adds: "and with what delight does it follow the well-connected thread of a play, or novel, which ever increases as the plot thickens, and ends most pleas'd, when that is most distinctly unravell'd?" (42). What he says applies particularly to the play and "novel" of his time (and his own "modern moral subject"). He does not mention the epic, which like history painting has no surprises to offer since the end is already known.

But the "intricacy in form" in his Beauty, Hogarth tells us, "leads the eye a wanton kind of chace." So to curiosity, problem solving, and the pursuit of truth he adds wantonness and pleasure. The spectator's searching and pursuing mind is excited or inspired by the undulating shape of the figure, which Hogarth genders: the Line of Beauty "explains" how and why "the form of a woman's body surpasses in beauty that of a man," for in the first illustrative plate, we are told, stay #2 (an overly straight one) would best fit a well-shaped man, while the most beautiful stay (#4) best suits a well-formed woman (66).[36] One reason Hogarth stressed the woman's body was because his St. Martin's Lane Academy had focused on sketching from the nude model, most controversially the female nude (there had been complaints that the motive was mere prurience), whereas the insurgents were now stressing, along with organization and hierarchy, the copying from casts and engravings.

Hogarth's Line of Beauty is very different from Addison's association with the mother's breast and a quiet, passive, and regressive childhood experience. Hogarth's Beauty is the attractive young woman in a situation of courtship or dalliance: "the many waving and contrasted turns of naturally intermingling locks" (also "wanton ringlets"), he writes, "ravish the eye with the pleasure of the pursuit" (45).[37]

Here the epistemological aspect of Beauty joins the definition of the beautiful object, typically the woman, and more particularly the amorous woman. This is the example he gives us, over and over in one form or another, in the *Analysis.* Returning to the "wanton ringlets": "A lock of hair falling thus across the temples, and by that

means *breaking* the *regularity of the oval,* has an effect *too alluring* to be *strictly decent,* as is very well known to the *loose and lowest class of women . . .*" (52; emphasis added). We can see all of those elements, in different degrees of tension, beginning in *Boys Peeping at Nature,* where Beauty was telescoped with Nature, Truth, and the earthy and specifically sexual. There Venus was not a sculpture of a Venus Pudica but a fertility idol, the many-breasted Diana of the Ephesians or Isis of the Egyptians. In *Strolling Actresses Dressing in a Barn* the actress playing Diana the goddess of chastity was unveiling herself, revealing the fertility goddess under the virgin huntress (and attracting a peeping Actaeon). Both elements are necessary for Hogarth's conception of Beauty.

The actress playing Diana could serve as a point of origin for one of the best-known sentences, and in many ways the epitome, of the *Analysis:* "Who but a bigot, even to the antiques, will say that he has not seen faces and necks, hands and arms in living women, that even the Grecian Venus doth but coarsely imitate?" (82). The "Grecian Venus" may be Hogarth's response to Shaftesbury's words: "Thus the best artists are said to have been indefatigable in studying the best statues: as esteeming them a better rule than the perfectest human bodies could afford."[38] Shaftesbury sees bodily beauty as the source of pleasures and desires that draw the perceiver away from, rather than toward, virtue. He is forced to maintain that the body itself has no pleasurable beauty to the true aesthetician, except for the moral beauty to be found in perceiving its maker's design.[39] In the chapter "Of Intricacy" Hogarth intermingles the serpentine lines of the woman's body with the sinuous movement of a smokejack, the object of desire with an object of utility.

In the first appearance of the undulating line on the title page (fig. 21) it stands upright and has a small serpent's head, and directly above it is the book's epigraph from *Paradise Lost:*

> So vary'd he, and of his tortuous train
> Curl'd many a wanton wreath, in sight of Eve,
> To lure her eye. (9.516–18)

This conjunction of Eve, Satan, and the Fall is the clearest acknowledgment Hogarth makes that his aesthetic centers on woman and the serpent as graceful forms, and therefore focuses on the scene of man's

fall from another kind of "grace." The Miltonic context suggests that when he wrote of Variety he was recalling the passage describing God's creation of Adam and Eve in a garden filled with fruit:

> all sorts are here that all the earth yields,
> *Variety without end* but of the tree
> Which tasted works knowledge of good and evil,
> *Thou mayst not* . . . (7.541–44; emphasis added)

"Variety without end" is curtailed by the Fall; the serpent on the title page is enclosed within a triangle. The original power and vision of Beauty are inseparable from the original sin; or, as in his painting *Satan, Sin, and Death* (ill., vol. 2), from Sin herself. (Sin's compound shape represents for Hogarth the same reconciliation of unity and variety, of beautiful and grotesque, invoked by Horace's mermaid in the *Ars poetica*.) He specifically links his Beauty to the "Infinite Variety" of Shakespeare (his transcendence of the rules), and of Shakespeare's character (the woman) Cleopatra—and not just Cleopatra but "Cleopatra's *power* over Anthony" (15; emphasis added). Venus becomes (in Lomazzo's words, which Hogarth quotes) "the goddess of divine beauty," but also of love and the power of love.

Hogarth recalls how he introduced the subject of the serpentine line in conversation as a bait to trap stupid artists and ignorant connoisseurs (10). And he connects this more encompassing sense of Beauty with the lady's lock of hair which entangles men in the same way that his own text entangles the reader (drawing on memories of Belinda's locks, whose "labyrinths," "slender chains," and "Hairy Sprindges" "betray," "surprise," and "draw" men to her). The words "wanton ringlets" (45) of course echo Milton's description of Eve: "Dishevell'd, but in wanton ringlets wav'd."[40] Indeed, the lines from *Paradise Lost* on the title page (Eve's temptation by the serpent[ine line]) suggest that Hogarth is of Satan's crew. And these lines could be augmented by reference to the fallen angels, at this point still "beautiful," who find "no end, in wand'ring mazes lost" (of false philosophy) and enjoy "ignoble ease, and peaceful sloth": "for who would lose, / Though full of pain, this intellectual being, / Those thoughts that wander through Eternity."[41]

In the first illustrative plate (fig. 22) Venus appears squarely in the center of the foldout, and, turning to catch the Apollo Belvedere's

eye while the Farnese Hercules's back is turned, she creates a romantic triangle. Below her statue are a pair of billing doves and Dürer's diagrams of the female and male anatomy. And in the second plate (fig. 23), in a situation parallel to the Venus–Apollo–Vulcan configuration, a young wife is receiving a love note from a young man behind the back of her older husband. In both cases the female figure formally represents Beauty, and the element of immorality is present not only as an admission that beauty and morality may not (as in the Shaftesburian equation) always go together, but to suggest that Hogarth's Beauty requires both of these elements.

To return to the quotation, the "regularity of the oval" of the female face is needed but also the "breaking" of the oval with the lock of hair, and this is because the effect is "too alluring to be strictly decent"—a phrase that leads Hogarth naturally to introduce the "loose and lowest class of women" such as the Harlot, and that sense of the fallen associated with Daughters of Eve and the lifting of Nature's shift in *Boys Peeping at Nature*.[42] Even his example of the bell (#35 and the *Analysis,* Pl. 1, #29) is related to the woman as a sexual symbol, as he had shown in *A Harlot's Progress* (see vol. 1, 264–65). Both the uniformity of the Grecian Venus and the unenclosable variety of the living woman are required, whether it is the undulating line within the triangle or the unruly lock of hair that breaks the perfect oval or the sin of Eve or Cleopatra which enlivens the static relations of their competing men.

Hogarth's initial notion in the *Harlot* had been that Shaftesburian civic humanism, with its image of a male aristocratic hero, seemed to call for an antidote in the form of a plebeian heroine. In the artist satires of 1737–1741 he used the young woman to mediate between high art and subculture energies. (Her emphatic position may in fact also have had an economic motive: to extend his audience—from patrician to the professional and commercial middle class—to include wives.) But then in the popular prints of 1747–1751 the young woman disappears in a simple contrast of order and disorder or virtue and vice, Goodchild and Idle or the good boy and Tom Nero of *The Four Stages of Cruelty*. The industrious apprentice has *married* the master's daughter now; she appears only with Goodchild, never with either the father/master or the other apprentice—the Prospero and Ferdinand, Satan and Death, of the earlier works; and in the *Stages of Cruelty* she is simply murdered by her lover Nero (whose name carries him back to the Rake's choice in *Rake* 3). Following from *Mar-*

riage A-la-mode in 1745, the opposing terms become essentially parent against child, without any space for a pretty mediator. There is no longer a middle term. But as the center of the "modern moral subject" is emptied of the pretty young woman, replaced by a simple unmediated contrast between opposites, the spectator's role increases in importance, moving toward Hogarth's aesthetics of "intricacy" and "pursuit" in the *Analysis*. And if the young woman is removed from the "modern moral subject," she returns to figure in the pretty-but-immoral women of the two *Analysis* plates.

CONTEXTS FOR VENUS (I): THE NEW POETICS

Hogarth's works, which had always kept pace with the literary movements of the time (beginning with the satire of Pope, Swift, and Gay in the 1720s), now reflect the theory and practice of the post-Pope generation.

In 1746 Joseph Warton, a young man just down from Oxford, published a manifesto expressing a new sensibility in poetry. In the "Advertisement" to his *Odes* he argued that true poetry is not the didactic, moral poetry of Pope, the great poet of the previous generation, but rather a "fanciful and descriptive" poetry in which "the imagination is much indulged." "Invention and Imagination [are] to be the chief faculties of a Poet." Poetry is to involve not a moral judgment of a social environment (as for Pope) but an emotional response to a picturesque or literary environment. No longer judgment but fancy is to be the criterion of poetry, and the chief muse of Warton's odes and those of his friend William Collins (also published in 1746) is a personification called Fancy. The question for both poets is essentially where is Fancy to be found in England in the 1740s.

Like another personification in these odes, Liberty, she is invoked, sought, and disputed with. At least two scenarios can be inferred from the disputation: in one the implicit, male Other is Didactic Poetry, virtually a Popean father figure who has kept the feminine Fancy locked away from the courtship of true poets.[43] In Collins's odes Pope is soon replaced by the even more inhibiting figures of Shakespeare and Milton (not to mention Aeschylus and Sophocles). But while there is a strong general truth in this oedipal reading of Collins's odes, a pre-Freudian reader—one familiar, for example,

with the works of Hogarth—would have seen a simpler scenario in which the Choice of Hercules topos is being revised. As Warton's word "indulged" (in "the imagination is much indulged") suggests, he is asking the poet to choose Pleasure/Fancy *over* Virtue/Judgment. In this reading Fancy comes to be regarded as essentially a mediator between the poet and the world (and, in other forms such as the personification Pity, between man and his distresses). The representation of Fancy as mediator does not, however, rule out seduction as one form of the interrelation between poet and mediator-muse. A sexual dimension is implicit in, for example, Collins's "Ode on the Poetical Character."[44]

Just prior to the Warton–Collins manifestos, in 1744, Mark Akenside (whose path will cross Hogarth's in the pages of Smollett's *Peregrine Pickle*) published *The Pleasures of Imagination,* a transitional poem whose aesthetics anticipated their own. The terms were the same: the "faculties of moral perception" are opposed to the "organs of bodily sense," but Akenside's conclusion is that Imagination requires not the choice of one over the other but their interplay. In Book 2 he sets out his own allegorical confrontation based on the Choice of Hercules, in which the poet does not choose between Virtue and Pleasure (he uses Milton's name for her in *L'Allegro,* Euphrosyny) but imaginatively melds them into a higher unity.[45] Here the goddesses of Virtue and Pleasure are not antagonists but supplementary companions, "the shining pair," while a third figure, the son of Nemesis, is introduced as antagonist of both.[46]

Akenside, however, interrelates the moral topos of the Choice of Hercules with the aesthetic formulation of Addison's "Pleasures of the Imagination," from which he takes his title. Thus Beauty and Greatness correspond respectively to the "organs of bodily sense" and the "faculties of moral perception," with the creative powers of the poet occupying a middle ground between them. (He takes Addison's middle term, the Novel, to mean essentially the surprising or wonderful.) As Richard Wendorf has written, Akenside, like James Thomson, "is able to picture nature in a *unified* manner that makes *moral* judgment possible."[47] This unification of Reason and Fancy in the *Pleasures of Imagination* is illustrated in Akenside's *Odes* (1745) and explains Warton's opinion that they were dull and insipid. Akenside still believes in the *concordia discors* that was embodied most elaborately in Pope's *Essay on Man*.

Although it was not published until 1748, James Thomson's *Castle of Indolence* had for years been passed around among friends. In the first canto the wizard Indolence tempts weary passers-by in search of refreshment into his castle with the enchantments of euphoria and narcotic dreams, seductively described; in the second canto the Knight of Arts and Industry frees them. But, as was well known, the stanzas began as Thomson's own self-defense against his friends' chiding for his notorious indolence, and his attitude toward the subject was decidedly ambivalent.[48]

The Castle of Indolence itself (Book 1) refers to—indeed represents—the circle of George Lord Lyttelton (which included Fielding, as well as some of Hogarth's Scottish friends, and Collins).[49] Hogarth and Thomson moved in circles that impinged at more than one point; their mutual friend, Joseph Mitchell (whom Hogarth had known as early as 1731), had written an ironic poem called *The Charms of Indolence* in 1722, in which indolence equals dullness.[50] In 1740 Hogarth etched a ticket for Thomson's (and Mallet's) *Masque of Alfred.* (He later took the ending of Book 2 of the *Castle* as a governing motif of his fourth *Election* painting.) His roots went back originally to Scotland, and he was a friend of both Ramsays, father and son. Another of his close friends, Morell, was aware of *The Castle of Indolence* as early as 1742 when he wrote verses on it.[51] Even if Hogarth did not know of the poem directly from Thomson, he would have known it from Morell, who was to assist him with his drafts of the *Analysis.*[52]

Thomson, who includes dullness, inertia, and sluggishness (idleness) in his meaning of indolence, is actually concerned with a refined hedonism, a cultivation of the choicest pleasures on the one hand and a virtuous and philosophic retirement on the other. The ambiguity depends on awareness of both the shopkeeper's idleness as "the devil's cushion" or his couch or pillow and the gentleman's sense of "the sweetness of being idle" ("Inertia dulcedo," "Dolce far niente," "Vis inertiae," and other well-known catch phrases).[53] Both the Thomson and Akenside poems were works that, however embedded in the *concordia discors* tradition, questioned (or resisted) the oversimplification of the Herculean choice. But they did so by merely upgrading the pole of Pleasure, Fancy, and self-indulgence. Warton and Collins more radically reversed the old Herculean choice and chose Pleasure/Fancy over Virtue.

These writings—which I assume Hogarth read, whose authors he

probably knew—are reflected in several ways in his subsequent work. We have already seen his response to Collins's "Epistle to Sir Thomas Hanmer" in his *Garrick as Richard III* (1746; in vol. 2, 254–55). In 1747 he published *Industry and Idleness,* with overtones of Hercules's choice and a demystification of the familiar polarity. He now introduced Virtue and Pleasure as personifications, called Goodchild and Idle, complicated the contrast, and replaced the Herculean Choice with an ironic, or not so ironic, personal psychomachia, in which one could find parallels to Thomson's psychomachia in *The Castle of Indolence.* Then a decade later, writing his memoirs, he repeatedly (perhaps recalling the terms of Akenside, Thomson, Warton, and Collins) insisted that as a youth he had to have his "pleasures" (which included a penchant for "idleness") as well as his "studies."

Hogarth had been representing, as far back as the 1730s, a female figure. No more an uncritical admirer of Pope than Warton and Collins, he could be said to have replaced Pope's Dulness with a positive female who mediates between the artist and nature, too much and too little order, or aristocratic Augustan Virtue and plebeian Pleasure (e.g., in *The Distressed Poet* and *The Enraged Musician*). With the examples of Akenside and Collins, she was elevated into a figure he could regard as his "muse"—as indeed he does in his self-portrait of the 1750s (which replaced his *Gulielmus Hogarth* of the 1740s), *Hogarth Painting the Comic Muse* (figs. 105, 52).[54]

Personification (as E. R. Wasserman, Jean Hagstrum, and others have demonstrated) relied to a large degree on a pictorial faculty—evident, for example, in Collins's many references to pictures in his poems.[55] If, as Hagstrum argues, the high-culture paintings of Guido Reni (who was regarded at this time as a second Raphael) were probably the ones visualized by Collins, Hogarth would have been aware that over the past decade he had himself been representing plebeian and urban versions of the female Fancy whom these young poets were now seeking in rural vales and caves. He had even come very close in his *Satan, Sin, and Death* to the sort of scenario (both mediated and oedipal) that Collins projects in his "Ode to Fear."[56]

These poets authorized the sort of formal emphases and simplifications in both comic and sublime modes that he began to explore in *Garrick as Richard III. Simplicitas,* as a corrective of *difficultas,* was part not only of the graphic tradition (the French war against the rococo) but also part of the new poetics of Great Britain. One need only run

down the titles of Collins's odes: to Pity, Fear, Simplicity, Mercy, and Liberty—all subjects inherent in *Industry and Idleness* and Hogarth's popular prints of 1750–1751.

As he would have seen, Collins's subjects are aesthetic (literary, artistic, affective). Aestheticism is Collins's replacement for religious feeling as it is for didacticism, though he retains some displaced effects of religious devotion in his invocations and prayers; and it could be argued that the same is true for Hogarth in the following years.

The other aspect of Warton's and Collins's *Odes* is the combining of poetics and politics.[57] Warton's Fancy is complemented by Liberty, who derives from Bolingbroke's "Spirit of Liberty" he opposed in his *Craftsman* essays to Walpolian "Faction," and thence from Thomson's female figures of Britannia and "Liberty." And Collins follows his poetic odes (to Pity, Fear, Simplicity, and the Poetical Character) with odes on the wars of 1745–1746 (to Mercy, Liberty, and Peace). In each group the two aspects are mingled: poetry and patriotism merge in Aeschylus and Sophocles, both poets and warriors; and, as with Warton, Fancy is essentially characterized as Liberty (as in the progresses of Poetry and, alternatively, of Liberty).

In the same way, Hogarth's muse in the 1750s carries associations that are both aesthetic and political—in *Election* 3 she is in fact Britannia. In the final revision of *Rake* 8 a wild-haired Britannia is the muse who presides over Bedlam (read: England) in 1763.

CONTEXTS FOR VENUS (II): THE NOVEL

Between *A Harlot's Progress* and *Marriage A-la-mode* Hogarth's women had been benign mediators; but Countess Squander was a dangerous, seductive, and destructive force, and so was Drusilla in *Paul before Felix* and even the substitute mother of *Moses Brought to Pharaoh's Daughter:* all during the post-*Pamela* years, perhaps reflecting Fielding's view of Pamela as Shamela. Richardson's *Clarissa* (appearing in 1747 and 1748) would have introduced a dimension of sexual threat and violation. But the crucial work was John Cleland's *Memoirs of a Woman of Pleasure* (later called *Fanny Hill*), published in two volumes in December 1748 and February 1749.

Though coincident with the publication of Fielding's *Tom Jones,*

and seemingly another Fielding-inspired response to the novels of Richardson (even the mandatory allusion to Pamela's "Vartue" is included), this work had been mostly written in the 1730s and included, if it did not originate as, a rewriting of Hogarth's *Harlot's Progress*.[58] It opens precisely as the *Harlot* does with a girl from the north country (near Liverpool in Lancashire), fed by a city girl named Esther on stories of elegant London ladies. Fanny "beheld Esther's scowered satin-gown, caps bordered with an inch of lace, tawdry ribbons, and shoes belaced with silver" (41). She travels with Esther to London in the Chester Wagon (vs. the Harlot's York Wagon) "to seek my fortune," carrying the sort of "portable box" Hackabout carried, and is deserted by her friend in the innyard as soon as they arrive. She is "left alone, absolutely destitute and friendless" (43), but instead of being picked up by a bawd in the innyard, as the Harlot was, she goes to a registry office seeking employment and there is intercepted by Mrs. Brown and lured to her brothel.

An elderly gentleman reminiscent of Colonel Charteris is the first to attempt her virginity in Mrs. Brown's establishment, but the Charteris–Needham story is displaced to Fanny's second abandonment, when her lover Charles (who is first seen by her [72–73] in the pose of Rakewell in *Rake's Progress* 3) is abducted: Mrs. Jones "goes out and returns with this very honourable gentleman, whose very honourable procuress she had been on this as well as other occasions" (95). The man, a conflation of Charteris and the Jewish keeper of Plate 2, cheats on Fanny and she revenges herself on him by seducing a young servant (like her, "just come out of the country," 106), and is eventually exposed. Unlike the Harlot, she is forgiven and turned out with severance pay. Here Cleland supplies the missing scene between *Harlot* 2 and 3 where she ends up "settled in lodgings of my own" (126).

Cleland's revision of Hogarth's *Harlot* consists in presenting the "scandalous stages of my life," as Fanny refers to her story, not as an ironic progress ending in punishment, disease, and death but as a progress from which (she writes) "I emerged at length, to the enjoyment of every blessing in the power of love, health, and fortune to bestow, whilst yet in the flower of youth, and not too late to employ the leisure afforded me by great ease and affluence" (39). Cleland—in this respect parodying Richardson's rewriting of the *Harlot* in *Pamela*—fills in the "stages" of his harlot's successful progress with sensory pleasures rather than disasters or self-denials.

Fanny alludes on her first page to Hogarth's *Boys Peeping at Nature,* the *Harlot's* subscription ticket:

> Truth! stark naked truth, is the word, and I will not so much as take the pains to bestow the strip of a gauze-wrapper on it, but paint situations such as they actually rose to me in nature, careless of violating those laws of decency, that were never made for such unreserved intimacies as ours. (39)

Cleland refers to his scenes as "pictures," and indeed voyeurism is central to his novel—not in the closed prurient sense of *Pamela* but as one aspect of his exploration of the senses in a young woman who flourishes in fashionable London and ends with a fortune and a husband she loves. A typical passage describes Fanny's seduction of a country boy when she avenges herself on her elderly keeper. Surely drawing on Hogarth's disheveled Diana in *Strolling Actresses,* Cleland has Fanny describe herself lying on a couch, "*in an undress* which was with all the *art of negligence flowing loose,* and in a most *tempting disorder: no stays, no hoop*—no encumbrance whatever . . ." (108; emphasis added). Of her friend Polly's vagina, Fanny writes: "whose lips vermillioning inwards, expressed a small rubied line in sweet miniature, *such as not Guido's touch or colouring could ever attain to the life or delicacy of*"; and her beloved Charles's body, she rhapsodizes, was "surely infinitely *superior to* those nudities *furnished by the painters, statuaries, or any art,* which are purchased at immense prices." She adds that "the sight of them in actual life is scarce sovereignly tasted by *any but the few* whom nature has *endowed with a fire of imagination,*" and once again distinguishes these bodies from "all the imitations of art, or the reach of wealth to pay their price" (68, 82; emphasis added).[59] Against Charles's real cathected body Fanny places to its disadvantage antique art, including its monetary value.

These are the elements (beginning with the "living woman . . . that even the Grecian Venus doth but coarsely imitate") Hogarth playfully echoes five years later in *The Analysis of Beauty,* but the point to be emphasized is that Hogarth's Beauty derives, or takes support, from Cleland's variations on Hogarth's own Harlot, which give her a positive valuation and raise her life, her sensuality, her art of seduction (which is her "art of negligence") into an aesthetics. It is an aesthetics based on seduction—and one in which morality and beauty are at odds, in which the old man (Charteris, Fanny's Mr. H—)

is replaced by an interloping, cuckolding young man. The situation is a romantic triangle of the sort Hogarth centers on Venus in both *Analysis* plates (a young wife in the second), and in this context we can surmise that the old man is also associated in Hogarth's mind with the Old Master paintings that hung on the walls of his earlier prints, and the seduction or cuckolding of the old man figures as his own fancied seduction of Beauty away from the antiquated authority of the art treatises.[60]

Cleland, who goes so far as to include a homosexual encounter in his spectrum of sexual exploration, was perhaps, from Hogarth's point of view, the Woolston of erotics. A freethinker, an ethical Deist, he illustrates the open nature of desire. Although there are many orgasms, and Cleland brings Fanny full circle to a happy closure with her "husband" Charles, the impetus of the novel is toward an endless string of erotic episodes in which desire is prolonged indefinitely, analogous to the "pleasure of pursuit" which does not finally come to rest.

The word "pleasure" in the *Analysis* applies to a man's enjoyment of a woman, in Jack Lindsay's words (168) "the desire to enjoy the world, to unite vitally with it." But the Venus figure combined with the metaphor of unveiling—removing layers, ultimately dissecting— is an extreme form of the original image in *Boys Peeping at Nature*. It suggests that the submerged sexual metaphor involves not consummation but (a metaphor shared with Shelley's poetics) an "infinitely extended . . . voyeuristic or readerly mode," essentially an extension of the hermeneutics involved in appreciating Hogarth's prints, which might be called "male interpretative desire."[61]

Fielding's *Amelia* was published at the end of 1751. It responds in various ways to Richardson's *Clarissa,* but it also reaches back to Hogarth's *Harlot* 1 in its central placement of Needham, Charteris, and his pimp Jack Gourly: here they are Mrs. Ellison, the Noble Lord (or Great Man), and Captain Trent. At the same time it is much concerned with the related subjects of beauty, love, and morality—in particular the beautiful mask that conceals immorality.[62] Fielding's introductory chapter is on the "Art of Life" ("Life may as properly be called an Art as any other"), by which he means a craft, an aesthetics based on life and living, opposed to Fortune. This is very

different from the actual aesthetics of the senses, of living and making love, in *Memoirs of a Woman of Pleasure,* but Fielding makes much of the contrasts Hogarth will explore in the *Analysis* plates, as in the "very pretty Girl" Booth sees in Newgate whose looks do not correspond to her morality—and, above all, the genteel "murderess" Miss Mathews (1.4; 33). Miss Mathews's and Booth's own narratives do actually serve to seduce Booth, and under the protestations of conjugal love Fielding shows misdirected, adulterous desire of the sort Hogarth will associate with beauty in the women of the *Analysis* plates.

Even Amelia's nose (notoriously shattered in a coach accident and only in the second edition repaired) anticipates an important aspect of the Hogarthian aesthetic. The upshot is Booth's words: "I know not whether the little Scar on her Nose did not rather add to than diminish her Beauty" (6.7), with which we should compare Hogarth's account in the *Analysis* of the perfect oval that must be broken by a lock of hair, without which contingency Beauty cannot exist.[63] A contingency is apparently *required* in physical beauty—because, as in Amelia's case, it produces heroism or magnanimity; because it distinguishes the human from the paradigm or, in Hogarth's terms, the cold stone statue.

Amelia is a love object, a muse, a mediator between Booth and the world, a Charlotte Cradock (Fielding's deceased wife), and much else. If the notable issue in *Tom Jones* was whether Tom could love Sophia and yet sleep with Molly, Jenny, and Lady Bellaston, then in *Amelia* it is the way to represent Amelia, to win her, to understand her virtue after marriage, and to relate her beauty and her virtue. The answer (which has to include the irony [straight from Pamela] that after Charlotte's death Fielding had married her maid) seems to be: by way of a blemish or flaw; ultimately (in the largest sense) through Amelia's flawed, erring husband Booth, and her would-be seducers. After the incident of her damaged-repaired nose, Booth (narrating their story) continues to define her by opposites: by his pseudo-love of Miss Osborn, her antithesis; by his sudden desertion to his sister; even by his fantasized image of her in rags; and, in the larger plot, by a situation of threat and testing of her virtue by the Noble Lord, Colonel James, and indeed Booth himself.

For Hogarth I suspect the crucial part of *Amelia* was the two opening chapters of Book 11, which juxtapose the subjects of beauty

and politics. In the first Colonel and Mrs. James are arguing over the respective appearances of Amelia and Booth. Criticizing Amelia's appearance—scarred nose, eyes too large, neck too long—Mrs. James says:

> 'There is such a Thing as a Kind of insipid Medium—a Kind of something that is neither one Thing or another. I know not how to express it more clearly; but when I say such a one is a *pretty Woman,* a pretty Thing, a pretty Creature, you know very well I mean a *little Woman;* and when I say such a one is a *very fine Woman,* a very fine Person of a Woman, to be sure I must mean a *tall Woman.* Now a Woman that is *between both,* is certainly neither the one nor the other . . .' (11.1; 454–55)

Mrs. James's formulation, based of course on Addison's Beautiful and Great, is intended to be negative; but Fielding's response is positive. The Novel, the area between Beauty and Greatness, is in effect experience. For Hogarth, as for Fielding, this means the blemished, "mixed," unexpected, and human. (This is also where Booth is described as having "a Nose like the proboscis of an Elephant, with the Shoulders of a Porter, and the Legs of a Chairman," a description of Fielding himself.)

In the preface to *Joseph Andrews,* Fielding had used Hogarth's "comic history-painting" to distinguish the area occupied by his novel work (which came to be called *the* novel), a "comic epic poem in prose," from both romance and burlesque.[64] Thus Hogarth's Beauty also occupies a middle area: the blemish, "mixed character," and Hogarth's description of his mode as an "intermediate species of subjects for painting between the sublime and the grotesque" all relate to the "composed variety" of the *Analysis*'s chapter "Of Variety," which leads to the chapter "Of Proportion" in the merger of Atlas and Mercury and the colors of the rainbow, and the rivalry of Apollo and Antinous (97–98, 100–102). Atlas and Mercury, "throwing off" and "augmenting," almost literally dress and undress their bodies until they meet in a "just similitude; which being an exact medium between two extremes," is perfect grace.

The political context that informed the *Analysis* was the passage of the Marriage Act, which was "fought stage by stage," through Lords and then Commons, between January and June 1753, as Hogarth was

writing the *Analysis* (his illustrative plates are dated 5 Mar.). As Law-rence Stone has noted, the popular response was intense and the pamphlet war extensive. Some clauses of the bill would have been of special interest to Hogarth, who had himself eloped with Jane Thorn-hill to a distant parish: for example, that unless an entry was recorded in the parish register, signed by the bride, groom, and at least two witnesses, as well as the officiating clergyman, the marriage was null and void.[65]

As Stone summarizes, the attack on the Marriage Act first stressed the allegation that its aim "was to give *parents* of *rank and fortune* a veto power over the marriage of their *children,*" and, second, argued that it was "not only a *threat to liberty* but . . . an unworkable restraint upon the twin *irresistible passions of love and sexual desire.* They prophe-sied widespread *cohabitation,* not an increase in church marriages" (126; emphasis added). The first stressed the liberty that was being sacrificed to the parent, supporting both Hogarth's assumptions about the parental (vs. democratic) model of a state art academy and the evil of copying models; the second pointed to the desire that was being curtailed, and would inevitably break out in such extramarital episodes as those Hogarth presents in his two illustrative plates. Evi-dent in the arguments surrounding the Marriage Act, as well as in the *Memoirs of a Woman of Pleasure* and *Amelia,* was the irreducible opposition between human desire and social power—the fear that desire can subvert social order.

The sex drive is for Hogarth a persistent subtext which cannot re-main hidden, whether under religious pretension or aesthetic theory; it is associated with seduction, deception, infidelity, but also "na-ture." While it may be said to have led the Harlot and Rake to disease and death, Hogarth's emphasis was on the fashionable copying that perverted this natural drive into unnatural and destructive (and self-destructive) channels. In the brighter works that followed the *Rake,* desire was only comically diverted (a Venus dresses as a Diana). In Hogarth's only explicit representation of the act itself, in *Before* and *After* (ill., vol. 1), the man seduces the reticent woman but then, hav-ing satisfied himself, is unable to satisfy the fire he has ignited in her. This is the comic situation of the "Imperfect Enjoyment" (a poem to be found in "*Rochesters Poems,*" a volume on the lady's dressing table); the more common situation—as old as Plautine comedy—involves the interference of a father or elderly husband (Prospero) or a rival (Caliban). If, as in *Industry and Idleness,* desire is associated

with the betrayal and death of one apprentice, it is also associated—by a comic contrast—with the upward mobility of the other.[66]

It is relevant at this point to ask whether Hogarth distinguishes between sexual desire and love (i.e., romantic love). Given his allegiance to Watteau, it is not surprising that his theme of art and nature employed Venus as the mediator—Polly Peachum or Miranda, motivated by "love" only, intervening between father and lover. But, as Swift would have taught him, romantic love is only literary. When Hogarth is not illustrating a literary text (*The Beggar's Opera, The Tempest,* or *Sigismunda*) there is only desire or charity; in all the "modern moral subjects" the only "love" is that of Sarah Young or the Poet's wife, based on delusion and without noticeable effect.

CONTEXTS FOR VENUS (III): THE WOMEN IN HOGARTH'S LIFE

In volume 2 we saw Hogarth's foregrounding of a female figure in relation to his intensely male club-oriented life, and we speculated on the way his wife Jane fitted into this pattern. In the *Analysis* we see Hogarth's elevation of this woman into a goddess of Beauty, but we shall also see more of that closed homosocial society (epitomized by Freemasonry) in which women were idealized but marginalized. While he centralized a woman in his work, it was only in order to define the relationship between two groups of men, specifically high and low. His formative experience was limited to three distinct areas: (1) the high culture, Augustan in literary tone and Latin-based; (2) the culture of dissent, rooted in the Bible; and (3) the unlettered plebeian culture, thoroughly traditionalist, addicted to the charivari, skimmington, cockfighting, bearbaiting, and the maypole. In his case the first was male and the second female, the worlds respectively of his father and his mother (to judge by the baptismal register and the family Bible—his mother's).[67] The third area was the child's as he wandered through Bartholomew Fair and the streets of London. The world Hogarth seems to have rejected was (2), his mother's, though he paid lip service to it, while he lived in both (1) and (3).

This schema may illuminate the unexplained iconography of the child in the *Harlot's Progress:* the subplot had to do with the birth and rearing of a little boy. His birth is announced in 3, the Harlot is preg-

nant in 4, and the boy himself appears in 5 and 6, in the first ignoring his dying mother and in the second replacing her. In retrospect, we might see this reflecting in some way Hogarth's fear that he had behaved callously to his pious dissenting mother by producing the kind of work epitomized by the *Harlot*—and this fear may have been subsequently internalized in the need to paint the occasional biblical scene. That need was of course overdetermined, but it is possible that his mother (vs. his classicist, perhaps freethinking father) represented to him religious art and explains his ambivalence toward it. Of course, this maternal plot in the *Harlot* was heralded by the many-breasted Diana of the Ephesians, highlighted by the analogy between Hackabout and the biblical Mary the Mother, and further emphasized in Plate 3 by the parallelism of the two pregnant women, Hackabout and the black woman.[68]

If Hogarth's mother embodied for him the Puritan bogeys of sexuality and impiety, it is easy to see him producing the story of a harlot but displacing the overt sexuality into the symbols (bell, teacup, spiggot) where his mother would not recognize them, couching the story in terms of a safe morality of crime and punishment. He performed a Woolstonian demystification of the sacred New Testament story but through allusions to iconography she would never recognize. But his learned father would have, and we can at this point presume that Hogarth's two audiences, the ordinary reader and the reader of greater penetration, were initially his mother and his father (though the father was by this time dead). We can even suppose that the Latin epigraphs, which were a gesture toward his father, hid the import of his work from his mother. But his feelings of guilt were expressed in the subplot of the Harlot's unfeeling son.[69]

His wife Jane seems to have represented to him another world, outside his personal experience and always just beyond his reach: the society of knights, M.P.s, and lords with whom Sir James Thornhill rubbed shoulders. Jane, the mediator between the ennobled father and the interloping lover (one form of the high and the low), only informs Hogarth's work *subsequent* to the *Harlot*—that is, containing such trios as Miranda, Prospero, and Ferdinand. But it is this idea of mediation that Hogarth develops; marriage, halted at the stage of courtship, remains "à la mode," always something of a constricting social form (undertaken as a subject but abandoned in the "Happy Marriage" paintings).

In the "modern moral subjects" these strands were mixed. Though

the Harlot and the milkmaid of *The Enraged Musician* appear to be distinct, one pregnant and guilty (and punished) and the other a happy mediator, the types were joined in those long-suffering mothers Sarah Young and the Poet's wife. In *The Stage Coach* there was both a mother and child and an icon labeled "No Old Baby"; in *The March to Finchley* the Madonna and Child were accompanied by metaphorical foundlings; in *Moses*—where the boy most resembles the Harlot's child—he was a foundling with true and adoptive mothers. At this point the plot of the Harlot's son has been modulated into the story of a foundling boy contested between (fought over by) his plain but true mother *and* a beautiful young woman. For the Venus of the *Analysis* Hogarth returns to the latter figure, less a mediator than a temptress and a betrayer of Puritan morality with a young lover in not a moralized but an aestheticized tale of Puritan sin.

Alas, Hogarth's timing was bad. In the 1750s women were beginning to be idealized as domestic figures, mothers rather than sexual creatures. Randolph Trumbach has pointed to the decline of divorce actions initiated by women and indeed would see the Foundling Hospital as established in order to idealize mothers by preventing them from murdering their children.[70] This was not a climate in which the gendered and sexually oriented aspects of Hogarth's aesthetics (and iconography) could flourish, a fact evident in the moralizing commentaries imposed on his works by Trusler and others after his death.

PLEASURE, IDLENESS, AND THE PICTURESQUE

Hogarth's career logically leads to a hedonist aesthetics. At the beginning, he held the general (British, Protestant, Iconoclast, Deist) preference for Nature over Art, embodied personally in his mnemonic technique that permitted experiential, sensuous contact with the real, contingent, contemporary world of London. His need for "pleasures" as well as "studies," which led to his sauntering picturesque "tours" of London, was his particular version of nature's superiority to art, and especially to "old religious pictures"; and this position was emblematized by his picturing art in his first subscription ticket as a faun peeping under Nature's shift at her mons veneris (he had

already decorated the stage of *The Beggar's Opera* with satyrs). In his second subscription ticket, for *A Rake's Progress,* he shifted from mimesis to audience response and so from *utile* to *dulce* ("pleasure"), the word he attached to the ticket in his advertisements ("A *Pleased* Audience"). Studies and pleasures, by the 1750s, referred to the St. Martin's Lane Academy and Slaughter's Coffee House respectively: studies were for connoisseurs (and the artists they had seduced), pleasure for the people *and* for artists like Hogarth. And from pleasures and studies followed the other dichotomies such as Idleness and Industry, Nobody and Somebody, which he had been gradually deconstructing in his prints of 1747–1752, recovering the first or "aesthetic" term.

In the manuscript draft of his preface Hogarth had shown the serpentine line and the labyrinthine way complicating—indeed replacing—the simple binary highways of the Choice of Hercules outlined by the moral philosophers, and even suggesting Vice's path of dalliance and pleasure. The labyrinth, that strangely natural image for a man to use who focused on the human and man-made, is a version, on the ground, of the principle of "intricacy" which is at the heart of Hogarth's epistemology of Beauty in the *Analysis.* Truth was traditionally defined either in terms of the hazards of the climb or the pleasure of the prospect from the top of the hill, specifically of the labyrinth through which one has struggled to reach the top.[71] The labyrinth was also a basic emblem in the Masonic initiations, "a number of *communicating passages* arranged in *great complexity* through which it is *difficult to find one's way without guidance;* it is also called a maze, and is *an intricate, tortuous* arrangement of features designed to *mystify*" (emphasis added).[72]

In the *Analysis,* where Hogarth formulates and urges the "pleasure" of the labyrinthine "chase," the question is whether he distinguishes this pleasure from—or confuses it with—the detached prospect from the top of the hill? In *Industry and Idleness,* he showed both at work, and it is difficult to say which he privileged there. The reader of greater penetration enjoyed the aesthetic pleasure of detachment, seeing *both* readings from a safe distance.

In 1748, as Hogarth was working on *Industry and Idleness,* William Gilpin published his *Dialogue upon the Gardens . . . at Stow,* which laid out the groundwork for the aesthetics of the Picturesque. One of the gentlemen he depicts visiting Stowe asks "why we are more

taken with Prospects of this ruinous kind, than with Views of Plenty and Prosperity in their greatest Perfection." The other gentleman replies:

> Yes: but cannot you make a distinction between natural and moral Beauties? Our social Affections undoubtedly find their Enjoyment the most compleat when they contemplate, a Country smiling in the midst of Plenty, where Houses are well-built, Plantations regular, and every thing the most *commodious and useful.* But such *Regularity and Exactness* excites no manner of *Pleasure* in the Imagination, unless they are made use of *to contrast with something of an opposite kind.*[73]

Gilpin registers the point at which the spectator's response to landscape shifts from a primarily moral to a predominantly "picturesque" one. Like Hogarth, he insists on the separation of physical and moral beauty. What was effected incidentally by the undifferentiation of industry and idleness was the planing away of distinctions until a moral structure has been virtually transformed into an aesthetic one. *Industry and Idleness,* which appeared to be all morality, in fact transformed Tom Idle into a figure not altogether unrelated to the one Gilpin was notoriously to admire somewhat later when his theory of the Picturesque was fully formulated (*Observations, Relative to Picturesque Beauty,* published 1786):

> In a moral view, the industrious mechanic is a more pleasing object, than the loitering peasant. But in a picturesque light, it is otherwise. The arts of industry are rejected; and even idleness, if I may speak, adds dignity to a character. Thus the lazy cowherd resting on his pole; or the peasant lolling on a rock, may be allowed in the grandest scenes; while the laborious mechanic, with his implements of labour, would be repulsed.[74]

Gilpin's scenes require men doing "for what in real life they are despised—loitering idly about, without employment."[75] He is also, of course, talking about the draining of meaning out of moral emblems: with the industrious and idle apprentices, so too the ass as emblem of dull, meaningless, stupid labor is replaced by the shaggy-coated beast who, Gilpin informs us, is preferable to smooth-coated horses, as a bearded is to a smooth-cheeked man, because roughness is a picturesque element. When morality is removed, and iconographi-

cal (to a large extent moral) meaning is reduced, one result is the Picturesque.

What Gilpin says about landscape, Hogarth says about figuration in *Industry and Idleness,* and carries on into the illustrations of the *Analysis.* Thus ruins, natural and figurative, carry the same "picturesque" associations—moral but also simply aesthetic.[76] Uvedale Price was to argue in his *Essay on the Picturesque* (1794) that a temple or palace "in its perfect entire state . . . either in painting or reality is beautiful; in ruin it is picturesque," and then—rationalizing the aesthetics of Hogarth's "modern moral subjects"—that among humans only ruined ones (corresponding to old mills and hovels) are picturesque.[77] Now in the *Analysis,* Hogarth (only a year or so after *The Four Stages of Cruelty*) recalls seeing a beggar "who had clouted up his head very artfully, and whose visage was thin and pale enough to excite pity, but his features were otherwise so unfortunately form'd for his purpose, that what he intended for a grin of pain and misery, was rather a joyous laugh" (141; earlier version, 187).

Hogarth's Beauty was in fact an attempt to find a middle way between the static Beautiful of Shaftesbury and Hutcheson and the uncontrollable chaos of the Sublime (which Burke's interpretation was to confirm for him). One can speak of a Novel/Picturesque scene or experience as Beautiful; the categories are interchangeable in a way that the Beautiful and the Sublime are not. One cannot say that a Sublime scene is Beautiful or vice versa without sounding confused. But the next generation, under the shadow of Burke's "Sublime," returned Hogarth's Beautiful to the Picturesque, reducing the Beautiful to *only* a serpentine, or curving line, as in gently swelling hills. For Gilpin, Price, and Richard Payne Knight the Picturesque consisted of an active pursuit involving curiosity and irritation, and the picturesque object was characterized by contrast, incongruity, and roughness.[78] The basic characteristic of Picturesque art, according to Price, is the portrayal and inducement of energy—and so of motion and change. "What most delights us in the intricacy of varied ground . . . is, that according to Hogarth's expression, it leads the eye a kind of wanton chace . . ."[79]—which can be both physiological and mental in the object viewed, in the viewer whose eye is led a "wanton chace," and in the viewer's mind or "working" imagination.[80]

Moreover, through those qualities of irritation and curiosity Price also sustains Hogarth's paradigm of desire. The Picturesque, he writes,

"by its variety, its intricacy, its partial concealments, . . . excites that active curiosity which gives play to the mind," and this takes the form of amorous intrigues. The examples given by Price include birds who "when inflamed with anger or with desire" ruffle their plumage. "The god of love," he goes on, "(and who will deny love to be a source of pleasure?) is armed with flames, with envenomed shafts, with every instrument of irritation."[81]

The sequence—from Hogarth's Beautiful to Gilpin's "Beautiful Picturesque" to Price's "Picturesque" vis-à-vis the Beautiful and Sublime—hinges on the term "variety," which became the central feature in discussions of landscape. The primary difference between the Novel, which Hogarth called Beautiful, and the Picturesque of Gilpin, Price, Payne Knight, and the others, is that Hogarth's focuses on the human body and human artifacts, while their focus is on nature.[82]

Contingency is the disruptive principle of both, but in the Picturesque it is subsumed under merely temporal change (leave a landscape alone and it will grow into picturesque shapes). As a consequence, Hogarth's Beautiful did not anticipate the conservative politics of Price's Picturesque—the return to and preservation of an old garden *already* "picturesque." Hogarth's Beautiful carries oppositional force, privileging the local, marginal, and specifically English against the Continental "high art" tradition which homogenizes art and culture. In landscape terms, Hogarth's Beautiful works on behalf of the local, the marginal, and the vernacular against the forces of "improvement"; it forms resistance against those who, ignorant or dismissive of cultural heterogeneity, seek to impose the same kind of pattern and order everywhere. In the same way, the superior vantage enjoyed by Hogarth's "men of greater penetration" above the labyrinth must be distinguished from the detachment of the Shaftesburian aesthetician: Hogarthian detachment expresses a critical attitude toward his culture and some substantial dissatisfaction with current values.

POSTSCRIPT: ON COLOR

Hogarth's chapter "Of Colouring" sums up everything in the *Analysis* to this point. As we might expect, he deals only with "the nature and effect of the prime tint of flesh," which, "when rightly under-

stood, comprehends every thing that can be said of the colouring of all other objects whatever" (125). The "fundamental principle" of coloring "will depend upon the art of varying"—"the great principle of varying by all the means of varying, and on the proper and artful union of that variety" (125, 129). And his particular example is "the fair young girl," whose bust he paints, focusing on her face and her "whole neck and breast" (#95, #96; 125). He regards the human body as layers of skin, "tender threads like network," which the artist mentally removes ("when the upper skin is taken away"), and makes interesting comments on the use of blue pigment "in parts of the temples, backs of the hands, &c. where the larger veins shew their branching shapes (sometimes too distinctly) still varying those appearances" (129). His favorite word in this chapter is "tender." As usual, his comments are delicate and perceptive.

Most significantly, he advocates Rubens's three-color theory (based on the primaries, red, yellow, and blue) and in particular his practice of keeping "tints bright, separate and distinct . . . light and separate," as opposed to "smooth'd and absolutely blended together, [which] would have produced a dirty grey instead of flesh-colour" (133). As thoughout his career, he employs in his own practice broken colors, separate strokes only lightly blended into one another—not a fashionable mode. Félibien, writing for the main tradition, had argued that brushwork should be smooth, *léchée* (licked), and criticized Rembrandt for his broad brushstrokes and impasto. He traced this technique to the Venetians also, but Hogarth, though he gives Rubens credit, would have inherited it from the Rembrandt–Kneller–Vanderbank succession. Richardson, being an admirer of Rembrandt, was relatively friendly toward the use of broken paint,[83] and Reynolds employs the method in his early portraits. As Jack Lindsay comments, Hogarth "was totally opposed to the painters seeking preconceived harmonies, such as Reynolds," by which he means ruling out the element of discovery in "the ceaseless study of nature."[84]

Sometimes Hogarth places tones and halftones next to each other, lights and shadows, so that the work looks like a sketch and falls to pieces if the viewer comes too close. What this amounts to, in terms of the *Analysis,* is that broken colors require the viewer to stand back and actively participate in the "pursuit" of the painting.

4.

THE ANALYSIS OF BEAUTY (II)

The Illustrations

PLATE 1: THE STATUARY'S YARD

I have said that in the text of the *Analysis* Hogarth privileges the pleasure of the senses over the imagination, but in his illustrative plates he reintroduces Addison's third element, the understanding. The plates (published 5 Mar. 1753) illustrate his argument, point for point, but they also demonstrate the "love of pursuit" (the deciphering of "allegories and riddles" or "the well-connected thread of a play, or novel") and, in this sense aimed at the public that followed Hogarth's prints, serve as a continuation of the "modern moral subjects." This was the emphasis of his advertisement, at the end of June 1752 (*London Evening Post,* 10 June–2 July):

> MR. HOGARTH, having proposed to publish by Subscription a Tract, call'd, the ANALYSIS of BEAUTY, together with two explanatory Prints, thinks it expedient to add, that the Subjects of the said Prints will be, a Country Dance, and a Statuary's Yard; that these will be accompanied with a great Variety of Figures, tending to illustrate the new System contain'd therein: and that he has endeavour'd to render it useful and interesting to the Curious and Polite of both Sexes, by laying down the Principles of personal Beauty and Deportment, as also of Taste in general, in the plainest, most familiar, and entertaining Manner.

The illustrations (figs. 22, 23), he urges in his preface, are worthy to "be examined as attentively" as his text—"how oddly soever they

may seem to be group'd together"; indeed, he distinguishes between the grace aimed at in his text and the figures, in which he "purposely chose to be least accurate, where most beauty might be expected, that no stress might be laid on the figures to the prejudice of the work itself." This is one of the paragraphs in the *Analysis* which end with the hope that his readers may be taught "to *see with our own eyes*" (21–22).

One plate depicts the town and fashionable man-made artifacts, and the other the country and people dancing in a country house decorated with paintings and sculptures. The artificial and the human (or natural) are persistently played off against each other. Addison, it will be recalled, saw a pleasure of the imagination in this reciprocity, and his garden in *Spectator* No. 477 with its "luxuriancy and Diffusion of Boughs and Branches" (vs. "cut and trimmed into a Mathematical Figure") is an implicit context of the first plate, which can also be understood as an outdoor elaboration of Hogarth's painting *Taste in High Life* (1742, ill., vol. 2), including equivalents of the fop and the sculpted Venus.

The setting is Henry Cheere's statuary yard at Hyde Park Corner, one of a chain of such yards that ran from Park Lane to Half Moon Street, which produced objects of lead and stone, mostly for English gardens: ornamental vases and dolphin fountains, statues of shepherds and shepherdesses, funerary monuments, and copies of classical sculptures. While giving his friend Cheere a free advertisement, Hogarth also uses Cheere's business as a type of the commercialization of foreign art that dominated English culture. These yards had been regarded with amused contempt as early as the 1730s, when Hogarth's friend James Ralph wrote:

> sorry I am that they afford a judicious Foreigner such flagrant Opportunities to arraign and condemn our Taste. Among a hundred Statues, you shall not see one even tolerable, either in Design or Execution: nay, even the Copies of the Antique are so monstrously wretched, that one can hardly guess at their Originals.
>
> I will not lay the Blame of this Prostitution of so fine an Art intirely on its Professors; no, I rather attribute it to the Ignorance and Folly of the Buyers, who, being resolv'd to have Statues in their Gardens at all Events, first make a wrong Choice, and then resolve to purchase their Follies as cheap as possible: This puts the Workmen in a wrong Taste of Designing, and hasty, and rude in Finishing: Hence Excellency is

never thought of, and the Master, like the *Highwayman* in the *Beggar's Opera,* is happy when he has turn'd his *Lead* into *Gold.*[1]

Cheere's statuary yard serves Hogarth as a modern version of Clito's statuary yard in Xenophon's *Memorabilia* where Socrates wandered about discussing beauty and illustrating his argument with the statues. The difference is also part of Hogarth's point: Socrates had Clito's marbles, Hogarth has only these commodified lead copies.[2] Inside his statuary yard, Socrates's answer to Aristippus's question "Is then a labourer's hod, or a dung basket a beautiful thing?" was: "Undoubtedly, . . . and a shield of Gold may be a vile thing, consider'd as a shield; the former being adapted to their proper use, and this not." These statues, even when they are individually examples of Beauty, in the context of Hogarth's first chapter, "Of Fitness," reveal *un*fitness in their setting, in the statuary yard and (implicitly) in a country-house garden and in England of the 1750s.

Xenophon's dialogue was mediated by a Renaissance text, Francesco Colonna's *Hypnerotomachia Poliphili,* and refurbished for Hogarth's time by Joseph Spence in his *Polymetis* (1747), which shows that by the 1740s a garden was the only place in England where one saw classical iconography, mingled (or contrasted) with natural features, trees and bushes and extended lawns. Classical iconography survived only in decoration rather than flourishing in poetry or in history painting. Spence offers Hogarth both a *Tabula Cebetis* dialogue (in which the visual is verbalized) and a joke about the Hyde Park statuaries that furnish Polymetis's garden, where Spence's dialogue takes place. He apologizes that the sculptures are Roman copies, remarking that "a Roman workman in the Aemilian square was probably pretty near on a level with our artists by Hyde-Park-Corner."[3]

Clearly Hogarth is responding to Spence. He simply moves the setting from the garden to Hyde Park Corner itself. The subject of *Polymetis* was the limitations of the iconographical lexicons as demonstrated by close analysis of the great classical sculptures.[4] The gist of Spence's argument, summed up in Dialogues 17 and 18, was that we should learn the nature of these gods by directing our own eyes to the sculptures rather than to the words of commentators who impose the sort of hermetic and hieroglyphic allegory Shaftesbury too had dismissed as outmoded in his *Notion of a Draught of the Tablature*

of Hercules. Spence introduces humans into the sculpture garden who can see and comment, and they make much of the "accidental" as well as "essential" attributes of the gods as seen in the sculptures. He explains in his preface that he has couched his treatise in the form of a dialogue in a garden because "the introducing a scene, and characters, helps to give life to a subject, that wants enlivening," and he emphasizes the strategy by playing one set of assumptions against another. Hogarth develops Spence's aim "to give life to a subject, the process of enlivening," highlighting the paradoxes of dead sculptures and live human beings, going far beyond Spence to explore the ironies of the figures' "accidental" and "essential" attributes as represented in copies of copies.[5] He juxtaposes with the sculptures two human figures in contemporary dress. One holds a book of anatomies reduced to geometric figures while gazing up at the Venus, in which (as the text tells us) art and nature join; the other is a posturing dancing master correcting with his straight posture the serpentine Antinous. The contrast is between nature rendered artificial and art that is natural.

As his primary examples for his account of the iconography of the Greek gods Spence chose the *Venus de Medici, Apollo Belvedere,* and *Farnese Hercules*—limiting his examples to deities, as he explained, with the single exception of Hercules.[6] Hogarth represents in his illustration (from left to right) the *Farnese Hercules,* the *Antinous,* the *Venus de Medici,* and the *Apollo Belvedere,* and in the background the *Laocoön* and in the foreground the *Belvedere Torso.*

These were the great works of the classical canon of taste around which the artist's imagination had circled from the Renaissance onward—which he copied in his academies, arranged into his own compositions, and from which he drew his ideas, expressions, iconography, and forms. These sculptures were collected, copied, and revered for their ancient historical associations and for their ideal beauty. Their authority was still in the 1750s nearly absolute, extending beyond the artist and the academy to the country gentleman who arranged copies of them in his house and garden. For him these antique sculptures signified not just a taste—the Grand Tour and the Society of Dilettanti—but his own continuity with the ideals of ancient Rome. That great taste setter Alexander Pope, for example, when planning the decoration of his villa at Twickenham, commis-

sioned painted copies of the *Venus de Medici,* the *Farnese Hercules,* and an Apollo (not, as it turned out, the Belvedere) for his stair. The poets, from Dryden and Pope to Samuel Johnson, like the ruling elite, found social and political, moral and literary support in Rome.

Thomas Coke, William Kent's patron and student in matters of art, built his Norfolk country house, Holkham, with a temple shape, Roman down to the bricks, especially baked in the Roman shape and color. (Holkham was open to the public, with sometimes an hour's wait in line.⁷) The entrance was a gigantic hall shaped as a Roman basilica, its colonnade of African marbles recalling the Temple of Fortuna Virilis in Rome, and its entablature from the portico of the Temple of Antoninus and Faustina. The message was that Coke had inherited Roman ideals, had devoted himself to public virtues, and had collected the symbols and memories of past authority. And so the entrance hall was lined with statues, and the original plan was to have placed the colossal *Jupiter,* the prize of his collection, on a pedestal in the middle of the stairway. A sculpture gallery was given prominence in the floor plan of the house, and the rooms in general were designed to show off antique sculptures.

Down the road from Holkham was Houghton, the country house of Sir Robert Walpole (now deceased). Equally Roman in style—that is, Vitruvian by way of Palladio—this was the grandiloquent pile that has been identified by some scholars as Timon's Villa in Pope's "Epistle to Burlington."⁸ Houghton highlighted the portrait of the Great Man as a Roman bust in a toga inscribed with the Order of the Garter (by Michael Rysbrack).

These sculptures were, in short, a mode of self-validation, carrying an especially defensive, and therefore powerful, charge in the age of the early Hanoverians. One peculiarly English feature was the totally contradictory uses to which the Roman artifacts and imitations were put, depending on party and circumstance, whether the associations were meant to be republican or imperial. Sir Robert had sought associations of the Roman Republic with the bust of himself by Rysbrack, while his opponents of the *Craftsman* had seen him as one of the decadent emperors.

It was easy for Hogarth to see such practices—personal, political, artistic—as symptomatic of the increasing attenuation of the classical canon in the eighteenth century. In the academy controversy, the

canonical sculptures represented models that stood in for nature: in Hogarth's opinion, false models repressing variety with uniformity. Students were forced to master every curve of these sacred casts before being permitted to draw from life. Scholarship had begun to notice that these sculptures were copies, composites, sometimes even forgeries. The *Venus de Medici,* for example, was the most copied of them, and (aside from questions of its own authenticity) the plaster casts were generally taken from aftercasts rather than the "original" in the Uffizi.[9]

Like the artists who composed their paintings out of these sculptures, the Cokes and Walpoles, who decorated their houses and gardens with these images, could create their own allegories—for example, by relating statues of Venus and Mars, an allegory of peace or war. At Stourhead Henry Hoare created a Choice of Hercules in his Pantheon by placing a Hercules-of-the-Labors (a copy by Rysbrack) between Ceres and Flora, the equivalents of Virtue and Pleasure as Industry and Idleness.[10]

In much the same way, Hogarth's Venus de Medici, representing Beauty but also withholdingness (she is a Venus Pudica, a Modest Venus, trying to conceal her private parts from view), is placed so that she appears to be exchanging amorous looks with the Apollo Belvedere, while a Hercules's back is turned in both partial and full-length versions. Both sculptures were called Hercules, said to be resting after his "labors."[11] Even Hercules's "labors" in Hogarth's new context become sexual labors—and so Venus, insatiable, no longer fitting the descriptions of this Venus Pudica, of "decent Bashfulness . . . spotless Modesty and Chastity . . . Sweetness, Beauty and Delicacy and Air of youth," is the Venus who betrays Vulcan with Mars.[12] Spence, however, had noted of her, "if she is not really modest, she at least counterfeits modesty extremely well" (67).

The *Apollo Belvedere* had already been used in little scenarios of this sort. The statue was thought to accompany Diana the Huntress as part of a group depicting the story of Niobe's Children, and in gardens he was placed with statues of Ceres or Flora so as to augment female with male beauty or Fruitfulness with Wisdom. The love of Venus and Apollo is emblematized in a conventional way by the pair of doves mating at Venus's feet, as well as by the reinterpretation of Laocoön "entangled" with the serpent—both the serpentine

coils of Venus's passion and the serpentine lines in which Hogarth found beauty.

Within his text Hogarth uses the *Antinous* to illustrate the "utmost beauty of proportion"; this statue "is allowed to be the most perfect . . . of any of the antique statues" (81–83). It was reproduced and used in the art treatises of writers from Bellori to Audran in measured illustrations of the proportions of the ideal human body, and Hogarth uses it, quoting Dufresnoy's words ("a fine figure and its parts ought always to have a serpentlike and flaming form," 6), to illustrate his serpentine Line of Beauty.[13]

But the juxtaposition with the contemporary dancing master (author of books on deportment, a recognizable portrait of John Essex), leads the spectator to ask more particular questions of the *Antinous* as well. Something not mentioned in the art treatises but evident in the history books, Antinous was the minion of the Emperor Hadrian, deified and celebrated throughout the ancient world in versions of this statue erected by the emperor in memory of his drowned lover. The Christian Fathers were outraged by the emperor's making a god of this boy who seemed to them no more than a male whore. In the context of Hogarth's composition, the effeminate dancing master activates these memories, suggesting that he may be indecently propositioning Antinous.[14]

We recall that Shaftesbury and Hutcheson set off "polite" or "high" culture from the "necessary," "mechanical," and "useful arts" by the distinction of property, commodity, and interestedness. For Hutcheson the term was "exterior sense," which arises from desire and is active, "sensual," and "voluptuous" at its lowest sexual desire; whereas the "interior sense" is passive, disinterested, in short lacking appetite. If initially in his "modern moral subjects" Hogarth, following Mandeville, revealed under the "interior sense" the sheer desire to emulate, later—in the 1750s, when he could take emulation for granted—he focuses on sexual desire. Thus in *Analysis* Plate 1 emulation appears as a subtext of the lead copies of canonical works of sculpture, while sexual desire is the text revealed by each sculpture.

But in Hogarth's statuary yard Apollo is placed in a double gestalt, one involving him in a context of desire with Venus, the other placing him in a political context with Caesar.[15] He seemingly knocks on the head an eighteenth-century statue of a stage Brutus who is (again seemingly for it is only a rolled speech he holds) stabbing in the back

Julius Caesar, who appears to fall forward because a rope is hoisting his statue into a standing position—or hoisting the man himself onto a gallows.

Pursuing the political parallel, we see that Hogarth has placed a Roman emperor's pathic on the left and in the middle the assassination of Julius Caesar (i.e., the end of the republic), with the avenging of his murder by the Apollo Belvedere, whose pose recalls the most famous antique statue of the Emperor Augustus.[16] It is worth noting that the *Apollo Belvedere* had already been used in England as an aristocratic portrait model: in 1748 Allan Ramsay painted his *Chief of Macleod* in the Apollo pose, and as Hogarth was writing *The Analysis of Beauty* Reynolds was painting his *Commodore Keppel,* another, more stately Apollo Belvedere, which would establish his reputation as England's premier portrait painter.

If we connect the principle of "intricacy" in the *Analysis* text with Hogarth's attack on secondhand forms in the first plate, we begin to recover the subject of his "modern moral subjects" (or "comic history-paintings"): "the surprising alterations objects seemingly undergo through the prepossessions and prejudices contracted by the mind.—Fallacies and prejudices strongly to be guarded against by such as would learn to see objects truly!" (25). Through all of this "love of pursuit" Hogarth is asserting that the canonical sculptures were now in the 1750s essentially empty signs waiting to be filled by the experiential interpretations of the ordinary passerby. He forces us to read the sculptures as an unfolding sequence: first, in the conventional code of the connoisseur, as an ideal beauty; second, as an arbitrary iconography (out of Ripa's *Iconologia*) in which one statue is Venus, another Apollo, another Hercules. Then he empties them of their iconographic as well as their aesthetic significance by placing them as lead copies in a sculpture yard (thus turning them into *vanitas* symbols, memories of a lost time) waiting as commodities to be sold and crated and delivered, and so subjected to yet another context. Finally, he places them as if in an existential situation, with at least one human who is both bystander and actor, so as to force us to read them within the unequivocally empirical sensory data of London in the 1750s, which fills the now empty signs with a new meaning: a meaning, however, which does not entirely replace those others but ironically corrects them.

The sequence of sculptures, framed by memorials to Antinous and

to a dead magistrate, imposes a sense of the memorial and dead that equally applies to the Venus, Brutus, and Caesar. The climactic figure of the magistrate wears a full-bottomed wig and heavy robes (which in the *Analysis* designate dignity, artificial and often unearned) with a pentecostal flame atop his head and at his feet a mourning putto holding a square signifying justice. In the existential context of the scene, however, the square recalls a gallows (like the one Caesar is being hoisted upon) and the putto's tears are for the wretches hanged by the deceased judge, whose judgments evidently produced only the ruins depicted around the base of his tomb—ruins equally consequential in the causal sequence that runs from Venus to Brutus to Caesar.

The memorialized judge makes a direct link to the magisterial figure in *The Reward of Cruelty* and to the subject of (in Fielding's words in his *Enquiry*) the judge's need for maintaining severity at the expense of mercy. He is depicted with the pentecostal flame on his head to show that, like the apostles, he is filled with the Holy Ghost. But in the context of the *Analysis* text he combines the bad judge of the courtroom and the connoisseur of paintings who, Hogarth points out, are judges, and, he adds for good measure, "it has ever been observ'd at all auctions of pictures, that the very worst painters sit as the most profound judges" (24). Within the text, the judge illustrates the use of a full-bottomed wig (and long black robes) to imply sagacity when the face alone does not. Characteristically, Hogarth ends an argument by reflecting, "I know not how further to prove this matter than by appealing to the reader's eye, and common observation, as before." As the common domestic objects of scrutiny attest, he has "endeavour'd to be understood by every reader," not by self-appointed "judges" of art (102, 106).

Virtually all of these canonical sculptures in their originals (the exception being the *Venus de Medici*) were part of the papal collection in the Vatican. In that sense they stood for authority, from the associations of Rome–Italy to Roman Catholicism to Stuart absolutism and Jacobitism. The one nonclassical sculpture is the tomb effigy. There were no such monuments in Westminster Abbey in the 1750s (the monument eerily anticipates the one to Lord Mansfield erected in the 1780s); but there *was* a place where such monuments did abound, and that was St. Peter's in Rome.[17] Presumably Hogarth's magistrate is given a papal monument to suggest the "infallibility"

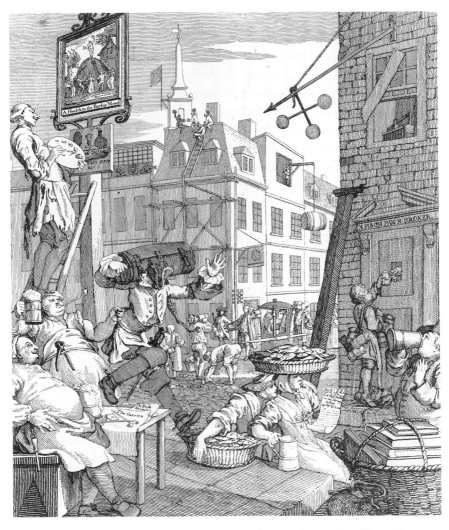

1. *Beer Street* (proof state); Feb. 1750/51; 14⅛ × 11¹⁵⁄₁₆ in. (Fitzwilliam Museum, Cambridge).

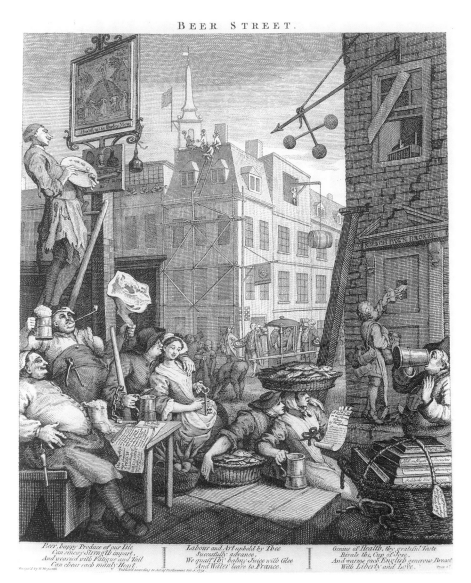

Beer, happy Produce of our Isle
Can sinewy Strength impart,
And wearied with Fatigue and Toil
Can chear each manly Heart.

Labour and Art upheld by Thee
Successfully advance,
We quaff Thy balmy Juice with Glee
And Water leave to France.

Genius of Health, thy grateful Taste
Rivals the Cup of Jove,
And warms each English generous Breast
With Liberty and Love.

2. *Beer Street* (third state); Feb. 1750/51 (courtesy of the British Museum, London).

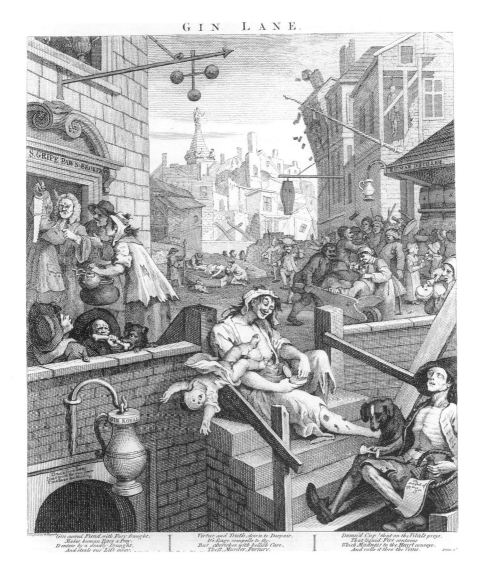

GIN LANE.

3. *Gin Lane* (second state); Feb. 1750/51; 14³⁄₁₆ × 12 in. (courtesy of the British Museum, London).

While various Scenes of sportive Woe
The Infant Race employ,
And tortur'd Victims bleeding shew
The Tyrant in the Boy.

Behold a Youth of gentler Heart,
To spare the Creature's pain
O take, he cries—take all my Tart.
But Tears and Tart are vain.

Learn from this fair Example—You,
Whom savage Sports delight,
How Cruelty disguste the view
While Pity charms the sight.

4. *The Four Stages of Cruelty;* Feb. 1750/51: *The First Stage of Cruelty;* 14 × 11¹/₁₆ in. (courtesy of the British Museum, London).

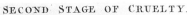

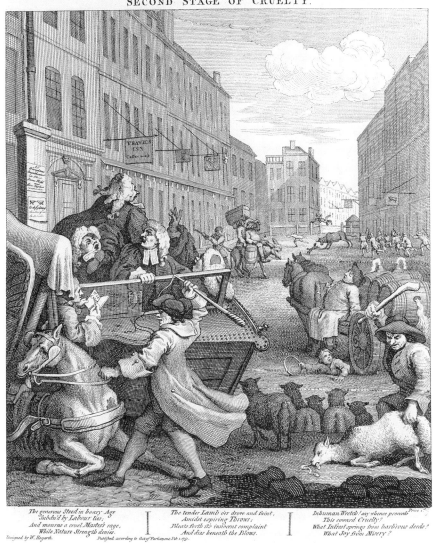

Designed by W. Hogarth. Published according to Act of Parliament Feb 1 1751.

The generous Steed in hoary Age
Subdu'd by Labour lies;
And mourns a cruel Master's rage,
While Nature Strength denies.

The tender Lamb o'er drove and faint,
Amidst expiring Throws;
Bleats forth its innocent complaint
And dies beneath the Blows.

Inhuman Wretch! say whence proceeds
This coward Cruelty?
What Intrest springs from barbrous deeds?
What Joy from Misery?

5. *The Four Stages of Cruelty: The Second Stage of Cruelty;* 13⅞ × 11¹⁵⁄₁₆ in. (courtesy of the British Museum, London).

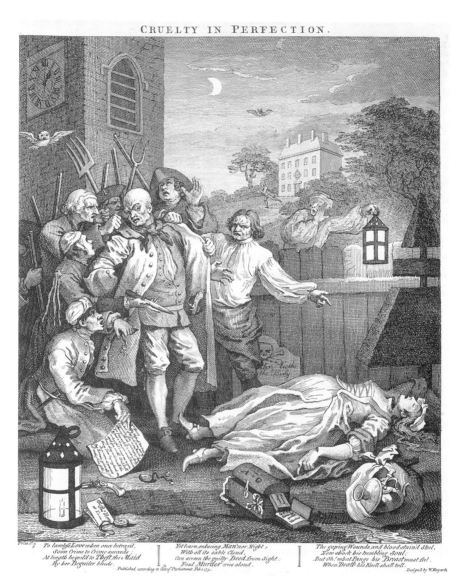

To lawless Love when once betray'd.
Soon Crime to Crime succeeds.
At length beguil'd to Theft, the Maid
By her Beguiler bleeds.

Yet learn seducing Man! nor Night;
With all its sable Cloud,
Can screen the guilty Deed from Sight:
Foul Murder cries aloud.

The gaping Wounds, and blood stain'd Steel,
Now shock his trembling Soul:
But Oh! what Pangs his Breast must feel,
When Death his Knell shall toll.

Published according to Act of Parliament Feb.1.1751.

Design'd by W. Hogarth.

6. *The Four Stages of Cruelty: Cruelty in Perfection* (engraving); 14 × 11¾ in. (courtesy of the British Museum, London).

7. *The Four Stages of Cruelty: Cruelty in Perfection* (woodcut by J. Bell); 17⅞ × 15 in. (courtesy of the British Museum, London).

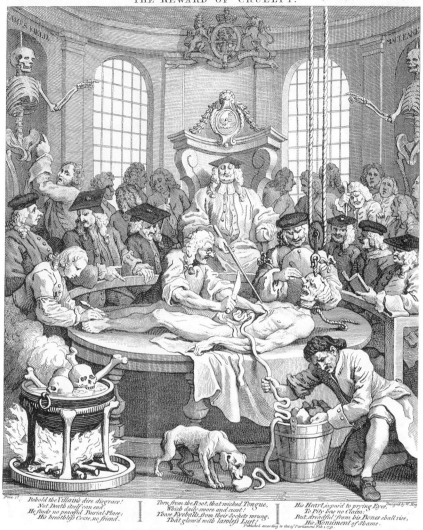

8. *The Four Stages of Cruelty: The Reward of Cruelty* (engraving); 14 × 11¾ in. (courtesy of the British Museum, London).

9. *The Four Stages of Cruelty: The Reward of Cruelty* (drawing); 18⅛ × 15⅛ in. (Windsor Castle, Royal Library, copyright 1992, Her Majesty Queen Elizabeth II).

10. *The Four Stages of Cruelty: The Reward of Cruelty* (woodcut by J. Bell); 17⅞ × 15 in. (courtesy of the British Museum, London).

11. *Henry Fielding* (engraving by James Basire); pub. Apr. 1762; 7⅛ × 4½ in. (courtesy of the British Museum, London).

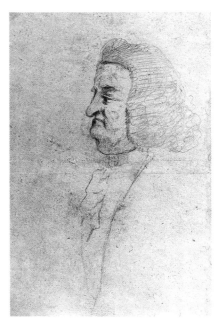

12. Unknown artist, *Henry Fielding* (?); drawing; ca. 1750 (courtesy of the British Museum, London).

A proofprint from this plate, designed and etched by
B. Wilson, was sold as a verry fine Rembrandt.
to one of the greatest Connoisseurs for Six —
shillings. the 17. April 1751.

13. Benjamin Wilson, *Rembrandt Forgery:* "Companion to the Coach"; 1751 (British Museum, "School of Rembrandt," 4: 190; courtesy of the British Museum, London).

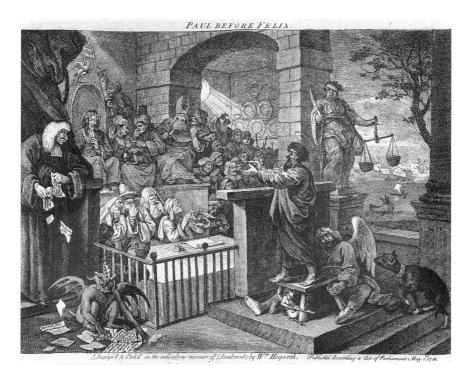

14. *Paul before Felix Burlesqued* (fourth state, without receipt); May 1751; 9⅞ × 13½ in. (courtesy of the British Museum, London).

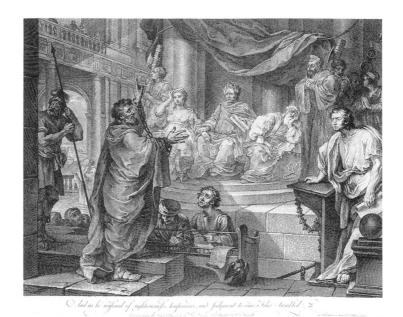

15. *Paul before Felix* (engraving by Hogarth); 1751–1752, pub. 1759; 15⅛ × 20 1/16 in. (courtesy of the British Museum, London).

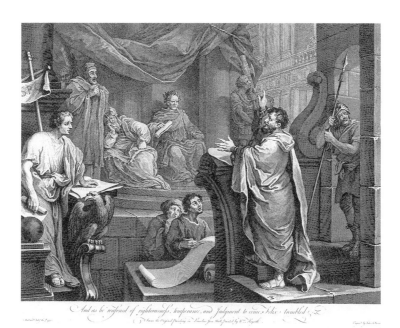

16. *Paul before Felix* (engraving by Sullivan); Feb. 1752; 15⅛ × 19⅞ in. (courtesy of the British Museum, London).

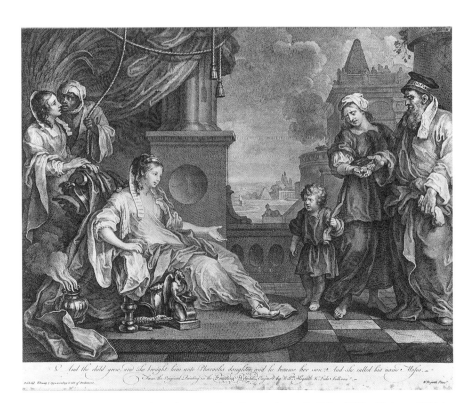

17. *Boys Peeping at Nature* (fourth state), revised as subscription ticket for *Paul before Felix* and *Moses Brought to Pharaoh's Daughter*; 1751; 3½ × 4¾ in. (courtesy of the British Museum, London).

18. *Moses Brought to Pharaoh's Daughter* (second state); Feb. 1752; 15⁵⁄₁₆ × 19⅞ in. (courtesy of the British Museum, London).

Rec'd 4 *August* of
five Shillings being the first Payment for a Short Tract in Quarto
call'd the Analysis of Beauty; wherein Forms are consider'd in a new
light, to which will be added two explanatory Prints Serious and
Comical, Engrav'd on large Copper Plates fit to frame for Furniture.

N.B. The Price will be rais'd after the Subscription is over.

W. Hogarth

19. *Columbus Breaking the Egg;* Apr. 1752; 5⅝ × 7⅛ in. (courtesy of the British Museum, London).

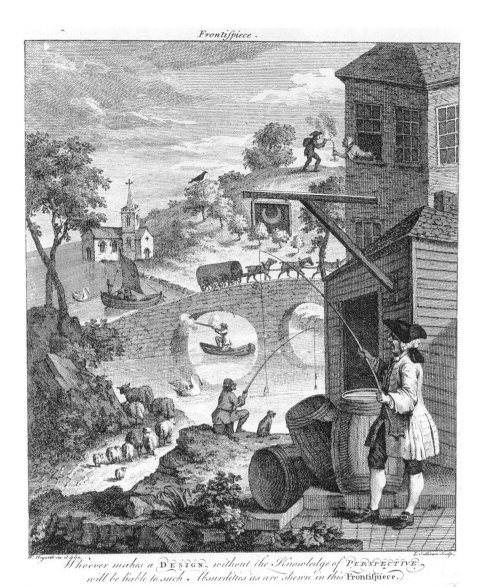

Whoever makes a DESIGN, *without the Knowledge of* PERSPECTIVE *will be liable to such Absurdities as are shewn in this* Frontispiece.

20. *"Frontispiece": Satire on False Perspective;* Feb. 1754; 8³⁄₁₆ × 6¾ in. (courtesy of the British Museum, London).

THE
ANALYSIS
OF
BEAUTY.

Written with a view of fixing the fluctuating IDEAS of TASTE.

BY *WILLIAM HOGARTH.*

So vary'd be, and of his tortuous train
Curl'd many a wanton wreath, in sight of Eve,
To lure her eye.——— Milton.

VARIETY.

LONDON:

Printed by *J. REEVES* for the *AUTHOR,*
And Sold by him at his Houſe in LEICESTER-FIELDS.

MDCCLIII.

21. *The Analysis of Beauty,* title page; pub. Dec. 1753.

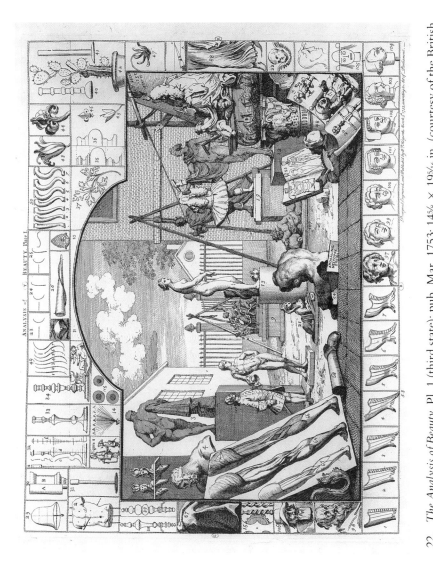

22. *The Analysis of Beauty*, Pl. 1 (third state); pub. Mar. 1753; 14⅞ × 19⁵⁄₁₆ in. (courtesy of the British Museum, London).

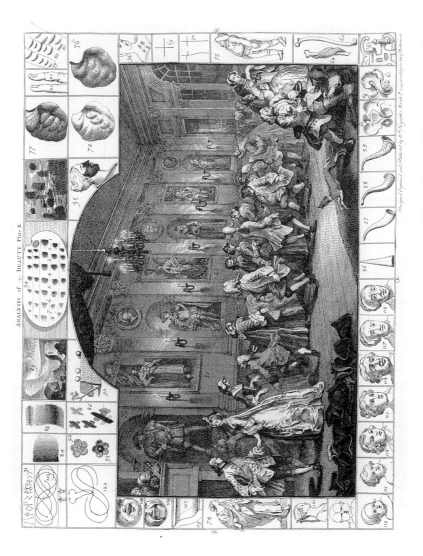

23. *The Analysis of Beauty*, Pl. 2 (first state); pub. Mar. 1753; 14⁹⁄₁₆ × 19⁵⁄₈ in. (courtesy of the British Museum, London).

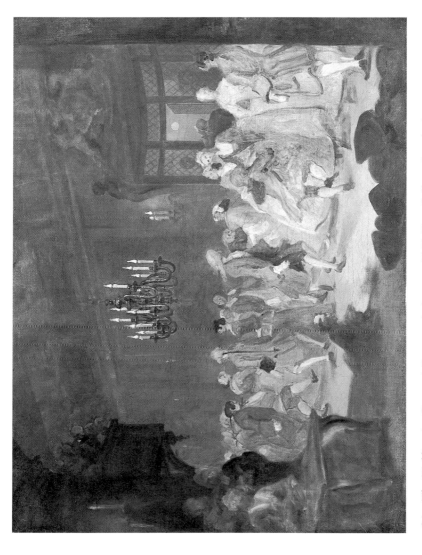

24. *The Wedding (or Country) Dance*; painting; ca. 1745 (Tate Gallery, London).

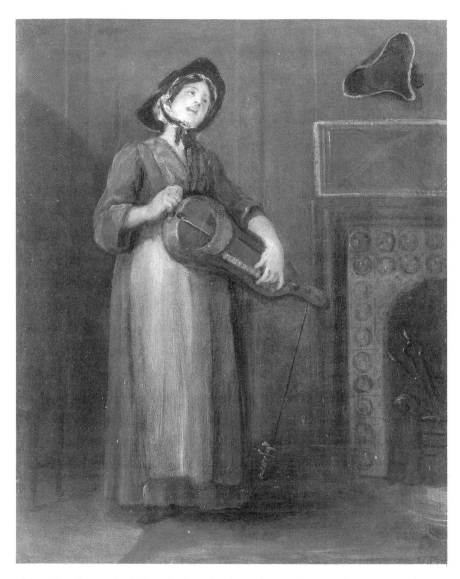

25. *The Savoyard Girl;* painting; 1749; 16½ × 13 in. (The Leger Galleries, London).

26. Paul Sandby, *Burlesque sur le Burlesque;* Dec. 1753 (courtesy of the British Museum, London).

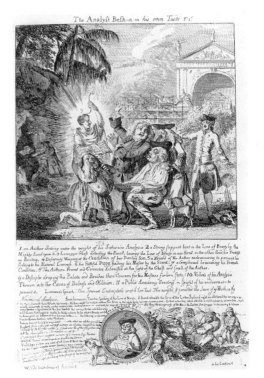

27. Paul Sandby, *The Analyst Besh–n;* Dec. 1753 (courtesy of the British Museum, London).

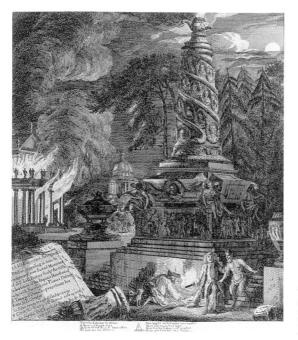

28. Paul Sandby, *The Vile Ephesian (The Burning of the Temple of Ephesus)*; Dec. 1753 (courtesy of the British Museum, London).

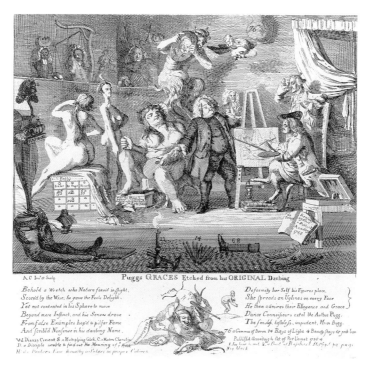

29. Paul Sandby, *Pugg's Graces*; 1753–1754 (courtesy of the British Museum, London).

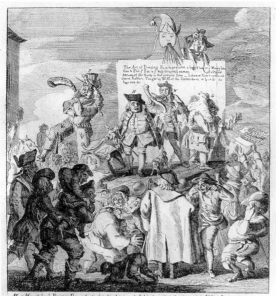

30. Paul Sandby, *A Mountebank Painter;* Mar. 1754 (courtesy of the British Museum, London).

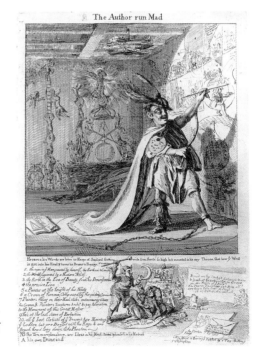

31. Paul Sandby, *The Author Run Mad;* Mar. 1754 (courtesy of the British Museum, London).

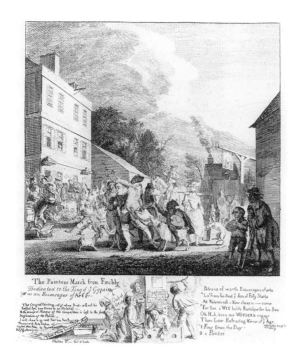

32. Paul Sandby, *The Painter's March from Finchly;* Apr. 1754 (courtesy of the British Museum, London).

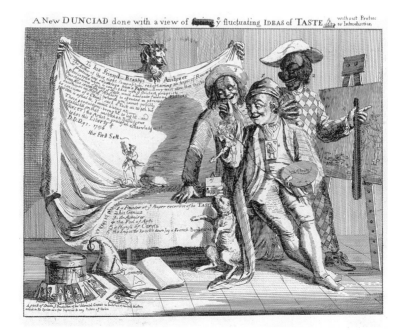

33. Paul Sandby, *A New Dunciad;* Apr. 1754 (courtesy of the British Museum, London).

falsely associated with magistrates and, by extension, with "judges" of art—as well as a climax to the Roman sequence from Republic to Empire to "Holy" Roman Empire. The epitaph, "Obit 1752," may indicate the coincidence of the hoped-for demise of bad judgment with the writing of *The Analysis of Beauty*.

There is no question that the first *Analysis* plate expresses once again Hogarth's idea of how to revitalize English art by infusing new, contemporary English life into moribund forms, myths, and iconography. The illustration expresses a doctrine Hogarth does not stipulate in his text: the Venus and the Apollo are, seen in one way, paradigms (or more specifically memories—memorials) of conventional beauty; but seen in another way they are infused with human feelings, desires, and (to use Spence's word) "counterfeits." Something that appears to be an art object is naturalized, popularized, and filled with a different meaning; something seen as a public, political act (avenging the murder of Caesar) is also implied to be a private act of passion. What is revealed as the living reality of the aesthetic object is not precisely moral wrong but human desire. In Hogarth's own terms, the revelation is the living, breathing, sensuous reality that is beneath—and preferable to—even the greatest but dead art object, and so his new sense of Beauty.

Since the *Harlot's Progress* idolatry had been one theme of Hogarth's satire: either the idolatry of any object that is denied its physical reality or the idol as a godless, that is, a lifeless statue. The English Protestant iconoclasts distinguished the true god from the dead, inanimate idol. The crux was Psalm 115, where idols, as opposed to the Jewish God, "have mouths, but they speak not: eyes have they, but they see not: they have ears, but they hear not," and so on—that is, they are dead images void of voice, sight, or breath, to be distinguished on the one hand from a true work of art and on the other from life lived.[18] Calvin also attacked the related notion that an image of a deity could be "fashioned from any dead matter," and Calvinists constantly referred to the crude materials out of which the idol had been made. This idea of dead matter out of which is fashioned a false image of deity was the other half of the reduction of the image to its basic crude physicality or utility.

English Calvinists ground down the idol but then, by a process

that has been called sacramental realism, remade the image, either by recasting the pulverized materials or by other modifications, into a different, more abject thing that could not possibly be worshiped. The idol was transformed downward into a secular object, a vulgar, commonplace equivalent: the surplice into a seat cushion, a triptych into a pig trough, a chapel into a dining room, an icon into a child's doll, an icon into plates to eat from.[19] The aim was to remove all of the old mystification and to replace it with utility, to bring down the abstract or spiritual to the commonplace and particular.

Pagan images of Diana or Venus, though of less concern to the iconoclasts than images of deity, did have in common with the idol their deadness and pastness or remoteness from nature and experience. And it was for this reason that Hogarth fastened on them, seeing them as the art objects that decorated the country houses of rich collectors and self-seeking politicians. He associates "idol" with old, dead art, with copies and forgeries, as well as with contemporary fashion, as opposed to a figure of voice, sight, and breath, who is the living and breathing woman he tells us is more beautiful than the most perfect antique Venus. Thus the culmination of the idea of dead matter out of which is fashioned a false deity appears in the lead statues Hogarth shows being sold in the statuary yard at Hyde Park Corner: death, emptiness, and all the qualities associated with the idol in Psalm 115 are here.

But then, having established their deadness, Hogarth reanimates them in much the same way Calvin insisted that the actual miraculous presence of Christ's blood and body, both the notion and the image, the wafer of the Mass, that stands for it, must be replaced with the common bread people ate in their daily lives. But he also augments the utilitarian lead copies of the antique sculptures with (around the margins) smokejacks, candlesticks, bells, and stays.

The Abbé Raguenet, in his *Monumens de Rome* (1700), described the great canonical sculptures as depicting "states which are neither Life, nor Death, nor Agony, such as the Niobe who is neither alive nor dead nor dying but turned to stone."[20] The Dying Gladiator represents "the very moment from Life to Death, the instant of the last breath." Raguenet suggested that the power of these sculptures lies in their showing better than any others the transitional states of expression, gesture, and being. This (evident as far back as the *Beg-*

gar's Opera paintings) was a view still shared by Hogarth, as earlier by Watteau, whose garden sculptures are often indistinguishably stone or flesh. (In this sense, the statuary yard is simply a parody of Watteau's gardens and their sculptures in his *fêtes galantes;* as *Marriage A-la-mode* 1 with its paintings parodied the interior of *L'Enseigne de Gersaint.*) The moment of transition is the moment shown in Hogarth's examples: Apollo turning or reaching out, Venus caught unawares and modestly covering herself, and Laocoön and his sons being crushed to death by the serpent. If we compare the Apollo Belvedere as he appears, for example, in the plate of Spence's *Polymetis,* with Hogarth's, seen from the same direction but reversed, we will notice that Hogarth has turned his head to profile. This gives a sense (to anyone knowing the plaster casts, or Spence's volume) of inclining as if by magnetic passion toward Venus and also of being in movement from one position to another and in transition from one state of being to another.

It is also interesting to note that Hogarth, as usual, does not bother to reverse as he engraves, and so the sculptures appear turned about, in a sense estranged; and he shows them from views and angles that suggest that he copied them not from the engravings (which do not show these views in most cases) but from the casts in the academy, where he could walk around and observe them from every angle. His purpose seems to be partly to show them in unaccustomed views and partly in the moment of turning from one pose to another.

Within the text, the crucial sequence in the chapter "Of Intricacy" is from the hunt to a "common [smoke] jack," and the "curling worm" of the screw, to the country dance, the wanton lock of hair, and the female body; and in "Of Compositions and the Serpentine Line" from a cone to a horn, a cornucopia, a ram's horn, and human bone forms, to the human body, and, once again, the female body (41–45, 67–82). These transitions fit into the spectrum of shapes, aspects, and attitudes of the human body that is the chief point of Hogarth's illustrative plates as they serve his text: from the candlesticks, corsets, and table legs to caricatures, anatomical diagrams, statues, and a tomb effigy, to a human overdressed dancing master and a man in the foreground examining Dürer's rules for drawing the human figure. If in the central scene Hogarth evokes Watteau's spectra of art and nature, around the border he recalls the graded

series in the physiognomic treatises that illustrated the progressive degrees of the passions as they change from the tranquil to the vehement (in particular Le Brun's *Méthode pour apprendre à dessiner les passions,* 1698, to which Hogarth refers [138]).

The figure of John Essex becomes an emblematic key to the plate if we remember that dancing masters were not only likened to hairdressers and tailors who distort and disfigure the human form, but at the same time practiced an art based on movement.[21] The dancing master points the transition to Plate 2, The Country Dance, where beauty is shown to be in the act of transition, specifically of a dance. In "A Dialogue concerning Art" (1744) James (Hermes) Harris had remarked that "dance has its being or essence in a transition: call it a motion or an energy." His point was that this movement is ephemeral, volatile, and impossible to formulate.[22]

PLATE 2: THE COUNTRY DANCE

The second plate moves art into the background, up onto a shadowy wall, and brings into the foreground at eye level the human figures—a group consisting of different classes of men and women dancing in a country house, illustrating in their human shapes the forms of Beauty and the "ridiculous." The setting was traditionally identified as Wanstead House with the first earl of Tylney, his countess, their children, tenants, and friends.[23] It is probably not this, but certainly some such country house with an analogous cast of characters. Figure 71 in the upper left corner—a diagram of the action—shows that two or three lines suffice to represent the attitude of each person, demonstrating that though any graceful person "may deform his general appearance by throwing his body and limbs into plain lines," these ugly lines are even more disagreeable in naturally awkward human bodies (146). The two dancers singled out as graceful are the host and his wife, represented by the two wavy lines on the left. The coupling of lines of Beauty and Grace with figures representing the British aristocracy returns the reader to the text.

Throughout the final sections of the *Analysis,* where Hogarth is summing up, his use of the words "grace" and "noble" calls for scrutiny. "Grace" is dissociated from the graceless icons of the monarch

and nobility on the wall (as usual, old works of art that are anathema to Hogarth), but it is embodied in the noble couple below the pictures, who are supposed to be real—that is, are Hogarth's own representations (as opposed to Van Dyck's above). As he moves from the Line of Beauty to the Line of Grace, Hogarth quietly introduces into his aesthetics another element: the "hand must move in that *more beautiful direction,* which is distinguished by the name of *grace;* and according to the quantity given to those lines, *greatness* will be added to *grace,* and the movement will be more or less *noble*" (153; emphasis added). We have seen that "grace" carries something of its religious sense; but Hogarth associates it most often in his text with gentility. The passage quoted is followed immediately by a reference to "*gentle* movements," and then: "The pleasing effect of his manner of moving the hand, is seen when a snuff-box, or fan is presented *gracefully* or *genteely* to a lady" (emphasis added). The first four senses of "genteel" in the *OED* involve the "gentry" or "a rank above commonalty," "appropriate to persons of quality," "having the habits of superior station; that ranks or claims to rank above the commonalty on the ground of manners or style of living," or "gentlemanly or ladylike in appearance; well-dressed." Only the fifth definition, derived from the preceding ones, introduces the notion of merely "elegant or graceful in shape or appearance."

Elsewhere Hogarth notes (referring to his Figures 82 and 83) that the principle of varying lines producing grace can even

> be observ'd in the fingers, where the joints are but short, and the tendons straight; and where beauty seems to submit, in some degree, to use . . . the difference will more evidently appear when you in like manner compare a straight coarse finger in common life with the taper dimpled one of a fine lady. (80–81)

The latter is the more beautiful. He associates lower class attributes ("coarse," "common") with the less beautiful lines, and a "fine lady's" with the more. In the subscription ticket, *Columbus Breaking the Egg,* he gives Columbus the gentility, his opponents the plebeian coarseness.[24]

While his paradigmatic young woman began for Hogarth with the particular face of the actress Lavinia Fenton, and went on to the goose-faced Harlot and the rather plain Sarah Young, in the artist

satires and the history paintings after 1735 her nose became straighter, her features more regular, and she revealed Hogarth's need to authenticate her as "beautiful." In *Industry and Idleness,* while he gave Tom Idle a plebeian face, he gave both his master's daughter and Francis Goodchild features according to the classical convention of beauty. In other words, the young woman, who within Hogarth's scene served a mediating function between the forces of order and disorder, may in fact have represented a figment of Hogarth's (not the Poet's or Musician's) ordering mind and so served primarily to contain (and perhaps "contain" is a synonym for "mediate") the plebeian energies that were welling up around her.

But Hogarth also notes in the *Analysis* that Beauty must "submit . . . to use" in order to achieve plain lines, and (speaking of animals): "All useful habitual motions, such as are readiest to serve the necessary purposes of life, are those made up of plain lines" (151–52). As he proceeds, he relegates the Line of Grace to a secondary role, used but occasionally, and rather at times of leisure than constantly applied to everyday actions. In fact, "the whole business of life may be carried on without these graceful movements"; properly speaking, they are only the ornamental part of gesture (152).[25] To say that actual living may be carried on without graceful gestures is to limit drastically their applicability, especially in light of his contrast between the *living* woman and the Grecian Venus.

THE AESTHETICS OF THE RIDICULOUS

Plate 1 addressed the subject of the relationship between beauty in art and in life, including human desire; Plate 2 extends the exploration (or "pursuit") to the relationship between beauty and morality, and finally beauty and class. Coincidentally, and appropriately, it illustrates Hogarth's theory of comedy, but not only in the plebeian country folk.

In the chapter "Of Quantity" the idea of exaggerated quantity (and greatness or false greatness) leads Hogarth into a digression on the ridiculous, a category, based largely on formal considerations, that complements the Beautiful. Hutcheson had seen an innate "*Sense* of

the *Ridiculous*" as "an *Avenue* to Pleasure, and an easy *Remedy* for Discontent and Sorrow." It serves also to check foolish enthusiasm and excessive admiration.[26] But Hogarth's is one of the earliest statements of the incongruity theory of comedy: "When improper, or incompatible excesses meet, they always cause laughter. . . . the ideas of youth and age are jumbled together . . . [, the] joining of opposite ideas." He goes on to point out that the joke is funny only when told in such a way that two different strains of association, two different shapes, are brought into conjunction suddenly and surprisingly (48–49, 180). This theory illuminates the sense in which Hogarth, the "moralist," the mordant satirist, whose plots are anything but funny, is nevertheless a comic artist. The most distinctive characteristic of the Hogarthian comic, as of Hogarthian aesthetics, is the sense of discovery—the surprising revelation that complicates and disorients. The "love of pursuit" invites the reader's ingenuity, and the consequent pleasure of discovery often explodes into laughter. Above all hovers the general effect of incongruity in the discrepancy between the harmless-looking object and what, in its context, it reveals; or between the story of a harlot or a rake and the witty juxtaposition of a *Bacchanal*, *Feast of the Gods*, or *Pietà*.

Hogarth does not, however, completely rule out the moral dimension in

> the joining of opposite ideas that makes us laugh at the owl and the ass, for under their aukward forms, they seem to be gravely musing and meditating, as if they had the sense of human beings.
>
> A Monkey too, whose figure, as well as most of his actions, so oddly resembles the human, is also very comical; and he becomes more so when a coat is put on him, as he then becomes a great burlesque on the man. (49)

By adding that the joining of element A (owl, ass) with element B (gravely musing) creates a "burlesque" of B, Hogarth shows that he is still thinking within the satiro-comic theory of the Augustans which saw ridicule, and not mere laughter, as the end of humor. The implications are that A is being ridiculed, or satirically attacked; and, whether A is a beau putting on too large a periwig or an owl looking wise, the subject of the attack is still essentially covered by Fielding's

term in the preface to *Joseph Andrews,* "affectation"—implying a moral rather than an aesthetic incongruity.[27] Laughter lies in the ideas behind the shapes—the idea of an old man's head attached to a baby's body or the graceful figure of Columbus juxtaposed with the grotesque figures of the disbelievers, or the composition of the Last Supper juxtaposed with the story of Columbus and the egg.

But, as in the representation of Columbus, Hogarth links the negative part of the incongruous juxtaposition with such terms as "inelegance" and "impropriety." In the argument of the *Analysis* the graceful, indeed the beautiful, is normative. The difference between sheer incongruity and adverse judgment can be sensed by comparing the oil sketch of *The Wedding (or Country) Dance* (fig. 24) with the engraving in Plate 2. The formal incongruities are there, as James Beattie noticed in his "Essay on Laughter" (1776), in the odd shapes of the rustic dancers contrasted with the normative lines of the young man at the right.[28] But in the engraving this man and his partner (now on the left) are denoted as aristocratic (he wears an order) and their genteel elegance sets off the "comedy" of the awkward plebeian dancers. The latter are comical in comparison to the aristocratic couple—who, in a later state, are made even more aristocratic as the Prince of Wales and a lady friend (fig. 81).

In the engraving, however, the social configuration is complicated by a moral one, which further complicates the simple aesthetic thesis of the text. The knot of people added at the right, opposite the aristocratic couple, contains one graceful figure. The simple juxtaposition of this young woman with her elderly husband who wants to go home (presumably to sleep) is comic, but it turns satiric with the addition of a third figure, a young man passing her a note, presumably arranging an assignation. An aesthetic contrast, by this detail, is turned into a moral epitome. The awkward lines of the husband may signify folly, but the beautiful curves of his wife do not in the context imply virtue, any more than does the S curve of the aristocratic dog who barks derisively at the clumsy dancers.

As in the first plate, the layout conveys the *Analysis*'s general juxtaposition of art and nature, but art is now associated on one side with genteel society and on the other with deception, and on the wall above with Old Master portraits. In the margin next to the young wife appears Sancho Panza, who in the text illustrates "one plain curve" that expresses "the comical posture of astonishment" as he

watches "Don Quixote demolish the puppet shew" (in Coypel's illustration, vol. 1, fig. 29). But in relation to the central picture of the dancers, Sancho's astonishment is directed at the wife who is deceiving her husband under Sancho's very nose. An inelegant, plebeian figure perceives the deception of an aesthetically pleasing and genteel but morally loose woman. Here a knowledge of the principle of Beauty, the serpentine line, leads some people to dance or gesture with grace, but no hint is supplied about the moral life that lies beneath.

Further, the plain curve of Sancho's "comical posture of astonishment," Hogarth continues (148), is contrasted to "the serpentine lines [of Beauty] in the fine turn of the Samaritan woman . . . taken from one of the best pictures Annibal Carrache ever painted" (*Christ and the Woman of Samaria,* Brera, Milan).[29] The illustration's judgment is aesthetic, but in the context of the design Sancho is astonished not by Don Quixote, who confuses art with reality, but by the Woman of Samaria (in the opposite margin), whose equivocation about her morals did not deceive Christ (John 1:18, "thou hast had five husbands; and he whom thou now hast is not truly thy husband"). And Carracci's Woman of Samaria stands next to the young nobleman/prince, clearly his formal model (his sash and the turn of his legs, the mirror image of the Samarian Woman's, emphasize the parallel, and in a later state Hogarth raised his leg to make it even closer); and the moral significance of the juxtaposition is an open question.

Placed above the nobleman/prince and his lady, moreover, is a very *ungraceful king* Henry VIII without *his* lady, adding to the context of this aristocratic couple. In the text, Henry represents simple uniformity and is said to resemble a perfect X, powerful but ungraceful (38, 148). A man standing immediately beneath the portrait is embarrassing his lady by pointing out Henry's codpiece, his prominent sexuality, which, unconcealed by manners, is quite different from that of the young nobleman. Though contrasted in shape, iconographically he is linked by his six wives to the Samarian Wife of Bath with her five husbands-plus-one; and his strident pose links him with the collapsed X of the cuckolded husband: the king who chopped off his errant wives' heads and the husband who meekly points to his watch as his wife arranges an assignation. Ironically (but accurate historically), the great Reformation iconoclast is himself niched and a form of idol, worshiped for his male potency—a priapic figure, related to the Woman of Samaria on one side and the contem-

porary adulteress on the other, and contrasted with the figure next to him of the virtuous but weak king, Charles I (like Henry's wives, beheaded).[30]

The living people are defined, like those in *Marriage A-la-mode,* by social knowledge or ignorance, by class and family models and pressures (with a plebeian Sancho, a servant or black slave, observing). As in those earlier scenes, the human shapes are reinforced by the icons of noble figures above them on the wall: full-length portraits and life-sized statues of—besides Henry VIII—Charles I, Edward VI, the duchess of Wharton, Queen Elizabeth, and "two other wooden figures," one of which is a general and the other a medieval king (148). The portraits inevitably recall the oppressive paintings on the walls in Hogarth's earlier moral series. These monarchs, elevated above the crowd of dancers, also materialize the topos of the one and the many, the ruler and the ruled, that has been implicit in the argument of the *Analysis.*

Charles I is composed of lines that lack variety and Edward VI of lines curlier than the Line of Grace, the duchess of Wharton is "thoroughly divested of every elegance," and the remaining figures are straight lines. In part they show again (as in Plate 1) that nature is preferable to art and that natural figures always exceed their artistic imitations in beauty and grace.[31] They also—as opposed to the classical canon of sculpture in Plate 1—direct our attention to portrait painting, a genre which Hogarth had attempted and to which he will publicly announce his return four years later (see Chap. 11). In the text, Van Dyck is particularly singled out for criticism, perhaps because he invented the kind of portrait that dominated the art market to the exclusion of other portraits and other genres by English painters—conversation pictures and "modern moral subjects," for example.

The row of portraits also allows Hogarth to continue the implications begun with the icon of Henry VIII, for, with the exception of Elizabeth, these were not exemplary monarchs. According to Bolingbroke's "Remarks on the History of England" in the *Craftsman* (1730–1731), the most tyrannical king was Henry VIII, but equally deplorable was Charles I, both contrasted with the admirable Elizabeth; which would suggest one reason Hogarth added the Prince of Wales below these warnings. (But in the text even Elizabeth is described as "a wooden figure" [148].)

The second illustration corresponds to the latter half of the *Analysis* text, the function of which is to demonstrate the ways in which variety (desire, pursuit, and the rest) can be composed (the term "composed variety" appears repeatedly), or more specifically closed in a social form. This part of the *Analysis* is introduced by the equation of beauty and gentility, followed by a discussion of instruction, emulation, repetition, and all the copying procedures Hogarth had criticized in the earlier chapters of the *Analysis* but here calls into service for the inelegant person who wishes to learn elegance and be genteel. As we have seen, this is signaled by a hiatus in useful activity: first the bow and curtsey are introduced, and then the larger forms of "composed variety," each involving an interaction of people in the dance, the drama, and marriage.

The most beautiful dance is the minuet—"the perfection of all dancing," we are told, because it contains the most serpentine lines; the country dance is comical because of its mixture of serpentine and other lines, but this can still make a "composed variety of lines." These dances are contrasted with both the "pompous, unmeaning grand ballets" and "the dances of barbarians . . . wild skiping, jumping, and turning round, or running backward and forward, with convulsive shrugs, and distorted gestures" (160). In the illustration, the nobleman (host) and his lady are dancing a minuet on the edge of the clump of yokels who are performing a country dance, demonstrating respectively the beautiful and the comic.

The drama is comically represented by (the equivalent of the country dance) the commedia dell'arte, and beautifully by the "genteel and elegant acting" of the London stage. Both exemplify a story of romance leading to marriage. In the text these are implied when Hogarth, explaining that the absence of serpentine lines makes a figure ridiculous, adds that this is "allowable in a man" while it "would disgust in a woman," and the man's role in the minuet is only beautiful "as the main drift of it represents repeated addresses to the lady." The "true spirit of dancing" is the expression of "elegant wantonness" (159). In the illustration this "elegant wantonness" is domesticated in marriage: the nobleman and his lady, if not married, are at least a couple, the older man and the young woman are presumably married, and on the wall Henry VIII and in the margin the Woman of Samaria have their different stories of desire in marriage.

In this sense, the *Analysis* closes much as *Fanny Hill* did. In de-

scribing her reunion with Charles, Fanny made a distinction between pleasure and love: "I was now in touch at once with the instrument of pleasure and the great-seal of love" (219). The final pages of *Fanny Hill* present the refinement of erotic pleasure in love and, its concomitant, marriage. In both *Fanny Hill* and the *Analysis,* sexual play, which is active, exploratory curiosity, is ultimately refined into a higher, composed (and legalized) state associated with class and property.

In Plate 2 this state is marriage literally (the painting was originally a "*Wedding* Dance"); in the conclusion of the text it is surrogate social forms, epitomized by the dance, but ending once again with the stage. Hogarth ends by privileging, as he has throughout, the actress who plays Venus over the actor who plays Apollo. But he gives the last word to the "comedian" (male), whose task is "to imitate" these "particular characters in nature," the ladies and gentlemen, actresses, actors, and statues: "for whatever he copies from the life, by these principles [i.e., of Hogarth's aesthetics] may be strengthened, altered, and adjusted as his judgment shall direct, and"—he adds as a strange anticlimax, the last words of the treatise—"the part the author has given him shall require" [157]. We do not know who that "author" is, but the comedian is presumably the author of the treatise.

Hogarth's turning his attention to aesthetics would at first seem a withdrawal from the problems of the real world, and especially odd in the same years he was making his most subversive social satires. But we have seen that there is an implicit socio-political commentary in his raising variety and liberty over the old doctrines based on unity and order (Shaftesbury's nature as order, harmony, and proportion; Hutcheson's uniformity and regularity; the Vitruvian orders in architecture; and "whatever is is right" in politics).

Hogarth's claim in *The Analysis of Beauty* is for beauty precisely in the common, the everyday, the fallen world of smokejacks and unfaithful wives, in some picturesque conjunction with the ideal antique Venus or the "Perfect Line of Beauty." What at first appears to be a process of formal abstraction turns out to be a search that reveals the same beauty in the Harlot and poor London milkmaids as in aristocratic ladies who are no better than they should be. Even the

one elegant man, the nobleman/Prince of Wales, who is clearly above reproach both aesthetically and morally, is subtly implicated with the adulterous Woman of Samaria and shares the notion of beauty as the ideal flawed by contingency.

Taste, the crucial term of aesthetics, invariably becomes a question of politics and power, of who has or should have the authority to judge and determine it. Thus Hogarth's subtitle "written with a view to fixing the fluctuating Ideas of Taste" turns out to be not a project to cultivate or refine taste but specifically to democratize it—and the *Analysis* asks to be seen in the context of both the discourse of taste (or politeness) and the discourse of art academies in the 1750s, and in both cases as a plea for democratization. The illustrative plates themselves (which could be purchased independently of the book) remind us that the democratization of taste corresponds to the infinite repeatability of Hogarth's prints—as the elitism of taste corresponded to the scarcity of Old Master paintings, which allegedly gave them their value.

And so the fact that Hogarth was meditating the *Analysis* at the same time he was producing *The Four Stages of Cruelty* is not surprising. His aesthetics is also a politics.[32]

THE PRECISE LINE

Nevertheless, when Hogarth's empirical process—basically skeptical—is formulated in the text of *The Analysis of Beauty,* and embodied in the serpentine Line of Beauty, the result is, paradoxically, a kind of rationalism—indeed, a mystification of art in a "principle" of aesthetics. From the text of the *Analysis* to the inscriptions on the *Tail Piece* (fig. 112) art takes on some of the very characteristics it is supposed to counter. It seeks systematization.

This was to be Burke's criticism of the *Analysis:* "Though the varied line is that alone in which complete beauty is found, yet there is no particular line which is always found in the most completely beautiful; and which is therefore beautiful in preference to all other lines."[33] Hogarth's aim was clearly to connect beauty with nature, freedom, and variety. While one could, as his contemporaries did,

associate the serpentine line with rococo forms, it was surely meant by him to serve a normative function, covering much more territory, including in particular the paintings of Raphael and the High Renaissance. It was misleading—and was to prove troublesome—though it was absolutely characteristic of Hogarth to put so much emphasis on *his* Line of Beauty, which was in fact only a synecdoche for his theory and its crucial terms of variety, intricacy, and pleasure. It was his theory reduced to a hieroglyph.

Moreover, as he warms to his subject and elaborates what he means by the Line of Beauty or of Grace, he tends to sound as if he is producing a rigid formula: the Line of Beauty is *exactly this*. At length he is stigmatizing lines that deviate from the "precise" Line—those with insufficient curve as "mean and poor," those with excessive curve as "gross and clumsy," in ways that make social if not moral analogies.

And yet if the text says this, distinguishing the "precise" Line of Beauty from the plain line, the *Analysis* illustrations show the almost infinite gradation of serpentine lines. These diagrams can be taken as a designation of *the* precise, *only* Line, *or* of the sense of multiplicity, movement, and vibration, even indeterminacy—the labyrinthine quality—that is demonstrated everywhere else in the illustrations.

Both aspects coexist in the *Analysis*. Hogarth's Line of Beauty is the formal "principle" that will allow nature's beauty to be transmitted in art: one can learn from ancient sculptures (as opposed to slavishly copying them) not because they are more than coarse imitations of the living woman's beauty, but because the ancient sculptors recognized nature's principle; that is, according to Hogarth, they had "perfect Knowledge" of "the use of the precise serpentine-line" (105).

From all the stories of artists' lives Hogarth chooses not a story of Apelles illustrating his powers of illusion (this would have been a Dutch theme) but his delineating a pure form—a simple line, which identifies him to his fellow artist. Hogarth thinks this was the serpentine line, whereas others have thought it was a perfect circle (16–17).[34] But it was an example of representation reduced to principle, as in the oval with which he replaced the lower parts of Nature in the revised *Boys Peeping at Nature* of 1751 (fig. 17). Apelles's "signature"

recalls the stories of Hogarth's game that involved delineating, for example, a grenadier with his pike entering an alehouse and his dog following him in only three strokes of the pencil:

The lines designate partly a formal essence, partly a hieroglyph (enigmatic until explained), and partly the sort of simple scrawl employed by a demotic artist.

Hogarth was tapping into the tradition of popular graffiti (as he also did into the tradition of shop signs): the primary examples in his earlier work are the stick figures of a hanged man in *Harlot* 4 and *Cruelty* 1—representing Justice Gonson and Tom Nero. In general, graffiti (like naïve perspective) employ for Hogarth an iconographic language understood by a larger audience than can read Italian Renaissance paintings. But he also uses graffiti as an expressive extension of reality and a commentary beyond the art of the paintings on the walls and even the natural gestures of the dogs and cats.[35] The graffiti of Gonson and Nero clearly indicate wish fulfillment, sympathetic magic, a primitive level of expression based on pure desire, which in the aesthetics of the *Analysis* Hogarth enormously refines but still draws upon. Indeed, the graffitilike lines of children's art are employed in some of the illustrative figures to demonstrate his aesthetic theory.

The basic form of beauty, then, turns out to be one of these forms that survive now only in graffiti, the serpentine line. The S curve, so goes Hogarth's story, was lost, was rediscovered by Michelangelo (from whom Raphael learned it), lost again, and unearthed in the

1740s by Hogarth. Thus nature is beautiful and various, but only with a knowledge of the principle behind the phenomenon can an artist like Apelles or Hogarth transmit it and ordinary people draw out the maximum beauty in themselves, their actions, and their surroundings.

Hogarth's cocky preface, which sounds like one of Fielding's introductory chapters in *Tom Jones* without the protective irony, opposes a "great principle" to imitation and announces "a work with a face so entirely new" that it "will naturally encounter with, and perhaps may overthrow, several long received and thorough establish'd opinions." Along with his talk of "nature," "the eye," and the "familiar," another discourse emerges and the offending phrases roll out: "so entirely new"—Hogarth versus "mere men of letters"—"system"— "principle"—"mystery"—"hieroglyphic"—"secret," even "the grand secret" and the "key"—, and finally "mysterious to the vulgar" and "secret from those who were not of their particular sects."

Serving as emblems for the central formulations of the *Analysis,* the triangle and the serpentine line are "the two most expressive figures that can be thought of to signify not only beauty and grace, but the whole *order of forms*" (16).[36] Schematizing the curves of the female body, bearing the head of a serpent and accompanied by the epitaph from Eve's fall, the line "mediates" the three points of the triangle as it connects the opposing elements of architecture, decoration, pieces of furniture, and the successive positions of a dance. It reappears in the illustrative plates in the figure of Venus and a beautiful contemporary woman, both involved in adulterous "triangles" with a husband and lover—the final schematization of the triangle in *The Beggar's Opera* of Macheath–Polly–Peachum, in which daughter mediates between father and lover.

The triangle also looks back to the reversed triangle of *The Sleeping Congregation* (ill., vol. 2) and forward to the triangle atop the pleasure thermometer in *Enthusiasm Delineated,* which is superimposed on the dove (the Paraclete) and inscribed with the tetragrammaton of the Jewish god (1759, fig. 64). It thus carries associations of Masonic, Rosicrucian, Jewish, and Christian symbolism. For Freemasons the square—out of which the perspective box was constructed—signified the material world of humanity, as opposed to the triangle which signified deity. (Brook Taylor, the theoretician of perspective on whom Kirby based his popularization, was a prominent Mason,

a member—with Martin Folkes—of the Bedford Head Lodge in the 1720s.) It will also be recalled that Addison's Great, Beautiful, and Novel made a secularized—or substitute—Trinity corresponding quite literally to the Father, the Mother, and some tertium quid that in the theory of Burke will become the Son. Addison wrote at the height of the Trinity controversy—the trump card of the whole freethinking fraternity—and Samuel Clarke's *Scripture Doctrine of the Trinity,* which effectively demystified the doctrine, was published in 1712, the same year as the "Pleasures of the Imagination."

The Trinity debates of 1750–1751 were under way as Hogarth was composing the *Analysis,* and François, duc de La Rochefoucauld, visiting England in 1754, recorded his impression that many Anglicans simply did not believe in the Trinity.[37] Hogarth is both aestheticizing and demystifying the Athanasian paradox. The triangle, and the union and fusion of opposites, presented as the center of a "mystery," suggests one of the Trinitarian heresies, and goes some way toward explaining the esoteric references he injects into his populist discourse.

In the chapter "Of Proportion" Hogarth's first example is "an exact medium between the two extremes" of a thick Atlas and a slim Mercury, which he concludes to be "the precise form of exact proportion, fittest for perfect active strength or graceful movement" (97). The color spectrum is his second example: "Any two opposite colours in the *rainbow,* form a third between them, by thus imparting to each other their peculiar qualities" (98); but this is no longer a "medium" or golden mean but a mystical union, explicable only in terms like those used in discussions of the Trinity.[38]

What is clear is Hogarth's desire to discover the essential form or principle, *the* fundamental shape, of a real living body or plant. In a number of ways, in spite of his general intention to praise vitality and variety (the simple, natural end of his spectrum), he tends to systematize and mystify at the hieroglyphic end. Perhaps this is to say only that the dogmatist, the cranky theorist, his father's son, emerges here and there to harden and overemphasize his theory. But it also could be claimed that Hogarth's own principle of Beauty, when he offered it, was as schematic as the "custom" he was attacking in the preface to his treatise. He was suffering the aesthetician's oxymoron of formulating the unformulatable, "disclosing the inner structure of the concrete."[39]

WARBURTON, PYTHAGORAS, AND THE MYSTERIES

On 28 March 1752/53 William Warburton wrote Hogarth a letter subscribing for two copies of *The Analysis of Beauty:*

> Dear Sir,
> I was plesed to find by the public papers that you have determined to give us your original & masterly thoughts on the great principles of your Profession.
> You ow this to your Country; for you are both an Honour to your Profession, and a Shame to that worthless crew professing *Vertu* and *connoisseurship;* to whom all that grovel in the splendid poverty of wealth & taste are the miserable bubbles.
> I beg you would give me leave to contribute my mite towards this work, & permit the inclosed to intitle me to a subscription for two copies.
> I am, Dear Sir, (with a true sense of your superior talents,) your very affectionate humble Serv[t]
>
> W. Warburton.[40]

Warburton, a controversial clergyman and probably the most powerful man of letters in England after the death of Pope, produced virtually a testimonial, and Hogarth preserved it.

Born in 1698, almost exactly Hogarth's age—and temperamentally not unlike him—Warburton was described as "impetuous, explosive, dogmatic, and unconventional," "warm, daring, and unguarded."[41] Criticized for not hesitating "to use illustrations which were then considered to be below the dignity of the pulpit" (witticisms, fabliaux, and comic scenes from Shakespeare), it is likely that he collected Hogarth's prints.[42] He had been the preacher at Lincoln's Inn from 1746 to 1760, appointed through the influence of William Murray, who had secured Hogarth the commission for the painting of *Paul before Felix;* Hogarth and Warburton may have become acquainted at that time.

Warburton probably wrote Hogarth because he had heard of his thesis and recognized homage to his own most famous work, *The Divine Legation of Moses.* The first volume (published in 1738) began as a strenuously anti-Deist tract, with a "Dedication to Freethinkers"

that especially criticized those who used ridicule as a weapon. But despite the dedication, Warburton employed as much ridicule as any Deist, and as an anti-Deist tract the *Divine Legation* was itself regarded as Deist by more orthodox clergymen such as William Law— and indeed embraced by Deists such as Thomas Morgan. Warburton remarked that he had been reviled for the *Divine Legation* more than any Deist.[43]

The argument, however, was submerged under massive learning, lengthy digressions, and curious asides. The primary interest of the *Divine Legation* for Hogarth lay in its discussion of symbolism in the second volume, specifically Book 4, section 4 (published in 1740). Warburton traces all the mysteries back to Isis and Osiris. In his discussion of Egyptian hieroglyphics he cites the *Diana multimammia* that Hogarth had employed in *Boys Peeping at Nature,* distinguishing the *Diana* as a natural symbol for Universal Nature (Nature considered *physically*) from "a winged globe with a Serpent issuing from it"—an artful, enigmatic, mystical symbol metaphorically considered. Hogarth would have noticed both the natural designation of the many-breasted woman *and* the enigmatic designation of the serpent (with a capital S), and connected them with his Venus on the one hand and his serpentine line on the other.[44]

In the discussion of Hogarth the Freemason (vol. 2) I noted that in some Masonic rituals the basic myth of the construction of the Temple was carried back all the way to Egypt, to the pyramids (ultimately the triangle) and to the cult of Isis. Freemasonry—that particular substitute for religion—may be the ultimate source of Hogarth's serpentine Line of Beauty and its aspect of mystery. The many-breasted goddess he invoked in *Boys Peeping at Nature* was both Diana of the Ephesians and the Egyptian Isis—the same image except for the headgear: Diana wore a tower, Isis a lotus. The latter appears in *Analysis,* Plate 1, #75, #85, and is cited on page 17.[45]

Warburton invokes Pythagoras: "The whole mystical system of Pythagoras was expressed by signs and symbols, which the initiated understood while the rest of the world, though in the midst of light, remained forever enveloped in the impenetrable darkness" (2: 4). And he emphasizes the origins of Pythagorean doctrine in Egypt. Pythagoras was another honorific name among the Freemasons. As James Anderson had written in his *Defense of Masonry* (1730), "I am fully convinced that Freemasonry is very nearly allied to the old Py-

thagorean Discipline, whence, I am persuaded, it may in some circumstances very justly claim a descent."[46] Pythagoras, whose school at Crotona was taken by many Masonic writers as the model after which Masonic lodges were constructed, divided his scholars into Exoterics and Esoterics, a distinction he borrowed from the Egyptian priests (with whom he had studied before returning to Greece). The Exoterics attended the public lectures, but only the Esoterics constituted the true School of Pythagoras.[47] The salient characteristics of the Pythagorean school were trials and initiation by stages into the mysteries; an esoteric doctrine concealed by symbols, primarily the Sacred Tetractys, a great triangle forming nine smaller ones constructed of the Greek delta, Δ, symbolic of the knowledge of godly things.[48]

As he gets under way in his preface, Hogarth outlines the genealogy of his serpentine line from Egypt to Greece and from Pythagoras to Socrates to Aristotle—and again from Egypt to Greece *by* Pythagoras (11, 12)—and connects the serpentine line, the triangle, Isis, and serpents (15–16). (Some figures of Isis showed her body entwined by a serpent.[49]) He would have read with great interest Warburton's history of hieroglyphics, noting in particular the emphasis on their secrecy and stimulation to "curiosity," and on the two meanings, "the greater and the less"—the lesser being regarded as "preparation for the *greater*."[50] But Warburton's main point—important to Hogarth throughout but in a special way in the 1750s in the context of the art academy and the *Analysis*—was that such rituals and religions were always "formed and propagated by Statesmen, and directed to Political Ends" (2: 179); indeed, he proceeds to argue that the Church Fathers incorporated the Eleusinian Mysteries (another version of the Mysteries of Isis, with Ceres and Isis interchangeable deities) into their rituals for political reasons (174).

Against the view that hieroglyphics were used by the Egyptian priests to conceal their knowledge from the people, or to mystify them ("in order to hide and secrete their Wisdom from the Knowledge of the Vulgar" [1: 66], a view consonant with that of both Deists and Freemasons), Warburton argues that they began as natural signs—pictures simplified to a characteristic (a serpent to a curve), an ideogram, a letter (S)—but were subsequently appropriated by the clergy and mystified. It may be of significance that Hogarth's Line of Beauty first began to be reported in the mid-1740s, shortly after Warburton's second volume was published.

The birth of writing "was *Nature and Necessity,* not *Choice and Artifice*" (2: 81). Warburton's general elevation of the natural and the graphic would initially have caught Hogarth's attention. The two kinds of writing he discusses, the hieroglyphic and symbolic, "were not composed of the *Letters* of an *Alphabet,* but of *Marks* or *Characters* which stood for *Things,* not *Words*" (2: 97). The simpler way substituted the principal part for the whole; the more artificial substituted one thing for another based on resembling qualities: "*To make the principal Circumstance of the Subject stand for the whole.* . . . This was of the utmost Simplicity; and consequently, we must suppose it the earliest Way of turning a *Picture* into an *Hieroglyphic;* that is, making it both a *Figure* and a *Character*" (2: 71).

The point, which would have seemed to apply to his own engraved works, is that "The *Egyptians* . . . employed the *proper Hieroglyphic* to record openly and plainly their Laws, Policies, public Morals, and History; and in a Word, all kind of Civil Matters" (2: 107). These signs, "plainly and openly delivered," then passed "from an Instrument of open Communication to a Vehicle of Secrecy" at the hands of "the *Priesthood* of almost all Nations," demonstrating "how one of the simplest and plainest Means of Instruction that ever was contrived, came to be converted into one of the most artificial and abstruse" (2. 108, 113, 132, 96). These mystified hieroglyphics, however, "lost their mysterious use, and recovered again their primitive Nature in the flourishing Ages of *Greece* and *Rome*" (2: 149)—or, Hogarth would have amended, England in the 1750s.[51]

Warburton's excursus on the history of writing in effect gives Hogarth his sanction—if not idea—for a spectrum at one end of which is the natural representation, the picture, which is simplified into the signs of his visual mnemonics until at the other end it becomes the "perfect," "mysterious" line.

One final aspect of the story remains, Hogarth's own role as initiate and initiator. It is clear that the majority of the dancers in Plate 2, ungainly plebeian figures, *do not know* the principle, indeed must learn it by (of all things) imitation. In one sense, they must learn it of their betters. But they can also learn it from the artist who has detected the principle and passed it on, and in this sense the *Analysis,* as its advertisements claimed, acts as a manual of "personal Beauty and Deportment." Thus the distinction between those introduced "into the mysteries of the arts" and "those whose judgements are unprejudiced" (22) is set up only to be replaced by a parallel one: *not*

the esoteric doctrine of aristocratic Men of Taste but a principle for all, including plebeians; this is an esoteric doctrine transmitted by certain artists, now revealed by Hogarth to all. Certainly the role he has assumed is of the revealer of mysteries, and the story is how the hieroglyphic symbol becomes the natural one—indeed how the two are "naturally" related.

Part of the Pythagoras story was that his school caused jealousy among the uninitiated, and a mob destroyed the building, killed many of the initiates, and drove Pythagoras from Crotona. At some point during the composing of the *Analysis* Hogarth's friend Townley sent him the following note to spur him on with his composition:

From an Old Greek Fragment

There was an antient Oracle delivered at Delphos, which says, That the Source of Beauty should never be again rightly discovered, till a Person should arise, whose Name was perfectly included in the Name of Pythagoras; which Person should again restore the antient Principle on which all Beauty is founded.

Πυθάγορας Pythagoras
Ὄγαρθ Hogarth[52]

Here is the germ of the paranoid narrative Hogarth developed in the 1750s following the publication of the *Analysis* and its reception. It goes back in a way to his father's story of his fate at the hands of the booksellers. But we cannot discount the influence of the Masonic ritual of initiation in the third degree, based on the story of Hiram of Tyre, the master builder of the First Temple of Jerusalem who alone knew the Master's Word (password). Because he will not disclose it to them, some unqualified workmen kill him and hide his body, which then has to be found by the true Masons in order to recover the word. He is eventually found and resuscitated by a special handgrip.[53] This basic myth, which absorbed other versions such as the death-rebirth of Osiris, Orpheus, Pythagoras, and John the Baptist, consisted of the hero who goes out to communicate to other nations the arts of civilization; and the conspirators who, upon his return, lure him to an entertainment (both reminiscent of Columbus's return invoked in *Columbus Breaking the Egg*), and kill him.

Significant also may be Hogarth's absence from Freemasonry's rec-

ords after the 1730s. This was a confused period of defections and apostasies. The schism that took place in 1751 would probably have found him, if he was still an active Mason, on the side of the "Moderns," which meant the old established Grand Lodge (the rival lodge called itself Ancient), rather as he was on the side of the St. Martin's Lane Academy against the faction that wanted to establish an academy of the "ancients." The conflict was over Christian symbolism, supposed by the "Ancients" to have been purged from the Grand Lodge by Anderson in his *Constitutions* of 1724: the "Ancients," according to their leader Laurence Dermott, wished to return to the Christian character of Freemasonry.[54]

We might think of aesthetic doctrine for Hogarth as deriving from the demystifying of religious belief (in his "modern moral subjects") assisted at least by Freemasonry. But Freemasonry also involved a remystification, something like the process Hogarth followed in *The Analysis of Beauty*. While the principle of his aesthetics is a demystification of Shaftesburian aesthetics, at the same time his great "principle," the "precise" "Line of Beauty," serves to *re*mystify what has been demystified. The theorist (political or academic) ordinarily looks for the unity in variety; Hogarth, the practicing artist, looks for the variety: but the "principle" he educes is of course another form of unity, a way of "composing" the variety. The alternative dichotomies, of geometrical-unity and serpentine-variety, however different their ideologies, are equally formulations that "compose" the heterogeneous.

In the text of the *Analysis* (though it reacts against these qualities in Shaftesbury's and Hutcheson's theory) there is inevitably a kind of unity, closure, and stasis. But the illustrations—the text's graphic equivalents—are as inevitably based on displacements, condensations, deformations, dispersions, and other forms of change ("variety"), opening up theory to what it excludes and represses. Hogarth, who always locates himself outside the system, whether it is the family, morality, or even aesthetics, stands outside his own system in the *Analysis* by means of his illustrations, showing that all order, even his own, conceals or represses something else. In the interplay of text and illustration there is revealed, in Hogarth's own terms, a comic incongruity.

5.

THE ANALYSIS OF BEAUTY (III)

Reception

Subscribers to the St. Martin's Lane Academy met at 7 P.M., Saturday, 24 March 1753, at the Turk's Head Tavern in Gerard Street "in order to settle the Accounts of the present Year, and to pay their first Subscriptions for the ensuing." Nothing more was recorded of the academy until the autumn when, with or without previous discussion within, some of the members, including Hayman, took academy funds and printed a circular (emphasis added):

> Academy of Painting, Sculpture, &c.,
> St. Martin's Lane,
> October 23, 1753.
>
> There is a scheme on foot for creating a public academy for improvement of painting, sculpture, and architecture; and it is thought necessary to have a certain number of *professors, with proper authority,* in order to *make regulations,* taking subscriptions, &c., erecting a building, *instructing the students,* and *concerting all such measures* as shall be afterwards thought necessary.
>
> Your company is desired at the Turk's Head, in Gerard Street, Soho, on the 13th of November, at five in the evening, to proceed to *the election of thirteen painters, three sculptors, one chaser, two engravers, and two architects,* in all twenty-one, for the purposes aforesaid.
>
> Francis Milner Newton,
> Secretary

The idea was to find a way to designate "the most able artists in their several professions, and in all other respects the most proper for conducting the design."[1] Apparently nothing was accomplished at this

meeting (chaired by Hayman) and the artists returned to "their former private situation" at the St. Martin's Lane Academy.[2] It is not known whether Hogarth refused to act with the other artists, or whether he went to the Turk's Head and debated with them.

What exactly did Hogarth do at this time to rouse the ire of some of his former colleagues? Though not officially published until the early part of December 1753, *The Analysis of Beauty* was in print by 25 November when Hogarth sent a copy to Thomas Birch for the Royal Society's library.[3] There must have been copies generally available by the first of December, because by then the attack on Hogarth's treatise had been undertaken by Paul Sandby. The artists must have thought it significant that this treatise should have been published at just this moment—"the first sustained anti-academic treatise in the history of aesthetics," as Michael Kitson has called it.[4] It opposed not only copying and training students in particular styles, those mainstays of academies, but also the whole system of categories (invention, expression, disposition, drawing, etc.) and of such superimpositions on reality. In particular and in general it attacked everything that the French Academy, upon which the plan was based, stood for.

Hogarth's remarks on the quarrel (in his rough notes for "An Apology for Painters"), themselves inspired by the criticisms of the *Analysis,* are confusing. Although he begins talking about Thornhill's academy, he is referring to himself when he says: "he was represented as an enemy by some to the artists because he would not assign [*or* assist?] them." But after "them," "in opposing them so" is struck through, and "of the promoter" (or "promotion") is added above the line. The manuscript is practically illegible at this point, as if Hogarth did not really want to put down what happened. John Ireland interprets his words to mean that he "refused to assign to the society the property (i.e., the studio, lamp, stove, etc.)," but they could equally mean that he had simply refused to "assist" the insurgents in the "promotion" of their scheme.[5] Perhaps the proximity on the page of Thornhill and his equipment, which Hogarth says he inherited and presented to the St. Martin's Lane Academy, supports Ireland; in which case we may assume that Hogarth's former colleagues tried to set up a new academy on lines he disapproved of, that this new academy threatened to destroy his and Thornhill's academy, and that Hogarth himself retaliated by refusing to let them

have—or perhaps even by removing—the studio equipment that was rightfully his. Thomas Jones, writing of the years 1764–1765, refers to "the *unique* Anatomical figure and the other Effects which were the joint property of the general Subscribers to the old Academy in St. Martin's Lane"; they were still in existence then, and they later became the nucleus of the drawing school at the Royal Academy, but by Jones's time they were regarded as "joint property," not as Hogarth's own.[6]

PAUL SANDBY

In December 1753 Paul Sandby published in quick succession three caricatures of Hogarth, followed in the early months of 1754 by five more—comprising a brilliant and destructive critique of the theories expounded in the *Analysis* and a savage ad hominum attack on Hogarth himself.

In the late 1740s Sandby, a young man of just under thirty, joined his older brother Thomas (who was in the employ of the duke of Cumberland) in sketching the work being done in Windsor Great Park. He had been with Thomas and the duke in Scotland, and in 1747, on the strength of this connection and the sketches, he was appointed draftsman to the survey of the Highlands made after the suppression of the Forty-Five. While in Edinburgh he learned to etch and produced etchings of Scottish landscapes, twenty-six plates altogether. On 6 December 1753 he published "Eight Perspective Views of Cities, Castles and Forts, in North Britain" (mentioned as already published were his six perspective views of Dublin).[7] His topographical watercolors and etchings were carefully observed scenes, reactions against the picturesque arrangements of the followers of Claude Lorrain or Gaspar Dughet; in this sense, they resembled Hogarth's "modern moral subjects." He was doubtless as amused by the formulations of Hogarth's treatise as by those of the Claudian landscapists, and his satiric response was similar to Hogarth's own satires on Kent and Burlington in the 1720s. His debt to Hogarth is evident in his *Twelve London Cries* (1760), in such stories as how he later traced "rare prints of Hogarth" in Horace Walpole's collection, and indeed in his anti-Hogarth caricatures.[8] At his most

effective, Sandby burlesques Hogarth's own *March to Finchley* in *The Painter's March from Finchly;* the *Analysis,* Plate 1, in *Pugg's Graces; Rake* 8 in *The Author Run Mad;* and in *The Analyst Besh–n* (and on the wall of *Burlesque sur le Burlesque*) Hogarth's burlesque ticket for *Paul before Felix,* his single excursion up to this time into the coarsely reductive humor that distinguishes Sandby's prints. Drawing on *Gulielmus Hogarth,* Sandby presents Hogarth as constantly accompanied by his pug and, in some instances, as himself half-man and half-dog (referred to as Pugg or *Doguin*). As Hogarth's luck would have it, Sandby was after him the most talented graphic satirist at mid-century.

Sandby's attacks on Hogarth were focused on the quarrels of the St. Martin's Lane Academy. It is not known whether he was ever a subscriber, but in early 1753 he and his brother Thomas were holding sketching classes of their own in their house in Poultney Street (now Great Pulteney Street near Piccadilly Circus). An invitation to one of these sessions with the living model has survived, dated 26 February, with a drawing by Paul and verses by Thomas (who may have collaborated in the same way with the anti-Hogarth prints). The invitation, addressed to Theodosius Forrest, who was a member of Hogarth's circle as well as a friend of the Sandbys, says that they are going "To Sit or Sketch a figure here / We'll Study hard from Six till Nine / And then attack cold Beef and Wine. . . ."[9]

Luke Herrmann believes it unlikely that the Sandbys "could have been at the van of the movements for an artists' Academy at this very early stage of their London careers" and speculates that their close connection with the duke of Cumberland might have prompted the attacks on Hogarth. This presupposes Cumberland's ire at the criticism of his Mutiny Bill implied in *The March to Finchley* and its dedication to the "King of Prussia," which could be taken as either a reference to his Prussian discipline or to Frederick the Great's patronage of the arts, as opposed to his father George II's philistinism (see vol. 2, 368–69). In either case, the duke may have taken offense. Sandby parodied the print in *The Painter's March from Finchly* (pub. Apr. 1754, fig. 32).[10] While Sandby's print is little more than a personal attack, linking Hogarth to the cuckolded husband of his *Evening,* it twice alludes to *Finchley's* dedication to the "King of Prussia," and the subscription for *An Election Entertainment,* just opened, is also mentioned. It is a fact that by May 1754 (a month

after Sandby's *Painter's March from Finchly*) Hogarth altered his sub-scription ticket for *An Election Entertainment,* changing the Prince of Wales's crown to the coronet of a younger son of the king (i.e., the duke of Cumberland), and that by this time he was supporting Cum-berland's chief supporter in Commons, Henry Fox (to whom he dedicated *An Election Entertainment;* see below, 174).

It is also evidently the case that in 1749, while he was working on *The March to Finchley,* Hogarth painted a small picture of a pretty young woman embellished with a satire on Cumberland. Elizabeth Einberg has convincingly argued that *The Savoyard Girl* (16½ × 13 in., fig. 25) refers to a young woman to whom the corpulent duke had made unsuccessful advances—an amour satirized in contempo-rary prints sponsored by the Prince of Wales.[11] The sword propped against the fireplace and pointing to her hurdy-gurdy refers to the duke's sword, lost in the melee following the notorious "Bottle Hoax" at the Haymarket Theatre of 16 January 1749, which he at-tended as one of the gullible. (The hoaxter, the duke of Montagu, had been a patron and Masonic brother of Hogarth's; see vol. 1, 220.) The Dutch tiles on the fireplace may refer to Cumberland's military defeat at Fontenoy in May 1745. Certainly the "lost" sword, the *cracked* mirror, and the *cocked* hat establish beyond question the sex-ual context.[12] It is possible to imagine Hogarth illustrating a squib published at that time in *Old England, or the Constitutional Journal:*

> Found, intangled in a slit of a lady's demolished smock-petticoat, a gilt-handle sword of martial temper and length, not much the worse of the wearing, with the Spey [i.e., the site of the battle of Culloden] curiously engraved on the one side, and the Scheld [site of the battle of Fontenoy] on the other: supposed to be taken from the fat sides of a certain great general in his hasty retreat from the battle of Bottle-noddles in the Haymarket. Who ever has lost it may enquire for it at the sign of the Bird and the Singing Cane in Potter's Row.[13]

Einberg thinks the painting was intended as a modello for an engrav-ing; but there is no similar shape or composition among Hogarth's engravings. More likely, he painted it for a friend, presumably George Hay, who owned the painting.[14] At the least, the painting suggests that Hogarth was willing to ridicule the amorous failure of the military victor of Culloden, while recalling an earlier military

failure as well; but he locates the satire as a background to one of his pretty young women, this time playing a hurdy-gurdy—an allusion that could have been a genuflection to the duke's elder brother, the Leicester House party, and its nostalgia for "Old England" (see below, 164). This was one of the "Ancient British" instruments preferred to conventional ones by Bonnell Thornton in April of this year in his burlesque "Ode on Saint Caecilia's Day, adapted to the Ancient British Musick." It is quite possible that Hogarth was alluding to this work (below, 338). But the reference to Cumberland in *The March to Finchley* was at once less direct and more severe, aimed at his principles of military discipline: this Cumberland could not have ignored.

On the other hand, Sandby's first three anti-Hogarth caricatures appeared in December 1753, and the references to *Finchley* came only in 1754. The immediate impetus, whatever the underlying motive, was the publication of the *Analysis,* Hogarth's recent attempts at sublime history painting (specifically his engravings of them), and—clearly most important—his attacks on the proposals for a new academy. In *The Analyst Besh—n* (fig. 27) Hogarth is preoccupied with his *Analysis of Beauty* while a Palladian structure, "a Public Academy," is being erected "in Spight of his endeavours to prevent it." And in the most striking of Sandby's etchings (fig. 28)—because here he could combine his talent for caricature with his talent for architectural drawing—Hogarth is portrayed as Herostratus, who burned down the temple of Diana at Ephesus (i.e., the "Public Academy") in order to ensure his posthumous fame. The Temple of Diana at Ephesus—constructed by the Greek master Masons, the third of the Seven Wonders of the ancient world—was, of course, the source of Hogarth's figure of Nature in *Boys Peeping at Nature* and the *Analysis* as well (above, 127).[15] Sandby shows the temple already in flames and Hogarth (assisted by his collaborator on the *Analysis,* Benjamin Hoadly) trying to light a fire under a column dedicated to the great artists of the past and encircled by a serpent who presumably demonstrates the unoriginality of Hogarth's theory.

At the beginning of 1753/54, in *Pugg's Graces* (fig. 29), Sandby shows Hogarth writing "Reasons against a Publick academy 1753," with his one visible reason being the paying of salaries to professors ("No Salary"). Underneath this can be read: "Reasons to prove erecting a Public Academy without . . . a wicked Design to introduce Popery & Slavery in to this Kingdom."

Sandby's attack on the *Analysis* falls into three parts: the folly of its pretentious theory, its lack of originality, and the assistance in writing it Hogarth received from his friends. The theory itself is satirized by showing all sorts of grotesque or ugly shapes that adhere to the Line of Beauty—a parody of Hogarth's own use of humble and vulgar objects as his examples. Hunchbacks seem to have been the example that first came to Sandby's mind. Proceeding one step further, he distorts normal shapes to make them assume the "precise Line," showing both the error in equating beauty with a single line and the rigidity of Hogarth's theory. Lomazzo's treatise peeks out of Hogarth's pocket in *Pugg's Graces,* and *The Analyst Besh–n* shows Lomazzo arisen from his grave to accuse Hogarth of plagiarism.[16] The cast of toadies surrounding Hogarth includes a fat man (Hoadly), who is present in almost every print; in *The Analyst Besh–n* he is "The Authors Friend and Corrector," and in *A Mountebank Painter* (fig. 30) he is "his Trumpeter." Accompanying these two there appears, from time to time, a thin, lantern-jawed man (Thomas Morell). In *Pugg's Graces* he is "a Disciple unable to find out the Meaning of yᵉ Book," and in *The Analyst Besh–n* he is "a Friend of the Author endeavouring to prevent his sinking to *his Natural Lowness.*" Hogarth had no doubt talked a great deal about his correctors-for-the-press in the unguarded days before the crisis arose in the St. Martin's Lane Academy. A thinnish young man also appears as a disciple in some of the prints, a figure who is not so remarkably distinctive as Hoadly or Morell but who resembles the portraits of Joshua Kirby. Kirby's *Brook Taylor's Perspective,* with its Hogarth frontispiece, had been advertised again in November and December 1753, and published in February 1754, just as Sandby was attacking Hogarth. The fulsome dedication to Hogarth would have contributed to the picture Sandby draws. He is called in *The Analyst Besh–n* "a Disciple droping the Palate and Brushes thro' Concern for his Masters forlorn State"; in *A Mountebank Painter* he is Hogarth's "Fidler standing in yᵉ Line of Beauty."[17]

The principal object of attack is Hogarth's self-conceit. He sees himself (as in Smollett's caricature in *Peregrine Pickle*) as a great painter of sublime history, which turns out in *Burlesque sur le Burlesque* (fig. 26) to be "A history piece, suitable to the painter's capacity, from a Dutch manuscript": Abraham sacrifices Isaac by pointing

a blunderbuss at his head, while an angel prevents him by directing a stream of urine to the firing pan of the weapon. (This joke, referring to a nonexistent Dutch original, had been current for half a century, going back to the time of William and Mary.[18]) Hogarth cuts himself off from the Old Masters, metaphorically closing out their light by his window shades (made from sheets from their "Lives") and turning himself into a magic lantern. But, despite his denunciations of copyists, he steals motifs from Dutch painters. What he cannot find in Dutch genre paintings he takes from *Joe Miller's Jests,* one of the books on his shelf. Ultimately he is a painter gone mad with delusions of grandeur: his pride and self-sufficiency put him in Bedlam (perhaps Sandby knew that he was a governor of the hospital), where he scribbles his fantasies on the walls of his cell: there he can be the greatest of painters at the top of the ladder, knocking off those who aspire to his mantle (fig. 31).

Finally, he is a hawker and mountebank (reference to his self-advertisements), a merchant who thinks up schemes like lotteries and auctions to dispose of his paintings. He is also, as Sandby sinks into miscellaneous private innuendoes, a henpecked husband: he is horned and pursued by a shrewish wife in *The Painter's March from Finchly,* which takes horns and wife from Hogarth's *Evening* and adds the suggestive explanation: "N.B. The principal Humour of this composition is left to the fertill Imagination of the Public. I will shew in my next Print how Poor Pugg was Treated with Rump Stakes, at a great Man's palace, by Presenting the silly Analysis."

Whether these references are particular cuts or only reductive decoration (like the incontinence of *The Analyst Besh–n,* which of course echoes *Paul before Felix Burlesqued*) cannot now be established. For example, if we are to believe that Sandby had seen Hogarth's studio and reproduces it in his first print, *Burlesque sur le Burlesque,* we might infer that Hogarth not only painted in the "Dutch manner" but had a large collection of Continental prints, from which he took motifs (as we know he did). But are the "students" shown at work Sandby's invention? Hogarth is not supposed to have taken students during these years. On the other hand, *The Gate of Calais* could have hung on his wall as shown, as yet unsold, and Hogarth may have had some such arrangement of blinds on his studio windows. If we are to trust Sandby, Hogarth had *two* pugs at this time, one of

them named Jewel ("Jewel bringing him a bone to pick in ye Line of beauty").[19]

The gross-featured figure meant for Hogarth (at the easel, in the magic lantern at the top, of *Burlesque sur le Burlesque*) becomes in the subsequent prints more individualized. The heavyset face has drooping eyelids, pouchy eyes, and noticeable jowls. The body is humped, slouching, and aging, but in motion it struts with a comical, military gait. For Hogarth, of course, it was doubly significant that these are "caricatures," not (what *he* produces) "characters."

When Sandby's attack began, Kirby, Benjamin Wilson,[20] and some other artists rallied to Hogarth's defense. A print by Thomas Burgess, published early in 1754, shows a group of connoisseurs sitting around a table, one trampling the *Analysis* underfoot (and Milton and Shakespeare with it) and all of them examining with pleasure Sandby's *Burlesque sur le Burlesque*. Against the wall can be seen "A List of Professors Public Academy Buckhorse Prof——," Buckhorse being a contemporary pugilist. William Kent's designs and Sandby's *Views of Scotland* are also in evidence, as well as volumes inscribed "Defense of Atheism" and "Romains Philosophy."[21] Not a very striking piece of work, it was soon followed by a second Burgess defense called *A Club of Artists,* which was answered by Sandby's *Painter's March from Finchly.*[22] *A Club of Artists* (which shows Hogarth being offered *Burlesque sur le Burlesque* for toilet paper) is summed up by its verses:

> O, H——h, born Our Wonder to Engage
> Thou all reflecting Mirror of the Age
> Tis thine still Conscious of transcendant Claim
> To look disdain on those who grudge thy Fame
> But since thy B-m gains Fodder by their Spite
> Oh, kindly puff their Praise when e'er you Sh—e.

Sandby's *Painter's March from Finchly* was sold on 1 April, by which time the "frontispiece" (fig. 33) was also on sale, and all eight prints were out and available in a set entitled *The New Dunciad, done with a view of fixing the fluctuating ideas of taste: dedicated to his friend Beauty's Analysis.*[23] A few more hostile prints appeared, riding on Sandby's coattails, for example *Mon. Grin's Critique on the new Analysis* and *Beauty according to a Modern Analysis.*[24]

REVIEWS AND COMMENTS

There is no way of knowing for certain how well Hogarth's subscription went: his enemies portrayed him with piles of unsold copies of the *Analysis* on his hands, and others being used as liners for pie pans and the like (e.g., in *Burlesque sur le Burlesque*); we do not know how large an edition he published, but it was not exhausted for twenty years. He was, of course, publishing a book this time, even though it included two of his best engravings and an illustrated subscription ticket, and it is possible that he miscalculated the size of his potential audience, certainly not the same as the audience that bought his prints. But we must also discount the images of Sandby, who was, after all, using all the weapons of the satirist's armory.

The formal reviews began to appear in late December and were uniformly favorable. The most significant (because it might have been written by Samuel Johnson) appeared in the *Gentleman's Magazine* in two installments.[25] The December issue carried a short notice:

> This is an attempt to shew what it is that constitutes beauty; and, consequently, how it may be produced; an attempt, which at least, has the merit of novelty, notwithstanding what may have been insinuated to the contrary. Of this work some larger account may hereafter be given; it is here sufficient to say, that it will gratify the imagination of those who read merely for amusement, by the variety of sentiment and examples that it contains; it will certainly instruct the artificer; and in many parts, it will enlighten the moralist, and assist the philosopher.

The next issue, for January 1754, had a full-dress review composed (as was the custom) of quotations, but ending with an appreciation and commenting again on Hogarth's detractors:

> A Book, by which the author has discovered such superiority, could scarce fail of creating many enemies; those who admit his analysis to be just, are disposed to deny that it is new. . . . The work however will live when these cavils are forgotten; and except the originals, of which it is pretended to be a copy, are produced, there is no question but that the name of the author will descend to posterity with that honour which competitors only can wish to withhold.

Laudatory reviews followed by Matthew Maty in his *Journal Britannique* and William Rose in the *Monthly Review*. The latter, cofounder of the *Monthly,* a learned translator of Sallust, master of a boarding school for boys in Chiswick, and Hogarth's neighbor, concludes that

> Mr. *Hogarth* has treated his subject with great accuracy, and in a manner entirely new; has thrown out several curious hints, which may be of no small service to painters and statuaries, &c. has fairly overthrown some long-received and deeply-rooted opinions; and that his essay may be read with considerable advantages by all who are desirous of acquiring a perfect knowledge of the elegant and beautiful, in artificial as well as natural forms.[26]

The reviews acknowledged both its originality and its usefulness for a variety of readers. But they also leave the impression that Hogarth had strong friends within the literary establishment, and that his enemies were a small group centered in the St. Martin's Lane Academy.

Beyond the printed reviews and puffs there were the letters written by readers, perhaps a more reliable index of public response to the work. On 20 December, Catherine Talbot wrote in her journal: "After Supper we studied Hogarth's Analysis of Beauty with his two Prints, & were much entertained with the little we read tho' some of it is toutefois peu unintelligible."[27] Lady Luxborough wrote to William Shenstone on 16 March:

> I have no new books, alas! to amuse myself or you; so can only return yours of Hogarth's with thanks. It surprized me agreeably; for I had conceived the performance to be a set of prints only, whereas I found a book which I did not imagine Hogarth capable of writing; for in his pencil I always confided, but never imagined his pen would have afforded me so much pleasure. As to his not fixing *the precise degree of obliquity,* which constitutes beauty, I forgive him, because I think the task too hard to be performed literally; but yet he conveys an idea between his pencil and his pen, which makes one conceive his meaning pretty well.

Shenstone's own reaction (perhaps reflected in Lady Luxborough's reference to Hogarth's not having fixed "the precise degree of obliquity") was influenced by his own parallel theory of gardening. He

wrote to Richard Graves, author of *The Spiritual Quixote,* on 19 April: "I have bought Hogarth's Analysis: it is really entertaining: and has in some measure, adjusted my notions with regard to beauty in general. For instance, were I to draw a shield, I could give you reasons from hence why the shape was pleasing or disagreeable. I would have you *borrow* it and read it." To Richard Jago, on 16 June, he wrote, "Of late I have neither *read* nor *written* a syllable. What pleased me last was Hogarth's Analysis." Beside the heading "Gradual Variation" in his copy of Burke's *Philosophical Enquiry,* which appeared two years later, he noted: "coincides with Hogs Doctrine of the serpentine Line." And in 1756 one of Shenstone's friends signing himself "Arcadio" composed "Verses Written at the Gardens of William Shenstone, Esq.," which follows Hogarth in finding the principle of the waving line everywhere from the "ringlets of Apollo's hair" to the "smooth volutes of Ammon's horn":

> The structure of the Cyprian dame,
> And each fair female's beauteous frame,
> Show to the pupils of Design
> The triumphs of the *Waving Line.*[28]

Hogarth's defenders liked to suggest that the connoisseurs were attacking him because he dared to encroach upon their preserve. As early as 15 December a note was printed in Arthur Murphy's *Gray's Inn Journal* headed Bedford Coffee-House, December 12:

Mr. *Hogarth*'s Analysis of Beauty has been the Subject, on which the *Beaux Esprits* of this Place have exercised their Talents for a few Days past. A Gentleman who had been frequently Witness to their Debates, penned the following short Copy of Verses.

To Mr. HOGARTH on his Analysis of Beauty.

> *Hogarth,* thy Fate is fix'd; the Critic Crew,
> The Connoisseurs and Dablers in *Vertû,*
> Club their united Wit, in ev'ry Look
> Hint, shrug, and whisper, they condemn thy Book:
> Their guiltless Minds will ne'er forgive the Deed;
> What Devil prompted thee to write and read?

The *London Evening Post* inserted a similar poem at the end of the London news for 7–9 February, "To Mr HOGARTH":

> Tho' Scriblers, Witlings, Connoisseurs revile,
> Thy Book shall live an Honour to this Isle:
> Exert, once more, thy *Analysing* Art,
> And give the World thy *Beauty's* Counterpart:
> Dissect the Passions which thy Works create;
> Delineate Envy, Ignorance, and Hate.

From his friend Townley, who had assisted in the revision of the *Analysis,* came a long and flattering poem along the same lines. But some periodicals—Murphy's *Gray's Inn Journal*—compensated for their dubiety about the *Analysis* by doubling their compliments of Hogarth's works of art.[29]

The most common ridicule—perhaps following Sandby's caricatures—was aimed at the Line of Beauty. *The Anti-Line of Beauty, a Poem* was announced as published in the *Public Advertiser* of 15 February:

> If we th'Idea of the Crooked Line
> Adopt for Beauty's, and for Grace's Sign;
> Then Bandy Legs must, henceforth, Strait outshine.
> If Curves contrasted still more Beauty shew,
> Humps then are Charms; deform'd the Belle and Beau;
> For oft the Lump, which Nature form'd behind,
> Has correspondent Lump before, we find.
> If Beauty's Form be like a cap'tal S,
> As one maintains (too like a Cap'tal A—s).
> The ugliest Camel then more Charms may claim,
> Than e'er adorned th' Arabian Courser's Frame . . . [etc.]

Already in the essay of the day in the *World* for 13 December 1753, Richard Owen Cambridge implicates the *Analysis* in a satire on the fashions that distort natural female beauty, surely recalling Hogarth's own *Taste in High Life* (ill., vol. 2, which by this time had been published as a print) by making Hogarth himself the stay maker. He refers to Hogarth as

> the nicest observer of our Times, who is now publishing a most rational Analysis of Beauty, [who] has chosen for the principal illustra-

tion of it, a pair of stays, such as would fit the shape described by the judicious poet; and has also shewn by drawings of other stays, that every minute deviation from the first pattern is a diminution of beauty, and every grosser alteration a deformity.[30]

He goes on to say that he knows of a man who is going to publish a work on deformity. *Deformity. An Essay. By William Hay, Esq.* was published, at 1*s*, 6*d*, on the same day as the *World* that touted it. This is a straightforward account of what it feels like to be deformed—specifically a dwarfish hunchback. The second edition carries a postscript remarking that since the author wrote this he had "heard of a very vigorous Performance, called *The Analysis of Beauty,* which proves incontestably, that it consists in Curve Lines; I congratulate my Fraternity; and hope for the future the Ladies will esteem them *Des Beaux Garçons.*" Hogarth might have appreciated the postscript were it not for Sandby's use of the idea in his *March from Finchly* and other anti-Hogarth satires. He must also have taken amiss the *World's* essay.

The *World,* a journal representing the connoisseurs, was answered in February—as it frequently was—by the *Connoisseur,* a tongue-in-cheek journal written by Bonnell Thornton and George Colman. Here Mr. Connoisseur recalls the Rembrandt hoax and Hogarth's other crimes against those who are now ridiculing him:

> Of what consequences would it be to point out the distinctions of Originals from Copies so precisely, that the paultry scratchings of a Modern may never hereafter be palmed on a *Connoisseur* for the labours of a *Rembrandt!* I should command applause from the adorers of Antiquity, were I to demonstrate that Merit never existed but in the Schools of the old Painters, never flourished but in the warm climate of Italy; and how should I rise in the esteem of my countrymen, by chastising the arrogance of an *Englishman* in presuming to determine the *Analysis of Beauty.*[31]

Favorable accounts of the *Analysis* sometimes tended to misconstrue Hogarth's purpose. For example, the verses "To Mr. Urban, on compleating the twenty Fourth Volume of his Magazine," attached to the beginning of the 1754 volume of the *Gentleman's Magazine,* included some lines on the *Analysis:*

THE ANALYSIS OF BEAUTY: RECEPTION

> The *Proteus* BEAUTY, that illusive pow'r,
> Who changing still, was all things in an hour,
> Now, fix'd and bound, is just what Reason wills.
> Nor wayward Fancy's wild decrees fulfills. [32]

The poem, listing the accomplishments of the twenty-four years, alludes to the magazine's frontispiece, which depicts them in an emblematic design; an angel holds a long list of great works in one hand and a sheet with "ANALYSIS of Beauty" in the other. Although Hogarth must have been pleased, he would have recognized that something of his intention was distorted by this emphasis on his having *fixed* and *bound* the imagination in the law of the Line of Beauty. Rule, in a sense, was what he had in mind, as James Ralph seemed to grasp a few years later (1758). Beauty, he wrote, is nothing new, "but no-body had been able to assign us a Rule by which it might be defin'd: This was Mr. *Hogarths* Task: This is what he has succeeded in: Composition is, at last, become a Science: The Student knows what he is in Search of: The Connoisseur what to praise: And Fancy and Fashion or Prescription, will usurp the hackney'd Name of Taste no more." [33]

Years later, Uvedale Price, in his *Essays on the Picturesque* (1798), recalled a story of his father's, which sums up the general, somewhat jokey view of the *Analysis* that was passed on to posterity:

> Hogarth had a most enthusiastic admiration of what he called the line of beauty, and enthusiasm always leads to the verge of ridicule, and seldom keeps totally within it. My father was very much acquainted with him, and I remember his telling me, that one day Hogarth, talking to him with great earnestness on his favourite subject, asserted, that no man thoroughly possessed with the true idea of the line of beauty, could do anything in an ungraceful manner: 'I myself,' added he, 'from my perfect knowledge of it, should not hesitate in what manner I should present any thing to the greatest monarch.' 'He happened,' said my father, 'at that moment, to be sitting in the most ridiculously awkward posture I ever beheld.' [34]

One can, in fact, follow Hogarth from his tactful and accurate presentation of his theory in the body of the *Analysis* to his rather pretentious preface, and thence, goaded by the ridicule of Sandby and others, and perhaps the general condescension of artists whom he

respected, to ever more dogmatic assertions—until he finally seemed obsessed with this and allied subjects. Hence his elaborate account of "character" beneath *The Bench* (1758), his continuing to tinker with that print up to the day before he died, and the inscriptions on the *Tail Piece* (1764) concerning his latest discoveries about the Line. The pedagogue in Hogarth emerged stronger than ever after this encounter.

The comments of Thomas Twining, who was in his twenties when the *Analysis* appeared, are more judicious and accurate than those of Price. While admitting "its imperfections," he thinks "it may fairly be said, that the public have not done full justice" to the *Analysis:* "perhaps, through the author's own fault, who did it *more* than justice himself, by his pretensions." He goes on to indicate the obscurity of the style and indeed of the thought. "Yet the book abounds, I think, with sensible, useful, and, at the time it was written, I believe, *uncommon,* observations. The ideas of eminent artists, relative to their own arts, must always be, more or less, valuable and useful." J. T. Smith's reminiscences make the same point: "I remember, when I was a lad, asking the late venerable President West, what he thought of Hogarth's *Analysis of Beauty* and his answer was, 'It is a work, my man, of the highest value to every one studying the Art.'"[35]

The responses of the artists were predictable. Reynolds drafted a heated reply, which on cooler consideration he filed away (surfacing in 1759 in *Idler* No. 76; see below, 254). His chief objection was that the beauty of Hogarth's Line lies in custom, not in anything intrinsic. People are simply "more used to that line than any other." Ramsay's response appeared in March 1755 in his *Essay on Taste;*[36] though it disagreed in a gentlemanly way with the *Analysis,* it praised Hogarth's histories. His quarrel with Hogarth's Line is that he doubts the validity of so objective a standard of beauty; his case is built on the same relative standard employed by Burke a year later, discussing Hogarth in his *Enquiry* and by Reynolds in 1759 in his *Idler* essay: "beauty" depends to a large extent on convention. (Samuel Johnson himself introduced the idea of relativity in his opening remarks on the "Idea of Beauty" in his *Rambler* No. 92, 2 Feb. 1750/51.)

A toad contains no Line of Beauty in its figure, says Ramsay, yet "it hardly admits of a doubt, that a blooming she-toad is the most beautiful sight in the creation of all the crawling young gentlemen of

her acquaintance." Although not included in the published *Analysis,* one passage shows Hogarth responding to the issue of relativity: The "most remarkable instance" of the power of custom, he writes, is "that the Nigro who finds great beauty in the black Females of his own country, may find as much deformity in the european Beauty as we see in theirs" (189).[37] He seems unaware, although he suppressed this particular example, that the argument could be turned against his own Line of Beauty, which might be as locally and perhaps as ethnically conditioned. The examples critics used against him were toads and spiders (cited by himself at the end of *Analysis,* chap. 9).

Ramsay's critique points up the singularity in the practical Hogarth's formulating a principle of beauty, and the basic idealism of Hogarth's position beneath his assumed empiricism. Ramsay then goes on to express admiration for the realism of Hogarth's art and for the wide basis of his popularity with the people—and implicitly his democratization of aesthetics in the *Analysis.* For, Ramsay's spokesman says, he has "reason to be convinced, by a thousand experiments, that the leading principle in criticism in poetry and painting . . . is known to the lowest and most illiterate of the people." What makes a country girl enjoy art, whether by La Tour or Lambert, is the painting's naturalness.

> The same country girl who applauds the exact representation of a man and a house which she has seen will, for the same reason, be charmed with Hogarth's *March to Finchly,* as that is a representation, though not of persons, yet of general manners and characters with which we may suppose her to be acquainted.[38]

It is not surprising that Hogarth himself thought Ramsay "the most able" attacker of his assumptions in the *Analysis.*[39]

On the other hand, Charles Rogers, the collector and associate of Arthur Pond, wrote to Horatio Paul on 21 January 1754: "The Town is not I think divided in its Opinion concerning his [Hogarth's] Performance, for the Unlearned confess they are not instructed, and the Learned declare they are not improved by it." The authority he cites is James Wills: "Mr Wills is sorry any one of the Profession should derogate so much from it as to print such stuff as Mr Hogarth has done."[40] Wills, the painter of *Suffer the Little Children* for the Foundling Hospital, was preparing to publish his translation of Dufresnoy's

De Arte Graphica; or, The Art of Painting, dedicated (perhaps signifi-cantly) to the duke of Cumberland. He recommends Kirby's *Brook Taylor's Perspective* but makes no mention of Hogarth's *Analysis;* in-ternal evidence, however, suggests that he was publishing a correc-tive to the *Analysis,* an inference that Hogarth's doctrine was neither new nor true.[41] Referring to the story of Apelles and Protogenes which Hogarth interpreted as involving communication through the Line of Beauty, Wills concludes (though never mentioning Hogarth's name):

> Did two such great men amuse themselves with such children's play, as making small lines, of no use in the art, or glory to the performer?
> Nor could it be a simple unmeaning bend, like the letter S. Very well! An accomplishment for a graver in copper; being what is called a fine stroke, and what tollerable prints are full of, but of little conse-quence to the extensive comprehensive art of Painting.[42]

The "graver in copper," of course, is Hogarth. The remark appears to pinpoint the area of disagreement within a large territory of hos-tility between the two men.

The Continental admirers of Hogarth's prints seem to have taken to the *Analysis,* especially in Germany. Hogarth encouraged (if he did not commission) a German translation by Christlob Mylius which must have been started before the original was published; it was finished and the preface dated 11 December 1753, the book bear-ing the imprint of both London and Hanover.[43] By 7 March 1754 Gotthold Ephraim Lessing was mentioning the *Analysis* in the *Berlin-ische Priviligierte Zeitung* No. 29 (he remarked that Mylius was still in London). On 3 May Lessing briefly but enthusiastically summarized Hogarth's ideas; characteristic of the author of *Laokoon,* he focused on the application of the theory to more than one art, outlining its use to the philosopher, naturalist, antiquary, and orator (in the pulpit or on the stage) as well as to the artist. On 24 June, again referring to the unity of the arts, he announced a new, revised, and cheaper edition of the German translation, which he brought out himself (published by Christian Friedrich Voss), wishing to make Hogarth's theory available to a wider public. The proposals published on 1 July assert that the *Analysis* will narrow the thousand different ideas of the word "beautiful" to one, "so that . . . where nothing reigned but occasional caprice, something of certainty will take its place by the

assistance of this theory." The new edition ("Verbesserter und ver-
mehrter Abdruck"), with Lessing's preface, was published in Au-
gust. Significantly, it was accompanied by a translation of Rouquet's
*Lettres de Monsieur***, suggesting the close connections between the
art treatise and the engravings.[44]

In 1761 an Italian translation was published at Leghorn.[45] In En-
gland, however, a new edition was not called for until 1772 when
William Strahan reprinted it "For Mrs. Hogarth"; in the interim,
Hogarth (and after his death Jane) continued to advertise copies of
the unexhausted first edition at the Golden Head.

The strange thing about the affair of the *Analysis* is that its sup-
porters were plainly in the majority: all the published reviews were
favorable, the learned appreciated it, and its fame quickly spread
abroad. But at home Hogarth found himself suddenly the object of
ridicule in his own medium, the broadside cartoon—attacked by a
fellow artist and hawked about the streets to be seen by his own great
audience, who knew nothing about the *Analysis* or the more personal
issues at stake. More visible than the reviews were the satiric poems
and squibs, often merely exploiting the *Analysis* as an occasion for
humor.

Hogarth's own feeling about the reaction to the *Analysis* was re-
corded a few years later, as he attempted to write his account of the
arts in England:

> it is a trite observation that as life is checquer'd every success or
> advantage in this world is attended with a reverse of one kind or other.
> So this work however well receiv'd both at home and abroad by the
> generality yet I sufferd more uneasiness from the abuse it occations
> me than satisfaction from its success altho it was nothing less than I
> expected as may be seen by my preface to that work.

The experts on optics and other sciences, he recalled, have "hon-
ored" the book "with their approbation"; but "those who adhere to
the old notions and either cannot or are determined not to under-
stand a word tell you it is a heap of nonsense or that there is nothing
new in the whole book"—and these are "of my own profession."[46]

As he suggests, the preface was undeniably a chip on the shoulder
that he was asking to have knocked off. The defensiveness of his
situation in this period made him begin to preserve letters and docu-

ments that seemed to him particularly significant: his own manu-
scripts, of course, and flattering notes concerning the *Analysis* from
Warburton, Rouquet, the vice-chancellor of Cambridge, and others.
Thereafter, whenever he suffered a crisis, he collected little batches
of these letters to remind himself that he still had supporters.

A second aspect of this defensive syndrome was that while he did
not publish a reasoned rejoinder to the attacks, he did promptly
sketch out a response of sorts: an ironic attack on himself which
shows him with ass's ears, stripped and tied to a cart's tail, being
lashed on by an old connoisseur with a long wig who says, "You'l
write books, will yᵉ." Above the painter's head is the motto: "Twere
better a millstone had been tied about thy neck, and (THOU) cast
into the sea." Underneath is the inscription, "A Christmas Gambol
from Leicester Square to Westminster Hall," showing that the draw-
ing was made immediately after the first satiric prints had appeared.
The iconography is obscure, but above the sketch, in Hogarth's best
script, is a long mock advertisement:

> N B Speedily will be publishd an Apology in Quarto Callᵈ Beauty's
> Defiance to Charicature? with a very extraordinary Frontispiece, a just
> portraiture, (printed on Fools cap paper) and discription of the Pun-
> ishment that ought to be inflicted on Him that dare give false and
> unatural description's of Beauty or Charicature great personages, it
> being illegal as well as mean practice, at the same time flying in the
> Face of all regular bred Gentlemen Painters, Sculptures, Architects, in
> fine Arts and Sciences.[47]

Beginning with this sketch of himself being lashed by his critics,
proceeding to his adaptation of Sandby's *Pugg's* caricature (in his self-
portrait painting the Comic Muse), and culminating in his annihila-
tion of his self-portrait in *The Bruiser,* he seems to be displaying a
kind of masochistic pleasure in first striving for an untenable position
and then, when the inevitable response follows, seeing himself as his
enemies see him. If he was always obliquely related to the subject of
his works, at this juncture they become more directly concerned with
his personal history and problems, with his past as well as the ques-
tions of art that grew out of it. The *Analysis* was in a sense one re-
sponse to this concern, and his "Autobiographical Notes" would be
another.

6.

ELECTORAL POLITICS

Four Prints of an Election, 1754–1758

THE *TABULA CEBETIS*

The last decade of Hogarth's life began propitiously with the subscription on 19 March 1754, only three months after *The Analysis of Beauty* was published, for a new plate called *An Election Entertainment* (fig. 35). It was the size and scale of, and originally intended as, a large single plate such as *Strolling Actresses* and *The March to Finchley* (16 × 21 in.). Coincidentally, on 1 March James Moor read an "Essay on the Composition of the Picture described in the Dialogue of Cebes" before a literary society in Glasgow. Though the essay was not published until 1759, one wonders whether he sent a copy to Hogarth.[1] "There are two ways," writes Moor, playing variations on Hogarth's "composed variety,"

> for a painter, to represent a variety of actions, which are supposed to have, all, one tendency; concurring to produce one event, and uniting in one final issue. the first is, by a Series, to be seen successively; the latter, still, connecting with the former; each representing some one of these actions; and, the whole, together, as ONE set, exhibiting the ONE final tendency of all. such kind of united sets of pictures are, Hogarth's progress of a rake; and, of a Harlot; and, of Industry, and Idleness.

The other way, Moor explains, is to include a variety or spectrum of actions in a single plate:

this way is, likewise, practiced by Hogarth; in his March to Finchly-common, and his Bartholomew-Fair; in which last, all the various scenes, of clamorous riot, dissolute diversions, and ludicrous accidents; which, at one time or other, commonly, happen, in the course of that fair; he exhibits, in one piece, together; as going on, all, at one time; but, among different persons; and, in the different booths, and quarters, of Smithfield, this, tho' just EXACTLY according to nature; yet, is a liberty universally allowed, in all the imitative arts; wherever, the effect of the whole will be stronger, by having all the parts, together, at once; than, by introducing them, severally, in succession.

This, he notes, is the method of Cebes, except that the *Tabula Cebetis* is an allegorization of life in general.

The *Tabula Cebetis* was, with Prodicus's *Choice of Hercules,* the classic instance of "reading" a painting. Both were standard texts in English schools. The British Library lists fifty-six editions in Greek and Latin (probably school texts) and thirteen in English prior to 1800. Of the many illustrations of the *Tabula Cebetis,* Romeyne de Hoogh's, dated 1670, is the one most probably known to Hogarth and closest to his own style of engraving (fig. 34).[2] In this dialogue Cebes stands before a painting and "reads" it to his friends. Life is portrayed as a walled enclosure spaced along a hillside (which recalls the hill of the Choice of Hercules) like the compartments in a comic strip, elucidating particular chronological aspects of human experience. A great crowd of people in the foreground, Cebes explains, represents men entering the Gates of Life, directed by Divine Genius but met by Deceit, who gives each a draught, more or less, of error and ignorance. Inside the gate they are faced with Fortune, "a blind distracted creature," who stands on a round stone and arbitrarily distributes smiles, honor, noble birth, children, tyrannies, and kingships. Already courtesans called Opinions, Desires, and Pleasures try to lead the crowd astray.[3]

In the second enclosure, which stands higher on the hill, men are shown surrounded by the courtesans Intemperance, Prodigality, Insatiableness, and Flattery. These seduce some men, taking away the gifts Fortune has bestowed, and then making them slaves, forcing them (in Shaftesbury's translation) "to act a vile indecent part, and for their sake to do everything that is pernicious; such as to defraud, to betray, to rob, and all things that are of the like kind" [69]). Then

they are shown delivering their slaves over to Torture, Grief, Vexation, and Anguish. Another area is presided over by False Learning, and so on. Hogarth—as in *A Harlot's* and *A Rake's Progress*—seems to have stayed within the first two enclosures.

Cebes, argues Moor, was the first to conceive the "alliance, between Philosophy and Painting" (40). Wishing to vindicate Cebes's picture against detractors, he quotes those who describe it as merely "so many swarms, of clustering groupes, and crouding mobs; and, such a rout, of sauntering, strolling, vagrant figures; as makes the whole appear, just, one great motely heap of—confusion, worse and worse confounded. . ." (42). In fact, Moor counters, there is

> no such perplexing multiplicity of figures, as is, by some, imagined; that, the chief groupes are in the fore-ground, next the eye; and, gradually, grow fewer, the farther they retire; till, at last, in the third inclosure, farthest back, there is not, so much as, one man, at all; that, the action, of each groupe, is expressed by a few of the foremost figures; so, as, the rest may, only, fill the eye, without distracting the attention. (47)

Moor's point seems to be that in *Southwark Fair* and *The March to Finchley,* as opposed to the progresses, the fair and the "march" represent life in general; a protagonist, divided into two alternatives in *Industry and Idleness,* is fragmented into a great range of possibilities. Moor shows one rationale behind Hogarth's diminution of the protagonist and increasing emphasis on a crowd in the monumental compositions that culminate in *An Election Entertainment* and the other three *Election* prints, each an independent "life" in the sense meant by Moor. Hogarth had begun with the representation of society as individuals—or at least as one individual against a group of predatory individuals who represent the ruling class.[4] But then, perhaps beginning with the last two extended prints of *Industry and Idleness,* certainly in *The March to Finchley,* he reverted to the idea of society as groups, factions, and political parties.

It is also worth noting that by the third plate of the *Election,* if not sooner, the *Tabula Cebetis*'s direct allegorization of experience has begun to merge with the popular strain in Hogarth's work: Britannia's coach has broken down in the vicinity of the hustings.

THE PAINTINGS

The *Election* paintings (figs. 35–40), three by five feet in size, represent a continuation of the scale and style of *Garrick as Richard III* and virtually illustrate Hogarth's remarks on expressive form in the *Analysis*. The simplicity of articulation recalls the "large, strong, and smart oppositions," which give "great repose to the eye," which he contrasts to the reading structure of his earlier "modern moral subjects": "when lights and shades in a composition are scattered about in little spots, the eye is constantly disturbed, and the mind is uneasy, especially if you are eager to understand every object in the composition" (123–24). In the *Election* the "breadth or quantity of shade . . . view'd with more ease and pleasure at any distance," which subordinates a great load of detail, is realized in both large pattern and small, in both composition and application of paint, by a stylized compartmentalization. More successfully than ever before, he shows the way architecture in relatively undistorted perspective can provide coherence of "reading" to a packed and complicated design. Within these frames the individual figures assume larger composite forms, as in the serpentine line made by the swirl of the crowd around the tables in the *Election Entertainment*. The paintings also recall the *Analysis*'s principle of *as much variety as possible within uniformity:* as a principle of composition, architectural structures are exploded by the drunken excesses of a mob.

In the fourth scene, to illustrate the release of disorder that is implicit but restrained in 1 and 2, Hogarth spreads out the architectural verticals and shows the crowd flowing unchecked in all directions. The next step would be the chaos of Gillray's *Union Club* or Rowlandson's *Exhibition Stare-Case*—not, as it turns out, an unthinkable step for Hogarth. Even here the crowd is barely confined within the area outlined by the vertical church tower and pursued in the gate, the diagonal of the wall, the lines of the second church, the crumbling uprights of the house, and the horizontal of the stone bridge. This *semi*-closure is now significant for Hogarth as both moralist and aesthetician.

The colors are less strikingly expressive than in the earlier series, less aimed at the passions and more concerned with defining relation-

ships. Intense bits of color point up the reading structure not by giving emphasis to the object itself but by drawing the eye to objects nearby or by suggesting parallels with other objects. In the fourth canvas the color is now made up of large areas of pale blue, gray, green, and ochre, with a few spots of bright red, blue, and white which do not assume important shapes themselves but draw the eye to them. They neither contradict nor embody but rather highlight the large formal torque that is the picture's basic structure. It begins as the twist made by the similar (but reversed) shapes of the candidate projected one way and the swine another, pivoting on the twisted body of the bruiser in the white shirt and continued in the reverse twist of the bear-keeping bruiser in the foreground, and so outward "turning and turning in a widening gyre" to his bear that is out of control and to a whole series of falcons who cannot hear their falconers—the embodiment of the painting's message about the human quotient within the order of the electoral process.

The chaired member is formally the center because he is the apex of the twist, but also because his grayish wig, in shape and color parallel to the goose flying above him, is bracketed between the white of the goose and the white shirt of the bruiser beneath him. The touch of red in the cushion of his chair finishes the matter. The red of one chair bearer's head scarf draws attention to another significant group, and so on. If the eye does not altogether come to rest, it is because it is studying ramifications of the central torque. If the shape of the member's wig and face connect him with the goose, the shape and neutral color of his body connect him with the swine beneath him, one going toward the right, the other toward the left, both falling.

The emphatic form, however, also parodies the baroque undulations of triumphal processions and conventional battle pieces. The eagle flying over Alexander's head in Le Brun's *Battle of Arbela* (Louvre) is reduced to a goose, and the arching bridge and routed cavalry of Rubens's *Battle of the Amazons* (Alte Pinakothek, Munich) to a sewer and a herd of fleeing pigs.

Hogarth may have started with the purely comic conjunction of "incompatible" forms he had discussed in the *Analysis* and illustrated in Plate 2 (the *Entertainment,* with its aristocratic candidates to one side of a mob of country types, takes off from this plate); but as events followed, the election crowd came to suggest the possibility

that too much variety can get out of control. The political question is what happens when the delicate balance of electors and popular crowd, which in purely formal terms is risible, breaks down. The crowd with its inchoate energies, representing one aspect of Beauty (variety), comes to threaten the other (unity).

If the *Election* compositions suggest barely restrained disorder, a sense of order is restored in the application of the paint, which is a distinct departure from the shifting focus and glittering, evanescent shapes, sometimes the flamboyant sketchiness, of paintings as recent as *The March to Finchley*. The brush now quite apparently imposes order on human flux, rather than sharing in it. In a way, this style, with its "large, bold patches of broad colour,"[5] is a freer version of the brushwork in *Marriage A-la-mode*. But here, on a larger scale, the broad application of paint, the compartmentalization of areas, and the heavy outlines recall the surface of the Raphael Cartoons (which resemble these paintings in scale and color scheme as well). But even more, these paintings are a direct link with the conception of Hogarth's popular prints and represent an attempt to utilize sign-board paintings much as he had block-print broadsides. His alla prima style has now become an application of paint analogous to the gouged white areas of the *Stages of Cruelty* woodcuts. He must have realized how effective some of the latter were as images. His own attempts to engrave *An Election Entertainment,* involving numerous trial proofs, and his ultimate recourse to another engraver, suggest the difficulties he encountered when he tried to convey the style of the paintings in the prints. Simple, traditional English directness was the quality he conveyed in the paintings, and the signboard (which he would invoke more directly in the Signboard Exhibition of 1762) might be regarded as the most indigenous manifestation of art available to an English artist in the second half of the eighteenth century.

THE OXFORDSHIRE ELECTION

Hogarth's subscription, begun in mid-March 1754, cannot have been helped by the unseasonable weather: "Almost as extraordinary news as our political," wrote Horace Walpole, "is, that it has snowed

ten days successively and most part of each day. It is living in Muscovy, amid ice and revolutions."[6]

The subscription ledger, dated 19 March 1754 on its binding, is inscribed on the title page 28 March. It explains that *An Election Entertainment* can be subscribed for at 5s down, 5s on delivery, until the last day of April. But when advertisements began to appear in the *London Evening Post* of 25–27 April, to the information in the subscription book was added: "In order to make a Set on this Subject, three other Prints, viz. Canvassing for Votes, Polling at the Hustings, and Chairing the Members, will be also finish'd and publish'd, in the same Manner, as soon as possible." The whole set could now be subscribed for at one guinea down and another on delivery.[7] It is not clear when the other three paintings were begun or whether they had in fact been part of the original plan.

In the month in which Hogarth opened his subscription ledger Paul Sandby published *The Author Run Mad* (fig. 31), which, below the main design, shows *An Election Entertainment* on the floor of Hogarth's studio ("a New Scheme to Humbug ye Public by a Ten shilling Subscription"). As Sandby must have noticed, Hogarth's announcement of the subscription was shrewdly timed to draw upon interest in the General Election that was going to be held in April—a septennial election, which Hogarth as well as the candidates had foreseen far in advance. But Sandby and Hogarth were both thinking about artists' academies at this time; it is no accident that *The Analysis of Beauty* was immediately followed by *An Election Entertainment*.

The model for both political and artistic life was still patronage; as in the argument of the *Analysis,* there were the Men of Taste and there was the general public. The British electoral system was epitomized by the duke of Newcastle, the "great Electioneer" (glimpsed through a window in *Election* 4), and an oligarchy that controlled multiple seats and boroughs. For example, if a designated M.P. happened to lose in one borough, his patron found him another "safe" seat. Then there were all the people who were aware that the constitution gave them liberty but also that it denied them equal participation in the political process by either disfranchising them altogether or, if they had a vote, by rendering their franchise meaningless because of the way in which elections were controlled by the rich and powerful, constituencies drawn up, and the number of M.P.s that any one area could choose determined. In Hogarth's *Election* this

electoral order is shown at every stage to be threatened by the plebeian energies he had earlier introduced in *The Enraged Musician* and *The March to Finchley*. The chaotic last scene may not have been painted until after the results of the General Election, but its thrust was already implicit in the *Election Entertainment* with its two very uncomfortable candidates.

For once Hogarth has moved his setting from London to the country. He places his compositions specifically in Oxfordshire, a borough that had been contested as early as 1752. For two years before the General Election it had been the center of persistent wining and dining, parading and—in particular—rioting. This last Tory-Jacobite stronghold—with (as in *The Stage Coach*) its "country" perspective—served Hogarth as a paradigm for the General Election, and this was based on the relationship of candidate, electors, and crowd.[8] In the first scene it is the candidate who is in bodily discomfort, but he has loosed this force himself by his concessions, promises, and bribes, and he may well be its victim (as in the final scene). The electors, who actually had the vote, are not to be confused with the crowd that tries to influence them; and the candidate, like the Harlot or the Rake, is not to be confused with the "great" whose cause he serves: the ministry, the duke of Newcastle, and his cohorts are glimpsed on signboards and, in 4, through the window of a house eating and (though there are many broken window panes, the result of bricks thrown) safely celebrating above the melee.

The two candidates who appear in *Election* 1 are of the Whig party (orange ribbons in the painting); the Tories (blue ribbons) parade outside with a sign "Marry and Multiply in spite of the Devil and the . . . ," expressing their opposition to the Marriage Act. Another Tory banner, "Give us our Eleven Days," referring to the conservative dismay at the new calendar begun in 1752, has been captured by a Whig bruiser and is now on the floor of the banquet hall. The slashed portrait of William III (the Whigs' hero) suggests that the Tories used the same hall the day before; the slogans also indicate how interchangeable the two parties are.

The second scene invokes a Choice of Hercules in which both Virtue *and* Pleasure offer the voter bribes. The subject of any election is, of course, Hogarth's familiar one of choice, but the irrelevance of the voters' choice is a symptom of the electoral system. Choices have been reduced to a simple minimum, blue and orange, as indistin-

guishable as Swift's Big and Little Endians. The choosers (that is, the electors) are besieged by equally bad candidates and their equally threatening supporters. The idea of choice is only an excuse for (or an alternative to) releasing all the restless, undirected forces in the crowd.

As luck would have it, the results of the Oxfordshire election were contested and the Oxfordshire Petition persisted as an issue before Parliament through 1754 and 1755, keeping alive the timeliness of Hogarth's allusions long after the General Election, while he finished the four plates. For example, while in the painting of *Election* 4 the chimney sweep urinates on the monkey, in the engraving the monkey shoots the chimney sweep, the gun over his shoulder firing upward. This alludes to an incident that took place in Oxford on Magdalen Bridge: the Scrutiny was concluded on 31 May 1754 with the referral to Parliament, and, perhaps sensing their imminent victory, the Whigs paraded from the city hall. When the parade reached Magdalen Bridge it was pelted with dirt by a Tory mob, and an attempt was made to throw some of the Whig gentlemen into the Cherwell. One Captain Turton fired out of his post chaise and shot a Tory chimney sweep dead.[9] And thus in the final scene the triumphal candidate falls in part because at Oxford, while the Blues won initially, they finally lost when the issue was referred to the Whig House of Commons.

The last two plates were not published until 1758, by which time the subject had changed from elections to the rise and fall of ministries and the conduct of the Seven Years' War. By the third scene the preoccupation with choice causes Englishmen to ignore the predicament of Britannia's collapsed coach (perhaps partly because, being female, she has no vote).

GEORGE BUBB DODINGTON

Hogarth's general alignment with the Opposition or Country Party had been evident in the 1730s and 1740s.[10] With Walpole's fall, however, nothing changed but the names of the ministers. Opposition now centered in the Prince of Wales's party in Leicester House, located geographically near Hogarth's own house. In 1747 Hogarth

had included Prince Frederick in the final plate of *Industry and Idleness* presiding benevolently over the lord mayor's procession (ill., vol. 2). The bible of the Leicester House faction was Bolingbroke's *Letters on the Spirit of Patriotism and on the Idea of a Patriot King* (pub. in 1749), which declared that *"party* is a political evil, and *faction* is the worst of all parties."* In choosing its rulers, writes Bolingbroke, "the multitude would do at least as well to trust to chance as choice, and to their fortune as to their judgment"—words illustrated by Hogarth's Choice of Hercules composition in Plate 2.[11]

Bolingbroke paints a picture of English corruption descended from Walpole's government by party and urges that the individual rise out of his lethargy and aspire to an ideal of active "patriotism"; his solution, especially in the *Idea of a Patriot King,* is the prince or the great man who will "espouse no party" and transcend the dangers of factionalism. Although not specified in the *Election,* this ideal may be inferred from the complete chaos in which the English political machine is shown to be floundering. A conviction of national collapse caused by factionalism, followed by a call to patriotism, and culminating in a faith in a "Patriot King" above parties—these stages, described by Bolingbroke, apparently characterized Hogarth's own position. The subject of the *Election* is parties and factions and the chaos they produce. One fact that gave great cogency to Bolingbroke's thesis and perhaps led such people as Hogarth to adopt it was the death of Prince Frederick in 1751 and the emergence of a new Prince of Wales (the future George III) who was a native-born Englishman, uninfluenced by the old Hanoverian ideas, and a source of hope for patriots.

Hogarth gives the toppling candidate of *Election* 4 the unmistakable features of George Bubb Dodington, one of the best-known politicians of the day. Dodington was a symbol of the old patronage system in that he controlled one of the larger groups of parliamentary seats. But as the 1750s opened he was in the Leicester House party and advocating a revision of the patronage system along the lines of Bolingbroke's "Patriot King." He was also one of the last of the great literary patrons, supporting, among others, Hogarth's friends Paul Whitehead and Henry Fielding. Fielding, who had dedicated his poem "Of True Greatness" to him in 1741, was close to Dodington in 1751 as he wrote *Amelia.* The eleventh book of *Amelia* began, we noted above (89), with a chapter on beauty; this was fol-

lowed by a chapter on "Matters Political," a significant conjunction for Hogarth at just the time he was conceiving the *Analysis;* and this chapter praised the principles of Dodington, whose current motto was "personal merit" and who was writing and paying Ralph to write in the *Remembrancer* on the "reformation of the patronage system," that "ministerial patronage" he associated with Walpole which was now being continued, he argued, by the Pelhams.[12] In Fielding's chapter Dr. Harrison, his spokesman (who is also a great admirer of Hogarth), refers to Dodington as "one of the greatest Men this Country ever produced," quotes from his *Epistle to the Right Honourable Sir Robert Walpole* of 1726, and delivers a long *beatus ille* passage starting, "Such a Minister . . . ," which opposes this idealized Dodingtonian figure to the old patronage system (464–65).

But Dodington's pose of political idealism had been shattered when (following the death of Prince Frederick) he returned in October 1751 to the Pelham fold—just two months before *Amelia* was published with the chapter on "Political Matters" embarrassingly intact. Given the dates of Dodington's latest tergiversation, *Amelia's* publication, and the General Election in which he once again served under Newcastle, we can see the *Election* as a reply to Dodington's political idealism and Fielding's book 11, chapter 2 (as well as chapter 1 on beauty), a final stage in the increasingly agonistic dialogue between the old friends that had begun with *Industry and Idleness.* (By the time *An Election Entertainment* was published at the beginning of 1755, however, Fielding was dead.)

Dodington was in fact defeated at the hands of the earl of Egmont, who represented Leicester House, after thirty years as M.P. for Bridgewater.[13] For this reason Hogarth shows him being unsteadily chaired over a *bridge* and a stream of *water.* Between 1754 and 1758, when the fourth plate finally appeared, the image continued to reflect Dodington's rises and falls. After losing Bridgewater, he found a seat at Weymouth (a seat that was in his pocket, the one he had given Thornhill back in the 1720s); by the end of 1755 he was in the Fox–Newcastle administration as treasurer of the navy (as he had been earlier under Pelham before his defection to Leicester House) and so presided over the disastrous naval operations at the opening of the Seven Years' War—referred to in Plate 2; but he was excluded from both the Pitt–Devonshire and Pitt–Newcastle ministries that followed in 1756 and 1757.

Hogarth makes Dodington the hero of his series insofar as it has one: the candidate in 4 looks very much like the candidate in 2, who employs the Jewish peddler, woos the young women, and stands directly below the show cloth of Newcastle and Fox, in whose brief ministry he served—by implication using the funds intended for the war for election bribery as they are shown doing.

THE CROWD

The triumphal candidate in the final scene fulfills the plight of the candidates in the *Election Entertainment*. He is falling because he cannot control the mob his campaigning has loosed. Dodington confided to his diary that his campaign at Bridgewater involved "infamous and disagreeable compliance with the low habits of venal wretches," the electors, including the disfranchised crowds.[14] Hogarth has Dodington's face rhyme with both the goose flying over his head and the swine (the "swinish multitude") running ahead of him. The "great Electioneer," the duke of Newcastle, was represented in political prints of the time as a goose: here his symbol heralds his "victorious" candidate, Dodington, while his proper person, in the window at the right, turns its back on the procession. But the goose also recalls the paintings of triumphal processions in which an eagle flies over the hero's head, and it echoes the cackling goose that warned the Romans of the barbarians' (another unruly mob's) approach on their city. The story, which in Virgil's *Aeneid* concludes, "The silver goose . . . by her cackle, sav'd the state," was modified in Pope's *Dunciad* to the modern Dunce who would "rob Rome's ancient geese of all their glories, / And cackling save the Monarchy of Tories."[15] And if the candidate is paralleled by the goose overhead, his constituents are paralleled by the Gadarene swine, into whom Christ transferred the "devils" of the mad men of Matthew 8:28–34.[16]

The ass trying to eat a thistle illustrates the old story of what caused Crassus, who had never laughed, to laugh. Dryden's version in "The Medal" (1682) may have been in Hogarth's mind:

> The man who laugh'd but once, to see an ass
> Mumbling to make the crossgrain'd thistles pass,

Might laugh again to see a jury chaw
The prickles of unpalatable law. (ll. 145–48)[17]

The ass is Hogarth's epitome of the electoral process, as the chicks
looking for their missing hen was of the military in *The March to
Finchley*. Dryden's passage about the ass immediately follows his clas-
sic statement of the conservative view of the "Almighty crowd" and
its "idol" the demagogic politician (ll. 82–144): the ass signifies the
Whig juries who find "unpalatable" the laws that force them to reach
just verdicts. And in the context of the whole passage, Hogarth's
crowd is as uncomfortable as the ass swallowing the actual election
results (which will *unseat* their candidate) which are controlled not
by them but by Newcastle and his cronies in Parliament, represented
as safely enclosed far above the hurly-burly.

The crowd must be understood—as in Dryden's account of it—in
the context of the classical *populus* and of the plebeian English crowd
ritual. The first—the crowd's antitype—drew on memories of the
"civic processions up the Athenian Acropolis" and "the assembly of
Florentine patriots around Michelangelo's *David*."[18] Hogarth only
recalls the classical precedent for this public in its antitheses, the over-
head goose which is not an eagle, the "barbarians" pillaging Rome,
and the "Gadarene Swine." The second, the English crowd ritual, is
the crowd he represented in the skimmington and the burning of the
rumps at Temple Bar of *Hudibras,* in the Tyburn and Guildhall pro-
cessions of *Industry and Idleness* 11 and 12. Seen from this perspective,
the Oxfordshire people in the first scene are specifically rioting, as
historically the London crowd did, to preserve the "Eleven Days"
the government stole from them in September 1752 by changing the
calendar, and to overturn the "Jew Bill," which naturalized nonnative-
born Jews; in the second scene the mob is rioting against the excise.
All of these are reactionary gestures, attempts to recover something
that had been taken away from them.

Those barbarians who (*pace* the goose) overran and pillaged Rome
were, in the Country rhetoric of Leicester House, the bold Goths
who overthrew a decadent Rome, followed by the Anglo-Saxons
who replaced Roman corruption with their Ancient Constitution,
northern liberty, and primitive virtue. Bolingbroke had defined an
agon between the "Spirit of Liberty" of the "people" and the corrup-
tion of the politicians in power. His point was that "if all men cannot

reason, all men can feel," and he referred to "the sense of the people" and "the Knowledge of the millions" as the force that could be summoned against tyranny.[19] This may have been one origin of Hogarth's democratic assumptions about the people, public opinion, and the function of the graphic satirist. But while in many ways he builds upon this Country ideology and its nostalgia for an idealized past, his view of politics in the *Election* is more realistic.

The hustings, which Gwyn Williams has called "the English mob institutionalized,"[20] represents the place and occasion where the crowd could respond to the candidates' speeches with everything short of votes, which were possessed only by those qualified for the franchise by a 40-shilling freehold. While the population had increased by around 18 percent between 1715 and 1754, the electorate had increased by only 8 percent.[21] The electorate and suffrage—the exclusion of the great mass of people—was not yet an issue, but the ability of the disfranchised majority to exert its influence of numbers on a few important occasions was, for example at the excise crisis (1733), the Gin Riots (1736), and the recent riots over the "Jew Bill" in 1753.[22] In the final scene it is important that the ceremony of chairing the member is carried out primarily by the crowd, not by the electors themselves. Hogarth does not quite show—though it is just around the corner—the crowd tearing (as it often did) the hustings apart with hatchets, crowbars, and their bare hands, pulling it down and carrying off the boards in triumph—and the successful candidate as well—preceded and followed with banners, up and down the main street of the town. After the candidate had been chaired, the chair was torn to pieces by the crowd. And the candidate himself in their love-hate grasp is clearly in a precarious position.

All four scenes describe a characteristic process. The candidate is first the oligarch who, at the wooing stage, stands outside, unpleasantly aware of the crowd; but once he is the successful candidate, he is absorbed by the crowd and made an effigy. In the same way, Hudibras skeptically eyed the skimmington, but he had himself become part of the Saturnalia in *Burning the Rumps at Temple Bar,* riding now as an effigy in the procession.

Although Hogarth is unsympathetic to the candidates, his attitude toward the crowd is beginning to support the view of Fielding the magistrate that it was not ruled by the "remarkable restraint" of the "moral economy" described by E. P. Thompson: the crowd implied,

rather, "a multitude confusedly pressed together" or a "promiscuous medley, without order or distinction" (according to Johnson's *Dictionary*).[23] In Plate 2 he places on the right the "Excise Office" being besieged by a rioting mob, one member of which, sawing off the "Excise" signboard from the wrong end, will fall with it to the ground. He would have remembered the Excise Riots of 1733, when a crowd outside Parliament mobbed Walpole and his supporters, and even though the Riot Act was read, blows and abuse followed. On the left is the sign of the "Portobello" tavern, referring to one of the few victories England could boast of (back in the War of Jenkins's Ear) and one of the few major examples of crowd celebration in the century, though he would have recalled the irony of how little effect that one victory had in a disastrous war.[24] He would also have remembered the riots in Leicestershire in 1748, at Bristol in 1749, and the frequent riots against turnpike gates and houses. Nationwide food riots had taken place in 1739–1740 and 1756–1757, during the work on the *Election*. In 1750, according to an eyewitness account, "a crowd of people assembled" in Walsall and proceeded to shout treasonable expressions and to fire shots at an effigy of George II.[25] Riots, in general directed against the ministry, were not uncommon during the later stages of the General Election of 1754. In February at a Whig supper in Banbury, "a drunken rabble which [the Tory candidate] had inflamed with liquor offered the highest affront to one honourable person there present," and in the ensuing riot the Tories claimed to have captured two prisoners. The worst incident took place near the end of the month when both interests held entertainments on the same day at Chipping Norton: a Tory mob and about fourteen Whig bruisers clashed, the White Hart was stormed, and a dinner was broken up. In Nottingham a dissenting chapel was destroyed, and in retaliation all the churches in the city had their windows smashed; "only two" men were killed.[26] All of this, but especially the Banbury and Chipping Norton riots, formed the context of Hogarth's first, third, and final plates with their violent crowds.

In *Industry and Idleness* he had represented the great public, popular rituals and scenes of Tyburn and the lord mayor's procession as an extension of the first ten plates—both in number and in width, as if the plebeian vitality of the crowd had pushed the limits outward. Although he dealt sympathetically in *The March to Finchley* with soldiers rebelling against military discipline, his attitude by the 1750s

was changing. One fact distinguished the election crowds from the earlier ones: The "crowd ritual"—the Hogarthian play—was becoming real in the deaths and destruction of property. By 1758 when the last *Election* prints were published, the crowd, now out of control, indiscriminately elevating and sweeping away its heroes (Admiral Byng, executed to satisfy the popular clamor against the Newcastle ministry, is also a subtext of the published prints), had gained respectability with the rise of William Pitt.

THE "JEW BILL"

The central figure in the Tory parade outside the window in *An Election Entertainment* is the effigy of a Jew, which is made to resemble caricatures of Newcastle, who with his brother was regarded as responsible for the passage of the Jew Bill in 1753, which naturalized individual Jews by private act of Parliament. This was the other crucial event preceding the General Election that contributed to Hogarth's conception of the *Election*. The City merchants had begun the hysteria with their fear of Jewish merchants as rivals, and the old Tories, by the 1740s and 1750s little more than defenders of the Anglican Church, woke to find in the Jew Bill one of the few issues around which they could still rally. Once again Whig and Tory, both as parties and in their old stereotypes as liberals and exclusionists, were prepared to clash. "Jew" was equated with Whig in the Tory propaganda, and the Pelhams became the "Jew Brothers." The violence of the reaction, abetted by intensive propaganda, frightened the Pelhams (who, it appeared, had no real conviction but had put through the act as a favor to their Jewish financial supporters) into repealing it in the next session, during the autumn of 1753 and some months before the election. This capitulation only intensified the Tory attacks on "the Act in favour of the enemies of our Blessed Redeemer," the "Crucifiers," and the potential "circumcisers" of English "manhood," who, it was feared, would outlaw the eating of pork in England.[27]

Jackson's Oxford Journal, the Tory weekly in which these phrases appeared (though many items were reprinted and amplified from the Tory *London Evening Post*), came out in May 1753 and, despite the

almost total absence of Jews in Oxfordshire, printed something about the Jew Bill in virtually every issue published during the remainder of the year. The Jewish peddlers who wandered about the countryside hawking buttons, pins, spectacles, penknives, and such trinkets, were practically the only contact a non-Londoner had with Jews. These (unlike the assimilated and prosperous London Jewish merchants—one of whom appeared in *A Harlot's Progress*) looked strange with their beards and ragged clothes to clean-shaven Englishmen. For this reason peddlers appear in the pages of *Jackson's Oxford Journal* as Jewish referents for its readers. As early as August 1753 the story was printed of a Jewish peddler's unsuccessful attempt (in another county) to cheat some young ladies:

> Huntington, Aug. 3. On Wednesday a Jew Hawker in this Town persuaded some young ladies to look at his Toys, &c. among which was a Diamond Ring, but the Ladies not chusing to buy any Thing, he pretended to look over his Goods, and said, he missed his Diamond Ring; the Ladies declared they knew nothing of it, but he insisted they did, and that they should pay for it; during the dispute a young Gentleman, a Relation of the Ladies, came in, and being told of the Affair, had the Jew immediately before a Magistrate, where his Box was searched, and the Ring he had charged the Ladies with found conceal'd in a private Part of the Box: The Fellow being had back to the Ladies, and having nothing to say in his Defence, the Mob seiz'd him, took him to a Horsepond, and duck'd him in a very severe Manner.[28]

Hogarth picked up this story with its "Mob" and introduced it in Plate 2, which shows the peddler and a candidate using his wares to win two young ladies. What he shows, however, is first the Jewish peddler and second the fat Tory candidate not hesitating to buy a Jewish peddler's ware with which to bribe two young ladies—and, in this context, the bribe appears both political and amatory.

We can only infer Hogarth's attitude to the Jew Bill. His friends Bonnell Thornton in the *Connoisseur,* Arthur Murphy in the *Gray's Inn Journal,* and James Ralph in the *Protector* all wrote against the bill or satirized it. Ralph's attacks, at least, were anti-Semitic. Hogarth's may simply reflect the City interest, which, as Todd M. Endelman says, "steadfastly fought every move of the Jewish community to improve its position."[29] Hogarth's strongest statement appears in the juxtaposition of the triangle of the Jewish peddler, Tory candidate,

and pretty young ladies with the grenadier who wears the star of David in his cap. Instead of guarding against electoral bribery, the grenadier is preoccupied with the inn mistress's shekels.[30] The Jew still retains the symbolism of economic interest he carried in the South Sea satires of 1721, embodied now in the star on the grenadier's arm and the jewels being offered to young women. Hogarth makes the central features of the election money and bribery (as in *The Stage Coach*), and embodies them in the Jew. By the time the series was finished this included money being siphoned off from the army into electioneering bribery and politicians' profiteering emblazoned on a shop sign which hangs directly above the peddler's head.

The final scene shows the same candidate who was bribing with Jewish baubles in 2 now—amid signs of "True Blue," the color of the anti-Jewish "Old Interest," the Tories—being carried in a triumphal procession (like the Jewish effigy in 1), led by a Jewish fiddler; while the pigs fleeing in another direction recall the adaptations of "The Roast Beef of Old England" to "Sing oh! the Roast Pork of Old England, / Oh! the Old English Roast Pork" and the Tory political dinners where pork and ham were served.[31] It is doubly ironic that a Jew leads off the procession of the triumphal Tory candidate: the "Jews" have won, even if the Jew Bill was repealed, and foreshadow the long-run victory of the Jewish (the money) interest. If the third scene progresses from satire to allegory in the collapse of Britannia's coach, the fourth carries allegory into Old Testament prophecy.

The plate reflects the satiric predictions that were being made of English life under Jewish rule, as in "News for One Hundred Years hence in the Hebrew Journal," in *Jackson's Oxford Journal* of 21 July 1753.[32] For example, "Last Night the Bill for naturalizing Christians was thrown out of the Sanhedrim by a very great Majority." Most suggestive, considering Hogarth's composition, is the report that "We hear that Mr. Alvarez Cardosso, Bookseller, has obtain'd a Patent for the sole printing of Mr. Wo[o]llston's excellent Discourses against the Miracles of Jesus Christ." A portrait of Thomas Woolston, who used a rabbi as his persona in his attack on New Testament miracles because Jews supposedly hated the New Testament, had hung above the Jew's head in *Harlot* 2 (see vol. 2, 288–91).

The most interesting fact about *Election* 4 is that it re-creates the painting of the Ark of the Covenant on the Jew's wall (above the

portrait of Woolston) in *Harlot* 2 (fig. 41). The Jew with his fiddle leading the victory procession of the chaired candidate is in the position of David with his harp, leading the Ark of the Covenant into Jerusalem. The chaired candidate is in the position of the Ark itself, tottering and about to fall, and the foremost carrier of the chair/Ark is being hit on the head by a bruiser as Uzzah was stabbed by the Anglican bishop. In place of Michal and her women are the group associated with Newcastle, in a window above the crowd, watching and jeering at the plight of the tottering candidate.

The scene carries an allusion which Hogarth expected his collectors and "men of greater penetration" to recognize: the allusion to the Ark implies that the candidate is regarded (or regards himself) as a Holy-of-Holies. The pretty young women being offered the Jew's baubles also recalls *Harlot* 2; the goose and the rhyming human face appeared in *Harlot* 1, as well as the materializing of a "fall." But by re-creating the painting in the total composition of *Election* 4 Hogarth is primarily suggesting that England has become Jewish. Secondarily, he recapitulates and recalls his own first triumph in the modern history mode.

I have discussed Hogarth's use of marginal characters (dogs, children, blacks, and, above all, women, in vol. 1) and suggested that Jews did not fit into this group because they seemed more successful at assimilating themselves. If the child and the black were the Harlot's complements, the Jew was her sinister alter ego. In *Harlot* 2 and 3, where they were both outsiders trying to rise into the dominant class, their social climbing was contrasted. But the difference can be seen in their origins as satiric types in the South Sea satires: the Harlot retained the sympathy of the low wench who suddenly (through gambling, through her physical charms) rises to be a lady, only to fall again, leaving the real lady unscathed and herself incidental to the desires of Great Men. The Jew, on the other hand, while also serving the South Sea directors and other Great Men, shared one important quality with them: he was the prototypical stockjobber, the middleman who connects the commercial interests with the politicians and the monarch, and manipulates and profits from both.

In the context of the naturalization bill and its repeal, the Jews alluded to in the *Election* are aspiring to assimilation (citizenship). In important ways, Hogarth believes, the Jew has achieved the end envisioned by the Harlot. Indeed, he is able to buy the Harlot, a Gentile

woman, to satisfy his notorious lust. Like Dr. Meyer Schomberg (himself a Jew and a friend of Hogarth's), Hogarth may have had two categories, *bad* Jew and *good* Jew, instead of Jew and Gentile. Schomberg's words in *Emunat omen* (*The Truth Faith,* 1746) could have applied to the Jew in *Harlot* 2: "Not only do they [London Jews] lie with women, daughters of the gentiles, as if they were fulfilling a Commandment, without shame, but they also live and dwell and lodge with them in intimate embrace and reject the *kasher* daughters of Israel who are our own flesh and blood."[33]

The Jewish question in the *Election* could be regarded as yet another case of Hogarth's xenophobia, parallel with his attacks on French influence on the English academy. Naturalizing foreign-born Jews is something Hogarth could be expected to disapprove of. Moreover, if we take the *Election* to be a continuation of the personal story Hogarth was constructing in the late 1740s, with Hogarth–St. Paul (as in *Paul before Felix*) persecuted by the Jewish priests and merchants, then the victorious Jews of *Election* 4 become doubly significant.[34]

The Jew also carried for Hogarth a second quality that set him off from the Harlot: if like her he is an ape of fashion, unlike her he believes in the violent gesture, which in his Old Testament terms is blood revenge, Shylock's pound of flesh, symbolized by the Old Testament pictures he hangs on his wall. In Plate 3, having discovered her infidelity, he has cast the Harlot into outer darkness.

Nevertheless, the Jew in *Harlot* 2 was both a successful version of the Harlot *and* a man she was deceiving, for whom the spectator feels both revulsion and sympathy. Placed in the context of Thomas Woolston, the Jew also carried along some of the sense of persecution (in Woolston's case at the hands of the Anglican clergy).[35] And contrasted with the prosperous Jew of *Harlot* 2, the Jewish peddler in the *Election* sells baubles for tempting Gentiles, specifically (once again) young women—but he is himself *used* by the politician, as the Pelhams were said to have used Jewish bankers and for this reason passed the Jew Bill.

But what the affair of the Jew Bill, and the election itself, represented to many sober Englishmen was the dismaying power of popular pressures, which could in a few months force a British Parliament to repeal an act it had just passed. As the earl of Chesterfield wrote to his son: Newcastle, by repealing the Jew Bill, had capitulated to

"the absurd and groundless clamours of the mob."[36] There was, for example, the drunken Tory mob in Oxfordshire which in December paraded with the effigy of a "Jew"—in fact of one of the local Whig candidates, Sir Edward Turner, Bart., a Gentile who had not even been in Parliament when the Bill was passed. "A half hogshead of ale was given to the populace, who were numerous and unanimous in their cries, No Jews; No Naturalization; but Wenman and Dashwood [the Tory candidates] forever."[37]

In the context of the Jewish allusions (and recalling *Gin Lane*), we must identify the significance of the Christian church. The interior shown in 1 gives no access or reference to a church, only the Jewish effigy seen through the window; but in 2 a small village church is visible in the far distance, breaking the horizon with its steeple. In 3 what appears to be the same church is now much closer, just beyond the bridge, but still on the horizon. In the final scene a different church, presumably inside Oxford, fills the immediate left (or right) foreground, carrying the admonition of a sundial inscribed "WE MUST [die all]" and a skull and crossbones on its gatepost (pointed spikes on its gate), but its steeple is displaced to the city hall.

Balancing the church on the opposite side of the picture is the lawyer's house, where the party leaders are meeting; opposite the sundial and its motto is the lawyer's clerk—his hand only showing—at work on an "Indinture." The building adjacent to the lawyer's house is (again in the idiom of *Gin Lane*) ruinous, as if to verbalize that "nothing can thrive in the shadow of the law." On the next lower level, the chimney sweep on one side is balanced by the party politicians on the other, both watching the mishap; the chimney sweep supplies the skull with a pair of spectacles so he can better take in the catastrophe below. But (in the engraving) the monkey's gun is discharging straight at the sweep, as if to materialize the admonition of the sundial. The Christian church is thus reduced—as Hogarth has always reduced it—to an admonition about death (a superstition) and equated with the legal profession (clericalism); and in this context, Judaism has been similarly reduced to commerce.

The sundial also serves with the lawyer's clerk as a level of commentary, glossing the action below: "WE MUST" die and "WE MUST" work are the two activities that relentlessly go on whatever the outcome of the election, though the foolish goose flies between.

Below, the responses of the skull, sweep, and woman who is fainting with fright (the equivalent of the young woman in 2, or possibly of Michal watching David) materialize the familiar spectrum of *l'expression des passions* in reaction to the candidate's fall. On the lowest level, the fiddler on one side and the bruiser on the other both turn away from the scene. This is a final reprise of the structure Hogarth initiated in *The Beggar's Opera, Harlot* 1, and *A Scene from "The Indian Emperor"* which united history painting and the stage—in terms of which the church and the lawyer's house merely serve as stage flats.

HOGARTH'S "POLITICS" IN 1754

With the death of Henry Pelham on 6 March 1754 (a month before the General Election), suddenly there were roughly equal groups contesting for power: Pelham's brother, the duke of Newcastle, carried on with jerry-built coalitions that attempted to conciliate the Princess Dowager of Wales and her young son in Leicester House, the duke of Cumberland and the armed forces, with Cumberland's spokesman Henry Fox, and even such annoying mavericks as the "demagogue" William Pitt—all rivals maneuvering for position through one or the other of these parties.[38]

Hogarth's Leicester House allegiance is plain in his subscription book, which begins with the names of the Prince of Wales, his mother, Princess Augusta, and Prince Edward. But the name of Henry Fox (presumably representing the duke of Cumberland) is added over an erasure and so may have been inscribed later; he is marked as the first to *pay* for his subscription. In the original subscription ticket, issued in March, Hogarth shows the royal sun shining down upon the Prince of Wales's crown (fig. 42). The ticket and perhaps the whole series were proffered in some degree as a gesture toward Leicester House and the future. In February 1751, before Prince Frederick's death, Hogarth had introduced a barely veiled portrait of the handsome young Prince George as the one good boy in *The First Stage of Cruelty*—as if to say that rank, or the disinterestedness it brings, was the only hope in a world of cruel boys and worse parish officers (fig. 4).

In May of 1754, however, at the end of the subscription for the *Election Entertainment,* when he launched a subscription for all four plates, he revised the ticket by replacing the crown of the Prince of Wales with that of his uncle, the duke of Cumberland (fig. 43). He did not simply add, as he might have done, the duke's crown; he removed the Prince of Wales's from the copperplate and replaced it with the duke's but kept copies of the former, distributing both versions throughout the remainder of the subscription.[39] This change can be regarded as support of the duke or a diplomatic concession to customers who might choose either crown. When the *Election Entertainment* was delivered in February 1755, however, it was dedicated to Cumberland's chief lieutenant, the secretary at war, Henry Fox. Ticket and dedication, in the context of politics in 1754–1755, imply that Hogarth is at that point declaring support for the Fox–Cumberland party.

The duke, as a child of twelve, had posed to Hogarth for his portrait. Under the influence of his tutor Sir Andrew Fountaine (whom Hogarth had also painted), he had become something of a patron, especially of the Chelsea China factory and the carpet factories at Paddington and Fulham. Even though he seems not to have collected anything by Hogarth (his name does not even appear in the subscription book for the *Election*), his gestures toward national products of this sort might have made him appear another conceivably educable patron.

The Cumberland party had begun to emerge with some cohesion by 1749–1750, making its first impact with the Mutiny Bill, framed by Cumberland and introduced by Fox as secretary at war. At this point Hogarth had introduced in *The March to Finchley* a ballad on the duke sold by a pretty sutler, while the *Remembrancer* (which had attacked him as "the Butcher" of Culloden) was hawked by an ugly Jacobite Amazon.[40] While clearly defending the victor of Culloden against what could be regarded as Jacobite slanders, at the same time *Finchley* ridiculed Cumberland's notions of military discipline; and in the same year Hogarth painted a small panel—intended for a close circle of friends—of a Savoyard girl and decorated it with the iconography of the duke's failure in love and war (at the Battle of Fontenoy; fig. 25). Hogarth may already have been on the fringes of the Leicester House party (this would explain the satire in *Finchley* di-

rected at both the king and the duke, his favorite son), but he was pointedly not attacking Cumberland "the Butcher."

With the death of Prince Frederick in March 1751, and the question of the regency to be settled, the attacks on Cumberland increased in violence. On the day Parliament met at the beginning of 1752 a pamphlet, *Constitutional Queries,* was circulated throughout London, comparing Cumberland to Richard III, the wicked uncle of the murdered princes in the Tower, and hinting at an attempt through his post as commander in chief to make himself king after his father's death. Those who had lamented that "the Butcher" and not his brother should have died attacked the idea of this dangerous man near or on the throne. George II wanted Cumberland to be sole regent, but the Pelhams, not unnaturally, opposed the idea of raising their unpopular antagonist; and so the Princess Dowager of Wales was named regent with a council of which the duke of Cumberland was called president. This example of popular force, of insult to the duke, and of the many-against-one may also have contributed to Hogarth's development of the *Election* series.

In short, he seems to have defended the duke in relation to his Scottish victory, criticized him for his views on military discipline, deplored the popular anger deployed against him, and supported his party when Fox was at its head. Fox had been both a friend of Cumberland and a faithful supporter of Pelham, as he had been of Pelham's master Sir Robert Walpole. But he gradually deviated from Pelham's policies toward Cumberland's and came to be recognized as the leader of his party. Fox too had earlier contacts with Hogarth, for whom he sat in the late 1730s for *Lord Hervey and His Friends* (ill., vol. 2). His elopement and marriage with Lady Caroline Lennox in May 1744 would have struck Hogarth as a curious coincidence considering that at the time Hogarth was working on *Marriage A-la-mode,* a satire of the planned marriage from which Lady Caroline escaped—and that he had himself eloped under similar circumstances. He had also painted Lady Caroline in the *Indian Emperor* conversation in 1732, and therefore both she and Fox had appeared in two of his most accomplished conversation pictures. Then in 1753 Fox generalized his own marital experience (as Hogarth was also prone to do) in his speeches attacking the Clandestine Marriage Act, against which *Marriage A-la-mode* served as ready-made propaganda.

He subscribed to *The Analysis of Beauty,* and when he made his last payment and received his copy on 4 January 1754, he purchased as well all of Hogarth's recent prints, going back to *The March to Finchley* (a suggestion that he had begun collecting Hogarth earlier). He and Hogarth seem to have been on friendly terms.[41]

Fox, the epitome of the conventional Walpolian politician, who under ordinary "Election" circumstances would have led a ministry, was at this time a man of far greater promise than Pitt. At first it appeared that he would succeed Pelham, but when all the interests had been served and the new cabinet was formed on 12 March he was only secretary of state for the South. On the 14th, suspecting Newcastle's duplicity, he requested to decline the seals, and on the 16th asked George II to let him remain secretary at war.[42] On the 18th or thereabout his name was registered in Hogarth's subscription book for *An Election Entertainment.* The General Election then supervened, and the new Parliament sat on 14 November 1754 to consider election disputes (including the Oxfordshire). In December, just before Hogarth's print was finished (and presumably dedicated), Fox took office as secretary at war in a coalition with Newcastle.

Another key figure for Hogarth was William Cavendish, marquis of Hartington. His initial connection with Hogarth had been thirteen years earlier; in 1741 when he was twenty-one years old and a newly elected M.P. for Derbyshire, Hogarth painted his portrait (ill., vol. 2). His name does not appear in the subscription book for the *Election,* but he and Fox were close friends, both of the Cumberland party.[43] Hartington was a powerful grandee, whose advantage lay in his connections among the various parties. By 1757, whether through Fox or his own efforts, Hogarth would obtain from him—now the duke of Devonshire—the reversion of the Sergeant Paintership.

THE FONTHILL FIRE

On the night of 12 February 1755, just before *An Election Entertainment* was published, a fire broke out in the stable of Fonthill, Alderman William Beckford's country seat in Wiltshire, spread to the house, and in two hours entirely consumed it "with all the rich Household Furniture."[44] Later reports corrected this: all but the two

north wings, the great kitchen, and the brewhouse had been destroyed. It was started by workmen who built a fire in a fireplace from which the chimney had been removed; the fire spread to a beam. Only four servants were present, Beckford then being in London; neighbors called, but it was nearly 3 a.m. before assistance came, "by which Time the Fire had consumed the great Hall, the fine Organ, with the rest of the Furniture, and all the North Apartments, with every thing therein." The neighbors managed to save "most of the rich Furniture in the South Apartment by Four o'Clock, when the whole House was in a Blaze, and soon after the Roof fell in." The loss was estimated at £30,000, and included Beckford's Hogarth collection.

In fact, only the *Harlot's Progress* was destroyed, and paintings claiming to be survivors have turned up ever since.[45] Hogarth, however, evidently went to his grave convinced that all the *Harlot* and *Rake* paintings had been destroyed. His only comment, written in the 1760s, was on the organ which, he said, "was heard in the midst of the flames to play a great variety of pleasing airs" (AN, 227). This means that there can have been no personal connection between Hogarth and Beckford. In June 1755 Beckford had joined Fox's party, but he was not a subscriber to Hogarth's *Election;* he and Hogarth were both present at the Dilettanti–Virtuosi feast of 5 November 1757, but they must not have spoken to each other. Beckford's silence on a matter that would surely have seemed of great importance to Hogarth is strange. We remember John Lane's account of how every time Hogarth saw him he asked about the *Marriage A-la-mode* paintings.

The conclusion that Hogarth and Beckford were not on friendly terms seems unavoidable and calls for a political answer. Beckford, son of an immensely wealthy West Indian sugar planter, had bought Fonthill in 1745, within a year of his return to England with the intention of entering politics. He had immediately set about decorating the house with "many modern paintings," including Hogarth's *Harlot* and *Rake*. As recently as 1755 he had been a Fox supporter. But his politics, while based on Tory principles, were strongly imperialist since his chief interest was in Jamaican sugar. As Namier and Brooke point out, though he claimed to be a merchant on the strength of his Jamaica holdings, he "was the first politician whose interests lay largely outside the City to seek to break through" the

custom that only citizens intimately connected with City affairs could be elected to represent it in Parliament.[46] Hogarth would have opposed him on the issue of imperialism alone, before his close association with Pitt began.

THE INVASION

Early in 1756 the Seven Years' War with France had begun, and, with rumors of invasion everywhere, in March Hogarth took enough time off from his regular work to etch a pair of plates called *The Invasion* (figs. 44, 45), popular images accompanied by verses written by Garrick.[47] But here too the sign of the duke of Cumberland on the tavern in Plate 2 ("Roast & Boil'd Every Day") could designate to the duke's supporters a great hero, after whom many taverns had been named following Culloden, now wantonly attacked whenever his name arose; or to enemies of "the Butcher" a right and proper fate for good Englishmen (like the ones shown in the print) to wish upon the duke. The first interpretation would be confirmed in 1762–1763 by a reference to Cumberland in *The Times, Plate 2* (fig. 99).

Again, the portrayal of the French heading for England with their tools of torture and their papist religion is at once a clarion call to Englishmen to rise and prepare and a gloomy forecast, based on a bumbling war effort. As popular prints they were quite successful; no sales figures are available, but judging by the copies used for recruiting posters and the like, they produced images that passed into the contemporary vocabulary of patriotism.

The jingoist message carried with it an aesthetic dimension: the invasion of French arms and French assumptions about art—and religion—were for Hogarth all one. He must have regarded the French war as not so much a godsend in his own war with his fellow artists as a confirmation of his Francophobia and suspicions of the French model for an academy. Prominent in the baggage of the French monks are an architectural drawing, "Plan pour un Monastere dans Black Friars a Londre," and an icon of St. Anthony, together with a flag inscribed "Vengence." The *England* plate, showing an English grenadier painting a sign on the wall of an inn—the king of France

holding a gallows instead of a scepter—at the same time recalls the judge of *Analysis* Plate 1 and comments on the strength of an indigenous English art.

FROM FOX TO PITT

On 24 February 1755 Hogarth announced *An Election Entertainment* as ready for subscribers to pick up and opened the new subscription, with the same date, for the other three prints.[48] A new title page is provided in Hogarth's subscription ledger, dated the 24th, and William Pitt is one of the new subscribers. This subscription closed on 25 May 1756, but names continued to be added in the book until 1 March 1757. Altogether there were only 165 subscribers, and so, to judge by the list, there were 296 subscribers to the first print who did not continue to subscribe to the other three. It was by no means so successful as the first subscription: time was passing, the General Election was long past, and Hogarth himself was inordinately slow getting out the prints. Indeed, by the 1750s the whole matter of subscriptions had outlived its usefulness and seems to have fallen into disfavor. (Warburton's advertisement for Pope's collected works of 1751 announced: "The Editor hath not, for the sake of profit, suffered the Author's name to be made cheap by a *subscription*.") After this Hogarth only attempted one more subscription, for the engraving of *Sigismunda,* entered in the same volume as the *Election* subscription, and this had to be called off, ostensibly for lack of an engraver and Hogarth's ill health, but also perhaps for lack of support. Meanwhile, purchasers probably bought the *Election* prints as they were published, and in all likelihood at the subscription price.

While *An Election Entertainment* was delivered in 1755, it was not until January 1758 that the other three prints were published, by which time their original intention was deeply scored with the momentous political events that filled the intervening years. The General Election and its aftermath registered the impact of "politicking" on England in the 1750s—and on Hogarth himself: not only the functioning of a contested election but the jockeying for power that took place in 1754–1756. For the real point of departure, unforeseen

by Hogarth when he began to paint, was the death of Henry Pelham and the subsequent restructuring of the government and of the whole political scene—a process not resolved until the establishment of the Pitt–Newcastle ministry in 1757. Pelham's death turned the General Election into a metaphor, focused on the "great Electioneer" Newcastle, on the rivalry of Fox and Pitt, and on the political maneuvering for dominance, which Hogarth continued to explore for the remainder of his career. By the completion of the *Election* series he envisioned a conflict between election process and demagoguery that seemed only resolvable by a strong monarch who was above party.

Supervening between the publication of *An Election Entertainment* and the completion of the other three prints were the fall of Fox and the rise of Pitt. In November 1755 Pitt spoke out as a champion of a new opposition against the Fox–Newcastle ministry based on Leicester House and the "popular" issue of the foreign subsidies (that propped up the Hanoverian interests on the Continent) including the Russian treaty (on the final vote for which the opposition had one of its highest votes), which may have been reflected in Hogarth's dedication of Plate 2 of the series to Charles Hanbury Williams, who had negotiated the treaty. War had begun; at the end of June 1756 Minorca fell, and Plate 2 (as published at least) reflects the popular feeling about the loss of Minorca, Admiral Byng, and the ministry that seemed to scapegoat him. By the summer of 1756 the attacks were focusing on Newcastle and Fox, who appear on the signboard as Punch and Judy.

This large signboard which dominates the scene projects a simplified popular image of the action—the final, powerful simplification of which would be the scrawl of graffito on the wall of *The Invasion*, Plate 2 (fig. 45). It characterizes the Newcastle–Fox ministry (which ended in the summer of 1756; the print was dated 1757) as one whose major interest is election bribery of the sort illustrated in the scene unfolding around it. By implication, this money could have done more good applied to the armed forces engaged in fighting the French. The king's guards not only are deprived of treasury funds but are decapitated by the low gateway to the recently completed Horse Guards building (1753). The signboard depicts the effects of partisan politics, but also reiterates Hogarth's equation of art and politics by taking a final cut at his old enemy William Kent (now dead), who was the architect of this Palladian building.

But the signboard is conspicuously ambiguous. It carries a positive charge of popular, elemental, native representation; but it can also designate "caricature" with its (for Hogarth) negative connotations of Italianate dilettantes and the elitism of English gentlemen on the Grand Tour, and, more specifically, of the political caricatures that George Townshend began to publish at about this time (fig. 61). In this case, the signboard represents a "caricature" version of the reality of the political situation; or rather, Fox could have read it that way. This sign—an antiministerial campaign poster—has been hung over a King's Head sign (Charles II's head, as on the brothel in *A March to Finchley*), which presumably designates an Oxfordshire Tory stronghold, superseded by Whigs.[49] The signboard could *not* have shown the precise scene it does before spring 1755 when the Newcastle–Fox coalition took office, but it must have designated some similar image of bribery and speculation, which Hogarth then updated.

Fox subsequently resigned, followed by Newcastle, and the Pitt–Devonshire ministry was formed, and then the Pitt–Newcastle ministry which utilized Newcastle's electoral influence to keep the popular Pitt in power. Fox simply retreated and disappeared, accepting the lucrative but impotent paymaster generalship of the Armed Forces and not reemerging until called upon in 1762 to manage the peace treaty in Commons (Hogarth shows him as a fox emerging from his kennel in *The Times, Plate 1,* figs. 91–92).

The dominant figure from October 1756 was Pitt, and before long he was being referred to as William IV and (in Fox's hostile *Test* and other journals) as "Man Mountain," the Lilliputians' name for Gulliver—which may explain the revision of Hogarth's *Punishment Inflicted on Lemuel Gulliver* (ill., vol. 1) published without his knowledge in January 1757, showing Pitt–Gulliver being purged of Newcastle, Anson, Hardwicke, and Stone.[50]

The second plate was not finished until the beginning of 1757. It was dated 20 February 1757, but there was no notice of its delivery to subscribers until the beginning of 1758, when all four were announced as ready. The fact that the subscription had been for either one or all four prints also makes it unlikely that Hogarth would have delivered the second one alone. But the date of the publication line suggests that he may have given it to those subscribers who asked for it—and were perhaps showing some impatience with his delay.

He blamed the delay on problems of engraving. In the *London Evening Post* of 9–11 March 1756 he remarked that the last three prints would have been delivered by now "if the most able Engravers had not been pre-engaged with other Works." And at the beginning of 1757 he made a strange announcement (24–26 Feb.):

> Mr. Hogarth is oblig'd to inform the Subscribers to his Election Prints, That the three last cannot be publish'd till about Christmas next, which Delay is entirely owing to the Difficulties he has met with to procure able Hands to engrave the Plates; but that he may neither have any more Apologies to make on such an Account, nor trespass any further on the Indulgence of the Publick, by increasing a Collection already grown sufficiently large, he intends to employ the rest of his Time in Portrait Painting chiefly.—This Notice seems the more necessary, as several spurious and scandalous Prints [i.e., *Punishment Inflicted on Lemuel Gulliver*] have lately been publish'd in his Name.

This testy speech says, among other things: no more *Elections,* no more history paintings from Hogarth, only portraits—now that everything is in such a sorry state.

Hogarth, at this point in his career, expresses a tone of pessimism regarding politics, the age, and mankind in general that reflected the views of many contemporary journals and pamphlets; and in his case the pessimism, equating decline in art and society, remained, deepening, until his death.[51] The most fervent and influential of the jeremiads that followed the defeats of 1756 was Dr. John Brown's *Estimate of the Manners and Principles of the Times* (1757), published at a moment when many English men and women were appalled at such military disasters as the loss of Minorca, and it went through seven editions in a year. Brown was a personal acquaintance of Hogarth, perhaps a friend, who paid him one of the few compliments (if a somewhat backhanded one) extended to contemporaries in his melancholy treatise: "Neither the comic Pencil, nor the serious Pen of our ingenious Countryman, have been able to keep alive the Taste of Nature, or of Beauty. The fantastic and grotesque have banished *both.*" And he goes on to describe the sort of chinoiserie Hogarth satirized in *Marriage-A-la-mode* 2. A footnote identifies "our ingenious Countryman" as a reference to "Mr. *Hogarth's* Treatise on the Principles of Beauty."[52]

Brown's treatise, a tireless chronicling of England's degeneration

into effeminacy and national incapacity, was important for Hogarth because it linked aesthetic with general political and moral issues. In line with Hogarth's *Election,* it argues that everything depends on "the *Capacity, Valour,* and *Union,* of those who *lead* the *People.*" Its theme is that England is now governed by an unprincipled and morally degenerate ruling class. The "effeminacy" of its manners—"the luxurious and effeminate Manners in the higher Ranks, together with a general defect of *Principles*"—is due to the influence of France. Brown argues "That the ruling Habits of young Men," who waste their time on the Grand Tour and travels that Frenchify them, should rather be restrained to remain in England, where they would be "severely and unalterably formed" to the laws, customs, that is, "the *Genius,* of their own *Country.*"[53]

Brown harps upon the idea of disunity in the nation—the same political factionalism Hogarth alludes to in the *Election.* While not attacking Pitt himself, he attacks the City and its new mercantile power, which he recognized as the basis of Pitt's strength, as setting the tone of selfishness for the age. These merchants, he claims, are the source of the present degeneracy: the prevalence of vice, the perversion of the old English ideals and national pride, and the corruption of taste in the arts. Brown's only hope lies in the incorruptible Pitt, but his discourse is that of the Leicester House party, with whom Pitt was momentarily in league (when the break came, however, Brown followed Pitt).

The signs of the times are discernible in Hogarth's dedication of the third plate to the political nonentity Sir Edward Walpole, whose only apparent importance to him was as a patron and collector of his works.[54] The dedication either expresses Hogarth's weariness with politics by 1757–1758 or represents a gesture away from blind party alignments toward the different world of art, music, books, and gardening that Walpole loved. Plate 4 was dedicated to Dr. George Hay, ostensibly a strong Pitt supporter but also a personal friend of Hogarth's who was a complete cynic about politics; this cynicism led him in another two years to desert Pitt for Bute (see Chap. 11).

Though it had made sense in 1755, by 1757 the dedication of Plate 2 to Hanbury Williams was also bizarre: he had been sent as "Embassador" to Russia in April 1755 (probably through Fox's influence) and concluded a treaty against the Prussian Frederick the Great, signed in September and ratified by the Empress Elizabeth in Feb-

ruary 1756. But on 16 January a second treaty was concluded be-
tween England and Prussia, and by April the empress had virtually
disowned the treaty. In the context of the print, Hogarth's reference
to Hanbury Williams could be a further compliment to Fox (and to
Lady Hanbury Williams, who was a subscriber), a nod to an impor-
tant member of the Dilettanti Society (with whom the St. Martin's
Lane dissidents were negotiating), or a way of drawing attention to
an ambassador who successfully brought off a treaty with Russia
only to have it repudiated by his own government.

Finally, in the *London Evening Post* of 9–11 March 1758, Hogarth
gave notice that all four of the *Election* prints were ready to be deliv-
ered to subscribers.[55] The early heroes of the series had sold them-
selves or been defeated; its own momentum had flagged in public
pronouncements about the artist's retirement and other delays. The
prints themselves progress toward a distrust of politics as well as
public fervor and the mob, and their creator seems to lose faith in
the electoral process. But the finished four plates take their place as a
central historical document of the 1750s, symptomatic of that decade
as *A Harlot's Progress* had been of the 1730s.

They bring up to date the myth of decline from Old English values
promulgated by Bolingbroke's Opposition, dating back to the Wal-
pole days, now utilized by Leicester House. And they show Hogarth
beginning to replace the popular (in politics, in art) with the primi-
tive, his former confidence in the "people" with a nostalgia for the
ways of "Old England."

7.

THE POLITICS OF ART, 1754–1758

The General Election and its aftermath would have carried overtones for Hogarth of the caballing of the St. Martin's Lane artists, which were also reflected in the *Election*. Rouquet's *State of the Arts in England* (1755), in which Hogarth probably had a hand, deplored the lack of any kind of state preferment for artists in utilitarian, mercantile England:

> For no lucrative post is given away in England, but with either a direct or indirect view of gaining or preserving a plurality of votes at parliamentary elections. According to this ministerial economy, founded on such wise and prudent principles, let an artist have never so great abilities, yet if he has no right to vote at elections, or no protectors possessed of such a right, it is in vain for him to think of any place or preferment.[1]

Rouquet's book, as well as hints in the individual *Election* paintings, suggest that Hogarth saw a connection between politics and the state of art in England in the 1750s.

The subscription ticket, before (or while) being used as ticket for the *Election,* also served as a celebration of the Engraver's Act of 1735, with a long inscription in place of the receipt.[2] The *Election* subscription book carried the names, besides those of politicians, of Luke Sullivan, William Trumbull, Joshua Reynolds, George Lambert, George Knapton, and other artists. But politics in another form continued to demand Hogarth's attention at the same time that he was painting and engraving the *Election*. He and his party seem to have retained momentary control of the St. Martin's Lane Academy in the winter of 1753–1754. He had doubtless engineered the invi-

tation to Kirby to deliver three lectures in January 1754 from his *Brook Taylor's Perspective,* after which Kirby was "unanimously" applauded and elected a member. As the anti-Hogarth caricatures reveal, Kirby was known as Hogarth's man, and when *Brook Taylor's Perspective* appeared on 9 February the first book was dedicated "to Mr. HOGARTH" and the second book, as significantly, "To the Academy of Painting, Sculpture, Architecture, &c." Moreover, on the list of subscribers, members of the academy were marked with an asterisk. Hogarth's name appears, credited with six copies.[3]

Joseph Highmore responded that spring with *A Critical Examination of Those Two Paintings on the Ceiling of the Banqueting-House at Whitehall,* written to correct Kirby's mistaken notions of perspective: Kirby, Highmore shows, at certain points lets his eye guide him instead of the mathematical rules of perspective. It is easy to see which side Hogarth would take, and when Kirby submitted his reply, Hogarth responded with a long letter, which Kirby incorporated in his second edition of the same year.[4]

We can infer that Hogarth's group had voted to keep the academy as it was for the time being at least, and that the dissenting group divided in two: those such as Hayman and Newton who wished to work within the framework of the St. Martin's Lane Academy and those who had withdrawn from it. The latter included Highmore, Hoare, Wills, Hudson, Knapton, Luke Sullivan, Lambert, and Roubiliac. That the last two names are not asterisked gives some idea of the schism dividing the old friends who met at Slaughter's. The visit to Italy in 1752 of Hayman, Roubiliac, and Hudson (without Hogarth) may have been a significant act in the skirmishing around the academy.

The idea of a state academy had been temporarily put aside but was by no means dead. John Buckeridge's *Essay towards an English School,* attached to an edition of de Piles's *Art of Painting* (1755), had urged an academy, and in January or early February 1755 a fifteen-page pamphlet was published called *The Plan of an Academy for the Better Cultivation, Improvement and Encouragement of Painting, Sculpture, Architecture, and the Arts of Design in General,* which contained a polemical introduction followed by the abstract of a royal charter "as propos'd for establishing the same."[5] The ostensible plan put forward was to turn to the "Benevolence of the Public" and seek contributions. The connection with the crown would be nominal, the funds actually being donated by the public to this benevolent insti-

tution. The source of the idea may have been John Gwynn's *Essay on Design* of 1749, which had proposed "Erecting a Public Academy to be Supported by Voluntary Subscription till a Royal Foundation can be obtained"; but the conception obviously derived from the practice, long supported by Hogarth, of connecting art with a benevolent institution and a public subscription—perhaps as a joint-stock company along the lines of the one Captain Coram had organized to support his Foundling Hospital. He must have found it ironic that his own method was now being directed toward an end of which he strongly disapproved. This plan, as he saw it, was based on the sad misconception that the wealthy Englishman would be as benevolent toward art as toward the sick and needy or his own entertainment.

If this was the ostensible aim of the *Plan,* however, there was also a covert one. Included were the usual clauses concerning professors, presentation of admission pieces, medals awarded to students, and the chance for the student to travel to Rome. The introduction, written in the ponderous words and balanced sentences of the *Rambler* (and so sometimes attributed to Johnson), takes a very high-flown and un-Hogarthian approach to the question of why art should be supported—echoing few of the old ideas about connoisseurs and foreign art that Hogarth favored. In the course of this introduction, after stressing that his "Undertaking is of a public Nature," the author alludes to "one distinguish'd Set of Noblemen and Gentlemen, long ago convinced of the necessity of such a Plan," who had set aside a sum of money for a similar project. Taking no chance that the inference would be lost, Francis Newton, still the secretary of the enterprise, sent a copy of the *Plan* to this "Set of Noblemen and Gentlemen," the Society of Dilettanti. The pamphlet was delivered to the Dilettanti on 2 February 1755 by Colonel George Gray, a sympathetic member of the society, and read.[6]

The Society of Dilettanti was founded in 1734 by some gentlemen who had made the tour of Italy and were "desirous of encouraging at home a taste for those objects which had contributed to much to their entertainment abroad."[7] Composed of such men as Simon (afterward Earl) Harcourt, Sir Francis Dashwood, Richard Grenville (later Earl Temple), and Sir Charles Hanbury Williams—as well as a few of the learned like Joseph Spence, and an artist to paint their portraits, George Knapton—it was essentially a drinking club. The president wore a scarlet Roman toga, the secretary dressed as Machiavelli, the

"archmaster" wore "a long Crimson Taffeta Robe full pleated with a rich Hungarian cap and a long Spanish Toledo": these rich young men drank and made up elaborate bylaws, first deciding what the president must wear (designed for his discomfort as much as pomp), and then the secretary, and so on.[8]

It was this unlikely society, whose very name suggested the internationalism Hogarth and John Brown distrusted, that in 1748/49 had entertained the plan of Robert Dingley and other members for support of an academy and drawing school for English artists; Dingley's plan may have been one factor motivating the St. Martin's Lane artists to agitate late in 1753. In the spring of 1755, however, the whole matter was raised again by the pamphlet sent to the Dilettanti. Communications were exchanged and some hopes entertained by the artists until the end of the year. By then it was apparent that the Dilettanti wanted more in return for their support than the artists were prepared to give. From document to document the artists' signatures dwindled until negotiations collapsed.[9]

Hogarth recalled the Dilettanti as those young men who went abroad, read the lives of Renaissance painters, and tried to pass for the popes and dukes who were Renaissance art patrons: "no wonder they should dislike those who deprive them [of] so much honour by daring to make themselves without their assistance." He juxtaposes the "schemers" and "castle builders" among the artists with the Dilettanti who

> had all this in their heads when they proposed a Drawing school at their expense, for here they were to be Lords and masters, but when the schemers pretended to bear a part in the school and pretended to carve for themselves, the dilettanti kept their money, and they were rejected with scorn. And the whole castle came to the ground and has been no more heard of.[10]

While Hogarth may be said to have won, or at any rate to have been proven right, he had lost the pace-setting role he played in the 1730s and 1740s. He may even have withdrawn, or at least absented himself more frequently, from the St. Martin's Lane Academy in these years: he makes no mention of it, nor do accounts of its functions mention him. The pattern of withdrawal had been the same with Coram and the Foundling Hospital and would be repeated with William Shipley and the Society of Arts.

Certainly Hogarth was now outside the activist group of artists, and the figure who rose to replace him was not Hayman, the good-natured soul who filled the presiding officer's chair, or Ramsay, who remained aloof from the proceedings (in Italy between 1754 and 1757). Moser seems to have been a mover, but he was not one about whom the artists could rally. The man they turned to, who apparently became prominent as teacher and administrator in the academy after 1755, the one most symbolically the antagonist (though Hogarth never mentions his name), was Joshua Reynolds, in his early thirties and just returned from Italy.[11]

REYNOLDS

Reynolds was born in Devonshire in 1723, like Hogarth the son of a schoolmaster, who taught him privately. His inclination to paint "was confirmed by his reading Richardson's Treatise on that Art" and by Richardson's theory of portraiture as a rival of history painting, in which the sitter is elevated into a history subject.[12] He was a bookish man, and never deviated from the ideal of the gentleman artist laid down by Richardson. In 1740, at the age of seventeen, he traveled to London and was apprenticed to Hudson, but before three of the four years of his indenture were up he had returned to Devonshire to paint portraits on his own. By December 1744 he was back in London and, according to a letter written by his father, on good terms with Hudson, who introduced him into "a club composed of the most famous men in their profession"—which may have been the group that met at Slaughter's.[13] He is again located in London in the spring of 1745, around the time *Marriage A-la-mode* was published (he later quoted a remark Hogarth made to him). His early portraits show evidence of close contact with Hogarth's portraits of the early 1740s. He was in and out of London between 1745 and 1749, but in the latter year he set off for Italy.[14]

The three and a half years Reynolds spent in Italy gave him his aesthetic frame of reference. Others had made the trip before, but without his power of assimilation and acute sense of the times and the English aristocracy. One may smile at some of his confections, with such provocative titles as *Lady Sarah Bunbury Sacrificing to the Graces* or *Lady Blake as Juno Receiving the Girdle from Venus,* but he

produced the first successful English adaptation of the Renaissance style of heroic painting and portraiture, managing to transform these rather dumpy and (as the Italian sculptors complained) horse-faced English men and women into the graceful shapes of Raphaelesque gods and heroes. To Hogarth, his solution implied not only dependence upon a foreign, alien convention but also unwarranted elevation of solid Englishmen, with particular virtues of their own, into the dubious gods he had shown Rakewell modeling himself on in *A Rake's Progress*. A Ramsay portrait of around 1739 (private collection) shows Catherine Paggen (Mrs. Humphrey Morice) costumed and posing as Diana, but, like the young woman in *Strolling Actresses,* she is only adopting the pose of Diana and is still clearly Mrs. Morice. Reynolds would have made her pass for Diana herself.[15] In the growing structure of Hogarth's political thought in the 1750s, Reynolds must have seemed a powerful contributor to the dangerous megalomania already affecting their contemporaries.[16] But Reynolds saw portraiture through the eyes of Richardson and the Italian Renaissance, as a way of universalizing and glorifying, with the important assumption that he was glorifying not the commonplace but people who were inherently important—the classical republican elite celebrated by Shaftesbury. This involved, among other things, accepting an image of the Englishman as arbiter of the age, which, fortunately for Reynolds, was confirmed by the end of the decade with the empire building of Pitt's great ministry—an image Hogarth ridiculed in his *Election* prints and continued to oppose even after the major victories of 1759. Reynolds's success was based at first on flattery and prescience, but by the 1760s his vision of the English Hero had to many Englishmen been vindicated, and Hogarth's less-optimistic vision discredited as that of a disappointed, provincial crank.

Reynolds arrived back in London in October 1752, and after a short visit to Devonshire settled the following year in a flat at 104 St. Martin's Lane; later in 1753 he moved to Great Newport Street. Although we cannot discount the possibility of coincidence, it is noteworthy that in May 1752, the month he set out for London, the English Academy in Rome had been founded—he may well have contributed to its inception.[17] And no sooner had he arrived in St. Martin's Lane, infused with the spirit of Italy and the English academy, than agitation and revolt broke out in the nearby academy— the first recorded in its twenty years of existence. In short, he was probably involved in, if not an instigator of, the disturbance in the

fall of 1753, and certainly participated in the 1755 plan to join the Dilettanti (his name is on the list). His notebook for 1755 has the word "Academy" opposite 19 March, probably the date on which the painters drafted their reply to the Dilettanti, and it has been suggested that he may have written the introduction to the printed *Plan*. His connection and relationship with Hayman, a fellow native of Devonshire, is undocumented but suggestive: the committee of artists' approach to the Society of Arts in 1759 was clearly stage-managed by Reynolds, though chaired by Hayman, and the same may have been true of the earlier efforts.[18]

Reynolds was another of those short English artists Vertue mentions, 5 feet 6 inches (not much taller than Hogarth), with blunt features and a florid complexion, cheeks scarred by smallpox and upper lip disfigured by a fall from a horse while on his trip to Italy. Although to his sister (and housekeeper) Frances he was "a gloomy tyrant"[19] and to his assistants a hard taskmaster, to society he was charming: "Your equal and placid temper, your variety of conversation, your true politeness, by which you are so amiable in private society"—so Boswell described him in his dedication to the *Life of Johnson*. An "uncommon flow of spirits" and "suavity of disposition" (Frances Burney's words) were the qualities most often mentioned by his friends.[20] But something of the "inoffensiveness" Johnson remarked, though not "a tame insipidity that never differed from a neighbour," depended on a careful avoidance of dispute, the preservation of a polite exterior, like the ironic mask of his *Idler* essays, which veiled his very decided opinions and a powerful ambition. Hester Thrale (Piozzi), who liked Hogarth and distrusted Reynolds, found "his temper too frigid, his pencil too warm."[21]

Reynolds and Hogarth were just enough alike to make them, through their differences, utterly incompatible. It is impossible to imagine Hogarth relaxed and friendly with Reynolds as he was with Hayman and Ramsay. Both Reynolds and Hogarth were self-conscious, ambitious, ruthless, and self-centered; but Hogarth was a blustery, aboveboard sort, almost ludicrously honorable in his actions even when they were obviously self-interested, and quite able, if not willing, to make a fool of himself. It is significant that no one seems to have disliked him for this until he had to be discredited for other reasons, but then there was a plentiful store of ammunition: the former friends—John Wilkes is the best example—dredged up all the little follies that had been amusing and tolerated up to that time.

Reynolds, on the other hand, never played the fool; he worked behind the scenes, through other people; he was an individualist like Hogarth but preferred to express himself through committees and organizations rather than isolated acts of his own, open to misinterpretation. Class was also a consideration: partly by his manner, partly by his satires, Hogarth alienated the aristocracy, while Reynolds's charm and politeness drew members of all classes together around his table.

Reynolds's success as a portraitist was phenomenal. His prices soon matched those of his master Hudson—12 guineas a head, 24 for a half-length, and 48 for a full-length. Already in 1753–1754 he was painting aristocratic sitters, the duke of Beaufort, Lord Cathcart, Lord Cremorne, Lady Anne Dawson, the duke of Devonshire, Earl Harcourt, the earl of Huntingdon, Lady Charlotte Fitzwilliam, Sir William Lowther, and the countess of Kildare. "It is scarcely an exaggeration to say, of this young man of thirty, that he became a fashionable painter overnight"[22]—certainly more than Hogarth had ever been, even in the days of his conversation pictures. In 1755, the year of his first surviving "pocket-book," he had 120 sitters; 150 in 1758 was the largest number in a single year.

Here then was a man who met the fashionable world on equal terms, spoke the language of civic humanism, and favored artists' incorporation with rather than isolation from each other: not as a solution to their economic problems but as an aspiration toward the Continental ideal of an academy and an international tradition of painting. Emerging as the most prestigious artist of his time, he attracted the support of those who believed that the artists' economic future and prestige lay not below (as Hogarth had shown) but above. The academy, to them, seemed a potential bridge between the artistic and an aristocratic market.

ROUQUET'S STATE OF THE ARTS IN ENGLAND

Hogarth, meanwhile, had been momentarily proven right and, perhaps feeling ill at ease with his old friends, refrained from publishing a treatise on the academy as he had threatened. It seems quite probable that at this time his views on the academy, as well as on art in

general, were incorporated in the magnum opus of his friend and disciple André Rouquet, *L'État des arts en Angleterre* (*The State of the Arts in England*).

Rouquet wrote Hogarth on 22 March 1753 from Paris to say that he eagerly awaited the publication of *The Analysis of Beauty* and wanted to have his copy before anyone else in France. But he also complained of the French climate and his continual headaches; if they abated, he said, he would return sooner to England.[23] He was back in London, living near Hogarth on the west side of Leicester Fields, by the summer or early autumn of the same year. Listed in the rate book as Andrew Rouquet, he replaced Francis Ruckett (an anglicization of his name, and a relative), and the ink colors suggest that he occupied the house after the first assessment of 29 June.[24] During the next two years he wrote, or at least completed the *State of the Arts,* his account of English culture, which was published in French at the end of 1754 (though dated 1755 on the title page); his own English translation appeared in October 1755.[25] In the same year, perhaps already in desperate condition, he returned to Paris and—exactly when is not clear—became insane and was removed to Charenton, where he died in 1758 or 1759.

In his letter to Hogarth he finds himself "disappointed by the tediousness of the progress of what I have begun," and this may refer to the book. One reason for returning to London may have been to be nearer the fountainhead, which in this case, it is clear from the results, was Hogarth. They must have worked in as close collaboration as they did on *Lettres de Monsieur.*** and the *Tableau.* It is, of course, difficult to draw a line between the two contributors. Rouquet was witty in his own right, as is shown by his *L'Art nouveau de la peinture en fromage, ou en ramequin, inventée pour suivre le louable projet de trouver graduellement des façons de peindre inférieures à celles qui existent* (1755). This twenty-page pamphlet, written about the same time as *L'État des arts* (though not translated), was a satiric response to the anonymous *L'Histoire et le secret de la peinture en cire.*

The driving force in *The State of the Arts in England* is the assumption—already influencing Hogarth in the *Election* series—that as a commercial people, the English have no interest in art aside from portraiture, with the exception of some fashionable paintings from the Continent purchased as tokens of social status. Rouquet says he is going to correct French misconceptions of the English, alluding in

particular to those of the Abbé Le Blanc, but what he does is simply shift from Le Blanc's emphasis on bad art to the bad conditions for creating art, pointing out how remarkable has been the art produced considering the obstacles.

It is characteristic of the book that while Rouquet covers almost all aspects of English creative endeavor, including cooking, the only ones that are treated in detail, and reflect great knowledge of the issues, are those that interested Hogarth: history painting and portrait painting, and of course the artist's economic situation. All of Hogarth's themes and crotchets, his victories and defeats, are the centers of interest. Except for a favorable opinion of the French Academy, of which Rouquet was a member, the views are Hogarth's, and whenever Rouquet turns to subjects in which Hogarth was obviously not interested, he becomes very general and perfunctory. The writing style, on the other hand, is light and bantering, totally unlike Hogarth's. But both enjoy irony: "such wise and prudent principles," referring to crassly mercantile ones, could be Hogarth's words. Surely too the reference to the only pensioned painter in England, the Principal Painter to his Majesty, displays Hogarthian irony. "This post is now enjoyed by Mr. Shackleton, who does greater honour to it than some of his predecessors"—which is not saying much, since these predecessors were dismal artists indeed.[26] On Ramsay there is a most backhanded compliment:

> Ramsay was an able painter, who acknowledging no other guide than nature, brought a rational taste of resemblance with him from Italy; he shewed even in his portraits that just steady spirit, which he so agreeably displays in his conversation. His works would have had still a greater superiority, if painting was in a certain degree susceptible of the influence of a most sound judgment joined to a very extensive knowledge.

—a graceful way of saying that he has all the makings of a great painter except talent. The stories about Kneller, too, are just malicious enough, and contain enough reference to technical procedures, to his arguing "against nature," and to his using drapery painters, to sound like Hogarth remembering stories told him by Thornhill (who had no reason to like Kneller). The emphasis on the evils of imitation—"the passion of copying Sir Godfrey, even to his greatest

defects"—recalls Hogarth's strictures on copying Old Masters, on country girls copying city ladies, and on bourgeois lads copying aristocrats. Vanloo's stay in London is particularly scored for having "produced a general emulation" in other artists (4, 37).

Many Hogarth ideas are here: that history painting cannot flourish in England because of its religion; that dealers help to keep the market Continental; that portrait painters are the only ones who can earn a living in England, and that they are essentially manufacturers. Even Hogarth's hints toward an aesthetics of cooking (one of the rejected passages of the *Analysis*) appears in a chapter on cooking.[27] And of course his "new kind of pictures" ("un nouveau genre de tableaux") is noted, and appears under history painting, just where Hogarth would have put it (it should be added that Le Blanc put it there too): "a new kind of pictures, which contain a great number of figures, and are generally seven or eight inches high. These extraordinary pieces are properly the history of some vices ["l'histoire de quelques vices"], frequently a little too much charged for foreigners, but always full of wit and novelty" (27). There is a great deal said about the *Analysis,* all favorable. Finally, like Hogarth, Rouquet writes a book on art that is also about manners and morals—areas that invariably overlap.

There is, of course, no external evidence as to which ideas came from Hogarth and which from Rouquet. All one can say is that some (concerning dealers and English principles of collecting) first appeared in Hogarth's "Britophil" essay, while others (smoking pictures, for example) appeared in the *Analysis;* and that the ideas in *The State of the Arts* are repeated in Hogarth's manuscript notes. Thus, while it is possible that Hogarth took some of his ideas from Rouquet, he was not the sort to waste his time writing down someone else's arguments; he, not Rouquet, had reason to express these particular thoughts on the St. Martin's Lane Academy, the proposed state academy, the Foundling Hospital. Everything suggests that he furnished the ideas if not sometimes the words, probably in some detail, as with Kirby's reply to Highmore; and Rouquet served as elegant polisher, arranger, and stylist. It also seems probable that one reason Hogarth did not write his treatise on the academy was that Rouquet offered him a more expansive survey in which he could transmit his views without the stigma of further publication.

Though in many ways a brilliant performance, Rouquet's little

book was not well received by the *Monthly Review,* which partly missed its point and partly reacted to its strictures on the English (as opposed to English artists).[28]

THE SOCIETY OF ARTS

In October 1755, then, Hogarth saw *The State of the Arts in England* published and disseminated. When it says that the attempt to found a state academy had collapsed, it is referring to the earlier attempts in 1753; Thomas Bardwell's *The Practice of Painting and Perspective Made Easy,* though published in 1756, remarks:

> I am informed there is a Scheme on Foot to establish an Academy for Painting and Sculpture: I wish it may succeed, as it must probably in time improve those Arts to the highest perfection, and will of course do Honour to the Nation, and to the Nobility, who will, from frequenting it for their Amusement, learn the Principles of those Arts, and so become real Judges.[29]

Hogarth seems to have recognized the necessity of producing some kind of an alternative to the proposed state academy. In December 1755, just as negotiations with the Dilettanti were collapsing, he became a member of the Society of Arts, another project for benefiting English art which must have appeared to him at first as more promising than the proposals for an academy because it offered a substitute for noble patronage.

The Society of Arts was the conception of William Shipley, a drawing master who came to London from Northampton in the 1740s to study art.[30] Back in Northampton, he practiced painting until about 1753, when he returned to London and founded a drawing school for the young. Unlike the St. Martin's Lane Academy, with which it coexisted, Shipley's had no life school and admitted no adults. In his desire to found such a school, Shipley was probably influenced by Gwynn's *Essay on Design,* which had urged the value of drawing for the youth of all classes. The fees were a half guinea for entrance and a guinea a month for two days a week studying (paper and pencils supplied as extras); the school contained "Men's Heads, and Plaster

Figures, Birds on Trees, Landscapes, all sorts of Beasts, Flowers, foliages and Ornaments." The training was directed toward industrial design and the decorative arts.[31]

Although the drawing school was to some extent the nucleus of the Society of Arts, Shipley remembered that he got the idea of using prizes to stimulate English industry from the Northampton horse fair. Its success, he observed, owed much to the horse races promoted by the king and others who offered prizes. After much laborious projecting, on 22 March 1754 the Society of Arts was founded at Rawthmell's Coffee House in Henrietta Street, Covent Garden, a favorite resort of Dr. Mead and other physicians, and Fellows of the Royal Society as well as authors. The founders, besides Shipley, included Viscount Folkestone, Lord Romney, the Reverend Dr. Stephen Hales— "Noblemen, Clergy, Gentlemen, & Merchants," as the minute book phrased it.[32] The first premiums were offered for the discovery of cobalt and madder in England (for use in dyes) and, reflecting Shipley's own interest, for young artists of promise.[33] Not much came of the search for cobalt and madder, but thirty-six boys and girls submitted drawings, and the society used "the most Eminent Masters of Drawing . . . to assist in determining yᵉ Merit of the Drawings"—Henry Cheere, Robert Strange, Richard Dalton, and Israel Bonneau. The decisions were announced at a meeting at Peel's Coffee House in Fleet Street on 15 January 1755.

The original purpose of the art premiums, according to Shipley, was not to train young people to become artists but to train them in the industrial arts—because "the Art of Drawing is absolutely necessary in many employments, trades and manufactures."[34] In this first list of premiums, prizes were offered to boys and girls under seventeen for "the most ingenious and best fancied designs, composed of Flowers, Fruit, Foliage, and Birds, proper for Weavers, Embroiderers, or Callico Printers." The competition itself was carried out by having the thirty-six candidates produce certificates of their age, and then on a specified day assemble and make their drawings in Shipley's school, where there would be no possibility of outside assistance. Shipley was paid 6 guineas for supervising the candidates while they made their drawings and for heating the room. Perhaps not surprisingly, all five premiums were won by students of Shipley's school.

Membership expanded rapidly with the subscription fixed at "not

less than" 2 guineas, but those who could afford it paid 3 and peers 5 guineas (life membership was 20 guineas). The society's income rose from £360 in 1755 to £632 in 1756 and £1203 in 1757.

It seems probable that Hogarth knew Shipley, but he was nominated by his friend, the sculptor Henry Cheere; and, unlikely as it might at first appear, he accepted. Perhaps he saw some hope here for the encouragement of art, if some power were in the hands of a knowledgeable artist like himself; he certainly saw the potential of premiums as an encouragement to English artists, and in the next few years the competitions were extended to include older age groups and the skills of engraving, mezzotint, and etching. Perhaps by this time membership in the Society of Arts had become a sign of status. One might note that Shipley had strong support from the Reverend Dr. Hales, the Clerk of the Closet to the Princess Dowager of Wales, and Hales brought with him other friends of Leicester House. Hogarth's explanation of the society's drawing power might apply to himself as well: "A Society for the encouragement of art manufactures and commerce," he writes, "was too sounding a title not to invite after once set on foot a great number of subscribers especially when a great man or two put themselves at the head." Here "people of leisure tired with public amusements found themselves in good company and amused with the formal speeches of such who still had more pleasure in showing their talents for oratory." A little later he remarks, "happy was he who had courage enough to speak tho ever so little to the purpose"; and he mentions that while the success or failure of the society was "no business of mine," he did have his "opinion asked whilst I had the Honour to be one of the society in what belonged to my own profession," and thus delivered a speech himself.[35]

Hogarth always wanted to be where the action was (or, in particular, near Leicester House): this is the simplest way to explain his election on 31 December 1755 to the Society of Arts, and the subscription of his 2 guineas. At the same meeting he was appointed to the year's committee of judges for drawings by boys and girls; the other members were Cheere, Hodgson, Dalton, Hayman, Strange, and Pond. (At this time only Cheere, Dalton, and Hogarth were members.)

Hogarth took his membership seriously, attending the next several meetings—they were held every Wednesday night at six in Shipley's

school in Craig's Court, Charing Cross, which the drawing master sublet to the society. At the meeting on 21 January, when prizes were announced, Hogarth was put on two committees, one for examining, auditing, and subscribing the accounts of the society, and the other to look into "several new Rules for the good Government and Regulation of the Society." There was no indication of the nature of the new rules. At the next meeting, on 28 January, Hogarth, having observed the functioning of the society for a month and in particular the procedure for awarding drawing prizes, made a formal address. He and Cheere and sixteen others were present. First Whitworth reported from the first committee that several subscribers had not paid their subscriptions ("Ordd That the Secretary do wait on them to recover the same") and that the committee wished more time for the other articles, and was scheduled to meet again that evening. "A Paper was read giving some Hints for the Improvement of the Paper Manufacture, in regard to the printing Fine Prints." This paper was referred to a committee consisting of Hogarth, Dalton, Goodchild, and Baker, also to meet that evening. "Order'd, That the above Paper be delivered to Mr Hogarth for his private perusal." (One can imagine Hogarth requesting it.) This was an important subject, and Hogarth's concern with it was perhaps one reason for his joining the society. English printers were largely dependent on the Continent for paper to use in books, let alone fine prints. Nor did the society solve the problem in Hogarth's lifetime.[36] After this business,

> Mr Hogarth presented a paper which he had drawn up containing some Hints relating to the Premiums for Drawings for the future.
> Resolved, That this Society will on Wednesday next at 7 o'clock in the Evening, Resolve itself into a Committee of the whole Society, to take the said paper into Consideration.

The society apparently considered Hogarth's recommendation important. Knowing Hogarth, and looking ahead to the later campaign by other artists to reform the premium giving, one may infer that he proposed that the premiums be awarded to more mature artists and that the drawings be made not under Shipley's eyes in his studio and from his casts but anywhere the candidates desired—for example, from life at the St. Martin's Lane Academy. Shipley's biographer observes that he must have found it difficult to reconcile "his position

as the promoter of a disinterested public society for the encourage-
ment of the arts with his proprietorship of a private drawing school
whose pupils were often successful in obtaining the monetary prizes
voted out of the funds subscribed by the society. The case against
him in its blackest form would have suggested that his object in
founding the Society of Arts was simply to advance his fortunes as
an art teacher."[37] Hogarth would certainly have noted, and perhaps
remarked on, the irony implicit in the relationship between Shipley's
school and the premium giving.

No more is heard of Hogarth's paper or the society's judging the
committee, and his proposals were apparently tabled or rejected. It
is unlikely that the "paper" was the speech Hogarth later recalled and
outlined in his "Apology for Painters" manuscript: that root-and-
branch statement must have followed upon the rejection of his pro-
posals. It was probably one of several speeches, increasingly critical
and increasingly ignored. A reminiscence, published many years later,
notes that Hogarth

> said one evening, in one of his speeches at the meeting of the Society
> of Arts, that Genius was Diligence and Attention. Gilbert Cooper
> took him up hastily, and said that he was surprised to hear him say so,
> a person so copiously gifted by nature, and possessing such peculiar
> talents. 'Thank you for your Compliment, Sir,' replied the Painter,
> 'but I am still of my first Opinion.'[38]

This opinion becomes clear in his notes from the major speech,
which often refer to the difficulty of artists surviving in a trading
nation; the refrain is the lament "how often have they [i.e., those
encouraged to draw by the Society of Arts] wished they had been
brought up cobblers."

He seems to have been genuinely appalled by the merchants who
dominated the society and their callous references to the poor: he
cites the "cruel speech" of one member arguing that it was useful to
have a great number of poor because they represented cheap labor in
the coal mines. He felt the premiums would delude children about
the rewards of art; the premiums for "improvement in kettles etc."
made more sense than those for drawing. Those in need of encour-
agement are the professional artists, who have all too few illusions
about their futures. He tells of the artists he knew who died in pov-
erty, and reiterates the danger of the competitions and premiums.

To what end are premiums given to entice such numbers of children into employing their minds in so useless a study. Surely did their parents enquire into those facts they would put their ingenious youth upon what would be more safely attained and beneficial to themselves and the public.

He adds, "there is something so bewitching in these arts there will always be too many Poets and Painters."[39] Hogarth continued to see the young artist in this context as yet another analogue of his Distressed Poet, the man who should be supporting his family but, deluded by the supposed glamor of his profession, wastes away romantically in a garret. Hogarth here was not really supporting the status quo, though some unsympathetic contemporaries thought so, but rather exhibiting compassion for the many incompetent artists he saw starving, as earlier for the young women he saw becoming prostitutes.

His preoccupation with the unsuccessful artist carried over into his private life. Around 1758 Mrs. Anguish, a Norfolk friend, no doubt connected with the Anguishes Hogarth portrayed in *The Betts Family,* brought to London a roll of drawings by young Thomas Kerrich, son of a clergyman of Norfolk. She took the drawings to Hogarth and wrote back to Dr. and Mrs. Kerrich:

Mrs. Anguish presents her Comp[s] to The Doct[r] & Mrs. Kerrich & returns them Master Kerrich's drawings, which M[r] Hogarth saw & thought them a very pretty Performance, but that in his opinion it was an Art too little to be depended upon for a Youth to be brought up to, Especially Considering the Numbers that are now aiming to Excell in it, since the Establishment of the Society of Arts and Sciences, & that if he had A Son believes he should not bring him up in that Way, As he knows several Eminent Landscape Painters &c. who get but a very small income.[40]

One wonders if Hogarth were not by this time beginning to see himself in the lonely and unknown artist; partly as a reaction to the insinuations that he wanted to keep all the fame to himself and so objected to an academy that might bring recognition to other artists, partly through his increasing isolation from more progressive artists, and partly because a decreased output (perhaps a sign of poor health) meant he had more time for contemplation.

One of the more intriguing aspects of Hogarth's association with the Society of Arts is his leave-taking: his name is violently struck out in the subscription book—the gesture can only have been his own. One reason for his not exhibiting with the other artists in 1760 may have been that they were using the Society of Arts' great room; he did exhibit the next year when part of the fun, so to speak, was breaking away and running competition with the society's exhibit.[41]

The early meetings of the society give an impression of much activity by Baker, Whitworth, Manningham—much concern over cobalt, saltpeter, silkworms, dyes, and so on. When Hogarth makes his appearance on the scene there is a flurry of interest in the arts, papers are read, motions made, all the old sounds one recalls from the Engravers' Act days. Then complete silence, except for the paper premium, which drags along, occasionally entailing the rejection of a proposal. And with this silence Hogarth stops attending meetings. Many, many members simply do not attend meetings at all, and the larger part of Hogarth's absences can be explained by the summer, when membership shriveled. Nevertheless, one has the distinct impression—perhaps in light of his refusal to resubscribe for 1757 and the crossed-out name—that he saw the society as a hope, attempted to reform it, then withdrew in despair; one can imagine him chafing at the dull concern with cobalt, saltpeter, and the rest. He undoubtedly opposed Shipley's intention of making art subservient to industry, and he felt strongly about multiplying the number of young artists suffering lives of misery and want. But all this comes from his later notes: committee minutes were not kept at the time, and one is left with his silence and virtual withdrawal, and the angry striking out of his name.

It appears that at least some of his reforms were carried out not long after his departure by other artists. Reynolds had been elected a member of the society on the proposal of James (Athenian) Stuart, 1 September 1756, and Ramsay, proposed by Earl Stanhope, on 14 December 1757. The 1757–1758 committee on drawings, perhaps with Ramsay's powerful Leicester House support, demanded reforms, which were at length accepted and went into effect the following year. The age limit was extended to twenty-four and the range of places where drawings could be executed was extended to include the St. Martin's Lane Academy, the duke of Richmond's gallery, and even the competitor's own chambers if he could produce a

witness to swear that he had received no assistance. In short, the rules were considerably relaxed, and at the same time categories were multiplied to include drawings after a human figure and landscapes after nature. With this reform Shipley's direct connection with the premium competition came to an end. But by then Hogarth had moved on to other concerns.[42] He had proved to his own satisfaction that one other alternative to the old St. Martin's Lane Academy was not viable.

8.

LAST HISTORY PAINTINGS, 1755–1759

THE RESURRECTION ALTARPIECE

The chief reason for the delay in delivering the *Election* prints was probably that in May 1755 Hogarth received his largest commission for a sublime history painting—and the only one from the Church of England. The vestry of St. Mary Redcliffe, Bristol, met on 28 May to discuss the replacing of their old altarpiece, painted by a member of the London Painter-Stainers' Company named John Holmes back in 1710 when the church had last been remodeled. It was resolved

> that the Altar Piece of the Parish Church of Sᵗ Mary Redcliff be new painted and that Application be made to Mʳ Hogarth to know whether he will undertake to paint the same and to desire him to come from London to survey and make an Estimate thereof. And it was also ordered that the present Churchwarden Mʳ Nathaniel Webb shall pay in the Expences of his Journey provided He shall not think proper to undertake the said Painting.[1]

Hogarth's name may simply have been the logical one, made known to the provinces through his publicly displayed histories and the widely disseminated engravings of these works. This circulation had been part of his original plan when he engraved them; he no doubt remembered that the success of the Burlingtonians in architecture had been due largely to the availability of their plans to provincial architects. His engravings might have generated either imitations by local artists or commissions for the painter himself. One should also bear in mind, however, that the Reverend Thomas Broughton,

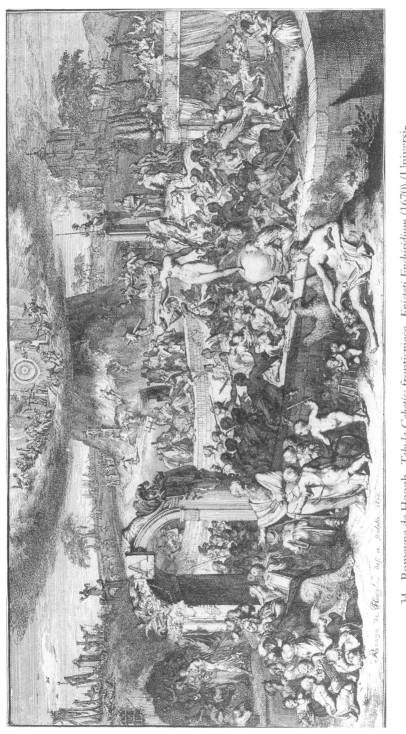

34. Romeyne de Hoogh, *Tabula Cebetis*; frontispiece, *Epicteti Enchiridium* (1670) (Universiteitsbibliotheek, Rijksuniversiteit, Utrecht).

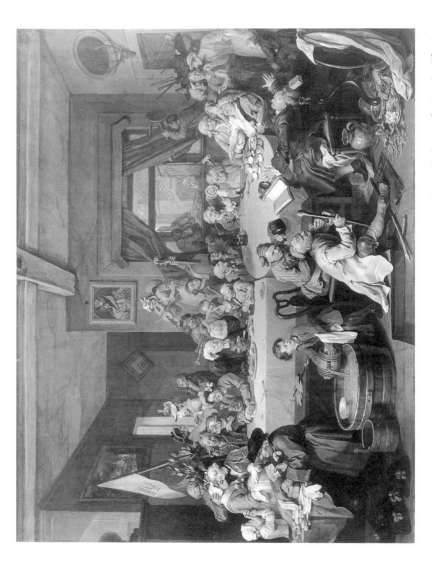

35. *An Election: Four Pictures*; paintings; 1753–1754; approx. 40 × 50 in. each. 1: *An Election Entertainment* (courtesy of Sir John Soane's Museum, London).

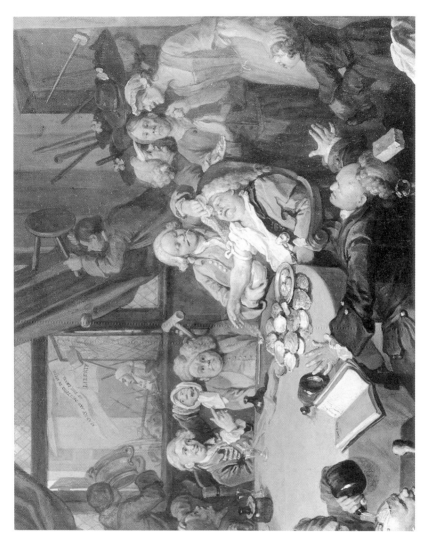

36. Detail of fig. 35.

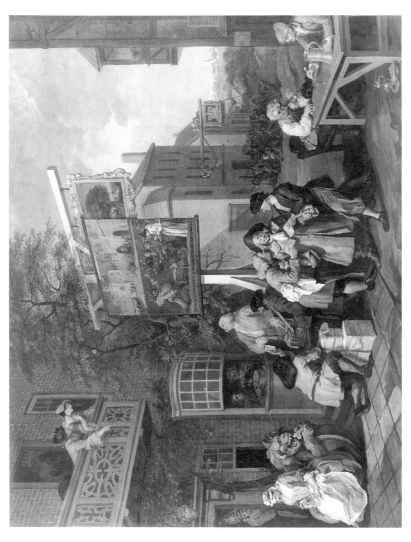

37. *An Election 2: Canvassing for Votes* (courtesy of Sir John Soane's Museum, London).

38. Detail of fig. 37 (engraving); pub. Feb. 1757 (courtesy of the British Museum, London).

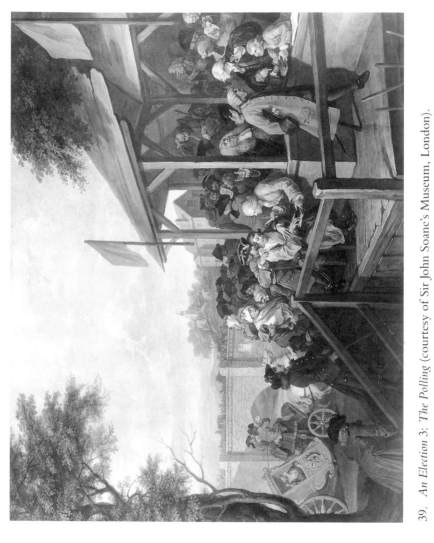

39. *An Election 3: The Polling* (courtesy of Sir John Soane's Museum, London).

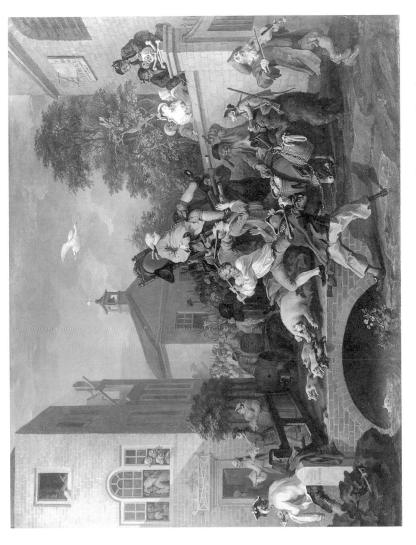

40. *An Election 4: Chairing the Member* (courtesy of Sir John Soane's Museum, London).

41. *A Harlot's Progress*, Pl. 2; 1732; detail.

42. *Crowns, Mitres, Maces, etc.* (first state); Mar. 1754; 8¹/₁₆ × 7³/₁₆ in. (courtesy of the British Museum, London).

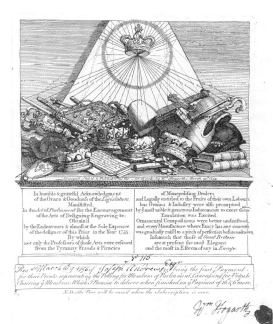

43. *Crowns, Mitres, Maces, etc.* (fourth state); 1755 (courtesy of the British Museum, London).

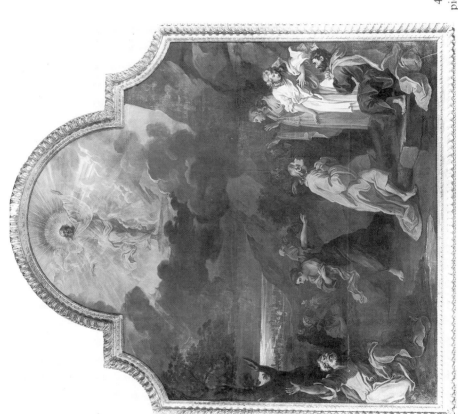

47. St. Mary Redcliffe Altar-
piece: (2) *The Ascension.*

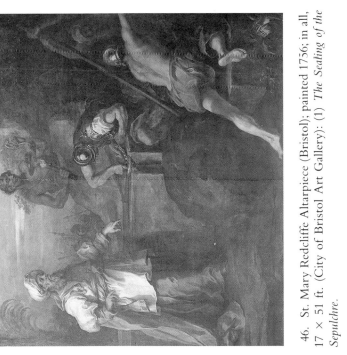

48. St. Mary Redcliffe Altarpiece: (3) *The Three Marys Visiting the Sepulchre.*

46. St. Mary Redcliffe Altarpiece (Bristol); painted 1756; in all, 17 × 51 ft. (City of Bristol Art Gallery): (1) *The Sealing of the Sepulchre.*

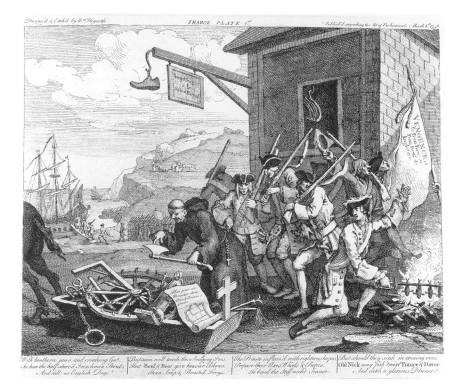

44. *The Invasion, Pl. 1: France;* Mar. 1756; 11½ × 17⅞ in. (courtesy of the British Museum, London).

45. *The Invasion, Pl. 2: England;* Mar. 1756; 11⅝ × 14¾ in. (courtesy of the British Museum, London).

49. Sir James Johnson, *The Nave of St. Mary Redcliffe;* drawing; nineteenth century (City of Bristol Art Gallery).

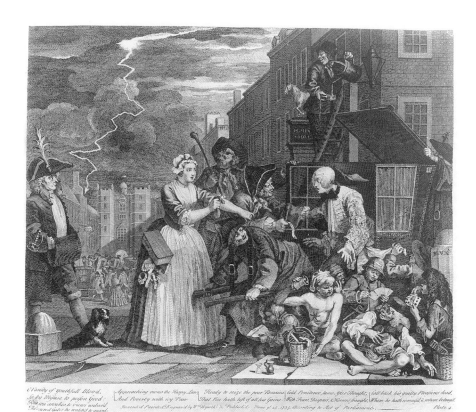

50. *A Rake's Progress*, Plate 4; engraving (third state); late 1740s; 12⅝ × 15¼ in. (courtesy of the British Museum, London).

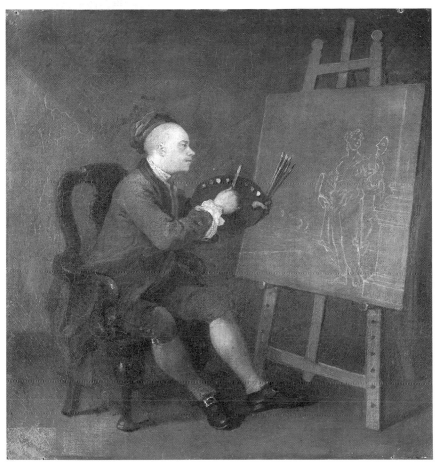

51. *Hogarth Painting the Comic Muse;* painting; 1757–1758; 15½ × 14¾ in. (National Portrait Gallery, London).

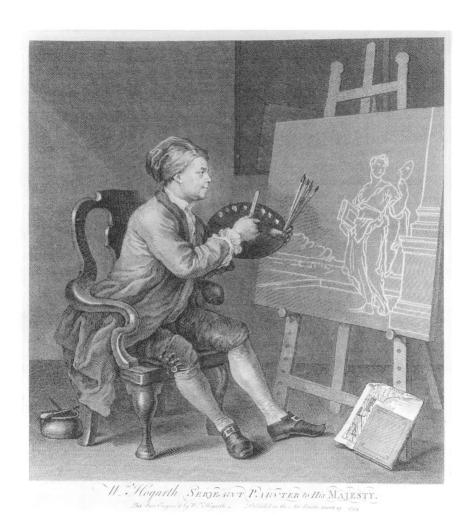

52. *Hogarth Painting the Comic Muse;* engraving (fourth state); pub. Mar. 1758; 14⅝ × 13⅝ in. (courtesy of the Print Collection, Lewis Walpole Library, Yale University).

the vicar of St. Mary's, was a nephew of John Wootton,[2] and that Walter Chapman of Bath, with whom Hogarth supposedly stayed while working on the altarpiece, was a prebendary of Bristol Cathedral and had a house and many connections in Bristol. His wife Susanna, whom Hogarth is said to have painted, was the daughter of Robert Dingley, the merchant and art fancier of London who had made the first proposal of a drawing school to the Dilettanti Society.[3] With Hogarth's commissions, as with those of any artist, it is well to enumerate both the personal and public connections that may have contributed to the choice of his name rather than that of a Hayman or Highmore, let alone a local painter.

With the offer before him, Hogarth presumably traveled to Bristol that summer, and saw Holmes's painting hanging on a curtain over the high altar, which in the remodeling of 1709–1710 had been moved back one bay east into the ambulatory and smack against the Lady Chapel screen. (Access to the Lady Chapel was only through a narrow corridor constructed from the end of the south choir aisle straight into the first bay of the chapel, passing through the two outside walls.) The alterations were intended to modernize the church according to the prevailing taste: the open area above the screen and below the gothic-arched stained glass window had been bricked in, and the window itself covered by the curtain. Not only the screen but the walls on either side were draped with curtains edged with gilt fringe and tassels, and this enormous area was to be filled by Hogarth. A Gothic structure had been clumsily restructured into a space suitable for a baroque design: precisely what Hogarth attempted to produce.

A fee of £525 was agreed upon, and he returned to London, where he apparently planned and painted the panels. Given their immense size, he may have used the backstage area of the Covent Garden Theatre, where the Society of Beefsteaks met (or perhaps Garrick's Drury Lane Theatre). A receipt among the churchwardens' vouchers is to a waggoner "for the carriage of a case containing the Altar-piece for St. Mary Redcliffe."[4] A writer for the *Critical Review* of June 1756 describing the pictures must have seen them in London.[5] By 8 July Hogarth was in Bristol supervising the installation of the altarpiece, and on 14 August he accepted his payment for the finished work.[6]

There is an old story that he was assisted by a local sign painter

and occasional church decorator, John Simmons. As Michael Liversidge has noted, if Hogarth painted the altarpiece in London, any assistance must have been from Londoners.[7] Although Simmons was only paid for "Painting, gilding, gold sizing and varnishing three new frames," the point of the story may be its poetic rather than factual truth, which depends upon Simmons's profession of sign painter. On his initial visit to Bristol to consider the commission, passing through Redcliffe Street, Hogarth is supposed to have been impressed by the sign of the Angel Inn; learning that the artist was Simmons, a local artist, he said, "then they need not have sent for me."[8]

The altarpiece (figs. 46–48) consisted of three panels, the whole being 17 feet high and 51 across. The form of the triptych of course offered Hogarth, famous as the author of progresses, a way of dealing with a religious subject as a sequence; one wonders if the authorities at St. Mary's may have had this in mind when they commissioned him. Raphael's *Transfiguration* seems to have influenced Hogarth's *Ascension,* with its mysteriously active humans along the bottom and an ascending Christ so high up (inside the arch at the top) that he seems to have nothing to do with these earthlings (fig. 47).[9] The style, however, is eclectic and allusive: the pompous high priest in the left wing recalls Sebastiano Ricci and the Venetian school, while the three Marys in the right wing recall the more sober Bolognese Seicento.

This was the fourth New Testament history painted by Hogarth, the second that represented one of Christ's miracles. It is therefore necessary to ask whether he was once again recalling Thomas Woolston's *Discourses on the Miracles of Our Saviour,* in which the climactic miracle was the Resurrection (*Sixth Discourse,* 1729).[10] Woolston, dealing with such a delicate subject, couched his skeptical reduction in a letter supposedly written by a rabbi. (The Jews, embodied in their priests and rabbis, represented the evils of clericalism, textualism, and rigid judgment; this rabbi insists that Jesus deserved everything he got and more [5].) Woolston's emphasis (10–11) is on the story in Matthew 27 of the precautions taken by the Jews against a sham resurrection: thus the high priest and the Jewish magistrates, not Pontius Pilate, personally seal the tomb.[11] For Hogarth as well the crucial action is the sealing of the tomb (figs. 46, 48): in the left panel he shows the sealing, with the high priest supervising, the

magistrates and other Jewish officials in the background. In the right panel he shows the broken seal, the "rolled back" slab, and the empty tomb—which Woolston's rabbi regards as "a manifest and indisputable Mark and Indication of Fraud" (15), that is, if there had been a "miracle" the seal would not have been broken. The effect in Hogarth's side panels is of before and after, harking back to his earliest serial effects.

Emphasizing as he does the sealing of the tomb, Hogarth also follows Woolston's allegorization of the "true history," which interprets the priests and the crucifiers of Jesus as those who prefer the letter of the Scriptures to the spirit. Citing St. Jerome, Woolston specifically connects the rending of the veil of the Temple (Matt. 27:51, Luke 23:45) with the rending of the seal and sepulchre (46). Thus he interprets "the whole Story, as emblematical of [Jesus's] spiritual Resurrection out of the *Grave* of the *Letter* of the Scriptures . . ." (48), and concludes:

> Bishop *Gibson* is for *Jesus* of *Nazareth*'s Messiahship, because he cured the *bodily Blindness* of many miraculously; and a good Work it was: But I am for the Messiahship of a spiritual *Jesus* to come, who will open the *blind Eyes* of our Understandings to discern Truth from Error, which will be a most glorious Operation, that his *Jesus* of *Nazareth* has not as yet done. (53–54)

This is a position that would have suited the Hogarth of *Columbus Breaking the Egg* and the many passages in *The Analysis of Beauty* where he urges his readers to see with their own eyes, not with the eyes of the connoisseur (for which read priest), and to judge accordingly. But the most striking detail, in the far distance of the central panel, is the bolt of lightning aimed at Jerusalem. Resembling the jagged lightning aimed at the gambling house in the revised state of *Rake* 4 (fig. 50),[12] it seems less an allusion to the rending of the veil in the Temple (Matt. 27:51) than to Christ's prophecy of the destruction of the Temple (23:37–39, 24:2), and thus to divine retribution against priestcraft—an odd subject altogether considering Hogarth's commission by the vestry of St. Mary's and one reminiscent of his treatment of the benchers of Lincoln's Inn when they commissioned him to paint a picture of the law in action. He covers himself, of course (as Woolston did), by the fact that these priests are Jews.

The continuation of the story of the tomb in the central panel, however, draws on the version in John 20. All the versions, naming the women who come to visit the tomb, single out Mary Magdalen, but John carries the story further, describing how "Then she runneth, and cometh to Simon Peter . . . ," to tell him of the miracle (20:2). This is the verse Hogarth illustrates. He has once again placed the Harlot (the conflation of the two Marys, the Mother and the Magdalen) at the center of his narrative, gathering together the disciples. Though in rapid movement, she still makes the familiar mediating gesture that goes back to Polly Peachum in Hogarth's *Beggar's Opera* paintings, Sin in *Satan, Sin, and Death,* Miranda in *The Tempest,* and the milkmaid in *The Enraged Musician.*

The fact that the artist of *A Harlot's Progress* makes Mary Magdalen the central figure of the central panel of his Resurrection triptych is outrageously appropriate, especially given the church's dedication to the Virgin Mary. The prominence of women in the triptych, and in particular of Mary Magdalen, also inevitably recalls the centrality Hogarth gave the adulterous woman in his aesthetics in the *Analysis* plates. The remoteness of the ascending Christ as against the immediate, gesticulating, and active woman in the foreground, may fulfill another aspect of the *Analysis's* aesthetics; and, once this possibility is acknowledged, we may see the women surrounding the empty tomb in the right panel as pointing to another Hogarthian allegory of the British artist as Hiram/Osiris, killed, buried, but destined for resurrection. In short, in his one New Testament altarpiece Hogarth goes some way toward secularizing Christ into a figure of the artist as he had earlier secularized Christianity into an aesthetics.

This said, there was nothing unconventional in the general appearance of the three panels that might have worried the St. Mary's vestry; the figures and their surroundings are suitably baroque and piously rendered. But in a more important sense, the total effect of the panels in situ was not happy. Hogarth's canvases filled approximately the same area taken up by Holmes's, with the space between the top of the *Resurrection* and the Gothic arch of the window filled in with a crimson drapery (fig. 49). Considering St. Mary Redcliffe's reputation as one of the most beautiful Gothic churches in England, the plan for Hogarth's altarpiece was ill conceived. The vestry minutes leave no doubt that he was asked to follow the plan already in existence. It does not seem possible that, even if he had wanted to, he could have persuaded the vestry to remodel the whole area—and

to what end? In a restored Gothic setting, a different artist would have been called for. The fact remains, however, that he acquiesced in the plan, perhaps a challenge to one who had always been interested in relating conflicting styles. The result shows that his taste was still in many respects that of his time, but also that a strong desire to get some paintings into a church made him accept the commission whatever the terms.

The worst aspect of the project was that, while the *Ascension* was visible from the door of the church, the flanking panels (crucial, we have seen, to Hogarth's plan) had to be flat against the side walls and so were virtually invisible except from a few places in the choir. The *St. James's Chronicle,* some years later, noted wryly that "at present, if we are not misinformed, these Pictures are so situated as to be seen to advantage from no other point than through a notch cut in a pillar at the corner of a private pew."[13]

Now displayed in the Bristol Art Gallery, the panels can be seen to better advantage (except for the problematic quality injected by restoration) than at any time since they were painted. The restoration is most vexing in the drawing and the application of paint, making it difficult to judge to what extent the inadequacies are due to the enormous scale, to a painting assistant, to the restorer, or to Hogarth's failing hand. In any case, the result is a falling-off—in every way except imaginatively—from the exactly contemporary *Election* paintings, which show Hogarth at the top of his form. The failure is probably generic; he did not find (or seek) a formal solution that corresponded to the audacity of the conceptual one. In their preposterous Gothic setting, the St. Mary's paintings, inappropriate as they were to his talents in scale if not subject, acted as a suitably ironic introduction to the last phase of his history painting, when he himself assumed (sometimes consciously, sometimes unconsciously) the same mock-heroic roles he had satirized in his "modern moral subjects."

SELF-PORTRAIT AS SERJEANT PAINTER TO THE KING

The St. Mary's altarpiece was not followed by other commissions for church decoration, and, perhaps wisely, Hogarth made no effort to have the paintings engraved.[14] While still to some extent supervising

the engraving of the *Election* plates, within six months of completing the altarpiece he had ostentatiously retired to another line of painting. In his advertisement in February 1757 announcing a further delay in the *Election* (182 above), he expressed his disgust at the difficulties he was having with his engravers, adding that he will produce no more comic histories but "intends to employ the rest of his time in Portrait Painting chiefly." This notice was to have its consequences—melodramatic requests for *one last history.*

We shall turn to an examination of these portraits and the sitters in Chapter 11. For the purposes of the present chapter it is sufficient to note that one work of 1757 or 1758 was a small self-portrait, intended as a modello for an engraving to replace *Gulielmus Hogarth* (fig. 105) as frontispiece to the folios of Hogarth's engravings (figs. 51, 52). Cleaning has revealed that he originally painted a hefty male model (or that he used a fragment of a larger, heroic composition). He represented himself sitting on a stool; his pug was lifting his leg to show his contempt for some framed paintings lying on the studio floor; the easel was in the center background, to the artist's left. It is difficult to make out what is on his canvas, but it is not the Muse of Comedy.[15]

The style and composition of the painting owe something to Rembrandt, who was primarily regarded at this time as a portraitist—preeminent as a self-portraitist. It would appear that Hogarth, having distanced himself from Rembrandt's history paintings, turned to Rembrandt as a model for some of his late portraits—in particular his self-portrait, but also portraits of close friends such as John Pine and Mary Lewis (figs. 72, 79).[16] The most interesting aspect is Hogarth's face: small, terrier- or monkeylike, closer to the facial structure of Roubiliac's bust (ill., vol. 2) than to the flattened, regularized face of the engraving, which could have been based on the face of *Gulielmus Hogarth.*[17] While clearly idealized, it is also strikingly heavier, puffier than Gulielmus Hogarth. Hogarth was careful to engrave the face himself, a fact that he registered in the publication line. Even at the earliest stages, and before the later revisions in which he worried it, darkened it, and turned down the corners of the mouth (fig. 110), the face is labored and somewhat uncertain. Hogarth is trying to show what he looked like without losing the generalization demanded in a portrait of the artist; he is trying to recapture Gulielmus Hogarth without losing altogether the Hogarth of 1758.

The face in the print in fact looks disturbingly like the face in the Sandby caricatures; and Hogarth's vacillation between an idealized portrait and a faithful rendering reveals an uncertainty about himself not apparent in the earlier self-portrait. The composition, too, down to *The Analysis of Beauty* propped against the easel, is reminiscent of Sandby's *Pugg's Graces* (fig. 29), which was itself probably adapted from one of Chardin's *singeries, Le Peintre* (engraved by Surugue fils in 1743). Hogarth was more and more to see himself simultaneously from his enemies' viewpoint and his own, self-defense blending into self-irony.

The self-portrait is primarily, of course, a portrait of the artist, and its composition is as important as that of *Gulielmus Hogarth.* He is not only painter (easel, palette, and brushes), engraver (a burin leans against the wall of a shelf next to a Hogarth folio), but author (a copy of the *Analysis*). Most important, he has replaced the pug with a female muse, summing up at the same time his genre (dramatic comedy) and his aesthetic theory. He draws on a tradition of artists painting their muses: Vermeer's artist painted Clio, the muse of history, and Metsu's painted Erato, the muse of lyric poetry. "Painting thus approaches Parnassus to take its place with the ancient muses." [18] Hogarth's muse has the mask, ivy wreath, and sandals of Thalia, the muse of comedy and lyric poetry; but to Thalia, who merely talks, he has added a book borrowed from Polyhymnia, the muse of rhetoric, who has a book inscribed *Suadere.*[19] But the particular relationship of Hogarth and his muse has to be seen in the context of his just-completed history painting of Christ and Mary Magdalen.

This self-portrait is a complete reversal of *Gulielmus Hogarth,* where Hogarth made himself the art object, with the real world contained in the symbols of his moral and aesthetic endeavor which surrounded his portrait. Now in the 1750s, the artist himself is the active protagonist, shown in the act of painting. He is in the real world, seated before his easel, and the painted image—but not the real model—of his comic muse is in sight. There is no external referent as there was in *Boys Peeping at Nature,* for instance; he is painting the muse herself and not a particular comic subject. The only model in sight is, in fact, the copy of his *Analysis of Beauty.* The serpentine lines of the comic muse are pointedly contrasted with the straight lines of the column next to her (illustrating one of the Vitruvian orders), and the other artifact, the chair Hogarth sits in, is notable for its serpentine

forms. The Line of Beauty also appears in nature, in the swelling calves of his legs.

A change in the artist's role vis-à-vis nature was already indicated in *The Gate of Calais,* only three years after *Gulielmus Hogarth* was painted: there Hogarth was out in the real world, an actor himself with no conventional mask between him and the moral world. But in *Hogarth Painting the Comic Muse* he is no longer sketching folly; he is finding Beauty and exploring nature's "capabilities"—in his studio, with a treatise and principles of Beauty in front of him—in the female figure "Comedy."

The engraving, dated 29 March 1758, was published just one month after the delivery of the last *Election* prints. But its title, "Wm Hogarth Serjeant Painter to His Majesty," refers back to 6 July 1757, when Hogarth was appointed to Thornhill's old post, which he had resigned in favor of his son John in July 1732. In the spring of 1757 John was evidently suffering from some incurable or incapacitating disease that made him resign his office. Hogarth's own memory of the occasion was that "I obtained after my brothers Death by means of my friend Mr Manning and Duke of Devonshire, the place of serjeant painter."[20] Since Thornhill lived until September, I take Hogarth to mean, in effect, his brother-in-law's imminent death. The *London Chronicle* of 5–7 July reported: "We hear that John Thornhill, Esq; Serjeant Painter to his Majesty, has resign'd his Place in Favour of Mr. Hogarth." Thornhill wrote his will that summer, dated 12 August, and then made a last visit to Chiswick to see the Hogarths and his mother, who was also in poor health and outlived him by only two months. The will itself shows that his closest friends outside the family were Ebenezer Forrest (who had accompanied him and Hogarth on the "peregrination" of 1732) and George Lambert. All three were members of the Beefsteaks, and Thornhill left money for a mourning ring for every member of the club.[21]

Despite the notice in the *Chronicle,* and judging by the correspondence surrounding Hogarth's death about *his* successor, it does not seem possible that the retiring Serjeant Painter could do more than recommend a successor. The "Mr Manning" Hogarth mentions bought paintings for the earl of Oxford at Mr. Collevou's sale in Covent Garden in February 1726/27, but is otherwise unknown.[22] The duke of Devonshire, however, had sat to Hogarth for his portrait in 1740 (ill., vol. 2) and in the 1750s was a chief mainstay of the Fox–Cumberland party—and moreover a close friend of Garrick's.

On 16 May 1757 he became lord chamberlain on the death of the duke of Grafton, who had held the position all these years since Hogarth's rebuff in the Chapel Royal at St. James's Palace in 1733. The Serjeant Paintership was within the gift of the lord chamberlain. If Devonshire, Fox, and the Leicester House party, or some combination of these, had not wanted to reward Hogarth, he would not have received the position. This was the period between the fall of Pitt's first ministry (the Pitt–Devonshire ministry) and the rise of the Pitt–Newcastle ministry. Negotiations of all sorts were afoot, Pitt making exorbitant demands, Newcastle trying to gather nerve to lead a ministry without Pitt, and Fox watching, advising, and hoping to pick up the pieces himself. John Wilkes's later innuendos (below, 370), though chronologically wrong, suggest that something political lay behind the appointment. Despite Wilkes's and Hogarth's own deprecating remarks about "pannel painting," the position was financially lucrative, and just what Hogarth seems to have been looking for in his last decade: a good source of income that would not require the exertion of much energy.

The Serjeant Painter was listed in the *Court & City Register* under both Ministry of Works and lord chamberlain, neither of which placed Hogarth in what he would have considered very exalted company. He must have found it comic to appear in the lord chamberlain's officers list with Stephen Slaughter, who was "Surveyor of the Pictures" (£200 a year); John Shackleton, who was "Principal Painter" (£200);[23] and John Gower, "Rat-killer to the King" (£48 3s 4d). His own salary was £10. In the Board of Works, where his actual profits lay, he was "Serjeant Painter of all his Majesty's Works," appearing among the Master Bricklayers, Master Carver, Master Glazier, Joiner, Plasterer, Wine Worker, and the Serjeant Plumber. If the job were taken at face value, he would merely have been a house painter.

While a court sinecure, the paintership was a relatively lucrative one that could not be judged by the paltry £10 per annum of salary. Hogarth may have secured a few more portrait commissions from the title and the contacts it brought with it, but its principal benefit was to provide a monopoly on the painting and gilding of all the royal palaces and conveyances, including banners and tents for royal troops and ships. Hogarth himself testified, in 1762 or 1763, that

the place of serjeant painter which might have been an hundred a year to me for trouble and attendance but two pattents of more than

80 pounds each the last occationed by His present majesty's accession
it has been in five years I have had at least one way or other £200 with
this competency of my own rating as independently as may be.[24]

This telegraphic statement ends, at least, with a sense of the security
he gained from the position. The records show that his income was
even greater than he suggests, and in 1763 and 1764 did not suffer by
comparison with Thornhill's. The amount Hogarth mentions corre-
sponds to what he cleared each year after paying his deputy, who did
all the work. Hogarth simply passed on the orders and perhaps
(though not necessarily) supervised the work, and then drew the
payment.

He began to receive payments in September 1757, and through-
out that year he was paid for work on the royal residences at the
Tower, Denmark House, Whitehall, St. James, Newmarket, Hamp-
ton Court Gardens, and Greenwich. These varied from as little as
£5 to £140, and (as he says) he was fortunate enough to be in office
during state funerals and coronations. His gross earnings in 1757
were £400, for 1758 nearly £700, for 1759 £947, for 1760 (which
would have included George II's funeral) £645, and for 1761 (the
coronation of George III) £982. If one accepts his own estimate,
about half went to his deputy and the painters, but the result was an
easy and welcome source of income. A note in his own hand for
August 1763 gives one payment as £200, out of which he paid his
deputy £60.[25]

Hogarth must have seen through the honor long before Wilkes's
attack, in fact probably supplying Wilkes with his ammunition by
showing him the mock patent he had himself drawn up. The actual
royal patent read in part:

And further know yee That for divers good Causes and Considera-
tions As hereunto Especial moving of Our Especial Grace and of Our
certain knowledge and meer motion Have Given and Granted and by
these Presentes Do Give and Grant unto Our Trusty and wellbeloved
William Hogarth Gentleman the said Office of Our Serjeant Painter
and Serjeant Painter of all Our Works whatsoever as well as in any
wise belonging to our Royal Palaces and Houses as to Our Great
Wardrobe to be Painted Gilded or Imbellished and also appertaining
or belonging to Our Office of the Revels and to Our Stables and to
Our Navys and Ships Barges and Close Barges Coaches Chariots

Charoches Litters Waggons and Close Carrs Tents & Pavilions Heralds Coats Trumpet Banners and also in any thing belonging to the Solemnization of Burials or Funerals.

Hogarth's parody of this patent begins with a huge initial P in a box with an indication of a head, like the king's, which appeared on his royal patents:

Punch by his order (Grace) and Deportment of all theaters in the world Nabob know ye that I for divers good causes and considerations as hereunto especial moving of our especial grace and our certain knowledge and meer motion have given and granted and by these presents do give and grant to my trusty and well beloved W H gentleman the office of scene painter and corporal Painter to all my whatsoever as well in any wise belonging to my

This was accompanied by a projected title page: "Various Designes offered to the Public as proper / Scenes to be exhibited at Punches Theatre / by the Patentee / [Frontispiece] / Representing the true form of his Lownesses Patent."[26] The project never materialized.

There were probably two reasons for his emphasizing the pompous title, "W^m Hogarth, Serjeant Painter to His Majesty," on the print that was to serve as frontispiece to his folios: one was the continuity with Thornhill (and most especially as a history painter), and the second was the relationship to the king implied by the title. The Serjeant Paintership cleared him of any stain left by Sandby's prints and the stories claiming that the dedication of *The March to Finchley* to the "King of Prussia" had been intended as an insult to George II— especially important at a time when the monarch's role was considered central in the negotiations for an academy.

The title is nevertheless a wry one for a print showing the artist painting the comic muse, and in view of the general awareness that the Serjeant Paintership was mainly a source of income. A personal cynicism, which was shifting its focus from art to politics, becomes noticeable in these years. Around this time, to judge by its first quoting, Hogarth told Ralph that "till fame appears to be worth more than Money, he will always prefer Money to Fame."[27] This cynicism acknowledged not only the hollowness of titles and the absence of history commissions, but also bitter feelings (stressed in his speech

to the Society of Arts) about the miserable poverty of most English artists. Thereafter profit became a central motif in his autobiographical writings. But there is also a sense in which his references to the money he earned by his paintings and prints was a way of saying that the artist's main aim is not to paint like the Italians but to make a living. He was pointing to the discrepancy between commerce and politeness in the English apprehension of art (recognized also by Rouquet in *State of the Arts*). His emphasis on commodification, which had been an aspect of his "modern moral subjects" in the 1730s, became one aspect of his aesthetics in the 1750s—a reaction against Shaftesbury's disinterestedness and his assumption that art precludes commerce. Another aspect was his acceptance of the role of "mechanic" (in his admiration for the Bristol sign painter, his image of the artist in *Beer Street,* and his own office as "pannel-painter" to the king) that led eventually to his elevation of the sign painter as true English artist.

The paintpot and brush just behind Hogarth's chair are his comment on the Serjeant Paintership. In earlier prints he always designated himself by his palette and brushes (in *Gulielmus Hogarth* and *The Battle of the Pictures,* as well as in the seals on his subscription tickets), but in *Strolling Actresses* he had added to the palette, as a reference to the degraded art of scene painting to which English artists had sunk, a pot (and brushes), which also rhymed with a chamber pot placed diagonally below it. Now again, above "W^m Hogarth Serjeant Painter to His Majesty," he places both palette and paintpot; the second clearly alludes to the equipment Hogarth will employ as Serjeant Painter, but its placement does not remove the possibility that it also serves as a chamber pot.

In March 1757 Hogarth received a letter from one Johann Friedrich Reiffenstein of Cassel, lavishing praise on his *Analysis of Beauty* and offering him honorary membership in the Imperial Academy of Augsburg.[28] The very name (Reif-ring) sounds suspicious in a man writing to the advocate of the serpentine Line of Beauty. Yet there was such a Reiffenstein, a dilettante who painted portraits and landscapes in wax and pastel, at this time serving as a Pagenhofmeister in Cassel.[29] There was also a Kaiserlich Francsizische Academia Liberalium Artium in Augsburg, although it had been founded in 1715,

not in 1753 as Reiffenstein claims.[30] Begun by one J. D. Herz, who had somehow persuaded the emperor to support it, the academy was largely fraudulent, founded to make money to support Herz's publishing house and carried on to support its directors by means of the lotteries referred to in the letter.[31]

"An universal reputation, and undisputed title to superiority, cannot but draw upon you the importunities of those who are ambitious of an acquaintance with men of genius"—thus Reiffenstein begins, and after this arresting sentence compliments Hogarth's *Analysis* for having "dispelled the mist, and cleared the difficulties that had previously attended a problem in painting, of exquisite nicety, and the greatest moment." Before Hogarth,

> the most eminent masters, and most sagacious theorists, had travelled in the dark or wandered through mazes in a fruitless search after beauty. To you alone it was reserved to unravel her windings, reveal her charms to open view, and fix her hidden, though genuine excellence.

For anyone who had read the preface to the *Analysis* and perused Sandby's caricatures, this had to be parody. To show their admiration, the members of the Imperial Academy at Augsburg "earnestly desire" Hogarth ("one no less distinguished in the republic of letters, than in the commonwealth of arts") to accept the diploma of counselor and honorary member. The academy, Reiffenstein explains, was founded three or four years ago (i.e., 1753, just when the Londoners attempted to form a state academy) by some artists of Augsburg "in order to promote and encourage the imitative arts, especially painting and engraving." They applied to the emperor for protection and received his sponsorship; they then "endeavoured to fix an institution for teaching methodically the art of drawing, or designing," and it was incorporated by the court "under the denomination of an Academy of Arts and Letters, and the Emperor was pleased to illustrate it with his own name." Furthermore,

> He conferred the honour of knighthood upon the President, and the title of Imperial Counsellor on the Director, impowering the members to choose those officers themselves; and moreover to appoint counsellors and professors. . . . To crown their hopes, a common stock was

still wanting for the supply of unavoidable expenses, such as salaries to masters, and teachers, charges of the press, *etc*. On this account they had recourse to a *tontine,* a kind of lottery, consisting of annuities for life, which has met with tolerable success, and will produce a capital sufficient to defray all necessary disbursements.

So goes Reiffenstein's letter, ending with a request (which Hogarth did attempt to fulfill in his "Apology for Painters") for "a sketch of the present improved state of the imitative arts in Great Britain."

The letter might possibly have been genuine. It could have originated from the anti-Hogarth camp as a hoax to exploit Hogarth's vanity and get him to accept an honorary membership in a dubious royal academy which in outline fulfilled almost every detail of the one he was opposing in England; or it could have originated among his friends as a joke on the proacademy camp. Hogarth had taken a hand himself in the same sort of hoax in his time. In his reply of 18 April, commenting on how "most agreeably surprised" he was ("nor could I help being much elated"), he accepted the honor.[32] His polite answer can be read either way—though its exaggerated delight sounds more like the answer to friends than to enemies.

PICQUET / THE LADY'S LAST STAKE

By the fall of 1758 Hogarth had undertaken two ambitious projects which (he wrote to his friend William Huggins) "require much exertion, if I would succeed in any tolerable degree in them."[33] He explains that "the terms they are done upon are the most agreeable that can be wish'd for, I am desir'd to choose my subject, am allow'd my own time, and what mony I shall think proper to ask." One was for Lord Charlemont, the other for Sir Richard Grosvenor, about which he concludes (ironically, considering the sequel) that "one should not conceal the names of such as behave so nobly." In his "Autobiographical Notes" he also emphasizes the amount of money involved ("the payment was noble," 219).

James Caulfeild, Lord Charlemont, was the attractive and promising young scion of a prominent Anglo-Irish family (see fig. 58); he bore a great reputation in Ireland. In 1746, at the age of eighteen, he

had set out on his Grand Tour, studying at the Royal Academy in Turin, spending a year in Rome and Naples, and in 1749 traveling from Leghorn to Greece and Constantinople—a trip whose pleasures and dangers he afterward described wittily.[34] Back in Rome in the 1750s, he supported a group of artists that included William Chambers and Thomas Patch, and became involved with Piranesi in a muddy dispute whose main consequence was the removal of his name from one of Piranesi's dedications. In 1753 he made a quick business trip to London, but he did not return for good until January 1755. During the following years he kept a house in Hertford Street, London, traveled back and forth between London and Dublin, and sometimes returned to the Continent. "His wanderings at this time," according to his biographer, "may probably have been largely due to a genuine need for change of air and water. But they seem to show a natural disinclination to settle down on one side or the other of the Irish Sea." In Dublin he was a great Irishman, "the admired of all beholders," although it was a fame that "is not easy to account for on any basis of solid achievement."[35] He seems to have been physically debilitated after his long stay abroad—supposedly the result of a love potion. Mrs. Delany met him in December 1756 in Spring Gardens and commented on his bad health. She later described him as "a very agreeable (ugly) man—sensible, lively, and polite."[36] In February 1757 he sat to Reynolds for his portrait.

When he first came into contact with Hogarth is not known. A close personal friend of the duke of Devonshire, earlier lord lieutenant of Ireland, now lord chamberlain, Charlemont may have met Hogarth through him. It looks as though he bought a folio of Hogarth's prints (personally chosen by the artist, as he later claimed, which meant that Hogarth picked out especially clear impressions for him).[37] He did not, however, keep up the collection, for only in the 1780s did he seek out impressions of *The Cockpit, The Five Orders of Periwigs, Credulity, Superstition, and Fanaticism,* and the other prints subsequent to the end of 1759, when he returned to Ireland for a longer stay than usual. He does not seem to have been any more interested in Hogarth's prints than in the sublime histories, but he wanted to own one of the comic history paintings.

Hogarth noted a few years later, in his subscription book for an engraving of *Sigismunda,* that he had decided to retire from painting because he could earn more by his engravings. This was a time, he

wrote, when he had "fully determined to leave off Painting, partly on account of Ease and retirement, but more particularly because he had found by thirty years experience that his Pictures had not produced him one quarter of the profit that arose from his Engravings, except in the instance or two mentioned hereafter"—and in a footnote he excepted the altarpiece for Bristol and *The Lady's Last Stake*.[38] He evidently forgot that his public announcement had proclaimed his abandonment of engraving for portrait painting—although it could have been read to include history painting. In the subscription book he implies that by using drawings, as he had done with his popular prints, he could avoid altogether the trouble of making paintings, which were so difficult to dispose of. Charlemont urged him, he remembered, before he "entirely quitted the pencil to paint him a picture leaving the subject to me and any price I asked" (AN, 219). For Charlemont he painted *Picquet, or Virtue in Danger* (fig. 53), presumably undertaken as an example of Beauty found in "comedy," to illustrate his self-portrait painting the comic muse. The subject, he says, was "a virtuous married lady that had lost all at cards to a young officer, wavering at his suit whether she should part with her honor or no to regain the loss which was offered to her."[39] The husband's letter she holds, Charlemont recalled, was supposed to say: "My dearest Charlotte, . . . your affectionate Townly.—I will send the remainder of the note by next post." (The note in the hat on the floor reads "four hund[red].") The picture over the chimney was to represent a "'virtuoso landscape,' such as, decorated by a long Dutch name, the connoisseurs of those times eagerly and dearly purchased at auctions."[40]

The painting remains Hogarthian in its symbolism. The Old Master painting over the mantle is a Penitent Magdalen in the desert. Harpies hold up the grate in the fireplace. On the clock (reminiscent of the one in *The Graham Children*) is a cupid with a scythe, and on his pedestal the ambiguous inscription "NUNC NUNC." Below on the half-circle that records sunrise and sunset, "Set" is replacing "Rise." The clock itself registers 4:55—very little time remains. Through the window the moon is rising. The subject is, once more, choice.

But the composition of the two large figures in the comfortable setting draws on Chardin and the Highmore of the *Pamela* illustrations rather than *Marriage A-la-mode*. Instead of choice it suggests an

intense erotic moment which looks forward to works like Frago-
nard's *Le Baisir à la dérobée* (Hermitage, Leningrad) and back to the
works that inspired *Before* and *After:* for example, the *Déclaration
d'amour* and *La Jarretière* of Jean-François de Troy (1725 Salon;
Wrightsman Collection). One feels that Hogarth's painting is less an
admonition than a celebration of the piquancy of the lady's situation
with husband and honor on one side, flying time, youth, and chance
on the other. The negative choice has now come to be associated
with the Beauty (along with the variety, pleasure, and curiosity) of
the *Analysis*.

Hogarth called the canvas *Picquet, or Virtue in Danger* in the cata-
logue of its first exhibition (1761), but it has come to be known as
The Lady's Last Stake: picquet was the card game in Colley Cibber's
play *The Lady's Last Stake* at which the virtuous but gambling-driven
Lady Gentle was tricked by Lord George Brilliant.[41] Hogarth has
simply illustrated the subplot of Cibber's play (the sort of play he
invoked at the end of the *Analysis*); indeed, only the spectator's
knowledge of the plot makes the painting comic and the lady virtu-
ous. We know that Lady Gentle has been tricked, that she *will* accept
Lord George's proposal of one final game, and *will* lose all but then
be saved by the intervention of Mrs. Conquest dressed as her twin
brother Sir John, who pays Lord George his £2000 and challenges
him to a duel (they are in fact the destined lovers of the comedy).
Though Hogarth leaves the choice and its consequences in the air,
the audience fills them in. It is unusual for him to let the meaning of
his painting be determined in this way by an external text, but he
repeats the strategy in his next painting, *Sigismunda*.

Hester Lynch Salusbury (later Thrale and Piozzi) now enters upon
the scene. Hogarth was a close friend of John Salusbury, her father,
who was the only subscriber for *Sigismunda* (1761) to refuse the re-
fund Hogarth offered when he failed to secure a satisfactory en-
graver. Born in 1741, Hester would have been a teenager by the time
of her story. Hogarth and her father, she said, "were very intimate,
and he often dined with us."[42]

> One day when he had done so, my aunt and a groupe of young cous-
> ins came in the afternoon,—evenings were earlier things than they are
> now, and 3 o'clock the common dinner-hour. I had got a then new
> thing I suppose, which was called Game of the Goose, and felt earnest

that we children might be allowed a round table to play at it, but was half afraid of my uncle's and my father's grave looks. Hogarth said, good-humouredly, 'I will come, my dears, and play at it with you.' Our joy was great, and the sport began under my management and direction. The pool rose to five shillings, a fortune to us monkeys, and when I won it, I capered for delight.

Accordingly, she writes, "the next time we went to Leicester Fields," Hogarth bade her sit for him for the lady in *The Lady's Last Stake.*

'And now look here,' said he, 'I am doing this for you. You are not fourteen years old yet, I think, but you will be twenty-four, and this portrait will then be like you. 'Tis the lady's last stake; see how she hesitates between her money and her honour. Take you care; I see an ardour for play in your eyes and in your heart; don't indulge it. I shall give you this picture as a warning, because I love you now, you are so good a girl.'

A slightly different version runs: "as he thought he discover'd in me an ardor for Play—this was meant as my Preservative—for Says he You *are* 15, but you *will* be five and Twenty."[43] "But," as Hester remarks, "he had scarcely attempted a likeness, having made his rash lady a beauty."[44] For the face, far from resembling Hester's, seems to be the same face he was to employ in *Sigismunda.* Indeed, it is clear that Hester's "over-fondness for play" reminded Hogarth of Lady Gentle, and her winning streak led him to use his new painting as an admonition—but for the purposes of play as much as morality. Other topics she remembered from Hogarth's conversation—"some odd particular directions about dress, dancing, and many other matters interesting now only because they were his"—show him filtering morality through the aesthetics of the *Analysis.*

Reminiscing over twenty years later, Charlemont could not remember the exact year the picture was painted;[45] but it seems probable that he approached Hogarth not long after the public announcement in February 1757. While Hogarth was painting the picture, they were seeing each other socially and Hogarth was instructing Charlemont in the danger of a "virtuoso landscape" and pictures "decorated by a long Dutch name." In later November 1758, around the day on which Hogarth wrote Huggins about his two commissions, Charlemont bought an *Old Man's Head* attributed to

Rubens and, as he recalled, "shew'd it to my Friend Hogarth, who under the Influence of Good Breeding, and perhaps of Friendship, seemed to approve of it. The next Day however, conscious of having acted with some Degree of Hypocrisy, and unable to long conceal his real Sentiments," Hogarth wrote him a letter (dated 26 Nov. 1758):

> by the way my Lord I have Something upon my conscience to disburthen if that head I saw yesterday is not done as follows I am mistaken, Recipe an old bit of coarse cloth and Portray an old bearded Beggars head upon it with the features much in shaddow make the eye red and row some slurrs of the Pencill by way of freedom in the beard and band clap a vast splash of light upon the forehead from which gradate by degrees from the Blacking pot, varnish it well, and it will do for Langford or Prestage [the auctioneers]. I scarce ever knew a fizmonger who did not succeed in one of these masterpieces. one old Peters famous for Old Picture making, use[d] to say, even in contempt of those easiest parts of Rubens productions that he could sh-t old mens Heads with ease consider my lord he was a dutchman.[46]

This was the sort of relationship Hogarth enjoyed, and one can imagine the complicity of the two friends in the developing conception of *The Lady's Last Stake:* where the lapdog came from, what the letter was supposed to say, what the picture on the wall meant and what the furniture signified—without too much concern for the fate of the young woman.

SIGISMUNDA

Another young man, Sir Richard Grosvenor, heard about the picture (perhaps from Charlemont) and saw it in Hogarth's studio in 1758. Taken by it, and learning the curious details of the commission, he made Hogarth the same proposition. "Seeing this picture," Hogarth recalled, "being infinitely rich, [he] pressed me with more vehemence to do what subject I would, upon the same terms, much against my inclination." And so Hogarth "began on a subject I once wished to paint." These statements were written in his "Autobiographical Notes" (220). In the subscription book for an engraving of

Sigismunda, a more public statement, he implies that Grosvenor alone drew him out of self-imposed retirement. *Sigismunda* "was Painted at the earnest request of Sr Richard Grosvenor, now Lord Grosvenor, in the Year 1759 [1760 in a later version], at a time when Mr Hogarth had fully determined to leave off Painting." However, he goes on,

> the flattering compliments as well as generous offers made by the above Gentleman (who was immensely Rich) prevail'd upon ye unwary Painter, to undertake Painting this difficult subject (which being seen and fully approved of by his Lordhp whilst in hand) was after much time and the utmost efforts finished.[47]

Thus, according to the public version of the episode, Grosvenor gave his sanction to the work while it was being executed (fig. 54).

If one accepts the statement in the "Autobiographical Notes" as the more authoritative, the commission may be dated sometime in the latter part of 1758; certainly it was settled by 23 November when Hogarth wrote Huggins that he was working on both the Charlemont and the Grosvenor paintings. For the "subject I once wished to paint" was Sigismunda weeping over the heart of her dead lover Guiscardo; the charm of this lady stemmed from the enormous price of £400 paid for a similar painting in May 1758 at Sir Luke Schaub's sale.

Hogarth's growing pessimism about England was implemented in the art world by the auctions of Henry Furnese's and Sir Luke Schaub's collections, both of which, as Walpole commented, brought much more than they deserved. Schaub had been "prime ministre connaisseur in pictures" (Vertue's designation) to Frederick Prince of Wales, himself a patron of the arts who can never have appealed much to Hogarth. Frederick had not even collected modern Italians, let alone Englishmen, but only the artists of the Italian Seicento, modeling his collection on that of Charles I. Poor Vertue, when Frederick proudly showed him his favorite "Guido," which had never been touched by that artist, discreetly praised the single true Guido in the prince's collection.[48] Schaub died early in 1758 and his own collection went on sale at Langford's on 26–28 April.

On the first day of the sale, "Sigismunda weeping over the heart of Guiscardo," attributed to Correggio (No. 29), was sold to Sir

Thomas Seabright for £404 5s, the highest price of the day since there were virtually no Correggios to be had in England.[49] Thus there were few Correggios with which to compare the Sigismunda (fig. 55); Hogarth, after seeing it, was convinced that it was not a Correggio at all. It was, in fact, the work of Francesco Furini, a seventeenth-century Florentine painter who, as Antal says, "in his numerous female half-figures, whether Magdalens or secular subjects, combined sentimentality with sensuousness in the common fashion of the baroque post-Reni paintings of this type."[50] The total for that first day was £2,102 13s, and for the three days £7,784 5s. Newspaper articles followed the extravagant prices, noting that "a little oval picture of Guido's of our Saviour asleep" brought £328 13s and a Van Dyck "Virgin and Child" £211 1s. The highest price of all went for a supposed Raphael, £703 10s, bought by the duchess of Portland.[51]

Sir Richard Grosvenor was very much in evidence at the sale. He was indeed "infinitely rich," having inherited the Grosvenor estates in Cheshire and Westminster. Originally Cheshire gentry of good but moderate estate, his ancestors had married into the Davies family and secured possession of the land stretching from Oxford Street to the Thames at Vauxhall and Chelsea, which at length became the streets and squares around Grosvenor Square and Park Lane, and the districts of Victoria and Pimlico. Richard, born in 1731, went to Oxford in 1748, proceeded to an M.A. in 1751, represented Chester in Parliament from 1754 to 1761, and succeeded to the baronetcy in 1755. He also collected pictures. It was he who bought the small Guido for £328 13s. But his purchases suggest a rather catholic taste: he bought not only the Italian masters but also works attributed to Lely, Holbein, Rubens, Murillo, and Teniers (the latter "A Conversation of Boors"). It is easy to see that, along with the Old Masters and Italian religious pictures, he wanted more earthy works for his back parlors; but he was not interested, as it turned out, in a sublime history by an early Dutch genre painter who was moreover a contemporary.

It is possible to imagine the comedy of Sir Richard telling Hogarth to paint just what he liked and name his own price, hoping for something like The Lady's Last Stake, a cross between Teniers and Boucher, and ending up with the lugubrious Sigismunda and a bill for 400 guineas. Hogarth pointed out in his reminiscences on the

affair that he thought this a reasonable sum—he had "spent more time and anxiety" upon this picture "than would have got me double the money in any of my other way and not half what a common face painter got in the time" (AN, 220). Wilkes too, in his *North Briton* No. 17, recalls that it was a labor of "many years" (no doubt something he heard Hogarth say); probably, as Hogarth insisted, *Sigismunda* did cost him a good deal of time. It is a careful if not labored performance, and he might have worked on it as long as a year (ca. June 1758—June 1759) before showing it to Grosvenor; then he spent many hours on the canvas before it was considered finished, with further changes to follow.

The passage in the "Autobiographical Notes" in which he recalls his intentions is worth piecing together and paraphrasing: because he "had been ever flattered as to [his ability to convey] expression," his aim in *Sigismunda* was "to fetch [a] Tear from the Spectator." As usual, he regarded his "figure" as an "actor," but this time—for the first time—an actress in a tragedy (perhaps to complement the "comedy" he had painted for Charlemont): "this I will aver [, that] as there are many living ladies especially that shed involuntary tears, I was to be convinced that Peoples heart[s] were as easily touchd as I have seen them at a Tragedy," which he designates as "an influence I never knew before in my life" (220).

Thus he selected a subject and composition the least suited to his talents—a female mourning her lost lover, with only her upper body and a table depicted—no interaction of characters. Then he offered the work to the least likely candidate for it, in circumstances suggestive of false pretenses. Nevertheless, the *Sigismunda* is an interesting painting that deserves consideration. Hogarth was trying to paint in a particular tradition without sacrificing his individuality. Both his and Furini's pictures were based in part on Guido Reni's much imitated half-length females, tragic Lucretias and Cleopatras. Hogarth seems indebted specifically to a theatrical portrait, *Adrienne Lecouvreur as Cornelia* (in Corneille's *Death of Pompey*) by Charles-Antoine Coypel, engraved in 1730 by Drevet (fig. 56).[52] Cornelia's décolleté smock and her pose clutching a goblet-shaped urn containing Pompey's ashes is close to Hogarth's treatment of Sigismunda, and when he advertised an engraving of the work a few years later it was probably no accident that he said it would be executed "in the manner of Drevet." While Furini's Sigismunda is brooding over her

lover's heart on a salver (on the verge of gnawing her fingernails, it seems), Hogarth adapts Coypel's scene, turning her face upward but rejecting the sentimental upturned eyes. Her left arm is in the same position, a diagonal defining the lower limit of the plunging neckline. But while Coypel's figure looks, aspires, and strains upward, Hogarth's spreads out laterally. His first oil sketch, which survives only in Dunkarton's engraving (1795), was vertical like Furini's, Coypel's, and other compositions of this sort by Continental artists. He ended, however, by using his more accustomed horizontal shape.

The composition proceeds beyond the simple two figures of *The Lady's Last Stake* to a single figure spreading languorously across the picture space. This painting continues the generalizing tendencies of *Moses* and *Paul,* with a touch of the French elegance from *The Lady's Last Stake* in such details as Sigismunda's outstretched, curved fingers pressed to her bosom and the elegant S curves of the table and her billowing garments. The brushwork itself is smoothed until the face and hands are hardly recognizable as Hogarth's, and his own hand only becomes evident in the goblet and accessories. At the same time, however, Sigismunda's movement as she draws the goblet to her bosom is more dramatic, more exaggerated than Coypel's. A tension exists, moreover, between the simple composition and the careful, crowded iconography. Hogarth has made the best of his few symbolic objects. The heart of the lover in the goblet is balanced against Sigismunda's bracelet bearing the head of a king, clearly her father, who killed her lover. Even the landscape on the side panel of the box details a church or castle on the left and a Palladian villa with a dome (resembling Burlington's Chiswick House) on the right.

At the time Sir Richard saw the painting there was blood on Sigismunda's fingers from the heart she was handling. This realistic touch cannot have charmed him, and the heart itself was based on anatomical evidence. Hogarth's friend, the surgeon Sir Caesar Hawkins (whose portrait he painted), is said to have provided him with a heart from one of his cadavers.[53] A reader of the *Analysis,* however, would have remembered that the heart was the only inner, concealed part of the body that, according to Hogarth, was beautiful, "a simple and well-varied figure" (59).

Despite its classicized elements, the painting was founded on Dutch realism, if the stories of the human heart are true—and of the posing of Jane Hogarth for Sigismunda. Much of Hogarth's sensi-

tivity about this picture may be traced to this source. Wilkes noted unkindly that it was Jane "in an agony of passion, but of what passion no connoisseur could guess," and a housemaid of the Hogarths at Chiswick recalled that it was Jane grieving for her dead mother.[54] If the latter story is true, Hogarth must have made sketches at the time and used them later, for Lady Thornhill had died in November 1757, and *Sigismunda* was probably not conceived until after the Schaub auction in April 1758. The story is somewhat blunted if we accept the resemblance between Sigismunda and the lady of *The Lady's Last Stake*—and recall Smollett's story, back in 1751 in *Peregrine Pickle,* that Pallet's wife posed for his history painting of Cleopatra (for which read *Moses Brought to Pharaoh's Daughter:* above, 4). Perhaps Hogarth was simply utilizing Jane as his model for attractive young women. But then there is another possibility: following the criticisms of the painting, which included the likeness of Jane, he may have generalized the face, making it more like the lady's in *The Lady's Last Stake*.

Nevertheless, one wonders whether the subject was called for by the "Correggio" painting that fetched the huge price, or whether it was rather the subject that drew Hogarth's attention to the "Corregio" and its price? If the story about Jane posing for Sigismunda is true, it only underlines an irony already inescapable in the subject. In Dryden's version in his *Fables* (the one cited by Hogarth in his subscription book), though not in any earlier version, Sigismunda and Guiscardo have not merely become lovers despite her father's disapproval, but have gotten married. She has married without her father's consent—married *beneath* her. It is a very hasty and perfunctory marriage ceremony followed immediately by their falling into bed. In the second place, Dryden's Sigismunda stands up to Tancred: she is not frail, as she is in Boccaccio's version, but active. The parallel to Hogarth's own experience with Jane and Sir James must have been unavoidable.

Sigismunda's father Tancred selfishly sequesters her, but she falls in love with a young man

> Of gentle blood, but one whose niggard fate
> Had set him far below her high estate:
> Guiscard his name was called, of blooming age,
> Now squire to Tancred, and before his page.[55]

Guiscardo is a young plebeian, raised up by Tancred to be his pro-
tégé, but when he discovers the youth has fallen in love with his
daughter he forbids the match. Dryden recounts the story of their
secret courtship under Tancred's eyes, how they steal away and are
married, and how, after their marriage, they are discovered by the
angry father, who kills Guiscardo and sends his heart in a goblet to
Sigismunda; she fills the goblet with poison and drinks. Hogarth's
persistent efforts to have the painting engraved, to show it to the
public, and to sell it for an exorbitant price all suggest something of
the deep personal feeling that accompanied it—exacerbated, of
course, by Sir Richard Grosvenor's *rejection* of it (perhaps a memory
of Sir James's rejection in 1729)—and by the adverse criticisms over-
heard at the Society of Artists' Exhibition of 1761, which caused him
to withdraw the painting.

In this context, we might return to the Resurrection altarpiece in
Bristol: if the central role assigned Mary Magdalen reenacted in
Christian terms the Masonic myth of Isis and Osiris, we might also
see this myth in *Sigismunda* as well. The parallels to Hogarth himself
following the attacks in the academy war might help to explain the
new form he gives the story of the apprentice in *Sigismunda:* in
Hogarth's idea of a tragedy the lover is murdered by his enemies, and
his heart recovered by his wife.

Following upon *The Lady's Last Stake,* where love and sexual
desire were contrasted (love tenuously winning out), *Sigismunda*
represents love in extremis. Hogarth's Line of Beauty was sexual,
associated with Venus and the female figure, but not with romantic
love. The beautiful mediator who appeared in his paintings of the
1730s and 1740s was the aspect of his world Hogarth abstracted and
tried to talk about in *The Analysis of Beauty,* and she is what led him
to abstract completely in *Sigismunda* what had been workable in the
Analysis as part of a total structure, including intricacy, curiosity, and
the "love of pursuit." The end result in *Sigismunda* is mere Beauty in
a few serpentine lines—but now placed in the intensified context of
paternal tyranny, rebellion, and death.

On seeing the picture in June 1759, Sir Richard was taken aback
by this most un-Hogarthian of works, and responded with polite sur-
prise or disbelief—perhaps reminiscent of Garrick's unguarded reac-
tion to the likeness in the portrait of him and his wife. (Charlemont
had not yet received his picture: next to *Sigismunda* in Hogarth's show-

room, it must have made a striking contrast.) Hogarth was offended by Grosvenor's evasiveness. He tinkered with the picture a while longer, and on 13 June he wrote to Sir Richard (a draft of this letter is the first of a series of documents he preserved and pasted into the subscription book when he attempted to have *Sigismunda* engraved):

> I have done all I can to the Picture of Sigismunda, you may remember you was pleased to say you would give me what price I should think fit to set upon any Subject I would Paint for you, and at the same time you made this generous offer, I, in return made it my request, that you would use no ceremony of refusing the Picture, when done, if you should not be thoroughly satisfied with it. This you promis'd should be as I pleased which I beg now you will comply with without the least hesitation, if you think four hundred guineas too much money for it. One more favour I have to beg, which is, that you will determine on this matter as soon as you can conveniently, that I may resolve whether I shall go about another Picture for M^r Hoar the banker on the same Conditions or stop here.[56]

Henry Hoare, the banker, was a friend of Lord Lyttelton and was, like him, a gardening enthusiast: he was erecting at Stourhead during these years a Pantheon, described by Lyttelton as "an Abode worthy of all the Deities in Olympus," and also a picture gallery. He evidently intended to add a Hogarth to the latter, but either Hogarth decided not to chance another rejection, or Hoare benefited by Grosvenor's experience.[57]

According to Hogarth, while the painting was under way Grosvenor had fallen "into the clutches of the dealers in old Pictures." Knowing, he adds plaintively, "what a living artist was to expect where these gentry once get footing, alarmed our author so that he thought it best to set his Lordship at liberty to take the Picture or leave it," and so wrote the letter of 13 June. Sir Richard replied on the 17th:

> Sir
>
> I shou'd sooner have answer'd yours of y^e 13th Ins^t but have been mostly out of Town. I understand by it that you have a Commission from M^r Hoare for a Picture. If he shou'd have taken a fancy to the Sigismunda, I have no sort of objection to your letting him have it; for I really think the Performance so striking, & inimitable, that the

constantly having it before one's Eyes, wou'd be too often occasioning melancholy ideas to arise in ones mind: which a Curtain's being drawn before it wou'd not diminish in the least.

 I am, Sir,

<div align="center">your most obedient servant,</div>

<div align="right">Richard Grosvenor.[58]</div>

This letter, poised between compliment and insult, must have infuriated Hogarth. Grosvenor has purposely misread Hogarth's remark (admittedly a tactical error in itself) about Hoare and used it as a graceful way out; he has taken the awkward hovering between pathos and bathos (which was to characterize so many of the history paintings of the next few decades, but here perhaps pushed over the brink by the bloody hands) and left Hogarth to decide whether he means in any sense that the picture is simply too sublime for him, or that it is too atrocious. Partly for self-laceration, partly to let Grosvenor know that he was not intimidated, Hogarth wrote him yet again:

Sr Richard

 As your obliging answer to my Letter in regard to the Picture of Sigismunda, did not seem to be quite positive, I beg leave to conclude you intend to comply with my Request, if I do not hear from you within a week.

Sir Richard took no further notice of the affair, though his interest in Hogarth's "drolls" continued, and some years later he bought the painting of *The Distressed Poet*.[59]

Hogarth had apparently spread the news of his *Sigismunda* as he painted it, as was his wont, and inevitably his audience, with Sir Richard's rejection, elaborated and exaggerated the story. "Ill nature spread so fast," he later recalled, that "now was the time for every little dog to bark in there [their] profession and revive the old splene which appeared at the time my analysis came out" (AN, 220). In the same year, 1759, Reynolds, who had been famous for his caricatures while in Italy, made a semiprivate joke at Hogarth's expense by painting his own version of a contemporary lady in the pose of a tragic heroine. He chose the courtesan Kitty Fisher, said to be his mistress, as "Cleopatra" (fig. 57), making her gesture, décolletage, and goblet look suspiciously like Sigismunda's. It seems likely that he knew the stories of Jane's posing.[60]

The sequel was Hogarth's obsessive concern with this picture, and his refusal to sell it for less than the "Correggio" had brought at Schaub's sale. Anecdotes of his love of flattery generally refer to *Sigismunda* rather than to those works about which he felt more secure. "Garrick himself was not more ductile to flattery," one of these accounts says. "A word in favour of his Sigismunda might have commanded a proof print or forced an original sketch out of our artist's hands. The furnisher of this remark owes one of his scarcest performances to the success of a compliment which might have stuck even in Sir Godfrey Kneller's throat." Wilkes, though maliciously, was undoubtedly remembering actual evenings with Hogarth and the circle—Thornton, Colman, and Churchill—that was gathering around him at this time over their cups and listening to the story of *Sigismunda:* "All his friends remember what tiresome discourses were held by him day after day about the transcendent merit of it, and how the great names of *Raphael, Vandyke,* &c. were made to yield the palm of beauty, grace, expression, &c. to him, for this long-labour'd, yet still *uninteresting,* single figure."[61]

One of these conversations in 1759 took place at Charles Perry's house, apparently near Chiswick, and afterward Hogarth let off steam by composing some Swiftian verses which he sent on 7 August to his friend Dr. George Hay (then on the board of Admiralty) and perhaps to others as well:

Chiswick 7th August 1759

Dear Dr Hay

Notwithstanding I was sensible that what you said to me at Mr Perrys, proceeded from friendship only, I could not help being more affected by it than by Sr Richards refusal of the Picture, as you may see by my setting down to scribble the following foolish verses which you have on the other side turn'd into English by my friend Paul Whitehead.

I am your most humble Svt
Wm Hogarth

To Risque, I own was most absurd,
Such labour on a Rich mans word,
Tis true a pittiful demand,
Must oft content a modern hand,
For living Artists ne'er were paid,

> But he agreed to grant me dead,
> As Raphael, Rubens, Guido Rene,
> Twas this indeed that drew me in,
> To lose two Hundred quiet days,
> Of certain gain for doubtful praise.
> When a new piece is ventured forth,
> Tis hard to fix upon its worth.
> Because you find no copied line,
> Or colours from the masters shine,
> The picture cant be right your sure,
> But say my Friend, or connoisseur,
> Why doth it touch the heart much more,
> Than Picture ever did before,
> Confest by even S^r himself,
> But used as Plea to save his Pelf,
> I have his letter on my shelf,
> Which Plea if t'was sincerely given,
> Is a most curious one by heaven,
> How'er I wish you'd understand
> On this I ground my whole demand. [62]

As the verses show, Hogarth would have liked to think that Grosvenor was not being ironic when he described the picture's effect on him; to some extent he may have believed Grosvenor, to some extent adopted his words as evidence for his argument, which required that the picture be powerful. The verses, much revised by Whitehead, appeared in a number of periodicals after Hogarth's death. [63]

Also in August, Hogarth finally finished Charlemont's painting and, perhaps still chafing from Grosvenor's response to *his* picture, asked him to name his own price. Charlemont, who was sitting for his portrait to Hogarth at this time, confessed with much flattery that he was very hard up and leaving immediately for Dublin:

Dear Sir Mount Street. 19^th Aug^ust 1759.
 I have been so excessively busied with ten thousand troublesome Affairs, that I have not been able to wait upon you, according to my Promise, nor even to find time to sit for my Picture. As I am obliged to set out for Ireland tomorrow, we must defer that 'till my Return, which will be in the latter end of January, or in the Beginning of February at farthest. I am still your Debtor, more so indeed than I shall ever be able to pay, and did intend to have sent you before my Depar-

ture what trifling Recompence my Abilities permit me to make you.
But the Truth is, having wrong calculated my expenses, I find myself
unable for the present even to attempt paying you—However, if you
be in any present need of Money, let me know it, and as soon as I get
to Ireland, I will send you, not the Price of your Picture, for that is
inestimable, but as much as I can afford to give for it. Sir, I am, with
the most sincere Wishes for your Health and Happiness
 Your most obedient Humble Servant

Charlemont.[64]

In January, with more flattery about the unworthiness of the price
for such an inestimable picture, Charlemont sent Hogarth £100:

Dear Sir Dublin. 2ᵗʰ Janʸ. 1760.
Enclosed I send you a Note upon Nesbitt for one hundred Pounds,
and, considering the Name of the Author, and the surprising Merit of
your Performance, I am really much ashamed to offer such a Trifle in
recompence for the Pains you have taken, and the Pleasure your Pic-
ture has afforded me. I beg you wou'd think that I by no means at-
tempt to pay you according to your Merrit, but according to my own
Abilities. Were I to pay your Deserts I fear I shou'd leave myself poor
indeed. Imagine that you have made me a Present of the Picture, for
litterally as such I take it, and that I have beg'd your Acceptance of the
inclosed Trifle. As this is really the Case, with how much Reason do I
subscribe myself
 Your most obliged humble Servant

Charlemont.[65]

Ignoring their evasiveness, Hogarth showed these letters expressing
Charlemont's satisfaction to visitors to his studio.[66]
 At first it is puzzling that Hogarth should have been so enthusiastic
over Charlemont, who seems to have paid him more in words than
in hard cash—and whose explanation of why he paid so little is re-
markably similar to Grosvenor's explanation for paying him nothing
at all. Perhaps Hogarth was so hungry for praise that he accepted
these letters at face value; perhaps kind words from a well-known
connoisseur and politician, scion of an old and noble family, meant
more to him than the money—certainly they offered a striking con-
trast to Grosvenor. Perhaps he knew that Charlemont was in fact
hard up; Grosvenor was immensely wealthy. According to Jane

Hogarth, writing to Charlemont years later, Hogarth "always used to mention, with the greatest pleasure and gratitude, the honour of that friendship your lordship conferred on him, with that ease, and politeness, peculiar to yourself; and I can say with the greatest truth, that, the kind manner you always behaved to him, was the highest pleasure he felt, in the close of his life."[67] Charlemont had elicited these words by recalling "the affection I bore" him, and "my high regard for his memory," suggesting that Hogarth had been one of the educative forces of his early life.[68]

They apparently continued to see something of each other in an informal way; probably Charlemont treated Hogarth with filial respect, and he later remembered that Hogarth promised him a written description of his plates (this would have been around 1763 when he was planning such a project), "which he said the public had most ignorantly misconceived; and it was his intention, at one time to have given a breakfast lecture upon them in the presence of his Lordship, Horace Walpole, Topham Beauclerk, and others"—but he never did. He also recalls that even after he had paid for *The Lady's Last Stake,* Hogarth kept the painting for another year, "with an intention to engrave it, and even went so far as almost to finish the plate, which, as he told me himself, he broke into pieces upon finding that, after many trials, he could not bring the woman's head to answer his idea, or to resemble the picture."[69] This would have been in 1760, the presumed year of Hogarth's illness; Hogarth at this point still intended to engrave both of his recent paintings, *The Lady's Last Stake* as well as *Sigismunda.* His inability to finish the former was the first of a series of uncompleted engraving projects during these years.

The Lady's Last Stake hung in a bedchamber in Charlemont House in Dublin.[70] The portrait (fig. 58), for one reason or another, was never finished. On an ochre ground only a bluish gray background is indicated, and a bit of red at the collar. Otherwise Hogarth finished only the face, a metaphor, in effect, for his relationship with Charlemont: the lips are too red, the smile too artificial, the face too idealized. Hogarth kept the portrait. The earl bought another Hogarth painting, *The Gate of Calais,* presumably after the Society of Artists' Exhibition in 1761 where it was shown.[71]

9.

Covert Politics

Beautiful versus Sublime, 1758–1760

CARICATURE AND *THE BENCH*

In mid-1758—after publishing the last of the four prints of *An Election*—Hogarth made a small, elegant oil sketch (5¾ × 7 in., fig. 59), on the same scale as the modello for his self-portrait, which he had published in March, but in style closer to the *Election* paintings; it is marked by the same stencillike application of paint, the same grays, blues, whites, and a single red in the fat judge's robe (the background is Hogarth's usual neutral grayish olive green). In September he published *The Bench* (fig. 60), which would have struck his public as a surprising subordination of illustration to text, not unlike a page from the *Analysis*.[1] It must have appeared to be another work of Hogarth the writer and pedagogue; the image was a meditation on taste and on the idea of judgment discussed in the *Analysis,* but the text returned to the subject of *Characters and Caricaturas* of 1743 (ill., vol. 2, fig. 88).

The idea of judgment had been put in question by the attacks on the *Analysis*. In chapter 6, "Of Quantity," Hogarth had referred to the "awful dignity" imparted to the judge's robes "by the quantity of their contents" and to the "sagacity" and "dignity" the wig adds to his countenance. His portrayal of the judges in *The Bench* exemplifies character as opposed to caricature; and there is a reason for his choice of this particular profession, where the wig and robes, themselves outré by his definition, almost conceal the faces. In chapter 11,

he defined "character, as it relates to form" as depending "on a figure being remarkable as to its form, either in some particular part, or altogether." But, he adds, "no figure, be it ever so singular, can be perfectly conceived as a character, till we find it connected with some remarkable circumstance or cause, for such particularity of appearance; for instance, a fat bloted person doth not call to mind the character of a Silenus, till we have joined the idea of voluptuousness with it" (99). That the thin, long-nosed judge is taken from the judge on the funerary monument in *Analysis,* Plate 1 (which would have appeared only half-a-dozen pages earlier in the folio of his collected works), suggests that Hogarth wishes to emphasize the connection. There the judge was an epitome of false sagacity, his robes attempting to conceal stupidity and cruelty, and a metonymy for the bad judges of art. Here the judges, dominating the picture with their heavy, pompous shapes and stupid, inattentive, or malicious faces, appear to be not only examples of character but, as judges, themselves caricatures of judgment.

The judges are sitting in the Court of Common Pleas—the court which dealt with cases between subjects (i.e., between Hogarth and his peers), not between subject and monarch. The wall behind the judges carries the royal arms with the unicorn and "MAL Y PENSE" and "SEMPER EADEM." Once again (as in *The Sleeping Congregation*) Hogarth cuts off the royal arms ("Honi soit qui mal y pense") to describe an aspect of governance: these judges, "always the same," "think evil."

The heavy judge in the center has been identified as Sir John Willes, the chief justice of the Court of Common Pleas.[2] Willes was a man whose learning and ability were dimmed by his reputation for immorality; he was another judge, in the mode of Felix in *Paul before Felix,* whose own morals are worse than those of the accused upon whom he passes judgment. He was also the judge who would not recommend mercy for Bosavern Penlez, a harsh judgment in which Fielding had concurred at the time. The judicial metaphor had played a part in Hogarth's work almost from the start,[3] but *The Bench* sums up his concern at this point with the metaphor of judgment in both moral and aesthetic matters.

Hogarth initially dedicated the print to the caricaturist George Townshend (fig. 60) but apparently thought it might be misunderstood and removed the dedication before publication, adding

"CHARACTER" above the design to recall *Characters and Caricaturas*. As the latter was inspired by Arthur Pond's importation and reproduction of Ghezzi's caricatures, *The Bench* was a response to Townshend's *political* caricature. As a connection with the *Analysis,* the print recalls that "Capt. T———d," credited by Sandby with the idea for *The Painter's March from Finchly,* was one of the attackers of *The Analysis of Beauty.* More recently, he had instigated the Militia Bill, aimed against the duke of Cumberland, at which Hogarth had made a swipe in *Election* 3. Townshend had served for a time as the duke's aide-de-camp, and they came to heartily dislike each other. Accordingly, when Newcastle appointed Fox, Cumberland's chief supporter, secretary of state and leader of the House, Townshend broke with Newcastle and became a supporter of Pitt. The Militia Bill he sponsored was both his way of attacking the duke and a method "of resuming a military life outside the Duke's domain," the regular army.[4] Townshend moved for the bill on 8 December 1755, and in the following months, as the bill was pending, he began to produce a series of cards with caricatures of political figures, beginning with one of Newcastle and Fox facing each other and crying, with Peachum in *The Beggar's Opera,* "Brother, brother we are both in the wrong" (*BM Sat.* 3371). Of course he caricatured Cumberland (fig. 61).[5]

Hogarth explained in a letter to "Mr. B." (who had queried him on his text) that the reason for making the print was "the Injury I have for this twenty years sustained by the wilful mistake of my enemies and the innocent mistake of my Friends, many of whom when I have set them to rights have blushed at the offense it would have been and thank me for my explanation." He recounts how he first made *Characters and Caricaturas,* and then fifteen years later, still dissatisfied, *The Bench.*[6] One difference is that in the former the image still predominated, although some words were used, while in the latter the words nearly fill the page—and overflow into the reply to "Mr. B." *The Bench,* is, in fact, the only piece of writing Hogarth published under his own name after the *Analysis,* and it may have been worked up from one of the rejected passages.

"B." notices that the text is indeed the primary part of Hogarth's print, "intended for the instruction of the ignorant world," and the print itself rather insignificant. His first point is that despite Hogarth's claim, the distinction between character and caricature is very

well known and hardly needs further explanation. Second, he hits upon the one point of originality in the inscription, in which Hogarth backs up the critics' position on the crudity of caricature (Félibien, for one, defines caricature as a likeness done in a few strokes), by pointing out that it encourages poor drawing in students. Caricature, "B." replies, is as valuable in its way as character. Exemplifying "character" by the works of Clarendon, Shakespeare, and Hogarth himself, "B." simply argues that "caricature" can involve as skillful drawing and as much genius as its more elevated opposite. The common sense of this letter should have reminded Hogarth that the caricature of an Italian singer he refers to in *The Bench* (a straight perpendicular stroke with a dot over it) is analogous to his own abbreviations of St. George and the Dragon or the grenadier and his dog entering a tavern (above, 123).[7]

If one implication of Hogarth's aesthetics of the Beautiful was an erotics, another—though Hogarth vigorously denied this—was caricature. Sandby, in his attacks on Hogarth, was implicitly noticing this fact; and his and others' responses led Hogarth to make the distinctions explored in *The Bench,* which attempted to raise his work above caricature. But basically the principles were the same, and Hogarth demonstrates in both the *Analysis* and the prints that followed (the *Election, Bench,* and *Cockpit*)—far more richly and significantly than Townshend—the point at which caricature joins art and politics.

The Bench shows the way from Hogarth's aesthetics of the Ridiculous to Rowlandson's bulging forms and particular version of caricature (which Hogarth would probably have regarded as "character"). The dual aspects of caricature as it emerged in the work of Rowlandson and Gillray were first its lowness—indecency and bad taste, its egalitarian "crowd" aspect, as it dredges up the old carnival imagery of body as well as projecting new populist images of equality—and second its etymological sense of *charge* (*caricare*), its exaggeration, quite literally its liberty in the handling of people, reducing the high to the low, *and* therefore its equality, its evenhanded leveling, its exposure of every universal to contingency. Hogarth had originally, in the 1740s, objected to caricature as a plaything of an elite, worse the young gentlemen who traveled to Italy to learn connoisseurship and follow foreign models. But he was forgetting that it originated among the Carracci as an escape from academicism, the relaxing play based on a single feature or line—precisely what he is

said to have amused himself doing.[8] Caricature assumed the conscious slumming of a sophisticated artist: the donning of lower-class trappings in order to be more expressive than was possible within the conventions of high art. Hogarth's own style was on the verge of being—as Gillray's style would be wildly—parodically baroque; and his baroque (the best example was the *Election*) was not normative but subversive both aesthetically *and* politically of all that the baroque stood for in England—the England of St. Paul's Cathedral and the Naval Hospital at Greenwich, the ceilings in Rubens's Banqueting Hall and Thornhill's Greenwich Hospital.

But another crucial fact Hogarth cannot have missed was that attaching caricature to political figures drew attention to the close interaction of art and politics, specifically in caricature's transgression of aesthetic and—linked to—political and social authority.

THE SUBLIME: BURKE AND PITT

In Hogarth's lifetime there were three translations published of Longinus's *Peri Hupsous,* in 1712, 1724, and in 1739 the popular one by William Smith. Even in his youth the Longinian vocabulary had informed the art criticism of Jonathan Richardson and others—history paintings were "great" or "sublime." In 1740 George Turnbull's *Treatise on Ancient Painting* had gone slightly further, probably following Addison's *Spectator* No. 412 on the pleasure that the imagination takes from the contemplation of space. This "greatness," contrasted with "beauty," is found in prospects of "a vast uncultivated Desart, of huge Heaps of Mountains, high Rocks and Precipices, or a wide Expanse of Waters . . . in many of these stupendous Works of Nature" (84–86). Hogarth had carefully distinguished sublimity from Beauty in his *Analysis:* "Huge shapeless rocks have a pleasing kind of horror in them, and the wide ocean awes us with its vast contents; but," he adds, "when forms of beauty are presented to the eye in large quantities, the pleasure increases on the mind, and horror is soften'd into reverence" (46). In his next history paintings, for St. Mary Redcliffe, he tried to conform to general ideas of sublimity, using a tomb, rocks, and great spaces.

Edmund Burke's *A Philosophical Enquiry into the Origins of Our Ideas of the Sublime and Beautiful* (1757) radically redefined the Sublime: no longer the general sense of elevation that Hogarth had already represented in his "sublime" histories but a more aggressive force that would have political overtones and come to represent for Hogarth in his final years the enemy of both the virtue of his "modern moral subjects" and the Beautiful of his aesthetics. Although the *Philosophical Enquiry* was allegedly well under way before Hogarth published *his* treatise, the timing of its publication made it appear a response to the *Analysis*. One can imagine Hogarth opening a copy and seeing in Part 1, section 1, the reduction of "curiosity" (a chief motive of his Variety/Intricacy) to "the most superficial of all the affections" with "always an appearance of giddiness, restlessness and anxiety"; and in the following sections the replacement of "pleasure" with "delight" and indeed "pain," because the latter are more powerful, "productive of the strongest emotion which the mind is capable of feeling": in short, the Sublime, based on terror and power, precisely the subject of Hogarth's negative meditations on Fielding's *Enquiry*.[9]

At this point Hogarth would have regarded Burke's treatise on the Sublime as an answer to his own on the Beautiful; and Burke's Sublime represented everything Hogarth saw going wrong with politics as well as art in the 1750s, much of it immanent in his *Election* prints. Burke associates beauty and pleasure (as Hogarth had done) with love and "multiplication of the species"; with society, "Good company, lively conversations, and the endearments of friendship" (43). But he clearly prefers the Sublime with its focus on self-preservation, solitude, and self-enclosure, but also on the destructive power which Hogarth had connected in *Analysis* Plate 1 with bad judgment, hangings, and ruined cities.

The affront, however, must have come when Hogarth turned to Part 2 and read Burke's sections 2 and 3, on "Terror" and "Obscurity," in which, without mentioning Hogarth's name, he argues for the superior sublimity of the poet's more suggestive (because vague) words over the painter's graphic image, which unfortunately must specify details that the poet can leave to the imagination. Burke denied the privilege Locke and Addison gave the visual ("a Picture bears a real Resemblance to its Original, which Letters and Syllables

are wholly void of. Colours speak all Languages, but Words are understood only by such a People or Nation" [*Spectator* No. 416]); he located the Sublime in words and the Beautiful in pictures, at the same time devaluing pictures as he devalued the Beautiful. Hogarth (following Locke and Addison) never questioned the primacy of sight or the fatal instability of words. Burke took up the term "obscurity" (the realm of Dulness and *Bathos* for Pope and Swift as well as Hogarth) and attempted to revalue it by turning it into the Sublime. And the particular subject he singled out as his example corresponded rather closely to a painting by Hogarth.

Hogarth's *Satan, Sin, and Death* (probably datable in the late 1730s, ill., vol. 2, fig. 42) would have been a topic of conversation among the St. Martin's Lane artists. Hogarth talked about such projects and displayed them in his shop. Burke, who was in London from 1750 onward, would have heard reports of Hogarth's attempt to illustrate Milton even if he had not seen the painting itself.[10] Indeed, we can imagine that Hogarth assumed Burke had not actually seen the painting, basing his judgment on hearsay, as, for example, Turnbull had based his theory of antique painting on verbal descriptions of paintings that did not themselves exist.

The subject of Hogarth's "sublime" history paintings would have been especially warm with the academy controversy and his painting and engraving of the biblical subjects, *Paul before Felix* and *Moses Brought to Pharaoh's Daughter*. When he painted these histories he was implicitly honoring the sense of "great" or "sublime" applied in the first half of the century to the heightened idealization of Raphael's cartoons and frescoes.[11] As we have seen, his use of St. Paul was at least partly because the latter was regarded as a "sublime" New Testament figure—a justification for sublimity in the New Testament, as opposed to the more familiar citation of the Old. "Sublime" may have been the wrong word for these uncomic histories; Hogarth—and probably Burke too, though derisively—would have regarded them as *beautiful*. But for his example of terror-as-obscurity Burke goes back to another, a peculiarly *un*-Raphaelesque composition in Hogarth's *Satan, Sin, and Death*.

Hogarth's painting, though unfinished and in places indistinct, could nevertheless have elicited the sort of response Charles Lamb later had to illustrations of Shakespeare in Boydell's Gallery: "To be tied down to an authentic face of Juliet! to have Imogen's portrait! to

confine th'illimitable." [12] There is no doubt that Hogarth's figures, especially with their brightly colored garments, are slightly comic in their reach for the passions and may have elicited Burke's remark that in history painting "a gay or gaudy drapery, can never have a happy effect" (82). Hogarth's evident retreading of the basic composition he had used for his conversation pictures—making of this "sublime" subject virtually another *Beggar's Opera*—might also have proved risible to the unsympathetic Burke, brought up on higher models of the graphic sublime than the group portrait (see vol. 1, fig. 59).

Burke in fact adopts, or perhaps more precisely echoes, Hogarth's particular composition of Sin holding apart Satan and Death, for which there was no graphic precedent among Milton illustrations. He simulates it in his text by quoting first Milton's description of Death and second—a page later—of Satan rising up from the fiery lake. The verbal example Burke adduces for terror-as-obscurity is Milton's figure of Death in Book 2: formless except for his crown, he cannot be grasped or comprehended, certainly not represented graphically by a painter. Then by adding the passage in Book 1 describing Satan rising to address his legions, Burke manufactures a confrontation of Satan and Death similar to Hogarth's. But he suppresses the third, and for Hogarth primary element, Sin. Between Satan and Death in this scene is implicitly the female figure of Sin, the daughter-lover, mother-lover of the two contestants—whose positioning in Hogarth's painting is central.

In short, Burke shifts his emphasis from Hogarth's woman (Hogarth's Beautiful) trying to reconcile Satan and Death (or in the *Beggar's Opera* paintings, Polly Peachum between Macheath and Mr. Peachum) to the oedipal confrontation of two interchangeable males, father and son, king and subject, over a repressed mother-lover. For Hogarth the female figure, Sin, represented Beauty—in all of *The Analysis of Beauty* senses, of novelty, pleasure, desire, energy, and variety/intricacy—which was omitted or polarized by Burke's Sublime. For Hogarth precisely the figure of the woman mediating between Shaftesburian order and the forces of disorder (now rendered sublime) constituted the Beautiful.

The Beautiful was also, of course, exemplified by a woman in Burke's system, but she is elsewhere, subordinated to the sublime male. Like Hogarth's Beautiful she is associated with ordinary domestic, bourgeois values and objects such as the smokejacks, corsets,

and candlesticks invoked in the *Analysis*. The features of this Beautiful are labor, utility, and repetition (literally epitomized for Hogarth in his own engraving process), which in a general way correspond to custom and constituted society. Hogarth's monist conception of Beauty regards the Sublime as simply outré when no longer subsumed under the Beautiful. Burke, following Addison, dichotomizes the aesthetic experience into Beautiful and Sublime, neither signifying without the other, its opposite. The Beautiful forms Hogarth's world (a social world), which he therefore saw threatened by the Burkean Sublime, embodied in the male who exerts power (assaulting the beautiful female) and represents an aristocratic, magisterial, warlike, and irrational ethos.

Already, however, Hogarth had begun to change the role and position of the beautiful woman. A tragic (or Puritan) strand began to appear in 1751 with the parody Madonna-Child of *Gin Lane* and the pregnant, murdered girl of *Cruelty in Perfection*. In the years following publication of the *Analysis,* this figure was distanced to the young women high above on a balcony, being courted by candidates, and Britannia stranded and ignored in her broken-down coach (*Election* 2, 3). Britannia may have been the transitional figure for Hogarth, merging as she does art and politics. In *Election* 3 he put her in the deserted and beleaguered position of Thomson's Britannia in his opposition poems *Britannia* (1729) and *Liberty* (1735, 1738), both dedicated to Prince Frederick. Thomson's popular song "Rule Britannia" appeared in his Opposition masque *Alfred* (1740), for which Hogarth executed a ticket (later used as one of the subscription tickets for the *Election; HGW,* no. 151). Now, after reading Burke's *Philosophical Enquiry,* Hogarth painted the young woman of *The Lady's Last Stake,* whose virtue is in the balance, and Sigismunda, who, though she is alone and dominates the picture space, is taking poison. Beauty is under threat, until finally, absent except for the broken Lines of Beauty, in *Tail Piece, or The Bathos* (fig. 112) it has been destroyed by the Burkean Sublime. The causes? Obviously the issue was not just the advent of Burke's *Philosophical Enquiry* but also the reaction to the *Analysis* and the academy quarrel, and especially Hogarth's disillusionment with politics and government in the mid-1750s. With the new political dimension of the *Election* prints, Burke's Sublime appeared in effect to be destroying Hogarth's Beautiful as the Pittites were destroying England.

THE COCKPIT

The Cockpit (called by Hogarth, in his advertisement and his print list, *A Cock Match,* fig. 62), published in December 1759, carries signs of the aesthetic controversy:[13] Hogarth now replaces his woman in the central position with the tall, imposing figure of a man, in fact a blind man. *The Cockpit* opens the last phase of Hogarth's engraved histories. This is basically a new composition for him, although it obviously owes something to the parodic Last Supper of *Columbus Breaking the Egg.*[14]

It is appropriate that he attended yet another performance of Gay's *Beggar's Opera* (with *The Cheats of Scapin*) on 21 November;[15] but it is also significant that a year before, he had received William Huggins's translation of Dante's *Inferno* and promised to read it.[16] His friend Huggins was the first English translator of *The Divine Comedy,* though only twenty lines of his *Purgatorio* were published in 1760.[17] Hogarth gently declined to furnish Huggins with illustrations, but he evidently read the *Inferno:* a few years before, he said regretfully, he might have undertaken such an ambitious project. Moreover, in 1756 in the *Essay on the Genius and Writings of Pope,* Joseph Warton singled out Dante's poem as an example of the Sublime: "perhaps the Inferno of Dante is the next composition to the Iliad, in point of originality and sublimity"; Warton's example was the story of Ugolino, another lonely male figure, surrounded by his sons.[18]

The influence of Dante's *Inferno* is evident in *The Cockpit,* which conveys in the actions of people trapped in futile and repetitive actions a sense of "damnation" which was not evident before in Hogarth's work. Even the circular structure—something required of a cockpit (and anticipated in the dissection theater of *The Reward of Cruelty*)—recalls the circles of Dante's hell.[19]

Once again literature has influenced Hogarth's art. But now it is no longer *The Beggar's Opera,* which imposed its pattern on *Satan, Sin, and Death;* what followed Hogarth's encounter with Dante's hell was a series of prints that return to the emblematic mode of his earliest efforts and in some sense portray hell, whether in a cock match, a Methodist congregation, or a fire in a London street. *Enthusiasm Delineated* (of about the same time, fig. 64) recalls the *Inferno,* down

to the Dantesque observer watching these damned souls with fascinated attention through a window. The women are marginalized to the infernal crowd, one suffering a religious seizure, another enthusiastically embracing a male member of the congregation. Huggins's Dante confirmed Hogarth's darker anxieties and the images (such as the *Election*'s out-of-control crowd) he had already selected to express them.

Dante's hell furnished Hogarth with a religious context, even one of apocalypse, an idiom for an alternative to Milton's hell in the first two books of *Paradise Lost,* and a response to Burke's criticism of *Satan, Sin, and Death. The Cockpit* is certainly within the sublime range, with more *terribilità* than *Satan, Sin, and Death,* as the print of *The Reward of Cruelty* is a more powerful expression of history painting than any of Hogarth's paintings. But its subject is not conflict, let alone mediation, but solitary obsession: the old Scriblerian interpretation of *hupsous* as *bathous,* of the "sublime" hero as self-deluded claimant to autonomous selfhood. *The Cockpit* produces an image of focused desire and self-enclosure which, in Miltonic terms, appears satanic. In terms of a Last Supper, the figure of Christ—in this context, anti-Christ—is a nobleman who gambles furiously among a crowd of equally obsessed plebeians (but including at least two other noblemen) who follow his lead. Even the man suspended in a basket (for failure to pay his debts) desperately tries to place another bet.[20] The central figure imparts a kind of sanction to all the others, as Christ did to the disciples, as Satan did to the rebel angels, with in this case the implicit verbalization of "The blind leading the blind."

One senses in the juxtaposition of the nobleman and the mixed orders grouped around him a residue of Hogarth's *Election* (certainly an echo of Pl. 1) and the political situation of the late 1750s. For the Cockpit—the Cockpit Royal in St. James's Park, referred to frequently in the papers at this time[21]—was not only the best-known place where cock matches were held in London (the print has "Pit Ticket" inscribed at the bottom); it was the name attached to a building opposite Whitehall Palace, erected on the site of Henry VIII's cockpit, used for government offices. It was a familiar designation for the "Treasury" and the "Privy Council chambers," and so a word designating the reigning ministry, while at the same time suggesting the analogy between this government and the gamblers at a cockfight.[22] In short, this is another print in the politico-allegorical mode

of *The Stage Coach* and *Election* 3 and 4, anticipating *The Times, Plate 1:* Pitt's ministry (and so England) is a "cockpit" (as later, in the revision of *Rake* 8, England is designated a madhouse), and the portrait of the nobleman, identified by early commentators as the blind Lord Albemarle Bertie,[23] doubles as a reference to Pitt (at the same time activating another Hogarthian pun, Cock-*Pitt*) with the "blindness" and the Christological pose part of the satire. For Pitt was precisely seen by his enemies as "blind" and, they felt, by himself as "Christ." The figure resembles Hogarth's versions of Pitt in *The Times* plates, especially his physique and wig (figs. 63, 92, 99). In the first state of *The Times, Plate 1* he also disguised Pitt, in that case as Henry VIII, an allusion to his absolute rule and his tyranny (fig. 91).[24] In *The Cockpit* the disguise alludes to Pitt's obliviousness ("blindness") and his reliance on the crowd—but also to his "gambling" with the fate of England as a frenzy that must have been linked in Hogarth's mind with the religious frenzy of *Enthusiasm Delineated,* with which it has much in common.

To understand how someone like Hogarth, whose position was in many ways ostentatiously democratic, could have distrusted the "Great Commoner" we must recall one description of Pitt in 1757 as "a man who has not the command of his own passions, or resolutions; whose ambition is *boundless* and his pride *without measure*, and is intoxicated with the adulation of his followers, and the applause of corporations, coffee houses, etc."[25] There are also references to "Pitt's vanity," "his ambition, his pride, or his resentment"; but the writer adds that he "was bold and resolute, above doing things by half; and if he once engaged, would *go farther than any man* in this country."[26] What is particularly notable are those words applied to Pitt—"boundless," "without measure," and "go farther than any man"—terms used by Burke to describe the Sublime.[27] Pitt's greatest fame was as an orator of unsurpassed eloquence—and with this went what has been called his "unique attempt to make 'popularity' a major continuing foundation of his political power."[28] Long before Burke, Longinus had associated the Sublime with the "power of the orator," and his suggestion that the Sublime carries all before it, including the orator himself, was a notion Hogarth used in the *Election* in his imagery of the crowd that is created by the unscrupulous politician whom it may then destroy (as in Pl. 4, fig. 40).

Of course, Pitt's oratorical powers and personality, which were (in

Marie Peters's words in *Pitt and Popularity*) "much better suited to appeal from above to the adulation of the people than to co-operate with colleagues in the normal workings of political connections" (of the sort analysed in the *Election*), *should* have appealed to Hogarth, whose aim was to circumvent the connoisseurs, dealers, and his fellow artists by appealing directly to the "public." But, as Peters explains:

> Opponents did not deny the claims to popularity and patriotism. Rather they sought to discredit them by suggesting that the popularity was unsoundly based, won by artifice from the giddy multitude who had no judgement in political affairs, that Pitt used it unscrupulously, and that the patriotic stands were insincere and inconsistent with previous or current actions.[29]

Pitt was a product of the forces unleashed by popular appeal— unchecked, Hogarth might have felt, by the subtle interplay of the popular and the polite, of the ironies that figure in his own rhetoric (and in his aesthetic theory in the *Analysis*). Pitt's oratory was regarded by his detractors as analogous to his ideology of aggressive commercial expansion that was supported by the financial interests of the City (not the middling merchants with whom Hogarth associated himself). This had taken the form of huge and wasteful gambling by May 1759, the year of Pitt's greatest triumphs, when the *London Chronicle* calculated the cost of Britain's part in the German war as £3,289,954 (compared to £823,759 in 1757).[30] The attacks on Pitt in June and July argued that he has been "blinded" by his military successes.[31] By the end of the year he was thought to be "gambling" on war gains against peace. This had become an issue in 1759, when "popular" opinion was gambling on holding all gains and reducing France to nothing, and "ambitions were growing with victories,"[32] while others, given the risks and the cost and burden of the German war, were arguing for cutting losses and agreeing to an early peace. Indeed, gambling could be read as a metaphor for trade: "Our dispute," as Beckford's pro-Pitt *Monitor* said, "is about the extent of trade; whether the trade genius of britain or of france shall prevail."[33]

The figure of the blind but magnetic Lord Albemarle Bertie is paralleled by the figure of the preacher in the print called *Enthusiasm*

Delineated (fig. 64). Both are surrogate Pitt figures as Hogarth had created surrogate Walpole figures in the 1730s (in a Macheath, a Cardinal Wolsey, a Sir John Falstaff), but characterized now by demagoguery, megalomania, and obsession. If the politician Walpole dominated the first part of Hogarth's career and stimulated his (as well as Fielding's) imagination, the politician Pitt can be said in the same way, but as a totally different sort of image, to have dominated the last years and determined their basic narrative.[34]

But, as I have suggested, an added element was the specific significance accorded to the Sublime in the late 1750s. It was discussed not just in Burke's *Philosophical Enquiry* but also in Alexander Gerard's *Essay on Taste,* published in 1759: in both the Sublime was a subject of chief concern.[35] "Great" now meant something very different from when Walpole—who had created the old oligarchic structure of power epitomized in the *Election* prints—was ironically, in a mock-heroic, bathetic way, referred to as the Great Man (as Fielding wrote of "Tom Thumb the Great"). Pitt, in the second half of the 1750s and especially in the context of the Seven Years' War, could be construed as a political equivalent of the Burkean Sublime; and the modification of those key words of the 1730s, "great" as well as "popular," must have created for Hogarth a dismaying Other.

Thus emerged the association of destructive power, tyranny, war, and the rest: Pitt's constituency and Burke's Sublime both find their effect in the "shouting of multitudes . . . [which] so amazes and confounds the imagination, that in this staggering, and hurry of the mind, the best established tempers can scarcely forbear being borne down, and joining in the common cry, and common resolution of the croud."[36] Indeed, in section 6 Burke quotes from Pitt's 1740 translation of the scene "at the mouth of hell" in *Aeneid* 6, invoking Chaos's "solemn empire [which] stretches wide around" and its "great tremendous powers."

Peter de Bolla has argued in *The Discourse of the Sublime* that the idea of excess in Pitt's personality, oratory, actions, and deeds was confirmed by the monetary, to some minds criminal, increase in the national debt that followed from (and made possible) the Seven Years' War—including the radical increase of foreign subsidies.[37] Foreign subsidies was an issue that would have interested Hogarth and reminded him of the influence of the foreign in art—and of the inconsistency and insincerity of Pitt, who, prior to being chief minis-

ter, had been the greatest opponent of foreign subsidies. And, of course, Pitt's dramatic about-faces, his inconsistencies, and his reputed unreliability and insincerity, as well as his gambling with fortune, introduced another dimension of the Sublime.[38] De Bolla's parallel between the Sublime and the national debt suggests why there was a shift from fear of the sublime excess to absorption of it into an aesthetic system (as by Burke); why contemporaries such as Hogarth who feared the monetary consequences of the war would also fear the theory of the Sublime, the supposedly growing power of the crowd, of Pitt, and of his oratory, and the national mania for gambling that is embodied in the hoisted gambler who cannot pay his debt but continues desperately to gamble. From Hogarth's point of view, however, the situation took him all the way back to the 1720s, to his *South Sea Scheme* and *Lottery* and to Addison's figure of credit (one moment Brobdingnagian, the next Lilliputian) as a trope for chaos; the Sublime remained for Hogarth resolutely the bathetic, as it had for Pope.

As in the academy controversy, in politics too Hogarth held the minority position. The press was almost totally behind the Pitt ministry by 1759, the "Year of Victories" ("this wonderful year," as Garrick put it in his song "Heart of Oak").[39] The other notable exception was Samuel Johnson, who questioned the wisdom of Pitt's imperialist position—of British, indeed European, intervention in other parts of the world—in terms of the effects on the natives as well as the bloodshed between French and English soldiers. He published his responses in the *Literary Magazine, or Universal Review* during the summer of 1756, and when that outlet was cut off he published in the *Universal Visitor* during the remainder of the year; in 1758 he returned with pieces in the *Universal Chronicle,* in both "Observations" on the war and his *Idler* essays.[40]

It seems likely that Hogarth also made an analogy on the level of imperialism between Pitt and the dissidents in his own world of art. Ironically, at the same time that the British were defeating the French in the New World, they had ended up colonized by the French and Italians in art. The Seven Years' War only brought to a head the theme Hogarth pursued since the 1730s in his paintings and engravings based on the dualism of native and colonist. His aim from the beginning had been to create a space for the struggles of the native English artist within the complex edifices of foreign power; but now

his colleagues in the artistic establishment (or at least an apparent majority) were begging for colonization at the hands of the Continental tradition, and this was coincident with the outreaching imperialist policy of the Pitt ministry.

But while the satire on art was out in the open, Hogarth's political satire, especially on Pitt, was so far covert and coded, recalling the dissident who, interrogated by the East German Stasi, was told: "I forbid you to write lines of poetry with double meanings."[41]

ENTHUSIASM DELINEATED

The term "enthusiasm" established the "sublime" connection between art, religion (the upsurgence of Methodism, the resurgence of dissent), and politics. *Enthusiasm Delineated* (fig. 64), though undated and unpublished, can be placed near the end of 1759 or the beginning of 1760. Its conception is illuminated by another sequence of events that began in the first half of 1759 with Hogarth's painting of *Sigismunda* for Sir Richard Grosvenor and Grosvenor's rejection of it, Warton's criticism of his history paintings, and Reynolds's *Idler* essays.[42]

In the advertisement of 1–4 December 1759 for *The Cockpit* (*London Chronicle*), Hogarth says he is also republishing the engravings of *Paul before Felix* and *Moses Brought to Pharaoh's Daughter*, "with the Rev. Mr. Joseph Warton's curious Remarks on the Author's Manner of treating serious Subjects." Warton's *Essay upon the Genius and Writings of Pope*, published in 1756, had (besides arguing for Dante's sublimity) at one point argued that a writer or artist cannot excel in more than one line, with Shakespeare and Garrick two notable exceptions, equally good at comedy and tragedy. Hogarth would probably have agreed. After seeing Garrick one night as Richard III, and the next as Abel Drugger, he said to his friend: "You are in your element, when you are begrimed with dirt, or up to your elbows in blood."[43] In Warton's essay, however, he found himself invoked, associated with Pope, who could *not* write sublime and pathetic poetry, only ethical, which Warton regarded as poetry of the second rank:

some nicer virtuosi have remarked, that in the serious pieces, into which Hogarth has deviated from the natural bias of his genius, there

are some strokes of the Ridiculous discernible, which suit not with the
dignity of his subject. In his PREACHING of St. PAUL, a dog snarl-
ing at a cat; and in his PHARAOH'S DAUGHTER, the figure of the
infant Moses, who expresses rather archness than timidity, are alleged
as instances, that this artist, unrivalled in his own walk, could not
resist the impulse of his imagination towards drollery. His picture,
however, of Richard III. is pure and unmixed with any ridiculous cir-
cumstances, and strongly impresses terror and amazement.[44]

If Hogarth was disturbed by this judgment of his art, he was doubly
irritated by Warton's error, which showed that he had not looked
closely at the painting in question. While both *The Pool of Bethesda*
and *The Good Samaritan* contain dogs (and the bas-relief has another),
there are none in either *Paul* or *Moses*.[45] Most likely Warton recalled
the burlesque subscription ticket, where a dog does appear wearing
a collar labeled "Felix."

It is possible that Hogarth and Warton had met, but they were only
friends of friends; the quarrel was carried out through intermediaries.
The year 1756, when the book appeared, was a relatively calm time
for Hogarth, and the matter was kept under control. On 21 April
1757 John Hoadly wrote Warton (in a letter already quoted from) to
say that the day before he had called on Garrick and Hogarth, and
read to the latter "your conscientious acknowledgement of your er-
ror with regard to his Pictures of Paul and Moses, and your promise
of amende honorable." Hogarth's reply to Warton was that "you
have more than conquered any resentment he might have harboured,
by your handsome acknowledgement; and your amende honorable is
a supererogation he neither expected nor desired." He sent with
Hoadly the two prints in question to prove his point, and Hoadly
goes on to explain Hogarth's intention in them.[46]

Apparently what Warton sent Hogarth was a draft of his emenda-
tion for the second edition. But the second edition did not appear
until 1762, and by 1759 Hogarth had painted his *Sigismunda* as a sub-
lime history painting and been rebuffed; and with his reputation
threatened (he feared) by Grosvenor's stories, his impatience got the
better of him. He was also at this time in close communication with
Huggins, who may have added to his suspicions of the Wartons.
Huggins would have convinced him of the stupidity of Joseph's
brother Thomas, whose *Observations on the Faerie Queene of Spenser*

(1754) he attacked in *The Observer Observed* (1756). His exclamations in the margins of his copy of Thomas's book are probably indicative of the tone of his conversation on the brothers. "Good Heavens!" he cries at one point, "what insolence! . . . what ignorance!"[47] One can imagine Hogarth and Huggins getting together to ridicule the error-prone Wartons, by 1759 no doubt impugning Joseph's motives for delaying publication of his retraction: and at the end of that year Hogarth engraved Warton's erroneous passages prominently on both *Paul* and *Moses* and reissued them with the clear advertisement of his intention. His feelings were so strong that he felt compelled to ruin the aesthetic effect of the prints (temporarily at least) in order to express them.

Warton's second edition did finally appear at the beginning of 1762, and on page 119 all but the complimentary reference to Hogarth's *Garrick as Richard III* is omitted, and a footnote is added:

> The author gladly lays hold of the opportunity of this SECOND EDITION of his work, to confess a mistake he had committed with respect to two admirable paintings of Mr. Hogarth, his PAUL PREACHING, and his INFANT MOSES: which, on a closer examination, are not chargeable with the blemishes imparted to them. Justice obliges him to declare the high opinion he entertains of the ability of this inimitable artist, who shines in so many different lights, and on such very dissimilar subjects: and whose works have more of what the ancients called the HΘOΣ in them, than the compositions of any other Modern. For the rest, the author begs leave to add, that he is so far from being ashamed of retracting his error, that he had rather appear a MAN OF CANDOUR, than the best CRITIC that ever lived.

Hogarth must have told Hoadly or Garrick that he thought Warton was ashamed to admit his error publicly. In January 1762 Garrick went to see Hogarth with a copy of the book, and described the scene to Warton:

> I was with Hogarth this morning, and alarmed him much with a dreadful account of your attack upon him. He grew very uneasy as I related the pretended manner in which you had shewn your resentment [for Hogarth's having printed the inscriptions after receiving an apology]—Confusion and shame overspread his face—He was much hurt. At last I told the real method you had taken to revenge your

injuries. This if possible hurt him more for what his peevishness had done; and he, thoroughly disconcerted, offered to destroy the plate in which your name is mentioned, for he declared that he would not be overdone in kindness.[48]

But a few days later Hogarth was again fretting, haunted by the possibility that Warton might have taken his revenge after all. Steevens rather maliciously remembers that

> when this ample, nay, redundant, apology by Dr. Joseph Warton first made its appearance, Hogarth, was highly delighted with as much of it as he understood. But not knowing the import of the word ΗΘΟΣ, he hastened to his friends for information. All, in their turn, sported with his want of skill in the learned languages: first telling him it was Greek for one strange thing, and then for another, so that his mind remained in a state of suspense; as, for aught he knew to the contrary, some such meaning might lie under these crooked letters, as would overset the compliments paid him in the former parts of the paragraph. No short time, therefore, had passed before he could determine whether he ought to retract or continue his charge against his adversary: but it was at last obliterated. For several months afterwards, however, poor Hogarth never praised his provision or his wine, without being asked what proportion of the ΗΘΟΣ he supposed to be in either.[49]

Besides the weight of the *Sigismunda* affair, another contribution to Hogarth's inscriptions on *Paul* and *Moses* may have been the *Idler* essays by Joshua Reynolds, published only a few months after the rejection of *Sigismunda*, just when they would have galled him most. Reynolds had earlier drafted some "Observations on Hogarth," which, beginning with "Sir," sound as if they were originally composed as a letter to some periodical. They appear to have been prompted by the academy dispute: "he treats his Brother Artists," Reynolds writes,

> pretty Cavilierly, by telling them that tho they knew the beauty of the line yet they did not know it Philosophically but as a Labourer who make[s] use of the Leaver [Hogarth's instance in his preface] knows not its powers as a Mecanical Philosopher; one might reasonably ex-

pect after this a philosophical investigation of this cause of the beauty of this line. Notwithstanding this air of superiority & self-sufficiency, he has given no philosophical account why this line of Beauty is so pleasing, it is so only because it is so.

He speaks of the "high prancing" of Hogarth's preface and his "galloping over his poor fellow-artists."[50]

This draft, however, never saw print; the cautious Reynolds decided to use the less direct, but more damaging, approach of irony: he has a connoisseur just returned from Italy parrot, of all people, "Britophil" Hogarth. The result was published anonymously in the *Idler* No. 76, 29 September 1759, by his friend Samuel Johnson. Reynolds was himself spectacularly flourishing. By 1759 his prices had gone up to 20 guineas a head, 50 for a half-length, and 100 for a whole length. In 1758–1760 he painted the duke of Cumberland, and duke of York, and the Prince of Wales, as well as Garrick, Sterne, Lord Ligonier, and many others. In July 1760 he bought a house on the west side of Leicester Fields, across the square from Hogarth's. His earnings totaled £6000 a year; soon he was riding in a splendid coach with allegories of the seasons painted on its panels and its wheels decorated with carved and gilded foliage.[51]

In *Idler* No. 76 the connoisseur, visiting Hogarth's beloved Raphael Cartoons, pauses before *Paul Preaching at Athens* (obviously the inspiration for *Paul before Felix*):

> "This," says he, "is esteemed the most excellent of all the cartoons: what nobleness, what dignity there is in that figure of St. Paul; and yet what an addition to that nobleness could Raffaelle have given, had the art of *contrast* been known in his time; but above all, *the flowing line,* which constitutes grace and beauty!"[52]

In one blow Reynolds has caught Hogarth's theories of "contrast" and the Line of Beauty, as well as his application of them in *Paul before Felix*. Reynolds's criticism is that Hogarth imposes a "principle," the serpentine line, on the practice of Old Masters such as Raphael. Not the "rule" but the actual, complex practice of the earlier artist should be studied, according to Reynolds. He catches Hogarth's position in the academy controversy by ironically referring to

"this enlightened age" in which "the art has been reduced to prin-
ciples" by an "education in one of the modern academies": *modern* as
opposed to the venerable French model. In the light of all the talk in
the *Analysis* about the "precise" line it was easy to forget that Ho-
garth's "principle," taken from experience, distilled from observa-
tion of life, was far less authoritarian than Reynolds's model of "the
blaze of expanded genius" of an Old Master, which (in Hogarth's
opinion) came down to mere copying. The first involved utilization,
the second emulation; the first a principle deduced from nature, and
the second from art. This opposition was at the heart of the contro-
versy over academies. For Reynolds's real point, as Hogarth knew,
was the *authority* of "Raffaelle" (as in the model-oriented system of
the French Academy) as opposed to the ad hoc practice of the St.
Martin's Lane Academy upheld by Hogarth.[53]

Reynolds wrote two more essays: No. 79, 20 October, was on the
"Grand Style of Painting," and No. 82, 10 November, was entitled
"The True Idea of Beauty." The last returns to Hogarth's "invari-
able" rule by arguing that beauty is based only on custom: a horse
is beautiful to a horse, a Hottentot to a Hottentot, and an English
woman to an English man.

No. 79, however, must have particularly irritated (and stimulated)
Hogarth. This essay begins with a statement that the nature of great
painting involves not mechanical imitation in the manner of the
Dutch genre painters, but the transformation of nature by the imagi-
nation in the Italian manner. Again Hogarth is Reynolds's quarry,
and he pointedly excludes from consideration Hogarth's experiment
of the "modern moral subject." First, he contrasts (as he does also in
No. 82) the Italian attention to "the invariable, the great and general
ideas which are fixed and inherent in universal nature" with the
Dutch attention "to literal truth and a minute exactness in the detail,
as I may say, of nature *modified by accident*" (emphasis added): pre-
cisely the "nature" of Hogarth's art, whether comic or "sublime,"
and of his aesthetics in the *Analysis*. Second, he criticizes Hogarth's
mixed mode: "To desire to see the excellencies of each style united,
to mingle the Dutch with the Italian school, is to join contrarieties
which cannot subsist together, and which destroy the efficacy of each
other." These words describe Hogarth's comic history painting, but
they can also be taken more specifically as an unsympathetic view of
his experiments in *Paul before Felix* and *Moses Brought to Pharaoh's*

Daughter, echoing the criticism of Warton. Reynolds, like Warton, calls for sublimity—and in this *Idler* he connects the sublime with "enthusiasm."

For, praising the "genius and soul" of Michelangelo's painting (aside from what he considers faults in technique), Reynolds writes: "If this opinion should be thought one of the wild extravagancies of enthusiasm, I should only say, that those who censure it are not conversant in the works of the great masters. It is very difficult to determine the exact degree of enthusiasm that the arts of painting and poetry may admit." He admits that too much as well as too little enthusiasm may be employed, and that even Michelangelo sometimes produced figures "of which it was very difficult to determine whether they were in the highest degree sublime or extremely ridiculous." Nevertheless, "One may very safely recommend a little more enthusiasm to the modern painters; too much is certainly not the vice of the present age" (247–48). As *Idler* 79 suggests, Reynolds, given his associations with the Continent and the Shaftesbury tradition of aesthetics, easily assimilated the Burkean Sublime.

If a trivial response to Reynolds's *Idler* essays was the inscriptions added to *Paul* and *Moses* to prove that Warton was wrong about the "Dutch part" of these paintings, a more significant one was Hogarth's launching into the engraving of *Enthusiasm Delineated,* in which he replied to Reynolds's taunt. *Enthusiasm Delineated* shows that, Reynolds to the contrary, it is not "very difficult to determine the exact degree of enthusiasm that the arts of painting and poetry may admit," and a thermometer is included for this purpose. What Hogarth does is conflate with Reynolds's "sublime" enthusiasm the religio-sexual sense satirized by Shaftesbury in *A Letter concerning Enthusiasm* and by Swift in *A Tale of a Tub.*[54] (Warton's dog also makes his appearance—though removed from the published version, *Credulity, Superstition, and Fanaticism* [1762, fig. 88]: his howling is parallel to the clergyman's preaching; his collar, labeled "Whitfield," suggests that he epitomizes the sound of Methodist oratory.)

Two impressions of the complete engraving have survived with the inscriptions added in ink. The handwriting is very shaky, perhaps suggesting the illness that seems to have overtaken Hogarth about this time. The conception is nonetheless vigorous, transforming the "enthusiasm" of the Old Masters into religious images that mingle with the sexual "enthusiasm" of religious fanatics. "The Intention of

this print," he wrote under the design, "is to give a lineal representation of the strange Effects of litteral and low conceptions of Sacred Beings as also of the Idolatrous Tendency of Pictures in Churches and prints in Religious books &c." (BM impression, reproduced). His examples, clear enough in the design but enumerated beneath, are those Reynolds listed at the end of *Idler* No. 79 as the highest examples of "the majesty of heroic Poetry": Raphael's ancient God supported by two angels, Rubens's muscular Devil holding a gridiron, and Rembrandt's roly-poly St. Peter. (He identifies only these three, but the puppetlike Adam and Eve probably allude to Dürer.[55])

As an example we can focus on the figure of the woman in the foreground of *Enthusiasm Delineated,* cradling a Christ image in her left arm, her teeth and hands clenched in a state of convulsion. John Ireland identified her as a likeness of Jenny Douglas, the most famous bawd of the 1750s, and the patch on her cheek may recall the face of the bawd in *Harlot* 1 (ill., vol. 1). Mother Douglas appeared as Mrs. Cole in Samuel Foote's *The Minor* (July 1760), where she is portrayed as a fanatical follower of Whitefield. Her death in June 1761 may explain why Hogarth changed her face into that of Mary Toft the "Rabbit Woman" in the 1762 revision, but Mrs. Toft may also recall Mrs. Cole's "comforts of the new birth" (spiritual rebirth) she has learned from Dr. Squintum: "So, in my last illness, I was wished to Mr. Squintum, who stepped in with his saving grace, got me with the new birth, and I became, as you see, regenerate, and another creature." After these words, she is offered "another thimbleful" of gin—which a hand is offering Mrs. Toft.

The figure is based on Giovanni Lanfranco's painting of St. Margaret of Cortona in ecstasy (Pitti Palace). History painting, as well as the equation of sexuality and religious enthusiasm, is the subject of Hogarth's print. On 2 December 1758 Robert Dodsley's tragedy *Cleone* had been produced at Covent Garden, supported by Johnson and condemned by Hogarth's friend Garrick, who had refused to produce *Cleone* at Drury Lane, calling it "a cruel, bloody, and unnatural play." The facts are that the heroine Cleone was played in contemporary dress, despite the protestations of Dodsley, and that in the climactic mad scene ("sitting by her dead child") she cradles the body of her murdered son while uttering an Ophelia-like rant. Then she goes into convulsions and, after a final moment of lucidity, expires. It is possible that the woman's contemporary attire and the

cradled Christ image, together with the memory of an ecstatic Roman Catholic saint by Lanfranco, may have overlaid the pious London bawd with another aspect of enthusiasm in art.

But St. Margaret is in ecstasy. The emphasis in terms of graphic art is on the Roman Catholics, whom Hogarth had recently shown carrying torture instruments of the Inquisition in the first *Invasion* print. By Roman Catholic Hogarth meant, in the context of the *Idler* papers, the ideas of art and academies associated with Paris and Rome. The Anglican clergyman reveals his close sympathy with the Roman church (disclosing his tonsure) by his assumptions about the religious art of Raphael, Rubens, and Rembrandt. The congregation as a whole is atavistic, reverting to the literal devouring of Christ's "body"—eucharistic figures whose phallic shape recalls the obscene pun of "Supper below" in *Masquerade Ticket* (ill., vol. 1). But many other sects, all enthusiast, are crowded into the church, itself a meeting house closely resembling Whitefield's in Tottenham Court Road.[56] At the reader's desk, the Methodist (who eschews images) exhibits his enthusiasm by preaching, singing, and weeping; and his sublimity is reflected in the audience's antics. The howling dog labeled "Whitfield" may permit us to recall Pope's note in the *Dunciad* (1743 ed., 2.258) that Whitefield "thought the only means of advancing Christianity was by the New-birth of religious madness." (In the revision the reader's face is changed to Whitefield's cross-eyed likeness.) A rabbi goes into ecstacy over a picture of Abraham sacrificing Isaac. Only the Muslim, outside the window, is quietly watching, like one of those foreign observers popular in satires of the time.

Although *Enthusiasm Delineated* is about art, readers could be excused for seeing it as part of a continuum with the hostile references to clergymen in the *Harlot, Rake,* and the eleventh plate of *Industry and Idleness.* It is likely, judging by the general composition, with the same arrangement of pulpit and reader's desk (though not the scale: 14 × 13 vs. 10 × 8 in.), that Hogarth intended an ironic contrast with the *un*enthusiastic *Sleeping Congregation* of 1736, already present on an earlier page of the Hogarth folio. As if to underline the parallel, Hogarth reissued a "Retouched & Improved" state of *The Sleeping Congregation* in 1762 two weeks after *Credulity, Superstition, and Fanaticism* (the published version of *Enthusiasm Delineated*), thus forcing the Hogarth collector to place the two prints on adjacent pages of the folio.

If Continental Roman Catholic art is the subject, the enabling phe-
nomenon—and the model in Hogarth's mind for the Pitt oration,
carrying out the parallel between politics and religion—was the
Methodist sermon, as delivered by George Whitefield and John Wes-
ley. Their preaching was characterized by the violent responses it
elicited. Members of the audience would appear to be possessed by a
spirit of terror and pain identified by Wesley with the devil's last
efforts to retain his hold: they would "roar for the disquietness of
their heart," would be "seized with a violent trembling all over," and
drop to the ground "as thunderstruck," sometimes in convulsions.
The phase of affliction was followed by relief, peace, and joy: they
would "burst forth into praise to God their Saviour" and were
"raised . . . up full of 'peace and joy in the Holy Ghost,'" or had
their "heaviness [turned] into joy."[57] Although Wesley denied it, he
and Whitefield were accused of having preached hell fire in order
to elicit this violent response (thus the devil the preacher holds in
one hand).

The fear of the Methodists was based on the vast crowds subject
to outbursts of religious fervor, the preaching itself which insisted
that master and man were equal in the eyes of God, the belief in faith
over good works, and the organization of Methodism into "soci-
eties" that were presented as alternatives *within* the Church of En-
gland. It was easy to see Methodism as a reflection of political
factionalism, the chaos of the election crowd, and the politics of a
rabble-rousing Pitt. Also perhaps rankling was the passage in the
Philosophical Enquiry in which Burke claims that "a fanatic preacher"
can arouse the passions more strongly than a painter—in the same
passage that introduces Satan and Death. But the basic equation is
between politician and clergyman.

The puzzled Muslim at the window is of course the virtuous pagan
of Deist mythology, who represented the true, non-Christian reli-
gion of nature (the love of God vs. the sham intervention being per-
petrated in various ways by the clergy) and was invoked in more than
one sermon by Bishop Hoadly. With the safe case of Methodism to
hand, the freethinkers of the 1750s had carried Woolston's hermeneu-
tical demystifying of New Testament miracles into a historical, more
scholarly exploration of the *post*–New Testament miracles reported
by the clergy themselves (who had been such staunch upholders of
Christ's miracles). The influential work for the 1750s was Conyers

Middleton's *Free Inquiry into the Miraculous Powers, which are supposed to have subsisted in the Christian Church* (1749), which quoted at great length the reports of miracles by the ante-Nicene Fathers, a hundred or so years after the New Testament stories.[58] With the evidence of innumerable quotations Middleton belabored the fact that Tertullian, Cyprian, Athanasius, and the rest were "constantly appealing to the testimony of *heavenly visions and divine revelations,*" and that "*all things of great moment, which related to the public state of the Church, were foretold to [them] in visions*" (101). Middleton's focus was therefore even more directly than Woolston's on the clergy themselves and his argument was that they used these "miracles" to maintain power over their congregations. (The examples of Wesley and Whitefield were implicit.)

The "miracles" are now cases of possession and prophetic vision, the casting out of devils, and the curing of demonics; of men and women in ecstatic trances, filled with the Holy Ghost and speaking in tongues—all authenticated by the clergy for "political" purposes. Many examples are given by Middleton of seizures that were the result of taking the sacrament under false circumstances (113–15). Thus the Gadarene swine Hogarth introduced in *Election* 4 can be seen in a different light if we suppose he had read Middleton, and in *Enthusiasm Delineated* he shows women devouring Eucharist Christs. He places the demystification of miracles in the Middletonian context, "that spirit of enthusiasm in the church," the "feigned distortions and convulsive agitations of the body" (99); and by linking Catholics, Anglicans, and Methodists he makes the connection with "enthusiastic" art of the sort Reynolds (out of Burke) advocates. This is surely the context in which Hogarth conceived his print—celebrating election crowds, wild Methodist congregations, and the Burkean Sublime. In this context the clergy, who foster enthusiastic illusions, are equated with the Reynolds type of artist and his art academy.

At about the same time Hogarth wrote in the manuscript "Apology for Painters" that religious art was out of the question for an English artist: "our religion forbids, nay doth not require, images for worship or pictures to work up enthusiasm" (89). *Enthusiasm Delineated* is dedicated to the archbishop of Canterbury, the patron of ecclesiastical art in England—reminiscent of the ironic dedication of *The March to Finchley* to "His Majesty the King of Prussia and En-

courager of Arts and Sciences!" The archbishop at this time was Thomas Secker, who reappears in *The Times, Plate 2* labeled "Dr Cants ye Man Midwife." Though educated in dissenting academies and beginning as a liberal theologian, once ordained Secker became "an indefatigable defender of orthodoxy." Among his chief objects of attack were the Deists. In particular, Secker encouraged Dr. Thomas Church, prebendary of Hogarth's own Chiswick in St. Paul's Cathedral, to write *A Vindication of the Miraculous Power which subsisted in the First Three Centuries of the Church* (1751), an attack on Middleton's *Free Enquiry,* followed by *An Analysis of the Philosophical Works of the late Viscount Bolingbroke* (1755).[59]

Secker's political connections were with Lord Hardwicke, a prime supporter of Pitt; Hardwicke had secured Secker the deanship of St. Paul's and then, in March 1758, the archbishopric of Canterbury. This made him, for Hogarth's purposes at least, a Pitt appointee and representative (an updating of Bishop Gibson, who in *A Harlot's Progress* represented Walpole and persecuted Deists).

In the examples above, Hogarth's newly formulated aesthetic of the Beautiful came into conflict with Burke's aesthetic of the Sublime at just the moment when Pitt's kind of political power seemed to be wiping clean the old slate of comfortable political relationships. From Hogarth's point of view, the publication of Burke's *Philosophical Enquiry* seemed synchronized with the advent of the "great" Pitt ministry and the successful phase of the expansionist war. Together these epitomized an excess in theory, oratory, actions, and power, not to mention actual monetary expenditure. And so in *Enthusiasm Delineated* Hogarth is reacting to both the "Sublime" of Burke and the "enthusiasm" of Reynolds, the oratory of Pitt and the preaching of Whitefield. He shows ethics and theology, the traditional subject of the Sublime (as in the writings of Dennis, Addison, Shaftesbury, and Hutcheson), replaced by sheer excess of feeling; the variety-in-unity of "Beauty" as presented in the *Analysis* replaced by variety out of control in divisive sects, every man his own church. The shock he registers is at the shift from the norm of the Beautiful to the norm of the Sublime, and from the Sublime as an ethical or theological to a merely psychological phenomenon.

Hogarth is formulating a narrative, which was to sustain him until

his death, in which Burke's Sublime tries to destroy *his* Beautiful, to which he assimilated the sense in which the "statesman's" politics of Pitt, associated with war, oratory, excess, unlimitedness, and other aspects of the Burkean Sublime, destroys the "beautiful" system of intricate variety known as Walpolian politics. In his narrative there was only one hope—and this one hope bound the politics of the nation with that of the artists' academy: the new monarch, George III and his unpolitical, nonpartisan minister, the earl of Bute.

SAMUEL JOHNSON

A final question is the position, between Reynolds and Hogarth, held by Samuel Johnson. Although in the late 1750s he was emerging as the center of a group that included both Burke and Reynolds, he was also an acquaintance of Hogarth's—at least someone Hogarth greatly respected. They agreed on their politics, both in their opposition to Pitt and (after 1760) their support of Bute and George III. Johnson's conversation, Hogarth told the young Hester Salusbury, "was to the talk of other men, like Titian's painting compared to Hudson's: but don't you tell people now, that I say so (continued he), for the connoisseurs and I are at war you know; and because I hate *them,* they think I hate *Titian*—and let them!" [60] On one occasion her father and Hogarth were talking of Johnson: "That man (says Hogarth) is not contented with believeing the Bible, but he fairly resolves, I think, to believe nothing *but* the Bible": a significant remark, perhaps, given Hogarth's skepticism of Scripture. [61] Johnson's distrust of any impiety in a work of art made it unlikely that he approved of Hogarth's *Harlot* and *Rake* with their juxtapositions of biblical allusions and low contemporary characters; but then, like Samuel Richardson, he may have respected Hogarth's religious paintings. At the same time, some words quoted by Hester suggest that he may have admired Hogarth's "modern moral subjects": he does not want to hear of ancient history because "such conversation was lost time (he said), and carried one away from common life, leaving no ideas behind which could serve *living wight* as warning or direction." [62]

Although Hogarth and Johnson knew each other and sat on committees together and must have talked, the only fact that survives of

their relationship is their first meeting. The story was told by Hogarth to Reynolds who passed it on to Boswell. He was at Richardson's house, and the date, from internal evidence, was June 1753. While Hogarth was, as usual, talking (Boswell recounts),

> he perceived a person standing at a window in the room, shaking his head, and rolling himself about in a strange ridiculous manner. He concluded that he was an ideot, whom his relations had put under the care of Mr. Richardson, as a very good man. To his great surprise, however, this figure stalked forward to where he and Mr. Richardson were sitting, and all at once took up the argument.[63]

What Johnson picks up is a conversation about the belated execution of Dr. Archibald Cameron, of the Forty-Five, with Hogarth defending George II's leniency. Johnson "burst out into an invective against George the Second," and, says Boswell, "he displayed such a power of eloquence, that Hogarth looked at him with astonishment, and actually thought that this ideot had been at the moment inspired." "Neither Hogarth nor Johnson," Boswell adds, "were made known to each other at this interview."

Johnson collected prints, mainly portraits, but while he had a copy of Kirby's *Perspective* with Hogarth's frontispiece, he does not seem to have owned the *Analysis* or been a subscriber to the *Election* series (the other source we have of a subscribers' list). He was usually hard up during these years, however, and not much can be inferred from this information. On the other hand, the list he kept of people with whom he drank tea in the mid-1750s included Richardson and Reynolds but not Hogarth. His friendship with Reynolds seems to have been strong and pursued more energetically on his side than on Reynolds's.[64] While he had a close friendship with Joseph Warton, with Hogarth's friend William Huggins he enjoyed at best a confused and unsatisfactory relationship.

The one essay Johnson produced on art was his *Idler* No. 45 (24 Feb. 1759), published seven months before Reynolds's *Idler* essays.[65] Its subject is history painting, and, in conjunction with his later public associations with Gwynn and Chambers, as well as with Reynolds and Hayman, it helps to locate his position in relation to the theory and practice of the 1750s. The essay is divided into two parts: first on portraiture, then on history painting. Johnson opens

with the old subject of the English tendency to patronize portraits instead of subject painting. But he does not begin, as many artists of his acquaintance would have, with the economic fact that the English commissioned only portraits from English painters, buying their history paintings from abroad. Instead he cites a "satirist" who imputes the encouragement of portrait painters to "national selfishness." Robert Folkenflik has noted that the word "selfishness" was used by Hogarth in this context in his manuscript "Apology for Painters."[66] Questions aside of whether Johnson could have read a version of this manuscript (if he and Hogarth were close enough friends, Hogarth might have asked his advice), this view was certainly associated with Hogarth—echoed, for example, in Rouquet's *State of the Arts in England*. Johnson counters with a rather unconvincing claim that in fact people commissioned portraits for their friends, not their own greater glory. But his point is plainly to contrast satiric denigration with a positive, loving portrait, and so implicitly Hogarth the satirist of "modern moral subjects" with Reynolds the portraitist. That his earlier reference to "*the* general lampooner of mankind" (i.e., a generalized one) avoids the direct naming of Hogarth (but then he had not named Fielding in *Rambler* No. 4 or 114 either; not naming confirmed the claim of the universal over the lampoon) and that Hogarth himself was a portrait painter also support Johnson's focus on issues rather than people. But Hogarth's particular view of art—as also expressed in *The Analysis of Beauty*—is at stake here, and Johnson seems to be placing himself in opposition.

Johnson is presumably stating his disapproval of particular satire (he had identified his cousin Cornelius Ford in Hogarth's *Midnight Modern Conversation*)[67] and his approval of the universal paragon, very much as he had in his polarization of Fielding and Richardson in *Rambler* No. 4. The last six words Johnson added to Reynolds' *Idler* No. 82 apply to this aspect of Hogarth: Reynolds writes that if the good painter, "by attending to the invariable and general ideas of nature, produces beauty," the bad painter "must, by regarding minute particularities, and accidental discriminations, deviate from the universal rule," and Johnson adds, "and pollute his canvas with deformity."[68] This is the view that Reynolds carried over into his *Discourses* a decade later, when Hogarth was dead, the Royal Academy he opposed a reality, and his kind of art safely consigned (as Warton had predicted) to a secondary status. By then Johnson had written

his beautiful epitaph on Hogarth, stressing the power of his aesthetics as well as his satire.[69]

But Johnson's *Idler* No. 45 also contains a passage in which he hopes that Reynolds will not transfer his talent from portraiture "to heroes and to goddesses, to empty splendor and to airy fiction." Portraiture itself is defined as an art "employed in diffusing friendship, in reviving tenderness, in quickening the affections of the absent, and continuing the presence of the dead." In absolute Johnsonian terms, there is of course no difference between the harmless delusion practiced by either history painting or portraiture. The difference (as suggested by his remark elsewhere about preferring a picture of a dog he knew to the most exalted graphic allegory) lies in the closer approximation of the portrait to reality. One can only speculate, therefore, on the way this admonition related to Reynolds's practice of the 1750s in allegorizing and deifying (however wittily) some of his sitters (but not, needless to say, Johnson).

By the 1760s and 1770s, in the period of Boswell's close attention, we see Johnson pulling Reynolds's leg about precisely these hierarchical assumptions about the genres and taste. As early as *Idler* No. 45 Johnson takes a position we do not ordinarily associate with Reynolds when he argues for the primacy of a recent English subject for history painting. The occasion was the announcement by the Society of Arts of a premium for a history painting.[70] He evidently thought the subject was going to include classical myth and allegory, and proposes all of these subjects.[71] But he ends with a very un-Reynolds subject, one from recent English history, the dissolution of Parliament by Cromwell. Johnson's description of the scene invokes the way Hogarth painted British history: Cromwell recalls by analogy Satan and Parliament the fallen angels of Pandemonium. One suspects that Johnson was suggesting a parallel (as Hogarth had between Henry VIII and Cardinal Wolsey, George II and Walpole) between Cromwell and William Pitt, who was felt by many to be regarding Parliament "with contempt" (a sentiment on which Hogarth and Johnson would have agreed).[72]

Reynolds himself, of course, became (he already was in his *Commodore Keppel* of 1753) adept at the sort of ironic layering of his images, past to present, which suggests analogies between his subject and a historical, typological precursor. He was always positive in his application of history to the present, becoming, as Johnson would

have seen, an apologist for British imperialism. Johnson, however, proposes a kind of history painting that would include Hogarth's deeply satiric prints of "deformity" with which he "polluted his canvas."

And yet we also know that, after writing *Idler* No. 45, he published Reynolds's three *Idler* essays on art, which certainly did attack Hogarth. He is identifiable in the caricature *The Combat* (fig. 86) of about this time as in the camp of Hayman, Gwynn, and Reynolds, supporting a national academy along the lines of the French—with, opposing, Hogarth and *his* supporters (though as a lexicographer he ridiculed the idea of the other French Academy). It seems clear that Reynolds and Hogarth were the aesthetic poles for Johnson, and that whereas his friendship was with Reynolds his attitude toward both positions was skeptical. Johnson was very much a polarizer who shifted poles, questioning whichever term was at the moment privileged at the expense of the other.

First of all, Johnson taught the artists associated with the Society of Arts and of Artists—and above all, Reynolds, but also Chambers—how to speak about the arts, and in a discourse that was more polite, genteel, social, and cohesive—less disruptive—than the discourse Hogarth had developed. *This,* the Hogarth of the post-*Analysis* prints and utterances, who appeared to be the predominant bullying artist of the moment, is probably the Hogarth Johnson refers to in the 1759 *Idler.* But once Hogarth was dead, his idea of an academy and of art defeated, and Reynolds was P.R.A., Johnson directed his ridicule at just the aspects of Reynolds's theory that Hogarth rejected. He balanced and corrected what he regarded as the silly polarities of aesthetic theory and practice.[73] He seems almost a mediator between the popular, satiric, iconoclastic, and empirical art of Hogarth and the highbrow, elitist, apriori, Continental aspirations embodied in Reynolds's paintings. When he is putting Reynolds down, he is speaking with the empiricist voice of his older friend Hogarth; when he is criticizing the negativity of a Fielding or Hogarth he is working out the vocabulary of the discourse Reynolds would inherit from him and apply—without his irony, as in the famous Imlac passage in *Rasselas* on poetry—to painting.

On Hogarth's aesthetics, Johnson's last word was *Rasselas* (1759), which shows all the Hogarth elements—pleasure, intricacy, variety—infantilized in the nursery world of the Happy Valley, out of

which Rasselas and his friends escape into a world of mature choices, which include (though it does not privilege) the Burkean Sublime. Johnson reminds us that Hogarth's Intricacy, his emphasis on the "love of pursuit" and "play," is merely another incarnation of the "artful" apprentice of Gay's *Trivia* who misleads the lost pedestrian for the "pleasure" of it, as opposed to his master (prudent and respectable) who misleads for profit.

10.

SPECIAL COMMISSIONS

THE MEDMENHAMITE BROTHERHOOD

The sort of special commission Hogarth carried out for Lord Charlemont had been part of his stock in trade from the beginning. The two versions of *Before* and *After* had been painted for randy and rakish young Englishmen, presumably to be hung in the smoking room. It is quite possible that William Beckford bought the *Harlot* and *Rake* to have stag pictures for his male friends to enjoy—such as the old man who claimed he was buying his own progress when he bid on the *Rake* paintings. From a personal allegory like Mary Edwards's *Taste in High Life* to blue pictures like *Before* and *After,* such special commissions arose from time to time throughout Hogarth's career.

They were often quite respectable. The wife of Francis Matthew Schutz commissioned a pious temperance exordium for her husband (fig. 65).[1] Hogarth shows him leaning over the side of his bed vomiting into a chamber pot. But, decorously, his lips are barely parted, and on the wall by the bed is an inscription from Horace: "Vixi puellis nuper idoneus, &c." (Not long ago I kept in shape for the girls [*Odes,* 3.26]); the "&c." refers to the lyre hanging beneath the inscription—Horace's speaker has hung up his weapons and his lyre as well as his lechery. The implication is either that Schutz has given up women (and should also give up wine) for marriage, or that his drinking now incapacitates him for fulfilling his marital duties. The learned allusions are continued on the floor in another Horatian quotation: "Cuius octav[i]um trepidavit aetas Claudere lustrum" (Whose life has already hurried past its fortieth year [*Odes,* 2: 4]). Since Schutz (1729–1779) was barely thirty in 1759, this inscription must

have been added at a later time.[2] The handling of the paint is very free and graceful, the colors soft, almost pastel: salmon pink bed curtains, green bedspread, olive green background, pale green bed hangings, and a darker red in the window curtains and chair seat. A descendent of Schutz had the basin painted out and substituted a newspaper; now restored, Schutz still looks as if he is reading a newspaper.

In a somewhat different category is a copy of Van Dyck's portrait (a drawing) of Inigo Jones, commissioned by Sir Edward Littleton around 1757 (Queen's House, Greenwich).[3] This portrait, painted around the time of *Garrick and His Wife* with its anti-Burlington subtext (288 below), makes one wonder whether the utterly blank paper Jones proffers (which should, as in Hogarth's other portraits of architects, hold a plan) was Hogarth's way of indicating the blankness of the Palladian tradition Jones inaugurated in England. On 19 May 1758 he casually wrote Littleton that he had finished the picture a year ago but had expected him to drop by; on 9 September: "I mistook the size and did not find my mistake till the frame, (which had been long making) came home. When the second frame came home, which had been a good while about too, I had lost your directions, but having at last found it, the picture will go on monday next."[4]

But the largest number of such commissions is associated with the Dashwood–Sandwich circle. Gustavus Hamilton, Viscount Boyne (with his family's Williamite associations), seems to have been the earliest to patronize Hogarth, and it may have been through him that Hogarth became involved with Sir Francis Dashwood (the large portrait of Dashwood [fig. 68] remains in the Boyne collection). It was reasonable that a painter famous for catching likenesses and depicting vice should have been approached for celebrations of vice. After he had painted Boyne's portrait (ill., vol. 2), probably in the mid-1730s, he was commissioned to place Boyne and his friends in a "modern moral subject": the result is a night brawl outside a tavern, including a coach and link boys (fig. 66). Lord Boyne is essentially the same figure as in the full-length portrait. According to a note in the Burwarton House sale catalogue, "It represents his lordship and Sir E. Walpole coming late from a Tavern. Sir E. Walpole having fallen into a kennel [gutter] is defended by Lord Boyne from the assault of a watchman: at the same instant, but for the timely check of the coach-

man, he was in more danger from the horses of Lord Peterborough's coach."[5]

An equivalent of *Lord Hervey and His Friends,* Hogarth's wittily knowing portrait of a homosexual enclave (ill., vol. 2), this conversation picture was followed in the 1750s by *Charity in the Cellar* (fig. 67), which shows Sir Philip Hoby in the center, surrounded by Lord Sandwich, Mr. de Grey (presumably Colonel George Gray) and Lord John Cavendish, with Lord Galway (who seems to have been the other man in *Night Encounter*) lying prostrate in the shadows on the left with wine dripping from a barrel into his open mouth.[6] The central group parodies a statue of Charity, to the right of them, whose breasts they turn into ale bottles. Another inanimate object is utilized grotesquely in the vial held between Hoby's legs to resemble a discharging penis. Like the later, indoor version of *Before* and *After,* the low message of this painting, rather than being depicted outright, is suggested through symbols and parallels. The men portrayed, if they are correctly identified, were all members of the Society of Dilettanti.

This society brought together themes of art, connoisseurship, paganism, libertinism, and freethinking. In the late 1750s Hogarth made a large painting of another Dilettante, Sir Francis Dashwood, as St. Francis at his devotions (48 × 35 in., fig. 68).[7] It could be a full-length and more elaborate pendant to Dashwood's Dilettanti portrait by George Knapton (1742, Society of Dilettanti): Dashwood was St. Francis in the Medmenhamite fraternity as well. But the size of Hogarth's canvas, the simple forms, and the freely handled areas of paint over gray underpainting suggest the late 1750s. Moreover, the nude being worshiped by Dashwood in Knapton's portrait was a statue, as it should be for a Dilettante, but in Hogarth's portrait it is a real woman, though miniature, being served up eucharistically on a reversed crucifix, parallel with the platter of luscious fruit on the ground. In place of a cross Dashwood adores this naked pink Venus, who bears a distinct resemblance to the nude in *The Pool of Bethesda* (ill., vol. 2). The open book before him reads "DE ELEGANTIAE LATINI SERMONIS," and the diabolic profile in his halo, inspiring him to his devotions, is that of Sandwich (cf. Sandwich's profile in *Charity in the Cellar*). By no means Hogarth's best work, it nevertheless contains bravura passages such as the Venus and the still life of the fruit.

Dashwood's connection with Hogarth was most likely through the satiric poet Paul Whitehead, who was one of Dashwood's closest confidants by the 1750s. Whitehead's "Honour, a Satire" (1747), imitating Pope's "Epistle to Dr. Arbuthnot," begins:

> "Load, load the Pallet, Boy!" hark, Hogarth cries,
> "Fast as I paint, fresh swarms of Fools arise!
> Groups rise on groups, and mock the Pencil's pow'r,
> To catch each new-blown folly of the hour."
> While hum'rous Hogarth paints each Folly dead,
> Shall vice triumphant rear its hydra head?

Whitehead's suggestion was that Hogarth took care of folly, but that he (Whitehead) was required to handle vice; Hogarth was a comic artist, Whitehead a satirist.[8] They were neighbors in Leicester Fields between 1739 and 1753.

We have seen (above, 187) that Dashwood was influential in the founding of the Society of Dilettanti in 1734, which involved dressing up in pagan attire and conducting complicated rituals, mostly concerned with their notion of pre-Christian behavior. These young men were followers of Shaftesbury's aesthetic code, extending his Deism and paganism to libertinism. Their primary interest in English art was in their own portraits—whether painted in ridiculous oriental attire by Knapton or in bawdy poses by Hogarth. But Dashwood stood out somewhat from this group, and Whitehead, a verse satirist who considered himself Pope's successor, pointed up Dashwood's peculiar character.

Dashwood was a lover of hoaxes, of dressing up, and of founding and conducting clubs. One story relates how, during his Grand Tour, he appeared in a monk's habit on Good Friday in the Sistine Chapel and added some real stripes to the feigned ones of the penitential monks there assembled. On his tour he also developed a friendship with John Montague, earl of Sandwich, who was touring the Mediterranean in the company of the artist Jean Liotard. As a result of Dashwood's tour of Turkey the Divan Club was formed with Dashwood and Sandwich as charter members. All that is known of this club is that members had to have been to Turkey; the minute book was "a red morocco quarto with the word *Al-Koran* printed on it in gold letters," and "The Harem" was the club's standing toast. It was,

as Dashwood's biographer has written, "one more manifestation of Sir Francis's passion for make-believe and his romantic longing for an escape from reality."[9]

Dashwood was a friend of Benjamin Franklin's and in the later 1760s collaborated on a simplified Book of Common Prayer; he admired Voltaire and hated the clergy and the Christian forms of worship, especially papism: his is a Deist profile. But he also took Church of England communion and was patron in his own paternalistic way of his parish church of St. Lawrence. In 1763, when he remodeled the church at his own expense, the most notorious addition was a huge golden ball on its top in which he and his friends supposedly gathered to sing "jolly songs very unfit for the profane ears of the world below."[10]

After 1751 and the death of his patron Prince Frederick, Dashwood turned his attention from London to Buckinghamshire and founded a more radical version of the Dilettanti, which allegedly extended pre- to anti-Christian rituals on the order of the Black Mass. He rented Medmenham Abbey, near Marlowe, a low, rambling, red-stained house.[11] Supervised by Nicholas Revett, in the greatest secrecy (the story goes), workmen were brought down from London and returned at twilight, and servants were sworn to silence. A ruined tower was added at the southeast corner and beneath it, somewhat better preserved, cloisters, and over the low square door at the east of the house was painted the Rabelaisian motto, "Fay ce que voudras."[12] Outside, the grounds were dotted with suggestive caves, cascades from under overhanging foliage, and upright columns; there were urns dedicated to Potiphar's wife and the Ephesian widow. These were a parody of all the temples of Apollo, triumphal arches, and statues of Mars, Venus, and other gods and goddesses that filled fashionable parks of the sort Hogarth took note of in *Analysis,* Plate 1; but they also reflected the paganism of the Dilettanti and extended its libertinism. John Wilkes—one of the "monks"—was most impressed by a painting on the grand staircase: "a very moral painting of a maid stealing to her master's bed, laying at the same time her finger on her lips."[13] The walls were covered with bawdy inscriptions and erotic pictures, many in the punning style we associate with Hogarth.

The costumery and rigid bylaws of the Medmenhamites would have amused Hogarth not only as a memory of the Dilettanti but of

the projected Royal Academy as well. There were two orders of friars, a superior and an inferior, twelve of each: the superior was known as the apostles, and this was the real brotherhood. The inferior order was composed of visiting friends and neighbors—and if Hogarth rode over to attend meetings during his summers in Chiswick, it would have been as one of this group. Their habit, as Walpole described it, was "more like a waterman's than a Monk's, & consists of a white hat, a white jacket, & white trousers. The Prior has a red hat like a Cardinal's, and a red bonnet, turned up with Coney skin." Each of the brotherhood (the superior order at least) had his own cell, with a bed for repose: "each is to do whatever he pleases in his own cell, into which they may carry women." [14]

Dashwood's biographer sees the Medmenhamites as Gothic romantics, in the manner of Fonthill Abbey and *Vathek* and of Strawberry Hill and *The Castle of Otranto*. Another writer (following the author of *Nocturnal Revels*) sees them as the last gasp of Augustan satirists and hoaxers, parodying Catholic ritual but also, probably, in the 1750s, ridiculing Methodist enthusiasm, ghost visions, and the like; to the extent that they corresponded to this profile, they were Hogarthian. [15] The tradition goes back at least to the Scriblerus hoaxes (Swift's Partridge–Bickerstaff papers, Pope's *Narrative of Dr. Norris*). [16] Two significant projects may be cited: Paul Whitehead, generally following Pope, but in this matter Hogarth's *Mystery of Masonry* (1724), set up mock-Masonic parades in 1741 and 1742, which eventually brought an end to the Freemasons' annual parades. And in 1746 Whitehead and Dashwood set up a mock-Jacobite society, a parody of the Culloden ceremonies. We do not know whether Hogarth was directly connected with either, though his *Savoyard Girl* of 1749 could have been an offshoot of the anti-Cumberland project (fig. 25). All of these are mock juxtapositions for the plain purpose of debunking, but they also reflect a certain sympathy (along the lines of Beckford's and Walpole's for the Gothic) for the primitive, with a common source in Country Party rhetoric (164, above).

The members appear to have expressed no special political bias until they were divided by the upheavals of 1761–1762. The chief members—Dashwood, Sandwich, and Dodington—were now strong supporters of George III and Bute. It was Wilkes, more than anyone else, but with help from others of the Opposition, who painted in heightened colors Dashwood's brotherhood as a sink of

vice and iniquity, given to sexual debauches and Black Masses. Wilkes's description of the "remarkable Temple" that served as a memorial to Dodington after his death in 1762 is punctuated with references to his political enemies:

the Entrance to it, is the same Entrance by which we all come into the World, and the Door is what some idle Wits have called the Door of Life. It is reported that, on a late visit to *his* Chancellor [i.e., Dashwood, chancellor of the exchequer], Lord Bute particularly admired this Building, and advised the noble Owner to lay out the 500 l. bequeathed to him by Lord *Melcombe's* [Dodington's] will *for an Erection,* in a *Paphian* Column to *stand* at the Entrance.[17]

Charles Johnstone introduced the Medmenhamite Brotherhood into the third volume of his roman à clef, *Chrysal* (1765). Although his details are suspect, his emphases are worth noting: he says the brotherhood was set up by Dashwood "in burlesque imitation of the religious societies," and uses the word "ridicule"; but also with the aim "to season his scheme as high as he could with impiety." From "the ridicule . . . against those societies of human institution" Dashwood went on "to attack the very essentials of the Religion established by the laws of his country, and acknowledged by every serious person in it, to be divine."[18] He then describes the parody of the twelve disciples, the obscene and blasphemous wall decorations, and the Black Mass invoking the devil—which ends with the notorious anecdote of Wilkes's introduction of a baboon into the ceremonies, which terrifies Dashwood, who thinks he has in fact summoned up the devil.[19] One wonders whether it is significant that the hoaxes in Medmenham Abbey are played *upon* Dashwood, who is presented as if he takes the ceremonies seriously.

Exactly how depraved the monks were remains a mystery: that Whitehead, the secretary of the brotherhood, burned all the records three days before he died (1774), might seem a sinister indication. But, in fact, there was probably a little debauchery and a great deal of playacting and fanciful writing back and forth. The wine books from Medmenham have survived and place Wilkes there (referred to as Brother John of Aylesbury) consuming large amounts of claret and port, as early as October 1760.[20] In Wilkes's earliest surviving letter (15 June 1762) he discusses with Charles Churchill both edito-

rial matters of the *North Briton* and a gathering of the monks of Med-
menham that Churchill was to attend with him: "next monday we
meet at Medmenham" sounds as if Churchill is familiar with the
group and has been there before.[21]

All the books on the Medmenhamite Brotherhood list Hogarth as
one of the members but none gives a satisfactory source other than
the painting of Dashwood as St. Francis. This, together with Ho-
garth's friendship with Whitehead and Wilkes and his general suscep-
tibility to such clubs, is the only evidence.[22] But given what we have
seen of his parodies of Roman Catholic and Methodist iconography,
not to mention his Woolstonian demystifications of orthodox Angli-
can beliefs, and what we recall of his parodic references to the clergy
(even his being cast as the devil's cook in *Ragandjaw*), it would not
be unreasonable to connect him with the Medmenhamites.

Certainly the point of his portrait of Dashwood is that Dashwood
is a Venus worshiper, as Hogarth was in his *Analysis,* or one who
constructs an aesthetics around Venus as Dashwood seems to have
created a religion. It is possible that Hogarth turned what was a
metaphorical worship of Venus (of female flesh, of harlots) into his
own channels and made Dashwood more of a Hogarthian than he in
reality was (rather than vice versa). It is possible to see in the Med-
menhamite monks a merger of freethinking and Dilettanti–Shaftes-
bury aesthetics which now includes aspects of the unorthodox
aesthetics of the *Analysis*—a Black Mass parody of Shaftesbury's
Moralists—and eventuates in the notorious *Essay on Woman* (written
by Wilkes or another of the monks). One logical end of these dispa-
rate strands is in the worship of Venus and the generative powers,
and in an aesthetics that becomes an erotics.

STERNE: ILLUSTRATIONS FOR
TRISTRAM SHANDY

In 1759 Laurence Sterne published the first two volumes of *Tristram
Shandy,* the most powerful contemporary confirmation of Hogarth's
aesthetics. On the first day of 1760 the two volumes were published
in London. If Fielding produced a literary equivalent of Hogarth's

"modern moral subject" or "comic history-paintings" of the 1730s, Sterne internalized the artist satires, *The March to Finchley*, and—the theorizing of their practice—*The Analysis of Beauty*. He uses the *Analysis* as a source for his aesthetics and hermeneutics based on curiosity and the love of pursuit, "digressions" and various "readers," on serpentine Lines of Beauty and (three-dimensional) Lines of Grace as opposed to straight lines and the grotesque curves of Dr. Slop. Early in the first volume Tristram goes one better Hogarth's quotation of Horace in *Boys Peeping at Nature* (to the effect that when circumstances require, an artist *can* disregard the rules), asserting that "in writing what I have set about, I shall confine myself neither to his [Horace's] rules, nor to any man's rules that ever lived."[23] But curiosity is paramount. He ends volume one with the words, "if I thought [the reader] was able to form the least judgment or probable conjecture of what was to come in the next page—I would tear it out of my book" (1.25; 80).

The key Hogarthian concepts and terms begin to appear almost at once: the first thing Uncle Toby notices about the child Tristram is his *"obliquity,* (as he call'd it) in my manner of setting up my top, and justifying the *principles* upon which I had done it" (1.3; 6; emphasis added). On the next page, as if preparing to unveil a Line of Beauty, Tristram talks of his "principle," and "principle" becomes "secret" as he addresses those readers "who find themselves ill at ease, unless they are *let into the whole secret"* (1.4; 7; emphasis added); and on the next page the enemy is designated: "rules" and "regularity."[24]

Many of Hogarth's doctrines—of contrast, of variety, and above all of intricacy—inform Sterne's novel, whose radical intention was to convey both the chronological sense of a narrative and the simultaneity of a painting. Of course, *Tristram Shandy*'s pictorialism is readily apparent in the importance of typography, the use of dashes, italics, diagrams, black or marbled pages, and other visual devices including blank spaces and pages, reversed chapters, and buried details, as well as in the unprecedented emphasis placed on the appearance and gestures of the characters. But Sterne's reader is meant to "read" and chase about in his book as in a Hogarth painting (leading "the eye a wanton kind of chace"). Tristram (the "author") is constantly instructing his reader "not to be in a hurry"; he orders a lady reader to go back and read a chapter again, which, he says, is "to

rebuke a vicious taste . . . of reading straight forwards, more in quest of the adventures, than of the deep erudition and knowledge"—the author's real content. A reader should not read straight forward—in a straight line, as on a printed page—but circle about, going back and forth, dealing with the text spatially, in short, as if reading a Hogarthian print.

After all, the *Analysis* was, in one sense, only the formulation of a way of reading already evident in *The March to Finchley*, which is, in a Shandean sense, all "digression." The army marching to war, the subject one would expect both from the title and the conventions of such military paintings, as with *The Life and Opinions of Tristram Shandy, Gent.*, is marginalized in the remote distance; what appears in the foreground is the troops *not* marching to Finchley, and the detail of the motherless chicks in the lower right corner in fact designates the subject of the picture. Where we expect the story of Tristram, we have instead the stories of Uncle Toby and Yorick; in the same way, Sterne highlights and focuses on details—a baize bag, a knot, a pair of forceps, a door hinge, a gesture or a word—which *are* in fact the emblems—or analogies—that tell us Tristram's story.

Indeed, *Finchley*—in which Sterne found not only the subversion of conventions but in particular of conventions of military heroism—was probably the Hogarth work principally in his mind when he wrote the first volumes of *Tristram Shandy*.[25] On public display as a painting and widely seen as an engraving, *Finchley* was created, at least in part, as homage to Fielding's *Tom Jones*,[26] and it picked up those aspects of the novel connected with the relationship between the microcosm of private life and the macrocosm of the state. Its subject was the Forty-Five and the notion of genealogy, Stuart and Hanoverian. Sterne retains the sense of legitimacy/illegitimacy (Tom and Tristram share a bend sinister); of sundered families, confused loyalties, and egregious misunderstandings; as well as of "foundlings," children abandoned by parents, soldiers without leaders. But seen from Sterne's perspective in the 1750s—once again the perspective of the Seven Years' War—*Finchley* was more a study in the relationship between order and disorder, subject and digression, or figure and ground. In the context of the intervening treatise, *The Analysis of Beauty, Finchley* would have designated a practical example of Variety and Intricacy, Contrast and Quantity, in tension with Fitness and Unity.

Sterne summed up *Finchley*'s Foundling Hospital theme (emblematized in the motherless chicks) in *Tristram Shandy* when Dr. Slop enthuses over the increase in the safety of child birth that will be brought about by his forceps: "I wish, quoth my uncle *Toby,* you had seen what prodigious armies we had in *Flanders*" (2.18; 144). In *Finchley* there is on the left the sign of the Adam and Eve nursery and, on the right, the sign of Charles II and the breakdown of all familial relations in the brothel: family and army, love and war, birth and wounding, wounding in the boudoir and in the Siege of Namur, the private person and the regimented soldier.

The emphasis on stimulation, provocation, and curiosity—on aposiopesis, gaps to be imaginatively filled in—indicates the unparalleled importance of the reader, who is also required to absorb masses of detail and discover their coherence. Sterne merely highlights the apparent incoherence—the excessive variety—and urges a reading that is theoretically at least creative. He singles out a "Sir" or "Madam" or "Your Worship," a male or a female, the ones who want to know "the whole truth" and those who accept the digressive form and understand *Tristram Shandy*—which is, among other things, a 1759 version of Hogarth's divided audiences (related to his and Fielding's theatrical model), focused on these hypothetical readers but assuming a true reader like Hogarth's (or Addison's) reader "of greater penetration."

Indeed, everywhere traces of Hogarth and Hogarthian assumptions are to be found. Under the confusion of every word and gesture Sterne always reveals human desire—as Hogarth did beneath the surface of the *Analysis* plates. ("Spiggots and faucets" in 5.1 surely recalls the Harlot's escutcheon in *Harlot* 6, and a crack in the wall reminds Uncle Toby of Mrs. Shandy's parturition and a cocked hat reminds Tristram of Jenny.) Walter Shandy's theory of names and their effects—a son named Judas, a sister named Dinah, a son named Tristram (sadness)—all of these, according to Walter, self-fulfilling prophecies, recall the self-confirming, oppressive names of Idle and Goodchild, Rakewell and Nero. The features of Roman Catholicism Yorick attacks in his sermon on Conscience are its extreme formalism, its adherence to the letter, and its use of coercion, specifically the physical torture of the Inquisition: essentially the objects of Hogarth's satire in the Counterreformation iconography of the Old Master paintings he depicted in his early works—until in the *Invasion*

prints of 1756 he specified the torture instruments of the Inquisition (which Sterne applies to the brother of Corporal Trim).

Tristram Shandy reminds us of Hogarth's place in the tradition of Locke, in which the opaqueness of words is corrected by the transparency of images or what is seen. Sterne sums up the tradition (and Hogarth's unique importance to writers such as Sterne) in the story of Uncle Toby, who, trying to explain where he was wounded—in both the personal and the military topographical sense—begins with words, and when they prove utterly inadequate goes on to maps and charts, and finally to a scale model of Namur. If he continued in logical progression, he would eventually have to re-create the event. Tristram, in the same way, must resort to increasingly graphic measures on the way to total representation in the futile attempt to make himself understood—which means explaining his own physical and metaphorical wounding.

Sterne visited London in the spring of 1760 to reap the rewards of his first edition and set his second in the right context: he wanted a dedication to William Pitt and an illustration by Hogarth, and he got both. Sterne was himself an amateur painter, whose "first ideal was Hogarth."[27] Thus after setting out quite clearly his indebtedness to the Hogarthian aesthetics, he got from Hogarth two illustrations, the most pertinent showing Trim reading the sermon on Conscience (Walter and Toby listening, Dr. Slop in the foreground, fig. 69), in which it is quite clear that Trim is *not* a Line of Beauty.

In London, Sterne became acquainted with the elegant equerry Richard Berenger (shortly to be George III's Gentleman of the Horse), a member of the Murphy–Foote circle, and an acquaintance of Hogarth's. The author of books on horsemanship, Berenger was praised by his contemporaries for his high spirits ("the joyous Berenger"), his charm, and his witty anecdotes. He was "a particular friend" of Garrick, and through him may have been introduced to Hogarth, as later to Sterne. Arthur Murphy records a dinner on the day when his *Orphan* opened, 21 April 1759, at which he, Berenger, Hogarth, William Fitzherbert, Sir Francis Delaval, Samuel Foote, and William Melmoth the younger gathered in happy conviviality.[28]

On 8 March Sterne wrote Berenger (at least two drafts were necessary to get the letter right) asking him to approach Hogarth about

an illustration, preferably of the Trim passage, for the second edition, which was expected in another month. "I would give both my Ears (If I was not to loose my Credit by it)," he writes in his first draft, "for no more than ten Strokes of *Howgarth's* witty Chissel, to clap at the front of my next Edition of *Shandy*." He modified this in the letter sent to Berenger to "what would I not give to have but ten Strokes . . ."[29] Berenger evidently went to Leicester Square equipped with a copy of *Tristram Shandy*. Between them, Berenger and *Tristram* charmed Hogarth, and he contributed an illustration for chapter 17, which, Sterne had written in his first draft of the letter to Berenger, "wᵈ mutually illustrate his System & mine." Accordingly Hogarth shows Trim reading the sermon but includes the description of Dr. Slop from the other passage in chapter 9, where Sterne presents him in terms of Hogarth's theory of comic shapes:

> Such were the out-lines of Dr. Slop's figure, which,—if you have read Hogarth's analysis of beauty, and if you have not, I wish you would;—you must know, may as certainly be caractur'd, and convey'd to the mind by three strokes as three hundred. (104–5)

Both descriptions, of Trim and Slop, are in fact based on the comic ratios of Hogarth's chapter "Of Quantity," and the only Line of Beauty—as Sterne notes—is in the calf of Trim's leg (as it was in his own, 211–212 above).

Apparently to approximate more closely the style of Sterne's characterization, Hogarth exaggerated more than usual, anticipating the still looser style of an even more Shandean Rowlandson. The drawing was engraved by Ravenet and finished by 2 April when the second edition appeared: "*Dedicated to the Right Honourable Mr. PITTT* [sic], / With a Frontispiece by Mr. Hogarth."[30]

Between the two illustrations he made for *Tristram*, Hogarth subscribed to Sterne's first volumes of *The Sermons of Mr. Yorick* in 1760.[31] But the first volume had as frontispiece Reynolds's portrait of Sterne (also engraved by Ravenet). On 20 March Sterne sat for this, the "Lansdowne portrait" (National Portrait Gallery, London); of course, Reynolds was also a subscriber to the *Sermons*, and at the beginning of the third volume (Jan. 1761) he seemingly replaces Hogarth. Walter's awkward, comic Hogarthian posture—the "ungraceful twist" (the "transverse zig-zaggery") of his gesture (a comic one

in Hogarth's terms)—is corrected. If it "had been easy—natural—unforced: *Reynolds* himself as great and graceful as he paints, might have painted him as he sat" (159). Significantly, neither Hogarth nor Reynolds is invoked in volumes 3 and 4 but rather Garrick; not a maker of images but an actor could tell Walter how to pose his body or Trim—the most eloquent rhetorician of the novel—how to make a point (278).[32]

Of course, there is a tension in *Tristram Shandy* between the acting of a Trim and the writing and printing of *Tristram Shandy* by Tristram/Sterne: Sterne is aware of his own dilemma when he turns a gesture into a document. But in one passage on connoisseurs (3.12), Sterne freely adapts *Idler* No. 76 (also on connoisseurs), almost certainly with full awareness that the anonymous author was Reynolds and that its object of attack was Hogarth.[33] There is more implied praise of Reynolds, however, than criticism of Hogarth: nothing of Reynolds's *Idler* which is critical of Hogarth is picked up except for the triangle. Sterne likes to be witty for its own sake, even if it cuts more than one way.

And yet he uses Hogarth's second illustration (the christening of Tristram) in volume 4, chapter 14 (pub. 28 Jan. 1761 with vol. 3). In volume 3 he invokes Hogarth's smokejack to suggest the association of ideas in Toby's mind (3. 19; 191–92). And his discussion of wigs in chapter 20 (202), which invokes Hogarth's discussion in his chapter "Of Quantity," also almost certainly influenced Hogarth's own conception of *The Four Orders of Periwigs,* published in November of the same year (fig. 85).

I would not put it past the opportunist Sterne to have included satire on Hogarth as a nod toward Reynolds; but his ethos was closer to Hogarth's and he primarily used Reynolds to perpetuate his public image in the portrait.[34] His and Hogarth's aesthetics, based on the senses, was totally at odds with Reynolds's ("not the eye, it is the mind, which the painter of genius desires to address"—*Discourses,* 50). Most significant, there is no inclination evident toward Reynolds's view of imitation, authority, and the high style (as in *Idler* No. 79). *Tristram Shandy* represents a position in the academy dispute that speaks for Hogarth's side.

The problem Sterne must have seen in Hogarth—although Reynolds in his *Idler* papers could have drawn it to his attention—is that sentiment can become a "principle," a convention, and replace the

gesture of spontaneity from which it was formulated. Sterne plays off the vital serpentine line against the written, published treatise, which includes not only the *Analysis* but the "Opinion of the Doctors of the Sorbonne," the Shandys' marriage contract, Arnulphus's Curse, and even his own Sermon on Conscience.[35] But he also questions the distinction in Reynolds's *Idler* between principle and model. In the case of ethical behavior, the model emulated could be the Bible, the Ten Commandments, "religion," or the Life of Christ—behavior corresponding to one or another preestablished pattern. This, he demonstrates repeatedly, is a theoretical as opposed to an engaged approach to life—*engaged* meaning resisting the temptation to replace "life," the real live woman (the constant subtext of desire and procreation), with a sculpted Venus or a philosophical system. Here is the point of contention in the academy struggle, between past (or Continental, French) authority and English empiricism. The paradox in Hogarth's case is his growing dissatisfaction with structure and form, yet his reliance instead on the "principle" of the "perfect Line." Sterne nevertheless chooses this principle over the alternative, the Reynolds model of a precursor's authority.

In *Tristram Shandy* Sterne shows a series of predetermined patterns of behavior rejected in favor of compassion and sentiment. As Hogarth begins with the canonical sculptures, Sterne, in his novel as earlier in his sermons, starts with a text, then subverts or tampers with it, regarding it as a repressive authority like the Ten Commandments, *in contrast to* the New Testament narrative of Christ, who replaces the Letter of the Law and the Pharisees with acts of charity and love ("Love thy neighbor") and is subsequently crucified by the unfeeling world: the scenario of Parson Yorick and, of course, Tristram himself in his efforts to be born. Sterne's concern with vitalism, serpentine lines, and paranoid autobiographical narratives aligns him closely with Hogarth.

Sterne and Hogarth also shared a personal experience of an organized group—the chapter/canons of York Minster and the St. Martin's Lane (and the projected state) academy of art—and both came out of the experience full of distrust for the bureaucratic organization, its excessive love of order, orders, manifestos, and documents; both were very aware of its base in power and shared a personal position that sought to expose and undermine (quite the reverse of empower) those organizations qua organizations, and both felt para-

noid about the group's repressive reaction (expressed by Sterne in his history of Yorick in volume 1; by Hogarth in his prints and writings of the 1760s). In *Tristram Shandy* the story is embodied in the official group, the York Minster chapter—the canons who meet to decide on Tristram's name; and on the other side, the unofficial and unorthodox Demoniacs of Crazy Castle who reappear in the Shandys, subversive parodies of both "church" and "family" as conventionially understood.

The Medmenham monks were, I suspect, only another manifestation of the ethos of Sterne's Demoniacs and his *Tristram Shandy*—and *Sentimental Journey* (1768) also, in which romantic or charitable sentiment is revealed to be sexual desire. Sterne's novels, particularly the second, depend on a spectrum of pursuit, flight, and dawdling along the way which is obsessively centered on a woman's body. It is important for an understanding of the Medmenhamite fraternity and Hogarth's relation to it (direct or indirect) to distinguish its apparent eroticism, man and woman in explicit sexual play based on sexual desire, curiosity, and seduction, which corresponds to Hogarth's Beautiful, from Burke's Sublime, based on power, compulsion, and pain. Sublime pornography (perhaps a tautology) involves the play of power and pain carried to an extreme of mutilation and death. The line usually drawn is from Burke, or the Burkean Sublime, the way of male power, leading to the fantasies of the Marquis de Sade. Sade's aesthetics merely fulfilled the fears Hogarth entertained (and represented in his final works) of the Burkean Sublime literally destroying the Beautiful.

11.

PORTRAITS AND LIKENESSES

DAVID GARRICK AND HIS WIFE

Hogarth announced in February 1757 that, continuing to have trouble with the engraving of his *Election* paintings, he was retiring to portrait painting, which did not require this effort. He was already painting an ambitious portrait that may have been intended to answer the innovative portraiture of Joshua Reynolds, who by this time dominated the London market. The double portrait of Garrick and his wife Eva Maria (fig. 70) was nearly finished when John Hoadly visited the Golden Head on 21 April: Hogarth, he says, "has got again into Portraits; and has his hands full of business, and at an high price. He has almost finished a most noble one of our sprightly friend David Garrick and his Wife." He also mentions one of Hogarth's (and Garrick's) friends, Dr. George Hay.[1]

The portrait of the Garricks was not, however, finished. Another of Hogarth's problems (always evident but exacerbated in his later years) seems to have been the inability to let go of a picture—he himself describes how long he spent on *Sigismunda*. But dissatisfaction with his sitter also played a part. Tradition has it that Garrick, whenever Hogarth thought he had the likeness, kept changing his expression:

> while the painter was proceeding with his task, he [Garrick] mischievously altered his face with gradual change, so as to render the portrait perfectly unlike. Hogarth blamed the unlucky effort on his art, and began a second time, but with the same success. After swearing a little, he began a third time, and did not discover the trick until after

three or four repetitions. He then got into a violent passion, and would have thrown his pallet, pencils, and pound brushes at Garrick's head, if the wag had not made his escape from the *variegated* storm of *colours* that pursued him.[2]

According to another version of the story, Garrick complained, or perhaps made a facetious remark, on the likeness, a quarrel ensued, and Hogarth slashed his brush across the portrait's eyes.[3] Garrick's later references to Hogarth show that they remained friends till the very end; still, Hogarth had already shown signs of touchiness. In the single letter between the two old friends that has survived, dated 8 January of the same year—which must have preceded, and perhaps led into, the sittings for the portrait—Garrick replies to Hogarth's doubts about their friendship, perhaps implying something about the aristocratic friends whose houses Garrick now frequented—Lord Burlington, the duke of Devonshire, and the rest:

Dear Hogarth.

Our Friend *Wilson* hinted to me this Morning, that I had of late been remiss in my visits to You—it may be so, tho upon my Word, I am not conscious of it, for Such Ceremonies are to Me, mere Counters, where there is no remission of Regard & good Wishes—As *Wilson* is not an Accurate Observer of things, not Ev'n of those which concern him most, I must imagine that ye Hint came from You, & shall say a Word or two to You upon it—*Montaigne,* who was a good Judge of Human Nature, takes Notice, *that when Friends grow Exact, & Ceremonious, it is a certain Sign of Coolness, for the true Spirit of Friendship keeps no Account of Triffles*—We are, I hope, a strong Exception to this Rule—

Poor *Draper* [Somerset Draper, who had died only a few months before, in 1756], (whom I lov'd better than any Man breathing) once ask'd me Smiling—how long is it, since you were at my house?—How long? why a Month or Six Weeks—a Year & some Days, reply'd he, but don't imagine that I have kept an Account; my Wife told Me so this Morning, & bid me Scold You for it—now if Mrs Hogarth has observ'd my Neglect, I am flatter'd by it, but if it is *Your* Observation, Woe betide You—Could I follow my inclinations I would see You Every day in ye week, without caring whether it was in Leicester Fields or Southampton Street, but what with an indifferent State of health, & ye Care of a large family, in which there are many froward Children, I have scarce half-an-hour to

myself—However Since You are grown a Polite Devil, & have a Mind to play at Lords & Ladies, have at you,—I will certainly call upon You soon & if you should not be at home, I will leave my *Card*

<div align="right">

I am Yours Dear Hogy Most Sincerely

D: Garrick.[4]

</div>

It is easy to imagine a quarrel, Hogarth losing his temper, marring the picture, and then feeling remorse. In the picture's present state the eyes are finished, and by Hogarth's hand, but there are signs of revision in the left eye. Perhaps made uneasy by Garrick's doubts about the picture, he kept it in his studio and tinkered with it. The fingers of Garrick's right hand and his pen have been altered, as well as the area around Mrs. Garrick's head and right arm and hand. The background was never finished: above Garrick's head there was a candle on a curved sconce, on which rested a little snuffer from which rose a wisp of smoke. On the wall was a bookcase and beyond that a small looking glass, some prints and paintings. From X-rays it appears that only the bookcase and candle were finished.[5]

An old tradition said that the painting remained in Hogarth's studio unpaid for at the time of his death and was given by Jane Hogarth to Garrick.[6] In fact, Hogarth did receive a £15 payment for "G——ks" in August 1763, shortly before the Garricks left for France.[7] The present state of the canvas may have been due to the Garricks' desire to have a finished painting or to Hogarth's impatience. The unfinished background was simply painted out with a flat greenish color, perhaps to remove the distracting detail of the background in accordance with his tendency in works of this period to simplify (another example was *Sigismunda*).

While the *Graham* and *Mackinen Children* recalled Hogarth's comic history paintings of the 1740s, *Garrick and His Wife* is based on the French situation of a letter writer surprised by his wife—a domestic subject of the sort he would develop a year later in *The Lady's Last Stake* (fig. 53). The figures make, as Hoadly put it in his letter of 21 April, "a fine contrast."

David is sitting at a table, smilingly thoughtful over an epilogue or some such composition (of his own you may be sure), his head supported by his writing-hand; and Madam is archly enough stealing away his pen unseen behind. It has not so much fancy as to be affected

or ridiculous, and yet enough to raise it from the formal inanity of a mere Portrait.

Knowing how Garrick loved to have artists paint him in his great roles, as a kind of self-advertisement, Hogarth shows him playing no role. In fact he is writing a prologue for Samuel Foote's *Taste,* a comedy that dramatized Hogarth's line about dealers duping collectors into buying faked Old Masters instead of works by contemporary English artists. Thus Garrick is trying on the Hogarth "role" of the satirist of connoisseurs—and in that sense serving the same corroborative function that he served in *Garrick as Richard III.*

The consequence of Eva Maria's intrusion will be to surprise Garrick, to elicit the theatrical "start" for which he was so famous, demonstrated in *Garrick as Richard III.* But the tension in the little drama arises from Hogarth's—and Garrick's—awareness of Eva Maria Garrick's link with the earl of Burlington and his countess. On her arrival in England, a dancer known as La Violette, she had been taken up by the Burlingtons (indeed, was rumored to be the earl's natural daughter). She lived in Burlington House and was destined to marry well with a dowry, when Garrick entered her life. Their courtship, against the Burlingtons' opposition, was a cause célèbre of 1749. They were married and Garrick mended fences with the Burlingtons. The possibility that from Hogarth's point of view this was a compromise in the war with the connoisseurs is materialized in Eva Maria's surreptitious attempt to make off with Garrick's pen, thus hindering him from writing his satire.[8]

Hogarth has adapted his composition from a double portrait by his old antagonist Jean-Baptiste Vanloo of Colley Cibber and his daughter (ca. 1740), in which the girl is playfully stealing her father's pen.[9] But, as Richard Wendorf has noted, this adaptation includes two objects of hostility, Vanloo for Hogarth and Cibber for Hogarth's late friend Fielding. Moreover, Vanloo had himself painted Garrick, also holding a quill pen.[10] Wendorf's analysis is ingenious and, I believe, correct:

> just as Cibber's reputation as an actor was eclipsed by the young Garrick, so Van Loo's vogue as a fashionable portrait-painter will eventually be [or at least *should be*] supplanted by Hogarth's own achievements. The formal and somewhat pompous style of Van Loo's

portrait, moreover, has its counterpart in the outdated, bombastic act-
ing style that Cibber and his generation had practised for so long on
the London stage. The more naturalistic and informal method of act-
ing introduced by Macklin and then triumphantly popularized by
Garrick, on the other hand, finds its appropriate analogue in Hogarth's
more realistic and intimate style of painting.[11]

Appropriating Vanloo's affectionate couple, Hogarth has turned
affection into choice. Garrick's choice between the blandishments of
his pretty wife and the duty to write a Hogarthian satire anticipates
The Lady's Last Stake, which only reverses the roles (the terms are
still pleasure and virtue). In the context of *Hogarth Painting the Comic
Muse* (fig. 51), of a year later, the issue is the muse: does she control
the artist, or he his muse? In Hogarth's case the artist, who is painting
her, seems to be in control. The Garrick portrait, recalling the ten-
sions of Garrick's letter to Hogarth, implies a subtext in which the
wife ought to be subordinated to her husband and the homosocial
bonding of friends but is not.

Further information about Hogarth's portrait painting comes from
Benjamin Wilson, who in 1756 had just returned from France. While
there, he saw and copied the Rembrandt of which the drawing pur-
chased by Hudson at Richardson's sale had been the first sketch, and
also demonstrated his electrical theories. When he returned to En-
gland and to his portrait practice, he found, as he put it, that

> Reynolds was rising into celebrity; and Hogarth, who had not equal
> success in portrait painting, proposed to Wilson to join him in this
> branch of the art in order to secure what he considered a just propor-
> tion of the public favour. Hogarth was so anxious for this partnership
> that he applied to Garrick, with whom both on account of his dra-
> matic excellence and his high qualities Wilson had formed a close in-
> timacy, to persuade him to accept the proposal.

This would appear to have been around the time Wilson passed on
Hogarth's complaint to Garrick. Nothing came of the "partnership":
"for good reasons, however," Wilson's account concludes, "Wilson
declined it." Wilson went his own way; his portraits brought him in
£1500 a year, and he still continued with his experiments. But one of

Hogarth's schemes for easing the labor of portraiture, apparently the object of his approaches to Wilson, emerges in the story that he suggested to his artist friends, and quite possibly to his sitters as well,

> that the profession of Portrait-painting might be considerably benefited if less time was required of the sitter, whose morning hours might, in many instances, be of so much value, as to render it inconvenient to allot so many of them to such purposes. He, therefore, proposed to paint a Portrait in four sittings, allowing only a quarter of an hour to each; and on that plan actually finished a portrait in oil of his very old and much-esteemed friend Saunders Welch. Esq. a Magistrate of Westminster.[12]

The portrait of Welch that survives (probably datable 1758, fig. 71) is only a face on a blank ground. Since no finished portrait is recorded, Hogarth may, as he did with other portraits from these years, have made it for himself—for (in Johnson's words) "quickening the affections of the absent."

Welch (1711–1784) is a good example of the friends he memorialized in his last portraits. A self-made man, he was a prosperous grocer who served as high constable for the Holborn Division and had closely assisted Fielding in establishing the London police force in the early 1750s (a man, Fielding wrote, "whom I never think or speak of but with love and esteem"). Sir John Hawkins's daughter remembered him as being, despite his low origins, "in person, mind, and manners, most perfectly a gentleman." In 1758 he joined Robert Dingley, with Jonas Hanway, John Fielding (Henry's half-brother and successor at Bow Street), and other civic-minded men, to propose an asylum for prostitutes: his *Proposal . . . to Remove The Nuisance of Common Prostitutes from the Streets of This Metropolis* was published in 1758, the same year as Dingley's *Proposals for Establishing a Public Place of Reception for Penitent Prostitutes* and Fielding's *An Account of the Origins and Effect of a Police*. Welch proposed a hospital in which prostitutes would be placed to be educated and returned to society as apprentices or servants. His argument (Hogarth's in his *Harlot's Progress*) was that it did no good to arrest and punish the prostitute; women, even after having fallen into prostitution, are redeemable. This project and its result, called appropriately the Magdalen Hospital, may have reflected the long-range effect of Hogarth's

Harlot (his own Magdalen had been unveiled in Bristol in 1756); it certainly suggests one reason for Hogarth's interest in Welch's friendship and for keeping his likeness. Moreover, it was another project like the Foundling Hospital. Daniel Lock, who founded the Lock Hospital in 1746 for the poor suffering from venereal disease (half its patients were women, mostly young prostitutes), was another subject of Hogarth's portraiture, probably painted at the hospital's request.[13]

Some of these late portraits, with symbolic as well as friendly associations, were commissions for frontispieces (Fielding and Morell, figs. 11, 78). Some were experimental and playful. Tapping the vogue for portraits in fancy (usually Van Dyck) dress, Hogarth painted Mary Cholmondeley (née Woffington, sister of the actress) in ruff and mobcap, wearing a cross and resembling Mary Queen of Scots; and Mary Lewis, Jane Hogarth's cousin, was similarly "disguised" (fig. 79).[14] The most interesting of the portraits is that of his old friend, the engraver John Pine (who died in 1756); this (figs. 72, 73) was painted, probably as a memorial portrait, in the impasto manner and costume of Rembrandt's late self-portraits, and Hogarth thought enough of it to have James McArdell reproduce it in mezzotint. His own self-portrait of 1758 was painted in the Rembrandt mode, though engraved in his own (above, figs. 51, 52). This sort of portrait, apparently associated with artists' self-portraits, had been undertaken by Hudson in his portrait of the drapery painter Joseph van Aken in the late 1730s (mezzotinted by Faber).[15]

WILLIAM HUGGINS

Huggins wrote Hogarth in November 1758 asking him to paint his portrait as a companion to the portrait of his father. Hogarth wrote back on the 9th ("My Dear best Friend"):

> how could you doubt I would refuse anything M^r Huggins would ask of me. Was the request to be no favour done to me you may and ought to command me at all time upon many accounts too tedious to mention. As to the size you woud have that picture you need only to bring to town with you the length and breadth of its companion together with just the Size of the face.[16]

The portrait of John, painted on a canvas with herringbone weave, very similar to that on which Anne and Mary Hogarth were painted, was done between 1740 and 1745. William must have traveled up from Hampshire, with the measurements of the canvas and his father's face, for his sittings.

The results (figs. 74, 75) are the last of Hogarth's great parent-child portraits. They are painted in different styles: John, delineated in hard, dry brush strokes, emphasizing the harsh, craggy face, is clearly a tough, mean, and grasping old man. William is done in broad strokes that emphasize his soft, flabby, good-natured face. Kindly and slightly fatuous, he is, like Horace Walpole and John Hoadly, another of the inheritors; he is shown with a bust of Ariosto and a plaque referring to his other literary endeavor, his translation of Dante. The father stands before a blank wall. It is a significant accident that Huggins chose to be portrayed in this way: no wife is present, and the father and son are isolated from each other in their enclosed circles of frame. The relationship with the successful father is clear enough if one begins with the younger Huggins's sad experience with his oratorio *Judith* and goes on to his *Orlando,* published anonymously but with a dedication to George II signed by Temple Henry Croker, and accordingly ascribed to Croker throughout the eighteenth century. Huggins was the first Englishman to translate the *Divine Comedy,* but only twenty lines of his *Purgatorio* saw the light of publication, despite his instructions in his will.[17]

The close friendship between Hogarth and Huggins is evident in the surviving letters: "I had great pleasure in reading every circumstance of yours that so very thoroughly figured to me the happiness of your Family. nor am I less sensible of your warm Expressions of kindness for mine," writes Hogarth, ending with regrets that he and Jane will be unable to visit the Hugginses in Hampshire. Before leaving for London, Huggins wrote back on the 15th, evidently sending Hogarth part of the translation of Dante he was working on, hoping to convince him to contribute illustrations. Hogarth's reply was the letter ("My Dear warm Friend") in which he laments his age and inability to undertake the Dante:

> but consider now my dear Friend Sixty is too late in the day to begin
> so arduous a Task[,] a work that could not be compleated in less than
> four or five years. The Bubble glory you hint I have no antipathy to,

weighs less and less with me every day, even the profit attending it. I grow indolent, & strive to be contented with with [sic] what are commonly call'd Trifles, for I think otherwise of what best produces [?] the Tranquility of the mind. if I can but read on to the end of the Chapter I desire no more. this is so truly the case with me, that I have lately (tho I enjoy and love this world as much as ever) hardly been able to muster up spirits enough to go on with the two Pictures I have now in hand because they require much exertion, if I would succeed in any tolerable degree in them.[18]

And he goes on to describe the commissions from Charlemont and Grosvenor, on which he was engaged. The letter tells a great deal: for the sake of tranquillity of mind he is limiting himself to trifles (*The Bench* and *Hogarth Painting the Comic Muse* besides portraits); the old dichotomy of his studies and pleasures has now broken down—he cannot "muster up spirits" to do serious work, but he can still "enjoy and love this world as much as ever"—and yet he has just undertaken two demanding paintings.

A final letter survives from 24 June 1760, written in Chiswick:

My Dear S^r
The Dante finish'd! well
I can never enough admire your Resolution and constancy, as well as ability, in in [sic] every thing you undertake. . . .

Failing to interest him in illustrating his Dante, Huggins had asked him to engrave the portrait he painted of him in the fall of 1758, and Hogarth replies:

but to the point I must beg you will excuse my attempting to engrave your portrait it is a thing [I] never did nor shall be able to succeed in witness the two damn'd things I labour'd at of my own Fiz for the Frontispiece to my works, the copying my own works is the devil. I am sure the poorest graver will do it better than I should.[19]

If no more, this letter confirms the evidence of Hogarth's many revisions of his face in *Hogarth Painting the Comic Muse* and his anxiety over getting the expression right.[20] Huggins died a year later in 1761.[21]

HAY AND MARTIN

George Hay and Samuel Martin were civil servants and placemen. Both were bachelors and professional men first, politicians second; both were supporters of Henry Legge, Pitt's lieutenant, and both deserted the Pittites for the peace party in 1762. Hay, a prominent speaker for the Pitt government, especially on legal and naval matters, was seriously considered for the speakership before the opening of Parliament in 1761, but was rejected partly at least because he was a Scot.[22] Bishop Butler's summation of his character suggests his importance to Hogarth:

> He had a better temper, a better understanding and a better character than he was willing the world should see. It required much knowledge of him to perceive this. . . . His conduct in politics was much blamed. The true account of it was that he had no opinion of any cause, but considered them all as the pretences under which men carry on their selfish schemes; yet he was a friend to liberty, and did not think it in danger in any hands. When he joined Lord Bute's party, for which I among others censured him, his apology was that Mr. Legge was declining in health, and that he liked neither Mr. Pitt nor any of the set, and thought the public full as safe in the feeble hands of Lord Bute as in theirs.[23]

His career in Commons exactly paralleled Hogarth's *Election* prints. He entered Commons in 1754 as a Newcastle supporter, switched his allegiance the following year to Legge and the Pitt faction, and as a result was dismissed from his office of king's advocate in May 1756; he was reinstated shortly after when the Devonshire–Pitt ministry took power and in addition was appointed a lord of the Admiralty. He lost his post on the Admiralty board when Pitt fell but regained it under the Pitt–Newcastle ministry; this was the position to which Hogarth drew attention when he dedicated the final plate of the *Election* to him in 1758. Behind the *Election* and Hogarth's other works of the later 1750s one senses the uncertainty, and perhaps cynicism, of a friend like Hay.

Hogarth seems to have known him as early as 1742, before he became a member of Doctors' Commons: an invitation, along with George Lambert and Ebenezer Forrest, to a Hogarth dinner has sur-

vived.[24] One of the tickets for *Paul* and *Moses* is made out to him in 1751.[25] *The Savoyard Girl* of 1749 (fig. 25) may have been a "special commission" proposed by Hay; or perhaps it began as one of Hogarth's good-looking young women and was filled in for Hay's benefit with the iconography of Cumberland's failures. But it may also have been merely a jocular gift to a close friend. In 1757 Hogarth was painting Hay's portrait at the same time as Garrick's.[26] John Hoadly saw the portrait in his studio and made the interesting comment, which supports Bishop Butler: "There is an admirable head of Dr. Hay of the Commons; which if I were like, I would not have my picture drawn: I should not like to meet that figure alive in the fields going to Chelsey, for fear of dying that night in a ditch— / With twenty gaping gashes on my crown."[27] It was to this man, however, that Hogarth confided his anti-Grosvenor verses in 1759; he followed Hay's political lead (or his Scottish sympathies) in 1762 when he supported the Bute ministry; and in 1764 his last surviving letter, concerning a drawing of *Sigismunda* and his efforts to have it engraved, was to Hay, who also owned the painting of *The Bench*.

Martin became a more notorious figure than Hay because in 1762–1763 he was blamed for dispersing the secret service money that bought Parliamentary votes for the peace, and in 1763 he nearly killed Wilkes in a duel. Martin began as a supporter of Leicester House and Legge; after Prince Frederick's death he served the Pelhams, and after Henry Pelham's death in 1754 Legge, as Newcastle's chancellor of the exchequer, appointed Martin his secretary. He fell from office with Legge and rose again with him under the Devonshire–Pitt ministry, becoming joint secretary of the treasury. Not reinstated by Newcastle in June 1757 in the new administration, he was bitter about his treatment, publicly spreading the story. Despite Newcastle's chagrin at the publicity, he restored Martin to the treasury post in April 1758; but Martin was no longer any friend of his, and he made contact with Bute and Leicester House. When the new court insisted on Legge's dismissal in January 1761, his protege Martin remained—"not thinking myself in the slightest measure bound . . . to quit my offices, because Mr. Legge was displaced."[28] Though remaining in Newcastle's treasury, he was an implacable enemy of the duke; in the spring of 1762 he was surreptitiously supplying Bute with treasury papers, and when Newcastle fell he remained a Bute man.

Like Hay, Martin was a man of slippery allegiance, but in his case (judging by the urgent letters from his father and his own replies) directed by ambition rather than disillusion or cynicism. As his post of secretary of the treasury suggests, he was an administrator, an expert on finance, rather than a politician. A man who seems to have devoted himself entirely to his work, he had no wife, few friends, and was personally abstemious. This "joyless man, solitary and self-centered," who "could not stand anyone permanently near him," must nevertheless have seemed sympathetic if not convivial to Hogarth.[29] He used Martin as his intermediary in the letter to a nobleman, probably Bute, over the future of British artists, and he painted his portrait (fig. 76), which was either made for his own wall or left unfinished at his death (he left it to Martin as a bequest in his will). The rest as far as Martin is concerned is speculation. Churchill's diatribe in *The Duellist* (1764) hints at secret and forbidden lusts but then turns to list conventional topics: he has raped a Lucrece and gambled away the support of a wife and children (he was a bachelor).

Finally, Henry Fox, momentarily Hogarth's choice for chief minister, had retired to the safety and profit of the paymastership of the armed forces, leaving the field to Pitt. He was another ambiguous figure in the comedy of the 1750s, preparing for the last act of 1762–1763. Hogarth seems to have remained on friendly terms: in 1762 he delivered Fox's portrait (fig. 77), one of his most striking, though apparently not Fox's own favorite among his portraits. As Namier remarks of it, "in spite of a certain massive grandeur, he appears anxious, almost hagridden." It is the Henry Fox Hogarth would have seen and understood at this time. He received 20 guineas for the portrait, and in 1763 a further £34 2s 6d for some unspecified work done for Fox.[30]

It was with such men as Hay, Martin, and Fox—at the head of their professions as technicians but of suspicious repute politically, and all presenting a strong contrast to the courageous and dedicated Pitt—that Hogarth was personally associated. Their friendship enabled him to extend one side of his character, but in the peculiar context of the times this led to an evident confusion between idealism and self-interest, involvement and detachment, that would become public in the year 1762.

There was overlap among these friends of different persuasions, Hay for one being a friend of both Hogarth and Wilkes. Speaking

against Wilkes in the debate on general warrants, 17 February 1762, Hay admitted to have "lived in friendship" with Wilkes, "till his violent and profligate behaviour made him quit him."[31] Dashwood and the Medmenham group may equally have served as a common bond, with Paul Whitehead as Hogarth's special friend and intermediary. They would all have continued to meet into the 1760s at the Beefsteak or Shakespeare Club (which met at the Shakespeare Tavern in Covent Garden) and other of the innumerable London clubs. Horace Walpole refers to the Beefsteaks as now being a "weekly club to which both [Sandwich and Wilkes] belonged, held at the top of Covent Garden Theatre and composed of players and the loosest revellers of the age."[32] Through all of these various groups Hogarth encountered Wilkes, the thin, irreverent joker, and Churchill, the huge, bearlike, moonfaced poet whose brilliant invective he would have cause to appreciate (see Chaps. 13, 14).

The old friends had faded away. Fielding died in 1754, Benjamin Hoadly in 1757, and Bishop Hoadly and John Huggins in 1761. The artists who had been his close friends in the 1730s and 1740s were polarized, and it appears that only a few such as Benjamin Wilson remained on the old friendly terms. Martin, Hay, and Garrick, born in 1714, 1715, and 1717, respectively, were a few years younger than the Fielding generation, and nearly twenty years Hogarth's junior. Wilkes and Churchill, and the Thornton–Colmon Lloyd group (see Chap. 12), were another ten years younger—about the age of the earl of Charlemont. Fielding and Garrick had been devoted to ends sympathetic and parallel to Hogarth's, and (despite the age differences) they acted as equals. The younger generation evidently served a different function for Hogarth: they accepted him as one of them, and their conviviality seemed to contradict his sense of aging, while at the same time they listened to him and cooperated in his attacks on the artistic establishment.

FAMILY CIRCLE

The great portraits of this period are the likenesses, the mere faces, of close friends. These faces were done by Hogarth for the sheer love of painting, to hang in his showroom as a sample of a variety of

likenesses for prospective sitters (who might then compare them with their originals), and/or simply to memorialize the faces of people who were dear to him. During these last years he apparently kept pictures of his friends around him; it is quite possible that he left *Garrick and His Wife* unfinished partly to have Garrick's portrait nearby when he did not call in person as often as he might. There were also portraits of John, Sir James, and Lady Thornhill, Hogarth's mother, his sisters Anne and Mary, Mary Lewis, and two or more of Jane.[33]

Jane's cousin Mary Lewis was a pretty young woman in her twenties, the daughter of David Lewis, reportedly harper to George II. Hogarth painted her in a ruff (fig. 79). "When Mr. Hogarth had finished the portrait," she recalled years later,

> he brought it to me and said, 'There, Molly, I have finished your portrait at last, and I have taken some pains with it. I have put you in a ruff to disguise you, for you are too handsome. Now, I have been offered twenty guineas for it. Therefore, if you like, I can let you have that instead of the picture.' I replied, 'No, Sir! I thank you for the pains you have taken to oblige me, and I shall keep the picture for your sake.'[34]

This glimpse of a relationship recalls that it was in Mary Lewis's arms that Hogarth expired, nearly ten years after completing her portrait; and it was Mary who continued to live with Jane for the rest of her life.

There was one other woman in the family, Julien Bere, of a Yorkshire family, who was with the Hogarths by 4 February 1759 when John Baker, the West Indies barrister, gave a brief glimpse of her in his diary: "Dined Mr. Banister's—Mr. Hogarth, the painter, and Uxor, and one Miss Bear (or some such name) who lives with them, and Mr. Sam¹ Martin and Mr. Sloper who all went before supper."[35] Miss Bere may have been a distant relative or she may have lived with the Hogarths as a boarder. She was especially remembered in his will among his friends. Considering his practice of painting the members of his family circle, she may be one of the unidentified portraits from those years.

In July 1759 her cousin John Courtney of Yorkshire made an

unsuccessful attempt to visit her. She and the Hogarths were in their Chiswick house for the summer. But on 19 April 1762 he returned accompanied by his mother and a Mr. Stonestreet and was entertained by the Hogarths in London. He recorded the event, preserving another glimpse of Hogarth: "Mr Hogarth is a plain Man show'd & explain'd the Election Pictures to us, talks much against the French."[36]

These personal portraits are summed up in a masterpiece, *Hogarth's Servants* (fig. 80), six simple heads on a canvas. They are independent portraits, each face finished, self-contained, and in its own umvelt, and yet the same scale and placed within a semi-coherent spatial system—in a rough attempt at making them appear to be standing as a group. We can only guess who they are. Hogarth had an old servant named Ben Ives; Jane had a manservant named Samuel and a housemaid in the Chiswick house named Chappel. The woman at lower left could be a younger portrait of Mary Lewis (cf. fig. 79). The number of servants portrayed does not advertise an unusual prosperity. The minimal needs of a country house in the later eighteenth century were set by Hogarth's commentator, the Reverend John Trusler, at five servants; one "to act in the capacity of coachman and to manage the farm," a second to serve as footman and gardener, a boy, and two maids. Clergymen on a yearly income of between £300 and £700 could maintain households on about this scale; a lawyer might keep as many as eleven. Hogarth's six, I would guess, were a coachman, valet, boy, and housekeeper with two housemaids. One of the men must have served as his printing assistant.[37]

These portraits also exemplify an aspect of Hogarth's art. If an elaborately organized portrait group like the *Garrick and His Wife* represents one sort of Hogarth composition, another is the consciously *un*structured picture, beginning in the 1730s–1740s with "Four Groups of Heads" and *Characters and Caricaturas* and ending in the 1760s with *The Five Orders of Periwigs* (fig. 85), which has no "plot" and represents an accumulation of unsubordinated gestalts. The ultimate example among the paintings is *Hogarth's Servants,* the most radical form taken by his belief in nature over art. In fact, as Lawrence Gowing has shrewdly remarked, there is a pointed defiance of compositional devices and all attention is directed to the character and structure of each sitter's physiognomy or expression.[38] This

had been the immediate source of Hogarth's interest in portraiture in the 1730s, and the interest in pure "nature" must be kept in mind against the relatively simple expressive shapes of *Sigismunda* and the last history paintings.

One form "nature" took was the compartmentalization of information, which led from the "modern moral subjects" with their reading structures into the diagrams surrounding the plates of the *Analysis;* here Hogarth uses diagram to get at truths about natural forms that are related to those in his oil sketches. We need only compare the pure forms and colors of *The Wedding (or Country) Dance* with the engraving used for *Analysis,* Plate 2 (figs. 23, 24), in which the truths demonstrated by paint are rendered in diagram, compartmentalized around the fully "finished" representation in the center. Even the painting, however, shows the tension that sometimes exists in a single picture between the coherence of the total composition as a study in essences and the autonomy of certain separate figures or objects quite independent of it.

Shape was used by Hogarth to relate objects in a scene but also to isolate them, making them slightly out of place in their context. The tendency of his theme as well as his own predilection was toward painting the discrepant details of a milieu. The houses in the background of *Election* 3 (fig. 39), the bowl of fruit in *Sir Francis Dashwood at His Devotions* (fig. 68), and the various objects in *Marriage A-la-mode* are rendered with a truth that is sometimes at odds with the overall composition. The unified whole of *The March to Finchley* does not quite subsume such separate images as the young couple kissing, all interlocking arms and faces. And in this sense, *Sigismunda,* in its own terms an experiment in the Reynolds mode, disappoints expectation as only a fragment of a lost Hogarth composition.

There is, of course, a tendency in all of his paintings to fragment: this begins as part of his theme, or it is a theme that evolves from a constitutional refusal or inability to subordinate parts (variety) to unity. Where Hogarth and Reynolds profoundly differed was in their evaluation of the great tradition and so of the general versus the particular (universal/contingent, unity/variety). They are, in that sense, the great antagonists, though their basic assumption of painting and poetry as "Sister Arts" was the same—and even Reynolds's insistence that one must be able to take in a picture at a single glance (apparently so different from Hogarth's "love of pursuit") was always one

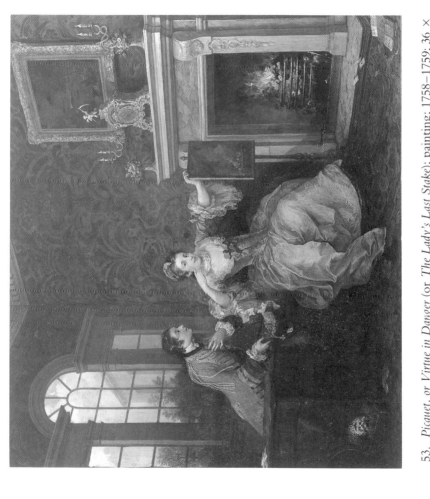

53. *Picquet, or Virtue in Danger* (or *The Lady's Last Stake*); painting; 1758–1759; 36 × 41½ in. (Albright-Knox Gallery, Buffalo, New York; gift of Seymour H. Knox, 1945).

54. *Sigismunda*; painting; 1759; 39 × 49½ in. (Tate Gallery, London).

57. Joshua Reynolds, *Kitty Fisher as Cleopatra*; painting; ca. 1759 (The Iveagh Bequest, Kenwood House).

56. Charles-Antoine Coypel, *Adrienne Lecouvreur as Cornelia* (engraving by Pierre Imbert Drevet); 1730 (courtesy of the British Museum, London).

55. Francesco Furini, *Sigismunda*; painting; ca. 1640 (Duke of Newcastle).

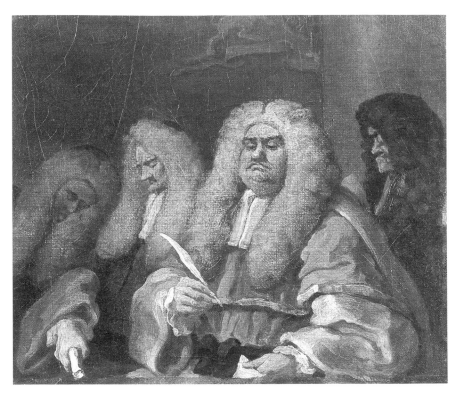

59. *The Bench;* painting; 1758; 5¾ × 7 in. (Fitzwilliam Museum, Cambridge).

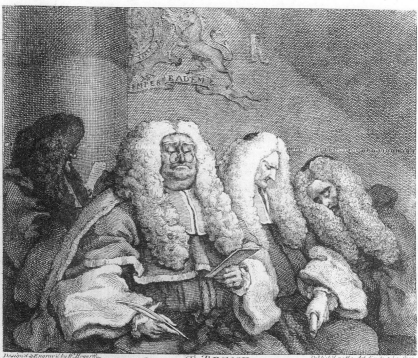

60. *The Bench;* engraving (first state); Sept. 1758; 6½ × 7¾ in., caption plate 4⅝
× 8⅜ in. (courtesy of the British Museum, London).

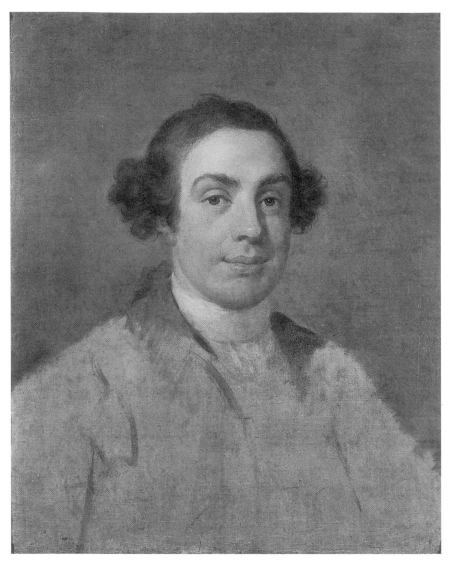

58. *James Caulfeild, first Earl of Charlemont;* painting; ca. 1759; 23½ × 19½ in. (Smith College Museum of Art; gift of Mr. and Mrs. R. Keith Kane).

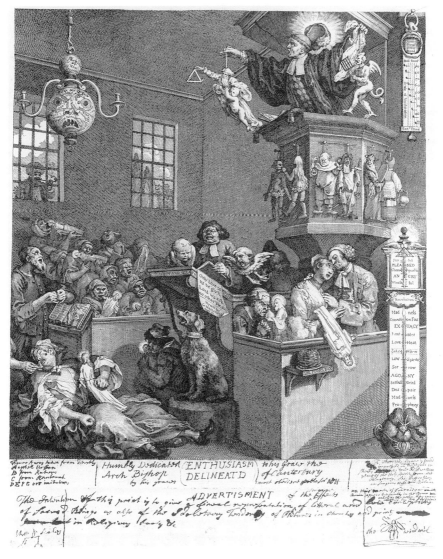

64. *Enthusiasm Delineated;* 1759–1760; 12⅝ × 14 in. (courtesy of the British Museum, London).

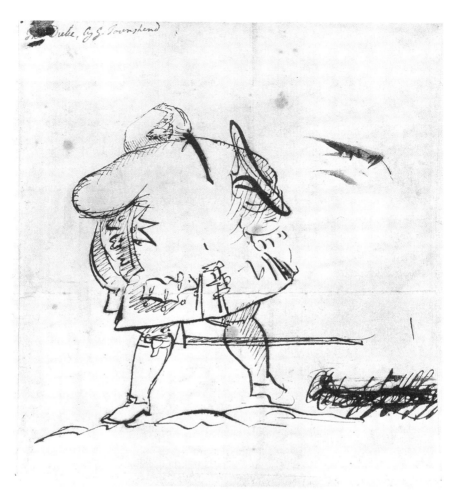

61. George Townshend, *Caricature of the Duke of Cumberland;* pen drawing; 1757 (Paul Mellon Collection, Yale Center for British Art).

63. Details of William Pitt from figs. 92 and 99 below.

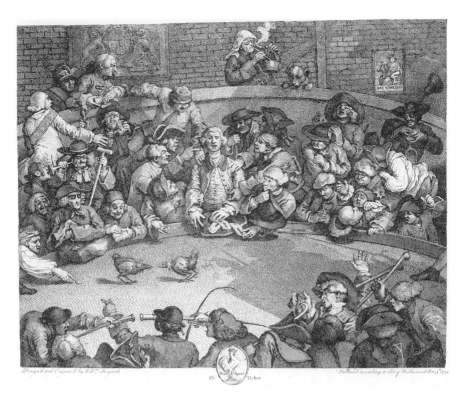

62. *The Cockpit;* Nov. 1759; 11¹¹/₁₆ × 14¹¹/₁₅ in. (courtesy of the British Museum, London).

65. *Francis Matthew Schutz Being Sick;* painting; late 1750s; 25¼ × 30 in. (Norfolk Castle Museum).

66. *A Night Encounter;* painting; ca. 1740?; 28 × 36 in. (the Right Hon. the Viscount Boyne).

67. *Charity in the Cellar;* painting; 1750s?; 39 × 49 in. (private collection).

68. *Sir Francis Dashwood at His Devotions;* painting; late 1750s; 48 × 35 in. (the Right Hon. the Viscount Boyne).

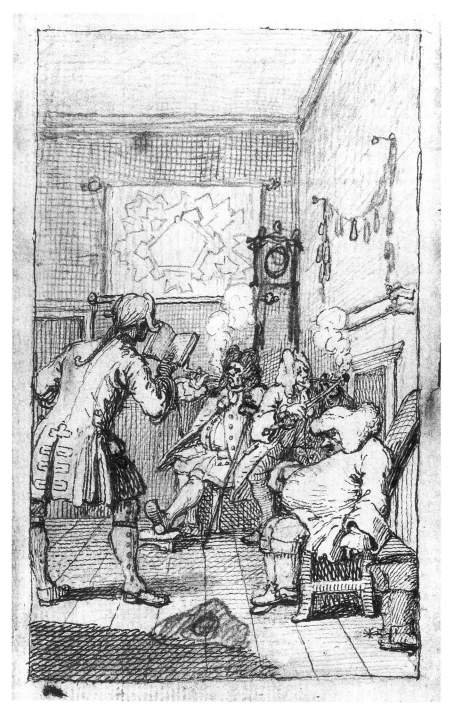

69. Frontispiece, *Tristram Shandy,* vol. 1; drawing; 1759; 5⅜ × 3¼ in. (Henry W. and Albert A. Berg Collection, New York Public Library, Astor, Lenox and Tilden Foundations).

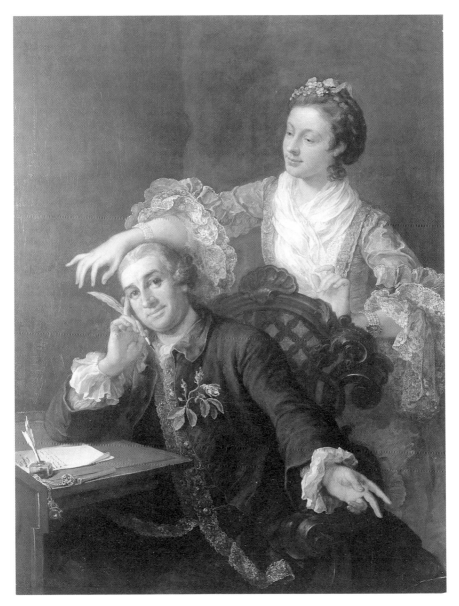

70. *David Garrick and His Wife;* painting; 1757; 50¼ × 39¼ in. (Royal Collection, St. James's Palace, copyright Her Majesty Queen Elizabeth II).

71. *Saunders Welch;* painting;
late 1750s; 23¼ × 19¼ in.
(Simon Houfe Collection).

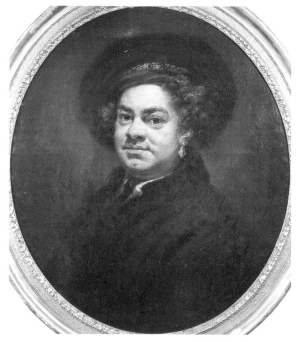

72. *John Pine;* painting;
ca. 1755; 28 × 24½ in., oval
(The Beaverbook Founda-
tion, The Beaverbrook Art
Gallery, Fredericton, New
Brunswick, Canada).

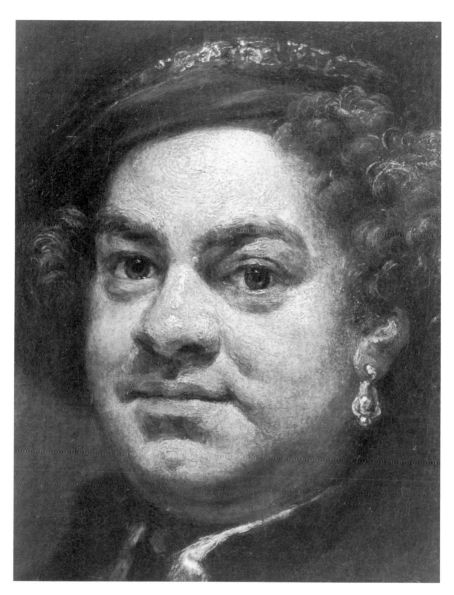

73. Detail of fig. 72.

74. *John Huggins;* painting; before 1745; 18 × 15¾ in. oval (Hyde Collection, Somerville, New Jersey).

75. *William Huggins;* painting; 1758; 18 × 15¾ in. oval (Hyde Collection, Somerville, New Jersey).

76. *Samuel Martin;* painting; ca. 1757 (or 1762?); 25 × 21½ in. (Koriyama City Museum of Art, Japan; photo courtesy Richard L. Feigen & Co., New York).

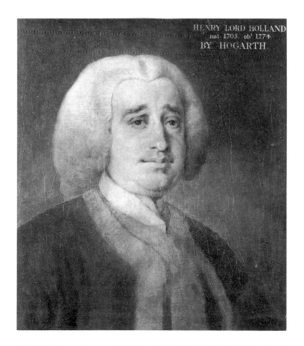

77. *Henry Fox;* painting; 1761; 23½ × 19 in. (private collection).

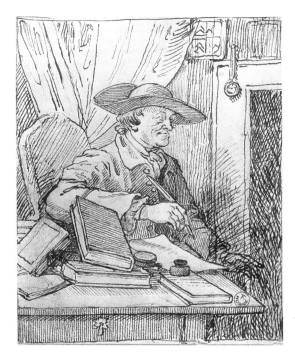

78. *Thomas Morell;* drawing; 1761–1762 (engraving by James Basire, pub. Feb. 1762); 7¾ × 6 in. (The Horne Collection, Florence).

79. *Mary Lewis;* painting; 1755[59]; 21 × 19 in., oval (City of Aberdeen Art Gallery and Museums Collection).

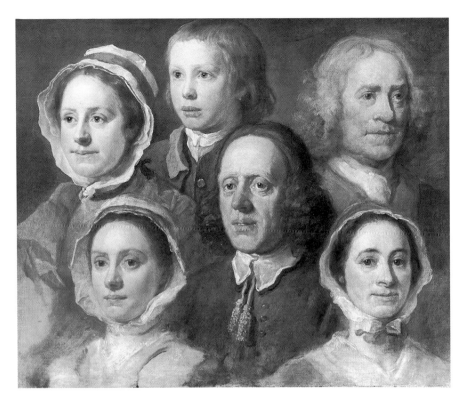

80. *Hogarth's Servants;* painting; mid-1750s; 24½ × 29¼ in. (Tate Gallery, London).

81. Detail, *The Analysis of Beauty,*
Pl. 2 (third state); ca. 1760 (courtesy
of the British Museum, London).

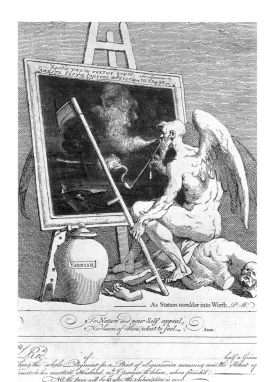

82. *Time Smoking a Picture*
(first state); Mar. 1761; 8 ×
6¹¹⁄₁₆ in. (courtesy of the Brit-
ish Museum, London).

Et spes & ratio Studiorum in Cæsare tantum.

Juv.

Published according to Act of Parliament May 7.1761.

83. Frontispiece to the *Catalogue of Pictures Exhibited in Spring Gardens;* May 176: 6⅞ × 5⅜ in. (courtesy of the British Museum, London).

W.Hogarth inv.t et del.

C.Grignion sculp.

Publish'd according to Act of Parliament May 7, 1761.

84. Tailpiece to the *Catalogue of Pictures Exhibited in Spring Gardens;* 4½ × 5⅛ in. (courtesy of the British Museum, London).

phase of Hogarth's strategy of reading. But in all of his works, Reynolds sought what Michael Fried has called absorption,[39] best summed up in his portrait of the near-sighted Giuseppe Baretti with his face buried in a book; everything is centripetal, focused inward toward an undivided unity of form and meaning. Hogarth, the "Shakespeare of English Art," as he was already being called by contemporaries, regarded that as an oversimplification. His paintings and engravings, both formally and literarily, refuse this stability as alien to human experience, their logical end being the independent faces redolent of life and energy in *Hogarth's Servants*.

The greatest of these isolated portraits is *The Shrimp Girl* (late 1740s or 1750s, ill., vol. 2, fig. 50). It is a freer, because less finished, and larger experiment in the direction Hogarth took in his simplest portraits; it is close to the pure color and form he explored in other oil sketches. What, at the other extreme from the prints and their readable structure, is one to say about *The Shrimp Girl*? It may seem irreverent to refer to this masterpiece as a jeu d'esprit, but that is exactly what it was in Hogarth's own terms; and as such it could also serve as a summation of his aesthetic theory in the *Analysis* and his series of beautiful young plebeian women. The main line of his development was the comic history paintings or modern moral subjects; even though, in our twentieth-century eyes, the great Hogarth may be the Hogarth of the oil sketches, that was not true in his own day. But he retained this picture, probably painted it for himself, and I would not want to rule out the possibility that this is a portrait of Jane. (Given Jane's remark about the painting—quoted below, 438— it seems more likely that this, *The Lady's Last Stake*, and *Sigismunda* all represent a *type* of good looks that may have included Jane, rather than portraits.)

The very fact that Hogarth's unfinished oil sketches expressed his most unofficial, free, and unconscious self is part of their importance as exemplifications of his aesthetic theory. The calligraphy of the brushwork expresses not only his belief in the Line of Beauty as an essential structure but also his freedom from the restraints of finishing a representation, closing a perspective, exemplifying a moral, or "preparing a face to meet the faces" of the critics or connoisseurs.

12.

THE ART EXHIBITIONS OF 1760–1761

THE SOCIETY OF ARTS EXHIBITION OF 1760

Although Hogarth only appeared there infrequently now, the Foundling Hospital was still London's center of public art, the one unifying and rallying ground for its artists after the dissension over the St. Martin's Lane Academy. The artists had fixed a pantheon of English painters in which each could be exalted for his particular excellence. At the annual artists' dinner at the Foundling on Saturday, 5 November 1757, with 154 present including Hogarth, Reynolds, and Ramsay, the group was entertained with an ode, "The Progress of the Sister Arts," by Samuel Boyce, sung to the music of Thomas Arne's "When All the Attic Fire was Fled." Britannia complains that while she has a great, powerful, and free country, "The Arts, the Heaven-directed Arts, / Are here, alas! unknown." She prays for artists, and God "gave th' assenting Nod"—

> Again Corregio's genius liv'd,
> The warmth of Claude Lorrain reviv'd,
> And Titian's own'd the God.
> Diffuse, he cried, o'er Britain's Isle,
> Let there the Soul of Painting smile
> Transcendent, all refin'd:
> A noble portion HAYMAN caught,
> Soon Picture started from his thought,
> And History won his mind.
> The spirit glow'd in HOGARTH's heart,
> He rose Cervantes of the art,

And boasts unrival'd praise.
The impulse flame a LAMBERT warm'd;
With Nature's rural beauties charm'd;
He wears eternal bays.
A SCOTT confess'd th' inspiring ray,
The rolling bark, the wat'ry way,
Assert the Master's hand;
And REYNOLDS felt the sacred beam,
Lo, Portrait more than Picture seem,
It breathes at his command.[1]

The grounds of the Foundling were by this time one of the most popular strolling places in London, and as early as 1752 the General Committee had ordered "That all Persons of Fashion be admitted into the Garden at all reasonable hours, except on Sundays" (for admission on Sundays a special written order of a governor was necessary). By 1756 a letter to John Fielding and Saunders Welch, justices of the peace for Westminster, asked for constables "to search for and apprehend all Persons selling Fruit, Spirituous Liquors, gaming, or begging on Sundays, within the Fields belonging to this Hospital."[2]

The size of the contributions to the charity boxes and the popularity of the paintings permanently on display in the public rooms of the hospital must have suggested to the artists the idea of annual exhibitions of their works. More cynically, the author of *The Conduct of the Royal Academicians* notes that the accessibility of the donated works of art "made those artists more generally known than others; and this circumstance it was, that first suggested an exhibition; which was no sooner proposed, than approved."[3] For the artists, exhibitions were a means both of keeping the polite public abreast of their work and of collecting money for various purposes—and, of course, a first step toward a royal academy. Another lesson of the Foundling experience was that the visitors to such an exhibition must be restricted in some way in order to keep out the mob.

Annual exhibitions were connected in the minds of English artists with the French Academy of Painting and Sculpture, which held regular annual salons from 1737 to 1751 (skipping 1744), and after 1751 biennial salons.[4] The English artists were attracted by the association of exhibitions and academies, but they were also developing another of the concepts Hogarth had demonstrated. Having failed with the Dilettanti Society, they decided to "appeal from the tribunal

of criticism to that of the people." The phrase is Goldsmith's. His *Enquiry into the Present State of Polite Learning in Europe* had appeared in April 1759, filled with the Hogarthian view of the critic as a villain who overshadows and ruins the poet as the connoisseur does the artist. "The ingenious Mr. Hogarth," Goldsmith writes, "used to assert, that every one, except the connoisseur, was a judge of painting. The same may be asserted of writing." Thus an exhibition was the most obvious means to carry out the essential "appeal."[5] The public had been the object of Hogarth's appeals all along, and probably the only reason he did not suggest annual exhibitions was their association with the French Academy—the aspect that drew the other artists. The artists lacked royal patronage, but they had an organization, and if they secured public support, patronage might follow.

However, annual exhibitions (as one commentator has observed, speaking of the French) tended to create "a public which had contact with art for a few hours every [year or] two years and which formed its standards from that casual contact; and they induced the artists to court the approbation of this ill-educated public." A second consequence, evident before long, was the creation of the professional art critic, only a slight improvement on the connoisseur. "The public felt lost in what they regarded as a multitude of pictures, . . . and professional students of art history and men of letters began to write articles in journals and periodicals" to guide taste.[6]

Hogarth did not participate directly in the planning that now began—certainly he was not on the committee that governed the artists at this time. After the Foundling dinner of 1757 he attended the yearly meeting of the governors on 10 May 1758—the only one of the artists to attend, and so he may have been their representative when John Shackleton's portrait of the king was presented and Shackleton was elected a governor. Wilkes was present at this meeting and was appointed a steward for the next anniversary dinner. He was also present at both of the next two meetings Hogarth attended: an extraordinary General Court of Governors on 7 February 1759 and the annual meeting on 14 May 1760, when Hogarth was appointed a steward for the next anniversary dinner.[7]

In his "Autobiographical Notes" Hogarth describes his failing health after the Grosvenor fiasco. The exertions "which attended this affair coming at a time when perhaps nature rather wants a more

quiet life and something to cheer it as well as exercise after long sedentary proceeding for many years brought on an Illness which continued a year which a horse chiefly when I got well enough to ride recovered me of" (AN, 221).[8] The year he refers to probably was 1760. After *The Cockpit* of December 1759 and *Enthusiasm Delineated* (of about the same time, but unfinished, perhaps because of the illness), nothing else came from Hogarth's studio until the spring of 1761, when the Frontispiece and Tailpiece to the *Catalogue* of the Society of Artists' Exhibition appeared, and Hogarth, himself active in the whole project, was reported in good health by Horace Walpole. In the interim only three prints were published: two were based on sketches he must have made in March and December for Sterne's *Tristram Shandy* and the other on a drawing made sometime before July for Kirby's *Perspective of Architecture* (below, 328).

After attending the Foundling's annual meeting on 14 May, he attended the meeting of 20 December. But he does not appear in the list, dated 7 December, of artists who agreed to appear at the next (1761) annual dinner in clothing made by the foundlings in the Ackworth establishment in Yorkshire. The artists' agitation for an exhibition apparently had commenced in early 1759, and the channel pursued was not the Foundling Hospital but the Society of Arts—from which Hogarth had angrily seceded in 1757. The Society of Arts had held exhibitions of its premium pictures, framed and mounted at the society's expense. In March 1759 Robert Edge Pine (the son of Hogarth's old friend) proposed to the society that it hire a room for exhibitions of the works of "the present painters and sculptors,"[9] but there was no room available. The Foundling artists bided their time until the Society of Arts had moved into its new quarters in the Strand across from Beaufort Buildings. Then at their annual dinner on 5 November 1759, Hayman, one of the members of both societies, proposed "a public receptacle to contain the work of artists for the general advantage and glory of the nation and satisfaction of foreigners." His proposal was received with applause.[10]

On the 9th a notice appeared in the *Public Advertiser:*

Foundling Hospital, November 5, 1759.
At a Meeting of the ARTISTS.
Resolved, That a General Meeting of all Artists in the several Branches of Painting, Sculpture, Architecture, Engraving, Chasing,

THE ART EXHIBITIONS

Seal-cutting, and Medalling, be held at the Turks Head Tavern in Gerrard-street, Soho, on Monday the 12th instant, at Six in the Evening, to consider of a Proposal for the Honour and Advancement of the Arts, and that it be advertised in the Public and Daily Advertisers.

JOHN WILKES, President
FRA. MILNER NEWTON, Sec.

Pleasant, easygoing Hayman was elected chairman. Such a peacemaker was needed among the unruly artists. Moreover, Hayman had roots in the St. Martin's Lane Academy almost as deep as Hogarth's, was a member of the contributing artists to the Foundling and the Society of Arts, and had chaired the earlier attempts of the St. Martin's Lane group to establish a new academy. It was he who made the proposal and conducted the meeting that took place at the Turk's Head a week later. Wilkes, a governor of the Foundling and intimate with the artists, served the honorary position of president. His particular friendship with Reynolds went back to the latter's apprentice days in Hudson's studio, and his name appears more frequently than any other in Reynolds's early pocketbooks, the record of his social engagements. As Waterhouse has observed, "It is a characteristic of Reynolds throughout his life—perhaps it is a very English characteristic—that he always acted in matters in which he was most interested with studious indirectness."[11] He maintained the same indirect approach a decade later as president of the Royal Academy. It appears quite probable that he was the moving force behind both Hayman and Wilkes. Perhaps the *Idler* essays on art, coming out in September, October, and November, were intended to lay the way for his moral leadership: attacking Hogarth, taking sides on important issues such as history painting, connoisseurship, and aesthetics, but remaining anonymous.

On 12 November the artists met at the Turk's Head as planned, and agreed to hold an annual exhibition the second week of April, at which "every Painter, Sculptor, Architect, Engraver, Chaser, Seal-cutter, and Medallist may exhibit their several Performances." The purposes of the exhibition were: first, to "encourage Artists whose Abilities and Attainments may justly raise them to Distinction who otherwise might languish in Obscurity and that their several Abilitys may be brought to Public View"; and second, to form a provident fund for the support of infirm and aged artists and their wid-

ows. For this purpose, a shilling entrance fee was to be charged. A committee of sixteen artists representing the various arts was elected to carry out the plan. These were the senior artists—Reynolds leading the list of painters, with Hayman, Richard Wilson, Samuel Wale, Richard Dalton, and Francis Newton—who thereafter governed the Society of Artists with an iron hand, creating an academy in miniature. The committee controlled the younger artists ("many of whom had been their Pupils"), as Thomas Jones recalled, "monopolizing those powers and privileges which the rest ought to have had a chance in sharing," including that of hanging their pictures in the best places in the exhibitions.[12] Considering that when he did join the artists he was elected to this group, it seems likely that Hogarth did not attend the 1759 meeting or, if he did, spoke against the plan.

The governing committee approached the Society of Arts early the next year, and in March their proposal was accepted "under such Regulations and Restrictions as the Society shall hereafter prescribe."[13] The Society of Arts agreed to bear all costs and receive nothing in return, but (like the Dilettanti) they did intend to control the exhibition and make it theirs, not the artists': there would be no charge for admission, a committee appointed by the Society of Arts would settle all questions of hanging if the artists disagreed, and the date proposed by the artists was advanced by two weeks. If Hogarth, with his previous experience of the Society of Arts, had not already withdrawn, no doubt he did so at this juncture; the other artists accepted the rejection of their entrance fee, but circumvented the loss by charging 6d for a catalogue.[14]

The first specially organized art exhibition in England opened on 21 April 1760, and was a popular success. There was no picture exhibited by Hogarth. As he must have grasped, even from the sidelines, the exhibition raised Reynolds to the highest eminence, in the eyes of the other painters as well as the public. Reynolds was careful to select four pictures illustrating the variety of his talents: a pair of unpretentious busts, supplemented by a pair of full-length portraits in his grandest manner. They were singled out for praise by an anonymous correspondent in the *Imperial Magazine*—praise Waterhouse thinks was directed by Reynolds himself, or perhaps by an intermediary.[15] Besides Hogarth, the other glaring omission was Ramsay, doubtless because of his semiofficial connections with the Prince of Wales.

The aftermath of the exhibition apparently roused Hogarth to action, at least momentarily. At the governing committee meeting of 15 May, with Reynolds, Chambers, and the rest present, it was decided that, contrary to the original plan to donate the profits (around £165) to superannuated artists, they should "be apply'd to the advancement of the Academy." At the next general meeting, on 23 May, this plan was presented but the wording was altered in a way that suggests the impingement of Hogarth's view:

> Resolved. That the money be applied towards the Advancement of Arts.
> That Time be taken to consider in what Manner the Money may be best applied for the above Purpose.
> Resolved. That after the General Meeting has come to a Determination in what Manner the Money shall be applied, the Execution be wholly in the Committee.

A motion was then made, perhaps by a Hogarth representative, "That all Future Committees should be open"; it failed to pass. The general sense of the meeting remained in favor of an academy. As Pye observed, the artists simply fell victim to "that vacillation of purpose which indicates a total absence of all law and good government."[16] But Hogarth saw their action as confirmation of his worst suspicions: these artists were not concerned with their less fortunate brethren but with their own advancement and glorification in their chimerical academy. (The funds were put into stocks to mature until they should reach £500.)

On 25 October the old king died and the hopes of all the artists soared with the accession of the new king, George III. This event in fact further divided the artists: some hoped that he would support native talent, that he would sponsor an academy, while others felt that any support would amount to interference. They had, as Pye put it, "become so disturbed by ferments among themselves, produced by the want of unity of purpose,"[17] that the first rift, the break with the Society of Arts, was virtually inevitable.

Hogarth, as well as the other artists and many politicians, had put great faith in the young Prince of Wales. He had introduced him as a boy into one print (fig. 4); and at some point he revised the graceful dancer in the *Analysis,* Plate 2, to resemble him (fig. 81). Since he is shown dancing with a young woman who is not his queen (whom

he married just prior to his coronation), Hogarth may have cele-brated his coming of age in 1756 (an occasion which he and the artists celebrated at the Turk's Head) or his accession in 1760. When he later portrayed the new king as the fountain of the arts on the *Catalogue* of the 1761 artists' exhibition (fig. 83), he was not merely carrying out the instructions of the artists' committee. It is clear from his notes on the proposed academy that he regarded the whole move-ment as stemming from hope in the new reign. It would appear that he shared this faith, while seeing a different end: not a state academy with a hierarchy but the old democratic academy, with support from the crown only in the form of commissions and patronage, which would not interfere with the artists' freedom to go their own way.

Once George became king, projects abounded to approach him and his parliament about a royal academy. Hogarth's written account (in "Apology for Painters") emphasizes that the artists petitioned king, Lords, and Commons—though it is not certain when or to which attempt he is referring. He concludes that "this mighty affair" having blown over, "now it rests with King George whether he will please to do what a painter [Thornhill, with his original academy] has done with the addition of salary for professors who can make most interest among the great." [18] In this plan, the king merely con-tributes a salary for the best-connected professors.

The only trace that has survived of the Society of Artists' activity at this time is the formal address made to the throne on George III's accession (though not mentioned in the minutes of the governing committee). It was published on the first page of the *London Gazette*, 6–10 January 1761, and, composed in Samuel Johnson's rolling pe-riods, included the significant paragraph: "Your Majesty's early Pa-tronage of the politer Arts has given the Painters, Sculptors, and Architects, Confidence to express, in your Royal Presence, their Sor-row for the Death of their late gracious Sovereign, and their Joy for your Majesty's Accession to the Throne." This says, in effect, that they hope for some royal assistance now that George III is king ("a Monarch no less judicious to distinguish, than powerful to re-ward"). [19] While nothing said in the whole address was at variance with Hogarth's views, as expressed in the frontispiece to the artists' catalogue later that spring, it showed that the group, separate at this time from Hogarth, was approaching the king—and that other more specific petitions were probably pending.

It must have been at this time that Hogarth drafted his letter to a

nobleman, mentioning that he has already made notes toward his own views on the academy question. This curious, hesitant, revealing letter apparently remained in the same rough form as the notes among which it was found. But, surprisingly full of information, it indicates what Hogarth was trying to do.[20]

There are two names mentioned in the draft: Samuel Martin and Allan Ramsay. The nobleman is unnamed, but in the context of these two names it has to be Lord Bute himself, the new king's favorite.[21] Hogarth is approaching him through his lieutenant Samuel Martin, secretary of the treasury and head of the English civil service. Hogarth evidently made contact with Bute through Martin and then drafted this letter asking for a private audience in which he could clarify a few points before finishing his formal proposal. The draft refers to his sickness, to his age ("upward of 60"), and to a "scheme" that is "on foot already," adding that "the author of it will naturally defend his own in opposition to mine." Hogarth alludes to "certain prejudices which I am perfectly assured stick to my character"—presumably his stake in the St. Martin's Lane Academy.[22] One reason for seeing Bute, he makes clear, is that he does not desire public controversy: "a thing I must positively avoid for my health's sake, for as I am circumstanced I had rather lose a most favorite point than break one night's rest" (AN, 224).

RAMSAY

Ramsay is introduced not as the "author" of the plan that is now "on foot" but as a supporter of it. He did not condescend to join the artists in their agitations; his name appears on none of their lists, and he did not even exhibit with them or join them in 1768 when a royal academy did emerge. The only related group to which he belonged was the Society of Arts, serving on the committee of judges for premiums. In December 1760, however, he did offer to serve, through his patron Bute, as the conduit for the "Address to the Throne," but was bypassed.

Hogarth and Ramsay were by this time friends; on 20 February 1757 Hogarth's announcement of the delay of the *Election* prints also noted that he would include "Gratis," with copies of *The Analysis of Beauty,* "An Eighteen-Penny Pamphlet, publish'd by A. Miller,

call'd The Investigator, written in Opposition to the principles laid down in the above Analysis of Beauty, by A. R. a Friend to Mr. Hogarth, an eminent portrait Painter now at Rome" (Ramsay had returned to Rome between 1754 and 1757 to polish his style). Twice also in his manuscript notes for an "Apology for Painters" Hogarth singles out Ramsay as "the most able person" to support the assertion that the *Analysis* is "a heap of nonsense" (80, 109).

Ramsay, like Hogarth and Reynolds a writer as well as a painter, had published two complimentary references to Hogarth: The first, in his essay *On Ridicule* of 1753, written before the *Analysis* appeared, placed the "incomparable Hogarth" at the head of all exponents of "graphic ridicule." This comment (which reflects Ramsay's reading of Fielding's *Champion* essay on Hogarth and his preface to *Joseph Andrews*) was followed by the comments on *The Analysis of Beauty* in his *Dialogue on Taste* (*The Investigator,* 1755). Arguing, as we saw above (147), that Hogarth's formula for Beauty is based on no more than "custom," Ramsay accepts, at the same time, another of Hogarth's tenets, that not the connoisseur but popular judgment is the final test of art—that this judgment is based on "nature," "the leading principle in poetry and painting . . . [which] is known to the lowest and most illiterate of the people."

The *Dialogue on Taste* showed how much the two artists had in common ideologically: Ramsay's attack on the Romans reflects the ironies Hogarth expressed in his "Statuary Yard"; like Hogarth, he associated Rome and the Roman church, both of which he castigates, invoking, by contrast, the "uncommon degree of perfection" to which the Goths had brought architecture, and his attack extended to the English Palladians who aped the Romans. This opinion reflected his attachment to Leicester House, but his anticlericalism would also have struck a sympathetic chord in Hogarth; even the radical relativism by which he criticized the Line of Beauty, which defined "Nature" for him (and reflected his friendship with David Hume), may have drawn Hogarth in the same direction. Unlike the Burkean Sublime, an equally doctrinaire alternative to his Beautiful, Ramsay's interpretation of "custom" and relativity supported the pessimism of Hogarth's final decade following the publication of the *Analysis*.

Also around 1754 Ramsay had adapted a more "natural" portraiture, with a deeper psychological resonance, which he could only have found in Hogarth.[23] Ramsay did not return from Italy until Au-

gust 1757, and in October he commenced his first full-length portrait of the Prince of Wales, and when this portrait was finished he painted another full length of the prince's "dearest friend," Lord Bute. The first led to the prince's command, on his accession, to paint the official royal likeness, and this in turn led to his status as Principal Painter in Ordinary, the official painter of the court. The portrait of the Prince of Wales, engraved in 1761 by William Wynne Ryland, was the one later, in less happy circumstances, ridiculed by Hogarth in *The Times, Plate 2* (fig. 99). Ramsay was now off by himself in the warm cove of royal patronage and the rest of his career was largely spent in producing copies of the royal portraits. (Hogarth's swipe at Ramsay the portraitist, in the line of identical Scottish *St. Andrew*s in *Battle of the Pictures* of 1745, proved prophetic.) But from his remarks in his essays it seems quite possible that he supported *an* idea (not necessarily the artists') of a royal academy, perhaps seeing it as much from the royal point of view as the artists', for after all what gave George III the impetus that eventually led to its founding was the Bolingbroke image of a king whose glory would be augmented by royal academies and such appurtenances.

What Hogarth says is that he knows Ramsay is no stranger to this plan, and he does not want to get into a controversy with such a practiced controversialist (on the back of the page he recalls the story of Ramsay's negative response years before to his claim that he could paint a portrait as well as Van Dyck).[24] Writing to Bute, it would of course be politic to take Ramsay into consideration, and mention of the influential Ramsay might improve his chances of a personal intervention.

No subsequent draft of this letter is known, and the undeveloped state of the surrounding notes supports the conclusion that Hogarth's health, or his circumspection, prevented him from carrying on—or that the artists' "scheme" subsided, or that (perhaps most likely) he was persuaded to join them when they broke away from the Society of Arts. Nevertheless, it appears that Hogarth received some sort of encouragement, since not long after he came out in active support of the Bute ministry.

Hogarth at this point was spending much of his time writing the notes on academies and on the Society of Arts, one of the series of

manuscript notes that have survived. They may have followed from the draft of his letter to Lord Bute, or they may be revisions of earlier notes like the ones Sandby alluded to in his anti-Hogarth satires of 1753–1754, which were probably incorporated in Rouquet's *State of the Arts in England*. He does not really get beyond the history of English academies, which he takes as far as the negotiations with the Dilettanti Society, but his own idea of a democratic and decentralized academy is quite clear by implication. The historical evidence is employed to suggest that the present plan has already been attempted with disastrous results in France and in pre-Hogarth academies of short duration in London. These were all based on hierarchy and regimentation, and failed.

But the notes are also about the teaching of young artists and broach certain questions crucial to Hogarth and his idea of an academy: whether or not they should travel to the Continent to copy Old Masters, what they can expect from the English mercantile-minded buyers, and what sort of persons should be encouraged to take up art in the first place. It is at this point that the Society of Arts project is introduced into the manuscript, and dealt with in some detail. Judging by his "table of topics" for his projected treatise "On the Arts of Painting and Sculpture," Hogarth now regarded the Society of Arts ("the premium society," as he called it) as "a silly attempt at a Public Academy."[25] These notes, allegedly based on one of the speeches he delivered to the society, raise one of the objections to a royal academy: it would, like the Society of Arts' premiums, stimulate too many to become artists who should be mechanics.

After one of his attacks on the society for trying to multiply the number of painters, his mind apparently turned again to the advances made to the king, and he suggests what he considers a preferable alternative to a royal academy: the prince, he says, should "set the example and furnish any part of his palace with a Picture of each of his most eminent subjects' work." But, he adds, even if this "might possibly make by example a fashion for a time," it would still not produce a market corresponding to the number of paintings produced (97).

He began writing on uniform sheets, probably with a single subject in mind, but before long he was using any size that came to hand, odds and ends—writing very rapidly, and not usually reading back over what he had written, filling in very little punctuation, omit-

ting plurals, crossing out either more or less than he intended. He evidently discussed whatever subject came to his mind. On a typical page, now separated from the main body of the manuscript in the British Library, he pauses to record what he has learned about varnishes.[26]

As they survive, these manuscripts were never intended to be read by anyone but Hogarth; perhaps for that reason, though they often verge on the undecipherable, they have the bite of his conversation. One can almost hear him speaking across a table, throwing out bitterly pointed opinions. They are pugnacious and dogmatic and disillusioned: the same qualities that dominate the prints he produced in the last decade of his life.

These notes, and others written on and off until his death, moving from topic to topic, gradually incorporating all the different subjects that mattered to him, provide the closest approximation to the workings of his mind. One page will suffice to show how he starts with a particular item, here "Some artists' behaviour to one another" (from his "table to topics"), and is carried away by his emotions and most pressing thoughts (82–83). Starting with the rivalry between artists ("especially when they are put in competition[.] what racer wishd his oponent might out run him or boxer that chose to be beat in complesance to his antagonist"), he quickly shifts to the artist who cannot be a hypocrite and *must* condemn his inferiors ("the most he can do is to be polite and civil but if he is so polite as to confess one he thinks his inferior he is a fool"), to the teacher-student relationship ("the pleasure of instructing other till they verge upon being rivals") and the example of Rubens's jealousy of Van Dyck, and on to another favorite thought: the difficulty even an Old Master would have surviving in England's mercantile society, dominated by portraitists ("had rubens or even Raphael lived at this ⟨this time in England⟩ [with] all their perfections ⟨and superior talents⟩ the[y] would have found men of very middling parts ⟨excellent⟩ face painters and who if they happen'd to be in vogue that would with ease get a 1000 a year by the assistance of a ⟨journeyman⟩ still life painter called a dresser or Drapery painter ⟨whilst [they] might scarce have found employment⟩"), and thence to the notion that a portrait painter is no more than a still-life painter ("copying the person sitting before him who ought to sit as still as a statue and nobody will dis-

pute a statues being as much still life [as] a fruit flower or a galipot broken erthen pan").

Michael Kitson comments on Hogarth's "disturbed state of mind" as revealed in these notes: "False starts, repetitions and ellipses are spattered over almost every page. Sentences continue for a dozen lines at a time, subordinate clauses packed within subordinate clauses, all without punctuation marks or capital letters." The source, he believes, is "not a striving for rhetorical effect but the pressure of the writer's emotions."[27] This is only part of the story: speed and carelessness are invariably typical of Hogarth, as in the *Analysis* manuscript when he was not under any emotional strain (though he undoubtedly was around 1760). What the evidence may point to is physical illness, no doubt accompanied by mental unease; but the interesting fact is not his loose syntax and irregular spelling—common flaws in the rough drafts of better educated and calmer men than Hogarth—but that he was never able to revise and finish them (as he had been able to do with the *Analysis*), and yet could not discard them either. These fragments were as far as he was able to go, but he evidently hoped to go further. He always preferred to finish a project he had undertaken; even in these last years his determination to get *Sigismunda* before the public—his public—spurred him to keep up his efforts from 1761 until the time of his death. But the *Sigismunda* project lapsed, was revived, and lapsed again; his writings proceeded in the same way, beginning again in 1761, then in 1762–1763, then stopping again.

THE SOCIETY OF ARTISTS' EXHIBITION OF 1761

The 1760 exhibition had satisfied the Society of Arts more than it had the artists. The absence of an entrance fee had allowed all and sundry to gather. The rule said that anybody "with an order from any member of this society or from any known artist" would be admitted, and this led to the presence of many undesirables. Before long it was necessary to give officers of the society discretionary power "to exclude all persons whom they shall think improper to be admitted, such as livery servants, foot soldiers, porters, women with

children, etc., and to prevent all disorders in the Room, such as smoaking, drinking, etc., by turning the disorderly persons out." The sum of 13*s* 6*d* was paid out for "windows broke," and the artists, when they again approached the society the next year, complained of "the intrusion of great Numbers whose stations and education made them no proper Judges of Statuary or Painting, and who were made idle and tumultuous by the opportunity of a shew." [28]

The second, and more vexing, ground for the artists' displeasure was the mingling of their paintings with the premium pictures, those paintings submitted by amateurs in various categories (boys under twenty-one, sons or daughters of peers, and so on), which hung resplendent with prizes. Seeing his picture next to these made the artist feel (in Samuel Johnson's phrase) "the disgrace of having lost that which he never sought." [29]

In the governing committee meeting of 8 December 1760, approving the request for an exhibition hall in 1761, the artists insisted that the exhibition be postponed until June to avoid rubbing shoulders with the society's prizewinners, and that the purchase of a shilling catalogue be the condition of admission. The letter was received by the Society of Arts and referred to a committee that included Ramsay and Athenian Stuart, and on 31 December it reported, recommending that the artists be given permission to use the room "at such time and on such terms as the Society shall think proper & convenient." All the artists' requests were rejected.

The artists' response was to delegate Reynolds and the architect James Paine to find a suitable place of their own in which to exhibit. By 4 March 1761 Cock's auction room in Spring Garden, Charing Cross, had been rented for £40, the advertisement was drafted, and the deadline for pictures set at 27 April (later postponed until 2 May). At the 11 March meeting the committee resolved to have their catalogue decorated with a frontispiece, and at the next meeting (18 Mar.) Nathaniel Hone and Wale produced sketches. Wale's design, showing Apollo distributing alms "For the relief of the distressed" from an altar behind which the head of George III appears on an easel, was approved on 23 March and given to Charles Grignion to engrave.

Hogarth's attendance at the meeting of the Foundling governors on 20 December 1760, his first since 7 February 1759, may have

been an overture on his part toward the artists.[30] The first advertisement of the artists' governing committee to solicit paintings for the 1761 exhibition was published in the *Daily Advertiser* of 7 March of that year. Hogarth's characteristic comment appeared in his etching, *Time Smoking a Picture* (fig. 82), which he distributed around the first of March as a subscription ticket for his projected engraving of *Sigismunda*. The satire, glancing back at such works as the Correggio–Furini *Sigismunda,* was aimed at the notion that old paintings improved with the mellow tints of age and varnish—a view that we know Reynolds took so literally as sometimes to mix varnish-brown with his paints.[31] More important than darkening modern paintings, however, was the valorization of darkness and the grimy quality of old paintings in general. As Burke wrote in his *Philosophical Enquiry,* the colors of a history painting should not be "gay or gaudy" but "of sad and fuscous colours, as black, or brown, or deep purple, and the like," and he is merely formulating the practice of such artists as William Gilpin, who recalled his drawings of the 1730s and 1740s: "I was never pleased with them till I had given them a brownish tint: And, as I knew no other method, I used to hold them over smoke till they had assumed such a tint as satisfied my eye."[32] The painting on the easel is presumably a generic Poussin, Claude, or Gaspar Dughet.[33]

Hogarth is illustrating Samuel Foote's farce, *Taste,* which had played on and off from 1751 to 1757 (pub. 1752) and was revived in April 1761, for which Garrick wrote a prologue (shown in Hogarth's *David Garrick and His Wife,* fig. 70). In *Taste* Lord Dupe says: "This, I presume, might have been a landscape; but the water, and the men, and the trees, and the dogs, and the ducks, and the pigs, they are all obliterated, all gone." To which Brush replies: "An indisputable mark of its antiquity; its very merit; besides, a little varnish will fetch the figures again."[34]

In fact, as opposed to Addison's view that Time improves on the artist (*Spectator* No. 83), Reynolds's idea—alas, misguided—was that since Time fades out the figures, varnish brings them back again by darkening the background. In this sense, we can see why Hogarth includes the jar of varnish next to the canvas—and around the same time he wrote out his own formula for the only varnish a painter should use.[35] In his print Time *is* the artist and should be contrasted with the figure of Hogarth himself in his self-portrait with the comic

muse (fig. 52).[36] In the drawing of *Time Smoking* (Art Gallery of New South Wales, Sydney; reverse of the engraving), he placed Time in a parallel position to himself in his self-portrait. *Time Smoking* is the first of the works of the 1760s in which he replaces himself with an antitype who undoes all of his efforts—though he had already begun when, in a self-mocking way, he based the self-portrait on Sandby's *Pugg's Graces.* Here Time applies color with his pipe (smoke) at the same time that, with the other hand, he destroys the canvas. The artist—and in a larger sense the artistic tradition—is destroying his own work. The word "Smoke" is a pun: it refers (1) to the obscuring substance, the dirt and grime acquired by the painting over time; but also (2) to the valuelessness of the painting—as in the Dutch iconographical sense, transient or without substance (cf. Time in the *Tail Piece,* fig. 112); and (3), as a verb, to perpetrate a fraud, trick, or hoax, as in the discreditable practices of contemporary painters and restorers. (4) Smoke also conceals and announces fire ("Where there is smoke there's fire"). Thus Time smokes the picture with one hand, destroying it with the other. The work of an English painter cannot avoid being co-opted by a sterile artistic culture which survives by destroying.[37]

The fraudulent auctioneer of *Taste,* Puff (originally played by Garrick; the name may have derived from the weathercock's label in Hogarth's *Battle of the Pictures*), enters the auction room disguised as the Baron de Grongingen to help sell a broken-nosed bust. "Upon my word, 'tis a very fine bust; but where is de nose?" Novice: "The nose? What care I for the nose? Where is de nose? Why sir, if it had a nose, I would not give sixpence for it. How the devil should we distinguish the works of the ancients, if they were perfect?" That Foote and Hogarth were not exaggerating is shown by the catalogue of the Oxford and Somers sale, 30 March, 1 April 1762, which included "No. 71. A bust of Antinous (without a head)." If Hogarth's example is the Vatican Torso (which was the only antique sculpture of prominence known *not* to be restored), the out-of-proportion arm refers to the practice of attaching unrelated arms and legs—or heads such as the one lying near the neck—amputated by Time's scythe before it penetrated the Old Master canvas.

The idea of Time the Destroyer had been in Hogarth's mind for a long time: he used it in his 1751 tirade announcing his sale of the *Marriage A-la-mode* paintings in the *Daily Advertiser,* and again in a

footnote to *The Analysis of Beauty* two years later.[38] Now it receives definitive form in this etching from his own hand, a hauntingly stark image in the style of his earlier subscription tickets, but also reminiscent of the *Stages of Cruelty* and the popular prints. While the etching served to remind subscribers of the forthcoming engraving of *Sigismunda,* it also opened the door to Hogarth's exhibiting the painting with the Society of Artists and set the tone for the confrontation that was to take place between the artists and the Society of Arts.

When the general meeting ("to which all Artists in Painting, Sculpture and Architecture are invited") was held at six on the evening of Tuesday, 7 April, Hogarth was among the sixty-seven present. He rose and made a proposal, which is recorded in the minutes:

> Mr Hogarth having made a Proposal for this Society associating—
>
> Unanimously agreed that this Society for the future should be called The Free Professors of Painting, Sculpture & Architecture.
>
> And that the said Society should from thence forward enter into an amicable union in order to promote a mutual interest and at proper Meetings concert such Measures as may best establish these Arts on a right Footing suitable to the Genius of this Country.
>
> As absolutely necessary thereto, Means proper to be put in practice be resolved on as may tend to explore those Errors & Prejudices which have hitherto misguided the Judgments of true Lovers of Arts as well as discouraged the Living Artists in the Progress of their Studies.[39]

Here, in characteristic rhetoric, Hogarth offers a motif for that year's exhibition, which, like *Time Smoking,* was to be a statement against such as the Dilettanti and their representatives in the Society of Arts. It was not just secession, it was war, and clearly Hogarth returned with the intention of declaring it and formulating its strategy. The name itself did not turn out to be his "Free Professors of Painting, Sculpture & Architecture," but an even more pointed one, the Society of Artists (as opposed to Arts).

The two satiric designs he contributed to the exhibition catalogue (figs. 83, 84), to supplement Wale's commonplace emblem, were essential to his plan of giving the artists the initiative. The Frontispiece represents the hopes the artists placed in the new king as a fountain that nourishes the arts: three fledgling trees marked Architecture, Sculpture, and Painting. As usual, however, a close look reveals

some qualifications. The presence of Britannia with her watering can serves to divert George III from wasting his benevolence on the barren ground directly in front of him. It is plain from the twisted, S-curved tree trunks that architecture is flourishing, while painting is stunted with a single leafy branch, presumably intended for portraiture. The Tailpiece shows the fate of artists who are dependent on monkeylike connoisseurs, whose only interest is in the dead art of the past—the paintings smoked, the busts fragmented, by time. The living, growing trees in the first are paired with the dead, withered sticks of the ancients in the second.[40]

The designs were finished, and engraved by Grignion, by 21 April when the governing committee met and the notice for the advertisement was read. It ended, "Catalogues at one Shilling each with two Prints designed by M^r Hogarth may be had at the Door." That Hogarth donated the design, and Grignion was paid for his engraving, can be seen in the list of the society's disbursements following the exhibition.

But Hogarth's contribution, his return to prominence, did not go unnoticed. At the next meeting of the governing committee, on 24 April, someone[41] raised the question of why Hogarth should be singled out in the advertisements—presumably because neither Wale nor any other exhibiting artist was. It was decided that one artist's name should not be mentioned at the expense of the others (to avoid a resurgence of the ill feeling caused by the premiums at the earlier exhibit). It was "Resolved. That it is the Opinion of the Committee that M^r Hogarth's Name should be omitted in the Advertisement but to remain as at present if M^r Hogarth chooses it." This resolution reflects the prickly tone of relations between Hogarth and some of the members of the governing committee. It meant, for one thing, that someone's pride overruled the commercial commonsense view (borne out by events) that a catalogue carrying Hogarth's name would sell better than one without, and should be advertised as such. Since in fact Hogarth's name was omitted from the published advertisement, one must assume that he went along with the proposal. The last clause of the resolution shows that the committee thought he would be offended. Behind the resolution one senses, too, the old suspicion of him as a self-serving publicity seeker.

Three days before the meeting at which Hogarth set forth the program for the artists' exhibition, Théodore Gardelle, a Swiss enamel

portraitist, aged thirty-nine, who frequented Slaughter's and lived on the south side of Leicester Fields, was carted past Hogarth on his way to execution. Gardelle had murdered his landlady in a particularly grisly fashion, which the newspapers played up as the work of a crazed artist. The cart passed through Leicester Fields, by the landlady's house. "The Criminal looked earnestly at the house, and wrung his Hands." Hogarth was evidently watching from a window on the south side of the square as the cart passed. A young artist, John Inigo Richards, was in the room with him and made a sketch of Gardelle wringing his hands, to which Hogarth supposedly added some touches to strengthen the likeness.[42]

The notice in the *Daily Advertiser* of 7 March soliciting paintings was followed by others on 21 April and 5 May, and these were followed by advertisements for the exhibition itself which ran almost daily from 12 May to the closing on the 30th. On 30 April Hogarth wrote to Lord Charlemont requesting the loan of *The Lady's Last Stake*. "We Artists as we call ourselves," he wrote with the irony he was accustomed to use when discussing artistic matters with Charlemont (and perhaps also alluding to the change from his suggested name "Free Professors of Painting" to the one adopted, "Artists"), "are to have an Exhibition of our own in Spring Garden next week." He strengthens his request by observing that the picture "wants a little cleaning and fetching out which may be done at the same time."[43]

The pictures Hogarth chose to show at the exhibition were carefully representative: three comic histories, *The Gate of Calais* (ill., vol. 2), *An Election Entertainment* (fig. 35), and *The Lady's Last Stake* (fig. 53); a sublime history, *Sigismunda* (fig. 54); and three portraits, only a head of Benjamin Hoadly being identified.[44] All of these were provocative choices. The *Sigismunda* had already been announced by the public print, *Time Smoking a Picture,* and *The Gate of Calais* was an anti-French, and so antiacademic statement. Iain Pears has explained its significance:

An English historical painting, it challenged the public to live up to their patriotic words and pay as much for domestically produced works as for foreign ones. It equally asserted that such works could also be as good. At a time when the first moves for setting up an English academy based on the belief in history were taking place, such

a painting could scarcely fail to arouse the interest of the audience. Although at one level the epitome of what the academy was meant to foster—that is a native school of history painting—at another level it undercut everything the body represented. Because it was painted by Hogarth, whose views were well known, the painting asserted that works of history could be produced without the need of the sort of academy its advocates wanted, that such a body was in fact little more than an unpatriotic and fashionable concession to foreign dominance, aimed at boosting the status of a few eminent painters at the expense of a genuine domestic style.[45]

Perhaps as striking as his selection is the fact of his showing only old pictures: *The Gate of Calais* was painted in 1748, the *Election Entertainment* in 1753–1754, *The Lady's Last Stake* and *Sigismunda* in 1758–1759. The portrait of Hoadly (who had died in 1757) must have gone back to the mid-1750s, but the other two portraits were presumably painted more recently. In short, Hogarth was engaged in writing and perhaps recovering his health, when the young Hogarth might have been expected to exploit the situation, rise to the challenge, and display a bright bouquet of new paintings. His total absence the year before may have testified to his condition: perhaps he refused on the grounds that he had no paintings that year. But in 1761 he still had no significantly new pictures, aside from his two drawings for the catalogue; evidently, at this stage of his career, he viewed the exhibition as a place to show the best available, not the newest, work. Like the writing he was doing around this time, it provided an opportunity for a retrospective defense of his career rather than a look forward. His role in the exhibition was that of propagandist—publicizing his own earlier pictures and works by English artists in general.

It was to advertise the engraving of *Sigismunda* that Hogarth etched *Time Smoking a Picture,* and it was to advertise the painting, and vindicate his faith in it, that he projected his subscription for the engraving. He had opened the way for the subscription when on 16, 17, and 18 February he exhibited *Sigismunda* at Langford's auction room: "If this Piece meets with the Approbation of the Public," he announced in the papers, "it will be engraved in the Manner of Drevet." The subscription itself was announced in the papers of 2 March, for half a guinea.[46] John Havard the actor saw the painting at Langford's and wrote a poem which starts:

Antiquity! be dumb—no longer boast
Arts yet unrival'd, or Invention lost:—

He compares Hogarth with the Greek Timanthes, who attempted to
paint Atrides' grief, but ended by concealing the face with a veil.

In *Sigismond* the Mind no Want supplies—
The Painter trusts his Genius to your Eyes:
Passion's warm Tints beneath his Pencil glow—
And from the Canvas starts the LIVING WOE.
At length he just—throw Prejudice aside—
The *Modern* SHEWS what the GREEK cou'd but HIDE:
Then from the Antient take the Palm away,
And crown the greater Artist of this Day.[47]

The subscription list (in the same book that held the *Election* sub-
scription) is dated 2 March 1761, and Hogarth's writing is much
shakier than before.[48] There are forty-four names up to 16 April
(only three after the end of March), among them Dr. Schomberg,
Dr. Hunter (William, presumably), Joshua Kirby, John Hoadly, and
Garrick. The subscribers are listed on page 30, and on 31 verso there
is a fragment of a paper that was once pasted to the page, only the
bottom corner remaining, on which can be made out:

But [he that filches from me my good name]
Robs me [of that which not] enriches [him]
And makes [me poor] indeed.

Hogarth had copied Iago's speech on reputation from *Othello* (III.iii.
159–61). Beneath this he wrote, sometime around 16 April: "M^r
Ravenet the Engraver having undertook to Engrave the picture of
Sigismunda, a Subscription for the Print was begun March 2^d 1761,
but some time afterwards, on finding that M^r Ravenet was under
articles not to work for any Body but for M^r Boydell the Printseller
for three years then to come, the Subscription was put a Stop to,
and the Money return'd to the Subscribers, there being no other
Engraver at the time capable of doing it as it should be done."
The names in the book are duly crossed out and marked "Money
Return'd"—and only John Salusbury (the father of Hester) refused
his money.

The painting remained in Hogarth's studio until, a month later, he exhibited it with hardly less misfortune at the Society of Artists' Exhibition. Anecdotes have collected around this picture and the exhibition. Horace Walpole, in his copy of the catalogue, notes that on 19 or 20 May, that is ten days after the exhibition opened, Hogarth withdrew *Sigismunda* and replaced it with another of the *Election* paintings, *Chairing the Member*.[49] Thomas Birch refers in a letter to Hogarth's "humiliation" over *Sigismunda* at this exhibit, but all that has survived is the story told nearly thirty years later, that Hogarth posted a man nearby "to *write down* all the objections made to it. Of these [there] were a hundred at least but Hogarth told the writer of this, that he attended but to one, and that was made by a madman! and perceiving the objection was well founded, he altered it. The madman after looking steadfastly at the picture, suddenly turned away saying *D—n it, I hate those white roses*. Hogarth *then,* and not till *then* observed that the foldings of Sigismunda's shift-sleeves were too regular and had more the appearance of roses than of linen."[50] At any rate, enough criticism was collected by Hogarth, always sensitive but extremely so about this particular picture, and he withdrew *Sigismunda* for revision. His withdrawal, of course, only added fuel to the adverse stories and did nothing to enhance the picture's reputation.

Morell recalled that the main problem with *Sigismunda* was all the advice proferred Hogarth during its composition, which in this case apparently influenced the usually self-confident artist and caused repeated repainting:

> it was so altered, upon the criticism of one Connoisseur or another; and especially when, relying no longer upon strength of genius, he had recourse to the *feigned* tears of *fictitious* woe of a female friend that, when it appeared at the Exhibition in 1761, I scarce knew it again myself. . . . In my opinion, I never saw a finer resemblance of flesh and blood, while the canvas was warm, I mean wet.

Morell's account is confirmed by the state of the canvas (Sigismunda's face in particular), as described by Elizabeth Einberg in the Tate catalogue: "The green curtain in the background covers an embroidered swag and tassel, and possibly a window. The table was originally a different shape, and a white napkin or paper dropping over its edge has been painted out. There are also changes to Sigismunda's

veil and neck, and the crinkly paint surface of her face suggests several layers of repainting here also."[51]

On 3 or 4 May, a few days before the exhibition opened, with *Sigismunda* still on his easel, Walpole visited his studio. He was so struck by the interview that he wrote down part of it in a letter to his friend George Montagu. I quote the scene in full, for it is the only direct representation of Hogarth, written within a short time of the event, that has survived—an epiphany that also illuminates Walpole's character and more generally Hogarth's relationship with the connoisseurs.

As background, we should recall that Horace Walpole, the first historian of English art, grew up in Houghton and other great houses surrounded by his father's great art collection—paintings of Poussin, Rubens, and Raphael. Converted to virtuosoship by his Grand Tour, he spent a lifetime engrossed in the arts: engraving as well as painting, architecture and landscape architecture, sculpture, ceramics, printing, the decorative arts, and interior design. In 1756 George Vertue had died, and in the summer of 1758 Walpole bought from his widow some forty of his manuscript notebooks, full of invaluable data on English art, including remarks indicating how Hogarth appeared to one contemporary. Walpole had known Vertue well and paid his widow £100 for these jottings. Hogarth of course got wind of this, and he also knew that Walpole had begun to use these notes as the basis for a history of English artists. Walpole had, in fact, begun his *Anecdotes of Painting in England* on 1 January 1760 and had finished the first volume by August, the second by the end of October. These were finally printed early in 1762, but did not carry the story to that point.[52] So in May 1761 he visited Hogarth's studio, where the artist was working on his portrait of Henry Fox, with the painting of *Sigismunda* displayed nearby:[53]

—but the true frantic oestrus resides at present with Mr Hogarth; I went t'other morning to see a portrait he is painting of Mr Fox— Hogarth told me he had promised, if Mr Fox would sit as he liked, to make as good a picture as Vandyke or Rubens could. I was silent— 'Why now,' said he, 'You think this very vain, but why should not one speak truth?' This *truth* was uttered in the face of his own Sigismonda, which is exactly a maudlin whore tearing off the trinkets that her keeper had given her, to fling at his head. She has her father's picture in a bracelet on her arm, and her fingers are bloody with the heart, as if she had just bought a sheep's pluck in St. James's market.[54] As I was going, Hogarth put on a very grave face, and said, 'Mr.

Walpole, I want to speak to you'; I sat down, and said, I was ready to receive his commands. For shortness, I will mark this wonderful dialogue by initial letters.

H. I am told you are going to entertain the town with something in our way. W. Not very soon, Mr Hogarth. H. I wish you would let me have it, to correct; I should be sorry to have you expose yourself to censure. We painters must know more of those things than other people. W. Do you think nobody understands painting but painters? H. Oh! so far from it, there's Reynolds, who certainly has genius; why, but t'other day he offered £100 for a picture that I would not hang in my cellar; and indeed, to say truth, I have generally found that persons who had studied painting least, were the best judges of it—but what I particularly wanted to say to you was about Sir James Thornhill (you know he married Sir James's daughter) I would not have you say anything against him; there was a book published some time ago, abusing him, and it gave great offence—[55] he was the first that attempted history in England, and I assure you some Germans have said he was a very great painter. W. My work will go no lower than the year 1700, and I really have not considered whether Sir J. Thornhill will come within my plan or not; if he does, I fear you and I shall not agree upon his merits.[56] H. I wish you would let me correct it—besides, I am writing something of the same kind myself, I should be sorry we should clash. W. I believe it is not much known what my work is; very few persons have seen it. H. Why, it is a critical history of painting, is not it? W. No, it is an antiquarian history of it in England; I bought Mr Vertue's MSS, and I believe the work will not give much offence. Besides, if it does, I cannot help it: when I publish anything, I give it to the world to think of it as they please. H. Oh! if it is an antiquarian work, we shall not clash. Mine is a critical work; I don't know whether I shall ever publish it—it is rather an apology for painters—I think it owing to the good sense of the English, that they have not painted better. W. My dear Mr Hogarth, I must take my leave of you, you now grow too wild—and I left him—if I had stayed, there remained nothing but for him to bite me. I give you my honour this conversation is literal, and perhaps, as long as you have known Englishmen and painters, you never met with anything so distracted. I had consecrated a line to his genius (I mean for wit) in my preface; I shall not erase it, but I hope nobody will ask me if he was not mad.

If it did not exist, this confrontation could have been invented by an author of "imaginary conversations." Were it not seen through Walpole's eyes, it would still be comic—two incompatibles talking at each other like characters out of *Tristram Shandy*. As to the degree of

their friendship, we have Walpole's remark in 1780 that he could not remember Hogarth's writing poetry, "though I knew him so well," which indicates some intimacy (see 491n.63). The most obvious basis for Walpole's friendship, the "wit" of comic history painting (and, more especially, engraving), was not at the moment evident in Hogarth's studio—the only works on display were a head of Fox, which Hogarth compared to a Van Dyck, and the *Sigismunda* (not yet disencumbered of the bloody hands). Hogarth the great comic artist, the exposer of affectation, now serious and humorless, exposing himself at every word, faces the sophisticated connoisseur, witty and aristocratic, also exposing himself at every word, and attempting in his commentary to assign the folly to his opponent. He does not wait to learn what Hogarth means by "I think it owing to the good sense of the English, that they have not painted better." "They" presumably refers back to "painters" (he is writing an "apology for painters"). Hogarth means that the empiricism and business sense of the English nation had deprived its artists of a market for their works. Walpole's conclusion—"you now grow too wild"—left Hogarth in mid-sentence, no doubt to turn in choked anger to the scraps of paper he was covering with notes about the state of the arts in an uncomprehending England.

The "Apology for Painters," which Walpole records Hogarth as mentioning, sounds ambitious enough to be connected with the pages of outline he wrote in an attempt to tie together all his notes up to this point. This table of topics was probably superimposed on what he had already written, with the addition of some others covering what he intended to write or fill in. A title page has also survived, perhaps of about this time:

> on the arts of Painting and Sculpture
> particularly in England
> To which is added Some observations
> A Short [Account—s.t.] ⟨explanation⟩ of ⟨all⟩ Mr
> Hogarth's [prints] [s.t.] ⟨Works?⟩
> written by himself[57]

There is Charlemont's story that Hogarth had promised him a description of his plates, "which he said the public had most ignorantly misconceived; and it was his intention, at one time, to have given a *breakfast lecture* upon them in the presence of his Lordship, Horace

Walpole, Topham Beauclerk, and others" but never did.[58] But the omnibus title, like the table of topics, was intended to contain most of what Hogarth had written on allied subjects, including the pages on the academy. Other subjects were arising, however, and perhaps being incorporated in the growing magnum opus. In a letter to the Reverend Herbert Mayo on 4 April 1761, concerning the Line of Beauty in music, Hogarth wrote, "I intend, as soon as possible to publish a Supplement to my Analysis."[59] About this time he also translated a passage from the 1761 Amsterdam edition of Claude-Henri Watelet's *L'Art de peindre,* apparently as part of his continuing dialogue on the themes of *The Analysis of Beauty.*[60] The draft of an advertisement for the supplement has also survived, and some notes of what probably would have been the preface, in which he comments on the reception of the *Analysis.*[61] The subject matter of the supplement was to be varied: he mentions music to Mayo, but his notes are on architecture, and these can probably be dated around the time Kirby's *Perspective of Architecture* was written and Hogarth made the drawing for its frontispiece (spring 1760; HGW, no. 235). Some of his notes could be taken as commentary on that drawing.[62]

As a dedication, expressing his point of view in the work, he drafted the following lines, which hark back to the drawings of Somebody and Nobody he added to the "Peregrination" manuscript in 1732 (vol. 1, 323–24):

<div align="center">The no Dedication</div>

Not Dedicated to any Prince in Christendom for ⟨fear⟩ it might be
thought an Idle peice of Arrogance
Not Dedicated to any man of quality [because—s.t.] ⟨for fear⟩ it might
be thought too assuming
Not Dedicated to any learned body of Men as either of ⟨the⟩ universitys
or the Royal Society [because—s.t.] ⟨for fear⟩ it might ⟨be⟩ thought an
uncommon peice of vanity.
Not Dedicated to any ⟨one⟩ particular Friend [because it may be thought
a Blunder—s.t.] for fear of offending another.

<div align="center">Therefore Dedicated to nobody</div>

But if [nobody—s.t.] for once we may suppose nobody to be every body as
Every body is often said to be nobody then is this work Dedicated to every
Body.

<div align="right">by their most hum^{ble}
and devoted—[63]</div>

All the notes, however, revolve around three general subjects, two of which were evident in the conversation with Walpole: the lack of patronage for English artists due to the mercantile preoccupations of their countrymen and the ease with which pictures could be obtained from abroad (what Hogarth meant when he spoke of English "good sense" to Walpole); the problem of judging a work of art; and the error of studying art through the literal copying of works of art or even nature. All three were also implicit in the issues Hogarth was raising in connection with the exhibition of the Society of Artists. Whether or not it was all projected at the time Walpole talked to him, the opus was to end with an account of Hogarth's own prints and his autobiography, and the notes that were composed at this time almost invariably return to a vindication of himself, his career, and his works. This was also implicit in the campaign against the Society of Arts in the spring of 1761.

Hogarth's satiric Frontispiece and Tailpiece helped to sell the exhibition catalogues, which went so fast that they had to be engraved over again by Grignion. According to one account, 13,000 were sold at 1*s* each (as opposed to 6,582 the previous year), earning the artists some £650. Another account states that over 6,000 catalogues were sold with probably as many as 20,000 people in attendance.[64] But the artists felt that too many people had attended the exhibition, including unsuitable riffraff. This became involved, in more than one way, with the corollary of why so many catalogues were sold, the explanation of course being the popularity of Hogarth's designs. Gwynn remembered that the exhibition "became a scene of tumult and disorder . . . the room was crowded with menial servants and their acquaintance; this prostitution of the fine arts undoubtedly became extremely disagreable to the Professors themselves, who heard alike, with indignation, their works censured and approved by Kitchen maids and stable boys."[65] Samuel Johnson, in the preface to the catalogue, recalling the reason the artists detached themselves from the Society of Arts' Exhibition, had commented: "Though we are far from wishing to diminish the pleasures, or depreciate the sentiments of any class of the community, we know, however, what everyone knows, that all cannot be judges or purchasers of works of art" (i.e., both judges and purchasers). And the next year the introduction

to the catalogue recalls: "When the terms of admission were low, our room was thronged with such multitudes, as made access dangerous, and frightened away those whose approbation was most desired"—that is, the higher orders of society whose approbation the artists sought.[66]

Since the Hogarth designs were undoubtedly part of the problem, in 1762 the catalogue was issued without Hogarth's illustrations and without charge, but there was a 1s admission ticket. The artists raised the price of admission to filter out the lower orders, at the same time asserting the right "to exclude all persons whom they shall think improper to be admitted, such as livery servants, foot-soldiers, porters, women and children etc., and to prevent all disorder in the room, such as smoking, drinking, etc., by turning the disorderly out."[67] The consequence was that for *these* people Hogarth set up the Sign Painters' Exhibition in 1762.

The exhibition of the Society of Arts opened on 27 April, followed by the Society of Artists on 9 May, but as early as the issue of 23–25 April the *St. James's Chronicle* printed a letter to Henry Baldwin (the printer) from "John Oakly" (i.e., a stout-hearted, no-nonsense Englishman).[68] Oakly begins with all the old Hogarthian generalizations about "the Tribe of Auctioneers, Connoisseurs, Picture-Brokers, Dealers, Menders, Cleaners, &c. &c. &c.," who control the trade in art, exerting their influence on the great patrons and the uninformed public. The English painter therefore labors "for a small Pittance," many "are absolutely starving," and only portrait painters are decently rewarded. Having made a number of unfavorable comments on the Englishman's love of "Looking Glasses," Oakly turns to the prime example of English genius: Hogarth.

> It is universally confessed by Foreigners, and even by our selves, for we are not the most quick sighted to the Merits of our Countrymen and Contemporaries, that we have now living as great a Genius as any Time or Nation has produced. He stands by himself, as the great Original of Dramatic Painting, if I may be allowed the Expression. He has invented Characters, Fable, Incidents, &c. and has put them together in such a masterly Manner, and with such Variety, that a Writer of Comedy might paint almost exactly after him, and furnish great

Entertainment for the Stage from his exquisite comic Paintings. In a Word, their Merit, Force, and Effect, are universally allowed; and yet, to our Shame be it spoken, one of his first-rate Productions [i.e. *Marriage A-la-mode*] was sold by Auction for a Price, the Mention of which would dishonour our Country, while the Drawings of Rembrandt, the Pictures of Teniers, and the scarce-visible Productions of some antiquated Dauber, have been bought up with a Kind of religious Enthusiasm. . . . Yet, notwithstanding their Vogue and Merit, I would rather, for my own Entertainment, be possessed of one of our Countryman's Performances, than of all the Chemists and Skittle Grounds of the Flanderkin.

Hogarth's argument with the connoisseurs and picture dealers had never been so cogently and vehemently stated before. Hogarth could only imply the personal damage he had suffered for lack of an appreciative clientele; Oakly was perfectly explicit about it. He continues with a passage that might have been excerpted from Hogarth's manuscript notes:

It may be thought, from what I have said, that I am one of those who decry the Merit of former Masters: So far from it, that I always see their best Works with Rapture, and have the highest Reverence for their Abilities. But then, my Zeal for the dead Professors of the Art is not attended with an unjust and partial Contempt for the Living.

Besides the use of "Professors" (cf. Hogarth's suggestion for a name for the artists' group), one is reminded of the passage about himself that begins in his notes: "They say that he abuses the great masters. Let me put a case & then let it be judged who abuses the great masters, he or they."[69] Although there are few direct verbal echoes, the ideas and stances are those of Hogarth's notes. It may not be coincidence that Oakly has worked in the quotation from Pope that Hogarth used in his "Britophil" essay ("Authors, like Coins, grow dear as they grow old: / It is the Rust we value, not the Gold"). After the couplet, Oakly remarks "Hogarth has most humorously commented upon these Lines in the little Etching of his Receipt for the Print of Sigismunda" (*Time Smoking*).

Now at last, says Oakly, the situation may be righted by the quarrel between the Society of Arts and the Society of Artists, "which, in all Probability, will bring about a Change and Advantage to our

English Geniuses, that was so much to be wished, but so little expected." Insisting that he bears both groups good will, he says his main point is that "the Arts must draw all their Nourishment and Vigour from the Artists themselves. We may talk what we please about Patronage, Encouragement, and Establishment [Hogarth's way of referring to the idea of a state academy]; but I will hereafter endeavour to convince the Castle-Builders [another phrase that appears in Hogarth's notes], that a proper Care, Conduct, and Connection among the Artists, will be the only Means of giving them a permanent Credit." He can assure us, he concludes,

> that the long-wished for Union among the Artists is now happily brought about, and that all little private Parties, Caballings, Suspicions, and Animosities, are laid aside for more general and generous Considerations; and that a noble Emulation among them will produce at their next Exhibition, what will do themselves and their Country great Credit and Honour. This I can foresee, and will venture to foretel without the Gift of Prophecy; for what may we not expect from the Merit of many I could name among them, cordially assisted by the Author of the Analysis of Beauty, in this free Country, under such a Government, and protected by such a King?

Here then is a clear statement of Hogarth's view of the artists and their search for an academy, the present unification of the diverse factions, and the function and meaning of the exhibition in Spring Gardens. Oakly particularly mentions that the artists are "cordially assisted by the Author of the Analysis of Beauty," using an identification that under the circumstances was certainly significant.

The letter was reprinted in the *Chronicle* of 5–7 May, which advertised the opening of the exhibition, because, a headnote explains, it has "been a Subject of much Conversation (in Consequence of which the Paper has been lost out of several Coffeehouses)." The next issue (7–9 May) announced the publication of a pamphlet supporting the artists:

> *A Call to the Connoisseurs, or Decisions of Sense, with Respect to the Present State of Painting and Sculpture, and their several Professors in these Kingdoms; together with a Review of, and the Examination into their comparative Merits and Excellencies. Intended to vindicate the Genius and Abilities of the Artists of our own Country, from the Malevolence of pretended Connoisseurs*

or interested Dealers, recommended to the Perusal of every true Judge and impartial Critic in Great Britain, previous to a View of the present Exhibitions of the modern Artists. By T. B. Esq. [Thomas Bardwell].

The following issue (9–12 May) carried quotations from this pamphlet, describing the leading English artists—all in rather fulsome rhetoric: "Mr Hogarth is the most perfect Master of all the Characters and Passions, expressed by the human Countenance, that ever existed; this makes his Conversations inimitable; and indeed was he to paint historical Subjects of the same Size, it is my Opinion he would be still more, what he is already, the Wonder of the World." A similarly extravagant, and somewhat longer paean explains Reynolds's superiority to Rubens and Van Dyck; Wilson is preferred to Claude; and so on. Although balanced by attacks on the connoisseurs, such praise should have made the artists uneasy—and apparently did give rise to some second thoughts in the *St. James's Chronicle* writers.

In the 7–9 May issue, however, the catalogue of the paintings was reprinted, concluding with a description of Hogarth's Frontispiece ("of which it is unnecessary to say more than it was delineated by Mr. Hogarth"). In the issue of 12–14 May Roubiliac inserted some verses of his own attacking connoisseurs, and on 14–16 May appeared "Oakly's" second letter, an attack on connoisseurs which again sounds in places as if it were based on Hogarth's manuscript notes. The young man who wants to be a connoisseur reads books and gets the idea that he can only appreciate pictures by going abroad:

he at once gave up his Eyes and his Understanding, to be led blindfold as they [his travelling acquaintances] pleased; and as a Proof of his Submission, he was put into the Hands of a certain *Picture-Dealer,* who was to clear his Eye-sight, refine his Taste, (that was the Phrase) and dispose of some Hundreds, which he had set apart for Pictures. This is a very common Practice, and puts me in mind of the Artifice made use of by a famous Oculist. He persuaded many Persons, that they had a Defect in their Vision, took them in Hand to remove it, half blinded them, and then made them testify to their Cure.

(The oculist, of course, was Taylor, of *The Company of Undertakers,* ill., vol. 2.) The young connoisseur comes back to England with his

pictures; and a sensible friend, being shown his collection, concludes that the only good pictures are two he had bought "upon [his] own Judgement when [he] first set out a Picture Fancier, and before [he] knew one Master from another."

Meanwhile, something less to Hogarth's liking had appeared. The *London Chronicle* for 12–14 May reprinted Reynolds's three *Idler* essays on art and Hogarth as a single "Letter on Painting" (above, 255); the author was still unidentified, but everyone must have known who it was by now. The young connoisseur returning from Italy to praise Hogarth's Line of Beauty may have inspired Oakly's piece in the *St. James's Chronicle* of 14–16 May. It certainly inspired the letter from "Admirer, but, thank God, no Encourager of the Polite Arts" printed in the *St. James's Chronicle* of 23–26 May, which also clearly focuses the battle between the artists and the connoisseurs on the rivalry of the artists and the Society of Arts. The "Admirer" comes to London and is met by a connoisseur friend, a member of the Society of Arts, who cries, "Come with me, and help me to despise the wretched English Dawbs at Spring Garden. . . . Lord," he goes on to his somewhat skeptical companion, "come along—you know nothing—there is a wretched Fellow, one Hogarth, has—" "Hold," says his companion, "I know Hogarth is the best Painter of Life and Manners in the Universe; and I know I gave 12 or 14 l. for his Prints, and would not take 500 l. for them." "Lord," says the connoisseur, "Hogarth! an absolute Bartholomew Droll, who paints Country Elections, and pretends to laugh at the Connoisseurs, for prizing." They enter the exhibition: "Heavens," cries "Admirer," "What's yonder; the unhappy Sigismunda with Guiscard's Heart! Would my Friend Dryden could but come to Life again to see his Thoughts so expressed, so coloured:—Who did it my Lord?" "Hogarth," says the connoisseur, "and he is quite out of his Walk." "Hogarth!" says his companion, "I could not indeed have expected this even of him." And so on, with Reynolds found better than Van Dyck and Wilson better than Claude, as in *A Call to the Connoisseurs*. Finally, the connoisseur shows his friend Hogarth's Tailpiece to the *Catalogue*:

'Pray look at the Tail-piece to your Catalogue, and see what you can make of that.—It is your Friend Hogarth's Conceit—can you guess what he means by it?' It struck me at once—'Pray, my Lord, do not ask me.'—He pressed the harder.—'Nay, nay, my Lord, says I, the

Author of the Election and the Sigismunda, can never draw without a Meaning, and I swear, I think this is very like,'—'Like who?'—'Just like your Lordship, upon my Honour.'

As these quotations indicate, the attacks were directed at the Society of Arts and the connoisseurship and dilettantism it stood for, with its premiums and patronizing attitude toward the artists. Those who had stayed and exhibited at the Society of Arts' rooms were not mentioned, or were, indeed, lumped with the artists in Spring Gardens against the connoisseurs.

A close observer of the artists' movements, Samuel Johnson may have had all of these contretemps in mind, as well as his own indifference to painting, when he wrote Baretti, after the exhibition, that it had "filled the heads of the Artists and lovers of art. Surely life, if it be not long, is tedious, since we are forced to call in the assistance of so many trifles to rid us of our time, of that time which never can return." (Reynolds, he comments in the same letter, "is without a rival."[70])

THE SIGN PAINTERS'
EXHIBITION OF 1762

BONNELL THORNTON AND THE
NONSENSE CLUB

The journal that spoke for Hogarth's interests in the Society of Artists' exhibition was the *St. James's Chronicle,* a newly-founded triweekly controlled by Garrick and two young Oxford men, Bonnell Thornton and George Colman.[1]

Like his old friend Hogarth, Garrick had suffered in the 1750s a reaction against the adulation of the previous decade and had come in for his share of criticism. "If there were no plays of merit, it was because Garrick would not produce them. If a play failed, it was a fault of his direction or of his acting."[2] Sensitive himself to criticism, he doubtless understood and sympathized with Hogarth's sensitivity. It was thus Colman's ironic *Letter of Abuse to D—— G——k, Esq.,* published in May 1757, defending the great actor from his carping critics, that first earned him admittance to the Garrick circle. With Colman came his friends Thornton and Robert Lloyd. On 14 March 1761 Charles Churchill's *Rosciad* was published, and this attack on virtually all the actors, writers, and managers except Garrick brought about the alignment of Garrick with Churchill as well. Together they battled Smollett's *Critical* reviewers, who had attacked *The Rosciad,* and all those who were tired of the "Garrick Gang."[3] To support and express the views of their group, Garrick helped found the *St. James's Chronicle.*

The first issue appeared 18 April 1761, and thereafter thrice weekly, "devoted primarily to letters, 'puffs,' chit-chat, gossip,

'news,' and essays to promote the interests of the 'triumvirate' and their allies."[4] The triumvirate consisted of Garrick, Colman, and (depending on the interpreter) Lloyd or Thornton. "Their allies" included Hogarth. In fact, the group seems to have regarded Hogarth, his reputation and ideas, as a phenomenon parallel to Garrick, to be supported and defended.

Thornton, Churchill, Colman, and Lloyd (as well as William Cowper) had met in the 1740s at Westminster School and formed the Nonsense Club. They grouped themselves around Vincent Bourne, the fifth-form usher who wrote Latin poems about everyday subjects. In 1734 he published *Poematia,* which included a poem "Ad Gulielmum Hogarth," which may have inspired Hogarth to Latinize his name on his engraved self-portrait with his pug. About the same age, Hogarth and Bourne appear to have been friendly. A few years later in "Conspicillium" Bourne alluded to the clergyman leering at the sleeping woman in *The Sleeping Congregation,* and his "Usus Quadrigarum," with its description of a man crammed in a coach between fat women, seems to have been in Hogarth's mind when he made *The Stage Coach* in 1747 (both ill., vol. 2). Bourne's appointment in November 1734 to be housekeeper and deputy sergeant-at-arms to the House of Commons (as the result of his dedication of *Poematia* to the duke of Newcastle) may have served Hogarth in his campaign toward the Engravers' Act (the petition was introduced early in the next year).

The main tie between the two men was symbolic. Bourne described contemporary life—the interior of a stagecoach or a sleeping congregation—in classical Latin. "His diction all Latin," as Charles Lamb observed, "and his thoughts all English."[5] A poem like "Cantatrices," on the ballad singers of Seven Dials, conveyed very much the effect Hogarth achieved by portraying harlots and rakes in poses taken from the Old Masters. Bourne must have been the original point of contact between the witty boys of the Nonsense Club and the work and mode of Hogarth, just as later Hogarth may have introduced Colman to Garrick.[6] Hogarth and Garrick were already involved in a Nonsense Club of their own, with the modus operandi already in place. As Garrick summed up, "I was never in better spirits or more nonsensical" than in July 1746 when he, Hogarth, and others performed the tragedy of *Ragandjaw* (vol. 2, 260).

Bourne, who died in 1747, would have had the strongest influence

on Thornton (b. 1725), the oldest member of the group, who was in Oxford by 1743 and by 1749 part of the London world of professional writers.[7] He was perhaps the upperclassman model of Churchill, Colman, and the others. Hogarth was already evident in his earliest publication, an "Ode on Saint Caecilia's Day, adapted to the Ancient British Musick in April 1749." (This was to be revived and performed in 1763 following upon the Sign Painters' Exhibition.) The "Ode" was written for the "ancient" and, in contemporary terms, plebeian instruments of the hurdy-gurdy, Jew's harp, saltbox, and marrow bone and cleaver—represented by Hogarth in *The Enraged Musician* and *Industry and Idleness* 6. Thornton's hurdy-gurdy is certainly related (it is difficult to know which came first) to the one Hogarth painted at this time in *The Savoyard Girl* (fig. 25). These musical instruments offered the same message as Hogarth's *exquirete antiquam matrem* (Seek out your *ancient* [*British*] mother) in the subscription ticket for *A Harlot's Progress.* But, of course, as in the *Musician*'s conjunction of plebeian music and a *Beggar's Opera* poster, the ultimate source was Gay's use of traditional English ballads. This primitivist aesthetic now identified one's politics with the Country ideology of Leicester House.

Thornton—or someone very close to him—first translated Rouquet's commentary on *The March to Finchley* in his friend Christopher Smart's journal *The Midwife: or, The Old Woman's Magazine,* 17–19 January 1750/51, and then published on 7–9 March an original explication in his own periodical *The Student: or, Oxford and Cambridge Miscellany.*[8] This sort of writing was not so common as to leave much doubt that the Hogarthian ethos was behind Thornton's satiric writing.

Thornton's first independent journal was *Have at Ye All: or, The Drury-Lane Journal* (from 16 Jan. 1751/52), a parodic attack on Fielding, his *Covent-Garden Journal,* and *Amelia.* Thornton deplores that Fielding has "lost his genius, low humour," and has become dull, pompous, and sentimental.[9] Thornton's spokesperson—his equivalent of Mr. Spectator or Fielding's Hercules Vinegar—is Roxana Termagent, a tough prostitute descendant of Hogarth's Moll Hackabout trying to eke out a living in "hack" writing.[10] She may well have served as a mouthpiece for Hogarth himself—a blunter outlet for his views on Fielding's establishmentarian opinions than the graphic images of *Beer Street, Gin Lane,* and *The Four Stages of Cruelty* (Chap. 2, above).[11]

It is possible to see Thornton as a younger replacement for Fielding as Hogarth turned away from the magistrate of *An Enquiry into the Late Increase in Robbers* and the Penlez Riots and moved into a circle of more libertine and slumming colleagues. Thornton's continuing argument is that the "low," besides being a satire on the high, can also serve as a corrective and offer an area to which the English artist or writer ought to turn for inspiration. The nationalist bias of the Nonsense group (a comic equivalent of the program outlined by Warton and Collins) was summed up in Lloyd's poem "To a Friend" in the second edition of the *Connoisseur* No. 125 (replacing his earlier "Ode on Friendship"): he attacks modern "correctness" as a straitjacket on the imagination—"modern rules" versus native "untutored" "genius," which returns to native origins, to Chaucer and Spenser in literature and so to equivalents in primitive music and art. Writing should be carried out *against* the rules, *against* imitative models, and therefore with a sort of uninhibited spontaneity—a principle that would eventually carry the group, or at least some of its members, into assumptions Hogarth found unacceptable. But their basic orientations were, at this point, in agreement.

Thornton was a prolific writer, and other journals followed the *Drury-Lane Journal*. The most important was the *Connoisseur* (Jan. 1754–Sept. 1756), founded as, among other things, an answer to another journal, the *World,* which had first appeared in February 1753, written by Edward Moore with assistance from Horace Walpole, the earl of Chesterfield, and William Pulteney, and thus heavily weighted with self-styled connoisseurs' essays on taste, art, architecture, furniture, and gardening. Thornton picked up this central term of the aesthetic battle being waged in the 1750s around the academy. His criticism was precisely Hogarth's from his "Britophil" essay onward: that the connoisseur's admiration for Raphael and Vitruvius–Palladio was inflexible and led him to neglect native and living English talent. When Mr. Town explains the way he writes essays, it is in terms of Hogarth's prints, "by a lively representation of what passes round about him":

Thus, like those painters who delineate the scenes of familiar life, we sometimes give a sketch of a marriage *à la mode,* sometimes draw the outlines of a modern midnight conversation, at another time paint the comical distresses of itinerant tragedians in a barn, and at another give a full draught of the rake's or harlot's progress. Sometimes we divert

the public by exhibiting single portraits; and when we meet with a subject where the features are strongly marked by nature, and there is something peculiarly characteristic in the whole manner, we employ ourselves in drawing the piece at full length.

This is essentially a survey of Hogarth's work between 1732 and 1754. No. 8 comments on the Rembrandt etching hoax and supports *The Analysis of Beauty,* and the next issue, No. 9, picking up on Thornton's earlier essay in the *Student,* introduces the subject of signboard painting. No. 48 follows Hogarth's line in the *Analysis* on the democratization of pictures:

> Every one who can see, is able to collect the meaning of an obvious picture . . . it is one peculiar advantage, that this effect may be produced on the rude and vulgar, on those who have never been improved by education, and who are neither able nor inclined to improve themselves by reading and reflection. [12]

Hogarth also remains a shadow over the one essay Thornton wrote for Johnson's *Idler* (No. 15, 22 July 1758), which paraphrases *Evening* of *The Four Times of the Day.*

In 1760 Thornton published a satirical essay, *City Latin, or Critical and Political Remarks on the Latin Inscription on Laying the First Stone of the Intended New Bridge at BLACK FRIARS,* which, while ridiculing the bad Latin of the inscription, urges the impropriety of substituting Latin for good native English words. Carrying Bourne's poetic representation of this impropriety one step further, Thornton favors retaining the English words. With the example of William Pitt, the subtext becomes political:

> *Pitt! Pitt!* a low *English* Word! *Sink, Ditch, Bog, Quagmire,* would sound equally noble. But if, instead of this, it had been written *Fossa,* how grandly would that have sounded! and, surely, every Admirer of antique learning will agree with me, that *Fossa! Gulielmi Fossae!* . . . would have made the illustrious name of the *Fossas* adored and remembered to all Posterity. [13]

On the aesthetic level he endorses plain Will Pitt, however gross, as well as the names Mangey, Rag, Belcher, Gorge, Grub, Trollop,

Nanny, and Hussey—and (by implication) names such as Idle or Hogg or Hogarth. Thornton would presumably prefer the English to the latinized *Gulielmus Hogarth*. He uses these strong but ugly names to satirize the pretentious Latinate oratory of Pitt, but also to make a case for the expressiveness of native English.

It is impossible now to say whether the ideas were passed from Hogarth to Thornton, Hogarth's spokesman, or whether Thornton extended his senior's ideas. Following *The Analysis of Beauty* Hogarth was in the mood to make an aesthetics of his native subculture, and Thornton may have encouraged him in the conceptualizing process, suggesting new strategies. But Thornton's position is also significant because it indicates the common ground shared by Hogarth, Wilkes, and Churchill.

By this time Thornton and Colman had joined their old Westminster friends Lloyd and Cowper in reviving the Nonsense Club. They met every Thursday evening, with Thornton the leading spirit, planning hoaxes and practical jokes. Churchill joined the group in 1758 when he succeeded to his father's curacy in Westminster.[14] In 1759 Garrick's farce *Harlequin's Invasion* joined the campaign, questioning the assumptions of polite culture in terms of popular, though the argument is the fairly weak one that we can enjoy pantomimes so long as we do not alter our opinion of Shakespeare's preeminence. So in March 1761 Thornton and Colman reappeared as founding partners of the joint-stock company that published the *St. James's Chronicle*.

THE *CHRONICLE* AND THE SIGN PAINTERS

The same issue of the *St. James's Chronicle* (23–27 May 1761) that carried "Admirer"'s letter about the Society of Arts connoisseurs observed on the back page, under "LONDON" news:

> The projected Exhibition of the BROKERS and SIGN-PAINTERS of *Knaves-Acre, Harp-Alley,* &c. &c. &c. is only postponed, till a Room spacious enough can be provided, as the Collection will be very numerous. In the mean Time the Several ARTISTS (Natives of Great-Britain) are invited to send to the Printer of this Paper, a List of those Capital Pieces,

which they intend to submit to the public Judgement. N.B. No Foreigners, and *Dutchmen* in particular, will be allowed a Place in the Exhibition.

Harp Alley, from Shoe Lane to Farringdon Street, was the center of the sign-painting trade. A "Number of Capital Paintings, Drawings, Busts, Images, &c." had already been received, and some were listed—common signboards that could be seen anywhere in England: "The Salutation, a Conversation Piece," "the Hen and Chickens, a Landscape," "Adam and Eve, an Historical Sign," and "a Half-length Portrait, designed for the Duke of Cumberland, but converted into the King of Prussia, with very little Alteration." All of these are references to Hogarth's *March to Finchley,* a work Thornton had singled out for analysis, and the "beautiful Head and Tail-piece *cut in Wood,* which will serve as a Ticket for Admission to the Exhibition," sounds like a plebeian version of the Frontispiece and Tailpiece Hogarth had engraved for the Society of Artists. The central issue, however, seems to be the advocacy of a native English art, satirizing the exhibitors' overemphasis on their Englishness and/or their actual reliance on foreign models. But native English signboards, seemingly standing for the popular art of Hogarth, are being used as a commentary on the art of the Society of Artists' Exhibition.

This good-humored sally may have been Thornton's first thought toward the exhibition that did materialize the next year. In the next issue, 26–28 May, "Timothy Coarse-Brush," a sign painter, submitted a list of the "Capital Performances" to be exhibited by the "true British Artists in the SIGN Way"—many of them glances at Hogarth:

> A Hand and Jaw, after the Manner of Hogarth.
> A Barber-Surgeon, ditto.
> St. John's Head in a Charger.
> A Dog's Head in a Porridge Pot.
> A Goose and Gridiron, in Still Life.
> A Noah's Ark, in Water Colours.
> St. George and the Dragon, an Historical Painting. . . .
> A Tetragon Pyramid, for a Rubric Post.
> Several Cones representing Sugar Loaves.
> A Spiral Pole, for a Barber.

THE SIGN PAINTERS' EXHIBITION

Ditto, with Candles pendant.
A crooked Billet, formed exactly in the *Line of Beauty.*

The exhibition is announced for the beginning of the next month. Then in the next issue, 28–30 May, "Theo. Coverley," another correspondent, writes to Oakly that he thinks the party of the Modern Painters

are as likely to carry their Admiration to their co-temporary Countrymen to as ridiculous an Extreme as ever was done by the Connoisseurs in favour of the ancient Foreigners. I have surveyed the two Exhibitions with some Attention, and I am sure, with great Impartiality; and I am sorry to declare, that, throughout the whole, for one good Picture there are at least ten bad ones. I shall not affront any of the Exhibiters by pointing out those which are most conspicuously bad; but really there are several amongst them, which are very little above Sign-daubing. As to Portrait Painting, I can hardly allow them to be called Painters. The only Talent they require is an accurate Eye; their whole Art consists in copying, and therefore Genius or Invention are entirely out of the Question. Now if from the Exhibition in Spring Gardens we subtract the Portraits, and Cassali's Works from that in the Strand, what have we remaining in either of them worth the Attention of Men of real Taste and Judgment?

This interesting document, while offering the same argument concerning portraitists that appears in Hogarth's notes, implies that Hogarth's paintings resemble signboards. Although this is not entirely farfetched if one considers the *Election* paintings on display, it was not meant as a compliment. The *St. James's Chronicle* often balanced one opinion with a contrary one, probably written by its own editors, and Garrick complained that his own paper criticized his acting from time to time. This letter sounds like a commentary on the Sign Painters' Exhibition, and if the notice that followed in the same issue is any indication, it effectively killed the possibility of such an exhibition in 1761:

We can assure the Publick, that the Exhibition of the Brokers and Sign-Painters will not be till after the Birth-Day [i.e. of the king], as it is supposed that Persons of Fashion are too busy in preparing their Birth-Day Suits to attend the fine Arts. The Collection of Paintings, &c. will be very curious; and we hear, that not one Picture exposed at

the Society-Room or at Spring-Gardens will be admitted. An eminent Artist of Harp-Alley has designed the Head and Tail-piece, which is now engraving (if we may call it so) by the greatest Woodcutter in all Europe, though an Englishman.

In the 30 May–2 June issue it was announced that the Sign Painters' Exhibition would certainly be held the following week, but no more was heard after that. By 2–4 June the exhibitions of both Society of Artists and Society of Arts were over, and the *St. James's Chronicle* printed a letter from a supporter of either side, both insipid. Interest had apparently died out because no more appeared for some time. Nevertheless, one wonders whether the letter from "Theo. Coverley" did not put the Sign Painters' Exhibition in a light that was not intended by its original projectors, leading them to drop the idea for the present.[15]

Dryden had written of signboard painting that it "will serve to remember a Friend by; especially when better is not to be had." And in 1743 Fielding had written in his *Miscellanies* how comic it would be "if an inferiour Actor should, in his Opinion, exceed *Quin* or *Garrick;* or a Sign-Post painter set himself above the inimitable *Hogarth.*"[16] Following upon *Beer Street* with its artist sign painter, he wrote in the *Covent-Garden Journal* No. 52 (30 June 1752) that bad translations "can give the Reader no more Idea of the Spirit of Lucian, than the vilest Imitation by a Sign-post Painter can convey the Spirit of the excellent Hogarth."[17] But in December of the same year a new note was introduced, as if in response, by Fielding's antagonist Thornton in *Adventurer* No. 9 (2 Dec.). Speaking in the persona of a sign painter, Philip Carmine, Thornton wrote:

> I am at present but an humble journey-man sign-painter in Harp-alley: for though the ambition of my parents designed that I should emulate the immortal touches of a Raphael or a Titian, yet the want of tast among my countrymen, and their prejudice against every artist who is a native, have degraded me to the miserable necessity, as Shaftesbury says, 'of illustrating prodigies in fairs, and adorning heroic signposts.'

He is probably putting these words into the mouth of the shabby painter in *Beer Street* (as he had used Moll Hackabout in the *Drury-*

Lane Journal), but now he introduces an aesthetics of sign painting with appropriately strong emphasis on the Englishness of the art. His advocacy of sign painting as an original art leads directly into the Sign Painters' Exhibition in which Hogarth was to play a leading role.[18] At the same time he continues to echo Hogarth's satire on the state of the clergy: "but why must the *Angel,* the *Lamb,* and the *Mitre,* be designations of the seats of drunkenness and prostitution?"[19]

Signboards structured the visual experience of the ordinary Londoner. Hogarth had balanced his *March to Finchley* with on one side the sign of "Adam and Eve" and on the other "The King's Head" (the first for a nursery, the second a brothel); but from the sign of "The Bell" in *Harlot* 1 to the "Baptist's Head" in *Noon* Hogarth had used signboards both as one of the sign systems on which he structured his pictures and as part of a collage that conferred on such noncanonical forms of art the respectability of folklore instead of an academic tradition. He had invented his own signboards in the cats atop the brothel in *Finchley* and in the church steeple conjoined with the three balls of the pawnshop in *Gin Lane.* The pivotal representation was *Beer Street,* in which the gin-drinking artist is painting a tavern signboard. A poor resident of Gin Lane, this English artist can only find employment painting signboards for the affluent beer drinkers of Beer Street.

Hogarth would have known that there were distinguished examples of signboards. Watteau's *L'Enseigne de Gersaint* was the best known, but Chardin painted signboards and, in the seventeenth century, Karel Fabritius and other Dutch masters. But Hogarth saw the sign painter's profession as a case of the conflict between craft and art, popular and elitist artifacts, or low and high cultures. An "artist" was situated somewhere on a scale from the plumber, who cast lead statues and decorated lead cisterns, to the plasterer, who did elaborate stucco designs, and the carpenter, who did fine wood carving, to the coach painter, who approached the status of official recognition as an artist. Herald painters, who painted emblems and coats of arms on coaches of the great, were paid more and accorded more prestige than the body makers, smiths, and trimmers of the carriages; but there was often a narrow line separating the one from the other and a confusion of social identities. Hogarth's theme in his "modern moral subjects" of the search for and confusion (or loss) of identity was a direct reflection of his own situation as an artist.

He is sometimes said to have painted signboards early in his ca-
reer—and in the 1750s his own head illustrated the signs of at least
two printshops.[20] But a signboard was an emblematic representation
often compartmentalized in the manner of Hogarth's prints, which
conveyed their messages by the same devices—subtly in his comic
histories, more obviously and strongly in the popular symbolic pic-
tures of the 1750s. The Hogarthian visual pun had one source in the
"cockney custom of punning on the name, so common in sign-
boards" (and noticed by Thornton), for example, "Two Cocks" for
Cox and the "Brace Tavern" for two brothers named Partridge; or,
going on to rebuses, a hare and a bottle stood for Harebottle and a
hat and tun for Hatton.[21] More important were the symbolic repre-
sentations: the implement of a trade (a measuring rule for a surveyor,
a cupping glass or a urinal and a gold-headed cane for a physician),
or the source of the produce (grape arbor for a pub), or the part for
the whole (Van Dyck's head for an artist, the Hogarth's Head for a
printseller, a knife for a cutter, a hand for a glover, a stocking for a
hosier).

Philip Dawes, an assistant or pupil of Hogarth, told Moser that
while Hogarth was mulling over *The Analysis of Beauty* in the early
1750s, he (Dawes)

> more than once, accompanied him to the Fleet Market, and Harp-alley
> adjacent, which were in those times the great marts, and indeed exhi-
> bitions, of signs, of various descriptions, barbers'-blocks, poles, etc.
> etc. which were then more in request than they have been of late years.
> In these places it was the delight of Hogarth to contemplate those
> specimens of genius emanating from a school which he used emphati-
> cally to observe was truly English, and frequently to compare with,
> and prefer to the more expensive productions of those Geniuses whom
> he used to term the *Black Masters*.[22]

There are stories (such as the one about Simmons in Bristol) of Ho-
garth's admiration for sign painters' work; one such concerned
Joshua Kirby, whose sign of the Rose he saw in Ipswich. Unlike the
artist of *Beer Street,* Kirby was an example of a successful artist who
rose from sign painting to be drawing master to Prince George.[23]

Sign painting was one of the few genuinely popular arts. But, as
opposed to the purer art of graffiti, it was commercial, producing
signs for businesses and shops, and the idea of an exhibition of shop
signs responded to the commercializing aims of the Society of Arts

(whose sign in *The Times, Plate 2,* is one of the premium palettes the society awarded to fledgling artists). Every shop had its signboard, at this time still perpendicular to the buildings, jostling each other for the pedestrian's attention. "Our streets," wrote Addison in *Spectator* No. 28 (2 Apr. 1711), "are filled with blue Boars, black Swans and red Lions; not to mention flying Pigs, and Hogs in Armour, with many other Creatures more extraordinary than any in the desarts of *Africk*." Addison launched a lighthearted attack on signboards, urging Londoners to "clear the City of Monsters," and outlined his version of the Augustan need to rationalize irrational modes. Recalling Horace's *Ars poetica,* he lamented that "creatures of jarring and incongruous Natures should be joined together in the same Sign." This practice, he explained, was often the result of merging shops, or families, each sign an example of Horace's familiar monster of *ut pictura poesis.* On the contrary, we should use or develop "a Sign which bears some Affinity to the Wares in which it deals." Probability (Shaftesbury's criterion in his *Judgment of Hercules*) demanded that those improbable combinations which began as erroneous puns should be rationalized.

Thornton, in his *Adventurer* essay of 5 December 1752, developed Addison's remarks. Originally a sign designated the occupation of its owner—hand and shears for a tailor, hand and pen for a writing master, hen and chickens for a poulterer (Thornton's examples). But then there appeared the sign of the publican who, not content with a bunch of grapes, must have a hog in armor, a blue boar, black bear, green dragon, or golden lion—pretentious heraldic devices (the upper-class version of shop signs). Or worse, he might (here Thornton returns to Addison's argument) hang above the door of his tavern an angel, a lamb, or a mitre. He urges that "some regard should . . . be paid by tradesmen to their situation; or, in other words, to the *propriety of place,*" and he projects a historical process of the independent origin of the shop sign, the subsequent emulation of heraldic devices of the great, and a debasement from which he hopes the original vitality can be recovered. Thornton's etymology projects a scenario parallel to Hogarth's for English art history.

Hogarth had continued to attend meetings of the artists, and perhaps it is significant that during this time the excess profits from the exhibition (which derived, of course, from his catalogue) were distrib-

uted to needy artists and their widows. He took care himself of the money dispensed to Mrs. Weldon, widow of Henry Weldon, a friend dating back to the days when they were both subscribers to Vanderbank's academy.[24]

The governing committee had asked the artists to increase its number from sixteen to twenty-four, though retaining the original proportions among the painters, sculptors, and so on, and at the general meeting of 15 December 1761 Hogarth was elected to the committee. At the next meeting, 22 December, George Lambert (himself absent) was elected chairman for the year, but only by a majority as opposed to the unanimous elections of Hayman in the past. Brian Allen suspects that Hayman's stepping down as chairman may have been due to his disagreement with the election of Hogarth to the Artists' Committee on 15 December (as well as to the onerous commission to paint four large history paintings for Tyers's Rotunda at Vauxhall Gardens). The evidence is scarce, but there is no further mention of Hogarth; on 16 March 1762, Hayman (not Hogarth) was desired to make a design for the catalogue of the forthcoming exhibition. According to early sources, the main political development of the interim had been the committee's move to give itself total power. Resolutions had been secretly passed among the members:

> That the arrangement or disposition of the several performances at all exhibitions should be absolutely left to the then subsisting committee; . . . that a president and secretary to the society, should be chosen by themselves out of their own body; . . . that, if any member of the committee should resign, &c. the choice of another to fill the vacancy, should be in themselves; and lastly (by injunction) that the resolutions of the committee should be kept a profound secret from the society, except when it was indispensably necessary to act otherwise.[25]

Whether because of these machinations and the increasingly centralized character of the committee and society, or for other reasons (he may have had no new pictures to show), Hogarth did not exhibit with them in 1762. He had attended the annual meeting of the Foundling governors on 13 May 1761 during the artists' exhibition, and was appointed one of the two scrutineers for the election of new officers. But this was the last meeting of the Foundling governors he ever attended, and he was not at the November 1761 artists' dinner. He was still invited to the annual dinner in 1762, and his name was

added to the printed list of exhibitors that year (in one of the few survivals of such a document); there is, however, no evidence that he attended the exhibition.

THE FIVE ORDERS OF PERIWIGS

In the autumn of 1761, with the coronation impending, Thornton and his friends pointed out that Westminster Abbey had now been turned into another exhibition hall like the ones in the Strand and Charing Cross. In the *St. James's Chronicle* of 11–13 August "the facetious Cobler of Cripplegate" writes that he expects to see a catalogue for this exhibition "with a curious original frontispiece of Taylor's, and an emblematical Tailpiece of Hogarth's."[26] Somewhat later it was reported that the Grand Triumphal Arch for the coronation was being painted by Mr. Oram, at Somerset House, to be placed at the north end of Westminster Hall, facing the throne.

> The four Cardinal Virtues bigger than Life; Mars and Neptune in superb Niches, with the Emblems necessary. A Medal of the King and Queen supported by Fame and Truth; the Lion and the Unicorn Couchant. A magnificent Arms of Great Britain. The Whole interspersed with Hieroglyphical Ornaments and Pillars of the Corinthian Order.[27]

Here indeed was inspiration for that complex and ambiguous exhibition of the sign painters: this work was a virtual sign, intended for a royal occasion, and painted, if not by Hogarth, at least by his subordinates—this was the Serjeant Painter's realm, another subject of Hogarth's irony. He most probably attended himself, as Serjeant Painter, when the coronation took place on Tuesday 22 September. Seats on the scaffolds were still advertised, costing anywhere from ½ guinea to 8. The amount of 2 guineas bought an unreserved place, and many went the evening before to secure a good one.[28]

The physical and temperamental demands of representing such a scene were beyond Hogarth's present capabilities.[29] His language was now the language of emblems and "Hieroglyphical Ornaments," but he may have taken note of the "Pillars of the Corinthian Order." The immediate result was an etching, *The Five Orders of Periwigs* (fig. 85),

which was published by 6 November.[30] Here he continues his attack on the Society of Arts through its protégé James (Athenian) Stuart and his promised measurements of the ruins of Greek temples.[31] He nods again to Ramsay's *Dialogue on Taste,* which (besides criticizing his Line of Beauty as mere "custom") had argued that the orders of architecture were based on no more authority than fashions in dress, which could as easily establish "a Corinthian capital clapt upon its shaft upside-down." He recalls Gerard's *Essay on Taste* of 1759 which had included as arts that "afford subjects of taste" such mechanic objects as headdress, furniture, and equipage. Thus he measures and regards wigs as the equivalent of Stuart's Greek temples, extending the range of areas in which taste is exercised and staking a claim for mere mechanics as the true artists.

He also reflects Burke's discussion of "a barber's block" in the essay "On Taste" he added to the 1759 edition of his *Philosophical Enquiry:* "A man to whom sculpture is new, sees a barber's block, or some ordinary piece of statuary; he is immediately struck and pleased, because he sees something like an human figure; and entirely taken up with this likeness, he does not at all attend to its defects" (18). Hogarth shows, in the manner of Swift's clothes philosophy in *A Tale of a Tub,* but also in the symbolism of signboards, that the block *replaces* the human head and the wig perched thereon *is* the man, at the very least a synecdoche for the man (and in that sense this print is a continuation of *The Bench*).[32]

What appears to be hieroglyphic, however, is in fact a daring pun on shapes. The "Triglyph Membretta," an ornamental pattern used in a frieze, becomes in the wig a short queue with a massive hanging on each side resembling a male *member,* small penis with huge scrotal sack; or the rear end of a sheep; or something else equally suggestive. The eucharistic figures of *Enthusiasm Delineated* reappear as the curls of the courtiers' queues which dangle provocatively near the faces of the queen's attendants, recalling in the court context Rochester's poem "Signor Dildoe" (Hogarth had given the young lady in *Before* a copy of *"Rochesters Poems"*). Everything, redolent of the bawdy jests of the Medmenhamites, denotes ambivalence about the coronation.

The queen and her maids of honor appear as a row of faces at the very bottom, suggesting a hierarchy descending from the wigs and barely glimpsed faces of the men (bishops, peers, judges, and the "Queerinthian" courtiers) to the full faces of the women wearing

coronets of a duchess, countess, viscountess, and baronness; the queen's face (at the far left) is the one face that is completely unadorned. Indeed, Hogarth may be recalling Pope's lines on the queen in his "Epistle to a Lady" (1735):

> . . . but, Artist! who can paint or write,
> To draw the Naked is your true delight.
> That Robe of Quality so struts and swells,
> None see what Parts of Nature it conceals. (188–90)

These lines could, of course, have suggested the idea of showing "what Parts of Nature" are concealed by wigs. They were followed by the lines: "From Peer or Bishop tis no easy thing / To draw the man who loves his God, or King" (195–96). We can imagine Hogarth connecting "Semper Eadem" in *The Bench* (judges in huge wigs) with the "Semper Eadem" of Pope's unadorned queen (l. 183), and so courtly wigs with the young queen who had only arrived in England a fortnight before the coronation, completely innocent of the court.[33] But alongside the compliment he leaves us to meditate the parallelism of her profile and the "blockhead" directly above her (another form of simplicity).

The male faces represent recent elevations to titles ("Peer or Bishop"): William Warburton (at top left) had been raised to the bishopric of Gloucester in 1760; Dodington had been rewarded in April with the title of Baron Melcombe of Melcombe Regis; and Samuel Squire had been consecrated as bishop of St. David's in May of 1761.[34] Warburton's profile, while an accurate likeness, may not have struck the bishop as flattering, and the other two are even less so.[35]

THE 1762 EXHIBITION

The *St. James's Chronicle* for 13–16 March announced:

GRAND EXHIBITION.

The Society of SIGN PAINTERS beg Leave to give Notice, that their GRAND EXHIBITION will be some Time next Month. A large commodious Room is provided for that Purpose, and their

Collection is already very numerous. In the mean Time they shall be obliged to any Gentleman who will communicate to them where any curious Sign is to be met with in Town or Country, or any Hint or design for a Sign, suitable to their Exhibition. Letters will be received by the Printer of this Paper.

From this notice, and from later reports, it appears that no paintings were created for the occasion—only *objets trouvés* were employed. The announcement for 23–25 March was more extravagant, pointedly juxtaposing the Sign Painters' Exhibition with that of the Society of Arts:

INTELLIGENCE EXTRAORDINARY.

Strand. The Society of Manufactures, Arts, and Commerce, are preparing for the Annual Exhibition of Polite Arts, hoping, by Degrees, to render this Nation as eminent in Taste as War; and that, by bestowing Praemiums, and encouraging a generous Emulation, among the Artists, the Productions of Painting, Sculpture, &c. may no longer be considered as Exoticks, but naturally flourish in the Soil of Great Britain.

Grand Exhibition. The Society of Sign Painters are also preparing a most magnificent Collection of Portraits, Landscapes, Fancy-Pieces, Flower-Pieces, History-Pieces, Night-Pieces, Sea-Pieces, Sculpture-Pieces, &c. &c. &c. &c. &c. designed by the ablest Masters, and executed by the best Hands, in these Kingdoms. The Virtuosi will have a new Opportunity to display their Taste on this Occasion, by discovering the different *Stile* of the several Masters employed, and pointing out by what *Hand* each Piece is drawn. A remarkable *Conoscente* who has attended at the Society's great Room *with his Glass* for several Mornings, has already piqued himself on discovering the famous Painter of the *Rising Sun,* (a modern *Claude Lorraine*) in an elegant Night-Piece of *the Man in the Moon.* He is also convinced, that no other than the famous Artist who drew the *Red Lion at Brentford,* can be equal to the bold Figures in *the London 'Prentice;* and that the exquisite Colouring in the Piece, called *Pyramus and Thisbe,* must be by the same hand as *the Hole in the Wall.*[36]

The reference to the Society of Arts Exhibition, with a specific allusion to the "Exoticks" in Hogarth's Tailpiece for the 1761 catalogue of its opposing Society of Artists, is typical of the satire. In the same issue an advertisement announced that the Sign Painters' Exhibition

would begin on Tuesday, 20 April, the same day that the Society of Arts Exhibition was to open. And in the issue for 25–27 March, while denying that the exhibition was "designed as a ridicule on the Exhibitions of the Society for the Encouragement of the Arts, &c. and of other Artists," Thornton does specify that the sign painters' "sole View is to convince Foreigners, as well as their own blinded country men, that how ever inferior this Nation may be unjustly deemed in other Branches of the polite arts, the Palm for SIGN PAINTING must be universally ceded to us." Initially at least, the satire was aimed at the Society of Arts and the connoisseurs who had been ridiculed in the *Chronicle* the year before.

On 15 March Hogarth signed and dated *Credulity, Superstition, and Fanaticism* (fig. 88).[37] (In the next chapter we shall see that if this print served in one sense as a link in the chain of atavistic images leading up to the Sign Painters' Exhibition of 22 April, in another it connected the anti-Pitt prints of 1759 with *The Times, Plate 1* of September 1762.) The devil, who appears in *Credulity,* is invoked in a letter to the *Chronicle* on 3–6 April, explaining that he is "at work to convince the Town, that the intended Exhibition of the Sign-Painters is meant to ridicule that which is to be made at the same Time by the Society for the Encouragement of Arts, &c.,"

> though I am persuaded the Collection is only made for the Entertainment of those who can enjoy the Humour of a Hogarth, without thinking they do a Violence to their Taste for the Works of Raphael; and can laugh at Garrick's Abel Drugger, without loosing a Relish for his Lear or Hamlet.

Hogarth was by this time presumably spending time in Thornton's chambers in Bow Street, where the exhibition was being prepared.

At the last minute the opening on the 20th was postponed, but Thornton assured the public "that every Thing is completely ready for their EXHIBITION, which will commence on *Thursday next*." In the *Daily Advertiser* (20 Apr.) he explained that they had not been able to "complete fitting up the Rooms, placing their Signs, and making out their Catalogue, till Thursday next; when the Publick may be assured, that everything shall be ready for the Admittance of those who please to honour them with their Presence."

On Thursday, 22 April, the Sign Painters' Exhibition opened "at

the large Rooms, the Upper End of Bow-street, Covent-Garden, nearly opposite the Play-house Passage"—Thornton's chambers, open from 9 A.M. to 4 P.M., admission 1s. The exhibition spread through a passage and a paved courtyard, opening into "a large and commodious Apartment, hung round with green Bays [baize], on which this curious Collection of Wooden Originals is fixt flat . . . and from whence hang Keys, Bells, Swords, Poles, Sugar-Loaves, Tobacco-rolls, Candles, and other ornamental Furniture, carved in Wood, that commonly dangles from the Penthouse of the different Shops in our Streets." Prefixed to the ticket was a catalogue containing the names of the signboard painters, who turned out to be the journeymen printers in Baldwin's office, where it (and the *St. James's Chronicle*) was printed.[38]

The exhibition seems to have consisted mainly of actual signboards, or rather signboards borrowed from shops or from the stock of sign painters in Harp Alley. They were all standard, recognizable signs, a readily understood vocabulary, and it is remarkable how small the iconographic repertory was and how many signs were repeated with variations. The signs were either touched up or mixed with imaginary signs to produce a new meaning.[39] Significance depended more on the relationship between signs than on the signs themselves. Nos. 53 and 54 ("by Sheerman") were two old signs of the "Saracen's Head" and "Queen Anne." Hogarth is supposed to have written under the first "The Zarr" and under the second "Empres Quean" (i.e., the czar of Russia and Maria Theresa, queen of Hungary, with the pun of "quean"-whore), and painted their tongues lolling out and their eyes turned toward each other, and over their heads a wooden label, "The present State of Europe." This sort of reciphering through juxtaposition runs through the exhibition, with "The Three Apothecaries' Gallipots" as a companion to "The Three Coffins" and "King Charles in the Oak" to "The Owl in the Ivy Bush."[40]

The one artist who was not a printer in Baldwin's shop was "Hagarty," a transparent pseudonym for Hogarth. Many of the signboards exhibited recalled Hogarth prints. For example, two versions of the sign of the "Good Woman" (Nos. 3 and 55) and a "John the Baptist's Head" on a charger (No. 33) appeared, as they had in *The Times of the Day: Noon*. The "Adam and Eve," the "King's Head," and even the "Hen and Chickens," from *The March to Finchley* were

there (Nos. 6, 13, 42).[41] But the Hogarth references centered on the Grand Room, where the works of "Hagarty" were hung. Hogarth–Hagarty (or his spokesman Thornton) has reciphered these signboards as a personal iconography, making each an emblem of an aspect of his art and life, a recapitulation of his career and favorite motifs. No. 1 in the Grand Room was (according to the catalogue) a "Portrait of a justly celebrated Painter, though an Englishman and a Modern," described by one observer as "Mr. Hogarth, or a wretched Figure done for him drawing his five orders of Periwigs." This was followed by No. 2, "A Crooked Billet, formed exactly in the Line of Beauty," a companion piece to No. 1. No. 5, "The Light Heart" (sign for a vintner), shows a heart outweighed by a feather on a pair of scales (the catalogue of the exhibition cites Ben Jonson's *New Inn* as its source). This obviously alludes to his ill-received painting in the 1761 Society of Artists' Exhibition, *Sigismunda*.[42] Since Hogarth seems to have been involved with the exhibition from the start, we have to conclude that "The Light Heart" was his good-natured preemptive (or self-protective) response to recent criticism.

Nos. 19 and 20 were the signs of Nobody and Somebody, or as the catalogue puts it, "Nobody, alias Somebody" and "Somebody, alias Nobody." The catalogue describes Nobody as "the Figure of an Officer, all Head, Arms, Legs and thighs," and Somebody as "a rosy figure with a little Head and a Huge Body, whose Belly swags over, almost quite down to his Shoe-Buckles. By the Staff in his Hand it appears to be intended to represent a Constable.—It might also have been mistaken for an eminent Justice of Peace." The sign itself was used in the seventeenth century (for a ballad printer in the Barbican),[43] and even without the catalogue's description we would recognize these figures as Hogarth's Frontispiece and Tailpiece of the manuscript "Five Days Peregrination" of 1732, most recently revived in the "No Dedication" to his "Apology for Painters."

If Somebody–Nobody is one Hogarth paradigm, "The Logger Heads" (No. 28), with the inscription underneath "We Are Three," is another. The two loggerheads within the design suppose—come to life only through—the third loggerhead, the spectator who looks at it *and* reads the inscription. And this tells us something of Hogarth's process in the exhibition: you take a well-known sign used by scriveners, which signified their secretarial silence and discretion,[44] and make it your own, a sign of your particular craft and of the way

a native English picture can function in relation to its audience. Nor does the process end here. The exhibition catalogue is augmented by the learned annotation of the *St. James's Chronicle* (written by Thornton and/or Hogarth), which cites the origin of "Logger Heads" in "the old Joke" and mentions Shakespeare's allusion "to this sign in his Twelfth Night, where the Fool comes between Sir Toby Belch and Sir Andrew Aguecheek, and, taking each by the Hand, says, 'How now, my Hearts, did you never see the Picture of We Three?'" This is Scriblerian annotation of the sort with which Pope decorated his *Dunciad* and Fielding his *Tragedy of Tragedies,* but it also draws attention to the origin of "Logger Heads" in folk art and to the use made of them by the national playwright, Shakespeare.

The signboards of the 1762 exhibition survive only in the description of the catalogue and the *St. James's Chronicle,* but from Hogarth's other works it is possible to see how he thought signboards could offer an example to contemporary artists. He remarked in the *Analysis* that sometimes Correggio's proportions were "such as might be corrected by a common sign painter" (9). Although it served as "a Design [made] without the Knowledge of Perspective," illustrating Kirby's *Brooke Taylor's Method of Perspective Made Easy* (1754), the print known as *Satire on False Perspective* (fig. 20) is constructed on the signboard principle. It is purely emblematic, without either narrative or interpersonal relationships, constructed out of elements of shop signs such as "The Complete Angler" and a "Swan and the Half Moon" (Sign Painters' Exhibition, Nos. 2 and 3 in the Passageway). The perspective errors (characteristic of signboards) are used to engender puns, to show not only how *not* to draw but, in a sense, *how* to draw—how to suggest a different set of relationships by using a different set of rules.

In his usual way, Hogarth is both imitating bad perspective and trying to extend the range of art, laying a theoretical groundwork for the sign painters' solution and the launching of other forms of popular art that do not adhere to rules. I have no doubt that this print has enjoyed its popularity (up to the versions by David Hockney) not because it exposes clumsy art of a sort but because the old crone who leans out a window with a candle and lights the pipe of a traveler on a distant hill—or the swan in the middle distance who is the same size as a dog in the foreground and a distant horse—supplies both the pleasure of naïveté and the insecurity of disorientation (what

Hazlitt called "a phantasmagoria").[45] These two sensations, summed up in the "Three Logger Heads," which have informed Hogarth's art, are here foregrounded.

For Hogarth is not only making fun of clumsy "artists" but celebrating the joy of the naïve eye that looks at signboards, and perhaps the world, not from single-point perspective but with an episodic and egalitarian contemplation of each object for itself, a far different phenomenon from the grading and differentiating of elements within a painting advocated by the academic tradition of imitation. The naïve eye allows one to see pure relationship, unhampered by conventions of verisimilitude or iconographic orthodoxy. (See above, 61.)

Now the signboard, long incorporated as one element of a sign system in Hogarth's prints, has been removed from nature altogether and juxtaposed with other signs in a picture exhibition. This designates the signboard a work of "art" and draws attention to its maker as "artist." A double-edged quality can be seen in the timing of the exhibition, which specifically coincided with the mercantile-oriented exhibition of the Society of Arts, but also overlapped with that of the Society of Artists, where Hogarth was *not* exhibiting this year. The *Chronicle* squibs claimed that only the Society of Arts, with its emphasis on premiums for the best paintings of poultry and fish, was being satirized. But exhibits such as *The Rising Sun* by a painter described as "a modern Claude Lorraine" and the responses published in the newspapers are proof that the exhibition of sign painters was taken as a commentary on the Society of Artists' as well.

It must have functioned for Hogarth as both a satire on the clumsy commercial objects associated with the Society of Arts and also a parody of the pretentious and high-flown imitations of Continental paintings being shown by the Society of Artists—and as an alternative, a proposal for a native English art as well. He and Thornton must have begun with the idea of the Sign Painters' Exhibition as an answer to the artists' definition of an exhibition as a place for "connoisseurs" and buyers, not for the everyday people of London. They simply admitted and addressed these folk, questioning the decorum, taste, and indeed "science" of the Society of Artists' notion of an exhibition—and of an academy and much else.

Perhaps equally important, Hogarth connected sign painting with the slurs upon his (and his father-in-law's) title of Serjeant Painter to the King, which caused him to be called by his enemies (with some

justice, given the duties of the job) a "pannel painter," one who decorated royal coaches with coats of arms. And at the same time one object in the exhibition was his own portrait on a signboard, the Hogarth's Head, and this was accompanied by a parody of his Line of Beauty in the "Crooked Billet." The totemic significance of the shop sign to Hogarth is unmistakable in this juxtaposition and in two related facts: his own choice for a shop sign over the door of his house-studio was not the pug he employed in his self-portrait but a Van Dyck's Head, which in June 1751, after his disappointment at the price brought by his *Marriage A-la-mode* paintings, he had taken down. The Sign Painters' Exhibition was a defiant return to popular art—his last exhibition as it proved. It was an exhibition that for Hogarth was part joke, part acceptance of the view of his art propounded by his enemies, and part a genuine conviction that signboards represented a native English art form to which English artists must return if they were to have any hopes of freeing themselves from the Continental traditions of religious and mythological painting to which they would be bound if the royal academy went into effect.

The first public reactions are difficult to gauge: if the outrage expressed at having old signboards foisted on the public and tickets with detachable catalogues (so that the buyer had to have a new one for every visit to the exhibit) was real, it was also exploited by the *St. James's Chronicle* as advertising and surrounded with ironic commentary. The *London Register,* with some of the same publishers as the *Chronicle,* printed a laudatory account, which was then reprinted in the *Chronicle.*[46] It singles out Hogarth and Thornton as the prime movers:

> To an Artist of our own Country, and of our own Times, we owe the practice of enriching Pictures with Humour, Character, Pleasantry, and Satire. Such an Artist could not fail of Applause in such a Nation as ours, and his Fame is equal to his Merit.
>
> The original Paintings, etc., the Catalogue of which now lies before us, are the Project of a well-known Gentleman, in whose house they are exhibited; a Gentleman who has, in several instances, displayed a most uncommon Vein of Humour. His Burlesque Ode on St Cecilia's

Day, his Labours in the Drury Lane Journal, and other papers, all possess that singular Turn of Imagination so peculiar to himself. This Gentleman is perhaps the only Person in England (if we except the Artist above mentioned) who could have projected, or have carried tolerably into Execution, this scheme of a Grand Exhibition.

The commentator goes on to say that "The Ridicule or Exhibition, if it must be accounted so, is pleasant without Malevolence; and the general Strokes on the common Topics of Satire are given with the most apparent Good-humour."

Thornton himself, as "a Plebeian," writes that "to a Man whose Fancy is shut up to Strokes of Wit and Humour, this Exhibition may appear rather a Catchpenny. But I will venture to affirm, that a Man who has the least Spice of that inimitable and matchless Humourist, H——h, will there find Entertainment, and many Strokes of True Wit and Humour; . . . nay, I can almost venture to affirm, that some of the Signs have the Marks about them of a masterly Pencil, who has seemed rather to hide his Excellence, in particular, the Representation of the Robin Hood Society, where the Variety of Character and Countenance (though a vile painted Picture) is, in Expression, almost equal to Hogarth." (This reference is to No. 61, a satire on Orator Henley, described in the *Register* account as "almost worthy the Hand of Hogarth.") He concludes that this exhibit cannot be taken as a particular attack on the Society of Arts Exhibition:

No; it was only meant, as it proves to be, an innocent laugh to those who relish true Humour, and expose properly the Frauds and Artifices made use of by rascally Auctioneers, and the Folly of those People who value no Picture that has not been *funkt,* as the Boys call it at Westminster, with Smoke and Time.[47]

The satiric prints that attacked the exhibition are the plainest evidence that Hogarth was popularly assumed to be behind, or at least connected with, the hoax. One of them, *The Combat,* which must be datable about this time (fig. 86), connects Hogarth and Thornton as attackers of the Society of Artists itself: Hogarth is shown as a Don Quixote tilting at windmills, urged on by Thornton, and opposing a great mob of artists, most of whom were recognizable caricatures: Hayman appears in the van, "The Chairman of a New club,

chosen into that office for his great Knowledge in the Argumentum baccalinum"; Samuel Johnson, who wrote the artists' manifestos, is also identifiable. Another print, *A Brush for the Sign-Painters* (fig. 87), shows Hogarth as a pug seated on a close-stool ("Camera obscura or Idea Box") with sheets of the *St. James's Chronicle* for toilet paper. Envy inspires him through her snakes, one guiding his brush, another ("a Motive") biting his forehead, and a third holding his brushes. The result, painted on a signboard, is *Sigismunda,* beneath which is a depiction of Aesop's fable of the frog that burst trying to puff itself up to the size of an ox. Hogarth is surrounded by Thornton, Colman, Lloyd, and Churchill. Thornton, the most prominent, has the head, tail, and legs of an ass. The print refers to the group as "four Eminent Master Sign-Painters, Compilers of a twelfpenny Catalogue, Retailers of Stale Wit, and Commentators on their own folly Vide. St. James Cron."[48] Churchill's appearance gives some evidence of how close he was, or at least appeared to be, to Hogarth in the months immediately preceding the publication of *The Times, Plate 1.*

These prints, as well as all the letters and poems, are also evidence of the exhibition's success. Following criticism of the catalogue policy, a notice was published in the *Public Advertiser* (5 May): "It is hoped that Ladies and Gentlemen do not take it ill, that no Person can be admitted with the same Catalogue twice; as otherwise it would be impossible to accommodate the Company." They were drawing crowds, perhaps away from the other exhibition.

The Society of Arts Exhibition ended on 17 May; on the same day the Society of Artists of Great Britain opened their exhibition at Spring Gardens. Reynolds's chief offering was his *Garrick between the Muses of Comedy and Tragedy*—his direct challenge to Hogarth, taking as his own the Choice of Hercules that Hogarth had made his personal signature since the 1730s, and capping his double portrait of Garrick and his wife with Garrick and *two* women. The Sign Painters' Exhibition continued a while longer, overlapping and commenting on the Artists as well. The *Daily Advertiser* of 17 May reports:

The Society [of sign painters] intended to have closed their Exhibition with that in the Strand [i.e., the Society of Artists]; but finding genteel Company still resort, they are determined to continue their Exhibition as long as that of the Artists is kept open at Spring Gardens. And, for

the convenience of many, they have extended the Hours of Admittance from Ten in the Morning till Six in the Evening.

Only four months later, the obvious sequel to the Sign Painters' Exhibition, Hogarth published *The Times, Plate 1* (Sept. 1762, fig. 91). At the left are emblematic signs of the exploitation of America by City merchants, George Townshend's Norfolk militia, the duke of Newcastle (a broken and collapsing "Castle"), Pitt (the removal of "The Patriot Armes"), and the "Temple Coffee House," the center of pro-Pitt propaganda. At the right are the sign of the "World's End" (No. 21 in the Sign Painters' Exhibition), the "Union Office," and—in the distance—two men shaking hands (the French-Spanish alliance), a German eagle, and a French fleur-de-lis. As a follow-up comment on the exhibition, *The Times* is simply a more schematic application of the principles of the signboard to Hogarth's art of the "modern moral subject," even down to the "sign" of the child with the clock in the lower right corner designating time running out. In Hogarth's terms art can go toward an emblematic melange of this sort (which is what the shop signs in the exhibition were) or toward the simplicity of the single signboard (which might have been his rationale for *Sigismunda*).[49]

14.

OVERT POLITICS

The Times, Plate 1, 1762

It was in the autumn of 1761 that a pamphleteer attacking the ministry following the resignation of Pitt wrote:

> I think it would be no difficult matter to draw a pretty ridiculous representation of a first minister, issuing his orders to the numerous standing army of placemen, and making out a list of members for a new parliament: and I would recommend it to Mr. Hogarth, to try his fertile imagination, in a drawing for a *political* print on this subject.[1]

He then, perhaps with the *Election* prints in mind, proceeded to describe such a drawing for Hogarth's benefit. There was no immediate response, but whereas in the past Hogarth had covered himself, relying on double meanings, the present crisis would serve to bring him out into the open—and on the unpopular, ministerial side.

THE COCK LANE AND OTHER GHOSTS

In January 1762 Pitt was out of office, peace negotiations were under way, the Pitt interests were doing everything in their power to hinder George III's peace initiatives, and one Richard Parsons began to report knockings and scratchings in his house in Cock Lane, apparently centered in the bedroom of his eldest daughter, a child of eleven. The "ghost" was interrogated, its replies interpreted, and word spread that it was the ghost of Miss Fanny Lynes, a young

woman who had rented rooms in Parsons's house with her brother-in-law William Kent (coincidentally the name of Hogarth's old antagonist) in 1759. They had moved to nearby lodgings, where in February 1760 Miss Fanny had died of smallpox. Her ghost rapped out the message that Kent had murdered her. The story attracted the attention of the Methodists, who took it up as a cause.

"The methodists," Horace Walpole wrote in his *Memoirs of the Reign of King George III,* "had endeavored to establish in Warwickshire, not only the belief, but the actual existence of ghosts. Being detected, they struck a bold stroke, and attempted to erect their system in the metropolis itself."[2] The Parsons family was Methodist. "This year," wrote John Wesley, "from beginning to end, was a year never to be forgotten. Such a season I never saw before."[3] Some prominent members of the clergy were involved: the Reverend John Moore, lecturer at St. Sepulchre's, was Parsons's confidant from the start of the affair; the Reverend Thomas Broughton, lecturer at St. Helen's, Bishopsgate Within, and All Hallows, Lombard Street, constantly attended the Parsons girl; and among the nobility who showed interest was William Legge, earl of Dartmouth, a Methodist sympathizer. All of which, as Walpole observed, "affected to cast an air of the most serious import on the whole transaction" (1: 97).

Samuel Johnson, John Fielding, and John Douglas (who had exposed Lauder's Milton hoax) were invited by the rector of St. John's, Clerkenwell, where Fanny Lynes was buried, to investigate. Johnson wrote up the skeptical report, "An Account of the Detection of the Imposture in Cock-Lane," published in the *Gentleman's Magazine* for February. Finally, on 21 February, the little girl was discovered making the rapping sound with pieces of wood concealed under the covers of her bed. In fact, Parsons had borrowed £12 from Kent, failed to repay it, and had been sued for repayment; this was his attempt at revenge. Parsons was subsequently tried, convicted, and imprisoned.

On 23 February Goldsmith's pamphlet *The Mystery Revealed* was published, containing references to King James's *Demonology,* Glanville's *Sadducismus Triumphatus,* and Richard Hathaway, the Boy of Bilston, who "vomited in public crooked pins, which he had previously swallowed in private."[4] Books 1 and 2 of Churchill's *The Ghost* were out in March, including a parallel between Fanny and Mary Toft the "Rabbit Woman" (whom Hogarth had depicted in 1726, ill.,

vol. 1) and personifications of "Superstition" and "Credulity."[5] Attacks on Wesley, Whitefield, and William Romaine and their "striking examples of the abjectness of superstition" continued through that spring.[6] Exploiting the opportunity, Hogarth revised the copperplate of *Enthusiasm Delineated* (fig. 64), which already alluded to Wesley and Whitefield; he added "Romaine" on the globe depicting the whole world as hell and incorporated the references from Goldsmith and Churchill. Toward the end of April he published this print, entitled *Credulity, Superstition, and Fanaticism* (fig. 88).

The earlier print had been about art, the sublime, and religious enthusiasm (above, Chap. 9). A friend, apparently John Hoadly, had persuaded Hogarth that, with all the sacred images, his intention would be regarded as antireligious. In the revision, the religious icons have been replaced by images associated with the Cock Lane Ghost as a phenomenon (indeed a hoax) taken up by the Methodists. Hogarth has replaced God the Father holding his Athanasian triangle with a witch (to accompany the devil held in the preacher's other hand); the religious images around the pulpit are replaced by puppets of famous ghosts (of Mrs. Veal, Julius Caesar, and Sir George Villiers); the Eucharist Christs with images of Fanny the Cock Lane Ghost. The general application of the earlier print has been narrowed to a safer subject. On the other hand, a typical quotation from Conyers Middleton's *Free Inquiry* could still have served Hogarth as epigraph: "even boys among us are filled with the Holy Ghost, and, in fits of ecstasy, see, hear, and utter things, by which the Lord thinks fit to admonish and instruct us."[7] Closer to home were Ramsay's attacks on ecclesiastical authority and dogmatism, especially his criticism of the clergy's exploitation of human credulity in *On Ridicule*. And a reader of David Hume's notorious essay "Of Miracles" (sec. 10 of *Philosophical Essays concerning Human Understanding,* 1748) would recall that "no human testimony can have such a force as to prove a miracle, and make it a just foundation for any . . . system of religion."[8] In the second part of the essay Hume discusses the appraisal of testimony and the credulity of the ignorant.

Earlier, in his essay "Of Superstition and Enthusiasm" (in his *Essays: Moral and Political* of 1741), Hume had distinguished between "enthusiasm" deriving from presumption and pride and "superstition" deriving from weakness and fear (they share ignorance), which he argues represents a progression from liberty and individualism to

slavery. Hogarth may have decided as of April 1762 that he had been wrong in *Enthusiasm Delineated,* or that the situation had changed: in fact England was governed not by enthusiasm (Pitt's oratory) but by the superstition unleashed by such oratory (by Pitt, Whitefield, and their like) against the new monarch and his chief minister.[9]

Hogarth would have known Cock Lane, which was only a block south of Smithfield, the neighborhood he lived in as a child. Like Walpole, he would have connected the craze with the City interest: "At first this farce, which was acted in Cock-Lane, in the city, was confined to the mob of the neighbourhood. As the rumour spread, persons of all ranks thronged to the house."[10] Like the folly portrayed in Pope's *Dunciad,* this madness spread from the City to the West End—but in the spring of 1762 this would have been cognate with the Beckford–Pitt City interest playing upon public "superstitions" to foil the interests of the monarch and his ministry in Westminster. The case of Mary Toft had also had, as Hogarth would have remembered, its political application.

The ghost of the Tedworth drummer, who recalls Addison's comedy *The Drummer, or the Haunted House* (1716, revived in Jan. 1762), serves as a reminder that in his final phase Hogarth once again returns to the aesthetics of the *Spectator.* In his "Pleasures of the Imagination" Addison had mentioned the primitive mode of fancy, in which *"Shakespear* has incomparably excelled all others":

> Our Forefathers looked upon Nature with more Reverence and Horrour, before the World was enlightened by Learning and Philosophy, and loved to astonish themselves with the Apprehensions of Witchcraft, Prodigies, Charms and Enchantments. There was not a Village in *England* that had not a Ghost in it, the Churchyards were all haunted, every large Common had a Circle of Fairies belonging to it, and there was scarce a Shepherd to be met with who had not seen a Spirit. (No. 419, 3: 572)

While obviously not to be believed by a rational man, nevertheless such "Descriptions raise a pleasing kind of Horrour in the Mind of the Reader, and amuse his imagination with the Strangeness and Novelty of the Persons who are represented in them" (571)—in short, they are another of the Pleasures of the Imagination, in the same Old English way as the ballad of "Chevy Chase" and sign-

boards. This passage, incidentally, leads into Addison's account of the "Emblematical Persons" of Milton's Satan, Sin, and Death (see vol. 2, 109–10). Richard Hurd quoted the passage in his *Letters on Chivalry and Romance* (1762), where he argues that the "Gothic manners and machinery" have the advantage over the classical "in producing the *sublime*" (53–54, 60).

Partly because of his own emotional involvement in the affair, Walpole appreciated Hogarth's print. But, already gestating *The Castle of Otranto* (published at the end of 1764), he may also have sensed something of the Gothic *frisson* and the print's culminative power in the Hogarthian oeuvre. This "satire on the Methodists," he wrote in his *Anecdotes of Painting* (the work about which Hogarth had badgered him in 1761), was "one of his most capital works": "Hogarth exerted his last stroke of genius on the occasion . . . ; the print he published on the Cock-lane Ghost had a mixture of *humorous* and *sublime* satire, that not only surpassed all his other performances, but which would alone immortalize his unequalled talents" (emphasis added). This work, which half a century later disturbed John Keats's dreams, was Hogarth's last venture in modern history.[11]

Bishop Warburton, however, perhaps already displeased with Hogarth's inclusion of his profile in *The Five Orders of Periwigs*, expressed outrage:

> I have seen *Hogarth's* print of the *Ghost*. It is a horrid composition of lewd Obscenity & blasphemous prophaneness for which I detest the artist & have lost all esteem for the man. The best is, that the worst parts of it have a good chance of not being understood by the people.[12]

Garrick's response to the affair of the Cock Lane Ghost was a farce, *The Farmer's Return,* first performed at Drury Lane on 20 March. The published version had a Frontispiece designed by Hogarth (engraved by James Basire, fig. 89). The play was dedicated to Hogarth and, according to the dedication, Garrick had decided to publish it only because of Hogarth's drawing. Garrick is seen as the farmer who, on his return from his trip to London for the coronation, regales his family with an account of his talk with Miss Fanny. The famous Garrick "start" is in this case conveyed not by Garrick but by the audience to his tale—a minor version of the situation of the congregation in *Credulity*.

Yet another "ghost" figures in a story of Hogarth's attempt to recapture the features of his old friend Fielding with the help of Garrick. Arthur Murphy had asked Hogarth, whom he greatly admired, to make the portrait as frontispiece to his edition of Fielding's *Works,* but Hogarth had trouble summoning up an image from his memory.[13] Garrick told one version of the story to Pierre Antoine de La Place, the translator of Fielding, in Paris sometime after Hogarth's death—an elaborate yarn involving his appearing before Hogarth disguised as Fielding's ghost: "Hogarth! take thy pencil, and draw my picture!"—Terrified, Hogarth obeyed. "Vastly well, Hogarth, Adieu! retire to thy chamber; and, on leaving the room, beware that thou dost not look behind thee!" Unable to accept the vision as supernatural, however, Hogarth rang his bell and questioned his servants, but to no avail. "Fearful of explaining himself too far, lest the idea of ghosts should seize his servants, or he himself might become an object of ridicule," he kept quiet. At length he related the adventure to Garrick, who confessed to the hoax and repeated his performance for proof. Hogarth "intreated him not to mention the adventure, at least during [his] life . . . ; Garrick promised, and religiously kept his word."[14]

Murphy's story did not even include Garrick, but rather a lady who "with a pair of scissors, had cut a profile, which gave the distances and proportions of his face sufficiently to restore [Hogarth's] lost ideas of him."[15] But Garrick's story (though puffing his own ability to alter his facial expression beyond recognition) has the virtue of connecting Hogarth's skepticism with underlying fears, of the supernatural and of appearing a fool.[16] On 26 April, after the Sign Painters' Exhibition had opened, Murphy's edition was published with Hogarth's portrait of Fielding.

Sometime after April, when John Courtney reported seeing the *Election* paintings in Hogarth's studio, Garrick bought them. According to Farington, Garrick told Benjamin West that Hogarth proposed to sell them for 200 guineas, to be raised by a raffle at 2 guineas each. "Garrick called on him & subscribed, but on leaving his House, reflected on what He had done as unworthy to so great an artist, went back, gave him a draft for 200 guineas & took away the pictures, thus relieving Hogarth from further trouble abt. them."[17] It was also in 1762 that Garrick bought some wood from a tree "commonly called Shakespeare's tree and said to have been planted by him"

and had it made into a chair for his Shakespeare Temple at Richmond. According to Samuel Ireland, who published a copy of this monstrosity of "variety," the chair was designed for him by Hogarth.[18] And it was on 16 December that Hogarth and Garrick, according to John Baker's telegraphic diary, were "ensemble Dom[enick] Farril's, Golden Square—horrible scene—execution," apparently attending one of the "real" experiences mentioned by Burke in his *Enquiry* as preferred by audiences to "the most sublime and affecting [stage] tragedy."[19]

THE TIMES, PLATE 1

In the summer of 1762, still under the influence of the powerful image of *Credulity, Superstition, and Fanaticism,* Hogarth set about a rather elaborate, though small, design in the popular style of *Industry and Idleness* but conceived in the emblematic tradition of his very earliest prints. This was *The Times, Plate 1* (fig. 92), which took him from the relatively safe ground of Methodist fanaticism manifested in an exposed hoax into the quagmire of political controversy—and without the veiling of *Credulity* or *The Cockpit* (though he began by disguising Pitt as Henry VIII [fig. 91], who had served in *Analysis,* Plate 1 to represent a graceless uniformity and the brutal power Hogarth associated with Pitt).

His stated purpose in making *The Times,* as he wrote in the fall of 1763, besides "stopping a gap" in his income, was to urge "peace and unanimity," and so, as he recalled, he "put the opposers of this humane purpose in a light which gave offence to the fomenters of destruction" (AN, 221). The pro-Pitt crowd was his main object of attack: their infatuation with the idol Pitt (on stilts), analogous to the Methodists with their spirits and the Catholics with their graven images, originated in their own ignoble aims. Why, the antiwar party wanted to know, when there appeared no further need, did Pitt wish to continue England's aid to Prussia and the prosecution of the war with France? The answer, stated in *The Auditor* and *The Briton* and suggested in *The Times,* was that he was supporting the London trade interests, who wanted to prolong war in order to retain their

contracts for war supplies and the rich Dutch and Hamburg trade, and, moreover, to cripple France as a commercial rival.[20]

To the extent that Hogarth's opinions still reflected wide public feeling, he was drawing on uneasiness due to the financial crisis of 1759 and support of the new English king who was opposed to the foreign (German) connection of his forefathers and the Continental fighting, and whose chief minister and immediate family as well as himself were under the most scurrilous attack by the war interest. He was speaking up, as Smollett did in *Briton* No. 37: "The reader will remember, that I did not lift the pen in this dispute, until I saw my S[overeig]n, whom I am bound up to honour, and his M[othe]r whose virtue I had cause to respect, aspersed with such falshood, and reviled with such rancour, as must have roused the indignation of every honest man." Hogarth was supporting his king, to whom he personally looked for the advancement of art as well as political justice in England. On 10 December 1761 George III had reissued the patent for the Serjeant Paintership to Hogarth, who felt strongly enough about the king's friendship to preserve the document (the earlier patent issued by George II is lost or was not kept).[21]

George III, for his part, remembered Hogarth with fondness. Benjamin Wilson recorded conversations with the king in 1776 about Hogarth's commendable "Knowledge of light and shade" (Wilson disagreed). "In this conversation," Wilson reports, "the King made repeated inquiries respecting the personal history of Hogarth, and his paintings of which he was a great admirer." They discussed *Marriage A-la-mode* and the "Happy Marriage" paintings, of which Wilson knew only the scene which depicts "the ceremony of breaking the cake over the heads of the bride and bridegroom," in Garrick's collection (vol. 2, fig. 102). The king subsequently borrowed the picture from Garrick and commended it, noticing that "the bride was a handsome likeness of the Queen." To this curious opinion Wilson added that "It was the best coloured and most beautiful head I had ever seen Hogarth paint."[22] In any case, a mutual admiration between monarch and painter seems to have existed.

Moreover, George III's chief advisor and favorite, Lord Bute, was talking about encouraging the arts.[23] Joshua Kirby was another strong link between Hogarth and royal patronage, having been appointed in 1759 as a drawing master to the then Prince of Wales. When the prince became king he made Kirby clerk of the works at

Kew and in 1761 patronized his *Perspective of Architecture* (which had a Hogarth frontispiece). The nature of Kirby's debt to Bute is stressed in his dedication to the third edition of his *Brook Taylor's Perspective* (1768); and this, compared with his dedication to Hogarth in the 1754 edition, sets up Hogarth and Bute as his two guiding stars.

Bute, who may have cultivated Hogarth in the preceding years,[24] was the favorite of the new king and a man of great personal wealth. According to Wilkes (*North Briton* No. 17), Hogarth made *The Times* in return for the Serjeant Paintership, but he has his dates confused by five years, unless he refers to the renewal of the patent in 1761. George Steevens wrote, many years later: "I am told that Hogarth did not undertake his Political Print merely *ex-officio,* but through a hope the salary of his appointment as Serjeant-Painter would be increased by such a show of zeal for the reigning Minister." Hogarth would hardly have expected an increase in his token salary, though he might have hoped for commissions of some kind from the Bute circle, or some other preferment; at the back of his mind may have been Sir James Thornhill's knighthood. At any rate, much was made of Hogarth's ties to the court, and he was linked with Samuel Johnson, another pensioner, though Johnson wrote nothing for Bute.[25]

On the other hand, Bute was desperately unpopular, and a Scot; Hogarth's consistent sympathy for underdogs may have combined with some specific sympathy for his Scottish ancestors.[26] English antipathy to the Scots had, since the rise of Bute, become almost as pathological as the enthusiasm of the Methodists shown in *Credulity, Superstition, and Fanaticism,* and probably colored Hogarth's imagery of conflagration in *The Times.* In *The Briton* for 19 June 1762 Smollett had a correspondent examine this prejudice, telling the story of the physician, a candidate for a position in a hospital, who was reassured that his opponent had no chance: "The worst they can say of you is, that you are an Atheist, and a S———e, but your competitor is a *Scotchman.*"

Thus Hogarth's print for the peace was also a print for Bute and for the small minority of Scotsmen around him. It was a print against the immensely popular and successful former minister, Pitt. Perhaps only at one point could such a print have expressed the feeling of the general public, including that of the City: immediately after Pitt's acceptance of a £3000 pension for himself and a title for his wife, pointedly announced by Bute in the official *Gazette* of 10 October

1761. In *The Times* Hogarth shows the £3000 as a millstone hanging from Pitt's neck—a conflation of the pension and Pitt's about-face on the issue of the foreign subsidies (Fox had replied "that we were then told [by Pitt a year ago] that [they] would hang like a millstone about the neck of a new minister but he [Fox] hoped this would hang an ornament on the neck of this new Minister").[27] But the public reacted only briefly against Pitt the "incorruptible"; by 9 November, the date of the lord mayor's banquet, the tide had turned, Pitt was being cheered and Bute hissed, and by the summer of 1761, when the crucial issue of the peace preliminaries was looming, public opinion was largely behind the fallen minister. By this time too the Scottish Tory Smollett had begun to issue his *Briton,* and Wilkes had responded with his *North Briton.* Smollett, handicapped by being a Scotsman defending an unpopular Scottish minister, never regained the initiative. It was at this worst of times, as should have been obvious to one so sensitive to the public pulse as Hogarth, that he set to work on *The Times.*

Politically, he may have always supported, spiritually at least, the Leicester House party. His recent prints had drawn upon the assumption that political factionalism was bad, a view inculcated in the young prince by his mother and tutors; the *Election* prints could have been a Leicester House tract on the value, in the midst of such electoral confusion, of a strong Patriot King. Their point of view coincided with that of the prince (who had been a subscriber), learned at the feet of Lord Bute: Hogarth, George III, and Bute shared the conviction "that corruption and moral decay were destroying England" and all three had "the meanest opinion of politicians."[28]

Factionalism also linked for Hogarth the politics of government with the politics of art, which in these years meant the politics of an academy. His support of a Hanoverian regime dedicated to defending against French Catholic dominance on the Continent was parallel to his support for an indigenous, English drawing school against the idea of an academy on the French model. Pitt's policy was for imperialist expansion, contesting the French "empire"—one could say, on the French imperial model—in the far-flung places of the globe. A narrow nationalism, a basic, perhaps Scottish-oriented xenophobia—a John Bullish common sense, embodied in an association with the lower orders and English pugs—has been, from the start, one way to describe Hogarth's politics.

Another way of looking at Hogarth's act of publishing *The Times*

is to separate his aristocratic yearnings from his business sense: his pride in his friendship with Lord Charlemont, perhaps also the duke of Devonshire, possibly even Bute; his evident pleasure in friendships with politicians such as Fox, Hanbury Williams, Sir Edward Walpole, and George Hay, and with people near not only to Bute but to the Prince of Wales and now the king himself. As usual with Hogarth, it is impossible from this distance to separate the personal from the public: the desire for advancement—the old delusion of the Titian or Rubens whose paintbrush the monarch retrieves—from the hope that George III might raise artists as individuals (not as part of an academy) to a higher position in England than ever before.

But it is also possible that Hogarth was reliving the events of 1711–1712 (when he was fifteen) and the struggle between war and peace parties over the ending of the War of the Spanish Succession. If so, he may have seen himself in the role of his great predecessor Swift, using every means at this disposal to secure the peace against the popular hero of that time, the duke of Marlborough.

WILKES

Wilkes begins his account of Hogarth's *Times* with the remark that he and Churchill had "for several years lived on terms of friendship and intimacy" with Hogarth.[29] Wilkes was the son of a well-to-do distiller of Clerkenwell, who lived in the square behind St. John's Gate where Hogarth had spent a few years of his childhood. Born in 1725, he was educated at Lincoln's Inn and Leyden and returned to London in the late 1740s to marry a rich wife and run through her dowry as if he were Hogarth's Rake. On 19 January 1754 he was elected to the Society of Beefsteaks, at a time when Hogarth was no longer a member, though probably a visitor. They would have become acquainted through their mutual interests in the Foundling Hospital and the St. Martin's Lane artists.

A lively, squint-eyed, ugly young man in his early thirties, he was about the age of Reynolds (with whom he was also friendly) and considerably younger than Hogarth. Like Hogarth, he had, it seems evident, an intensely homosocial orientation. He belonged to every possible club; he was, of course, a Freemason, belonging to both

Ancient and Modern lodges, though apparently preferring the former. But in his case he began with passionately homoerotic relationships in school in Leyden. In some cases, as with Horace Walpole and his circle, these relationships continued after college; but with Wilkes (who at least maintained the reputation of a rake by having well-publicized heterosexual affairs) we are probably talking about homosocial not sodomitical relations thereafter with the group around Dashwood, with the St. Martin's Lane artists, with Hogarth, and with Churchill and the Nonsense Club.[30] Nevertheless, Wilkes and Churchill at any rate were extremely close. The Wilkes–Hogarth relationship with its explosive sequel raises the question, especially in light of the relationship Wilkes had in Leyden with an older man: did the excessive vehemence of the break over Hogarth's reference to him and Churchill in *The Times* reflect personal feelings for Hogarth; or did it reflect only his close relationship with Churchill? The circles Hogarth moved in from Freemasonry on down were strongly male bonded, and now they consisted of much younger men such as those of the close-knit Nonsense Club. His sensitivity to slights by Garrick, apparently centered on the interloping wife (see above, 289), could suggest a parallel to Wilkes's response to his own "betrayal" in *The Times.*

David Garrick and His Wife was a mild example of Hogarth's tendency in his last decade to be increasingly testy, belligerent, perverse, and (perhaps) arrogant in his treatment of friend and foe alike. He placed Fielding and Dodington in the *Election* in an equivocal context, exploiting an irony that compromised both men, of whom at least one was his close friend. Other examples were Fielding in *The Reward of Cruelty* and Warburton in *The Five Orders of Periwigs*—and now in *The Times, Plate 1,* Wilkes and Churchill. It appears that in each case he is dealing with a friend or ally and either reproving him or testing his friendship—or, as in the profiles of Queen Charlotte and the "blockhead," perhaps he could no longer restrain his wit or had developed delusions of omnipotence.

The intense friendship between Wilkes and Churchill dates from 1761–1762, though they may have known each other as early as 1759.[31] In the autumn of 1758 Churchill returned to London to be curate of St. John the Evangelist's, Millbank, and took up with his Westminster classmates, Thornton, Lloyd, and Colman—and with Hogarth as well. By 1757 Churchill was well known for his *Rosciad,*

which was quickly followed by a train of other sharp, personal satires; his biting wit enlivened his conversation as well as his poems. An example: at one of the clubs to which he belonged, he was said to have retorted to a member who was boasting of his descent from the official who sentenced Charles I: "Ah, Bradshaw, don't crow! The Stuarts have been amply avenged for the loss of Charles's head, for you have not had a head in your whole family ever since."[32]

Wilkes was also a close friend of Reynolds's and deeply involved with the Reynolds faction of the artists. One wonders how much of the politicking of the dissident artists was orchestrated by Wilkes, the talented propagandist and political organizer, especially in the crucial years of 1761–1762; and how much this activism—or some offshoot of it—may have influenced Hogarth in his decision to attack Wilkes and his Pittite friends, which also could help to explain the vehemence of Wilkes's response.

In the summer of 1762 (just following the tense art exhibitions) Wilkes undertook the *North Briton,* sponsored by Lord Temple (Pitt's brother-in-law), and was soon joined by Churchill. It was a periodical saturated, as Walpole wrote in his *Memoirs of George III,* "with an acrimony, a spirit, and a licentiousness unheard of before in this country." In reputation it was never particularly savory, and it was frowned upon by the respectable, but its effect was powerful. The triumvirate of Temple, Wilkes, and Churchill, and their *North Briton,* led Walpole, actually anti-Bute, to reflect that "nations are most commonly saved by the worst men in them. The virtuous are too scrupulous to go the lengths that are necessary to rouse the people against their tyrants." As early as the issue of 3 July Wilkes carried his attack to the limit, introducing (in a feigned letter to the *North Briton)* the parallel between Bute and Mortimer, the Dowager Princess and the widow of Edward II. Walpole tells a story that when urged to tone down his attacks, Wilkes replied that "he had tried the temper of the Court by the paper on Mortimer, and found they did not dare to touch him."[33]

That summer Wilkes, a colonel of his regiment in the Buckinghamshire militia, was stationed in Winchester, guarding some French prisoners, sitting on courts martial, and drinking with other officers, and in his spare time writing the *North Briton,* making quick trips to London, and urging Churchill in letters and in person to meet his

deadlines. An unnamed friend wrote him that Hogarth was soon to publish a political print called *The Times,* "in which Mr. Pitt, Lord Temple, Mr. Churchill, and himself, were held out to the public as objects of ridicule. Mr. Wilkes on this notice," as Wilkes told the story,

> remonstrated by two of their common friends to Mr. Hogarth, that such a proceeding would not only be unfriendly in the highest degree, but extremely injudicious; for such a pencil ought to be universal and moral, to speak to all ages, and to all nations, not to be dipt in the dirt of the faction of a day, or an insignificant part of the country, when it might command the admiration of the whole.[34]

The last, much emphasized in *North Briton* No. 17, was no doubt the sugar that sweetened the warning: the print would be "injudicious" both because Hogarth would be confining his natural talent and because Wilkes and Churchill were dangerous men to cross.

Hogarth, according to Wilkes, replied that neither he nor Churchill was attacked in the print, though Temple and Pitt were, "and that the print should soon appear."

> A second message soon after told Mr. Hogarth, that Mr. Wilkes should never believe it worth his while to take notice of any reflections on himself, but if his friends were attacked, he should then think he was wounded in the most sensible part, and would, as well as he was able, revenge their cause; adding, that if he thought the North Briton would insert what he sent, he would make an appeal to the public on the very Saturday following the publication of the print.

Although he was preserving letters he considered significant during these years, there is no record of this one, which may suggest that the message was conveyed by word of mouth. Ralph Griffiths confirms the general gist of Wilkes's story, saying he heard it from Hogarth himself shortly before his death.[35] If the important point, to which Wilkes returns later, that Hogarth did not keep his word about depicting him and Churchill, is true, one must assume that Hogarth was being disingenuous about the two figures he shows leaning out of the garret windows: he gives them blank faces.

Despite Wilkes's later protestations against Hogarth's personal sat-

ire, obviously this was what originally attracted him, and doubtless Churchill as well; both were skillful satirists, and if there was an immediate precedent for the directly personal satire of *The Times* it was Churchill's satires. But it seems evident that Wilkes originally admired Hogarth the lover of "liberty" and "variety," revealed in his prints and in certain aspects of *The Analysis of Beauty* and, above all, in *The March to Finchley*. Hogarth the advocate of the generative power of underclass or popular art would also have appealed to Wilkes, whose political program (once he formulated it) was parallel to Hogarth's: bypass Parliament as Hogarth wished to bypass the noble patrons, the Men of Taste and connoisseurs, and create a popular base for power. He probably read his own political radicalism into Hogarth's attacks on the aristocratic patrons of art and the Whig aristocracy, and he was naturally shocked when he learned that Hogarth—who doubtless had ridiculed his Serjeant Paintership in his presence as mere panel painting—announced himself as a true placeman and supporter of the government.

The term "radicalism" designates a set of ideas only incipient at this time, which showed concern for the "people" and demanded a greater degree of participation for them in the political process. A few years later, when the radical ideology was in fact shaping, Wilkes was called a Patriot and advocated equality between certain hitherto deprived sections of the public and the ruling elite. The ideology was libertarian rather than egalitarian and did not see political power reaching down to the poorest; but Wilkes's program was based on the principle that more people should be involved in governing, and to some extent at least he spoke for the poor. The overlap with Hogarth's own position, as shown in the prints he published between 1748 and 1751 and *The Analysis of Beauty,* would have been clear to Wilkes.[36]

But Wilkes, unlike Hogarth, Thornton, and the rest, seems to have pushed the "love of pursuit" to the edge of libertinism and beyond. In his way he was as cynical as Hogarth's friend George Hay, and the degree of his seriousness must always have seemed problematic. Walpole put it well, though maliciously, and probably would have received a nod of approval from Wilkes himself, when he defined "Wilkes and Liberty": "To laugh and riot and scatter firebrands, with him was liberty."[37] Though referring to an older, more scarred Wilkes, Nathaniel Wraxall's comment seems to sum up his

charm, his unpredictability, and his potential dangerousness: "An incomparable comedian in all he said and did, . . . he seemed to consider human life itself as a mere comedy."[38] He apparently ridiculed everyone, especially in private conversation—friends and foes alike. Years later at a lord mayor's banquet he was heard by an amazed Edmund Burke ridiculing his own City adherents; James Harris heard him repeating a story "concerning a missionary who laughed to think he could make twenty thousand men believe what he did not believe a syllable of himself."[39] It would be difficult to decide in a given situation whether such a man was really serious, whether he intended to carry out the plans or threats he projected, or what in fact motivated his plans to begin with. Hogarth may be excused for underestimating him.

An expensive parliamentary contest in 1754, the cultivation of an interest at Aylesbury, and the wild London life he enjoyed in the late 1750s had brought Wilkes to the brink of financial ruin. He had hitched his star to Pitt in Commons, and Pitt's resignation cut off one possible path of political advancement and financial retrenchment. By 1762 he was deeply in debt, and it was at this point that he turned to journalism—though hardly for money alone—with Earl Temple's fortune behind him, and the hope that his writing would win him both Pitt's approval and a place in the next Pitt administration, which seemed as inevitable as Bute's fall. He miscalculated Pitt; his journalism brought him notoriety, which satisfied one side of him, but negated any future with the cold and proper Pitt.

Churchill too had been overwhelmed by his debts in 1760–1761, was forced into bankruptcy, and saved from debtors' prison only by the intercession of Lloyd's father. (The proximity to debtors' prison, which may have drawn Hogarth to him at the time, was used against him in *The Bruiser*.) At about the same time he separated from his wife and left her with his children. While he wanted none of her, devoting himself to prostitutes who repaid him with serious venereal infections, he was conscientious about the financial support of his children, and he eventually repaid Dr. Lloyd and his creditors.

Hogarth's print, "A New HISTORICAL PRINT called THE TIMES," dated 7 September, was advertised on the 9th, priced 2*s*.[40] It would appear that by 6 September, when a print called *John Bull's*

House sett in Flames dated the 2d appeared (which looks like the work of Paul Sandby, fig. 90), word about the symbolism already had leaked out.[41] It shows Churchill carrying a bucket of water marked "NORTH BRITON" as he helps a dignified Pitt and others to put out a blaze in St. James's Palace begun by Bute, "Smallwit" (Smollett), and other Scotsmen. The Pitt–Wilkes camp naturally sought to anticipate Hogarth and make his print appear a copy of theirs. The metaphor of Europe on fire, logical in terms of Hogarth's conception, is turned around in *John Bull's House* with fire fighters and incendiaries reversed.

Wilkes criticizes Hogarth in *North Briton* No. 17 for both the plagiarism (he also mentions the borrowing of the figure on stilts and his supporters from Callot [fig. 94]) and the poverty of the fire conceit. With this simple image Hogarth presumably hoped to reach the broad popular audience he regarded as his own. It may also have had a personal significance for him, if he recalled Fielding's second *True Patriot* (12 Nov. 1745) and its essay on true and false patriots: "No Man can love his Country who would set it on fire." He may have remembered an anonymous letter signed "An Englishman" which he had received, dated 12 December 1759 (he preserved it among his manuscripts). The "Englishman," comparing gin drinking to a dangerous fire, urged him to produce more *Beer Street*s and *Gin Lane*s, "that you may have the honour and advantage of bringing the two fire engines to the fire; and work them manfully at each corner of the building," and so on, continuing the metaphor of Hogarth's satire as fire fighting.[42]

The Times, Plate 1 was, with *Credulity,* a further experiment in what Walpole referred to as Hogarth's "sublime" mode of satire; from Hogarth's point of view, this meant that Burke's Sublime—war, fire, and destruction—was now loosed on England and a small band of sensible patriots was trying to restore the Beautiful. *The Times* is also of a piece with *Credulity* in its use of emblems, popular imagery, and folk stories—in Hurd's term, "Gothic"—including spirits and the demonizing of popular figures such as Pitt. The frenzied Methodists have become the mob of City officials, merchants, and bruisers (clanging their bones and cleavers) who are worshiping a false idol (Pitt, War, and Trade) at the expense of King and Peace. In the foreground, among the wretched inhabitants of his ruined country, an equally crazy Frederick the Great contentedly plays his

fiddle "while Rome burns" (recalling the imagery of *Rake* 3). The less-demented people in the picture are craftily impeding the efforts of the single fire fighter, the earl of Bute, who tries to direct his hose at the nearest burning house.

The print shows a city (Europe) being consumed by the fire of war, its refugees huddled with their few belongings in the foreground. The three relatively unharmed houses represent England, or different segments of it. The one on the left is the government: the fanatically and divisively clenched fists of the "Patriot Armes" (Pitt's administration) are being lowered to be replaced by the clasped hands of Bute's insignia, the "Union Office." Indeed, the small group of fire fighters unites English- and Scotsmen in the only sign of order in the chaotic scene. The "patriots" have withdrawn to the "Temple Coffee House" next door; Temple, the faceless man in the lower window, was Pitt's colorless brother-in-law, the only cabinet member to follow him in his abrupt resignation of October 1761. Up in Temple's garret are Churchill (identified by his clerical bands) and Wilkes, his propagandist hacks in the Pittite cause of continued war, shooting water at Bute from clyster pipes. The third house, with the flaming world over its door and fire breaking through a window, appears to be the residence of the English citizenry; the open door and the proximity of the kneeling City officials around Pitt suggest that they are worshiping the very man who is fanning the fire that destroys their house.

Fox appears, barely visible in the lower left corner, as a fox emerging from his kennel. His acceptance of the lucrative post of paymaster general of the armed forces must also have contributed to Hogarth's disillusion in the 1750s; he refers to it as a safe haven, a retreat, like the kennel in *The Stage Coach* (ill., vol. 2). After years as paymaster during an expensive war he had become one of the richest men and most unpopular politicians in England; but he was emerging now to guide Bute's peace treaty through Parliament.

The Times, Plate 1 was a public statement, but it was the work of an artist who had made himself personally well known to most English men and women. The conjunction of print and artist could not help bringing the Pittites, the many sincere admirers of the great minister, and his talented propagandists down upon Hogarth's back: very much what had happened when Hogarth took the unpopular side of the academy dispute. For a public print, moreover, it featured

distinctly personal traces. Most obviously, Hogarth had been a friend of both Churchill and Wilkes. The clyster pipes he gives them to spray Bute inevitably recall his print of 1726, *The Punishment Inflicted on Lemuel Gulliver* (ill., vol. 1, fig. 55), which had been revived without his permission in 1757 as an antiministerial cartoon. In fact, the English citizens worshiping the idol who fans the flames that burn down their own house recall the Lilliputians who punished Gulliver for putting out the fire ravaging their royal palace.

This house has one distinctive architectural feature, the bow window above its front door. This is almost precisely the bow window on Hogarth's house in Chiswick (see fig. 93). It is not only the house of England but of one beleaguered Englishman in particular. And if we may contrast the clyster pipes with the fire hose, the Gullivers of this print are implicitly opposed by the one brave man who will not worship idols. The great change from *Credulity* is that the detached oriental observer looking in a window is now taking action.

The crowd itself, of course, carried personal connotations for Hogarth.[43] The threatening crowd of the *Election* had now gone through a further stage of development into the mad congregation of *Enthusiasm/Credulity* and become the Pittite mob. Recently there had been such events as that of 9 November 1761, the lord mayor's banquet, when the crowd gave Pitt a greater ovation than the king and hissed and pelted his chief minister's carriage. The crowd was organized, it was said, by William Beckford, Pitt's chief City supporter. The lord mayor's inquiry found that Beckford "had visited several public-houses over night, and had appointed ringleaders to different stations, and had been the first to raise the huzza in the hall on the entrance of Mr. Pitt." Beckford, who appears in *The Times* pointing up to a signboard showing the source of his wealth (and referring to the sugar tax of 1759, Pitt's reward to his supporter)[44] and holding a trumpet to his mouth ("blowing his own trumpet"), has organized the unruly crowd into a circle around Pitt as the Jewish fiddler in *Election* 4 led the crowd in its political dance.[45]

By way of contrast, Hogarth refers to George Townshend's militia in the signboard of the "Norfolk Jigg," which is crowned with a clock above orderly columns of militia and bears his initials, "G.T. fect" (as he signed his caricatures). By utilizing a signboard, Hogarth conflates Townshend's fanaticism about the idea of a militia with his artistic pretensions. The visual puns suggest that the militia's "clock-

work" discipline is another Townshend "caricature." In February and March 1762 he had agitated for a new militia bill that included a compulsory clause for delinquent counties, and when the attorney general moved for a term of seven years, he opposed the idea, wanting it to be permanent.[46] In fact, he was a staunch supporter of Bute. Hogarth plays, as he did in *The March to Finchley,* with the comic contrast of these "clockwork" columns and the chaotic crowd, probably recalling the serious rioting that had followed upon the Militia Act in the late 1750s. But his point now is that the "enthusiasm" of Townshend's "clockwork" army is no different from that of the Pittite mob, which indeed is "composed" in a ring around its idol (Hogarth rhymes the clockface, millstone, and circle of worshipers, who prominently include the clergy).[47]

On the 9th, the day Hogarth's print appeared, Wilkes was in London, staying in his town house in Great George Street, Westminster, and trying to see Churchill, who was ill; he returned to Winchester on Saturday the 12th.[48] First report of the print was from Hogarth's acquaintance Thomas Birch, confidant of Lord Hardwicke, who had been an admirer of Hogarth as early as 1738, when on 30 October he dined with him in Leicester Fields and recorded in his diary: "Pransus sum apud G. [Gulielmus] Hogarth Pictorem clarissimum." He recorded visits to Hogarth's studio on various occasions to see or show his work to friends.[49] He saw nothing offensive in this print; nor did the poet who composed "On seeing Hogarth's Print of the Times, extempore," in the *Royal Magazine* for September, though the poem itself suggests that Hogarth's debut in politics deserved notice.[50] Even the *Universal Magazine,* a pro–Pitt periodical, gives a neutral but useful explication of the print, which Hogarth copied out and kept among his papers.[51]

At this stage, Hogarth was evidently still concerned to prevent a break with Wilkes and, being at Salisbury on the 16th, he called upon him "with the good-natured intention of shaking hands."[52] But Wilkes was away, and they did not meet again.[53]

Hogarth's life at this point can be defined by neither his art nor his actions but only by the responses of friends, enemies, and anonymous journalists. Wilkes's reply, according to his warning to Hogarth, was to be out the following Saturday. It did not in fact appear

until 25 September, by which time other attacks had already been launched by Earl Temple's propagandists. Paul Sandby produced the earliest and the wittiest, as he had a decade before; he was enlisted, or volunteered, to reproduce again his old caricature of Hogarth—if anything more puffy and bleary eyed than in 1753–1754. As the Pittites must have realized, Sandby was a genuinely gifted political satirist, a graphic Churchill; *John Bull's House sett in Flames* looks like his work, as does another unsigned, untitled print (*BM Sat.* 3910) which presents the whole dramatis personae of the Bute–Pitt conflict, including Hogarth carrying a Scotsman on his back. The two immediate responses to Hogarth's *Times,* however, were *The Fire of Faction*[54] and *The Butifyer, A Touch upon the Times* (figs. 95, 96), both published on the 23d.

In *The Fire of Faction* Sandby gives Hogarth the bellows he had given Pitt in *The Times, Plate 1,* and has him fanning the hell-mouth fire into which he, the scurrilous engraver-poet Henry Howard, and others are plunging, all clinging to his huge engraver's burin. In *The Butifyer* Hogarth (parodying the poor artist of *Beer Street*) is whitewashing the sign of a jackboot labeled "Line of Booty" (punning on Bute's name, his supposed bribing of Hogarth, and Hogarth's *Analysis of Beauty*), which is hung on a curved post marked "the Precise Line." His paint bucket is labeled "Pension" and his palette with its inevitable Line of Beauty hangs from the spur of the boot. His careless daubing spatters paint on innocent passers-by that include Pitt and Temple.[55] A fat clergyman intended for Churchill is shown belaboring a Scotsman in a lion's skin (presumably Smollett) who is helping Arthur Murphy mix more whitewash for Hogarth out of a mash of the "Briton" and the "Auditor."

Not long after, an elaborate but very crude parody of *The Times, Plate 1,* called *The Times, Plate 2* (fig. 97), appeared with the central group of the fire fighters replaced by Hogarth himself standing in the pillory for libeling (a motif he picked up, replacing himself with Wilkes, in his own *Times, Plate 2*).[56] Around Hogarth's neck, like the millstone he had dangled from Pitt's neck, is his palette with "200£ per Ann.," referring to the profits from the Serjeant Paintership.

The "Nonsense" group's official attitude toward politics was detachment. *The Student* had banned political subjects and the *Connoisseur* made fun of the Oxford election and the war fever of the mid-1750s. The *St. James's Chronicle* tried to maintain a position of

impartiality in the dispute between the *Briton* and *North Briton*, publishing excerpts from both Opposition and ministry papers. Colman, for example, contributed a parodic "North Briton Extraordinary" in the issue of 16–19 October and followed it with an "Auditor Extraordinary" on 28–30 October. No excerpts were printed from *North Briton* No. 17 and no support given to Wilkes's attack on Hogarth.

Garrick, though as close as ever to Hogarth, was very much involved with Churchill and Colman at this time. It may have been he who served as the mutual friend between Hogarth and Wilkes prior to the publication of *The Times.* His relations with Churchill were always a little uneasy: Churchill had attacked all the actors except Garrick in *The Rosciad* (1761), but in *The Apology,* out in April of the same year, he had made some gestures toward chastising Garrick too—perhaps "partly to show his power."[57] Garrick gratified him with an anxiously protesting letter sent through Lloyd, which established a balanced relationship between the two men. Churchill was all too aware of his power and liked to brandish warnings of his retaliatory strength. The relationship also involved Garrick's supplying Churchill with periodic loans. Writing for money shortly after the appearance of *The Times,* Churchill concluded ominously:

> I have seen Hogarth's print, sure it is much unequal to the former productions of that Master of Humour. I am happy to find that he hath at last declar'd himself, for there is no credit to be got by breaking flies upon a wheel. But Hogarths are Subjects worthy of an Englishman's pen.
>
> Speedily to be published,
> An Epistle to W. Hogarth by C. Churchill[58]

One notices throughout the Churchill correspondence, especially with Wilkes, the sense of game, play, irresponsibility, and pride in power for its own sake that is so unlike the utterances of Pope, and distinguishes Churchill's very personal approach from that of his Augustan predecessors. His norm is not society, but his own genius. It was his custom to announce a title before he had written a line, and in this case it was nearly a year before his threat was fulfilled. As to his quarrel with Hogarth, it sprang presumably from his support of Wilkes and the *North Briton,* and the pleasure of demonstrating his

power, although there is another story that it began in the parlor of the Bedford Arms in Covent Garden, over a rubber of shilling whist.[59] There may have been some such incident, but it seems significant that Churchill could not muster up enough indignation to compose an attack on Hogarth at this time.

Garrick's reply to Churchill showed his serious concern for what might follow; he began by explaining why he could not lend any money until next week ("however Should you be greatly press'd, I'll strain a point before that time, tho I suppose it is ye Same thing to You"), and then turned to Hogarth:

> I must intreat of You by ye Regard You profess to Me, that You don't tilt at my Friend Hogarth before You See Me—You cannot sure be angry at his Print? there is surely very harmless, tho very Entertaining Stuff in it—He is a great & original Genius, I love him as a Man & reverence him as an Artist—I would not for all ye Politicians in ye Universe that You two should have the least Cause of Ill will to Each other. I am sure You will not publish against him if You think twice—I am very unhappy at ye thoughts of it, pray Make Me quiet as soon as possibly by writing to me at Hampton or Seeing Me here.[60]

It is doubtful that Garrick's letter had much effect on the ebullient Churchill; but, as it happened, his poem remained for the time being unwritten and he does not seem to have assisted with *North Briton* No. 17. Already dilatory in his writing for Wilkes, during September he felt the first symptoms of the malady that by December was undeniably syphilis, and his productivity suffered accordingly.

Wilkes, however, was true to his word, and on the 25th he published a *North Briton* devoted to Hogarth. Setting the tone and vocabulary for the attacks to follow, he evokes essentially the same Hogarth Smollett depicted a decade earlier, adding another dimension: the moralist who betrays his sacred trust by descending to scurrilous particulars. Here is the Hogarth who "possesses the rare talent of gibbeting in colours, and in most of his works has been a very good moral satirist," but who deviates from his true forte into sublime history painting (much is made of the unfortunate *Sigismunda*), self-interested attacks on the Old Masters, and now politics. Hogarth can only portray the dark side of things—a *Marriage A-la-mode* but not a "Happy Marriage"; he cannot even celebrate a Pitt, but must scrutinize all through his distorting glass.

I own too that I am grieved to see the genius of *Hogarth,* which should take in all ages and countries, sunk to a level with the miserable tribe of etchers, and now, in his rapid decline, entering into the poor politics of the faction of the day, and descending to low personal abuse, instead of instructing the world, as he could once do, by manly satire.

Wilkes makes much of Hogarth's personal vanity and jealousy of other artists; of the "rapid decline" of his powers in *The Times* ("he now glimmers with borrowed light"—copying *John Bull's House sett in Flames* and a print of Callot's [fig. 94]); and of the sinecure he had accepted from the king to paint walls ("for he is not suffered to caricature the royal family").[61] It is implied that Hogarth's health and mind are deteriorating.

Throughout, the piece would have read much more gallingly to Hogarth than to most outsiders: there are many touches to the quick, some true, some expansion of partial truths, and perhaps some outright falsehoods. In particular he would have been hurt by the long passage on *Sigismunda,* which Wilkes knew he was sensitive about to begin with, and which includes a personal reference to Jane Hogarth: "if the figure had any resemblance of any thing ever on earth, or had any pretence to meaning or expression, it was what he had seen, or perhaps made, in real life, his own wife in an agony of passion, but of what passion no connoisseur could guess." In short, Hogarth can only *caricature* reality. Wilkes goes on to recall those "tiresome discourses" Hogarth delivered "day after day" about *Sigismunda's* merit vis-à-vis the Old Masters. He must have known that these revelations would be exceedingly painful to someone who, while always in a sense a public figure, nevertheless carefully guarded his private life. "How often," Wilkes writes, "has he been remarked to droop at the fair and honest applause given even to a friend, tho' he had particular obligations to the very same gentleman?"

Even worse, he seeks to discredit Hogarth's relationship with his public. "The public never had the least share of his regard," he writes; "or even his goodwill. Gain and vanity have steered his light bark quite thro' life. He has never been consistent, but to those two principles." Like the personal revelations, these words were just close enough to the truth to be disturbing. Hogarth had always ostentatiously appealed to the general public as the foundation audience of his prints; but now, Wilkes asserts, he portrays this same public as a

disorderly and dangerous mob. Then Wilkes turns to the artists and the academy: "What a despicable part has he acted with regard to the *arts and sciences?* and how shuffling has his conduct been to the whole body of artists?" He alludes to both the Society of Arts and Artists as having "experienced the most ungenteel and offensive behaviour from him." Hogarth is merely a tiresome, quarrelsome old man without friends: "There is at this hour scarcely a single man of any degree of merit in his own profession, with whom he does not hold a professed enmity."

Wilkes comments on a caricature Hogarth made of Lord Hardwicke "as a great spider in a large, thick web, with myriads of the carcases of flies, clients I suppose, sucked to death by the gloomy tyrant." This description, with its mock deference to the lord chancellor, may have been based on a story or a sketch of Hogarth's; but here it serves as an attempt to alienate him from one group for whom he was trying to speak, at the same time getting in a cut at Hardwicke. The touch had its effect. Birch's response to *The Times* promptly altered its tone; he wrote to Hardwicke on 25 September: "The *North Briton* of today upon Hogarth, which I send your Ldp. is a proper discipline for that Painter, if he meant what is imputed to him by the great *Spider & Cobwebs* in his late print." [62] The "late print" Birch refers to must be his attempt to appear no less knowledgeable than Wilkes: no such print has ever been recorded, and Wilkes' description must apply to a drawing.

The responses of the newspapers and other periodicals tended to divide along party lines, but in general Hogarth was made light of, as in the lines printed in the *London Chronicle* of 26–28 October:

> Says a Friend to Will H——th,
> my dear little Billy
> Don't you think you have been
> injudicious and silly?

Wilkes's linking of Hogarth's apostasy to the artistic and political establishments is carried over into many of the caricatures. On 25 November a print parodying Hogarth's *Five Orders of Periwigs* appeared called *A Sett of Blocks for Hogarth's Wigs* (fig. 98). [63] Bute is constructed of emblematic objects—including a wig block, a jackboot, and an indecently placed bagpipe (another allusion to his supposed

affair with the Princess Dowager of Wales)—and is surrounded by his blockhead supporters. At the far right are two heads labeled "K" for Joshua Kirby and "H" for Hogarth, alluding to their mutual dependence on the crown and opposition to the idea of a state academy. An open volume is inscribed on one page "Brook Taylors Inspe[c]tive or Clearing into Obscurity by I. K.," and on the other "An Assay on the Beauty of Pannel Painting by W H." Near Hogarth's blockhead appear a graving tool ("W-H"), a whitewash brush, a money bag, and a palette marked "Line of Buty." A scroll, labeled "The Times" and "A Grand Scheme for a new Academy the professors to be pension'd Before Hand," links Hogarth's apostasies to the artistic and political establishments.

Most vividly, in *The Vision or M-n-st-al Monster,* a print of 16 December,[64] the monster Bute's legs are made of a fox (Henry Fox) and a goose (the duke of Bedford, who was negotiating the Peace of Paris), and his genitals arc Hogarth, the testicles being formed by two palettes inscribed with Lines of Beauty.

Hogarth's own account of *The Times* in his manuscript "Autobiographical Notes" remarks only that one of "the most notorious" opposers of the peace had been "till now rather my friend," and observes that "a flatterer" attacked him in the *North Briton.* He makes no mention of any preliminary negotiating, but adds that this person (he often omits names when he feels strongly) attacked him "in so infamous a manner that he himself when pushed by even his best friends [who] would not stand [for] it, (wonderful) . . . was driven to so poor an excuse as to say he was drunk when he wrote." The attack hit Hogarth the harder because his health had again seriously deteriorated during September. He said himself that "being at that time at my worst in a kind of slow feaver, it could not but hurt a feeling mind" (AN, 221).

Allan Ramsay's letter to Lord Bute of 28 October indicates the gravity of Hogarth's illness: "I was told yesterday that Mr Hogarth was dying, and that Mr Wilson the Portrait Painter was making application to the Great people of his Aquaintance to succeed him as Sergeant Painter to the King."[65] He writes that he does not himself wish to add fuel to sedition by being appointed Serjeant Painter to the King in the event of Hogarth's death, but if Hogarth died and

John Shackleton were appointed in his place, the latter's salary would then devolve upon Ramsay. The context of this letter was that George III, upon his accession, had intended that Ramsay should be his Principle Painter in Ordinary, but through a misunderstanding the duke of Devonshire had renewed Shackleton's patent for the office, and so Ramsay had to be content with being "one of His Majesty's Principal Painters in Ordinary." Ramsay had received this appointment in December 1761 at the same time that Hogarth received the renewal of his patent as Serjeant Painter. When he heard that Hogarth was dying, Ramsay—fulfilling all the functions of Principle Painter without the title or salary—suggested that Shackleton could be made Serjeant Painter—or, alternatively, that Stephen Slaughter, Keeper of the King's Pictures, might be given the job and relinquish his present position to Ramsay, which would give him "particular pleasure."[66]

Wilkes, with quite different motives, wrote to Earl Temple on 23 November: "Mr. Hogarth is said to be dying, and of a broken heart. It grieves me much. He says that he believes I wrote that paper, but he forgives me, for he must own I am a thorough good-humoured fellow, only *Pitt-bitten*."[67] On 5 December he wrote to Churchill: "To-morrow night is the Shakespear meeting, and I hope *our* certain meeting. Hogarth is too ill to be able to attend—I hope you will now indemnify me for this long absence by *eclogue* and *epistle* too."[68] Hogarth was not, of course, attending the Shakespeare Club these days, and Churchill, by this time suffering the salivation cure, does not seem to have made the appointment either. But Hogarth was well enough to be up and around by 16 December: on that day (we have seen) John Baker met him and Garrick in Golden Square to witness a public execution.[69]

15.

THE TIMES, PLATE 2, 1762–1763

The title of *The Times, Plate 1,* called for a sequel, and although *Plate 2* was never published, it was nearly completed (fig. 99).[1] The matter of Hogarth's poor health makes it difficult to say how early it was begun. It must, however, be datable between December, when the peace preliminaries were passed and Fox began purging the old placemen and replacing them with new, and Bute's resignation on the next 7 April. There is no reason to think that Hogarth was afraid to publish the print, but he may have sensed the ambiguity of his symbols, reflecting his changing but yet unresolved feelings. He began a written explanation, suggesting that he planned to include this in his bound volumes of prints: "[P]late 2 the two patriots [i.e., Bute and Fox] who, let what party wi[ll preva]il, can be no gainer yet spend their Blood and ti[me which] is there fortunes for what they think is Right. . . ." He speaks of their "sperits and resolution ever to die in the Cause which often hapens in these contentions," and adds, "what did the greatest Roman Patriots more" (AN, 231). It is difficult to judge the degree of irony in the words, since they do not correspond to the image of *The Times, Plate 2.*

The print, as it stands, implies that Hogarth is now disillusioned with all parties. The change could have come with the peremptory dismissal of the duke of Devonshire from the Privy Council in November 1762 (if we assume he was Hogarth's particular ally);[2] it clearly reflects his opinion of the bribery Fox was employing and his disappointment in Bute as a patron of the arts (perhaps his knowledge of Ramsay's intriguing for his Serjeant Paintership). The figures attacked in *Plate 1* are still present, though now marginalized.

In the right foreground of the print is Fox (his hat resembles the muzzle of a fox), a gardener replacing the old plants and shrubs with

new. But his efforts are being hindered: his foot is caught in a garden roller (labeled £1000000000), which could refer to the war debt, to his own profiteering as paymaster general, or to the huge bribes he was supposedly offering to secure ratification of the treaty (and recalls the relatively modest £3000 millstone around Pitt's neck in *Plate 1*). Moreover, he is replacing the old topiary shrubs ("GR," the Whig placemen of the previous reign) with rosebushes (the crossed-out but legible name of "James III," the Old Pretender, has been replaced with "George") and orange trees (Williamite Whigs) to whose "Republican" label has been added "GR," making them royalist "Republicans." On the right is Bute himself controlling the water supply that is piped into the royal lion's mouth and thence out through crowns, mitres, and maces as patronage to the placemen of the new reign.

Friends of the house of Stuart, as Walpole reports, now received preferment, and even so rampant a Jacobite as Sir John Philipps had become a privy counselor. On 28 January 1763 Lord Strange moved that the House sit on the 30th, the anniversary of Charles I's martyrdom, and "laughed at such a saint's day," but the House voted him down. "Fox was of the majority, who, very few years before, had been for putting an end to that Jacobite holiday—a clear indication of the principles of the new Court."[3] On 1 February Nicolson Calvert, M.P. for Tewkesbury and "a mad volunteer, who always spoke what he thought," carried the debate further by "a very bold and extraordinary speech" in which he "drew a picture of a fictitious family in Surrey, whom he called *the Steadys,* describing two old Steadys and a young one; with a very particular account of young Steady's mother, and of her improper intimacy with a Scotch gardener—he hoped the true friends of young *Steady* would advise him to recall his old friends, and turn away the Scotch gardener."[4]

It seems quite likely that this speech was one source of Hogarth's gardening metaphor. But the general setting alludes to the so-called Butifying of London that was in progress from 1762 onward. (As one 1763 satire suggested, this was the *Scotch Paradise: A View of the Bute-full Garden of Eden-borough.*) This had begun with the act to clean, lighten, and widen the streets of Westminster, signed into law on 2 June 1762.[5] While mainly concerned with the removal of nuisances in the streets, the act soon generated bills for other districts, which began to affect signboards. They were coming down at least

as early as November 1762, when the *Daily News* noted: "The signs in Duke's Court, St. Martin's Lane, were all taken down and affixed to the front of the houses."[6] The only signboard Hogarth shows is the huge palette that serves this function for the Society of Arts (little silver palettes were given to promising youths as prizes for their art). But the Butification (linked in Sandby's *Butifyer* to the art and theory of Bute's lackey, Hogarth) provides the setting for the scene: Westminster (Parliament sits at the left, Lambeth Palace at the right) with "improvements" being made in the street, and a very wide panorama all the way to the Kew Pagoda.

The topography is somewhat askew. From the center of government Kew Gardens lay west and St. Mary-le-Strand, the Society of Arts, and the new "Hospital" were to the east. But the Westminster panorama complements the City view of *Plate 1*—the political and the economic centers of England. The water refers back to the water in *Plate 1*. The general point is that the fire fighters of *Plate 1* are trying to turn their attention to peaceful pursuits—gardening, rebuilding, and improving London; the water is turned from fighting a fire to cultivating a garden. *Plate 1* represented the agitation before the peace treaty was drawn up, *Plate 2* the struggle while it was in Parliament being ratified. Thus, whereas in *1* Pitt is out in the streets of the City with his mob, in *2* he is within the House of Commons shooting at the peace dove that flies overhead (it was also overhead in the first plate).

In this plate, however, the gardeners are regarded with more ambivalence than were the fire fighters. They (or the system of patronage through which they must work) are pointedly not watering the duke of Cumberland's laurel bush (labeled "Culloden") but rather the Scottish Jacobite supporters of George III, who had no warm feelings toward the victor of Culloden. The maimed veterans of the Seven Years' War receive only a few drops of the water from a leak in the royal pavement.

Two sources of extraroyal irrigation, however, make an appearance. Cumberland, ignored by Bute, is nevertheless watered from above by Aquarius. (Hogarth has tampered with the order of the zodiac: on one side of Aquarius the water-bearer is Pisces—another watery sign, often associated with sorrow—but on the other he has skipped over Scorpio, Sagittarius, and Capricorn in order to show Libra, the sign of justice.)[7] And another form of liquid, urine, is

being dispensed by a schoolboy to where it belongs, on the feet of "Wilkes," who is being pilloried for the "Defamation" of Hogarth in "North Briton No. 17" (the number is punningly represented by the fold in the paper around his neck).

The "fountain of honor," which should be serving as a channel for royal patronage of the arts, bestows pensions and places as bribes to pass the peace treaty. Hogarth's hopes that George III might raise artists as individuals (not as part of an academy) to a higher position in England had been reduced to the single patronage of Allan Ramsay. Hogarth, however, prudently distinguishes the monarch from his chief minister and chief painter: Bute controls his patronage and Ramsay has reduced him to straight lines and geometrical shapes. The attached rule is a pun suggesting both the rigidity of rules criticism (Ramsay distrusted Shakespeare, for example, because he neglected the rules) and Ramsay's mechanical style, as in the numerous copies he churned out of the royal portraits.

The "fountain of honor" is an ironic, and perhaps personal, reference back to Hogarth's earlier fountain on the Frontispiece to the *Catalogue* (fig. 83) and to its hopes in the new reign—which has in practice contributed only the "Royal" Society of Arts, a new Palladian hospital, an imitation Chinese pagoda, and Ramsay's geometrical paintings of the king.

Kew Gardens, designated by the ten-story pagoda, was the residence of George, his mother, and (it was thought) Bute. The garden had been laid out by William Chambers, William Ayton, and other Scots in a style that was certainly not British, rather plundering the whole world for motifs. Hogarth would have noticed the irony that the "kings' men" opposed Pitt's imperialism and yet Kew represented an eclecticism, ranging from Roman to Muslim and Chinese, that drew on the far-flung British empire.[8]

Religion is not forgotten. Aside from the leak in the irrigation system, the only nourishment available to the crippled war veterans, or the poor in general, is from "Dr. Cants," Thomas Secker, the archbishop of Canterbury. Secker is placed just behind the Cock Lane Ghost to indicate his Methodist inclinations. He had interceded for the Methodists connected with the affair, "for Secker had a fellow feeling for hypocritical enthusiasm" (Walpole's words).[9] The Cock Lane Ghost herself is specifically linked with her pillory mate, Wilkes, to suggest the demagoguery that connects the Methodists

and the Pittites. It is possible that Hogarth may also be expressing his feeling that while the aristocrats' West End squares and streets were being improved, the poor and their slums were ignored, except by the "enthusiasm" of the Church of England.

The church of St. Mary-le-Strand, being crowded out by the Society of Arts, dates back to 1717, designed by James Gibbs (an associate of Thornhill's). Its lovely tower, about to be obscured by the "Premium" sign and set off by the crane on the society's roof and the pagoda in the distance, must be taken as an ideal against which the rest of the scene is to be judged. Certainly it recalls the obscured or distanced churches of *The South Sea Scheme* and *Gin Lane,* though no longer with the sense of distance and inefficacy but of an artistic ideal—one of the post-Wren steeples—that Hogarth would have remembered as a beauty of his youth.

In the lower right-hand corner is the artist's signature, a paintpot and brush. The palette of *Hogarth Painting the Comic Muse* (fig. 52) is now missing (replaced by the Society of Arts signboard); all that remains is the sign painter's brush, which in the context of the figures on that side of the print (especially the boy urinating) reminds us of its resemblance to a chamber pot—imagery that will return in *The Bruiser.* This emblem serves as Hogarth's final comment on the scene.

If he had published the print (which in fact said he plays no favorites), Hogarth must have realized, he would have been accused of turning his coat and attacking Bute, perhaps even the king. In fact, he seems to have changed his mind and recognized that, as his friend Hay no doubt argued, Bute was neither better nor worse than Pitt. Everything in the London scene was changing for the worse: for this reason, because he was dissatisfied with the symbols he had chosen, because Bute's resignation rendered the print meaningless, or because of declining health, he left the plate unfinished.

He did finish one other print on the subject (fig. 100), showing a closed sedan chair being carried behind a tradesman loaded down with chamber pots into a doorway guarded by grenadiers holding back an angry crowd. John Ireland insisted that the "scene is certainly in the vicinity of St. James's Palace; and the entrance to it, the private door through which his Majesty now passes in his way thither."[10] But the modest architecture suggests rather one of the buildings at Kew. "Jack in an Office" can refer to only one person: Bute, "Jack-Boot" in countless satires (as, for example, in *The Boot and the Block-*

Head and *A Sett of Blocks for Hogarth's Wigs*). A Jack in an Office was a person both officious and seated on a close-stool—underlined by the subtitle "or Peter Necessary with Choice of Chamber pots." Bute's policy, it was by this time clear to many, amounted to no more than the utensils being carried into the palace. That such utensils should have access to the palace through a side door (with guards keeping off the curious or angry multitude) was consonant with the fact that whenever Bute went out of his house he surrounded himself with bodyguards as protection from the crowd;[11] but also with the way Bute achieved power and even with the scandalous story that he was the lover of the Princess Dowager of Wales. This is a much stronger, less ambiguous statement than *The Times, Plate 2*. It must refer to the time after Bute's resignation when, most people believed, he still governed through (so to speak) the side door.

The print was not sold and survives in only a handful of impressions; it was presumably etched for private distribution among close friends—Hay, Martin, perhaps Garrick (on the order of *The Discovery* or the Hardwicke spider). Its form is a ticket, and it may have been Hogarth's burlesque invitation to a gathering of these close friends. Iconographically, it takes off from the derisive paint-/chamber pot of *The Times, Plate 2,* grown here into a fardel of chamber pots.

THE PORTRAIT OF WILKES

Hogarth's prophecy, based on *North Briton* No. 17, that Wilkes would stand in the pillory was realized with the publication of No. 45, which attacked the king's speech closing Parliament and praising the peace; it refused to make the conventional distinction between the king and his ministers who wrote the speech, casting aspersions on the monarch himself. A general warrant was issued on 29–30 April to arrest the "authors, printers, and publishers" of the paper, and Wilkes was taken into custody and lodged in the Tower. On 3 May he was brought to the Court of Common Pleas and remanded to the Tower until 6 May, when he was returned to Westminster.

On the 6th the Society of Artists was preparing its 1763 exhibition

at Spring Gardens, which was to open on the 14th. Hogarth had nothing to do with the society now; on that day he was in Westminster Hall to see and record Wilkes for posterity. Wilkes's account of this second trip to Westminster notes that "Mr. Hogarth skulked behind in a corner of the gallery of the court of Common Pleas, and"—waxing indignant—

> while the Chief Justice Pratt, with the eloquence and courage of old Rome, was enforcing the great principles of *Magna Carta,* and the English constitution, while every breast from him caught the holy flame of liberty, the painter was wholly employed in *caricaturing* the *person* of the man [Wilkes], while all the rest of his fellow citizens were animated in his cause, for they knew it to be their own cause, that of their country, and of its laws.[12]

This time Chief Justice Pratt (in fact a Pitt ally) discharged him, and the London crowd that had assembled made wild celebration.

Though the crowd does not appear in Hogarth's *John Wilkes,* its celebration is an important context for the print. What Hogarth heard on this occasion was Wilkes's momentous extension of the concept of "liberty" he had maintained throughout the first forty-five issues of the *North Briton* to the poor and dispossessed. Addressing the court, Wilkes said:

> The liberty of all peers and gentlemen and (what touches me more sensibly) that of all *the middling and inferior set of people, who stand most in need of protection,* is, in my case, this day to be finally decided upon; a question of such importance, as to determine at once whether English liberty be a reality or a shadow.[13]

But, as Hogarth would have recognized, sitting in the courtroom sketching him, Wilkes was contesting a significant segment of his audience; this was the segment Hogarth had explored in his prints since 1747, making graphic images that precisely prefigured Wilkes's words—which, of course, Hogarth would have seen as a perversion of his images. He would have agreed with the *Plain Dealer* which, on 25 June, described the Wilkite "people" as "that rude, licentious rabble, who having neither fortune to lose nor reputation to risk, indulge themselves in clamorous invectives against their governors,

according to their own capricious humours, or the artful suggestions of others"—without realizing, as Wilkes doubtless had, that his own message in the six prints of February 1750/51 could have been equally so construed. For when Hogarth, in these prints and in the *Analysis* and *The Bench,* had ostentatiously turned from the Men of Taste to the general public, he was (in the words of the *Plain Dealer*) turning from "the discipline of a well-ordered government, and submitting what should be controuled by law, to the arbitrary decision of a pernicious ill-judging multitude."[14] Wilkes's example might have shown Hogarth that his own argument in the *Analysis* could be interpreted (as it was by Reynolds) as using the multitude to gain for himself the right to make the laws.

When Wilkes criticized Hogarth in *North Briton* No. 17 for betraying his public, the two men were contending for the same public, which theoretically (though not practically) included the poor, weak, and dispossessed, who therefore *as a mob* became angry and violent. In fact, Wilkes's constituency, which was the lower part only of Hogarth's "general public," was the disfranchised citizens of the *Election* prints who were just below the lowest rung to which political power descended (small shopkeepers, tradesmen, skilled and semiskilled workers, craftsmen, and mechanics). Both men sought to construct a coalition of the "middling" and "inferior" types which operated, however, in the interests of the "middling." One could sympathize with Wilkes for believing that Bute had recruited Hogarth precisely because he knew this was Hogarth's constituency, one he and only he could contest with Wilkes.

The crowd ritual that celebrated Wilkes's acquital was precisely the sort of action Wilkes might have expected Hogarth (on the basis of *The March to Finchley*) to participate in. What they had shared up to a point was an appreciation (shared by Thornton) of the subculture, and in particular of the public parade or spectacle, the massing and movement of symbolic crowds, the Saturnalia or Carnival that overcomes Lent. Pitt in 1762 or now Wilkes in 1763—the one symbolically, the other literally—is at the center of the crowd and the source of its energy. Indeed, as Wilkes would have recognized, he was himself both Tom Idle and Francis Goodchild, the malefactor on his way to Tyburn and the lord mayor on his way to the Guildhall. As the two figures merged in the final plates of *Industry and Idleness,* so Wilkes, being carried aloft or his coach drawn by the crowd, is on

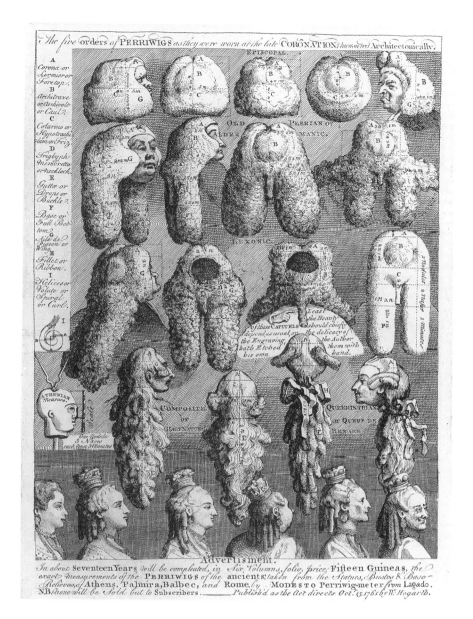

85. *The Five Orders of Periwigs* (first state); Nov. 1761; 10½ × 8⁵⁄₁₆ in. (courtesy of the British Museum, London).

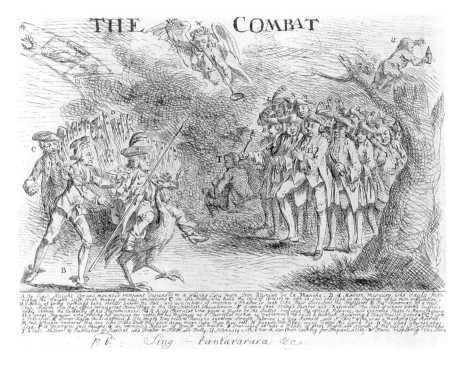

86. Unknown artist, *The Combat;* 1762 (courtesy of the British Museum, London).

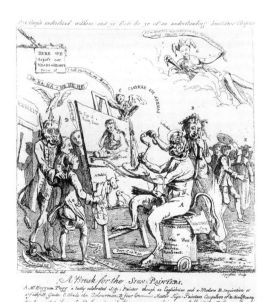

87. Unknown artist, *A Brush for the Sign-Painters;* 1762 (courtesy of the British Museum, London).

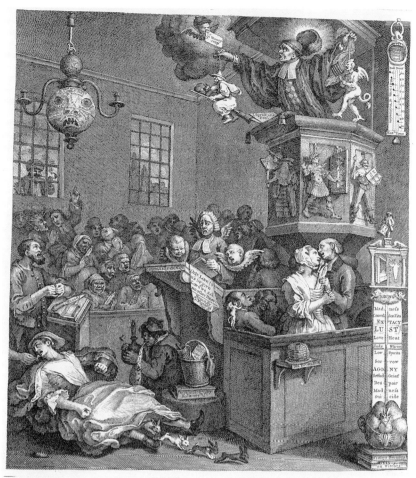

88. *Credulity, Superstition, and Fanaticism;* Mar.–Apr. 1762; 14½ × 12⅝ in. (courtesy of the British Museum, London).

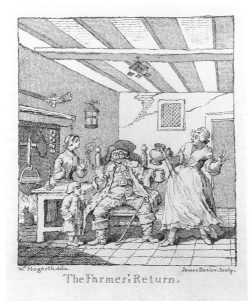

The Farmer's Return.

W. Hogarth delin. James Basire Sculp.

89. Frontispiece for Garrick's *The Farmer's Return* (engraving by James Basire); Mar. 1762; 6⅞ × 6 in. (courtesy of the British Museum, London).

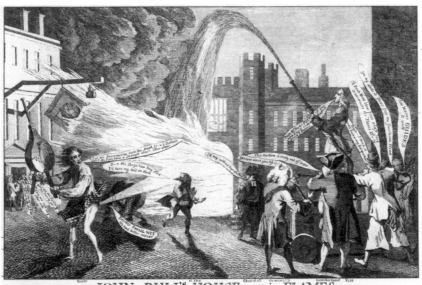

90. [Paul Sandby?], *John Bull's House Sett in Flames;* Sept. 1762 (courtesy of the British Museum, London).

93. Hogarth's House, Chiswick (photograph courtesy of Hogarth's House).

94. Jacques Callot, *Smaraolo cornuto. Ratsa di Boio;* 1621 (courtesy of the British Museum, London).

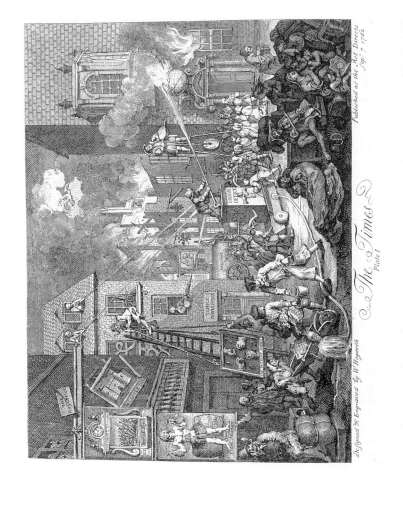

91. *The Times, Plate 1* (first state); Sept. 1762; 8⁹/₁₆ × 11⅝ in. (courtesy of the British Museum, London).

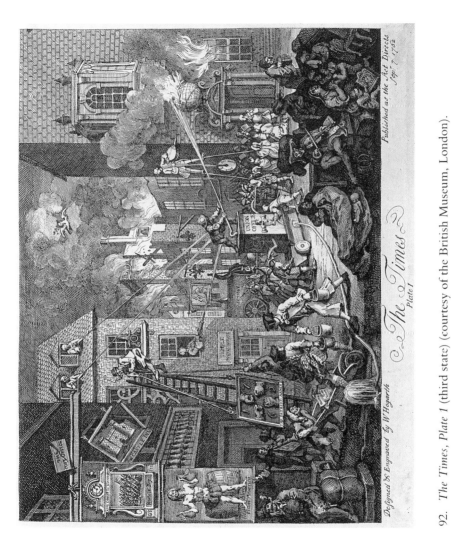

92. *The Times, Plate 1* (third state) (courtesy of the British Museum, London).

The Fire of FACTION

The Fly MACHINE for SCOTLAND

Perform'd if God permit by the BRITON. Places taken at the Sign of the TREASURY.

Invented by Robert Bagnal Sculptor

—heap coals of fire on his head and the LORD will reward the—sist. Explain'd by the Bystanders

Ay Good Lord! What the Devil have we got here?
'Tis a Hellish good Scene, if the meaning was Clear
A meaning! why these things have seldom that got.
We suppose that this here runs a rig on the Scot.
Smoke Mr King Art. with his engine the Bellows
Which blew up the Fire at Mr Bull's Ale house.
He fail'd of a Booty tho, yet still he Puff's hearty
To blow up the PITT for the Friends of his PARTY

There, his Fried Harry F——d, me easy can tell
By his long Ass ears, and the Cap with a Bell.
Jo Old Nick at top there, the Devil rides clearer
A Hellish good Guttle for them Sons of the Graver
He seems to cry out, Stir the fire there, Mind, ma!
Some Folks of Distinction are coming behind me
For their Service above stairs, d is both just & proper
We Air their Apartments and give them a Supper

Publish'd as y Art Directs Sr 1762

95. [Paul Sandby?], *The Fire of Faction;* Sept. 1762 (courtesy of the British Museum, London).

The BUTIFYER. A Touch upon *The Times* Plate I

SCOTCH CARE PIT MANUFAC

with what judgment ye judge ye shall be judged. Mat, Ch 7.2

Mr Hogarth.

*In Justice to P. Sandby the Engraver of this Plate:
Declares to the Publick, He took the hint of the Butifyer.
from a print of Mr Pope White washing Lord Burlingtons
Gate, at the same time Bespatring the rest of the Nobility.*

Published as the Act Directs Sr 1762 Price

96. Paul Sandby, *The Butifyer;* Sept. 1762 (courtesy of the British Museum, London).

97. Unknown artist, *The Times, Plate 2;* Sept. 1762 (courtesy of the British Museum, London).

98. Unknown artist, *A Sett of Blocks for Hogarth's Wigs;* 1762 (courtesy of the British Museum, London).

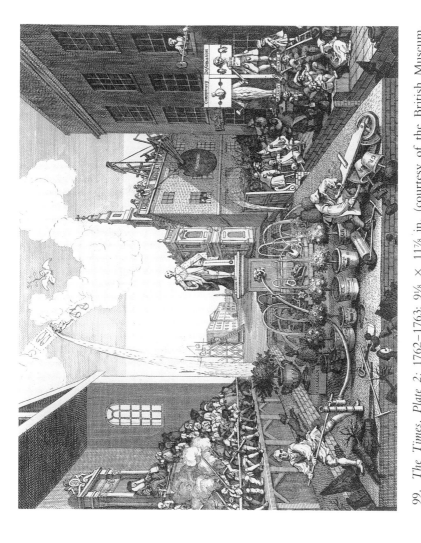

99. *The Times*, Plate 2; 1762–1763; 9⅛ × 11⅞ in. (courtesy of the British Museum, London).

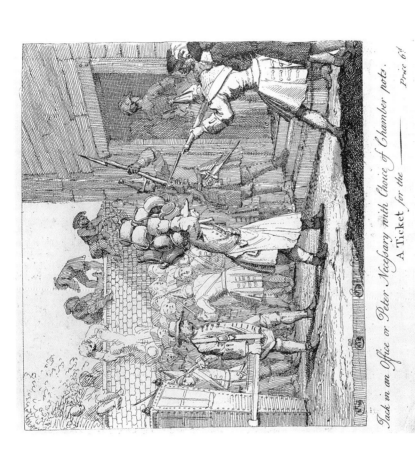

Jack in an Office or Peter Necessary with Choice of Chamber pots.

A Ticket for the ———

Price 6ᵈ

100. *Jack in an Office or Peter Necessary;* 1763; 7¹⁵⁄₁₆ × 8¾ in. (courtesy of the British Museum, London).

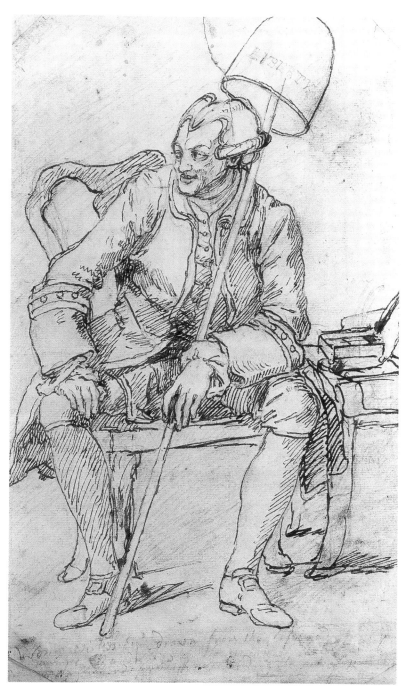

101. *John Wilkes, Esqʳ.;* drawing; May 1763; 14 × 8½ (courtesy of the British Museum, London).

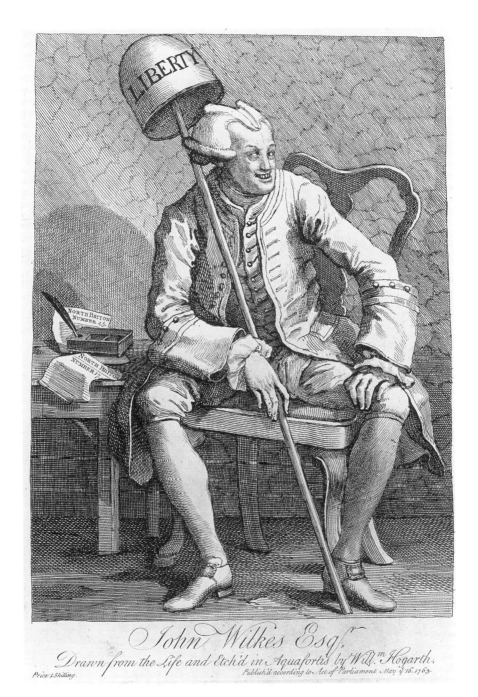

102. *John Wilkes, Esq^r.*; May 1763; 12½ × 8¾ in. (courtesy of the British Museum, London).

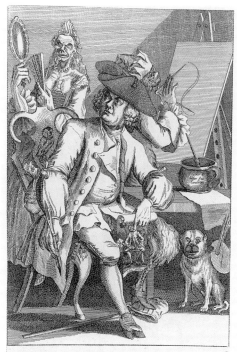

An Anfwer *to the* Print *of* IOHN WILKES E.SQ.ᴮ *by* Wᵐ HOGARTH.

Sold in Leicester fields Price 6 Pence.

103. Unknown artist, *An Answer to the Print of John Wilkes Esqʳ by Wᵐ Hogarth;* May 1763 (courtesy of the British Museum, London).

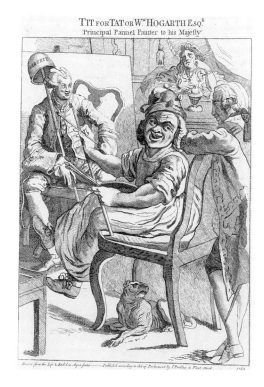

TIT FOR TAT OR Wᵐ HOGARTH E.SQ.ᴿ
Principal Pannel Painter to his Majefty

Drawn from the Left & Etch'd in Aqua fortis ————— Publifh'd according to Act of Parliament by I. Pridden in Fleet ftreet 1763

104. Unknown artist, *Tit for Tat or Wᵐ Hogarth Esqʳ;* May 1763 (courtesy of the British Museum, London).

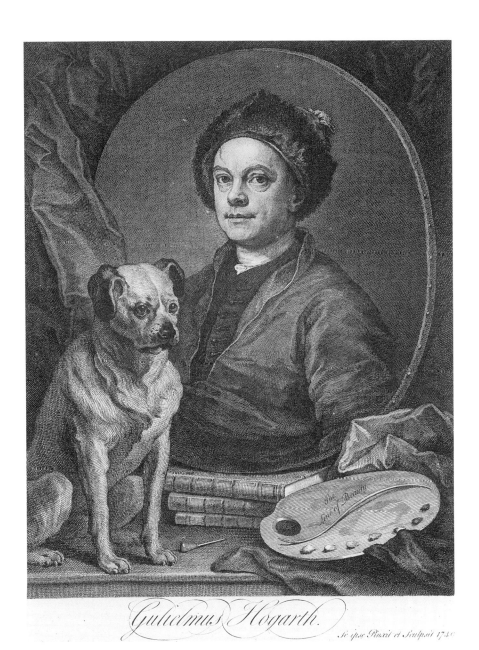

105. *Gulielmus Hogarth;* engraving; 1748/49; 13½ × 10⁵⁄₁₆ in. (courtesy of the British Museum, London).

106. *The Bruiser* (first state); Aug. 1763 (Windsor Castle, Royal Library, copyright 1992 Her Majesty Queen Elizabeth II).

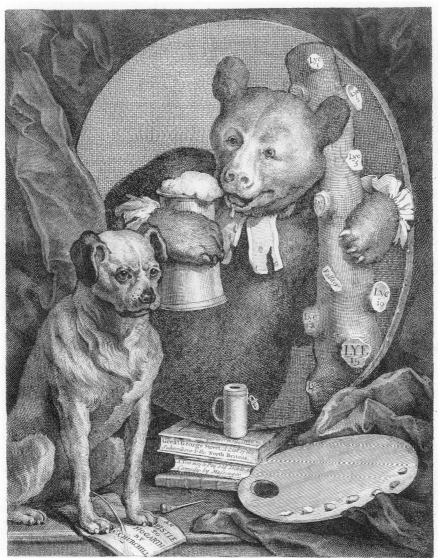

THE BRUISER, C. CHURCHILL (once the Rev.ᵈ) in the Character of a Modern Hercules, Regaling
himself after having Kill'd the Monster Caricatura that so lovely Gall'd his Virtuous friend the Heaven born WILKES:
— But he had a Club this Dragon to Drub, Or he had ne'er don't I warrant ye: —
Design'd and Engraved by W.ᵐ Hogarth Price I Publish'd according to Act of Parliament August 1. 1763.

107. *The Bruiser* (second state); Aug. 1763 (courtesy of the British Museum, London).

108. Detail, *The Bruiser* (seventh state); Oct. 1763.

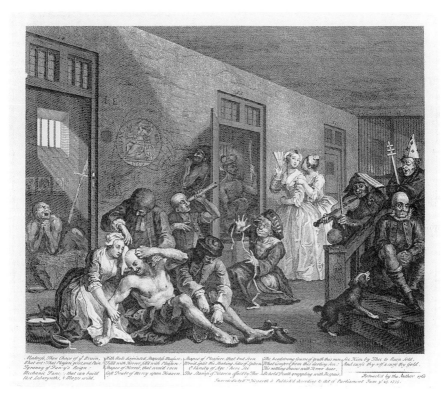

109. *A Rake's Progress,* Plate 8 (third state); 1763 (courtesy of the British Museum, London).

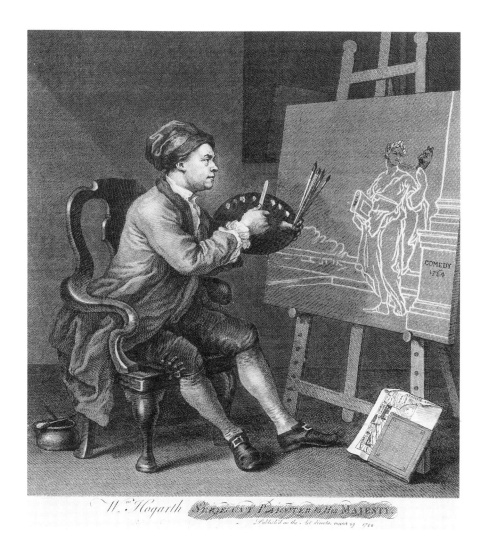

110. *Hogarth Painting the Comic Muse* (sixth state); 1764 (courtesy of the British Museum, London).

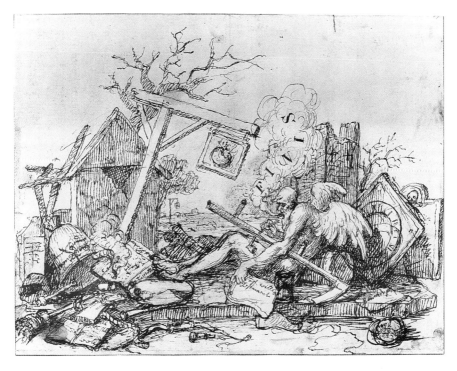

111. *Tail Piece, or The Bathos;* drawing; 1764; 19⅛ × 13 in. (Windsor Castle, Royal Library, copyright 1992 Her Majesty Queen Elizabeth II).

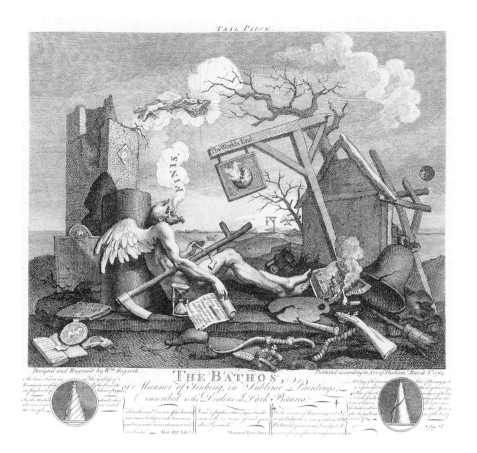

112. *Tail Piece, or The Bathos;* engraving; Apr. 1764; 10¼ × 12¹³⁄₁₆ in. (courtesy of the British Museum, London).

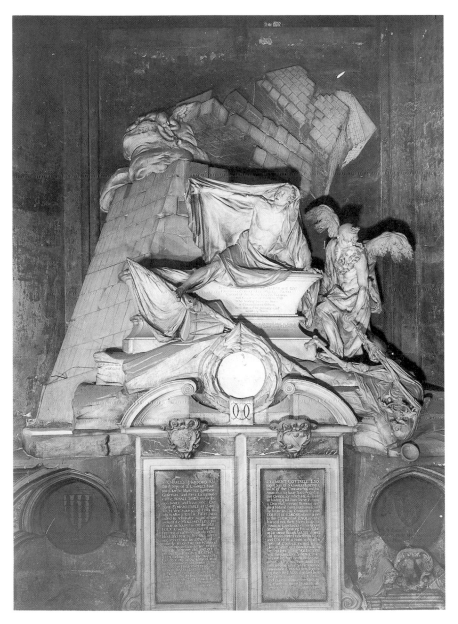

113. Louis François Roubiliac, *Monument to William Hargrave,* Westminster Abbey; sculpture; 1757 (photo: Warburg Institute, London).

114. *The Bench* (fourth state); Oct. 1764 (courtesy of the British Museum, London).

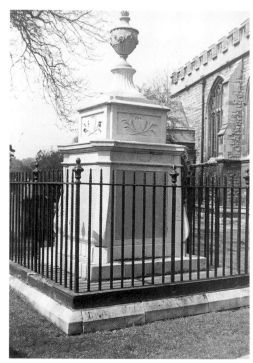

115. Hogarth's monument, 1771; St. Nicolas's Church, Chiswick.

the one hand the martyr of the governing system and on the other the crowd's "monarch and ruler" and the person of whom they chanted "God save great Wilkes our King" and posted handbills on church walls urging parishioners to pray not for the monarch but for "Wilkes and Liberty."[15] The Wilkite processions conducted him (personally or in effigy—represented, if nothing else, by a hieroglyphic "45" for the crucial *North Briton*) to and from prison.

The figure of Wilkes himself in Hogarth's caricature is as close as one can come without masking to a Lord of Misrule, the mock king of the Saturnalia when slaves rule their masters. The characteristics everyone noted of this Punch figure were his physical deformity (his ugly, cockeyed face—the contrary of the ideal quality associated with aristocratic icons), his sexual potency, his high (inebriated) spirits, and his persistent violation through destruction, not appropriation of property.

From the drawing itself (fig. 101), it appears that Hogarth made a sketch on the spot with a portecrayon and later marked it with pen and brown ink, then incised it to transfer it to the copperplate.[16] Hogarth was not a well man: the drawing, and even more the print, are the work of a shaky hand, perhaps partially paralyzed. It is curious that in his notes on the Wilkes–Churchill affair he keeps buttressing his obvious sensitiveness to attack by recalling on the one hand his illness, and on the other his concern with money. When Wilkes had attacked him, he said, "my best was to return the compliment & turn it to some advantage." And so he waited his chance and made the sketch in Westminster Hall:

> his Portrait done as like as I could as to feature at the same time some indication of his mind fully answered my purpose. The ridiculous was apparent to every Eye, a Brutus, a savior of his country with such an aspect was an arrant Joke that tho it set every body else a laughing gauld him and his adherents to death. This was seen by the papers being every day stuffed with invectives till the town grew sick of seeing me always. (AN, 221)

Despite the manifest signs of physical infirmity, the print *John Wilkes* (fig. 102) was a masterful and damaging piece of propaganda—the most effective of the whole campaign on either side. Announced for publication on 21 May, the portrait of Wilkes was

designed to hang alongside that of the traitor Lord Lovat. "The Print," said the advertisement in the *London Chronicle* (14–17 May), "is in direct Contrast to a Print of SIMON Lord LOVAT, first published in the Year 1746, and is of the same Size and etched in the same Manner. . . ." Wilkes holds aloft on a staff of maintenance a vessel simulating a Cap of Liberty with "LIBERTY" written across it. We notice that he has usurped the place of the female Liberty, appropriating her chief attribute, the pole and Cap of Liberty. The cap is poised over his head like a self-appointed halo, in ironic contrast to the diabolic squinting leer and the impression of horns created by his wig.[17] Four thousand copies were turned off at first printing, and the demand was so great that presses had to work day and night.[18] It was indeed a sister print to Lovat, whose popularity had been as great.

John Wilkes was evidently to be seen by 17 May when it was first advertised: already by the 18th the *Public Advertiser* was running a letter from one N. O. (ironically posing as a supporter of Hogarth) who argues that *Wilkes* cannot be by Hogarth but must be an imposition to ruin his reputation. All the *North Briton* details appear: Hogarth, "the supposed Author of the Analysis of Beauty," author of the "excellent Print of King Richard the Third in the Tent Scene, (tho' I cannot take upon me to say for whom the Resemblance is design'd, whether Garrick or Barry) . . . has of late been in a very declining Way, totally incapable of expressing, nay even of forming humourous Ideas."

Naturally Hogarth elicited many replies, from attempts to beautify Wilkes to imitations putting Hogarth in Wilkes's place. On 21 May appeared a reprint of the *North Briton* No. 17 with a bulbous-nosed caricature of Hogarth's self-portrait in *The Gate of Calais*.[19] In the same month appeared a parody (fig. 103) in which Hogarth is himself sitting in the Wilkes pose with his cloven hooves trampling on a Cap of Liberty, his long diabolic fingernails around a pen, a paintpot labeled "Colour to blacken fair Charachters," and a moneybag labeled "£300 per Ann. for distorting features." In the background is an ape making Lines of Beauty and the ugly one-eyed crone from *Rake's Progress* 5, presumably to imply that he portrayed his own family circle in his prints. The pug is present, as in all of the anti-Hogarth caricatures. This print was followed in June by *Tit for Tat or W^m Hogarth Esq^r. Pannel Painter to his Majesty* (fig. 104), which shows the artist in the pose of *Hogarth Painting the Comic Muse,* paint-

ing his portrait of Wilkes alongside his *Sigismunda;* the implication being that they are equally caricatures. Bute looks over his shoulder approvingly.

On 12–14 June the *St. James's Chronicle,* from a point of view that would not have conflicted with *The Times, Plate 2,* commented "On seeing the Picture of Lovat and Wilkes, drawn by Hogarth":

> From Forty-five to Sixty-three,
> What Changes *Times* do bring?
> 'Tis now as bad to hate the Scot,
> As then to hate the King.
> Old Lovat lov'd a Stuart well,
> Hogarth his Picture drew.
> Wilkes hates a Stuart from his Heart,
> And Hogarth joins the two.[20]

The same day *Wilkes* was published the *Public Advertiser* announced the performance on 10 June, at Ranelagh Gardens, of Thornton's burlesque *Ode on Saint Caecilia's Day* (originally published in 1749): "A GRAND BURLESQUE ODE" by "BONNELL THORNTON, Esq."[21] Much advertising followed and several letters, the most important of which, signed "CROMATIC" (Thornton), appeared in the *Public Advertiser* of 26 May. All the familiar issues are here. Thornton claims to address (in Hogarthian fashion) "*the polite,* as well as *the ordinary,* Part of the Public," that is "Readers of *every Class*" (emphasis added); and he outlines a theory of burlesque which, as in the Sign Painters' Exhibition, while ridiculing "the Affectation of Writers for, as well as Composers of *Music,* in harshly, inharmoniously, injudiciously labouring to convey Sound by Sense, or Sense by Sound," and to "laugh at the amazing Powers attributed to Music by the Ancients," at the same time seeks to infuse into this moribund form the vitality of popular art. The "Ode" itself consisted of an agon, recalling of course *The Enraged Musician,* between classical musical instruments and their demotic equivalents. The overture, performed on the conventional instruments, was silenced by the voices of singers, one commanding, "Be Dumb, be Dumb, ye inharmonious Sounds," and the other standing up "in Defense of OLD *English* Music." The *St. James's Chronicle* of 11 June (probably Thornton himself) commented that Ranelagh

"never was honoured with a more truly *British* Company than last Night, to hear the Performance on mock old British Instruments, the Jews-Harp, Salt-Box, Marrow-Bones and Cleavers, and the Hurdy-Gurdy."

This sounds like another of Thornton's Hogarthian performances; and yet "truly *British* Instruments" (clarified as "truely South British") would have carried anti-Scottish, anti-Butite overtones, and Wilkes himself was present at the performance (and Hogarth is not mentioned). The *Chronicle* review associates the vulgar instruments with a specifically Wilkite liberty. The occasion dramatizes how sadly close Hogarth and Wilkes actually were at this moment of unbridgeable schism.

CHURCHILL AND *THE BRUISER*

In *The Author* (1763) Churchill had attacked all the literary Butites, including Murphy, Smollett, and Samuel Johnson, assailing them as "vile pensioners of State." In March 1762, before the political controversy had begun, he had ridiculed Johnson ("Pomposo—insolent and loud, / Vain idol of the scribbling crowd") as a self-appointed literary dictator, and then, when Johnson accepted the pension, his eloquence overflowed in "Pomposo": "Horrid, unwieldy, without form, / Savage, an OCEAN in a storm . . ."[22] If, at the urging of Garrick, he had withheld his attack on Hogarth, he now had a new motive with the appearance of Hogarth's *Wilkes*.

Two months before this event, however, on 16 March he had written to Wilkes that he planned a poem on Hogarth. "I shall get him on Paper, not so much to please the Public, not so much for the sake of Justice, as for my own ease—a motive ever powerful with indolent minds." But in the same letter Churchill wrote that he feared an outbreak of gonorrhea, and by mid-May his indisposition was preventing him from completing his answer to Hogarth.[23] The *Public Advertiser,* which was printing much anti-Hogarth material, advertised the poem "Speedily to be Published" on 19 May, just as *John Wilkes* appeared. The issue of 14 June published a poem "To Mr. WILLIAM HOGARTH, On some late Political Productions"—a

fable of the monkey who, imitating his master running the dull side
of a knife across his neck, cuts his throat:

> Thus, when in Humour's harmless Cause
> Thy Merit justly claim'd Applause,
> (Ere thou began'st to play the Fool
> With Politics,—that *cutting* Tool,—
> And, duped by Party Rage, and Pride,
> Did'st blunder on the dang'rous Side,)
> Such Praise, HOGARTH, to thee was due,
> By all acknowledg'd,—that some few
> Thought thee possess'd of Judgement too.

The real function of the poem as harbinger of Churchill's verses then
emerges:

> But soon shall CHURCHILL's nervous Rhymes
> Expose thy Folly of the TIMES:
> In full-fraught Humour every Line
> Shall descant on thy quick Decline:
> In lively Colours shall be shewn,
> (Colours, more lasting than thy own,)
> That *mimic* Wit has no Pretence
> To trespass on the Ground of Sense. . . .

The *Public Advertiser*'s poem of the 14th was reprinted in the *St.
James's Chronicle* of 12–14 June with ironic commentary: "The Effect
of the above Poem has been wonderful; it has already (though it ap-
peared but this Morning in the Public Advertiser) lowered the Price
of Hogarth's Prints above Half, and has raised Wilkes' Subscription
from One Guinea to Two. One may reasonably hope from hence,
that Hogarth's Humourous Works (as the ignorant Mob of Virtuo-
so's used to call them) will by To-morrow fall from their Yesterday's
Price of Ten Guineas to One, the Price of Wilkes's Proposals; and the
truly valuable Proposals of Wilkes will rise in the like Proportion."
This sounds like Thornton trying to put things in perspective; he
refers to the subscription just begun for a handsome publication of
Wilkes's case, to help pay his debts, dated "Great George-Street
[Wilkes's address], Westminster, May 23, 1763"—which Hogarth
would refer to in *The Bruiser* as "a New Way to Pay Old Debts" (a

double pun, as it applied both to Wilkes and to Hogarth, who was paying him back for *North Briton* No. 17).

Churchill's *Epistle* continued to be announced, however—again on 28 May, to be published on 29 June—undoubtedly to some extent as psychological warfare, to increase Hogarth's apprehension. He must have shown some signs of concern. Birch, writing to Lord Royston on 25 June, devoted a paragraph to him:

> Hogarth, who has all his Life dealt in Satire in his way, is render'd extremely unhappy by the attack upon him in the North Briton & other papers, & by the Apprehension of the threatned poem of Churchill, w[ch], it is imagin'd, will be almost a Death's wound to him. His Vanity with his Success always made him impatient of any mortification as that of Lord Grosvenor's refusal to take his Sigismunda, & the Contempt shewn it at the Exhibition, now a shock that near overset him. Churchill is now known not to have been the Writer of the North Briton ag[st] Hogarth: and Wilkes himself speaks of his poetical Friend as no master of Prose, & allows him scarce any Share in the North Briton, or at least none worth airing.[24]

When the *Epistle to William Hogarth* did finally appear at the very end of June, it was something of an anticlimax. Morell, who was the first to carry a copy of the *Epistle* to Hogarth, and read it to him, told Nichols that "he seemed quite insensible to the most sarcastical parts of it. He was so thoroughly wounded before by the North Briton, that he lay no where open to a fresh stroke." This accords with Hogarth's own account: "at length, Churchill W[ilkes's] toadeater put the North Briton into verse in an Epistle to me, but as the abuse was the same except a little poetical heighting which always goes for nothing, it not only made no impression but in some measure effaced the Black stroke of the N B."[25] There were, of course, really no new charges in Churchill's poem, whose most eloquent passages amounted to strong praise of Hogarth's now moribund talent.

Moreover, compared to his earlier (and later) attacks on Butites, it was quite mild and rather dull. He did not even get to Hogarth until line 309, by which time Hogarth may well have concluded that most readers would have given up. The two charges are that Hogarth is envious of all genius, past and present (not new: Wilkes made the point in *North Briton* No. 17), and an enemy of "liberty," as demon-

strated by his satiric portrait of Wilkes. The latter (ll. 409–18)—presumably the immediate cause of Churchill's indignation—receives the major emphasis, being immediately followed by the vivid description of Hogarth's decrepitude. As Walpole commented, this poem ("not the brightest of his works") let its satiric emphasis fall "on a defect that the painter had neither caused nor could amend—his age; and which however was neither remarkable nor decrepit; much less had it impaired his talents, as appeared by his having composed but six months before one of his most capital works, the satire on the Methodists."[26] Walpole's error of chronology (the *Epistle* was published over a year after *Credulity,* which had been largely executed in 1759) might lead one to question his memory of Hogarth's physical condition. But he expresses the general reaction to the poem. Finally, Hogarth the artist is so complimented that he may have considered how much worse he might have come off: on the balance, he may even have been flattered by it, thinking that it is a better thing to be a great artist than a good-natured man.

The *Epistle,* "the reduction to nothing of Hogarth's once effective talent," is, in fact, a characteristic Churchillian satire. Images that suggest the sterility, uselessness, decrepitude, even nonexistence of the object of attack are opposed to some form of greatness or superiority, usually associated with Churchill himself. Though related to Pope's device of showing the Dunces as disintegrating figures, Churchill's effect is quite different: the villain, like poor, dying, disappearing Hogarth, may be only an exaggerated case of the Popean dunce, but the hero, whose superiority is vaguer than Pope's moral superiority, is another matter. As Morris Golden has put it, he shows preoccupations "with clear and evident power (essentially, for himself) coupled with, and often destroyed by, a profound doubt that anything has significance." While Churchill had Hogarth's poor health to build upon, the disintegration of his satiric object, being merely a convention of his satire, tells very little about Hogarth. His own megalomaniac fantasies stand out more plainly; they are less conventional, more personal, and related in a way to those played out in Hogarth's own autobiographical notes.[27]

The usual pro-and-con poems appeared in the *St. James's Chronicle,*[28] but the reviews of Churchill's poem began to sound weary of the whole personal affair.[29] *An Epistle to C. Churchill* had been announced for publication on the 20th, and the *Chronicle* of 24–26 July

published this or another such poetic epistle dated Brighton, 9 July. The lines also survive in manuscript in a letter addressed to Hogarth, which he preserved and perhaps himself inserted in the *Chronicle*.[30] Hogarth's defender puts the case for Churchill's ineffectiveness nicely:

> Epistles; Pho! they're tedious Things
> Their very Length disarms their Stings!
> They ask, before they reach the Head,
> The Task, the Labour to be read.
> And Readers may mistake the Matter,
> Who have not Sense to find the Satire.

As he recognized, Hogarth had a natural advantage over Churchill.

> No varying Verse, tho' most divine,
> Can match with Raphael's stronger Line.
> The Pencil, like contracted Light,
> Strikes with Superior Force the Sight;
> Takes every careless Eye, that passes,
> Which without Reading, sees it's Lashes.

Garrick, however, read the *Epistle* with dismay and on 10 July wrote to George Colman from Chatsworth (where he was visiting the duke of Devonshire):

Pray write to me, & let me know how yᵉ Town speaks of our Friend Churchill's Epistle—it is yᵉ most bloody performance that has been publish'd in my time—I am very desirous to know the opinion of People, for I am really much, very much hurt at it—his description of his Age & infirmities is surely too shocking & barbarous— is Hogarth really ill, or does he meditate revenge?—Every article of news about these matters will be most agreeable to me—pray write me a heap of stuff for I cannot be Easy till I know all about Churchill, Hogarth, &c—[31]

Colman's reply has not survived, but his own feelings seem to have been mixed. In the political columns of the *St. James's Chronicle* he tries to see both sides of the argument, and in one of his *Terrae-Filius* articles he refers to Churchill's "having snapped the last cord of poor

Hogarth's heart-strings"; in the same article he mentions Hagarty of the Sign Painters' Exhibition as someone he would like to have do his portrait.[32]

Hogarth's health was at best doubtful. In the *St. James's Chronicle* of 2–5 July a news item reported: "We hear that Mr. Hogarth is much indisposed with a Paralytic Disorder, at his House in Leicester-Fields." He was, however, well enough later in the same month to "meditate revenge" and respond with an anti-Churchill plate. This was not a revenge that took much meditation. From a sympathetic pamphlet called *Pug's Reply to Parson Bruin,* published on 9 July, he took the image of Churchill as a bear in clerical bands, opposed by a small Hogarthian pug.[33] The pug in the pamphlet represents not Hogarth but his pug, or the pugnacious, earthy part of his character: if he had not been held down by the pug in him, he would have risen as high as the Italians in history painting. As it is he has risen high above any of his countrymen who criticize him. The dialogue between pug and bear settles, after a few pages, into the pug's monologue, which is a defense of Hogarth. For example, he answers the *North Briton*'s accusation (repeated in Churchill's *Epistle*) that Hogarth never praised merit in another artist:

> . . we declare, on the contrary, that he never was an enemy to real merit, but was ever so to all pretenders thereto, the bane of the polite arts: thou hast been misinformed, Bruin, in this point by certain artists, whom he always held cheap, and thought their success reflected a dishonour on his country: the slight he marked to them, they have long laboured to pervert to an universal enmity to merit in others. (13)

The pug also contrasts Hogarth's print of Wilkes, done out of loyalty to his government, with Churchill's attack on Hogarth, done out of loyalty to a friend.

Taking these two symbols, Hogarth turned to the old plate of *Gulielmus Hogarth* (fig. 105), which already contained one of them, the pug; obliterated his own face; and replaced it with the leering, beer-swilling bear, shown holding a Hercules club. He also erased the Line of Beauty from his palette (figs. 106, 107). It did not take a great deal of work, and was published by 6 August.[34] Hogarth's own explanation is distinctly ironic: "Having an old plate by me with some parts ready such as the background and a dog, I thought how I could

turn so much work laid aside to account, so patched up a print of M^r Churchill in the character of a Bear" (AN, 221–22).

This was an important symbolic act, one we should examine carefully. After 1758 Hogarth had replaced *Gulielmus Hogarth* with *Hogarth Painting the Comic Muse* as frontispiece to the folios (but of course *Gulielmus Hogarth* remained in the pre-1758 folios as a point of reference).[35] By reusing the copperplate in the way he did in *The Bruiser,* Hogarth meant that this was an old, outdated plate, on the scrap heap, good for nothing better than a picture of Churchill; but also that as Wilkes in *John Wilkes, Es^qr.* was trying to usurp (replace, pass for) the image of Liberty, here the swaggering Churchillian bear is doing the same with the public image of Hogarth. The times we live in are such that Churchill (originally a "Modern Hercules," the inscription was changed in the published print to a "Russian Hercules") has replaced the representative of heroic virtue.

But another, darker meaning must have been evident to Hogarth and at least some part of his audience. On 3 August Churchill, having seen *The Bruiser,* wrote Wilkes: "I take it for granted You have seen Hogarth's Print—was every anything so contemptible—I think he is fairly Felo de se"—which of course is another way of interpreting Hogarth's removal of himself.[36] The displacement, even accepting the fact that it was an unprized portrait of himself as a younger man, carries grim overtones. While on one level making a satiric comment on the times, analogous to the close of Pope's *Dunciad,* on another Hogarth was accepting Churchill's own terms in the *Epistle* and responding by eradicating himself, replacing his own face and erasing his trademark as well, the Line of Beauty. From Sandby's first caricatures onward, Hogarth seems, on one level at least, to have self-destructively accepted the evaluation tendered by his detractors.

What remains in *The Bruiser* is the purely Hogarthian symbol, which antedated the Line of Beauty if not Hercules: the crude pug showing his scorn of Churchill's *Epistle to William Hogarth,* but also defying the Churchillian bear. Implicit is an animal fable, of the dog and the bear, recalling the bearbaitings of *Hudibras's First Adventure* and Hockley-in-the-Hole (see vol. 1). In the experience of Londoners, it was usually the agile dog that bested the clumsy bear—and thus the comedy underlying the sport. Hogarth's reputation, deriving from his use of the pug symbol, has always been for "pugnacity" (Latin *pugnare,* to fight), for belligerence, combativeness, truculence,

in short "Englishness." But the gesture of pissing-on comes much closer to Hogarth's sense of "pug" as the animal nature underneath our human affectations and as his own strategies of subversion. Indeed, the pug in *The Bruiser* closes Hogarth's idea of the dog that began with his conversation pictures (and the flea-scratching canine of Watteau's *L'Enseigne de Gersaint*). Only now he is up against a bear, and specifically a beer-swilling one who affects a clergyman's bands.

In the conjunction of the clergyman bear, the pissing dog, and the metamorphosis of Hogarth's own portrait and palette, *The Bruiser* is a further excursion in the fairy-tale mode begun with *Satire on False Perspective* and continued in *Five Orders of Periwigs* and the Gothic of *Credulity*. It originated on the one hand with the incongruous juxta-positions of "the ridiculous" in the *Analysis* (i.e., an *old* baby), and on the other with the mixture of emblematic and realistic details in Hogarth's earliest prints, now become, because they are expressing an irrational world, a form of the "grotesque" mingling of animal, human, and plant forms (once again anticipating both Rowlandson and Gillray in their different ways).

In his letter to Wilkes of 3 August, Churchill picks up the print's pun on Massinger's *A New Way to Pay Old Debts*—referring to both the debt Hogarth owes Wilkes for his *North Briton* No. 17 and the financial debts Wilkes has incurred throughout London—and continues:

> He explains it as a New Way to pay old debts wholly to you, but as the Print is really inscrib'd to me I think not to let him off in that manner—he has broke into my pale of private Life, and set that example of illiberality, which I wish'd—of that kind of attack which is ungenerous in the first instance, but justice in the return. I intend an Elegy on him, supposing him dead, but my dear C.W. [his mistress], who is this instant at my elbow, and towards whom I feel my Spirit stir and my bowels yearn tells me he will be really dead before it comes out. Nay, she at the last tells me with a kiss that I have kill'd him, and begs I will never be her enemy.

Wilkes replied from Paris on 29 August that he had not seen the print and wished that Churchill would send it to him: "I have a rod steeping for him."[37] The tone of their letters, and especially Churchill's,

remains cocky and adolescent, shot through with his sense of power and irresponsibility.

John Taylor, who was ninety-three in 1832, told J. T. Smith that Jonathan Tyers had introduced him to Churchill in Vauxhall Gardens at the time Hogarth's print appeared.[38] "Mr. Tyers asked Mr. Churchill what he thought of it. 'Oh!' said he 'it is a silly thing, sir. I should have thought Hogarth had known better.'" On 6 August, writing Lord Royston again, Birch devoted a paragraph to Hogarth:

> Hogarth has supported the publication of the Epistle to him from Churchill better than he did the Apprehension of it; & seem'd to me much more in Spirits, when I met him about a fortnight ago, than he had been for some time past. His print of the Poet, his Antagonist, publish'd on Thursday has some Humour in it.

Royston replied on the 9th, referring back to the story of the spider: "I wish, when you met that artist, you had asked him, what foundation there was for Wilkes's charging him with abusing Lrd H—ke under yᵉ shape of a spider. For my Part, I do not believe the story."[39]

In the same issue of the *St. James's Chronicle* that announced *The Bruiser* (4–6 Aug.), one T. L. contributed a poem on the back page "on seeing the Print of Mr. Churchill in the Character of the Russian Hercules":

> Whilst Hogarth his Rival denotes by a Bear,
> And the Dog does his own dear Likeness declare;
> An honest rough Mortal in Churchill we see,
> But the surly base Cur does with Hogarth agree.

The public seemed to be tiring of this sport, and it was generally felt that neither of the great satirists had gained much reputation from the exchange. A poem Walpole copied from the *St. James's Chronicle* on 17 August, called "The Sister-Arts. An Epigram," equates the two:

> To various Things, just as they strike,
> We oft the Arts compare;
> But who'd have thought the Sisters like
> A Bull-dog and a Bear?

Another that the *St. James's Chronicle* copied from the *London Magazine* is called "Pug and Bruin":

> The Painter smarts from Churchill's manly Line,
> And tit for tat, pays Poem with Design.
> Who's right, who's wrong, I neither know nor care;
> I read, I gaze, and so—fight Dog, fight Bear.

Walpole's own conclusion summed it up: "never did two angry men of their abilities throw mud with less dexterity."[40]

Some complaints must have reached Hogarth to the effect that *The Bruiser* had been a weak reply, indeed a *felo de se,* made by a man as sick and decrepit as Churchill had painted him.[41] To prove his powers he added a little inset cartoon (advertised as a "PETIT PIECE") on the palette he had stripped bare of the Line of Beauty (fig. 108). The "PETIT PIECE" is a miniature *Times, Plate 3,* showing that the dove has now alighted on the royal standard (peace has been concluded) and Hogarth is himself protagonist (the *Gate of Calais* portrait with its old associations), who puts the Churchill bear (now muzzled) and the Wilkes monkey through their paces, brandishing a scourge over them (Temple, still faceless, stands behind them, like Frederick the Great, fiddling). This is in some ways an upbeat revision of *Election* 4, in which a muzzled bear, with a monkey on his back, led the crowd that had been manipulated into a political "dance." Pitt is now a tomb effigy (politically dead), though still alive enough to fire off a canonball at the dove. He uses the same match with which he has lit the pipes smoked by his tomb "supporters," the Guildhall figures of Gog and Magog (read: City, West Indies trade, tobacco interest). The strong assertiveness of the "PETIT PIECE" qualifies if it does not negate the pessimism of the print as a whole.[42]

By this time Hogarth seems to have recovered his health to some extent. "The satisfaction and pecuniary advantage I received from these two prints," he wrote, "together with constant riding horse back restored me as much health as can be expected at my time of life" (he was now sixty-six). On 26 August he scribbled some profits on one of his papers, which show that he retained £120 from his painting for the crown out of £200 earned (apparently £40 for his deputy); from his print of Wilkes £4 2s, and from his print of

Churchill £30 15*s:* he must have sold around 600 of *The Bruiser* and—presumably since the publication of *The Bruiser*—80 more of *Wilkes*.[43] He also continued to receive and save letters from admirers who told him they stood up for him against Wilkes and Churchill.[44]

Wilkes had also attacked Hogarth's friend Samuel Martin, the secretary of the treasury (*North Briton* No. 37, 12 Feb. 1763); and Martin, not having Hogarth's recourse to the burin, practised with pistols during the summer. In November he challenged Wilkes to a duel: their first shots missed, and Wilkes's second missed but Martin's struck Wilkes in the groin.[45] Wilkes told Martin to flee to the Continent to escape prosecution, and he did. Even Wilkes's enemies noted the restraint with which Martin controlled his temper all those months between the insult and his revenge; the careful wording of his note of challenge by which he deprived Wilkes of his privilege of choosing weapons; and the target practice during the summer. Martin's reputation seems to have suffered, but Churchill's inevitable response, *The Duellist,* published in January 1764, spent its attack on Bishop Warburton, and was treated with less sympathy by the critics than the *Epistle to William Hogarth:* they were losing patience with his personal attacks on respected people. The duel did not alienate Hogarth, who kept Martin's portrait at hand, continued to see him after his return from abroad in 1764, and bequeathed the portrait to him in his will. The words in the will are, among other things, a final gesture toward the man who had nearly killed Wilkes in protecting his honor.

Events, however, were closing in on Wilkes. Whatever sympathy Martin's bullet gained him in high places was counteracted by the scandalous accounts, spread by the government, of his *Essay on Woman;* but the crowd was still on his side. In May 1763 his discharge had been greeted with crowd action and cries of "Wilkes and Liberty," and in December the crowd prevented the public hangman at the Royal Exchange from burning No. 45, pelting the sheriffs with dirt and carrying away copies of the offending issue. Nevertheless, on 24 December Wilkes slipped out of his house and fled to France, and on 13 January he sent to the Speaker of Commons a certificate signed by two French surgeons that he was too ill to return to England. On 2 January his expulsion from the House had been voted,

and even his own party, while attacking the use of general warrants, disowned Wilkes himself and was relieved by his absence. It was soon disclosed that he had cheated the Foundling Hospital while treasurer of the Aylesbury branch. Stories, some true and others false, rose to cloud the reputation of "honest John." [46]

Churchill was living well enough. When he wrote *The Rosciad* he had found no publisher willing to bring it out; so he published it at his own expense, and thereby reaped all the profits of this work said to be "the most popular Poem that has ever been published in England since Pope's Dunciad" [47]—it ran through eight editions in Churchill's lifetime. This, "financially, the smartest move that Churchill ever made," [48] was of course based on the same principle that ensured Hogarth's financial success with his prints: the elimination of the middleman. The indignant Elizabeth Carter commented in 1763, "I have lately heard that Churchill, within two years, has got £3,500 by his ribald scribbling! Happy age of virtue and genius, in which Wilkes is a patriot, and Churchill a poet!" [49]

Throughout the quarrel, or at least after *The Times, Plate 1* (which probably alienated many Pittites), respectable opinion, to a large extent, favored Hogarth; Wilkes was feared and abhorred, and Mrs. Carter typified the general attitude toward Churchill, that talented devil whom ladies read and shivered over. Living up to his reputation, he appeared less as a bear than a wolf entering the sheepfold and departing with obvious signs of his depredations. In the fall of 1763 he seduced and made off with the daughter of his and Hogarth's old friend Sir Henry Cheere. Elizabeth Montagu, probably the most reliable gossipmonger of the incident, wrote on 4 December: "The disgrace Wilkes will incur for his blasphemy and this last instance of Churchill's wickedness in running away with the daughter of his benefactor, who has kept him from starving, will discountenance the ribald freedom of writing and conversation for a time. Churchill is a married man, the poor girl is under 15 years of age whom he debauch'd; she is sent home to her unhappy father Sr Henry Cheere." [50] The young woman, after her return, was apparently taunted by her sister until she again ran away to Churchill, who settled down with her in Richmond and later on Acton Common.

Thus from a bourgeois point of view, not too different from Hogarth's own, the wicked escaped punishment or actively flourished.

The virtuous were attacked like Hogarth, or fled the country like Samuel Martin. Even Garrick, in a situation not unlike Hogarth's, had departed England by the end of 1763. The preceding season had been his busiest on the stage: he appeared on nearly one hundred nights, as opposed to hardly half as many in most years. He also took on his last new role, that of Sir Anthony Branville in Mrs. Sheridan's play *The Discovery,* on 3 February 1763. But though only in his forties, he was beginning to feel his age, and, as with Hogarth, the London scene no longer seemed as sweet to him as it once had. The mob rule depicted by Hogarth in his recent prints became a reality to Garrick in January 1763 when the "Fitzgiggo" or the "half-price riots" nearly destroyed Drury Lane. Inspired by an enemy of Garrick's, Thomas (Thady) Fitzpatrick, the trouble stemmed from the theater's announcement that the public would no longer be admitted at half price after the third act of a new piece. The mob broke up both Drury Lane and Covent Garden; the following night Garrick capitulated, and shortly after Beard of Covent Garden also. Reminiscent of the riot of November 1755, this one prompted Garrick to leave at the close of the season for the Continent, where he remained for two years, and never saw Hogarth again. His departure was one more symptom of the collapse of order which Hogarth was preparing to express in his "Autobiographical Notes" and the *Tail Piece.*

16.

"FINIS"

The *Tail Piece*, 1763–1764

In the early autumn of 1763 Hogarth made the additions to *The Bruiser* and began to look back over his life. He accompanied his retrospect with on the one hand writings and on the other revisions of his copperplates—his final legacy. All of this, even the "Autobiographical Notes," expressed unequivocally the feeling that England was a place he could no longer understand. The England he had known and chronicled for over forty years seemed to have passed. His friends were dead, retired to the Continent in self-imposed exile, turned against him, or fallen into some sort of disrepute (as, in a sense, he had himself).[1] Even the friends of the *St. James's Chronicle* group were reduced to factions, and apparently only Thornton remained on close terms with Hogarth (though he also supported Wilkes in his troubles).[2] The Society of Artists was proceeding on its way, oblivious of Hogarth. His own health and powers were failing, and he naturally projected some of this onto his work. He did not finish another print during this period except the *Tail Piece,* which signaled the end of all things, including his creativity (figs. 111, 112).

It was to the canon of prints, however, that his thoughts turned in the last year of his life: he wanted to strengthen their fading lines and, by revisions, confirm their significance or place his own final interpretation upon them. He was also writing an explanation to augment Rouquet's commentary up through *The March to Finchley,* and this included an account of his life. The several drafts of his opening begin with a statement of the need for a continuation of the commentary and then move on to his autobiography. In one draft he specifically alludes to the attacks of 1762–1763:

it becomes at this time still more necessary than ever as not only im-
perfect but wilful misrepresentation of some of them [his prints] have
been publishd with an intent to render them either ridiculous or im-
oral the effects of which tend not only to the injuring me in my prop-
erty but sully my character as a man the latter of which to an honest
mind is far more painfull than either his Interest or his reputation as
an artist.[3]

Hogarth explains that these are notes on his prints ("not only a dis-
cription but also what ever else occur'd to me as relative to them")[4]
which he is going to send to a Frenchman as basis for his commen-
tary; the complete life and commentary would then be distributed,
as Rouquet's had been, with sets of his prints sent abroad. There
seems little doubt that the book would also have appeared in English.
Although the commentary on his prints was the immediate cause of
his writing his autobiography, he must have been contemplating the
subject independently; it was included in the projected title page of
"On the Arts of Painting and Sculpture," intended as the work's cli-
max. He understood that what he had to say about contemporary
English art was inextricably bound up with his own life; and it is not
easy to decide which takes precedence in the notes that emerge.

These notes were more carefully written than most of his jottings,
some passages appearing in multiple drafts, the main points repeated
over and over as Hogarth sought to express himself exactly. The
earliest parts, probably begun in the summer of 1763, were written
on various sizes of paper; then he turned to a small notebook and
carried the story through to completion there. A column of sums,
written upside down on folio 28b, bears the date 26 August 1763,
which more or less corresponds to the chronological end of the au-
tobiography with the publication of *The Bruiser*. In the margin of
folio 38, however, Hogarth inserted and circled with a stroke of
his pen the lines from Horace, "Segnius irritant animos demissa per
aurem / Quam quae sunt oculis subjecta fidelibus" (What we hear, /
With weaker passion will affect the ear, / Than when the faithful
eye beholds the part.—trans. Philip Francis). This insertion was not
made before December 1763, when the Reverend John Clubbe pub-
lished his tract *Physiognomy;* he quoted the lines in his dedication to
Hogarth, who had supplied a design for his frontispiece.[5]

The burden of the autobiography is that he was self-taught, a

tradesman, a patriotic Englishman: he was a champion of liberty of the individual against printsellers, pirates, connoisseurs, and political extremists; the enemies affronted by his independence and aggressiveness closed in on him and reduced his career from a series of successes to a losing battle with 'the system,' leading up to the events he considered decisive. He begins the notebook with the generalization: "The three things that hav brought abuse upon me are 1st the attempting portrait painting 2d the analysis 3rly the Prints of the times." Throughout these notes runs a strain of paranoia: "I have been severly treated . . . I fear Persecution . . . I have suffer'd a kind of persecution, nevertheless from the bigots." And a little later he says that he never did anyone an injury, can point "without ostentation" to many he has benefited, has made "everybody about me tolerably happy," and has defied the high as well as the low (AN, 213, 209, 215).

The enumeration of the "three things" is followed by several pages of theory; then he reverts to the autobiography and carries it straight through the episode of *The Times* to its strangely provisional ending. He seems about to close on a rather hopeful note, having finished the two portraits of his enemies Wilkes and Churchill to his "pecuniary advantage" and recovered his "health as [much as] can be expected at my time of life." Then, on the next page, is the cryptic conclusion: "What may follow god knows / Finis." The rest of the page is blank (221–22). The upbeat sounded just before the ending—either resigned or jaunty, ironic or self-satisfied, depending on how it is read—suggests the ambivalence of his reaction to recent events: he is putting them in the best possible light (claiming a tactical and financial coup), but clearly he regards himself as waging an uphill struggle.

After the page marked "Finis" there are more jottings on the moral purpose of his art (he would rather be responsible for the *Stages of Cruelty* than the Raphael Cartoons, speaking "as a man not as an artist"), and a few fragments on his life: "when a man is cruelly and unjustly treated he naturally looks round and appeals to the standersby," and "My Phylosophical friends bid me laugh at the Abusive nonsense of party writers But I cannot rest myself." Describing the genesis of Rouquet's *Lettres de Monsieur * *,* he suddenly interrupts himself: "their Malice so great as they could not [*word illegible*] it that they endeavourd to wound the peace of my family," and circles the

sentence (222, 230). His final graphic comment, moreover, was the *Tail Piece,* with the last breath emerging from Father Time's mouth marked "Finis"—though this too combines an image of the end of all things and his end as an artist with an inscription that reveals him still busily in pursuit of Beauty, defending and explaining his theory.

But it was the pessimism, not the jaunty victory sign, that he developed in the revisions of his copperplates. Though his notes indicate that he was "improving" his plates, in fact he was strengthening the lines that had become worn, to make sure they lasted and to clarify their meaning (as he now saw it). These were in a sense his last testament—to his public that had stood by him all these years, and to his wife, who would need the plates as financial security for many years to come; above all, his prints, always his one source of appeal beyond his "enemies," were his final plea to posterity. They were a projection of himself into that dark world beyond his present sickness and discontent.

Some of the plates had been altered shortly after publication, and the *Harlot's Progress* was reworked somewhat when in 1744 the second edition was printed. But the final changes date from *The March to Finchley* (engraved by Sullivan), to which he added personal touches and the inscription "Retouched and Improvd by Wm Hogarth, republish'd June 12th 1761." The next was *The Sleeping Congregation,* "Retouched & Improved April 21 1762 by the Author," republished as a pendant to *Credulity, Superstition, and Fanaticism,* which had appeared only two weeks earlier. The revision of *Rake* 8 (fig. 109) is datable by the large coin of the realm for 1763 bearing a wild-haired Britannia and added to the wall of Bedlam, implying that England by this time had itself become a madhouse. (Britannia recalls Thomson's line "Loose flow'd her tresses" in *Britannia* [l. 6], which reflects not madness but grief at the decline of British virtue.) Returning to the second plate of the *Election,* he extracted the teeth of the British lion. These were characteristic of the revisions made in 1763 and 1764; in the latter year he removed the smile from the lips of his self-portrait (*Hogarth Painting the Comic Muse* [fig. 110]), changed the comic muse to the satiric, and replaced the title "Serjeant Painter to His Majesty" with the starkly prophetic "William Hogarth 1764." Until the end he continued to work over the plates, assisted by several other engravers whom he took with him to Chiswick.[6]

It is very difficult to distinguish between paranoia and convention in the "Autobiographical Notes" and the final revisions of the copperplates. There was the housemaid at Chiswick who said that after Churchill's verses Hogarth never smiled again.[7] On the other hand, the erasure of the smile and the changing of the comic to the satiric muse may simply reflect a convention of Juvenalian satire: in dark times, a darker, more severe tone must be taken. "*Difficile est saturam non scribere.*" Smollett, for example, after experiences at least as scarifying as Hogarth's, left England for the Continent in June 1763, and in his *Travels through France and Italy* (published in 1766) transformed his experience into the railing of a Juvenalian satirist faced with the immorality of the world.[8] Fielding had imposed a Juvenalian convention on his last novel *Amelia* (1751) and included a scene in his autobiographical *Journal of a Voyage to Lisbon* (1754), written as he was dying, in which he describes himself carried onto the ship, helpless on a stretcher, being jeered at by the sailors and watermen who line the way. Evidently the eighteenth-century literary syndrome in England entailed growing pessimistic with age, feeling that one's personal decline implied the decline of one's environment, one's personal loss of empathy the breakdown of all communication and order.

It was not, of course, so simple: Fielding was expressing a real despair in the social life of London and England, from criminal lowlife up to the highest rungs of the social ladder. Pope, in his last works, no doubt felt real despair in a world governed by Walpoles and Cibbers. But in both cases the fact that the aging, ailing artist was very likely soon leaving it to these fools must have played a part. In his final *Dunciad* Pope invoked Chaos, the only muse, he felt, now remaining, and in 1757 Gray had the last surviving bard curse the monarch who had killed all the other bards and leap to his death. Though Hogarth's interpretations and predictions were based on personal feelings, as a shrewd and experienced social commentator he was also speaking for some objective collapse that seemed imminent. By June 1764, on the strength of Wilkes's successful attack on the legality of general warrants, fourteen printers had won verdicts for damages against the messengers of the secretaries of state, and Lord Halifax himself was forced to pay damages of £4000. Wilkes would eventually resume his seat in Commons and be elected lord mayor of London. In 1780 he would witness, completely appalled,

the Gordon Riots, a materialization of *The Times, Plate 1;* he, "Sublime" Burke, and Jane Hogarth would all live to see the French Revolution.

Before turning to the *Tail Piece,* another strain in the notes Hogarth was compiling, also reflected in that print, should be traced. Following a typical pattern of thought, he moves from autobiographical facts to a generalization about his art, then digresses into one of his crotchets, leaving his subject far behind. In one attempt at an opening he starts with his birth, youth, apprenticeship, and the painting of conversation pictures; suddenly portraiture reminds him of drapery painters, and he runs on about this subject (202). At length he winds down and resumes the story of his life. After stating the "three things that hav brought abuse upon me," he sets off on some thoughts on a new subject—perhaps a new pamphlet—entitled "Painting & Sculpture considered in a new manner differing from every author that has as yet wrote upon the subjects." Here, intertwined with this new idea for a treatise and accounts of his prints, he sketches his final conclusions about comic as opposed to sublime history, confirming his emblematic representation of himself in *Hogarth Painting the Comic Muse* (not long before he changed it to the satiric muse). He starts conventionally with a discussion of the lowest genres—still life and portraiture, merely another kind of still life in the hands of most artists. Then he works up to the pinnacle of history painting. "Subjects of most consequence," he writes, "are those that most entertain and Improve the mind and are of public utility," proceeding in a nearly incoherent sentence to a favorable comparison of comic and sublime history: "comedy in painting stands first as it is most capable of all these perfection[s] the latter has been disputed with the *sublime* as it is calld" (214–15). These sentences suggest a truth about his whole career: that even when painting the sublime he knew that his full energies were only engaged by the comic.

By bringing together other fragments, one may infer his ultimate definition of the comic. The subjects that intersect to suggest this definition are nature, his method of visual mnemonics (vs. copying), the stage, and comedy. He disposes of "nature" succinctly: "I grew so profane as to admire Nature beyond Pictures and I confess sometimes objected to the devinity of even Raphael Urbin Corregio and Michael Angelo for which I have been severly treated." This passage

is struck out, and a new version appears above: "I do confess I fancied I saw delicacy [in] the life so far surpassing the utmost effort of Imitation that when I drew the comparison in my mind I could not help uttering Blasphemous expressions"—that is, blasphemies directed at the "divinity" of Raphael. The phrase "the life" has to be taken in conjunction with all the references to his need to combine his "studies" and his "pleasures": life was experience, the material of his art.

After some attempts to express his sense of the persecution these "blasphemies" have engendered, he turns on the same page to his apparent solution: "Subjects I consider'd as writers do." This sentence is allowed to stand, but he begins "my Picture was my Stage and men and women my actors who were by Mean of certain Actions and express[ions] to Exhibit a dumb shew." Life, the stage, and his pleasures are somehow clustered together—he does not quite make the connection himself, but the contiguity of these subjects establishes it. The stage was perhaps his greatest pleasure; life was structured like the stage, whose proscenium arch replaced the frame of those "Pictures" he preferred to ignore for "Nature." Explaining his visual mnemonics, which he seems especially eager to clarify, he writes: "thus stroling about my studies and my Pleasures going hand in hand the most striking things that presented themselves made the strongest impressions, in my mind." The next dangling clause makes the connection with the theater unmistakable: "Whether they"—presumably meaning these "impressions"—"were comical or tragical, for I mean to speak of only such Subjects as the human species are actors in[.] And these," he goes on, "I found out were such [as] had but seldom if at all been done [in] the manner I imagin'd them capable of." Near the bottom of the same page, he explains "I have endeavoured to weaken some of the prejudices belonging to the judging of subjects for pictures, by comparing these with stage compositions" (209–11). Hogarth's concern with prejudices, whether relating to pictures or human actions, with his faith in the human eye (direct experience) as opposed to the ear (secondhand knowledge), and his sense of the immediacy of a stage presentation as opposed to a painting, together suggest that his particular meaning of "life" or "nature" is real people: those whom the artist can immediately experience, cast in certain roles and block in on a stage, with light and shadows placed for effect, and a script that develops their moral significance. As in the *Analysis,* he ends with the "comedian" and the stage.

As he writes in another draft, painters and writers never mention history paintings "of any intermediate species of subjects . . . between the sublime and the grotesque," implying that he refers to the comic mode, which art theory has tended to overlook. This recalls the passage in which he argues that "true comedy" in painting ought to stand first as most certain to "entertain and Improve the mind" and be "of public utility" and refers to it as "the sublime genteel comedy" which is the "same in high or low life" (212, 215). In yet another note, apparently written at about the same time (Houghton Library), he specifically contrasts comedy and tragedy, arguing that comedy "represents Nature truely in the most familiar manner tho not in the most common manner," that is "what might very likely have so happen'd," what might "have been so spoke and acted in common life." Tragedy, on the other hand, "is composed of incidents of a more Extraordinary nature[,] the Language more Elevated and the manner both of acting and speaking more heightend than in common life." He applies to tragedy words associated with the Sublime: "exaggerted Elevated swoln not only in the language but in all its imports," adding that "the actor must swell, his voice enlarges his movements and even his dress is expanded to give it dignity equal to his deportment." He seems to be linking the exaggeration of tragedy with caricature: "Tragedy is still true nature but outréd to a certain degree so as to fill the idea."[9] The whole world regarded tragically when it is of course only, in the final analysis, comic becomes the subject of the last print, whose subtitle is *The Bathos*.

THE *TAIL PIECE*

The *Tail Piece* (figs. 111, 112) was announced in the *St. James's Chronicle* for 14–17 April, and the advertisement sums up its creator's intentions:

> *This Day is published, 2s. 6d.*
> Designed and engraved by Mr. HOGARTH,
> A Print called FINIS, representing the Bathos, or Manner of sinking in sublime Painting. Inscribed to the Dealers in dark Pictures. It may serve as a Tail-Piece to all the Author's Engraved Works, when bound up together; at the Bottom of the Print is annexed, a remark-

able Circumstance relative to his Analysis of Beauty. All which are to
be had at the Golden-Head, in Leicester Fields.

Since it is hard to imagine how other prints could have been added
once his tailpiece was "bound up" at the end of the volume of Ho-
garth's prints, the readers of the advertisement must have regarded it
as a swan song.

In fact, it is a final plate of the *Times,* the "PETIT PIECE" of *The
Bruiser* turned into a *Tail Piece.* The flanking buildings are now in
ruins, and Pitt's tomb, modelled on Rysbrack's reclining Sir Isaac
Newton in Westminster Abbey (designed, incidentally, by William
Kent)—but with the globe over Newton's head replaced by Pitt's
£3000 millstone—has been replaced by Time's tomb, and the globe
set afire. The *Tail Piece* is a cross between Rysbrack's Newton and,
adjacent to it in the Abbey, Roubiliac's Hargrave Monument of 1757,
with its allegorical figures of Death and Time and tottering ma-
sonry—Roubiliac's attempt at a sublime history in sculpture
(fig. 113).[10]

Time is surrounded by funerary emblems of mortality: some are
paralleled, the great with the small, a cracked bell and a broken
bottle, the sun going down and a candle guttering out, the world on
a tavern sign and the world in the *Times* print being consumed by
fire. A gallows, an unstrung bow, and a broken crown indicate the
"end" of a robber, a poet, and a king. These examples become in-
creasingly verbal, as Hogarth puns on a scale unprecedented even in
his work. Time himself, dying with his scythe and hourglass broken
and his pipe snapped, comes to his end uttering in a puff of smoke:
"FINIS." Near him is "The Worlds End" tavern, and around him lie
the last pages of a play ("Exeunt Omnes"), a rope's end and a candle
end, the butt end of a musket, the worn stump of a broom, and a
shoemaker's "waxed end" twisted around his wooden "last."

The shoemaker's last, at center and directly below Time's will, is
the emblematic detail that corresponds to the manacled dogs in *Mar-
riage A-la-mode* 1 or the hen and chicks in *Finchley.* It alludes (espe-
cially in the context of the two cones and the inscriptions about
Beauty below) to Pliny's story of Apelles and the cobbler, which
follows the story of Apelles and Protogenes Hogarth had cited in the
preface to his *Analysis*—which had been focused upon by his hostile
critics:

There is a story that when found fault with by a cobbler for putting one loop too few on the inner side of a sandal, he corrected the mistake. Elated by this the cobbler the next day proceeded to find fault with the leg, whereupon Apelles thrust out his head in a passion and bade the cobbler 'stick to his last,' a saying which has also passed into a proverb.[11]

Hogarth, who could well have associated himself with Apelles, whose fame was as both portraitist and theorist, is saying to those critics of the *Analysis:* "Stick to your last." He may be responding as well to Sandby's *The Butifyer* of 1762 (fig. 96), which associated his Line of Beauty with a simple boot.[12]

On Sunday, 1 April, a total eclipse of the sun took place, the first in forty-nine years.[13] Hogarth incorporates this phenomenon in the eclipse he shows darkening the world as the chariot of the sun crashes to earth and the moon wanes. The eclipse darkens art as well as life. The *Tail Piece,* the inscription and advertisement tell us, is dedicated to the dealers in "dark pictures," for here Time's darkening means that both British history and its paintings are being darkened by politicians and foolish artists (as already noted in *Time Smoking a Picture,* fig. 82).

The *Tail Piece,* as inscription and advertisement make clear by their reference to *The Analysis of Beauty,* is a final image of both political and aesthetic decline. Hogarth is having a last word on the Burkean Sublime, specifically the sublimity of Milton's Satan (facing Death, the subject of Hogarth's *Satan, Sin, and Death*): it consists, Burke wrote, "in images of a tower, an archangel, the sun rising through mists, or in an eclipse, the ruin of monarchs, and the revolutions of kingdoms." If one accepts Father Time as an archangel, this kind of description is exactly what Hogarth presents in the *Tail Piece:* the viewer's mind is indeed, as Burke says, "hurried out of itself, by a croud of great and confused images." And the "dark, confused, uncertain images" Burke refers to on the same page would have served as context for Hogarth's extension of eclipse to the "dark pictures" of the Old Masters.[14]

But the *Tail Piece* was both an end and a continuation. For if the design shows the "end of all things," the inscription under it concerns the "conic Form" under which Venus was worshiped at Paphos, and other matters which "did not occur to the author till two or three years after the publication of the 'Analysis' in 1754." Some-

time in the interim he had this symbol of the cone painted on his coach by Charles Catton, the coach painter (who also did the elaborate decoration of Reynolds's coach).[15]

Notably absent from the *Tail Piece* is Hogarth's muse (his equivalent of Pope's muse, Gray's bard). There *is* no woman in the *Tail Piece* (as the female Liberty was replaced by the male impersonator in *John Wilkes, Esq*.); destroyed by Burke's Sublime, canceled from the physical world, she survives only in the inscription underneath, where, among all the words, the Cyprian Venus is abstracted into a merely "conic term." Both Latin epigraphs emphasize that this symbol is without the physicality of the real woman's body: "Simulacrum Deae non effigie humana" ("the goddess does not bear the human shape") and "cuius Simulacrum nulli rei magis assimile, quam albae Pyramidi" ("her statue cannot be compared to any thing but a white pyramid, the matter of which is unknown").

The two cones are introduced, nevertheless, as Hogarth's way of contrasting his Beautiful with the Burkean Sublime. The Line of Grace, coiled around a cone, "by its waving and winding at the same time in different ways, leads the eye in a pleasing manner along the continuity of its variety" (*Analysis,* 55). Burke's Sublime, by contrast, is made up of discontinuities, of broken and jagged lines, of decaying and purposefully shattered objects. All the curves shown are broken and thus rendered straight intersecting lines, which refer back to the passage in the *Analysis* where Hogarth writes of Beauty as variety: "I mean here, and everywhere indeed, a composed variety; for variety uncomposed, and without design, is confusion and deformity" (35). The bow, which would have formed a Line of Beauty, has been broken and now forms discontinuous curved lines; most significantly, the painter's palette itself, with its generous curve, must be shattered to fit the Sublime. The print of *The Times* is torn and set afire, a metaphor of the times themselves and of the print's author—and of Sublime art. In *Time Smoking a Picture* Hogarth had shown how only damaged paintings could conform to the fashion. And yet he also makes certain that within this maze the principle of the "waving and winding" pursuit of the eye still applies, even within the ravages produced by Burke's Sublime.

Hogarth's last print is therefore at once an attack on false sublimity, a sad acknowledgment of its victory, and an affirmation of his idea of Beauty. As the subtitle "the Art of Sinking in Painting" indicates, he is still thinking in terms of Pope's *Peri Bathous* and the

Augustans who were his first inspiration. While Pope presented a false sublime practiced by his contemporaries, against which he implicitly posed the true sublime (*Peri Hupsous*), Hogarth opposes the (false) Burkean Sublime with his own Beauty, an affirmation of order and continuity associated exclusively with himself; these elements are in this context personal as well as moral and aesthetic.

If the Beautiful is still affirmed as a possibility, a way of dealing with the Sublime, so also is popular art and the power of popular symbols. At first sight of this print, it might appear that Hogarth has come full circle: his final mode is as emblematic as his earliest efforts, the ticket for Spiller and *The South Sea Scheme* (ill., vol. 1). But in fact the *Tail Piece* is composed of the detritus of signboards, part of the immediate contemporary environment (many of which had appeared in the Sign Painters' Exhibition). Even the eclipsed moon uses the sign of Man in the Moon taverns. The "World's End" (No. 21, Grand Room, in the exhibition) can be traced back as far as the mid-seventeenth century, usually marking the last house in a built-up area or along a road—or a pub or "ordinary" to indicate the last place for obtaining drink or food in the area. The sign, in its most common form, showed a fractured globe against a dark background with fire and smoke issuing from the fissure. Hogarth had represented this sign in *The Times, Plate 1,* where it was the sign of a house that is itself in flames. In the *Tail Piece* he shows it with its label "The Worlds End" in a context where it means precisely that. It has also become his own final shop sign, marking the end of his volume of engravings and his career, the last in a series of substitutions that began with his Van Dyck's Head and approached the end with the replacement of his face by Churchill's bear face in *The Bruiser.* Hogarth has once again absorbed the popular sign into his own sophisticated, ultimately personal structure of meaning—which is also retrospective and includes the Bell (*Harlot* 1, but also *Analysis,* 57), the palette (from the Society of Arts building in *Times, Plate 2*), and—a special kind of sign—the gallows from *Industry and Idleness* 11.

Wilkes had joked about the poverty of Hogarth's imagination when he likened the European war to a fire, but Hogarth shows that such simple analogies penetrate to the roots of popular feeling and produce a more powerful image. He has also framed a final reply to Churchill's gibe that he was decrepit and dying: if I am dying, Hogarth says, my demise (1) is, to judge by this print, much exag-

gerated, and (2) is symptomatic of—but (3) must be distinguished from—the world Churchill and Wilkes are ushering in, the world first indicated in *The Times, Plate 1*.

The self-destructive was the aspect of the print picked up in the satiric responses from the other side; they reread it as an allegory not of the times but of Hogarth's art. Churchill saw the print, supposedly as early as 18 April, and wrote beneath it:

> All must old Hogarth's gratitude declare,
> Since he has nam'd old *Chaos* for his heir;
> And while his works hang round that anarch's throne,
> The connoisseurs will take them for his own.

The *London Chronicle* for 5–8 May published an epigram, "On seeing H——th's Print, called, Finis, or Bathos in Painting":

> Thy *Tail-piece*, H——TH, speaks thy head-piece gone;
> True *Bathos* now seems H——TH's part alone;
> Here *Nature, Chaos, Finis* all agree
> To sign an act of Bankruptcy on thee.

A satiric catalogue of "An Exhibition of Polite Arts," following the artists' exhibition of 1764, had a picture "By Mr. Ram's-eye," and included "Jemmy Twitcher betraying his Friend—An ill-done Thing," "The pouring of Poison into the Ear of a good and unsuspecting king—A Scene in Hamlet," "The Fall of Mortimer—Not finished," and after these allusions to Sandwich, Wilkes, Bute, and others, the list ends with "A Thing without Meaning" and "The FINIS, by Hogarth—Its Companion."[16]

PAINTING AND PRINT: A FINAL WORD

According to an anecdote about the print's composition, when he had nearly finished he cried, "So far, so good . . . nothing remains but this"—and taking up his pencil "in a sort of prophetic fury," he added the painter's broken palette. "Finis," he is supposed to have

exclaimed, "the deed is done—all is over."[17] The print, though made six months before his death, and four before he wrote his will, may have been accompanied by such a gesture; he had always been given to dramatic gestures, but in the last decade of his life the ontological status he bestowed on his works began to change: they became less representations of the world than actual objects in that world. This objectification can be traced back to his public gestures. Disillusioned with his patrons after the sale of *Marriage A-la-mode,* he took down the Golden Head from above his street door; at about the same time he replaced the satiric faun in *Boys Peeping at Nature* with a panel designed by the chaste putto who restrains the faun in the earlier version; and in *Time Smoking a Picture* he replaced his own figure at the easel as creator with Time the destroyer. The advertisement announcing that he was going to cease depicting moral subjects, and perhaps also the heavy scoring-out of his name in the Society of Arts' book, find their final expression in his gesture of making a *Tail Piece,* after which he is silent. The *Tail Piece* is both a representation of the end of all things and, as a "tailpiece" to his folios, a concrete emblem of the end of Hogarth's art. The act of executing it was as significant as its content.

Hogarth, who began by playing with the attributes of gods, giving them to contemporary humans or taking them away, reduces himself in his last years to a few symbolic attributes and then goes through a series of self-effacements. Disillusioned by the apparent popularity of the Wilkes–Churchill anti-Hogarth propaganda, he destroys his self-portrait of 1749, replacing it with a bearish Churchill, and erases the Line of Beauty from his palette (as he had already replaced his palette with the Society of Arts signboard and Liberty with Wilkes). He even replaces his trademark Hercules with the "Russian Hercules" Churchill, and a few months later the words "Serjeant Painter" on his more recent self-portrait with a simple name and date, in the manner of an epitaph (both were also images that recalled his association with Thornhill).

In the *Tail Piece* his print of *The Times,* his palette, and his Line of Beauty have all been destroyed. The "enemy" is destroying them, as he probably thought "they" had symbolically taken down the sign of the Golden Head. By the same sort of substitution in which Hogarth's smile becomes a frown, the muse of comedy replaces that of satire and Bedlam replaces England. But in a sense he was strip-

ping himself of the symbolic equivalents of his earlier selves, as he did with the faun of *Boys Peeping at Nature,* the face of *Gulielmus Hogarth,* the Line of Beauty, and the palette—a process Churchill referred to as *felo de se.* Hogarth, recalling the iconoclasm of self in Swift's "Verses on the Death of Dr. Swift," may have meant to preserve his moral part only. What survives (in Swift's case, his indomitable spirit) is the puggish aspect of himself.

This bizarre phenomenon of self-revision can be traced back to the publication of his prints in bound books, when people such as Townley began to speak of them as "one of the classics," and he and his audience came to regard his oeuvre as canonical. To such a book an emblematic portrait of the artist was as necessary as the apologia that begins Juvenal's *Satires.* But Hogarth also felt that the self-portrait should be kept up to date: the Hogarth of 1749 was not the Hogarth of 1758 (it was the former he allowed Churchill to destroy), just as the England of 1735 in the last plate of the *Rake's Progress* was not the same as the mad England of 1763. He began to make prints that reflect on earlier ones—*Wilkes* requires *Lovat* of fifteen years earlier; and the fountain in *The Times, Plate 2* requires the fountain in the optimistic Frontispiece to the *Catalogue.* The ordinary purchaser of a print, of course, would see only Hogarth's last version. But the folio ensured the mutual existence of original and revision, of old and new, as a sequence. In a sense the punning that characterizes the individual prints carries over into the dichotomy of the Prince of Wales's subscription ticket for the *Election* and the duke of Cumberland's, of *Gulielmus Hogarth* and *The Bruiser,* or of the self-portraits with a comic and a satiric muse. Within the context of his bound moral works, Hogarth could have it both ways: the moment of the present in all its personal despair, but in the perspective of the frontispiece portrait, *The March to Finchley,* or the second plate of the *Analysis.*

The desire to tidy up and to be understood also occasioned further attempts to get *Sigismunda* published and placed before the general public. On 2 January 1764, with his writing much shakier than before, Hogarth again opened the subscription book: "All efforts to this time to get this Picture finely Engraved proving in vain, Mr Ho-

garth humbly hopes his best indeavors to Engrave it himself will be acceptable to his friends."[18]

Sometime before June he abandoned the idea of engraving more than the head himself. He turned to the young Edward Edwards, employing him to make a drawing of the painting from which an engraver could work.[19] On 12 June Hogarth copied out his account, apparently for some friend, of how he had come to paint *Sigismunda*. The words are almost exactly the same as those in the subscription book for *Sigismunda,* but the tone of the conclusion above his signature calls to mind the ambivalent finale to his "Autobiographical Notes," or the *Tail Piece:* "[*Sigismunda*] was after much time and the utmost efforts finished, BUT HOW! the Authors death as usual can only positively determine. / Wm Hogarth." And on the same day, thinking about the same subject, he wrote his last surviving letter, to his old friend Hay:

Leicester fields June 12 1764

Dear Dr Hay

As you have always been so good as to interest yourself in my trifling affairs, I flatter myself you you [sic] will not be displeased at my sending you the Drawing to see, which has been made by one Mr Edwards from my Picture of Sigismonda for the Engraver. The Print will have much the same appearance as the drawing in general but more delicate, the Engraver Mr Basire who has a surest command of the Burin being determin'd to make it his masterpiece in order [to] show what he can do.

I am dear Sr your
much obliged humble Svt
Wm Hogarth.

I shall take care of the head myself. The Engraver being out of town the drawing can be spared for some time.[20]

It is apparent that in June Hogarth still intended to engrave something after the *Tail Piece,* but got no further than the planning stages. Nichols heard that Hogarth first employed Grignion to engrave *Sigismunda* and then, dissatisfied, turned to Basire.[21] Basire, William Blake's master, had etched Hogarth's sketches of Fielding and Morell and his illustration for Garrick's *Farmer's Return,* producing a light, wavering line better suited to reproducing classical antiquities than Hogarth's designs. *Sigismunda* might have lent itself more to his ap-

proach. While engraving Edwards's drawing of Hogarth's painting he was also preparing for the Society of Antiquaries two plates of an antique bronze so grotesque that, according to one story, Hogarth was willing to see him postpone *Sigismunda* to finish this, declaring that "he could not have imagined that the Antients had possessed so much humour."[22] Perhaps as a result, the engraving of *Sigismunda* was still hardly more than an etching when Hogarth died.

Hogarth had saved all the letters connected with both the Grosvenor and Charlemont commissions, as contrasting examples of patronage, and he now pasted these into his subscription book following the subscription list, together with drafts of his own letters to Grosvenor and a running commentary. The former subscription for *Sigismunda* had been followed by the artists' exhibition, the painting's showing and withdrawal, and (according to Nichols) an attempted raffle in 1762 using as ticket *Hymen and Cupid,* engraved many years before for Thomson's *Masque of Alfred.*[23] The painting's various misfortunes had been played up by Wilkes and others, and, as Hogarth put it in his subscription book, "things having been represented, in favour of his Lord[p] [i.e. Grosvenor] much to M[r] H[s] dishonour, the foregoing plain tale is therefore submitted to Such as may at any time think it worth while to see the whole truth, of what has been so publicly talked of."[24]

The engraving did not materialize and the painting remained unsold, the price set at £400. And so it remained during Jane Hogarth's lifetime, at last finding a buyer at her sale in 1790. It went, appropriately, to Alderman John Boydell, whose Shakespeare Gallery was inspired by such works as Hogarth's *Garrick as Richard III* and perpetuated the sort of painting Hogarth produced in *Sigismunda.* Boydell paid £58 16s.[25]

The *Election* was Hogarth's last successful painting-engraving enterprise. He vowed that he would not engrave a painting again, and—despite the attempt to have *Sigismunda* (and also apparently *The Lady's Last Stake*) engraved—he lived up to his word.[26] We saw in volume 2 that when he had explored the painting-engraving relationship at its most complex in *Marriage A-la-mode* (where he employed French engravers on the reproductions), he stopped and diagramed the polarization in the free and painterly "Happy Mar-

riage" paintings and the popular engravings of *Industry and Idleness*. The "Happy Marriage" series was his first attempt to carry his love of pure paint and form to a point where there could be no engraved equivalent—until, significantly, he used one of them (*The Wedding [or Country] Dance,* fig. 24) as a point of departure for his aesthetics in *The Analysis of Beauty*. But the *Analysis* also implied that an engraving was, with a candlestick or corset, as aesthetic an object as a painting.

From the beginning Hogarth had developed in the engravings his interest in the meaning of objects and actions and in the paintings his interest in their essential forms. Shape was used to relate objects in a scene but also to isolate them, making them slightly out of place in their context. The tendency of his theme as well as his own predilection was toward painting the discrepant details of a milieu. In fact, the needs of the engraving led him to change the forms and assumptions of his paintings, producing a tension between painting and engraving that wrought changes in both, working both ways. Jack Lindsay puts the issue very well when he writes that Hogarth in his paintings "had to think of the engravings to come even when that went against the grain of his painterly impulses." Therefore, in his mature paintings, and in particular *The March to Finchley* and the *Election* paintings, he "packed his spaces, worked out systems of light and shade that would be effective in engravings rather than using a method of baroque gradations towards a light center . . ."—a procedure that less compromised his painterly instincts than pushed his paintings in new directions explored by no other contemporary artist.[27]

If we regard painting and print as a kind of Hogarth dialectic, we can define the synthesis as that area he was seeking in the 1750s as the Beautiful. The painting and the print joined in the "Beauty" of the joy of pursuit; in the painting this took the form of the artist's exploration of brush and pigment on the canvas; in the print it was the spectator's exploration of its patterns of meaning. Then, taking the objective aspect of Hogarth's "Beauty," we can say that he represented in the doubleness of painting-print a jointure of the ideal and real, the universal and contingent, and (in aesthetic terms) unity and variety. In the painting the ideal of form and color predominates, in some degree of tension with the contingencies and particularities of the representation. In the print the close representation of the contingencies carries a message, juxtaposing the real shapes and details of a

London prostitute with allusions to the imaginatively ideal forms of Hercules, the Virgin Mary, Diana, and the paintings of Raphael. The painting itself was the ideal; the print, the real; and so—as they were originally exhibited side by side in Hogarth's shop—they required each other in tandem for fulfillment of the Hogarthian "Beautiful."

But in this last decade the painting and engraving drew further apart on their separate courses, producing two independent kinds of art. Hogarth's perennial dissatisfaction with engravers who could not make satisfactory equivalents of his paintings came to a head in the endless trial proofs of *Election* 1. In the 1761 Society of Artists' Exhibition *Sigismunda,* the latest of his paintings, was criticized and withdrawn, while his engravings for the catalogue were immensely popular (figs. 83, 84). His painting of *Hogarth Painting the Comic Muse* had little or no connection with the engraving: the first is a private Rembrandtesque modello, the second a public logo (figs. 51, 52). The lovely oil sketch for *The Bench* is lost in the complex patterns and inscriptions of the print—to which he continued to make diagrammatic additions until the day of his death (figs. 59, 60, 114). His last days were preoccupied with revision and commentary focused on the engravings.

Otherwise, in his final years, Hogarth kept to paintings without engravings and engravings without paintings; engravings that are monumental and powerful (indeed painterly) compositions, and paintings, culminating in the *Election,* that attempt to express the utmost within the medium of paint itself, including the exigencies of the engraving. Painting and print were now separate and could develop independently the strengths of each mode: the engravings include not only the simple blockprint forms of the popular prints of 1751 but also the elaborate painterly effects of the *Analysis of Beauty* plates, *The Cockpit,* and *Enthusiasm Delineated.*

The Hogarth folio, removing the print from the status of furniture hung at some distance on a wall, forced the viewer to read—creating, in Arthur Danto's words, "a different, more intimate relationship with the image than that of looking at a virtual scene through a window on the wall, which was the standard way of thinking about tablaux." But the close-up experience of folio reading was also the equivalent of blowing up the engraving to the scale of a history painting, perhaps ten times its size (as indeed David Hockney did literally when he copied Hogarth's *Satire on False Perspective*).[28]

Both painting and print were attempts to find a new point of ori-

gin for a school of English painting, as a corrective to the Continental longings of his colleagues. The painterly equivalent of the great popular prints of 1751 he found in the English shop sign or signboard; but by this time, theory outstripping practice, he could only project his idea in an "exhibition" of signboards in competition with the exhibition of conventional paintings by his colleagues in the Society of Artists. The sense of that exhibition was summed up—its positive proposals, its despairing description of the times—in the engraving, the *Tail Piece*.

Hogarth must have recognized that as fluent and often wonderful as his paintings were, they were not the masterpieces of Raphael, Rubens, and Watteau; his unique contribution to English and (as he emphasized) European culture was the Hogarth print. As an art work it was—however indebted in its origins—essentially sui generis and unequaled "in its way." As he must also have realized, the phrase "in its [or *his* or *This*] way" was usually meant as a thoughtful compliment (more often than not intended to express admiration without condescension) indicating that his particular mode was outside the usual categories of art; although the phrase suggests that Hogarth has not *transcended* the old categories, it does acknowledge that he has *augmented* them.

THE LAST DAYS

James Barry, whose history painting ambitions were very like Hogarth's, arrived in London in the last year of Hogarth's life. Years later he remembered his one glimpse of the old painter. He was walking with the sculptor Joseph Nollekens through Cranbourne Alley when Nollekens exclaimed, "There, there's Hogarth."

> 'What!' said I, 'that little man in the sky-blue coate?' Off I ran, and though I lost sight of him only for a moment or two, when I turned the corner into Castle-street, he was patting one of two quarrelling boys on the back, and looking steadfastly at the expression in the coward's face, cried, 'Damn him! if I would take it of him; at him again!'[29]

That is as good a final glimpse of Hogarth in 1764 as one could wish for.

On Sunday 19 February 1764 John Courtney made his last stop at Leicester Fields during Hogarth's lifetime. It does not sound as if he saw the artist: "Drank Tea at my Cousin Miss Beres at Mr Hogarths." His next visit was in 1766 ("calld at Mrs. Hogarths"). On 2 March a letter from Jane Hogarth to the Reverend Dr. Coningsby in Pencomb near Bromyard noted that she was sending him "best Impressions" of a set of Hogarth's prints and *The Analysis of Beauty* (£15 11s for the whole).[30]

The last spring and summer are not further documented except for the *Tail Piece,* the final *Sigismunda* project, and the revision of old plates. No great events were unfolding around him: the political excitement had died down with the peace and Bute's resignation in 1763, and the flight of Wilkes to France at the very end of the year. Blackfriars Bridge was under construction, and in May the artists again exhibited at Spring Gardens. Reynolds contributed, his full-length portraits now selling for 150 guineas, his half-lengths for 70; he had been unaffected by the political struggles of the last years, in the midst of which his "painting-room was neutral ground, where as yet all parties might meet."[31] On 18 June a bad storm hit London, inflicting £2000 worth of damage on St. Bride's steeple (one of those Hogarth had admired in the *Analysis*).[32]

In June Benjamin Franklin wrote Hogarth ordering a set of his complete works for the Philadelphia Library Company. The letter was transmitted through the publisher William Strahan, who reported that it was delivered to Hogarth, "but he was soon after taken ill, and still continues so dangerously bad, that he could not yet comply with the Order." Strahan's letter was written on 19 September.[33]

On 16 August Hogarth wrote his will.[34] The copperplates were his main bequest, both a source of revenue and (we have seen) an extension of himself. He stipulated that they were not to be "Sold or Disposed of without the consent of my Said Sister and my Executrix," Jane Hogarth; that they remain in the possession of Jane for her natural life "if she continues Sole and Unmarried and from and immediately after her Marriage my Will is that the three Sets of Copper Plates, called Marriage Alamode, the Harlots Progress and the Rakes Progress,"—evidently his best-selling prints—"shall be Delivered to my said Sister." If Jane died, they were all to go to Anne. Beyond

this, unspecified moneys and securities were bequeathed to Jane, and of course the properties in Leicester Fields and Chiswick. An £80 annuity was bequeathed to Anne; to Jane's cousin Mary Lewis, "for her faithful Service," £100; and to Miss Bere (John Courtney's relative), a ring valued at 5 guineas. Samuel Martin was remembered with Hogarth's portrait of him, and Dr. Isaac Schomberg with a ring valued at 10 guineas.[35]

By September Hogarth was apparently too sick to handle the Serjeant Painter's routine business, and Samuel Cobb, his deputy, begins to appear in the records.[36] In September and October he was in Chiswick, working with assistants on the revision of his copperplates. On Friday 25 October he was conveyed "in a weak condition, yet remarkably cheerful," from Chiswick to the house in Leicester Fields. Mrs. Hogarth evidently remained in Chiswick; thus it would appear that he was not considered to be in immediate danger. A letter from Benjamin Franklin was awaiting him—perhaps inquiring about his health, unless it was the first letter, which had never been answered. Nichols describes his last hours:

> receiving an agreeable letter from the American Dr. Franklin, [he] drew up a rough draught of an answer to it; but going to bed, he was seized with a vomiting, upon which he rung his bell with such violence that he broke it, and expired about two hours afterwards in the arms of Mrs. Mary Lewis, who was called up on his being taken suddenly ill. . . . Before our Artist went to bed, he boasted of having eaten a pound of beef-steaks for his dinner, and was to all appearance heartier than he had been for a long time before. His disorder was an aneurism.[37]

He died sometime in the night between 25 and 26 October, just a few days short of his sixty-seventh birthday.

His body was returned to Chiswick, a cast was taken of his right hand, and one week later, on Friday, 2 November, he was buried in St. Nicolas's churchyard.[38] The plot already contained the body of Lady Thornhill, and not far away was the grave of his friend James Ralph. Inside the church, in the Burlington vault, lay his old antagonists Lord Burlington and William Kent. In 1771 his sister Anne was buried next to him and a monument was erected with an epitaph by David Garrick (fig. 115).[39] In 1789, after twenty-five years of selling

his prints and furthering his reputation, Jane Hogarth joined him, and in 1808 Mary Lewis.[40]

The plate he was working on when he died was *The Bench* (fig. 114): still concerned that his stand on character-caricature be understood, he erased a strip across the top of the plate and began to introduce faces in varying degrees of caricature, rather like those beneath *Characters and Caricaturas*. Only the sharp-nosed judge is repeated: the other heads are once again those from *The Sacrifice at Lystra* and other Raphael Cartoons—perhaps from Thornhill's old sketches of the heads. It is fitting that Hogarth, like Thornhill, should end his career with these Raphael heads. His career had been devoted to finding ways to use Raphael and to equal him in eighteenth-century England. On the unfinished plate as it stands one of his assistants has added, "This Plate would have been better explain'd had the Author lived a Week longer."

Of the obituaries that immediately followed his death, only that of the *London Evening Post,* with which he seems to have had the longest association, went beyond the facts of death. In its issue for 28–30 October it devoted a paragraph to his talents and virtues:

> In him were happily united the utmost force of human genius, an incomparable understanding, an inflexible integrity, and a most benevolent heart. No man was better acquainted with the human passions, nor endeavoured to make them more subservient to the reformation of the world, than this inimitable artist. His works will continue to be held in the highest estimation, so long as sense, genius and virtue, shall remain amongst us; and whilst the tender feelings of humanity can be affected by the vices and follies of mankind.

His friends left little record of their reactions. Garrick had written to Colman from time to time asking him to give his love "to all the Schombergs, Townleys, Kings, Hogarths, Churchills, Huberts &c. &c." In his letter to Colman of 10 November he commented on the shock of hearing of the death of the duke of Devonshire, a Mr. Hubert, and Hogarth all at once: he waxes most agitated over the duke, who died 3 October in Spa, only a few days after Garrick had visited him. "I heard nothing of Hubert & Hogarth before your letter

told me of their Deaths—I was much affected with your News, the loss of so many of my acquaintance in so short a time is a melancholy reflection." And he adds: "Churchill I hear, is at y^e point of death at Boulogn . . ."[41]

Horace Walpole wrote to Lord Hertford on 3 November, with perhaps an unintended anticlimax: "Hogarth is dead, and Mrs. Spence, who lived with the Duchess of Newcastle."[42] He had already written *The Castle of Otranto* (published in December, dated 1765), where he isolates the Hogarthian Beautiful in the curiosity of the simple-minded servants who try to understand the sublime activity going on around them among their betters, which in fact (as Hogarth would have noted) proves to be no more than a mundane issue of property and inheritance, but is framed by the Burkean scenario of the flight of the beautiful Isabella, pursued by the tyrant Manfred, who intends to rape her in order to retain possession of Otranto.

The *Gazetteer* of 31 October reported: "We hear that great interest is making by two eminent painters at the west end of the town, to succeed Mr. Hogarth as Painter to his Majesty's Board of Works." On 2 November James Harris wrote to George Grenville, the prime minister, recommending James (Athenian) Stuart for the "office of Pannel Painter to the crown being now vacant by the death of Mr. Hogarth," and on 21 November the Serjeant Paintership was awarded to Stuart, the antiquarian draughtsman whom Hogarth had ridiculed in *The Five Orders of Periwigs*—the scion of the Dilettanti and the Society of Arts.[43]

On 4 November, nine days later, Charles Churchill died of a fever in Boulogne. The projected elegy on Hogarth had never materialized, but in *Independence,* published in early October, Churchill had made one last strange allusion to Hogarth. He is describing himself just as Hogarth drew him in *The Bruiser:*

> A Bear, whom from the moment he was born,
> His Dam depis'd, and left unlick'd in scorn. . . .
> A Subject, met with only now and then,
> Much fitter for the pencil than the pen;
> HOGARTH would draw him (Envy must allow)
> E'en to the life, was HOGARTH living now. (ll.149–50, 177–80)

Since Hogarth did not die until the 26th, Churchill must have heard a false report of his death; or he is extending the *Epistle*'s fiction of

Hogarth's annihilation (the death of his genius). But he has incorporated—in effect appropriated—all the elements of *The Bruiser,* turning them into a positive image of plebeian Englishness (the Bard vs. the Lord, natural genius vs. chance birth). The bear, Hercules, oak stump, and the ragged signs of clerical attire are all here (ll. 149–74) reassembled into a persona who contests Hogarth's own self-image of the people's artist.

Walpole mentioned to Horace Mann the coincidence of Churchill's death nine days "after his antagonist Hogarth. Was I Charon," he added, "I should without scruple give the best place in my boat to the latter, who was an original genius."[44] Their deaths cemented the importance of their relationship, which might otherwise have been recorded as an interlude. The myth has endured that Churchill's *Epistle* "accelerated" Hogarth's death, but as the author of Hogarth's obituary in the *Public Advertiser* of 8 December 1764 put it: "we may as well say that Hogarth's pencil was as efficacious as the Poet's pen, since neither long survived the contest."[45]

A "Dialogue of the Dead" between Hogarth and Churchill was inevitable, and appeared in the *Public Advertiser* of 30 January 1765. Churchill confesses that all his fine pose of patriotism was only "French cookery," and Hogarth concedes, "I will freely own to you, that I suffered not so much from the Keenness of your Calumny however, as concerning the ill Reception my Answer of it met with from the Public." Replies Churchill, "Set as lightly by my Pen as you please, Sir, I assure you it was universally reported upon your Death, that the Wounds I gave you had proved mortal; but, from your own Account of the Matter, I am rather disposed to think you died a Suicide." Hogarth responds, "You may be satisfied, that my Life was ended neither by your Hand nor by my own. I was not so lamentably void of Philosophy, not to say common Sense, as to turn Trifles into Matters of Life and Death; nor can I at all be surprized at any Falsehood of vulgar Report." Then they see Lloyd coming up to join them (he too had just died). The tone throughout is mellow, past feuds forgotten.

A final word from Wilkes was reported by Colman in a letter to Wilkes on 21 June 1765: "at Paris I have heard you regret the difference between you & Hogarth. Resentment dies, the remembrance of old intercourse rekindles our good will, & we wish to have been able to have smothered the hasty sparks of passion."[46]

Already on 2 February 1765 Jane Hogarth was advertising that "The Works of Mr. Hogarth, in separate Prints or complete Sets, may be had, as usual, at his late Dwelling-house, the Golden Head, in Leicester Fields; and NO WHERE ELSE." Impressions were still being turned off: "Commissions from abroad will be carefully executed; and particular Regard had to the correctness of the Impressions."[47]

In 1766 she employed the Reverend John Trusler to write explanations of the prints, along the line of her husband's last project, and on 5 August announced in the papers: "As many Beauties in the late Mr. HOGARTH'S Prints have hitherto escaped Notice for Want of a minute Explanation, Mrs. Hogarth has now engaged a Gentleman to explain each Print, and moralize on it in such a Manner as to make them as well instructive as entertaining."[48] We must assume that Trusler's egregiously reductionist moralizing (it has come to be known as "Truslerizing") met with Jane Hogarth's approval. *Hogarth Moralised* was sold at the Golden Head along with the prints. Perhaps this was how she had seen her husband's prints—or wanted to see them—all along; the times were also changing, and the sober morality of the prints had to be emphasized at the expense of their wit and what Hogarth himself would have called in his commentary on the prints their variety and truth to "nature." But Jane ("old Widow Hogarth") acknowledged *this* aspect of her husband's work when she used to show visitors the "Market Wench" (*The Shrimp Girl*) and exclaim, "They say he could not paint flesh. There's flesh and blood for you; —— them!"[49]

Hogarth's life work was apparently undone by the founding of the Royal Academy and the long hegemony of Reynolds, whose urbane *Discourses* instructed the next generation in the copying of various grand manners. Hogarth had no direct heirs in the main (the academic, the Sublime) line of English painting. "In his way" Johan Zoffany, the German-born artist (a pupil of Benjamin Wilson's), carried on the playfully subversive aspects of the conversation picture, while George Stubbs developed the primitivist (producing contemporary histories of great power focused on animals) and Joseph Wright of Derby the skeptical aspects (secularizing, demystifying, and aestheticizing sacred icons). Gillray and Rowlandson, labelled "caricaturists," were regarded as minor because comic draftsmen.

Ironically, Hogarth's influence remained indirect and peripheral but decisive in two great landscape painters. Thomas Gainsborough (introduced to art in the St. Martin's Lane Academy) drew upon Hogarth's witty aesthetics, producing a kind of picture that can be called in spirit Hogarthian, perhaps in a way that justified Uvedale Price's Hogarthian definition of the Picturesque. There survived, in short, during the decades following Hogarth's death, a vibrant though sub rosa antiacademic tradition that derived its assumptions about art from Hogarth. The most notable case, however, was J. M. W. Turner, a painter of the Burkean Sublime who nevertheless glossed it (often impertinently) with the mundane Hogarthian details, detritus, and contingencies. His major history paintings were endless versions of the *Tail Piece* which reversed the ratio of broken images to landscape, reducing the first and enormously expanding the second, carrying on Hogarth's losing battle of Beautiful against Sublime, man (or woman) against the "Fallacies of Hope." Turner (who also supplied that Hogarthian disideratum, a "Distressed Painter") acknowledged this apparently paradoxical filiation by donating Hogarth's palette to the Royal Academy (his chief rival, Constable, donated Reynolds's).[50]

Notes

ABBREVIATIONS AND SHORT TITLES

Analysis	William Hogarth, *The Analysis of Beauty* (1753), ed. Joseph Burke (Oxford, 1955).
Antal	Frederick Antal, *Hogarth and His Place in European Art* (London, 1962).
Apology for Painters	Hogarth's "*Apology for Painters*," ed. Michael Kitson, Walpole Society, 41 (Oxford, 1968): 46–111.
AN	William Hogarth, "Autobiographical Notes," in *The Analysis of Beauty,* ed. Joseph Burke (Oxford, 1955).
Battestin, *Fielding*	Martin C. and Ruthe R. Battestin, *Henry Fielding: A Life* (London, 1989).
Beckett	R. B. Beckett, *Hogarth* (London, 1949).
Biog. Anecd.	John Nichols, George Steevens, Isaac Reed, et al., *Biographical Anecdotes of William Hogarth* (London, 1781, 1782, 1785).
BL	British Library
BM	British Museum
BM Sat.	*British Museum Catalogue of . . . Political and Personal Satires* (London, 1873–1883).
Commons	*Dictionary of the House of Commons: 1709–1754,* ed. Romney Sedgwick (London, 1970); *1754–1790,* ed. Sir Lewis Namier and John Brooke (London, 1964).
Croft-Murray	Edward Croft-Murray, *Decorative Painting in England, 1537–1837, 1: Early Tudor to Sir James Thornhill* (London, 1962); *2: Eighteenth and Early Nineteenth Centuries* (London, 1970).
DNB	*Dictionary of National Biography,* ed. Leslie Stephen and Sidney Lee, 66 vols. (London, 1885–1901).
Dobson	Austin Dobson, *William Hogarth* (London, 1907 ed.).
ECS	*Eighteenth-Century Studies*

Edwards, *Anecdotes* Edward Edwards, *Anecdotes of Painters who have resided or been born in England . . . Intended as a Continuation to the Anecdotes of Painting of the Late Horace Earl of Orford* (London, 1868).

Garrick Letters *The Letters of David Garrick,* ed. D. M. Little and G. M. Kahrl, 3 vols. (Cambridge, Mass., 1963).

Gen. Works John Nichols and George Steevens, *The Genuine Works of William Hogarth,* 3 vols. (London, 1808–1817).

GM *The Gentleman's Magazine*

HGW Ronald Paulson, *Hogarth's Graphic Works: First Complete Edition* (New Haven, 1965; revised eds., 1970; London, 1989).

HLAT Paulson, *Hogarth: His Life, Art, and Times.* 2 vols. (New Haven, 1971).

HMC *Historical Manuscripts Commission*

J. Ireland John Ireland, *Hogarth Illustrated,* 3 vols. (London, 1791–1798; 1805 ed.)

S. Ireland Samuel Ireland, *Graphic Illustrations of Hogarth,* 2 vols. (London, 1794–1799).

Jarrett Derek Jarrett, *The Ingenious Mr. Hogarth* (London, 1976).

Lindsay Jack Lindsay, *Hogarth: His Art and His World* (London, 1977).

Lippincott Louise Lippincott, *Selling Art in Georgian London: The Rise of Arthur Pond* (New Haven, 1983).

LM *The London Magazine*

LS *The London Stage,* pt. 2: 1700–1729, ed. Emmett L. Avery, 2 vols; pt. 3: 1729–1747, ed. Arthur H. Scouten; pt. 4: 1747–1776, ed. George Winchester Stone, 3 vols. (Carbondale, Ill. 1960–1962).

Mellon, Yale Paul Mellon Collection, Yale Center for British Art

Moore Robert E. Moore, *Hogarth's Literary Relationships* (Minneapolis, 1948).

NPG John Kerslake, *National Portrait Gallery: Early Georgian Portraits,* 2 vols. (London, 1977).

J. B. Nichols J. B. Nichols, *Anecdotes of William Hogarth* (London, 1833).

Nichols, *Literary Anecdotes* John Nichols, *Literary Anecdotes of the Eighteenth Century,* 9 vols. (London, 1812–1815).

Oppé A. P. Oppé, *The Drawings of William Hogarth* (London, 1948).

Paulson 1975 Ronald Paulson, *The Art of Hogarth* (London, 1975).

Paulson 1979	Paulson, *Popular and Polite Art in the Age of Hogarth and Fielding* (South Bend, 1979).
Paulson 1982	Paulson, *Book and Painting: Shakespeare, Milton, and the Bible* (Knoxville, 1982).
Paulson 1989	Paulson, *Breaking and Remaking: Aesthetic Practice in England, 1700–1820* (New Brunswick, 1989).
Paulson, *E and E*	Paulson, *Emblem and Expression: Meaning in English Art of the Eighteenth Century* (London and Cambridge, Mass., 1975).
Phillips	Hugh Phillips, *Mid-Georgian London* (London, 1964).
Pye	John Pye, *Patronage of British Art* (London, 1845).
Quennell	Peter Quennell, *Hogarth's Progress* (New York, 1955).
Roberts	J. M. Roberts, *The Mythology of the Secret Societies* (New York, 1972).
Rouquet	Jean André Rouquet, *Lettres de Monsieur** à un de ses amis à Paris* (London, 1746).
J. T. Smith	J. T. Smith, *Nollekens and His Times* (1828), ed. Wilfred Whitten, 2 vols. (London, 1917).
Spectator	*The Spectator,* ed. Donald F. Bond, 5 vols. (Oxford, 1965).
Tate	Elizabeth Einberg and Judy Egerton, *Tate Gallery Collections, II: The Age of Hogarth, British Painters Born 1675–1709* (London, 1988).
V & A	Victoria and Albert Museum, London
Vertue	George Vertue, *Notebooks,* 6 vols. (Oxford Walpole Society, 1934–1955).
Walpole, *Anecdotes*	Horace Walpole, *Anecdotes of Painting in England,* 4 (1771, released 1780), ed. James Dallaway (London, 1828).
Walpole, *Corr.*	*The Yale Edition of Horace Walpole's Correspondence,* ed. W. S. Lewis (New Haven, 1937–1983).
Walpole, *George II*	Horace Walpole, *Memoirs of King George II,* ed. John Brooke (New Haven, 1985).
Walpole, *George III*	Walpole, *Memoirs of the Reign of King George III* (Philadelphia, 1845).
Waterhouse	Ellis Waterhouse, *Painting in England, 1530 to 1790* (London, 1953).
Waterhouse, *Three Decades*	Waterhouse, *Three Decades of British Art* (Philadelphia, 1965).
Whitley	W. T. Whitley, *Artists and Their Friends in England, 1700–1799,* 2 vols. (London, 1928).

PREFACE

1. Shaftesbury, "Advice to an Author," in *Characteristics of Men, Manners, Opinions, Times, etc.*, ed. John M. Robertson (New York, 1900), 1: 214. As Addison put it in *Spectator* No. 29 (3 Apr. 1711): "Music, Architecture and Painting, as well as Poetry and Oratory, are to deduce their Laws and Rules from the general Sense and Taste of Mankind, and not from the Principles of those Arts themselves; or, in other Words, the Taste is not to conform to the Art, but the Art to the Taste." Jonathan Richardson, Hogarth's old friend, who had died in 1745, also theorized on the practice of painting, addressing himself to the artist in *The Theory of Painting* (1715), but he supplemented this in 1719 by his *Science of the Connoisseur,* which addressed the spectator and (it often followed) purchaser of the painting. See vol. 2.

2. "Philosophical criticism," as this was usually called, was not referred to in England as "aesthetics" until the end of the century. See Howard Caygill, *The Art of Judgement* (London, 1989), 38.

3. Eagleton, *The Ideology of the Aesthetic* (London, 1990), 13.

4. See McKeon, "Politics of Discourses and the Rise of the Aesthetic in Seventeenth-Century England," in *Politics of Discourse: The Literature and History of Seventeenth-Century England,* ed. Kevin Sharpe and Steven N. Zwicker (Los Angeles and Berkeley, 1987), 35–51. For example, on the left, the dissenter Philip Doddridge could write: "It is certainly the duty of every rational creature to bring his religion to the strictest test, and to retain or reject the faith in which he has been educated, as he finds it capable or *incapable of rational defence.*" And on the right, Charles Leslie could write: "God never required any man to believe *anything that did contradict any of his outward senses*" (Doddridge, *Correspondence and Diary* [London, 1829–1831], 2: 423; Leslie, *Theological Works,* [Oxford, 1832], 2, "The Socinian Controversy Dismissed").

5. Barrell, *The Political Theory of Painting from Reynolds to Hazlitt* (New Haven, 1986). For an effective critique of Barrell's narrative and his use of J. G. A. Pocock's term "civic humanism," see Andrew Hemingway, "The Political Theory of Painting without the Politics," *Art History,* 10 (1987): 381–94.

6. In some ways it parallels my account of the other, usually ignored aspect of aesthetics, the *making* of the aesthetic object (Paulson 1989)—whose emphasis is on "practice"—perhaps reasonably ignored by aestheticians since aesthetics *is* literally the study of perception not production.

7. William C. Dowling, "Ideology and the Flight from History in Eighteenth-Century Poetry," *The Profession of Eighteenth-Century Literature,* ed. Leo Damrosch (Madison, 1992), 140. See Bertrand A. Goldgar, *Walpole*

and the Wits: The Relation of Politics to Literature, 1722–1742 (Lincoln, 1976), esp. 137–50.

1. HOGARTH'S REPUTATION

1. This section is a revision of my note, "Smollett and Hogarth: The Identity of Pallet," *Studies in English Literature,* 5 (1965): 351–59. (Cf. J. L. Clifford's edition of the first edition of *Peregrine Pickle* [Oxford, 1965], 787–88.)

2. The portrait of Akenside, though not noticed by reviewers, was recognized by his earliest biographers: Johnson, Anderson, Dyce, and Gilfillan, as well as by Smollett's biographers. See Howard Buck, "Smollett and Dr. Akenside," *Journal of English and Germanic Philology,* 31 (1932): 10–26; C. T. Houpt, *Mark Akenside: A Biographical and Critical Study* (Philadelphia, 1944), 126–29.

3. Chap. 46. Quotations are from Clifford's edition.

4. Vertue, 3: 124; see also *Biog. Anecd.,* 50.

5. Pallet's Christian name, Layman (mentioned only once, in chap. 68), suggests the lay figure artists used as a model.

6. Chap. 47. A few chapters before Pallet appears (chap. 40), Peregrine travels from Calais to Boulogne, where at dinner he encounters the cook who, in Hogarth's print, is struggling under the weight of a sirloin of beef: "a tall, long-legged, meagre, swarthy fellow, that stooped very much; his cheek-bones were remarkably raised, his nose bent into the shape and size of a powder-horn, and the sockets of his eyes as raw round the edges, as if the skin had been paired off; on his head he wore an handkerchief, which had once been white, and now served to cover the upper part of a black periwig, to which was attached a bag, at least a foot square . . . his middle was girded by an apron tucked up, that it might not conceal his white silk stockings rolled." (See Moore, 169–71; Moore notices other echoes in *The Reprisal* and *Ferdinand Count Fathom* [chap. 28].)

7. There are other references to Hogarth's prints scattered through these chapters: for example, by 1751 a reference to Moll King's tavern (chap. 70), which closed in 1739, could only have recalled Hogarth's picture of it in the first of *The Four Times of the Day* (1738). Pallet's criticisms of "the foreshortening of that arm" and the "absolute fracture in the limb" in one of the paintings in the Palais Royal (chap. 46) may have been based on Smollett's memory of Hogarth's *Burlesque of Kent's Altarpiece* (1725), which parodied Kent's anatomical shortcomings.

8. There is, however, Dr. John Moore's statement that Smollett was in Paris in the summer of 1750, and that "the painter, whom Smollett afterwards typified under the name of Pallet, was in the capital of France at that

time" ("Life of T. Smollett, M.D.," in Moore's edition of Smollett's *Works* [London, 1797], 1: cxxiii). Hogarth was not, so far as is known, in Paris in 1750; and the painter's opinion of Paris as being "very rich in the arts," is hardly Hogarth's. But neither is it Pallet's. The passage Moore echoes (and has perhaps conflated) appears in chapter 46: "France, to be sure, is rich in the arts, but what is the reason? the king encourages men of genius with honour and rewards: whereas, in England, we are obliged to stand upon our own feet, and combat the envy and malice of our brethren; agad! I have a good mind to come and settle here in Paris; I should like to have an apartment in the Louvre, with a snug pension of so many thousand Livres." This statement is perfectly consistent with Hogarth's views of patronage in England, of both church and nobility; the emphasis falls on the Englishman's need to "stand upon our own feet"—which in Hogarth's own case meant turning to a popular audience. However, if Moore's memory is accurate, Smollett may have made a composite portrait. Pallet's threadbare condition, his physical cowardice, his duel with the doctor, and the various pranks played on him by Peregrine are either references to someone other than Hogarth or (perhaps more likely) merely the same reductive decoration that appears in Smollett's descriptions of Newcastle (Fikakaka) and others in *The Adventures of an Atom* (1766).

9. *London Evening Post,* 28–30 July 1748; *Letter Book of Thomas Edwards,* Bodley MS. 1011. See Paulson and T. Lockwood, *Henry Fielding: The Critical Heritage* (London, 1969), 320, 42, 160, 370, 373.

10. The line is evident in the Abbé Jean-Bernard Le Blanc's *Lettre sur l'exposition des ouvrages de peinture, sculpture, etc. de l'année 1747* (Paris, 1747), but becomes concentrated in Jean-Baptiste d'Argens's *Réflexions critiques sur les différentes écoles de peinture* (Paris, 1752), 258, and La Font de Saint-Yenne's *Sentiments sur quelques ouvrages de peinture, sculpture et gravure écrits à un particulier en province* (Paris, 1754), 132. For others, see James A. Leith, *The Idea of Art as Propaganda in France, 1750–1799* (Toronto, 1965), 8–9.

11. Le Blanc, *Letters on the English and French Nations* (Dublin, 1747), 1: 156–57, 158–59.

12. Ibid., 161–63.

13. *GM,* 7 (1737): 517; quoted, Pye, 44n.

14. *Conference between a Painter and Engraver containing some useful Hints and necessary Instructions proper for the young Artist* (London, 1736), 30.

15. *Human Physiognomy Explain'd* (1747), iv–v.

16. Gwynn, *An Essay on Design* (London, 1749), 17–18, 42–43.

17. Nikolaus Pevsner, *Academies of Art Past and Present* (Cambridge, 1940), 42.

18. Pevsner, 13, 16–17, 54–55. For a study of the French Academy at this time, see J. Locquin, *Peinture d'histoire en France de 1747 à 1785* (Paris, 1912).

19. Pevsner, 91; *Apology for Painters,* 92.

20. Rouquet, *State of the Arts in England* (London, 1755), 27.

21. *The Diary of Joseph Farington,* ed. Kathryn Cave (New Haven, 1982), 5: 1988–99. Vertue's earliest reference to Moser (b. 1704) was in the spring of 1742; he writes as if Moser had recently arrived from Geneva and was then studying at the St. Martin's Lane Academy (3: 107). His reference in 1744/45 does not make it clear whether Moser was a student or teacher (3: 123). In 1745 he lists Moser as chaser at the academy (3: 127) and again in 1746 (6: 170). See also J. T. Smith, 1: 54, and Edwards, *Anecdotes,* 1: xxi; Whitley, 1: 27, while mistakenly dating Moser's merger with Hogarth's academy as around 1735, adds (strengthening the later date) that he was supported in his Salisbury Court school (at one time carried on in Greyhound Court, Arundel Street) by Marcus Tuscher and James (Athenian) Stuart.

22. *Apology for Painters,* 94.

23. Dobson, 147.

24. Pye, 44, 74–75.

25. *Apology for Painters,* 95.

26. Rouquet, *State of the Arts,* 23–24. Hogarth's academy had a fixed subscription of 2 guineas for a member's first season, 1½ thereafter, and this entitled all participants to equal rights.

27. Sir Robert Strange, *An Enquiry into the Rise and Establishment of the Royal Academy of Arts* (1775), 61.

2. POPULAR AND POLITE PRINTS

1. The advertisement was repeated frequently, and in the *London Evening Post* for 23–26 February the third paragraph was revised to read: "This Day were also publish'd, four Prints on the Subject of Cruelty, Price and Size the same."

2. On Fielding's transformation as seen by contemporaries, see Battestin, *Fielding,* 389, 421–23, 475.

3. *A Charge Delivered to the Grand Jury,* in Fielding, *An Enquiry into the Causes of the Late Increase of Robbers and Related Writings,* ed. Malvin R. Zirker (Middletown, 1988), 23–24.

4. Ibid., 26.

5. *Enquiry,* ed. Zirker, 77–78.

6. The insignia on Nero's arm is of St. Giles Parish, in the Seven Dials area, which had one of the highest crime rates in London; every fourth house was a gin shop (see George Rudé, *Hanoverian London, 1714–1808* [Berkeley, 1971], 91; George Clinch, *Bloomsbury and St. Giles* [London, 1890], 73–75).

7. *Enquiry,* 110–11, 122.

8. The steeple in question was a subject of mirth for Hogarth's contemporaries, one of whom wrote (*European Magazine* [June 1801], 442–43):

> When Henry the Eighth left the Pope in the lurch
> The Protestants made him the head of the church;
> But George's good subjects, the Bloomsbury people
> Instead of the Church, made him head of the steeple.

Both St. George's and St. Giles parishes are singled out in Fielding's *Enquiry* as areas of the desperately poor, and so St. George's steeple *could* be construed as simply Hogarth's indication of *another* area like Gin Lane.

9. See Paulson 1979, chap. 1. Also supporting Hogarth's view of gin, see Mandeville, *The Fable of the Bees,* ed. F. B. Kaye (Oxford, 1924), 89 ff.

10. See vol. 2, 438 n 35.

11. T. G. Coffey, "Beer Street, Gin Lane: Some Views of 18th-Century Drinking," *Quarterly Journal of Studies on Alcohol,* 27 (1966): 669–92, esp. 673–76, 690–91. See also Sidney and Beatrice Webb, *History of Liquor Licensing in England* (London, 1903), 20–22, 29; and Brian Inglis, *Forbidden Game: A Social History of Drugs* (London, 1975), 67.

12. See vol. 1, 323–24.

13. The woman in the sedan chair is an image of "Fashion" taken from one of the pictures on the wall of *Taste in High Life* (ill., vol. 2).

14. E. P. Thompson, "The Moral Economy of the English Crown in the Eighteenth Century," in *Customs in Common* (New York, 1991), 203. From the perspective of Thompson and his school—and by implication, Bakhtin's popular carnivalesque mode—we get a Hogarth quite different from the "reformer" who tries to save the lower classes by attacking their gin drinking, let alone the case of the rising bourgeois, in Antal's Marxist interpretation.

15. Place, corrected proofs of *Drunkenness,* BL Add. MSS. 27825; quoted in Lawrence Stone, *The Family, Sex and Marriage, 1500–1800* (New York, 1977), 638. Burke was to say much the same thing in his *Philosophical Enquiry* (1757): "Fermented spirits please our common people, because they banish care, and all consideration of future or present evils" (ed. James T. Boulton [London, 1958], 15).

16. Quoted, Peter Linebaugh, *The London Hanged: Crime and Civil Society in the Eighteenth Century* (London, 1991), 241, and, more generally on the plight of journeymen tailors, 241–43; see also Battestin, *Fielding,* 524.

17. In 1759 Goldsmith referred to the apprentice's "twopenny copper plate" (*Bee* No. 5, 3 Nov. 1759; in *The Works of Oliver Goldsmith,* ed. Arthur Friedman [Oxford, 1966], 1: 453).

18. Two years later in *A Journal of a Voyage to Lisbon* (1754) he refers to

"a lively picture of that cruelty and inhumanity, in the nature of men, which I have often contemplated with concern; and which leads the mind into a train of very uncomfortable and melancholy thoughts" (ed. Harold Pagliaro [New York, 1963], 45).

19. "The Tyburn Riot against the Surgeons," in *Albion's Fatal Tree: Crime and Society in Eighteenth-Century England,* ed. Douglas Hay, et al. (New York, 1975), 115. The upper-class audience might have seen the print as graphically reminiscent of the tradition of dissection scenes in high art (see W. H. Heckscher, *Rembrandt's Anatomy of Dr. Nicholaus Tulp: An Icono-logical Study* [New York, 1958], 102–6).

20. Another analogue worth mentioning is Bruegel's engraved series of "Virtues." Each "Virtue" is dominated by a central figure, whether Justice or Temperance, who is, ironically, the contrary of everything Justice or Temperance *should* mean. Bruegel's series does not depict reversals of what should be but rather what, alas, actually is, as opposed to what (by impli-cation) ought to be. In the foreground of Justice are torture and execution scenes, while in the far distance is a tiny cross. This sort of contrast (first explored in *The Four Times of the Day* and *Strolling Actresses* of 1738) is employed in Hogarth's popular attacks on social evils.

21. See J. Ireland (1791), 2: 72n. However, given Freke's appearance and his specialty (eye surgery), it seems as likely that he is the man gouging out Nero's eye. See the bust in the Library Gallery, St. Bartholomew's Hospital (reproduced, *St. Bartholomew's Hospital Journal,* 59 [Aug. 1955]. For Ho-garth's relations with Freke, see vol. 2, 63, 160. The Act for Preventing the Horrid Crime of Murder (*925 George II,* cap. 27) was introduced in spring 1752 and signed 25 March (Linebaugh, "Tyburn Riot against the Sur-geons," 76–78). Fielding was in fact opposed to the Murder Act, which he considered to have been substituted by a naïve legislature for his own pro-posals (see Bertram Goldgar, ed., *Covent-Garden Journal* [Middleton, 1988], index s.v., "murder, Act against").

22. T. G. Coffey, "Beer Street."

23. He invokes a "poor Wretch, bound in a Cart, just on the Verge of Eternity, all pale and trembling with his approaching fate" who recalls Ho-garth's Idle in Plate 11.

24. Fielding is foreshadowing an aesthetics of terror based on punish-ment, of the sort Edmund Burke would carry to its logical conclusion a few years later when he asserted in his *Philosophical Enquiry* (1757) that any au-dience at a stage tragedy, informed that an execution was to take place out-side in the street, would choose the latter. See Battestin, *Fielding,* 518.

25. Locke's *Some Thoughts concerning Education* (1693) is also in the back-ground: "if they [children] incline to any such *Cruelty* [i.e., to animals], they should be taught the contrary Usage. For the custom of Tormenting and

Killing of Beasts, will, by Degrees, harden their Minds even towards Men; and they who delight in the Suffering and Destruction of inferiour Creatures, will not be apt to be very compassionate, or benign to those of their own Kind" (ed. John W. and Jean S. Yolton [Oxford, 1989], 225–26).

26. From the perspective of Fielding's *Enquiry,* the portraits of Sacheverell and Macheath in the Harlot's chamber could be interpreted as Hogarth's warning against pardons and mercy; but in the context of *Harlot* 3 they contrast her wishful thinking with the unrelenting rigor of Justice Gonson—as her *Abraham Sacrificing Isaac* print contrasts mercy with strict justice.

27. Battestin, *Fielding,* 529.

28. BM 1892.8.4.5; Battestin, "Pictures of Fielding," *ECS,* 17 (1983): 1–13 (repro. Battestin, *Fielding,* pl. 47). The identification of Fielding is made in the BM acquisitions log as well as by Battestin in the *ECS* essay, and seems probable. It is considerably more doubtful that the artist is (as the BM entry tentatively proposes and Battestin believes) Joshua Reynolds.

29. *General Advertiser,* 8, 15 Dec. 1750; *Penny London Post,* 7–10, 12–14 Dec. 1750; see Battestin, *Fielding,* 511 and n154. James Macleane (or Maclaine) was also a significant figure for Hogarth to include as a skeleton. "There are as many prints and pamphlets about him as about the earthquake," wrote Horace Walpole, who had himself been robbed by Macleane on 8 September 1750 (*Corr.,* 20: 188). Macleane was hanged on 3 October. On 23 September, the first Sunday after his condemnation, "3000 people went to see him; he fainted away twice from the heat of his cell" (ibid., 20: 199). "His behavior on the high-way procured him the name of the *Gentleman Highwayman:* and when he appeared in a private social character, he very much affected the fine Gentleman, both in dress and equipage . . ." (*Universal Magazine,* 8: 174). He came of a good family fallen on bad times, spent the money he stole on dress, and made a full confession when apprehended. His contrition and his stance of virtue and high spirits perverted by society, all reported in the newspapers, had a powerful effect on the popular imagination. When Fielding decried such sentimentality as one of the causes of the rising number of crimes in his *Enquiry,* he may have had Macleane in mind.

One print showing Macleane surrounded by his friends, entitled *Newgate's Lamentation of the Ladies' Last Farewell of Maclean,* was based on Hogarth's *Beggar's Opera* paintings with Macleane a reincarnation of Macheath (*BM Catalogue of Engraved British Portraits,* ed. Freeman O'Donahue [London, 1908], 3: 131).

30. See Hesther Lynch Thrale's account, below, 263.

31. AN, 226; also on *Industry and Idleness,* 225. A Mr. Sewell, bookseller in Cornhill, reported that Hogarth had said (this would have been around the time of the Wilkes–Churchill affair): "Sir, it gratifies me very highly,

and there is no part of my works of which I am so proud, and in which I now feel so happy, as in the series of the Four Stages of Cruelty, because I believe the publication of them has checked the diabolical spirit of barbarity to the brute creation, which, I am sorry to say, was once so prevalent in this country" (*European Magazine* [June 1801], 442–43).

32. *Apology for Painters,* 70; AN, 222. It might be noted that while Hogarth makes it sound as if he had himself witnessed such scenes of cruelty as that of the dog in Plate 1, the image in fact (or also) alludes to Callot's image of the devil punishing a sinner in hell, i.e., Tom Nero is "devilish" (*Temptation of St. Anthony*).

33. Turnbull, *A Treatise on Ancient Painting, containing Observations on the Rise, Progress, and Decline of that Art amongst the Greeks and Romans . . .* (London, 1740). The term "summary" is John Barnell's (*Political Theory of Painting,* 11). Turnbull also warned that *modern* painting operates directly on "the Sentiments and Feelings of the vulgar, . . . even on ordinary Women and Children," and that limiting conditions must be placed on discussions of painting in order to distinguish polite men of taste from the mob (45), presumably the people of Beer Street (a distinction the artists would insist on in the 1761 Exhibition of the Society of Artists—to which Hogarth would respond with his Sign Painters' Exhibition of the following year). The Hogarth of *The March to Finchley* would also have remembered Turnbull's insistence that "the Ancients delighted in martial Pieces, and these are *truly moral* Pictures" (65, emphasis added); as opposed to Steele's opinion, which was Hogarth's: "Battle-Pieces, pompous Histories of sieges, and a tall Hero alone in a crowd of insignificant Figures about him, is of no consequence to private Men" (*Tatler* No. 209).

34. Cf. Dr. John Kennedy's comment on Dr. John Hill's works: "Perhaps, indeed, those of them which have been collected and bound, may have some Chance of passing through that intermediate State assigned them by the ingenious, nay, the judicious Mr. *Hogarth*" (*Some Remarks on the Life and Writings of Dr. J—— H——, Inspector-General of Great Britain* [1752], 39).

35. But another fact that may have interested Hogarth was that the author of the Latin translation of *Paradise Lost,* plagiarized by Lauder, was William Hog (or Hogg), a name that might have carried Hogarth back to his Latin-scholar father and the exploitation of *his* work by such fraudulent pedants as Lauder. Also Lauder's *Proposals* (1747) had carried an endorsement by Samuel Johnson, which Lauder used as preface to the full book, published in December 1749. Johnson's response, after the exposure, was to make Lauder sign a confession of his guilt. John Douglas's *Milton Vindicated from the Charge of Plagiarism* was published in November 1750. See J. L. Clifford, *Dictionary Johnson* (New York, 1979), 57–70.

36. In the words of Fielding's *Examples of the Interposition of Providence*

in the Detection and Punishment of Murder (1752), citing Genesis 4:10: the "Crying of the blood of the slain for vengeance against the murderer" (in *Enquiry*, ed. Zirker, 180). In this work Fielding comes out in the most primitive way for the possibility of divine intervention in everyday life— something Hogarth has persistently denied.

37. *Enquiry*, ed. Zirker, 170.

38. *Analysis*, 89.

39. Swift, "Digression on Madness," in *A Tale of a Tub* (1704), ed. A. C. Guthkelch and D. Nichol Smith (Oxford, 2d ed., 1958), 173.

40. Furnese (d. 1756), originally a London merchant, was an M.P., a supporter of Dodington in the 1750s (see *Commons, 1754–1790*, 2: 480; *GM,* 1756, 451; *LM,* 1756, 452). Strange advertised his subscription in the *London Evening Post,* 12–14 Feb. 1754.

41. James Northcote, *The Life of Sir Joshua Reynolds* (London, 1819), 1: 17–18 (probably told him by Reynolds).

42. The growth was despite Mead's appalled reaction, and perhaps because, being a dealer, Pond himself helped to stimulate the fashion. There are several 5*s* items in Pond's account book to a Dutchman for lessons in 1737 and 1738 (BL Add. MSS. 23724); Vertue, 3: 89, 125–26. The taste begins to appear in Pond in the late 1740s, but was already evident in Jonathan Richardson (see Lippincott, 60, 61, 90). Hogarth first shows a negative view of Dutch art in *Marriage A-la-mode* 6.

43. On the English rage for Rembrandt's etchings, see Christopher White, *Rembrandt in 18th-Century England* (New Haven, 1983), 5–6.

44. The quotations are based on Wilson's autobiographical MS., in H. Randolph, *Life of General Sir Robert Wilson* (Wilson's third son), 1: 13–15.

45. J. T. Smith, 1: 159–60. Hudson's portraits of the late 1740s show the influence of Rembrandt; he owned a self-portrait attributed to Rembrandt. He had accompanied Hogarth to the Continent in the 1748 expedition, and after Hogarth was detained in Calais he went on to Paris and the Netherlands. See also Edwards, *Anecdotes,* 147–48; Whitley, 1: 123–25.

46. White, *Rembrandt,* 27.

47. For example, the best-known portrait (by an unknown Italian artist) in the National Portrait Gallery, London. On the other hand, it must be admitted, Smollett cites the print in *The Adventures of an Atom* (1766) without any reference to Felix (ed. Robert Adams Day, [Athens, Ga., 1989], 34).

48. *The Records of the Honorable Society of Lincoln's Inn, the Black Book,* 3: From A.D. 1660 to A.D.1775 (London, 1900), bk. 13. 68 [344]. For the drawings, see Oppé, cat. no. 69, fig. 23.

49. Thomas Lane (Steward), *The Student's Guide through Lincoln's Inn,* 2d ed. (1805), 27; Vertue, 3: 155.

50. In 1819 the painting was cleaned and the frame freshly gilt (*GM,* 1819, 445), but there is no evidence that any substantive changes were made.

51. This material was first published in the *Burlington Magazine,* 94: (1972): 233–37, in reply to Clovis Whitfield, *Burlington Magazine,* 93 (1971): 210–14.

52. White, *Rembrandt,* 26–27.

53. *Pug the Painter following the Example of Messrs Scumble Asphaltum & Varnish* (*BM Sat.* 3277, undated and unsigned, attributed to Sandby.

54. J. Ireland, 2: 92; *Biog. Anecd.* (1782 ed.), 451.

55. Hogarth may have remembered Fielding's account of Joseph Andrews's combat with the hounds, "a Battle we apprehend never equalled by any Poet, Romance or Life-Writer whatever," followed with the words: "We shall therefore proceed in our ordinary Style." The point is to say something in more than one way, now as the story of Joseph and Potiphar's wife, now as the parable of the Good Samaritan, or as the story of Telemachus; but also to suggest that no way of saying corresponds more than obliquely to the truth.

56. John Hill, *A Parallel between the Characters of Lady Frail and the Lady of Quality in 'Peregrine Pickle'* (1751); see also Arthur Murphy, *Gray's Inn Journal,* No. 38, 7 July 1753, which links Hogarth and Fielding in similar terms. For more citations, see Battestin, *Fielding,* 530–31.

57. 28 Dec., John Upton to James Harris; quoted, Battestin, *Fielding,* 533.

58. Waterhouse, *Three Decades,* 42–43; David Irwin, "English Neoclassicism and Some Patrons," *Apollo,* 78 (1963), 360–67.

59. Dobson, 85; *London Evening Post,* 10–13 Dec. 1748; 23–25 May 1749. Cock's auction was held the week of 22 May. William Kent died 12 April 1748 (see Vertue, 3: 140).

60. This paragraph was added in the *London Evening Post* of 1–4 June, which, however, omitted the last sentence of the second paragraph and all of the final paragraph.

61. Lane's account is reproduced in *Gen. Works,* 1: 183–88; *St. James's Chronicle,* 10–12 July 1781. Lane's account is later since it corrects this account in several particulars. Lane's letter to Nichols on Hogarth's character, however, is dated 3 May 1781 (the MS., with Nichols's deletions marked, is in the Nichols papers in the National Portrait Gallery, f. 277). Lane's account of *Marriage A-la mode* is ff. 273–76.

62. BL Add. MS. 27995, f. 6 (repro. with changes in J. Ireland, 3: 99).

63. At Lane's death (1791) they passed to a nephew, Colonel J. F. Cawthorne, by whom they were put up to auction in 1792, and again in 1796, but apparently bought in both times. On 10 February 1797 they were bought at Christie's for £1050 by John Julius Angerstein, and with the rest of his collection they went to the National Gallery in 1824.

64. The Senhouse MSS. are in the Cumberland County Record Office; quoted in Edward Hughes, *North Country Life* (1952), 89–95.

65. At this time Brown held the living of Morland, Westmorland. He was a friend of Lyttelton, to whom he wrote a famous letter on the beauties of the Lake District in 1753. See Nichols, *Literary Anecdotes*, 2: 339n.

66. As to the other artists, Brown explains that Hudson charges £80 a year "and says that a Boy of Genius will make a sufficient Progress under him in three or four years," Knapton charges £50 a year, Pond £200 for five years, and Hoare 100 guineas for seven years, besides expense of board and lodging; Devis charges 150 guineas for seven years, "supposing him to be a Boy of Genius, otherwise not at all," and Grignion charges 100 guineas for an apprenticeship of seven years.

67. "Tuesday 24. was a tryal at the Court of *King's Bench* in *Guildhall* (being the first on the Statute) between a printseller in *Fleetstreet*, plaintiff, and a publisher on London bridge, defendant, for the latter's selling several base and spurious wood print copies of a graving, the plaintiff's property, contrary to an act of parliament made the 18th [error for 8th] of his present majesty, inflicting a penalty of 5s. per print; a verdict was given for the plaintiff" (*GM*, 20 [July 1750]: 331).

68. The pirated copy appears in a foldout opposite page 396 of *LM*, 20 (Sept. 1752). See *Gen. Works*, 1: 76 and n for Hawkins's account. For the case itself, see Charles Ambler, *Reports of Cases Argued and Determined in the High Court of Chancery . . .* , 2d ed. (London, 1828), Case 81, No. 164. For engraving copyright law in general, see *Mews' Digest of English Case Law to 1924*, 5: 1355–57.

69. Rouquet, *State of the Arts*, 28.

70. Lord Ilchester, *Henry Fox, First Lord Holland: His Family and Relations* (London, 1920), 1: 189.

71. Many records of payment for Hogarth folios survive in bank accounts of the period. E.g., in the records of Barclay's Bank, Gosling's Branch, we read that John and James Rivington paid £10 for a set in 1755 (13 May) and Samuel Richardson paid 11 guineas in 1757 (25 Feb.). Hogarth's printed price lists give the current price of sets year by year (see *HGW*, 18–19).

72. *Gen. Works*, 1: 394n.

3. *THE ANALYSIS OF BEAUTY* (I): THE TEXT

1. *London Evening Post*, 29 Feb.–3 Mar. 1751/52.

2. Garrick to Hoadly, 14 Sept. 1746, *Garrick Letters*, 2: 86. For the visit to Alresford, see vol. 2, 257–60.

3. *Analysis*, 157.

4. The quotation is from *Gen. Works*, 1: 348–49; *GM*, 47 (1797): ii, 1088; Hodgkin MSS., *HMC*, 15th Report, app. 2 (1897), 91–93; *DNB*. For the portrait, see below, fig. 78. For Hoadly and Ralph, see vol. 2.

5. *DNB*.

6. J. Ireland, 1: lxxix–lxxxiii. When the *Analysis* came out, Townley also published a long poem of praise under the signature of "A Connoisseur," and a decade later when Hogarth died he contributed a real epitaph, though it did not find its way to the Hogarth tombstone.

7. Kirby was advertising prints as early as 1745 (e.g., *Ipswich Journal*, 1 June), and by the time of the publication of *Beer Street* and *Gin Lane*, he was acting as Hogarth's agent (*Ipswich Journal*, 9 Mar. 1750/51). See James Gandon, *The Life of James Gandon, Esq. . . . with Original Notices of Contemporary Artists* (Dublin, 1846), 212.

8. Letter to Hogarth, 3 May 1753 (saying he will have Sullivan engrave the drawing unless Hogarth recommends another engraver), BL Add. MS. 27995, f. 9; *London Evening Post*, 25–28 May 1751. Kirby's *Dr. Brook Taylor's Method* was a digest and popularization of Brook Taylor's *Linear Perspective* (1715) and *New Principles of Linear Perspective* (1719), the basic eighteenth-century work on perspective.

9. *London Evening Post*, 27–29 Mar. 1753; engraved by Ravenet.

10. Lindsay thinks that through Wilson's *Essay on Electricity* (1746), followed by further treatises and papers in the *Philosophical Transactions of the Royal Society*, the idea of forces as fluids "helped Hogarth to a sense of the dynamic and fluid movement of the line of beauty, energy, and life. During 1753 there was widespread interest in electricity through Franklin's linking of electricity and lightning. Wilson was one of those who verified the thesis. On 12 August 1752 he wrote a letter from Chelmsford where he had got 'electrical snaps' from an iron rod at the end of a thunderstorm. He would have discussed with Hogarth the whole question of attraction and repulsion as revealed in electrical phenomena" (Lindsay, 169–70; *GM*, 1788, 564, 656).

11. Wilson's autobiographical notes, *Life of General Sir Robert Wilson*, 6–7, 9, 10–12; BL Add. MS. 27995, f. 14. I date the letter spring or summer because this would have been the earliest that Hogarth would have been likely to stay at his Chiswick house.

12. *Analysis*, 19.

13. Ibid., xxxi.

14. Ibid., 19; cf. 185–86.

15. *Gen. Works*, 1: 222.

16. *Analysis*, 100.

17. *Gen. Works*, 1: 222.

18. J. Ireland, 1: lxxx–lxxxiii.

19. J. Ireland, 3: 102. Charles Macklin was writing "The Science of Acting" during these years—another instance of a self-made man who wanted to generalize his own experience for other actors, but also for the educated theatergoer and in some sense for the connoisseurs. This manuscript was

lost at sea, but Macklin sounds very much like Hogarth in his manuscript notes: "Acting the art of it. The Eye is the Judge of Painting, the Ear and the Eye of Acting—the Criterion or Standard they both are to be tried by is Nature" (Diary, Folger Library, f. 111).

20. In his preface Hogarth claims, perhaps somewhat disingenuously, to have read none of the basic art treatises—Lomazzo, Dufresnoy, de Piles—before evolving his theory, which was based strictly on observation. He shows elsewhere, however, that he was aware of the tenor of such treatises, perhaps originally encountered at the academy, and that he kept up with the treatises appearing in his time. It is quite possible, for example, that while he is perfectly truthful when he writes that Dr. Kennedy drew his attention for the first time to Lomazzo's passage on the serpentine line, he may have read it years before in John Elsum's *Art of Painting After the Italian Manner* (1703) and forgotten about it but retained the germ of the idea. It is evident that after getting his "idea" he did read other treatises, whose apparent wrongheadedness prompted him to write his *Analysis* and cast it in the form he did, which was a modification if not contradiction of the whole approach to art perpetrated by the treatises. As he suggests in the preface, they showed how to paint or judge a picture, regarding the total painting as a moral and intellectual, indeed a literary, construct, and the divisions were invariable based on the terms Invention, Disposition, Proportion, Color, and Light, and thence progressed to the listing of the hierarchy of genres (history, portraiture, landscape, etc.) found in the "arts of poetry" by writers from Horace to Boileau.

21. Richardson, *Works* (1773), 6.

22. For Shaftesbury, beauty and good are "one and the same" and recognition of this equivalence is the foundation of "true taste" (*The Moralists, Characteristics,* 2: 128–29); for Hutcheson, see *Inquiry Concerning Beauty, Order, Harmony, and Design,* preface (2d ed., 1726), xvi. And for both Shaftesbury and Hutcheson, the sense of the beautiful is cultivated through custom and social practices: for Shaftesbury, it is found in the "communities, friendships, relations, duties . . . laws, constitutions, civil and religious rites" (2: 21); in the *Inquiry* it is acquired primarily through education. These are the scales Hogarth urges his reader to drop in his Preface in favor of the unmediated common eyesight.

23. John Andrew Bernstein, "Shaftesbury's Identification of the Good with the Beautiful," *ECS,* 10 (1977): 304.

24. *De Re Aedificatoria,* bk. 9, chap. 5; see Anthony Blunt, *Artistic Theory in Italy, 1450–1600* (Oxford, 1964), 15.

25. Hogarth's references to St. Paul's are obsessive: 23, 33, 46–47.

26. Ordinarily "variety" occurs in the art treatises referring to the composition of various parts within a unified harmony of proportions, as in Richardson's *Theory of Painting.* Richardson commented on the question of

introducing "as much Variety in the picture, as the Subject will admit of
. . . Rembrandt has succeeded admirably" (*Works,* 36). This passage leads
into his praise of Rembrandt's *Hundred Guilder Print,* which Hogarth used
as a model for his first New Testament painting, *The Pool of Bethesda.*

27. Howard Caygill has put it this way: "Whenever diversity is to be
unified, beauty appears with a promise of a different order"—a case of
sugar-coating, subliminalizing, or—simply—naturalizing. For, without
the sanction of "beauty" or "art" "the unification of diversity is undisguised
violence," or compulsion rather than suasion or pleasure. See Caygill, *Art
of Judgement,* 17. The idea of a "civil society" was picked up from Antonio
Gramsci (see Eagleton, *Ideology of the Aesthetic,* 19–20).

28. *Characteristics,* 2: 126–27; cf. also *Spectator* No. 418 on the subject.

29. Hutcheson follows with the argument that "the pleasure does not
arise from any *knowledge* of principles, proportions, causes, or the useful-
ness of the object, but strikes us at first with the idea of beauty. . . . Neither
can any resolution of our own, nor any prospect of advantage or disadvan-
tage, vary the beauty or deformity of an object" (*Inquiry,* sec. 1.12, 36). The
exclusion here is of the reasoning faculty, which includes consideration of
the utility of the object—"the usefulness of the object" or "any prospect of
advantage or disadvantage" to the spectator.

30. Shaftesbury: "great comeliness in action and behavior can be found
only among the people of a liberal education" (*Characteristics,* 1: 125).
Hutcheson: "The *Poor* and the *Low* may have as free a use of these Objects,
in this way, as the wealthy or Powerful." "Rusticks" must inevitably have
bad taste, the "relish of beauty" that is produced by "advantage" (*Inquiry,*
81).

31. *Fable of the Bees,* 1: 24, 7. And in the words of F. B. Kaye, Mande-
ville's editor: "whereas to Mandeville the totality to which each particular
act contributed so perfectly was the actual work-a-day world, to Shaftes-
bury it was the universe from the point of view of the Whole. Their entire
emphasis, too, was different. Shaftesbury said, Consider the Whole and the
individual will then be cared for; Mandeville said, Study the individual and
the Whole will then look after itself" (*Fable,* 1: lxxiii). The latter was also
Hogarth's position.

32. Cf. Caygill: "Not content with *denying Shaftesbury's argument that civil
society is intrinsically harmonious,* Mandeville insists that *such harmony can only
be achieved through violence*" (*Art of Judgement,* 52). He replaces Shaftesbury's
providence with the manipulative self-seeker, the private vice.

33. Hutcheson does employ "pleasure"—as the transitional term from
"beauty" to "virtue" (from the first to the second treatise of his *Inquiry*):
"Our *Sense* of Pleasure is antecedent to *Advantage* and *Interest* and is the
foundation of them" (103; cited, Caygill, 57).

34. *Essay concerning Human Understanding,* ed. Peter H. Nidditch (1975;

Oxford, 1979), 7 (cf. 508). Cf. *Second Treatise of Government* (pub. 1704), 5.30: "And even amongst us the Hare that any one is Hunting, is thought his who pursues her during the chase," where he extends the metaphor into property (see Paulson 1989, 156).

35. See also his introduction, at the very outset, of the term "Curiosity" (3 and 10, and the prints, 21).

36. See also: "There is an elegant degree of plumpness peculiar to the skin of the softer sex, that occasions these delicate dimplings in all their other joints, as well as these of the fingers; which so perfectly distinguishes them from those even of a graceful man; and which, assisted by the more soften'd shapes of the muscles underneath, presents to the eye all the varieties in the whole figure of the body, with gentler and fewer parts more sweetly connected together, and with such a fine simplicity as will always give the turn of the female frame, represented in the Venus the preference to that of the Apollo" (81).

37. Near the end of the *Analysis,* where he sums up with the figure of the dance, Hogarth returns to the subject: "on the woman's side . . . elegant wantonness . . . is the true spirit of dancing" (159).

38. "Freedom of Wit and Humour," *Characteristics,* 1: 96. On Venus (beauty and grace), see 1: 92, 217.

39. *Characteristics,* e.g., 2: 131, 177.

40. See *The Rape of the Lock,* 2.23–28; the whole passage in *Paradise Lost,* bk. 4, describing Eve, sounds as if it may have been significant for Hogarth:

> Shee as a *veil* down to the slender waist
> Her unadorned golden tresses wore
> *Dishevell'd,* but in *wanton ringlets* wav'd
> As the vine curls her tendrils, which implied
> *Subjection,* but required with *gentle sway,*
> And by her yielded, by him best received,
> *Yielded with coy submission,* modest pride,
> And *sweet reluctant amorous delay.* (ll. 304–11; emphasis added)

41. *Complete Poetry and Major Prose,* ed. Merritt Y. Hughes (New York, 1957), 245, 235, 237. On the other hand, cf. Milton's warning in *Paradise Lost* against the shortest way: Sin and Death may build a "broad and beat'n way" from earth, but this smooth and easy path, Milton reminds us, leads directly to hell. So also in book 9, Satan promises Eve speed: "If thou accept / My conduct, I can bring thee thither soon," and when Eve is won over, he makes "intricate seem straight" and guides her "swiftly" to the forbidden tree. At the center of the aesthetic experience for Hogarth is the matter of Miltonic choice—where, as in *Paradise Lost,* the audience must

pause between conflicting interpretations and choose—and in his idea of an academy the student is free to choose models and manners.

42. Hogarth would also have remembered his Harlot and Steele's description of the prostitute in *Spectator* No. 266 with which the *Harlot's Progress* began; "She affected to allure me with a forced Wantonness in her Look and Air"; as well as Polly–Lavinia's affair with the duke of Bolton, intimated in the final version of *The Beggar's Opera*.

43. This is the interpretation put forward by Harold Bloom and his followers, in particular Thomas Weiskel and Paul Sherwin.

44. In Collins's odes (as opposed to Warton's) the scenarios of mediation and seduction are in the end overcome by the loss of the muse—or, for Collins or any modern poet, her unapproachability; and so implicitly the poem becomes a work of mourning.

45. "Pleasure" was the name given to Vice in Addison's version of the Choice of Hercules in *Tatler* No. 97; this alluring figure argues for "Pleasure" against "Business"; whereas her opposite number says: "I . . . must lay down this as an established Truth, That there is nothing truly valuable which can be purchased without Pains and Labour": her way is "long and difficult" rather than "short and easy."

46. *Pleasures of Imagination,* 2.381 ff. A. O. Aldridge, who pointed this out, interprets the passage to mean that "the path of virtue is at the same time the path of pleasure and that one way cannot be attained without the other," a view "less stoic and severe than Shaftesbury's" ("The Eclecticism of Mark Akenside's *The Pleasure of Imagination," Journal of the History of Ideas,* 5 [1944]: 312–13).

47. Wendorf, *Collins and Eighteenth-Century English Poetry* (Minneapolis, 1981), 34.

48. Patrick Murdock, "Life of Thomson," in *The Works* (1762), 1: xiv; and cf. Johnson's "Life of Thomson," *Lives of the Poets* (1779–1781; ed. 1880), 3: 297.

49. See Fielding's puffing of *The Castle of Indolence* in *Jacobite's Journal,* 4 June 1748. Fielding and Thomson shared the same publisher, Millar, as well as the Lyttelton circle.

50. *Poems on Several Occasions* (1729), 1: 55. In 1731 Mitchell had published *Three Poetical Epistles,* one of which was to and in praise of Hogarth (see vol. 1).

51. These verses have been dated 1742; see A. D. McKillop, introduction, James Thomson, *The Castle of Indolence and Other Poems* (Lawrence, Kans., 1961), 6–8.

52. He also assisted Handel with a libretto on the subject of the Choice of Hercules.

53. Thomas Adams, *Works* (1630), 197; Alexander Ross, *The History of*

the World (1652), preface, attributing this to the Church Fathers; James Howell, *Parly of Beasts* (1600), 134: Tacitus, *Agricola,* sec. 3; Pliny the Younger, *Epistles,* 8.9.

54. On the maternal figures invoked by Collins, Akenside, and the Wartons to protect and nurture them, and grant them poetic power, see John Sitter, "Mother, Memory, Muse, and Poetry after Pope," *Journal of English Literary History* 44 (1977): 312–36; and *Literary Loneliness in Mid-Eighteenth-Century England* (Ithaca, 1982), chaps. 3 and 4.

55. Wasserman, "The Inherent Values of Eighteenth-Century Personification," *PMLA,* 65 (1950): 435–63; Hagstrum, *The Sister Arts* (Chicago, 1958), chap. 10.

56. See Paulson 1982, 109–10.

57. See Howard Weinbrot, "William Collins and the Mid-Century Ode: Poetry, Patriotism, and the Influence of Context," in Weinbrot and Martin Price, *Context, Influence, and Mid-Eighteenth Century Poetry* (Los Angeles, 1990), 3–39.

58. See William Epstein, *John Cleland: Images of a Life* (New York and London, 1974), 92–94, and Peter Wagner, ed., *Fanny Hill or Memoirs of a Woman of Pleasure* (New York, 1985), introduction. My references are to this edition.

59. Hogarth would also have remembered Fielding's description of Sophia Western in *Tom Jones:* "the highest Beauties of the famous *Venus de Medici* were outdone. Here was a Whiteness which no Lillies, Ivory, nor Alabaster could match" (ed. Martin Battestin [Middletown, 1974], 4.2; 1: 157). But Cleland offered him a sensuality and outrageousness that is not in Fielding. The Venus de Medici was the example Hogarth chose for Plate 1.

60. Cleland's aesthetics of the "pleasure of pursuit" is, of course, given the point of view of Fanny, centered on the male, not the female, and so focused not on breasts, etc., but on the penis.

61. See Shelley's *Defence of Poetry,* "Veil after veil may be undrawn and the inmost naked beauty of the meaning never exposed" (*Shelley's Prose,* ed. David Lee Clark [London, 1988], 291); and, for the phrases in quotation marks, Paul Hamilton, "'A Shadow of a Magnitude': The Dialectic of Romantic Aesthetics," in *Beyond Romanticism,* ed. Stephen Copley and John Whale [London, 1992], 14).

62. For Fielding's chapter on Beauty, see 6.1 in *Amelia,* ed. Martin Battestin (Middletown, 1983), 230.

63. Amelia's nose (and her mask) has been analysed by Terry Castle in a way useful to my argument (see *Masquerades and Civilization* [Stanford, 1986], 67). It is perhaps significant that Gotthold Ephraim Lessing quotes, in his *Laokoon* (1766), the treatise that closed the tradition of the "Sister Arts," a passage from the *Analysis* explaining that the Apollo Belvedere

"calls forth surprise" in the beholder because "upon examination its disproportion is evident even to an untrained eye": its feet and thighs are "too long and wide for the upper parts." It is, of course, first necessary that there be that element of "surprise," says Lessing, but then it follows: "If we examine the beauties of this figure thoroughly, we may reasonably conclude, that what has been hitherto thought so unaccountably *excellent* in its general appearance, hath been owing to what hath seem'd a *blemish* in a part of it" (*Laokoon,* chap. 22; trans. Edward Allen McCormick [Baltimore, 1962], 120). The passage Lessing quotes compares the Antinous and Apollo, the first calling forth "admiration," the second "surprise." One can read those words, in conjunction with the illustrative plate, in more than one sense (see below, Chap. 4).

64. Fielding may be recalling Le Blanc's "deux extrêmes," "le Sublime & le Burlesque," pairing Callot and Scarron against Raphael and Virgil (*Lettres d'un François* [The Hague, 1745], 1: 210–11).

65. Stone, *Road to Divorce: England 1530–1987* (Oxford, 1990), 123.

66. For what seems to me the wholly untenable view that there is a Puritan moralism to Hogarth's sexual imagery, associating the sex drive with disorder, brutality, and crime, see Hans-Peter Wagner, "Eroticism in Graphic Art: The Case of Hogarth," in *Studies in Eighteenth Century Culture* (Publication of the American Society for Eighteenth-Century Studies, 1991), 22: 53–74. The following paragraph expresses my second thoughts on a remark I made many years ago to the effect that "Love for Hogarth is only something that is perverted . . ." (Paulson 1975, 48–49).

67. This is a point I failed to emphasize in volume 1: that it was the Gibbons, not the Hogarth family Bible (BL Pressmark C.45.e.15), which passed from Hogarth's mother's family to his mother and thence to himself. See *HLAT,* 1: 10; 2: Appendix B.

68. The father may or may not be an issue in the *Harlot;* but we ask: Was it Charteris? the Jew? Dalton? or a fantasy unnamed father? Just previously, in *The Denunciation,* there had been a newly born child whose paternity was in question.

69. I am aware that in volume 1 I interpreted the *Harlot's Progress* as, on the biographical level, a story of Hogarth's father or of himself (328–29); but I see nothing untoward in his also supplying a subplot in which *another* aspect of himself is played out (as he was to do in the two apprentices of *Industry and Idleness*).

70. See Randolph Trumbach, *The Rise of the Egalitarian Family* (New York, 1978), and "Sex, Gender, and Sexual Identity in Modern Culture: Male Sodomy and Female Prostitution in Enlightenment London," *Forbidden History: The State, Society, and the Regulation of Sexuality in Modern Europe,* ed. John C. Fout (Chicago, 1992), 97–98. For the changing views of

woman's nature, see Lawrence Stone, *The Family, Sex and Marriage in England, 1500–1800* (New York, 1977); Felicity A. Nussbaum, *The Brink of All We Hate* (Lexington, 1984), 93, 136; Marlene Gates, "The Cult of Womanhood in Eighteenth-Century Thought," *ECS,* 10 (1976): 21–39; Kathleen M. Rogers, *Feminism in Eighteenth-Century England* (Brighton, 1982), 119–47. One example was the case of John Home's tragedy *Douglas,* produced in 1756, which, in Susan Staves's words, "attempted to articulate and dramatize what was in 1756 a new sentiment: elaborated tenderness between mothers and children" ("Douglas's Mother," in *Brandeis Essays in Literature,* ed. John Hazel Smith [Waltham, 1983], 53).

71. The labyrinth itself was an ambiguous topos: after all, Truth is naked, and when masked (or painted with cosmetics) she becomes Falsehood. See, e.g., Donne, "Third Satire," *Poetical Works,* ed. H. J. C. Grierson (Oxford, 1971), 139; John Steadman, *The Hill and the Labyrinth* (Berkeley, 1984), 3–8.

72. James Stevens Curl, *The Art and Architecture of Freemasonry* (London, 1991), 36; emphasis added.

73. Gilpin, *Dialogue upon the Gardens . . . at Stowe* (1748), 5; emphasis added.

74. Gilpin, *Observations, Relative to Picturesque Beauty . . . Particularly Mountains, and Lakes of Cumberland, and Westmorland* (1786), 2: 44. Here is Gilpin on Hogarth's Line of Beauty (undated, but probably in the 1760s), in a note now in the Mellon Collection: "The *waving line* was, no doubt, always more pleasing to an eye formed on the principles of beauty, than a *straight,* or *crooked* one; tho I know not that any one ever examined it scientifically, under the denomination of the *line of beauty,* before Hogarth. According to him (& he exemplifies, in his Analysis, all his positions) it pervades almost every thing beautiful both in art, or nature. In landscape, it's grand objects are *roads, & rivers.* It adds a beauty often to *trees*—to *surfaces of land*—& other forms, are often used by way of contrast. But in *roads, & rivers,* unless the reach be very short, the line of beauty is essential." Gilpin's letter to Hogarth concerning a fault in *Paul before Felix* is recalled in a letter to William Lock of 13 Sept. 1781, quoted by Carl P. Barbier, *William Gilpin* (Oxford, 1963), 24n.

75. "Instructions for Examining Landscape," 7–18 (MS., Fitzwilliam Museum, Cambridge).

76. Gilpin, *Forest Scenery* (1791), 2: 227. See Malcolm Andrews, *The Search for the Picturesque* (Stanford, 1989), 29; and 49: "We may find it more comfortable to live in a regular building, but the *imagination* can only be fully pleased with 'a ragged Ruin, with venerable old Oaks, and Pines nodding over it,' such as Stowe's 'old' Hermitage. The division is complete. The imagination or 'Fancy' craves satisfactions which seem wholly contrary

to those required by morality, the 'social Affections.' Since it is above all the painter who is concerned chiefly with what gives *imaginative* pleasure, the adjective 'picturesque' is duly applied to this type of aggressively anti-utilitarian scenery."

Hogarth's Beautiful/Picturesque also includes in Intricacy the sense of allusion/association with a painting or a poem (classical or English) as part of the "pleasure of pursuit." The same applies to landscape and the "modern moral subject" sharing a common "stage" setting: Gilpin refers to the elements of a landscape as "something like the scenes of a playhouse, retiring behind each other."

77. Price, *An Essay on the Picturesque* (1794), 71.

78. Gilpin, in the *Dialogue* and for many years after, regards the picturesque as simply the picturable. However, as early as his *Essay on Prints* (1768), which has some pages on Hogarth, Gilpin wrote that "Roughness forms the most essential point of difference betwen the *beautiful* and the *picturesque*" (6); but there is some indication too in the *Dialogue* in words like "ragged" (5). While Hogarth's serpentine line and S curves suggest smoothness, and he obviously regarded the transitions of his reading structure as serpentine, the effect was rather of rough textures juxtaposed with smooth and surprising contrasts and incongruities.

79. Price, *Essay on the Picturesque,* 103–10; for Price on intricacy, see 17, 198; on "curiosity," see 18, 86. Gilpin picks up Hogarth's metaphor of the chase in *Dialogue,* 48.

80. Hogarth's picture of himself as flaneur, recounted in his "Autobiographical Notes" of the 1760s, probably originating in second thoughts on the *Analysis,* sets up precisely the importance of *movement* that Gilpin emphasizes in his definition of the Picturesque. In youth he called his walks "stroles," defined as a kind of dawdling, but by the *Analysis* the terms are "pursuit" and "chase." Kim Ian Michasiw distinguishes the publics of Gilpin's Picturesque from those of Price and Payne Knight of the next generation: Gilpin writes for "the travelers and tourists . . . transient presences in the landscape, whose separation from any agency in it is everywhere apparent. His project is to instruct these aliens on how best to see, appreciate, and horde up in memory a fleeting acquaintance with a scene that is not their own"; whereas Price and Payne Knight write for "the local improver" of the landscape ("Nine Revisionist Theses on the Picturesque," *Representations,* no. 38 [spring 1992], 82–84). By this distinction Gilpin, Hogarth's younger contemporary, appears much closer to the epistemological focus of Hogarth's Beautiful.

81. Price, *Essay,* 110; also 64.

82. Their opinions of actual painting practice, however, differed: Gilpin, admiring Salvatore Rosa, did not approve of the low subjects of the seven-

teenth-century Dutch painters, whereas Price's theory was based on the landscape of the Dutch (and of Gainsborough) and Payne Knight located the Picturesque in the work of Rembrandt.

83. Félibien, *Entretiens sur les vies des peintres* (1619–1695); Richardson, *Works,* 70–71.

84. Lindsay, 94 (see 92–94). He continues: ". . . from his [Hogarth's] practice and theory alike we can see that he had a deep understanding of colour and pigment as defining form, not as something merely added to it." Lindsay, with some exaggeration but as a salutary corrective, calls Hogarth "the most experimental of eighteenth-century painters in the use of bold brushwork, fluidity of handling, and broken colour effects."

4. *THE ANALYSIS OF BEAUTY* (II): THE ILLUSTRATIONS

1. *The Weekly Register: or, Universal Journal,* 24 Nov. 1733; the *Beggar's Opera* reference is to Air xx. See also M. I. Webb, "Henry Cheere, Sculptor and Businessman, and John Cheere, I.," *Burlington Magazine,* 100 (1958): 236–39. The first section of this chapter is based on Paulson 1989, 156–202.

2. First noted by Joseph Burke, "A Classical Aspect of Hogarth's Theory of Art," *Journal of the Warburg and Courtauld Institutes,* 6 (1943): 151–53.

3. Spence, *Polymetis: or, an Enquiry concerning the Agreement between the Works of the Roman Poets, and the Remains of the Antient Artists* (1747), 5.

4. Louise Lippincott suggests that it may also parody Pond's *Roman Antiquities* (1745–1751), which consisted of "the eclectic groupings of sculpture, architectural elements, and tourists" of compositions by Pannini: in particular No. 3, *Basilica of Antoninus, Temple of Fortuna Virilis, Mausoleum of Hadrian, Medicean Vase* (1746), which includes the Farnese Hercules, though seen from another angle. I see no resemblance to the "arrangement of buildings in the background" which she notes, however, and Hogarth does not seem to me much concerned "to draw distinctions between Pond's work and his own. Evidently," Lippincott thinks, "he was concerned about the similarities between their respective publications which were causing confusion," as with "caricature" and "character" in *Caricatures and Caricaturas* (144). Lippincott sees rather narrowly from the perspective of Pond, who never seems to have worried Hogarth overly much.

5. In January or February 1752, just prior to Hogarth's subscription proposal for the *Analysis,* Spence brought out another work, *Crito: or, a Dialogue on Beauty,* whose subject was limited "to visible Beauty; and of that, to such only as may be called personal, or human Beauty; and that again, to such as is natural or real, and not such as is only national or

customary . . ." (6–7). Indeed, Spence's dialogue, though its conclusions are quite different from Hogarth's, comes closer than any earlier treatise to his approach and structure, to his concern with the human body in nature; and may have stimulated him at the beginning of 1752 to announce and proceed with his own treatise. Spence's *Crito* he probably included among the works of the "moral philosophers" who had lost their way. (Spence's pseudonym in *Crito* is Sir Harry Beaumont. See Austin Wright, *Joseph Spence* [Chicago, 1950], 126 and n 43.)

6. Spence, *Polymetis,* 142. The seated Jupiter, which he also reproduces, reappears in modern dress in Hogarth's print as the seated magistrate on a tomb, as well as parodied in the drawing of Jupiter by the dancing master.

7. See Esther Moir, *The Discovery of Britain: The English Tourists 1540–1840* (London, 1964), 6; R. W. Ketton-Cremer, *Norfolk Assembly* (London, 1957), 194.

8. See Kathleen Mahaffey, "Timon's Villa: Walpole's Houghton," *Texas Studies in Literature and Language,* 9 (1967): 193–222.

9. For accounts of all of these canonical sculptures, see Francis Haskell and Nicholas Penny, *Taste and the Antique* (New Haven and London, 1981).

10. Actors modeled themselves on the canonical sculptures. Barton Booth, according to Theophilus Cibber, "frequently studied, and sometimes borrowed Attitudes" from these sculptures, "which he so judiciously introduced, so finely executed, and fell into them with so easy a Transition, that these Masterpieces of his Art seemed but the Effect of Tragedy." Where Booth "could not come at" the original objects, Cibber tells us, "he spared no Pains or Expence to get the best Drawings and Prints" (Cibber, *Reflections upon Theatrical Expression in Tragedy* [London, 1755], 51). In Hogarth's *Strolling Actresses,* which carries the germ of the Statuary Yard, the central young woman was frozen in the pose of the famous statue of Diana the Huntress (another of the canonical sculptures), her right arm reaching back to take an arrow, her left holding a bow; but the gesture is meaningless because both quiver and bow are missing and the iconographical signs are inappropriate to this buxom, attractive young woman with her skirts down around her ankles.

11. Hercules, in fact, appears three times, since the Belvedere Torso was usually identified as Hercules. The first, the *Farnese Hercules,* was extensively restored (as is perhaps suggested by the appearance of the separate head and shoulders), while the other, the Torso, was remarkable among antique sculptures as the one piece that was not restored: presumably because Michelangelo (as Hogarth notes) "is said to have discover'd a certain principle in the trunk" (5), which was a source of Hogarth's own formalist principle of the serpentine Line of Beauty. (Hogarth shows the Torso in

Time Smoking a Picture as grotesquely restored, with an unfitting arm and another statue's head, which Time seems to have lopped off with his scythe [fig. 82].)

12. See Maximilien Misson, *Nouveau Voyage d'Italie fait en l'année 1688* (The Hague, 1691), 2: 151–52.

13. The *Antinous* in the eighteenth century was reproduced with both arms—arms salvaged from some other fragmentary sculpture—as he appears in Hogarth's print. See Haskell and Penny, *Taste,* 142.

14. The figure of the dancing master is, moreover, complemented by the drawing in the book displayed at the lower right: figure #20 is identified by Hogarth in the text (49) as an absurdity, a dancing master representing Jupiter—and this, in terms of the illustration, sets up Jupiter–Ganymede associations with the pair in the statuary yard.

15. Cf. the double gestalt of *Harlot* 1—clergyman, Harlot, and bawd; Harlot, bawd, and Colonel Charteris.

16. The story that Hogarth alludes to in the *Analysis* (104 and n, taken from Richardson, *Works,* 176) has it that the *Apollo Belvedere* was found by Augustus and removed from the site of Apollo's oracle at Delphi.

17. I am indebted to Michael Fried for the suggestion that Hogarth's allusion is to St. Peter's.

18. See Addison's definition of *idol* in *Spectator* No. 73; also above, vol. 2, 98–99, and Paulson 1989, 14–20.

19. See Ann Kibbey, *The Interpretation of Material Shapes in Puritanism: A Study of Rhetoric, Prejudice, and Violence* (Cambridge, 1986).

20. [Raguenet], *Les Monumens de Rome, ou descriptions des plus beaux ouvrages . . . qui se voyent à Rome* (Rome, 1700), 321–26; trans. Haskell and Penny, 30.

21. On the other hand, in *Amelia* Fielding referred to Essex's opinion "that Dancing is the rudiment of polite Education, as he would, I apprehend, exclude *every other Art* and science" (199; emphasis added).

22. Harris, "A Dialogue concerning Art" (1744), 54. Harris was one of Fielding's closest friends.

23. S. Ireland, 1: lxxvi; see *Tate,* 120 (cat. no. 105).

24. As Walter J. Hipple notes, "the figure of Columbus . . . is, in this context, graceful and genteel; those figures expressing vulgar astonishment, chagrin, or arrogance are not" (*The Beautiful, the Sublime, & the Picturesque in Eighteenth-Century Aesthetic Theory* [Carbondale, 1957], 66).

25. The usual distinction was between the "polite" and the "productive" or "useful," the one solid and substantial, the other ornamental. The "useful" people, the "useful part of mankind," were divided into the "industrious," "busy," or "business" people and (at a lower level) the "laborious," "laboring," or "mechanick" folk. By contrast, the "polite" were (in Law-

rence Klein's words) "those who turned leisure to account through a dedication to the ornamental, to fashion, style and display." (See Klein, "Politeness for Plebs: Some Social Identities in Early Eighteenth-Century England," "Consumption and Culture Workshop," Clark Library, 11 Jan. 1991.) Obviously in a sense, not altogether ironic, Hogarth saw himself as one of the "useful part of mankind," the "mechanicks" of the Shaftesburian aesthetics. The Goodchild–Idle dichotomy was also implicit in the distinction between "industrious" and "mechanick."

26. Hutcheson, letter to the *Dublin Journal* in 1725, later reprinted in *Reflections on Laughter,* in *Collected Works,* 7: 121, 127. Corbyn Morris, in his *Essay towards Fixing the True Standards of Wit, Humour, Raillery, Satire, and Ridicule* (1744), tried to distinguish between our *pleasure* in raillery (traced to the embarrassment of the victim) and the fuller *pleasure* in ridicule (Augustan Reprint Society, no. 4 [Los Angeles, 1947], 37, 42, 44, 51). On the developing theories of comedy, see Stuart Tave, *The Amiable Humorist* (Chicago, 1960).

27. Hogarth's point is made even clearer in a rejected passage from his *Analysis* manuscript: "Is it not," he asks, "the same kind of Jumble or Junction of circumstances, that makes up the Humorous Characters of Trapolin in Duke and no Duke & nell in the Devil to Pay?" (180). The inconsistency and mixture of incompatible matter that causes involuntary laughter in Nahum Tate's *Duke and No Duke* lies, significantly, in Trapolin's change from "a Pimp and Buffoon" to an Italian duke; and, in Charles Coffey's *The Devil to Pay,* in the transformation of Nell from an innocent country girl to Lady Loverule, a transformation analogous to the one desired by Hogarth's Harlot.

28. Beattie, "An Essay on Laughter and Ludicrous Composition," in *Essays on Poetry and Music* (1776; 3d ed., 1779), 326.

29. He could have seen the engraving of Carracci's painting (see M. Calvesi and V. Casale, *Le Incisioni dei Carracci,* Rome, 1965, no. 208). He had used Coypel's Sancho nearly thirty years before in a similar way in *The Mystery of Masonry* (ill., vol. 1).

30. See a satire like "The History of Insipids" (1674), ll. 7–10, which refers to Charles I's eldest son:

> The virtues in thee, Charles, inherent
> (Although thy count'nance be an odd piece)
> Prove thee as true a God's vicegerent
> As e'er was Harry with the codpiece.

31. Hogarth's comment on the representation of such a dance applies more pointedly to these portraits: "the best representation in a picture, of

even the most elegant dancing . . . must be always somewhat unnatural and ridiculous; for were it possible in a real dance to fix every person at one instant of time, as in a picture, not one in twenty would appear to be graceful, tho' each were ever so much so in their movements" (147).

32. In Eagleton's words on Theodor Adorno, Hogarth's *Analysis* provides "a paradigm, rather than a displacement of emancipatory political thought" (*Ideology of the Aesthetic*, 360).

33. Burke, *Philosophical Enquiry*, added in the second edition (ed. Boulton, 115–16).

34. The story had been retold by Matthew Prior in "Protogenes and Apelles" (1718), the line being a circle and Protogenes's response to make it more "Full, and Round, and Fair." See H. van de Waal, "The *linea summae tenuitatis* of Apelles: Pliny's Phrase and Its Interpreters," in *Zeitschrift für Aesthetik und allgemeine Kunstwissenschaft*, 12 (1967): 5–32.

35. In *Rake* 8 the writing on the wall is Whistonian geometry, a different thing; but in this plate and in *Harlot* 5 initials are written on walls to indicate who was there. *Invasion* 2 shows the king of France holding a gallows, for hanging Englishmen; and this is the more elaborate idiom of political caricature. For further thoughts on this subject, developing the work on signboards in Paulson 1979, see Pierre Georgel, "'The most contempible meanness that lines can be formed into': Hogarth et les arts 'autres,'" in *Image et société dans l'oeuvre graphique de William Hogarth*, ed. Frédéric Ogée (Paris, 1992), 91–111.

36. Hogarth follows John Elsum's version of Lomazzo's citation of Michelangelo on the serpentine line and pyramid, which adds: "But for as much as there are *two Sorts of Pyramids*, the one Straight as is that near St. *Peters* in Rome call'd *the Pyramid of Julius Caesar*, the other waived like Flame and is called *Michael Angelo's Serpentine*. This latter also a Painter must imitate, his *Contours* must turn and wind like a Serpent" (*Art of Painting*, 27–28).

The painter Giles Hussey's theory of triangles for producing true proportions in figure drawing may have been one of the points of departure for Hogarth's *Analysis*. It was a theory which, as Vertue recorded with gentle irony, shows that all the ancients wrought in error: "Hogarth (in opposition to Hussey. scheem of Triangles.) much comments on the inimitable curve or beauty of the S undulating motion line, admired and inimitable in the antient great Sculptors & painters" (1: 126). For some idea of Hussey's theories, see his letter to Robert B. Wray (1756), in Whitley, 1: 128, and, relating specifically to figure 64 of Plate 1, Sheila O'Connell, *Burlington Magazine*, 126 (1984): 33–34.

37. La Rochefoucauld, *La Vie en Angleterre au XVIIIme siècle*, ed. Jean Marchand (Paris, 1945), 118; Roland Stromberg, *Religious Liberalism in Eighteenth-Century England* (Oxford, 1954), 48–49.

38. Cf. Akenside's Choice of Hercules in which the poet does not *choose* between Virtue and Pleasure but by his imagination melds them into a higher unity (above, 82).

39. Eagleton, *Ideology of the Aesthetic,* 16. Posing the problem of the oxymoron of "aesthetic thought," Eagleton (1) pictures the mind "struggling to register [the object's] density and recalcitrance at just the point it impoverishes it to some pallid universal" (341). (2) But if "the concept can never appropriate the object without leaving a remainder, then it is also true that the object . . . fails to achieve the fullness promised by its concept" (344). (3) "Art may thus offer an alternative to thought . . ." (347), which Hogarth supplied with his illustrative plates (vis-à-vis his text).

40. BL Add. MS. 27995, f. 7. One of the two copies was intended for Ralph Allen's library, perhaps an indication that Allen collected Hogarth's prints (see Benjamin Boyce, *The Benevolent Man: A Life of Ralph Allen* [Oxford, 1967], 204).

41. Quoted, A. W. Evans, *Warburton and the Warburtonians* (Oxford, 1932), 188.

42. Evans, *Warburton,* 136.

43. Nichols, *Anecdotes,* 2: 176–77; Cf. Stromberg's comment, *Religious Liberalism,* 79.

44. *The Divine Legation of Moses,* 4.4, 2: 122–13.

45. Montfaucon, *The Supplement to Antiquity Explained* (London, 1725), 65. For the Diana–Isis equations, see Montfaucon, *Antiquity Explained,* 1: 93–98. For the importance of the pyramid, see also Jean Terrason's *Séthos* (trans. "Mr. Lediard," 1732), 1: 114 and 148 ff.; and on the serpent, 1: 127–47; on the trinity of Isis–Osiris–Horus, 1: 164.

46. See also on Pythagoras and his origins in Egypt, Anderson, *Constitutions of the Free Masons* (1723), 20–21.

47. See Albert G. Mackey, *Encyclopedia of Freemasonry* (Chicago-New York-London ed., 1921), 602.

48. J. N. Casavis, *The Greek Origin of Freemasonry* (New York, 1956), 123.

49. The serpent and the triangle also appear in the Laocoön (Plate 1), the snake deity Python, whose priestess sat on a Pythian Tripod resting on a three-headed serpent of brass. A pillar of Hercules entwined with a serpent appears in the upper part of Hogarth's Walpole Salver (above the head of Hercules—ill., vol. 1). The pillars of Hercules (symbolizing new aspirations and achievements) had been adopted as part of Masonic symbolism, employed in the entrance to some Masonic temples [see David Stevenson, *The Origins of Freemasonry: Scotland's Century, 1590–1710* (Cambridge, 1988), 148]. Finally, the serpent and goddess have been simplified into a cone in the *Tail Piece* (fig. 112).

50. Warburton, *Divine Legation,* 1: 2.4, 142–44.

51. The same progress is outlined for the fable, which is sophisticated

and mystified "by quaint and far fetched Allusions, into a Parable, on set Purpose to throw Obscurity over the Information" (143), and then "returned to its first Clearness, and became a *Proverb* plain and intelligible to all" (149).

52. The note from Townley is among the Hogarth MSS., BL Add. MS. 27995, f. 2.

53. See Samuel Prichard, *Masonry Dissected* (1730), reprinted in *The Early Masonic Catechisms,* ed. Douglas Knoop, G. P. Jones, and Douglas Hamer (Manchester, 1943), 118–20; and *The Purjur'd Freemason Detected* (1720), in ibid., 142; and Stevenson, *Origins of Freemasonry,* 144–45.

54. See Bernard E. Jones, *Freemasons' Guide and Compendium* (London, 1950), 193–212.

5. *THE ANALYSIS OF BEAUTY* (III): RECEPTION

1. *London Daily Advertiser,* 23 Mar. 1753; William Sandby, *The History of the Royal Academy of Arts from Its Foundation in 1768 to the Present Time* (1862), 1: 26–27.

2. Edwards, *Anecdotes,* xxiii. Edwards produces the same (xxii–xxiii) from the copy sent to Paul Sandby. For a more recent history of the background, see Sidney C. Hutchison, *The History of the Royal Academy, 1768–1968* (London, 1968), chaps. 1–3. According to Pye (76), the real business had been enacted by a governing committee, with the general meeting merely sanctioning their action.

3. BL Add. MS. 4310, f. 122. The vice-chancellor of Cambridge had his copy and returned his thanks on the 28th (Add. MS. 27995, f. 10). It was probably distributed to the subscribers as promised on 1 December, and on the 17th to the general public. The *London Evening Post,* 17–20 Nov. 1753, announced the *Analysis* for 1 December; the *Public Advertiser,* 17 Dec., announced it as "This day is published. . . . Those Gentlemen who subscribed for the above Work, and have already received it, are desired to send to the Author for an additional Leaf, which is intended for the more easy finding such Passages in the Book, as relate to the Figures in the Prints." The notice was repeated in the next issue and frequently for the rest of the month, January and part of February.

4. *Apology for Painters,* 65.

5. Ibid., 95; cf. J. Ireland's transcription and reconstruction, 3: 67.

6. Jones, *Memoirs,* ed. A. P. Oppé, *Walpole Society,* 29 (1951): 14.

7. G. M. Hughes, *A History of Windsor Forest* (1890), 289, 290. The "Eight Perspective Views" were announced as published in the *Public Advertiser,* 6 Dec. 1753. See also William Sandby, *Thomas and Paul Sandby, Royal Academicians* (1892); and the memoir published in the *Monthly Maga-*

zine, 1 June 1811, now known to have been by Paul's son Thomas Paul Sandby (A. P. Oppé, "The Memoir of Paul Sandby by His Son," *Burlington Magazine,* 88 [1946]: 143–47). On his early days in Scotland, see Luke Herrmann, "Paul Sandby in Scotland," *Burlington Magazine,* 106 (1964): 339–43; and *Paul and Thomas Sandby* (London, V & A exhibition catalogue, 1986). See also Johnson Ball, *Paul and Thomas Sandby—Royal Academicians: An Anglo-Danish Saga of Art, Love and War in Georgian England* (Cheddar, Somerset, 1985), which corrects the birth dates of both Paul and Thomas.

8. Walpole, Corr., 15: 338; also, *Library of the Fine Arts,* 2 (1831): 345.

9. E. H. Ramsden, "The Sandby Brothers in London," *Burlington Magazine,* 89 (1947): 15–18.

10. Herrmann, *Paul and Thomas Sandby,* 19.

11. Not necessarily, as Einberg states, Jacobites. See Elizabeth Einberg, "Music for Mars, or the Case of the Duke's Lost Sword," *Huntington Library Quarterly,* 56 (May 1993). The painting was sold by Phillips, 19 Nov. 1991 (lot 21), bought by the Leger Gallery, London. The satiric prints Einberg refers to include *John of Gant in Love* (July 1749) and *John of Gant Mounted* (pub. Aug. 1749), her figs. 3 and 4.

12. Cf., e.g., *Tristram Shandy,* 2.7; 8.11. Satires on Cumberland refer to his dubious manhood, perhaps because of his eunuchlike bulk; for example, during the Jew Bill controversy, in one print a woman warns him, "Can you bear Circumcision youl have nothing left then"; to which the duke replies, "Whats that to me it cant do me much Harm" (1753, *BM Sat.* 3209).

13. Dated 1749 and quoted, H. Paton, ed., *The Lyon in Mourning, or a Collection of the Speeches, Letters, Journals etc. Relative to the Affairs of Prince Charles Edward Stuart by the Rev. Robert Forbes, Bishop of Ross and Caithness* (Edinburgh, 1895), 2: 231. John Potter owned the Haymarket Theatre at this time (Phillips, 92–93).

14. The painting is first recorded in Hay's collection by Nichols and Steevens (*Gen. Works,* 1: 24; 2: 201–2). Another example of a small painting probably made for a friend (in this case Theodosius Forrest) was *The Politician* (17½ × 14¼ in., Alupkinsky Palace Museum, Alupka, Crimea). I would date *The Politician* in the 1750s. See Ralph Lillford, "Hogarth's *The Politician,*" *Apollo,* 97 (1983): 100.

15. See Casavis, *Freemasonry,* 152.

16. It was another friend, Dr. John Kennedy, the learned numismatist, who provided Hogarth with the quotation from Lomazzo which was to cause him so much annoyance: he encountered it long after he had developed his thesis, and it does not precisely relate to his subject, but by honestly presenting it in his preface he offered ammunition to those who argued that he had stolen the whole idea from somebody else. It is possible that Paul Sandby would never have heard of the Lomazzo passage if Hogarth

had not himself supplied it. Hogarth's reference to Lomazzo (*Analysis*, 5–6) quotes the *Trattato del arte della pittura* (ed. 1584, 1.1, 23: English trans. by Richard Haydock, *A Tracte containing the Artes of curious Paintinge Carvinge & Buildinge written first in Italian by J°: Paul Lomatius painter of Milan*, [1598], 17); which was repeated by John Elsum in his *Art of Painting*, (27–28). For an interesting account of Hogarth's idea of the line in relation to other thinkers on aesthetics, and in particular the ideas of Antoine Parent in *Journal des Sçavants* (of 14 and 22 Nov. 1700), see J. Dobai, "William Hogarth and Antoine Parent," *Journal of the Courtauld and Warburg Institutes*, 31 (1968): 336–82, esp. 352–82.

17. For Hoadly, cf. Hogarth's portraits, vol. 2, figs. 62, 69; for Morell, see fig. 78 (the engraving in *HGW*, no. 246); for Kirby, see Ellis Waterhouse, *Gainsborough* (London, 1958), pls. 9, 16.

18. See [James Ralph?], *The Touch-Stone* (1728), 54; William Rufus Chetwood, *A General History of the Stage* (1749), 13; and *The Tell-Tale: Or, Anecdotes Expressive of the Characters of Persons Eminent for Rank, Learning, Wit, or Humour* (1756), 1: 170–71.

19. *Burlesque sur le Burlesque,* with its French inscriptions, was later reissued when it joined the series of *The New Dunciad* with English translations and additional inscriptions (and the angel's penis censored). The line quoted is from this later state (BM).

20. For Wilson's pro-Hogarth words on the *Analysis,* see BL Add. MS. 27995, f. 14.

21. *BM Sat.* 3246. Hogarth alludes to Romaine in *Credulity, Superstition, and Fanaticism,* fig. 88.

22. *BM Sat.* 3278.

23. *Public Advertiser,* 1 Apr. 1754; the prints were sold by Robert Sayer, who by this time had also acquired a number of Hogarth's copperplates not in Hogarth's own possession (e.g., the *Hudibras* plates, acquired from the Bowles brothers; see *HGW,* 17).

24. Announced, *Public Advertiser,* 18 Jan. 1754. The issue of 2 February announced *Hogarth Vindicated, Or, The Line of Beauty proved to be Serpentine, by a Lady.*

25. *GM,* 23 (Dec. 1753): 593; 24 (Jan. 1754): 11–15 (rpt. in the *Scots Magazine,* 16 [Jan. 1754]: 36–40). The second is attributed to Hawkesworth in *Gen. Works,* 1: 331; both are attributed to Samuel Johnson, on the basis of style and what is known of his reviewing at the time for the *GM,* by Arthur Sherbo, "Samuel Johnson and the *Gentleman's Magazine,*" in *Johnsonian Studies,* ed. M. Wahba (Cairo, 1962), 146, 150–51. The evidence of the style is supported by Hogarth's strong commendation of Johnson to Hester Lynch Salusbury in 1758 or 1759, a sure sign of Hogarth's appreciation (see, 263). But O. M. Brack, who is editing Johnson's *GM* reviews for the Yale edition, is inclined to believe they were written by Hawkesworth.

26. *Journal Britannique,* 12 (Nov.–Dec. 1753), 360–80; *Monthly Review,* 10 (Feb. 1754): 100–110. For the identification of Rose, see B. C. Nangle, *The Monthly Review, First Series, 1749–1789* (Oxford, 1934), 127; also, T. Faulkner, *History . . . of Brentford* (1845), 349 ff.

27. MS. Journal of Catherine Talbot, BL Add. MS. 46689 [722E].

28. *Letters written by the late right honourable Lady Luxborough, to William Shenstone, Esq.* (London, 1775), 380–81; *Letters of William Shenstone,* ed. Marjorie Williams (Oxford, 1939), 396, 400; Burke, *Philosophical Enquiry,* 3.15 (Shenstone's copy is in the Harvard University Library); "Verses," in S. Johnson, ed., *Works of the English Poets* (1779), 54: 316–19. Interestingly, Burke's *Enquiry* met with the same kind of strictures applied to Hogarth's *Analysis:* the writer in the *Critical Review,* while commending the work, accused him of limiting the sublime to terror, excluding all other emotions; and thought his theory lacked originality (*Critical Review,* 3 [April 1757]: 363–64; see Herbert A. Wichelns, "Burke's Essay on the Sublime and Its Reviewers," *Journal of English and Germanic Philology,* 21 [1922]: 646–47).

29. J. Ireland, 1: lxxx–xi; *Gray's Inn Journal* No. 38, 7 July 1753.

30. Cambridge pursued the subject with a discussion of "variety" on 20 Dec.

31. *The Connoisseur, by Mr. Town, Critic, and Censor-General,* 1 (Feb. 1754): 8.

32. *GM,* 24 (1754), attached to the beginning of the volume.

33. *The Case of Authors by Profession or Trade* (1758), 17.

34. Uvedale Price, *Essays on the Picturesque* (1798), 2: 269–70 n.

35. Thomas Twining, *Aristotle's Treatise on Poetry* (1789), 2: 403 n.; J. T. Smith, 2: 274.

36. Reynolds, MS. "Observations on Hogarth," in Mrs. Copland-Griffith's collection, published in Derek Hudson, *Sir Joshua Reynolds* (London, 1958), 66; Ramsay's *Essay on Taste* was published in London in a volume called *The Investigator, Number 332* (the first number, 331, had appeared in Jan. 1754).

37. Addison had met this point in *Spectator* No. 411 when he noted that each species "is most affected with the Beauties of its own kind" (his example was birds; see 3: 542–43).

38. *The Investigator* (1762 ed.), 56. The review of Ramsay in the *Monthly Review* was not favorable, remarking, "The subject is curious, but is treated with no great accuracy or precision."

39. *Apology for Painters,* 109.

40. Plymouth, City Museum, Cottonian Collection, transcripts of letters; quoted, Lippincott, 123.

41. It was also a response to Highmore's *Critical examination of those two Paintings on the Ceiling of the banqueting-house at Whitehall.*

42. *De Arte Graphica; or, The Art of Painting* (1754), 3. 17, 19, 21.

43. Mylius's translation is called *Zergliederung der Schönheit, die schwankenden Begriffe von dem Geschmack festzusetzen, geschrieben von Wilhelm Hogarth* (London and Hanover, 1754).

44. *Berlinische Priviligierte Zeitung* No. 29 (7 Mar. 1754), in Lessing, *Werke,* ed. Julius Petersen and Waldemar von Olshausen (Berlin, 1929–35), pt. 9, ed. F. Rudder, 316; No. 65 (30 May 1754), *Werke,* pt. 9, 330–31; No. 76 (25 June 1754), *Werke,* pt. 9, 337–39. The second announcement of the new edition came on 1 July (*Werke,* pt. 7, 77–79; quoted, *Gen. Works,* 1: 241), saying the book would appear in about six weeks, accompanied by Rouquet's *Lettres de Monsieur**.* Lessing's preface is reprinted in *Werke,* pt. 7, 79–83.

45. For a complete list of editions, see Stanley E. Read, "Some Observations on William Hogarth's *Analysis of Beauty:* A Bibliographical Study," *Huntington Library Quarterly,* 5 (1941–42): 360–73.

46. AN, 203; *Apology for Painters,* 109.

47. Horne Collection, *Disegni ingelsi della Fondazione Horne in Firenze* (Florence, 1966), cat. no. 3; see J. Ireland, 3: 112–13n.

6. ELECTORAL POLITICS

1. Moor (1712–1779), *Essays; Read to a Literary Society; at Their Weekly Meetings, within the College, at Glasgow* (Glasgow, 1759), 40–50.

2. De Hoogh's version includes vignettes close to scenes developed by Hogarth in his *Rake's Progress.* Translations as well as prints of the *Tabula Cebetis* tended to interpret the "ancient" as (to use Hogarth's phrase) a "modern moral subject." In Jeremy Collier's translation of 1701 the men dispatched by the courtesans Intemperance and Prodigality to Torture and Grief are called "the *Rakes*" and the place where they are "maul'd and mortified" is called "this *Bridwell*"; they are then "committed to Gaol, where *Unhappiness* is their *Keeper.*" See E. H. Gombrich, "A Classical 'Rake's Progress,'" *Journal of the Warburg and Courtauld Institutes,* 15 (1952): 254–56; M. Boas, "De illustratie der Tabula Cebetis," *Het Boek,* 12 (1920): 1: 105; and *Cebes in England: English Translations of the Tablet of Cebes . . . ,* ed. Stephen Orgel (New York, 1980).

3. I quote a translation with notes, dictated by Shaftesbury or made under his supervision (Shaftesbury's *Second Characters,* ed. Benjamin Rand [1914], xvii–xviii; 64–87).

4. Gender conflict was very different in the *Harlot* than in *Pamela* and *Clarissa* (see vol. 1, chap. 8). The Harlot was pitted against all those powerful Mr. B.s and Lovelaces; Pamela and Clarissa had only one apiece plus the power to engage and, in their different ways, conquer each.

5. Antal, 168. Hogarth's brushwork gives rise to speculation on the in-

fluence of Canaletto's handling of paint in his English landscapes, painted in the late 1740s. It is quite possible that Hogarth met Canaletto during his visits, begun in May 1746, since his friend Samuel Scott was the most notable English perpetuator of the Canaletto mode and style. By the time he came to England Canaletto's painting had entered a new phase, which indeed caused confusion among his English patrons to the extent that his identity was doubted when he first arrived. This new style, bold and stenciled ("mechanical and caligraphic," as W. G. Constable has put it), very much in evidence in *Eton College Chapel* (1746–1747) and *The Procession of the Knights of the Bath* (1749), resembles the clear demarcations of colors broadly applied in the *Election* paintings. Some of the colors that distinguish the *Election* from Hogarth's paintings of the 1740s—the cool blues, reds, grays, and creamy light shades—also remind one of Canaletto. There is a canvas of sketched figures in the Gemäldegalerie in Dresden which brings out even more sharply the resemblance to Hogarth's new painting style. (See Constable, *Canaletto* [Oxford, 1962], 1: 139; for Canaletto in England, Vertue 3: 149, 151.)

6. To Richard Bentley, 18 Mar. 1754, in Walpole, *Corr.*, 35: 171.

7. *London Evening Post*, 25–27 Apr. 1754 and the next two issues; *Public Advertiser*, 30 Apr. and throughout May. As usual, the price was to be raised after the subscription. From 28 March to 31 May 1754, the closing date, there were 461 subscribers. They could subscribe for the one plate or for the putative set of four—and there were 127 such sets. See "Subscribers Names to Four Prints of an Election March 19th 1754," BL Add. MS. 22394. k. 1, fols. 2–28, and index at back of the volume (following f. 132).

8. "Country" views supposedly "reflected the true interests of the nation at large, the country, against a small corrupt faction, the Court and its minions" (Marie Peters, *Pitt and Popularity: The Patriot Minister and London Opinion during the Seven Years' War* [Oxford, 1980], 24–25). For the Oxfordshire election, see R. J. Robson, *The Oxfordshire Election of 1754* (Oxford, 1949), and Quennell, 240–61.

9. See *Jackson's Oxford Journal*, 22 June 1754; Robson, 128–29.

10. He had painted his patronness Mary Edwards, in order to show her staunch Opposition politics, with a bust of Queen Elizabeth and a copy of her speech to the English troops as they set sail at Tilbury to fight the Spaniards (ill., vol. 2, fig. 87). The second bust is of King Alfred, a king of central importance in the Opposition view of history: Hogarth etched the admission ticket for Thomson and Mallet's *Masque of Alfred*, which was performed privately in September 1740 for Prince Frederick, who had gone into active opposition in 1737 (*HGW*, no. 151). The terms "Country"/ "Court" parties were introduced by Bolingbroke in his "Dissertation upon Parties" in *The Craftsman* in 1735.

11. Henry St. John, Viscount Bolingbroke, *Letters on the Spirit of Patriotism and on the Idea of a Patriot King,* ed. A. Hassall (Oxford, 1917), 93, 56.

12. Battestin, ed., *Amelia,* 457 and n1; Dr. Harrison's views echo those summed up by Ralph in his *Remembrancer* of 3 June 1750; cited Battestin, op. cit., xxxvii. It is possible that the anti-Dodington piece in the *Daily Gazetteer* of 13 May 1741, which Battestin takes to refer only to Fielding, may also include Hogarth: the allegory has Dodington a bear, who has fallen out with his old friends (Walpole & Co.), now taking up with "Vermin," including the "mischievous" monkey (Fielding), "more in favour with the Bear than all the rest." But the following account of Dodington's patronage also includes a "pug." Pug and monkey are not the same; and since pug by 1741 could have indicated Hogarth, we should entertain the possibility that he was also included. (See Battestin, *Fielding,* 279–80.)

13. Cf. other caricatures of Dodington by Hogarth (Oppé, cat. no. 32), Sandby, and Townshend.

14. *Political Journal of George Bubb Dodington,* ed. John Carswell and Lewis A. Dralle (Oxford, 1965), 264.

15. *Aeneid,* 8.655–56, Dryden trans.; *Dunciad,* 1.211–12; the author of the *Poetical Description of Mr. Hogarth's Election Prints* (1759) sensed, though he did not draw, the connection, when he referred to the candidate and his goose: "His voice he'll in the Senate use; / And cackle, cackle, like—a goose." The representation of Newcastle as a goose was under way at least by 1755–1756 when his association with Henry Fox reminded satirists of fables of fox and geese. See, e.g., *BM Sat.* 3330, 3373, 3589. Cf. Hobbes's antiheroic image of the defense of Rome and the cackling of the geese (letter of dedication to *Leviathan*).

16. Also Mark 5:1–14 and Luke 8:26–34; they probably recall Circe's swine as well. Hogarth is also remembering the route of the enchanter Indolence, after the victory of the Knight of Arts and Industry, in Thomson's *Castle of Indolence:* led by "Gaunt Beggary," who resembles the Jewish peddler, "Scorn . . . with nose upturned," they are a "herd of bristly swine" (2.lxxix–lxxxi).

17. The story is told in *Aesop's Fables* and Cicero's *De Finibus,* 5.30.92; also by St. Jerome, Erasmus in his *Adagia* and *Praise of Folly,* and others.

18. These are Thomas Crow's words applied to the French concept, which shared most of its assumptions with the Shaftesburian, adding the French memory of "the massing of Easter penitents before the portal of Chartres Cathedral" (Crow, *Painters and Public Life in Eighteenth-Century Paris* (New Haven, 1985), 2.

19. *Craftsman,* 27 July 1734; Locke, *Essay concerning Human Understanding,* 2.28.12; cited, Jürgen Habermas, *Structural Transformation of the Public Sphere,* tr. Thomas Berger and Frederick Lawrence (Cambridge, Mass.,

1989), 93.

20. Williams, *Artisans and Sans Culottes* (London, 1968), 11.

21. See John Brewer, *Party Ideology and Popular Politics at the Accession of George III* (Cambridge, 1976), 6.

22. For the riot that most seriously impinged on Hogarth in his youth, see Geoffrey Holmes, "The Sacheverell Riots," *Past and Present,* no. 72 (Aug. 1976), 55–85. Horace Walpole, perhaps with Hogarth's *Election Entertainment* in mind, described in 1761 the experience of having to stand for office: "Think of me, the subject of a mob, who was scarce before in a mob, addressing them in the town hall, riding at the head of two thousand people, dining with above two hundred of them, amid bumpers, huzzas, songs, and tobacco, . . . I have borne it all cheerfully" (*Corr.,* 9: 350; to G. Montagu, 25–30 Mar. 1761).

23. For Fielding's most recent adverse opinion of the mob, see *Amelia,* 7.6, ed. Battestin, 519–20. For Thompson, see his "Moral Economy of the English Crowd in the Eighteenth Century," *Past and Present, 50* (Feb. 1971), 76–136; cf. John Steven's critique of Thompson's position: "The 'Moral Economy' of the English Crowd: Myth and Reality," in *Order and Disorder in Early Modern England,* ed. Anthony Fletcher and John Stevenson (Cambridge, 1985), 234–35.

24. Nicholas Rogers, *Whigs and Cities: Popular Politics in the Age of Walpole and Pitt* (Oxford, 1989), 374–76.

25. John Stevenson, *Popular Disturbances in England 1700–1870* (London, 1979), 60, 44, 26; Andrew Charlesworth, ed., *An Atlas of Rural Protest in Britain 1548–1900* (London, 1983), 48–49; Robert F. Wearmouth, *Methodism and the Common People of the Eighteenth Century* (London, 1945), 22.

26. *Jackson's Oxford Journal,* 9 Feb. 1754; 16 Feb.; 23 Mar.; 16 Mar.; 11 May. See also issues for 6 Oct., 13 Oct. 1753, and 27 Apr. 1754.

27. See Thomas W. Perry, *Public Opinion, Propaganda, and Politics in Eighteenth-Century England, A Study of the Jew Bill of 1753* (Cambridge, Mass., 1962), 39, 31, 74; Lewis Namier, *England in the Age of the American Revolution* (London, 1930), 211–22; Lucy Sutherland, "The City of London in Eighteenth-Century Politics," in *Essays Presented to Sir Lewis Namier,* ed. R. Pares and A. J. P. Taylor (London, 1956), 54–55.

28. *Jackson's Oxford Journal,* 11 Aug. 1753; rpt. from *London Evening Post,* 4–7 Aug.

29. Endelman, *The Jews of Georgian England 1714–1820: Tradition and Change in a Liberal Society* (Philadelphia, 1979), 21. Of course, as the *Crisis* noted (1754), "Jew" at this time was merely a term applied by any party to its opponents: "In the mouth of a Jacobite, Judaism is another name for the revolution of 1688, a limited monarchy, the Hanoverian legacy, and the royal family. . . . In the mouth of a pretended patriot and flaming bigot,

Judaism is a Whiggish administration and House of Commons, a Protestant Bench of Bishops, Liberty of conscience and an equitable toleration" (quoted, Endelman, *Jews*, 90).

30. In September 1756 there was the affair of the Hanoverian soldier, "arrested for the theft of two handkerchiefs but then released to the Hanoverian authorities on the order of the Secretary of State [Fox] and thus exempted from the ordinary process of law" (Walpole, *George II*, 2: 85; Peters, *Pitt and Popularity*, 50). Could the soldier peering at the woman counting her coins be Hogarth's reference to this episode?

31. For a fictional account of such a dinner, see the *Connoisseur*, 25 Apr. 1754; *GM*, 23 (1753): 384. Hogarth's Whigs in 1 are eating lobster and oysters, but on one plate appears something that closely resembles a hog's trotter.

32. Rpt. from the *Craftsman*, 24 Feb. 1753; it was widely reprinted, e.g., in the *London Evening Post*, 12–14 July, and the *London Magazine* for July, 302–3. See also *Pieces on the "Jew Bill,"* ed. Roy S. Wolper, Augustan Reprint Society, No. 217 (Los Angeles, 1983).

33. Trans., Harold Levy, in Edgar R. Samuel, "Dr. Meyer Schomberg's Attack on the Jews of London," *Transactions of the Jewish Historical Society of England*, 20 (1959–61): 103. Meyer (1690–1761) was a fellow Mason, as was his son Isaac, also a physician (1714–80), who collected Hogarth's works, appears on subscribers' lists, and treated him in his illnesses of the 1760s. Though also after the fact, and perhaps reflecting Hogarth's image, Fielding's *Miss Lucy in Town* (pub. 1742) shows a high-class London brothel patronized by wealthy Jews.

34. Warburton had attacked the Jews at great length in the second volume of his *Divine Legation of Moses* (1741), regarding the Ark of the Covenant as an example of Jewish idolatry. It was important for his anti-Deist argument to discredit the Jews and elevate Moses at their expense. He distinguishes Jews, ancient and modern, as mercenary usurers and idolaters from the divinely legated Moses. Equally important, the Jews, embodied in their priests and rabbis, represented the evils of clericalism and textualism. See *Divine Legation*, 5.2; the second volume (1741) is dedicated to "The Jews"; see also Stromberg, *Religious Liberalism*, 60, 79. To complete the picture, we should note that Jews were also excluded from the Masonic lodges "as being the great enemies of the Grand-Master" (the type of Christ). See Thomas de Quincey, "Rosicrucians and Free-Masons," *Collected Writings of Thomas de Quincey*, ed. David Masson (London, 1897), 13: 427.

35. Woolston also returns as a shadowy memory in *Election* 4 because of his satiric treatment in his *Discourse* (1728) of the story of the Gadarene swine. He pointed out that "its not credible there was any Herd of *Swine* in

that Country. . . . The *Jews* are forbidden to eat Swine's Flesh"; and he speculated that perhaps the Gadarenes were "not *Jews,* but neighbouring *Gentiles,* with whom it was lawful to eat, and keep *Swine.*" His symbolic interpretation was that the madman worshipped false gods (i.e., devils), and that the devils turned into swine was an allegory of "*Hereticks* of impure Lives, and furious Natures" (37).

36. Chesterfield, letter to his son, 26 Nov. 1753.

37. *Jackson's Oxford Journal,* 29 Dec. 1753.

38. For many day-to-day details I am indebted to J. C. D. Clark, *The Dynamics of Change: The Crisis of the 1750s and English Party Systems* (Cambridge, 1982). For the division of the court and its political lineup in 1753, see the letter from Hogarth's friend James Ralph to Dodington, 1 Feb. 1753 (*HMC Various,* 6: 23; quoted, Clark, 38).

39. See *HGW,* no. 197.

40. The older woman recalls the Amazonian women who, it was claimed in anti-Jacobite satire, were the real force behind the Jacobite cause.

41. See below, 296. His son, Charles James Fox, remembered as a child spending hours over his father's folio of Hogarth's prints. See Earl of Ilchester, *Henry Fox, First Lord Holland: His Family and Relations,* (London, 1920), 2: 105. For his subscriptions to *Finchley, Paul before Felix* (and *Burlesqued*) and *Moses,* and the popular prints of 1751–1752: see Hampstead Public Libraries; photo, Witt Library, Courtauld Institute.

42. For Fox's position at this point, see Clark, *Dynamics of Change,* 50.

43. Clark, *Dynamics of Change,* 38. Fox would have offered access to Hartington of the sort that had bailed out Hogarth's friend Ralph in 1753; Ralph had used as his approach to Hartington another common friend, David Garrick (who with Ralph subscribed to the *Election*). See Jarrett, 168.

44. See *London Evening Post,* 18–20 Feb. 1755.

45. While Nichols reported all destroyed, John Ireland claimed that only five of the six had burned and that the survivor was in Lord Charlemont's collection—which, however, is only a copy from the engraving (1: 25). For the most recent claimant, see vol. 1, 372n3.

46. See *Commons, 1756–1790,* 1: 75–78. For Fonthill, see Dr. Richard Pococke's account in July 1754: James Cartwright, ed., "Travels through England of Dr. Richard Pococke . . . during 1750, 1751 and later Years," *Camden Society,* n.s. 44 (1889): 47; John Harris, "Fonthill, Wiltshire— Alderman's Beckford's Houses," *Country Life,* 140 (24 Nov. 1966): 1370–72.

47. *London Evening Post,* 9–11 March 1756; where he also repeats his notice of the delay of the *Election* prints. For Garrick, see *Gen. Works,* 1: 260.

48. *Public Advertiser,* 24 Feb. 1755; *Gen. Works,* 1: 258.

49. It specifically recalls a print called *Punch's Opera with the Humours of*

Little Ben the Sailor, published in October 1756 (*BM Sat.* 3394), which shows Fox as Punch and the duke of Newcastle as "Punches Wife Joan," a hunched figure wearing a dress, shawl, and apron.

50. In his advertisement of 24–26 February 1757, Hogarth referred to "several spurious and scandalous Prints" which had "lately been published in his Name." One was his own plate of 1726, *The Punishment Inflicted on Lemuel Gulliver,* now owned by the printseller Robert Sayer.

51. For these pessimistic views on the "depravity of human nature" in the age, see Robert D. Spector, *English Literary Periodicals and the Climate of Opinion during the Seven Years' War* (The Hague, 1966), 66–68.

52. Brown, *An Estimate of the Manners and Principles of the Times* (1757), 1: 47; also *GM,* 27 (1757): 168. Brown's *Essays on the Characteristics* (1752) was an attack on many aspects of Shaftesbury's philosophy. Brown's pessimism was closely connected to, if not an offshoot of, the view of contemporary corruption promulgated by the Country ideology of Leicester House during these years, preparing for the resumption of Old English "liberties" and "patriotism" with the new reign.

53. *Estimate,* 1: 72, 34–35, 180–83.

54. *Commons, 1754–1790,* 3: 595; Walpole to the duke of Bedford, 27 Aug. 1759 (Bedford MSS.).

55. Repeated 16–18 Mar.; *Public Advertiser,* 13 Mar., repeated to the end of the month. On 3 March 1759 a poem was announced: "Dedicated by Permission, to Mr. HOGARTH, and written under his Inspection, A Poetical Description of his ELECTION PRINTS, in Four Cantos . . ." (*Public Advertiser,* 19 Mar., pub.; a copy is in the Cambridge University Library).

7. THE POLITICS OF ART

1. *State of the Arts,* 15.

2. See *HGW,* no. 197.

3. *London Evening Post,* 24–26 Jan. 1754.

4. The whole letter, dated 7 June 1754 (in the James S. Browne Collection), is transcribed in *HLAT,* Appendix H. Both Paul and Thomas Sandby appear on the subscribers' list for Kirby's second edition (1755), though not asterisked. Reynolds's name now appears and is asterisked.

5. Also in 1755 appeared an anonymous pamphlet (probably by the landscape painter Alexander Nesbit) called *An Essay . . . on the Necessity and Form of a Royal Academy,* which establishes some continuity between the artists in search of a state academy and the Hogarth of the "Britophil" essay and the attacks on picture dealers and cleaners. It is the "Dealers and Cleaners, and all other ignorant and designing People, who will be inveterate Enemies to an Academy," he argues (7). He parts company with Hogarth,

however, when he recommends that the president of this academy be "not a Painter" but "a Man of Consequence—chosen for life," and that the professors be procured from foreign academies (24–25, 34).

6. Lionel Cust, *History of the Society of Dilettanti* (London, 1898), 53. The printed document itself can be found in the library of the Metropolitan Museum of Art, New York; see also Pye, 76–77; Charles R. Leslie and Tom Taylor, *The Life and Times of Sir Joshua Reynolds* (London, 1865), 1: 131; F. W. Hilles, *Literary Career of Sir Joshua Reynolds* (New Haven, 1936), 15 and n.

7. Preface to the *Ionian Antiquities* (1769).

8. Cust, *Dilettanti*, 25–29. For the relationship between the Dilettanti and the Medmenham monks, see below, Chap. 10.

9. For a detailed account of the negotiations, see *HLAT*, Appendix I. The subscribers to the St. Martin's Lane Academy met as usual on 12 April and 11 October at the Turk's Head to settle accounts and pay subscriptions for the ensuing season (*Public Advertiser*, 10 Apr., 8 Oct. 1755).

10. *Apology for Painters*, 105.

11. See Whitley, 1: 149.

12. Edwards, *Anecdotes*, 185. The earliest source, and perhaps known to Edwards, is Boswell's notes toward a biography of Reynolds, in F. W. Hilles, *Portraits of Sir Joshua Reynolds* (New York, 1952), 22–25. The following account is based on Derek Hudson, *Sir Joshua Reynolds* (London, 1958).

13. Quoted, Hudson, *Reynolds*, 21; that the Slaughter's group was meant was assumed by Leslie and Taylor, *Reynolds*, 1: 28 n.

14. Hudson, *Reynolds*, 22–23.

15. For an account that emphasizes the playful irony of Reynolds's portraits of children, some women, and an occasional man, see Robert E. Moore, "Reynolds and the Art of Characterization," in *Studies in Criticism and Aesthetics*, ed. H. Anderson and J. S. Shea (Minneapolis, 1967), 332–57.

16. This is Waterhouse's thesis in *Three Decades*.

17. Its formation was announced in the *Daily Advertiser*, 8 June 1752.

18. See Waterhouse, *Three Decades*, 61.

19. Joseph Farington, *Memoirs of Reynolds* (1819), 262.

20. Farington, *Memoires*, 260; Madame d'Arblay, *Memoirs of Dr. Burney* (London, 1832), 2: 365.

21. See *Thraliana*, ed. Katherine C. Balderston (Oxford, 1942), 473, 728.

22. Hudson, *Reynolds*, 51.

23. BL Add. MS. 27995, f. 12.

24. Poor Rate Books, St. Martin-in-the-Fields Parish, Westminster Public Library.

25. *Public Advertiser*, 28 Oct. 1755.

26. *State of the Arts*, 15, 16.

27. *Analysis,* 176–77; Rouquet, *State of the Arts,* chap. 29.

28. *Monthly Review,* 14 (Nov. 1755): 399 (author not identified by B. C. Nangle, *The Monthly Review, First Series, 1749–89* [Oxford, 1934]). For a more favorable, French review, see *L'Année littéraire,* 2 (1754): 124–39 (Lettre 6), but with no mention of Hogarth.

29. *The Practice of Painting and Perspective Made Easy* (1756), 7. Bardwell begins with a plea for a state academy; but copying is his bone of contention with Hogarth. Like Hogarth, he thinks artists would be better off staying in England than going off to Italy, but while Hogarth advises the copying of nature, he recommends the Van Dyck portraits of English ladies, which he thinks "as much preferable to the Antiques, as the animated Beauties of nature are to the cold Imitations of her in stone." He is skirting Hogarth's contrast of flesh and stone in the *Analysis,* but his point is made clear when, in the middle of his book (whose subject is actually coloring), he inserts a chapter entitled "Copying" in order to defend the copyists attacked by Hogarth. "The Author of the *Analysis of Beauty,*" Bardwell writes, "has given his opinion on Copying in his true Spirit and Genius; treating with Ridicule one of the most useful Parts of Painting. This I impute to his Want of Skill in this Branch of the Art, or to a most ill-grounded Prejudice." For, he goes on to explain, all the greatest masters copied each other and improved accordingly (7, 20–22). Bardwell was mauled critically in the *Monthly Review,* 15 (1756), 162 ff. and 282 ff. On 285 the reviewer (apparently James [Athenian] Stuart) defends Hogarth, though somewhat wryly. For Stuart (just returned to England after fourteen years in Italy and Greece), see below, 350. For Bardwell, see M. Kirby Talley, "Thomas Bardwell of Bungay, Artist and Author, 1700–1767, with a Checklist of Works," *Walpole Society,* 46 (1976–1978), 91–163; and Talley and K. Groen, "Thomas Bardwell and His Practice of Painting," *Studies in Conservation,* 20 (1975): 44–108.

30. One story places Shipley in Slaughter's around 1746, just after the Rebellion, where his taciturnity, his sober demeanor, and his strange papers covered with projects led to his being denounced as a Jacobite. He was so silent before the magistrate that things might have gone badly for him had not some of his artist friends arrived to vouch for his character. See Joseph Moser (nephew of G. M. Moser), *European Magazine,* 14 (1803): 176–78.

31. See the Ozias Humphry MSS. in the Royal Academy Library (1: 56, 59) and G. C. Williamson, *Life and Works of Ozias Humphry, R.A.* (London, 1918). For Shipley in general, see D. G. C. Allan, *William Shipley, Founder of the Royal Society of Arts* (London, 1968); about anticipations of the Society of Arts, 14 ff.; on its foundation, 50–55; on Shipley's drawing school, 76–88.

32. Its importance to industry, according to its chronicler, Sir Henry Trueman Wood, was great: "The old conditions of regulance and support

had long since disappeared. The new conditions of competition and the absence of restriction were not yet conceived, let alone formulated. The various young industries, textile, metallurgical, ceramic, and the rest, all wanted patronage and help. They wanted, too, advertisement and notoriety. All this they got from the newly-formed Society . . ." (*A History of the Royal Society of Arts* [London, 1913], 20.) See also Derek Hudson and Kenneth W. Luckhurst, *The Royal Society of Arts, 1754–1954* (London, 1954).

33. Society of Arts minute books, 1: 11, in the library of the Royal Society of Arts.

34. *GM,* 26 (1756): 61. Cf. Shipley's advertisement for his drawing school, *Public Advertiser,* 6 Apr. 1757; see also advertisements in the same paper, 25 June and 8 July 1757.

35. *Apology for Painters,* 87–88.

36. See *The Library,* 9: 132; Marjorie Plant, *The English Book Trade* (London, 1939), 202–3. In 1769 Ralph Bigland wrote to a friend: "The paper I had for our Plate I buy of one Mr. Boydell, one of the first if not only importer of the proper paper for the copper-plate work in London. It comes chiefly from France; the English make is too smooth or fine for it" (Nichols, *Literary Anecdotes,* 8: 717).

37. Allan, *Shipley,* 76. Shipley's equivocal use of the Society of Arts may also be reflected in his advertisement in the *Northampton Mercury* of 27 May 1754 announcing that he was still taking orders for his painting business from London.

38. *Whitehall Evening Post,* 27 Mar. 1798; repeated in William Seward's *Biographiana* (1799), 2: 293; *Gen. Works,* 1: 140.

39. *Apology for Painters,* 98. His views were echoed, and perhaps clarified, by his friend Ralph in his *Case of Authors* (1758): "If those worthy Gentlemen [of the Society of Arts] could also be prevail'd upon to do as much for History and Landscape Painters (whose Profits bear as little Proportion to those of their younger Brethren the Portrait-Men, as the Authors to the Players), their Plan would be so much the more perfect, and the Public would, consequently, entertain a higher Opinion of it: There being something apparently absurd, in giving Rewards to increase the Number of Adventurers [i.e., beginning artists], and making no Effort to open a Market for them, after they are become Masters" (62n). Hogarth also argued, taking the society's ostensible aim of encouraging art in order to improve standards of industrial design, that English manufacturing would not be improved by raising standards of design, and that this would not gain them any commercial advantage over the French (*Apology for Painters,* 101).

40. Rev. Edmund Pyle, *Memoirs of a Royal Chaplain,* ed. Albert Hartshorne (1905), 61.

41. On the other hand, the society's minute books show no outright

break with Hogarth. He was at the next 4 February (1756) meeting, bringing the engraver Thomas Major as his guest, and he reported that "the Paper Manufacture proper for fine Prints might be brought to great Perfection, if Encouragement was given thereto." Then Hogarth, Dodsley, Crisp, and Anthony Highmore were asked to draw up an advertisement for a premium to be offered for paper. Hogarth's report on this was to be at the next meeting; he then proposed Major as a member. He was also placed on a committee to examine John Fielding's quarters in the Strand as a new meeting place for the society. He was present again at the next meeting, on 11 February, when Major was elected and Dodsley "delivered in writing Reasons for giving a Premm for making Paper like the French proper for Copper Plates." It was "Resolved, That Mr Hogarth's Report be postponed." All that is ever heard of Hogarth's postponed report is a paper delivered by Major, written by Anthony Highmore, on the paper problem at the next meeting, 18 February, which Hogarth did not attend.

He was absent again on the 25th, but present at the annual meeting on 3 March when John Fielding and Saunders Welch were elected members. Absent on the 10th, he was back again a week later when it was announced that the committee on drawings and designs would meet the following Wednesday morning. At this meeting Whitworth also reported that his committee had drawn up an advertisement for making paper "nearest in all its Qualities to the French Paper, proper for Copper Plates." At some point Whitworth, the old faithful, had taken over from Hogarth the responsibilities of the paper premium problem. The advertisement for the paper premium may have been drafted by Hogarth: "Notwithstanding the Art of Paper-Making is arrived to great Perfection in England, yet as considerable Quantities of a particular Sort are imported from Abroad; it is therefore proposed, to give as a Premium, for making one Rheam of Paper, which upon Tryal shall be judged to come nearest in all its Qualities to the French Paper, proper for recovering the lost Impressions from Copper Plates; to be produced on or before the first Wednesday in February 1757 £20." At the time of her death, Jane Hogarth was still using French paper for the printing of her husband's plates (sale catalogue, no. 68).

Although absent for the next few meetings, Hogarth was put on committees to consider buff leather and choose a device for the honorary medals, and was present when reports were made on 14 April. He also attended the meeting on 28 April, after which he may well have left London for Bath and Bristol to work on the altarpiece he was painting for St. Mary Redcliffe. When he appeared again, on 15 December, he was put on a staggering series of committees: for discussing a premium for the "producing of cocoons in the province of Georgia," "for planting and raising the largest and best Roots of Madder for the Year 1758," "for making the most and best . . .

and Smalt, from English Cobalt, for the Year 1758," "for making Borax in this Kingdom, for the Year 1758," for drawings by boys and girls, designs, etc. The list goes on, each moved by a member. At length paper proper for copperplates was added to the list, perhaps by Hogarth himself. He may have been told that drawing premiums were coming up again; he may have been interested in the colors sought. At any rate, the society clearly did not yet consider him a lost cause. He was again present on 2 and 8 February, and 9 March. Although mentioned a few times thereafter, he never attended another meeting. The strong line through his name suggests that he made a resounding speech and withdrew, but the minute books indicate that he faded away in discouragement and boredom.

42. Allan, *Shipley,* 84; see also Society Minutes, 9 Nov. 1757 and 5 Apr. 1758.

8. LAST HISTORY PAINTINGS

1. St. Mary Redcliffe minute book, 1709–1766; Holmes's work is mentioned by Croft-Murray, 1: 222b.

2. Wootton's wife Rebecca's eldest sister Mary married the Reverend John Broughton, whose son Thomas held the living of St. Mary Redcliffe from 1744 to 1774 (see George E. Kendall, "Notes on the Life of John Wootton with a List of Engravings after His Pictures," *Walpole Society,* 21 [1932–1933]: 23–42).

3. See Ruth Young, *Mrs. Chapman's Portrait: A Beauty of Bath of the 18th Century* (Bath, 1926), 71–74. For Dingley, see Vertue, 3: 161; 4: 80; above, 188.

4. M. J. H. Liversidge, *William Hogarth's Bristol Altarpiece* (Bristol, 1980), 9–10.

5. *Critical Review,* 1 (June 1756): 479 (pub. 1 July, according to the *London Evening Post,* 26–29 June). William Barrett, *The History and Antiquities of the City of Bristol* (Bristol, 1789), incorporates the *Critical Review*'s description with a few changes.

6. The Ledger of Benefactions, 1734–1784, 465. Hogarth's receipt reads: "Recd Augst 14 1756/Of Mr Nathl Webb the sum of five Hundred and Twenty five Pounds for three Pictures Painted for the Altar-piece of St Mary Redcliffes Church at Bristol in full of all Demands/ Wm Hogarth." For the frames, the joiner Brice Seed was paid £50; for carving them, Thomas Patty, £63; for gilding, John Symons (or Simmons), £100; and for the red drapery used to fill in the space above the altarpiece (the painting did not reach to the top of the Gothic arch), James Howell, upholsterer, was paid £6 18s 6d. The total expense was £721 6s 4p (Churchwardens' Accounts, 1756–1757).

7. Liversidge, *Altarpiece,* 10–11, citing the churchwardens' vouchers and the *Critical Review.*

8. The earliest source for the story is *The Bristol Memorialist* of 1816, which also tells us that Simmons was born in 1715, worked later on an Annunciation altarpiece for All Saints Church, Bristol, and exhibited portraits at the Royal Academy between 1771 and 1780. The story is retold by J. F. Nichols and John Taylor, *Bristol Past and Present* (Bristol, 1881), 3: 192; John Latimer, *The Annals of Bristol* (Bristol, 1893), 342; and others.

9. The source for St. Peter in the extreme left foreground is probably François Duquesnoy's St. Andrew (St. Peter's, 1629–1640); Hogarth included a sketch of a cast of the head in one of the MS. drafts of the *Analysis.* The Roman soldiers in *The Sealing of the Sepulchre* and the angel in the *Three Marys* may derive from figures in the *Liberation of St. Peter* fresco in the Vatican which, like *The Transfiguration,* Hogarth would have known from engravings. There is a surviving sketch for the figure of the soldier at the left of the left panel (Oppé, cat. no. 84.) A general influence in the *Three Marys* panel may be Andrea Sacchi's 1640 *Vision of St. Romuald* (Vatican Gallery), which Hogarth mentions in the *Analysis.*

10. Woolston, *Sixth Discourse on the Miracles of Our Saviour* (1729). See vol. 1, 288–92; 2, 88–92.

11. In this case, cf. the conventional accounts in the commentators. More recent controversy included, on the Deist side, Peter Annet, *The Resurrection of Jesus Considered . . . by a Moral Philosopher* (1744), e.g., 75–77, and, of course, Hume's "On Miracles" in *Philosophical Essays concerning the Human Understanding* (1748). On the orthodox side, see Thomas Sherlock, *The Trial of the Witnesses of the Resurrection of Jesus* (1729) and Gilbert West's defense (rpt. in Richard Watson, ed., *Collection of Theological Tracts* [1785], vol. 5).

12. This can be dated only approximately, after Rouquet's description in 1745 and before the Greenberg folio of 1753, where the later state appears. See *HGW,* 20.

13. *St. James's Chronicle;* quoted *Gen. Works,* 1: 266–67 (I have not found the original, but if the quotation is from that journal, it must have been in 1763 or 1764, when its proprietors were at odds about whether to support or attack Hogarth). With the Gothic revival, J. P. Malcolm remarked that "the greatest misfortune attending the sacred spot, is the eclipse of the fine East window, by Hogarth's painting of the Ascension; in which, to use the attendant's words, 'the *white* men are angels, and the *red* man one of the Saints'"—referring to Hogarth's characteristically strong colors (*Excursions* [1807], 236). When the church was proposed for restoration in the 1840s, "the most important restoration of the interior," the projector wrote, "is that at the east end, involving the removal of Hogarth's pictures, and other

inappropriate attachments, and the reinstatement of the east and clerestory windows." In 1858 Alderman Thomas Proctor bought the pictures for £20 on condition that they be handed over to the Bristol Academy for the Promotion of the Fine Arts, now the Royal West of England Academy. They were by this time in such a desperately bad state of preservation that little could be said about their quality. In March 1955 they were bequeathed to the Bristol Art Gallery, cleaned, and large areas restored. (John Britton, *Restoration of the Church of St. Mary, Redcliffe* [Bristol, 1842], 10; see also *The Altarpiece of St. Mary Redcliffe* [undated]. A small print, drawn by E. Bird and engraved by W. Angus [published by John Aggle, August 1809] shows Hogarth's altarpiece in position, as do two watercolor drawings in the Bristol Art Gallery, M1949, M1967. The proceedings to change the altar area appear in the vestry minutes, 2 May and 20 Aug. 1853.)

14. They were engraved in mezzotint in 1794 by J. Jenner.

15. See John Kerslake, "The Hidden Hogarth," *London Sunday Times,* 11 July 1971, and *NPG,* 1: 146; cat. no. 289.

16. See White, *Rembrandt,* 21.

17. Note that in Roubiliac's bust Hogarth has his own hair, showing profusely beneath his cap. In the self-portrait of 1758 he has a shaved head.

18. Lawrence Gowing, *Vermeer* (London, 1952), 139.

19. Gowing, *Hogarth* (London, 1971), no. 137. Hogarth may have had in mind Akenside's lines on ridicule in *The Pleasures of Imagination,* bk. 3: "how Folly's awkward arts / Excite impetuous Laughter's gay rebuke; / The sportive province of the comic Muse" (*Pleasures of Imagination* in *Poetical Works* [1855 ed.], 43).

20. AN, 219; see P.R.O., King's Warrants, E403/2748: 152–54; Patent Roll, no. 7, 6 June 1757, 30th Year of Geo. II: 253; the document itself, C. 66/3657. Privy Seal Docquets, Index/6760, dated 2 June 1757. Hogarth is entered as Serjeant Painter in the Docket Book of the Signet Office in May 1757 (Index/16972, f. 52*v*), and this means that the decision had been made and the order sent to the Signet Office for the warrant to be made out. His salary began on 6 June (Ministry of Works, Letter Books, P.R.O., Works 1/ 3). But a note, partly in Hogarth's hand, records: "Abstract of Mens time Paid by Mr Hogarth in finnishing Mr Thornhill's work that was begun before July 16th 1757 *which was the day Mr Hogarth entered upon the business of serjeant painter*"—dated 16 July (V & A, Forster Bequest, attached to a print of Livesay's etching, *Hogarth's Crest;* a note by John Ireland attached to the MS. explains, "The two last lines, beginning with '*which was the day etc.*' are Hogarth's hand-writing").

21. P.C.C. Herring, 1757, f. 289 (dated 12 Aug., proved 24 Sept.; a codicil is dated 15 Sept.). John Thornhill had taken the freedom of the Painter-Stainers' Company in 1739 (by patrimony) and served as master in

1748–1749 (Guildhall MS. 5667/2, "Painter-Stainers; Court Minute Book, 1649–1793"; free by patrimony, Oct. 1739; liveryman, Sept. 1743; upper warden, Oct. 1746; master, Oct. 1748). (For the memorial ring, see vol. 2, 399n38.) Lady Thornhill died on 12 November 1757, aged 84 (*London Chronicle*, 13 Nov.; *GM*, 17 [1757]: 531; *LM*, 26 [1757]: 563).

22. AN, 219; Vertue, 2: 23. He might possibly be the John Manning who was "an ingenious statuary of Hyde Park Corner" (see W. R. Gunnis, *Dictionary of British Sculptors*).

23. *Court & City Register* (1757), 80, 97. Cf. Rouquet's remark on Shackleton, *State of the Arts*, 16.

24. AN, 219.

25. Hogarth's deputy appears to have been one Samuel Cobb, who continued to receive payments in September and October 1764 after Hogarth was apparently too sick himself to handle the disbursements of funds. The fees paid Hogarth were somewhat less than those dispensed in Sir James Thornhill's day. In a comparative list drawn up in 1765 (Royal Archives, no. 16817), it seems that for 3 coats of paint he was paid 7*d* a yard, whereas Thornhill had received 8*d;* for 2 coats 5*d* (vs. 6*d*), and so on. He was also responsible for varnishing the wainscot (8*d* a yard), painting sash frames (1*s* 2*d* for three coats), sash squares (1½*d*), window lights (4*d*), window bars (3½*d*), and casements (3½*d*). He also cleaned old paintings (1*d*) for sizing (2*d*). Gilding, the prerogative Thornhill insisted on when Kent was encroaching, brought 4*s,* and the price remained the same in Hogarth's time. For the actual accounts, see the Accounts of the Paymaster of the Works (Audit Office Index 2463/193–99); monthly bills, Accounts Abstracts, Ministry of Works, P.R.O. Works 5/61–63; Letter Books, Works 1/4; accounts of payments for Works and Buildings, AO 1/2463/194–98. For the note of August 1763, see above, n. 20.

26. P.R.O., King's Warrants, E403/2478; 152; Fitzwilliam, in the Nichols Hogarth collection, vol. 5, labeled a sample of Hogarth's writing.

27. Ralph records in his *Case of Authors* (1758, 18): "Mr. *Hogarth* will tell you like an honest Man, that, till Fame appears to be worth more than Money, he will always prefer Money to Fame."

28. J. Ireland, 3: 128–34. The manuscripts are unlocated.

29. See Karl Justi, *Winckelmann und seine Zeitgenossen* (Berlin, 1923), 3: 77, 79, 319; also the entry in U. Thieme and F. Becker, *Lexikon der bildenden Künstler* (1907).

30. Perhaps Ireland read 3 or 4 for 30 or 40.

31. It was still extant as late as 1788 when the Danish engraver and professor in the Copenhagen academy, J. M. Preissler, spoke of himself as a member. See *Tableau de l'Académie Royale de Peinture, Sculpture et Architecture*

de Copenhague (Copenhagen, 1788), 6; E. Welisch, *Augsburger Maler im 18. Jahrhundert* (Augsburg, 1901), 99 ff.; Pevsner, *Academies,* 117–18.

32. J. Ireland, 3: 134–35.

33. To Huggins, 23 Nov. 1758; Hyde Collection, Somerville, N.J. (transcribed in full, *HLAT,* 2: 264–65).

34. See Maurice James Craig, *The Volunteer Earl, Being the Life and Times of James Caulfeild, First Earl of Charlemont* (London, 1948).

35. Craig, *Volunteer Earl,* 107.

36. Mrs. Delaney, *Life and Correspondence,* 3: 455, 511, 566.

37. *HMC,* 12th Report, app., pt. 10 (1891), 384.

38. BL Add. MS. 22394 (the correspondence between Hogarth and Grosvenor), f. 32.

39. AN, 219. The subject may also have been suggested to Hogarth by the *World* of 11 December 1755.

40. *HMC,* 12th Report, 364.

41. First produced (and published) in 1707, *The Lady's Last Stake* was performed five times in the 1740s, the last being at Covent Garden in 1748. It was revived on 27 March and 30 May 1756 at Drury Lane (and not again until April 1760: *LS,* pt. 2, 1: 39; 2: 534, 542, 790). Charlemont was in London and could have seen the 1756 performances, as could Hogarth (who must have been already familiar with the comedy. It was available in volume 2 of *Plays Written by Mr. Cibber* (1721; rpt. 1732, 1736, and 1747) and in Cibber's *Dramatic Works* (1754).

42. Hester Lynch Piozzi, *Autobiography, Letters and Literary Remains,* ed. A. Hayward, 2d ed. (1861), 2: 28, 308–9. For other accounts of the sitting for *The Lady's Last Stake,* see a letter to her daughter Queenie, 28 Mar. 1812 (Lansdowne MS.); E. Mangin, *Piozziana* (1833), 11; *British Magazine,* 92 (1822): 486–87; J. L. Clifford, *Hester Lynch Piozzi* (Oxford, 1941), 23 and n.

43. Mrs. Piozzi's "New Common Place Book" (Hyde Collection) in 1815, 111 (quoted by Clifford, *Piozzi,* 23–24); Mangin's version differs in other details (see *Piozziana,* 24 n 66).

44. Mangin, *Piozziana,* 486–87.

45. It may "be probably ascertained," he said, "from the records of the Haymarket Theatre, as the dog therein introduced is the portrait of a lapdog belonging to the signora Mingotti, then first singer at the opera." Signora Mingotti sang at the King's Theatre in the Haymarket during the 1755–1756 and 1756–1757 seasons; she was gone the next year and when she returned in 1758–1759 she was at Rich's Covent Garden Theatre (*HMC,* 12th Report, 364; cf. *LS,* pt. 4, 2: 495, 553, and 681).

46. BL Add. MS. 40015, fols. 19–20. John Peeters, a native of Antwerp, was Kneller's chief assistant: "a proper lusty man of free, open temper, a

lover of good company and his bottle," who was Vertue's juvenile drawing instructor. He was known in the London art world as "the Doctor" because of his skill in repairing and retouching; Vertue says he could add a stroke or two to old, poor drawings that would make them pass as Old Masters to the connoisseurs (Vertue, 3: 33).

47. AN, 220; BL Add. MS. 22394, f. 32. Another version is reproduced in *Historical and Literary Curiosities,* ed. C. J. Smith (1840), pl. 45.

48. Michael Levey, *The Late Italian Pictures in the Collection of Her Majesty the Queen* (London, 1964), 1: 10; see also 1: 26–27.

49. Mrs. Delany (3: 495) records the price for Seabright as £404.5.0; but then she writes that it had been sold to the duke of Bedford for £200 before the sale: "only put into the sale and puffed up for fear it should otherwise hurt the sale" (497).

50. Antal, 156; Walpole (*Anecdotes,* 4: 142) identified the picture as a Furini, and subsequent scholars have agreed (see Waagen, *Art Treasures in Great Britain,* supp., 519).

51. Clippings from a newspaper of 27–29 April in the V & A, P.P. 17. G, 11–13. A copy of the catalogue is also in the V & A, R.C.s.1, 2, and Box 6.23.A. On the Correggio cult in England at this time, see J. R. Hale, *England and the Italian Renaissance* (London, 1954), 68, 73, 78, 111; Gerald Reitlinger, *Economics of Taste* (London, 1961), 6, 7, 34, 282.

52. It was Antal (157–58) who drew attention to Hogarth's debt to this portrait.

53. *Biog. Anecd.,* 1781, 42–47; *Gen. Works,* 1: 189–90.

54. Wilkes, *North Briton* No. 17 (see Chap. 14). The housemaid, a Mrs. Chappell of Great Smith Street, Westminster, survived far into the nineteenth century. See [Edward Draper], "Memorials of Hogarth," *Pictorial World,* 26 Sept. 1874. The story, however, had appeared long before in J. Ireland, 1: xciii.

55. Dryden, *Works,* ed. Sir Walter Scott, 11: 406. For the advertisement mentioning Dryden's version, see the *Public Advertiser,* 16 Feb. 1761; the subscription ticket emphasizes that Guiscardo was Sigismunda's "murder'd Husband." Hogarth's subject is not related to James Thomson's *Tancred and Sigismunda,* produced at Drury Lane in March 1745.

56. BL Add. MS. 22394, f. 32.

57. In 1762; quoted, Rose Mary Davis, *The Good Lord Lyttelton* (Bethlehem, Pa., 1939), 185. For Henry Hoare's records, which show only a transaction with Hogarth for prints in 1757, see Kenneth Woodbridge, "Henry Hoare's Paradise," *Art Bulletin,* 47 (1965): 101–6. The original connection with Hoare may have been through Benjamin Wilson, who sold his *Romeo and Juliet* to Hoare in November 1757.

58. BL Add. MS. 22394, ff. 32, 37.

59. Ibid. See *GM,* 53 (1783): 317.

60. Reynolds adapts the particular pose from a Trevisani in the Spada Gallery, Rome; the date is given in the *Catalogue of the British Institutions Exhibit* (1813), no. 140; Waterhouse, *Reynolds,* 121. I pointed out the Hogarth–Reynolds connection in *HLAT* (2: 276); Nicholas Penny, in *Reynolds* (London, Royal Academy, 1986, no. 34), seems to agree (though without acknowledgment). On Kitty Fisher as Reynolds's mistress, see Hudson, *Reynolds,* 136.

61. Whitley, 1: 33 (see also Whitley Papers, vol. 6, "Hogarth," in BM Print Room); *North Briton No. 17.*

62. New York Public Library, Berg Collection. For Charles Perry, see 2: 125. The Hogarths were also in Chiswick in July 1759 (*Diary of John Courtney* [*1734–1806*], 1: 30–31; in the East Riding Archive Office, Beverley, Yorkshire).

63. They later appeared, with additions (presumably by Whitehead) making a total of 43 lines, in the *St. James's Chronicle* (undated clipping in vol. 5 of Nichols Collection, Fitzwilliams Museum). They were reprinted in *GM,* 36 (Feb. 1766): 88; as "Epistle to a friend by the late William Hogarth, occasioned by a Picture's being returned on his hands by Sir R. G.," in John Almon's *The Fugitive Miscellany* (London, 1774), 47–49; and in *Gen. Works,* 1: 322–25. Walpole, noting this poem, refers to his own "stupidity or forgetfulness about Hogarth's poetry, which I still am not sure I ever heard of, though I knew him so well . . ." (to Dalrymple, 11 Dec. 1780; in *Corr.,* 15: 144). An epigram on Quin and Macklin attributed to Hogarth has also survived, reprinted in *Gen. Works,* 1: 325n.

64. BL Add. MS. 22394, f. 33.

65. BL Add. MS. 22394, f. 35.

66. E.g., to Lane; see *Gen. Works,* 1: 189–90.

67. Jane Hogarth to Lord Charlemont, 30 July 1781, *HMC,* 12th Report, app., pt. 10 (1891), 388.

68. Charlemont to Edmond Malone, 2 July 1781, in ibid., 386; also his MS. note opposite the frontispiece of his collection of Hogarth's prints (Fitzwilliam Museum, Nichols Collection, vol. 1), dated 6 March 1783.

69. J. T. Smith, 2: 114 (told him by Col. J. Phillips); Charlemont to Malone, 29 June 1781; *HMC,* 12th Report, pt. 10 (1891), 385. Cf. *Biog. Anecd.* (1781 ed.), 16.

70. J. T. Smith, 2: 113.

71. If he had bought it earlier, it would have been mentioned in the letter Hogarth wrote asking him for the loan of *The Lady's Last Stake* for that exhibition (dated 30 Apr. 1761, Pierpont Morgan Library). It is just possible

that he did not buy it until around 1781, when his ownership is first mentioned in *Biog. Anecd.*, and he became a Hogarth collector.

9. COVERT POLITICS

1. *The Bench* was published by 5 September; see *London Chronicle*, 5–7 Sept.; *London Evening Post*, 9–12 Sept.

2. Nichols, *Biog. Anecd.*, 1782, 318; 1833, 250. For a full account, see *HGW*, no. 205. An interesting sidelight: Pitt's Habeas Corpus Bill, introduced in the spring of 1758, supporting the "people," included attacks on lawyers and judges, and Pitt spoke against a motion in mid-June to increase judges' salaries (Marie Peters, *Pitt and Popularity: The Patriot Minister and London Opinion during the Seven Years' War* [Oxford, 1980], 108).

3. It had also dominated Fielding's work, leading up to *Tom Jones;* Fielding had produced more than one corrupt magistrate (Squeezum in *Rape upon Rape,* 1730), though Hogarth may draw specifically upon memories of Justice Thrasher in *Amelia* (1751).

4. See, e.g., *Commons, 1754–1790*, 3: 549.

5. On Townshend, see Herbert M. Atherton, "George Townshend, Caricaturist," *ECS*, 4 (1971): 437–46.

6. Written probably no more than a month after publishing *The Bench,* this served as notes for a reply to "Mr B." (Fitzwilliam Museum). "B." published a letter in the *Monthly Review,* dated 20 Sept. (19: 318–20), claiming that Hogarth's distinctions were all wrong. "B." could stand for Thomas Bardwell.

7. He was still explaining himself in the letter to "B."; and shortly after followed the scene (dated 1758 by its teller) in James Townley's kitchen in Christ's Hospital. When Townley questioned him about this distinction he was so concerned with, between caricature and character, Hogarth responded, "I'll shew you, master Townley" and took an old dirty pen out of the kitchen ink bottle and made another sketch in which a face starts as character and in two stages is exaggerated into caricature; in the second stage it looks very like a portrait of Pitt. (Letter from James Townley the younger to Dr. Isaac Schomberg, n.d., in *Gen. Works*, 1: 286. The drawing is lost; see Oppé, cat. no. 108 and fig. 45 for a copy.)

8. Games of the sort Hogarth liked to play were played, as C. C. Malvasia recalled, by the Carracci (*Felsina Pittrice. Vite de pittori bolognesi* [1678], 1: 468.)

9. *A Philosophical Enquiry into the Origins of Our Ideas of the Sublime and Beautiful,* ed. James T. Boulton (London, 1958), 31, 39. In the second edition Burke added a gracious reference to "the very ingenious Mr. Hogarth; whose idea of the line of beauty I take in general to be extremely just,"

followed by a caveat on his discussion of variety (115). This section was originally written as "Politics and Aesthetics: Hogarth in 1759," in *British Art 1740–1829: Essays in Honor of Robert R. Wark,* ed. G. Sutherland (San Marino, Calif., 1992), 21–48.

10. By the 1750s the painting seems to have been in Garrick's collection, but we do not know that Burke and Garrick were acquainted before 1758. I first proposed this connection between Hogarth and Burke in Paulson 1982, 104–15.

11. See Samuel Holt Monk, *The Sublime: A Study of Critical Theories in Eighteenth-Century England* (New York, 1935), 164–202. Jonathan Richardson's sense of the great or sublime was simply "the most excellent of what is excellent, as the excellent is the best of what is good" (*Theory of Painting,* in *Works,* 124–25).

12. Quoted, W. Moelwyn Merchant, *Shakespeare and the Artist* (Oxford, 1959), 67.

13. *London Chronicle,* 1–4 Dec. 1759; for the price list, see *HGW,* no. 206.

14. One wonders if Hogarth's Last Suppers (going back as far as *Harlot* 6) do not recall Thornhill's prominently displayed *Last Supper* in St. Mary's Church, Weymouth (presented in 1721 by Thornhill, who was elected M.P. for the borough the next year).

15. *Diary of John Baker,* ed. Philip C. Yorke (London, 1931), 130: Baker went with John Wilson, Ralph Payne, and John Bannister "in hack to 'Beggar's Opera' and 'Cheats of Scapin,' Mr. Banister and I sat and chatted Hogarth."

16. Hogarth to Huggins, 9 and 23 Nov. 1758 (Hyde Collection, Somerville, N.J.; quoted from below, Chap. 11).

17. *British Magazine,* 1 (1760): 266.

18. *Essay on the Genius and Writings of Pope,* 1: 257.

19. It may also have recalled Burke's words on the sublimity of circularity (the "rotond"). See *Philosophical Enquiry,* 2.9: 75. When Dante did begin to stimulate illustrators, it was long after Hogarth's death (as in Reynolds's and Fuseli's versions of the Ugolino story).

20. See *London in 1710, From the Travels of Zacharias Conrad von Uffenbach,* ed. and trans., W. H. Quarrell and Margaret More (London, 1934), 49; cf. Count Frederick Kielmansegge, *Diary of a Journey to England in the Years 1761–1762,* trans. Countess Kielmansegge (London, 1902), 241–42.

21. E.g., *London Evening Post,* 28–30 June; 19–21 July 1759.

22. See *HGW,* no. 206. For cockfighting, see Walter Besant, *London in the Eighteenth Century* (London, 1902), 348.

23. *Gen. Works,* 2: 241. For a portrait of Bertie (d. 1765) of the late 1740s, see *Peregrine Bertie, Third Duke of Ancaster, with His Brothers and Sisters* (Lord

Wimborne; repro., Ellen G. D'Oench, *The Conversation Piece: Arthur Devis & His Contemporaries* [New Haven, 1980], pl. 20). I am not aware of any political associations with Albermarle Bertie, but members of his family held seats in Commons during these years for Westbury, Whitchurch, and Boston, as well as (the senior Bertie, the duke of Ancaster) in Lords. The third duke collected Hogarth (see vol. 2, 237), and in fact the one record of a Bertie gambling on a cock match is to him: A "great Cock-Match, between his grace the Duke of Ancaster and Major Mathews, was fought at Stamford," and won by Mathews, according to the *St. James's Chronicle* (19–22 June 1762).

24. Cf. *Analysis,* Pl. 2; above, 117.

25. John Campbell to his wife, 30 Apr. 1757; Cawdor MSS., 1/128; quoted by Clark, *Dynamics of Change,* 379; emphasis added.

26. Waldegrave, *Memoirs,* 129–32; quoted, Clark, *Dynamics of Change,* 424–25.

27. For an example of 1756, see *A New System of Patriot Policy Containing the Genuine Recantations of the British Cicero.*

28. Peters, *Pitt and Popularity,* 16.

29. Ibid., 27, 30. The distinction between oratory and painting as potential demagoguery was made by Horace Walpole in the first volume of his *Anecdotes of Painting in England* (1762): "Pictures cannot adapt themselves to the meanest capacities, as unhappily the tongue can" (*Anecdotes,* 1: xiii). For the comments of Fox's *Test* on Pitt and the giddy multitude, see nos. 1 (6 Nov. 1756), 6; 2 (20 Nov.), 4–5; 19 (19 Mar. 1757), 103; 23 (16 Apr. 1757), 128–29; 29 (28 May 1757), 163–64; 30 (4 June 1757), 169ff.; 35 (9 July 1757), 201. This may suggest that Hogarth was still following a Fox party line.

30. *London Chronicle,* 29–31 May 1759.

31. Especially *A Defence of the Letter* [*from the Duchess of M—r—gh*] of July 1759.

32. Peters, *Pitt and Popularity,* 164.

33. *Monitor,* 15 Sept. 1759.

34. Although it would have appeared to Hogarth, and most English men and women, that Pitt was in total control of English politics from 1757 to 1760—and continued to dominate the English imagination thereafter, I suppose we must add: in a sense, as Clark has shown (in *Dynamics of Change*), Newcastle and George II were still very much in control, and to some extent Pitt's control was illusory.

35. Gerard's *Essay on Taste* had won a prize offered by the Philosophical Society of Edinburgh in 1756. Gerard shows admiration for Hogarth; in particular, he counts Hogarth among the "moral" artists, against not only those concerned only with transport, but also those who ridicule. Though

obviously a few steps lower, Hogarth is nevertheless on the same ladder with Raphael, rather than with Butler and Swift (cf. 1, chaps. 6 and 7). But Hogarth's definition of Beauty as variety, intricacy, etc., has been returned to Addison's "Novelty." In the chapter on Novelty Gerard describes the pleasure of art that "strike[s] out in a new track," and in the chapter entitled "Taste of Novelty" he sounds very like Hogarth in his discussion of the "exertions of the mind" and (a term Gerard uses repeatedly) "moderate difficulty." The last becomes, toward the end of the chapter, the extra pleasure of "very considerable difficulty," which seems to correspond to the sort of exercise Hogarth asked of his "readers of greater penetration." Gerard's moral position is also still with Shaftesbury and Hutcheson (not with Hogarth's deconstructive *Analysis* illustrations): "What is virtuous and obligatory is often also beautiful or sublime. What is vicious may be at the same time mean, deformed, or ridiculous" (206).

36. Burke, *Philosophical Enquiry* (2.7), 82.

37. A war, de Bolla remarks, fought "less over specific land. . . . than over the right to exploit various territories for reasons of trade" (*Discourse of the Sublime* [London, 1990], 106).

38. It is quite possible that Hogarth's opposition, like Smollett's, began with Pitt's about-face on the issue of foreign subsidies, the most notorious example of his unreliability. One of the most important aspects of Country Party doctrine, from the time of William III through George II, was the resistance to a foreign monarch—in the 1740s–1750s, opposition to "the subordination of English interests to Hanover and against the expense of subsidies and Continental war" (Peters, *Pitt and Popularity,* 26; see also Robin Fabel, "The Patriotic Briton: Tobias Smollett and English Politics, 1756–1771," *ECS,* 8 [1974]: 100–14).

39. See Spector, *English Literary Periodicals,* 52–53, 61.

40. See especially *Idler* No. 22, 16 Sept. 1758, and No. 81, 3 Nov. 1759. See also Donald J. Greene, "Samuel Johnson and the Great War for Empire," in *English Writers of the Eighteenth Century,* ed. John H. Middendorf (New York, 1971), 37–65; and Greene, ed., Samuel Johnson, *Political Writings* (New Haven, 1977). One wonders what Hogarth must have thought when he heard the argument of the Foundling governors on 10 March 1756, just two days before his *Invasion* prints were published, supporting a petition to Parliament for increasing funds for the hospital, that it was in the national interest to save the lives of abandoned children because the country needed more troops for national defense? It was more cost effective, it was argued, to save this native population than to hire mercenary soldiers. The government responded with almost unlimited appropriations. (See Ruth Perry, "Colonizing the Breast: Sexuality and Maternity in Eighteenth-Century England," in Fout, *Forbidden History,* 107–37).

41. Amos Elon, "East Germany: Crime and Punishment," *New York Review of Books,* 14 May 1992, 8.

42. One may wonder whether the break with Grosvenor in June 1759 had any effect on Hogarth's feelings about Pitt. Grosvenor was one of Pitt's staunchest supporters. On 23 November 1758, seconding the address, he called the Newcastle–Pitt administration "the glory of this country" and Pitt himself "the shining light or rather the blazing star of this country" (James West to Newcastle, 23 Nov. 1758, BL Add. MS. 32885, f. 524). His peerage was obtained on Pitt's recommendation. In Lords, however, he no longer followed Pitt, and on 9 December 1762 he seconded the address of thanks for the peace preliminaries.

43. Arthur Murphy, *Life of David Garrick* (1801), 1: 31.

44. Warton, *Essay upon the Genius and Writings of Pope,* 1: 122, 123. In the first rank are "our only three sublime and pathetic poets; SPENCER, SHAKESPEARE, MILTON." In the second class are those who have the true poetical spirit in more moderate degree, but who "had noble talents for moral and ethical poesy," such as Dryden, Prior, Addison, and others. Interestingly, when the second volume eventually did appear in 1782, Warton placed Pope in the first class, though "Not, assuredly, in the same rank with *Spencer, Shakespeare,* and *Milton,*" but "*just* above *Dryden.*"

45. He was writing with the authority of Jonathan Richardson (*The Theory of Painting,* in *Works,* 35).

46. *Gen Works,* 1: 210–11.

47. Quoted, L. F. Powell, "William Huggins and Tobias Smollett," *Modern Philology,* 34 (1936–1937): 181.

48. *Garrick Letters,* 1: 353.

49. *Gen. Works,* 1: 209 n.

50. MS. "Observations on Hogarth," in Mrs. Copland-Griffith's collection, published in Hudson, *Reynolds,* 66.

51. Hudson, *Reynolds,* 70, 71, 76–77.

52. My text is Samuel Johnson, *Idler and Adventurer,* ed. W. J. Bate, John M. Bullitt, and L. F. Powell (New Haven, 1963), 255; emphasis added.

53. Hogarth was closer in this respect to Reynolds's master Jonathan Richardson, who wrote that painters should "learn not to attach themselves meanly and servilely to the imitation of this or that particular manner of master, . . . but to have more noble, open, and extensive views; to go to the *fountain head* from whence the greatest men have drawn that which has made their works the wonder of succeeding ages; they would thus learn to go to *nature,* and to the *reason of things.* Let them receive all the light they can from drawings, pictures and antiques, but let them not stop there, but endeavour to discover what rules the great masters *went by, what principles they built upon . . .*" (*Science of a Connoisseur,* in *Works,* 280; emphasis added).

54. For the reference to Whitefield in this context, Hogarth could have drawn upon such recent works as William Mason, *Methodism Displayed, and Enthusiasm Detected* (1756), and Theophilus Evans, *The History of Modern Enthusiasm* (2d ed., 1757).

55. See *Analysis,* 9. The two proofs are in the BM and the Palace of the Legion of Honor, San Francisco (see *HGW,* no. 210).

56. Whitefield opened his tabernacle in London about the same time Smollett's *Critical Review* began publication, and the *Critical Review* maintained a steady attack, calling Whitefield the grimy "apostle of Tottenham-Court" and Whitefield and Wesley "the false apostles" of the age (*Critical Review* No. 11 [Jan. 1761], 40; and No. 8 (Nov. 1759), 419). In the *Continuation* of Smollett's *History of England* on the year 1760 (4: 121–22): "Imposture and *fanaticism* still hung upon the skirts of religion. Weak minds were reduced by the delusion of a *superstition* styled Methodism, raised upon the affectation of superior sanctity, and maintained by pretensions to divine illumination. Many thousands in the lower ranks of life were infected with this species of *enthusiasm,* by the unwearied endeavours of a few obscure preachers, such as Whitfield, and the two Wesleys, who propagated their doctrine to the most remote corners of the British dominions, and found means to lay the whole kingdom under contribution" (emphasis added).

57. Cited, Rupert E. Davis, *Methodism* (Harmondsworth, 1963), 69–70.

58. Conyers Middleton's *Life of Cicero* (1741), one of the important books of the 1740s, compared the progress of Rome from Republic to Empire with England's ancient simplicity, the Norman Conquest, the republican phase of balanced government, and now the imperial future. Middleton also discusses the role of the populace (plebeians) in Rome vis-à-vis the patricians, laying out the assumptions that began to appear in both Fielding and Hogarth in the 1740s: that is, that the Roman crowd was a force in the replacement of the Republic by the Empire. His *Life of Cicero* represented a responsible scholarship based on the use of diverse texts that anticipated the method of the *Free Inquiry.* (Fielding's negative response to Middleton's *Cicero* in *Shamela* was to the fulsome flattery of the preface, Middleton's attempt to assign the Roman Republican virtues to Lord Hervey.)

59. Norman Sykes, *From Sheldon to Secker: Aspects of English Church History, 1660–1768* (Cambridge, 1959), 219. Walpole drew attention to his Dissenter origins, describing the "tone of fanaticism that he still retained" in his sermons; in short, he was a canting preacher, another orator of the sort associated with both Whitefield and Pitt. When he was designated archbishop of Canterbury Walpole wrote some verses:

> The Bench hath oft posed us, and set us a scoffing
> With signing Will: London, John Sarum, John Roffen;

But *this* head of the Church no expounder will want,
For his grace signs his own proper name, Thomas *Cant*.

Horace, whose dislike may have gone back to Secker's votes against Sir Robert, refers to him as having "been bred a Presbyterian and man-mid-wife, which sect and profession he had dropped for a season, while he was president of a very freethinking club," and accuses him of promulgating "a medley of religions" (see Walpole, *George II*, 1: 45–46; 3: 14n).

60. *Anecdotes of the Late Samuel Johnson, LL.D.* (1786), 136–37. On Ho-garth's relationship with Salusbury and Hester, see Clifford, *Hester Lynch Piozzi*, 23–24.

61. *Thraliana*, ed. Balderston, 40–41, 473n. "Johnson (he added), though so wise a fellow, is more like king David than king Solomon; for he says in his haste that all men are liars. This charge, as I afterwards came to know, was but too well founded." This remark, however, Mrs. Thrale at-tributed in *Thraliana* to herself (468).

62. *Anecdotes*, 87. See also Paul Fussell, *Samuel Johnson and the Life of Writing* (New York, 1971), 58–59.

63. Boswell, *Life of Johnson*, ed. G. B. Hill (New York, 1889), 1: 169.

64. See J. L. Clifford, *Dictionary Johnson* (New York, 1979), 180.

65. I draw upon my review of Morris Brownell's *Samuel Johnson's Atti-tude to the Arts*, in *ECS*, 23 (1990): 358–65.

66. Folkenflik, "Samuel Johnson and Art," in Folkenflik and Paul Alkon, *Samuel Johnson: Pictures and Words* (Los Angeles, 1984), 79.

67. J. Ireland (1: 95), whose informant was Mrs. Thrale.

68. Again, in Johnson's citations from Reynolds's *Discourses* (all from the fourth) used in the second edition of the *Dictionary*, the key words are *general, nature, universal*, and *universality*.

69. See *Poems of Samuel Johnson*, ed. D. Nichols Smith and Edward L. McAdam (Oxford, 1941; 2d ed., 1974), 181–82.

70. In February 1759 the Society of Arts Committee on Premiums re-ported a premium of 100 guineas for the best history painting "containing not less than three human Figures as big as Life" and 50 guineas for second best. The suggested subjects were Boadicea relating her injuries to Carac-tacus and Paulinus in the presence of her two daughters, Queen Eleanora sucking the poison out of King Edward's wound after he was shot with a poisoned arrow, Regulus taking leave of his friends on his return to Car-thage, the death of Socrates, the death of Epaminondas, and the birth of Commerce as described by Mr. Glover in his poem called "London" (min-utes of the Society of Arts, 28 Feb.).

71. Though, perhaps significantly, he substitutes for a Choice of Her-cules—the subject par excellence of Hogarth, and many of his own allego-

ries (to be further parodied a year later by Reynolds in his *Garrick between the Muses of Comedy and Tragedy*)—the *death* of Hercules.

72. See, e.g., Johnson's account of Pitt at the end of the allegory of *Idler* No. 22, 9 Sept. 1758 (*Idler and Adventurer*, 316).

73. His prefaces to the artists' catalogues in 1761 and 1762 take a position on the side of the artists and against the opinion of the populace (which he contrives to exclude as ignorant), but this position is at odds with his argument for the hanging of Mauritius Lowe's *Deluge* some years later, and in general he seems to have taken the position against the cognescenti. Johnson's patronage of Lowe was out of "friendship and Christian charity," but also an enunciation of the principle that artists cannot always tell a good painting (Morris Brownell, *Samuel Johnson's Attitude to the Arts* [Oxford, 1989], 68].

10. SPECIAL COMMISSIONS

1. Schutz was a third cousin of Frederick, Prince of Wales. His father, Col. John Schutz of Sion Hill, Middlesex, was a second cousin of George II and held various court appointments. Members of the family were painted by Philippe Mercier in his *Hanoverian Party on a Terrace with the Schutz Family, Cousins of George II* (Tate; ill. vol. 1). Schutz lived in Gillingham Hall, Suffolk; he had married Susan Bacon in 1755. His court connections, and Hogarth's position (since 1757) as Serjeant Painter, may have brought Hogarth the commission. See Andrew Moore, "William Hogarth, 'Francis Matthew Schutz in His Bed,'" in the *National Art Collections Fund Review* (1990), 139–141.

2. By Schutz or some other, when (as Moore notes, "Hogarth," 139) "he was himself either embarrassed by this record of a profligate youth, or proud of it."

3. This was the Sir Edward Littleton of Teddesley Hall, Staffordshire, who also bought in 1756 Rysbrack's terra-cotta of the marble relief for the chimney in the room the artists decorated with their history paintings in the Foundling Hospital.

4. The letters are in the library of the National Maritime Museum, Greenwich.

5. Burwarton House sale catalogue, 17–20 July 1956, no. 241. This picture (now in Lord Boyne's collection) is a copy of the one reproduced (fig. 66). Copies were made for friends—by Hogarth, an assistant, or someone working directly for Boyne.

6. Burwarton sale catalogue; for Galway, cf. his Dilettanti portrait by Knapton (Dilettanti Society).

7. Hogarth's portrait would appear to be from the mid-to-late 1750s.

Ronald Fuller dates the earliest portraits of the friars in their robes from 1753–1754 (*Hell-Fire Francis* [London, 1939], 271), presumably referring to the portraits said to be by Hogarth of Arthur, Henry, and Robert Vansittart. The Vansittarts are portrayed as friars of Medmenham with blue tam-o'shanters, the motto "Love & Friendship" woven about the brims—now at Shottesbrooke Park. But these are either copies or not by Hogarth. Fuller adds that Robert (1728–1789) "knew Paul Whitehead and was intimate with Hogarth," but without a reference (but perhaps the MS. memoir furnished by C. N. Vansittart and the Vansittart papers; Fuller, 94 and n; see *DNB* and *GM* [1889], 1: 182).

8. See Capt. Edward Thompson, *The Poems and Miscellaneous Compositions of Paul Whitehead; with Explantory Notes on His Writings, and His Life* (1775), 54–61. For Whitehead's not very informative memoir, see *Annual Register*, 18 (1775): 54–61; and MSS., letters, etc., in the Aylesbury Museum.

9. Fuller, *Hell-Fire Francis*, 67–68. See also Betty Kemp, *Sir Francis Dashwood: An Eighteenth-Century Independent* (London-New York, 1967), 130–36.

10. Wilkes, quoted by Donald McCormick, *The Hell-Fire Club* (London, 1958), 49.

11. The Duffields seem to have been living in the abbey as late as 1750 and only mention moving in 1751 (A. Plaisted, *The Manor and Parish Records of Medmenham* [1925], 219; see Fuller, *Hell-Fire Francis*, 271).

12. See Walpole, *George III*, 1: 138; Charles Johnstone, *Chrysal* (1760 ff.; 1785 ed.), 3: 184 (Johnstone was Dashwood's tutor on his Grand Tour—Fuller, *Hell-Fire Francis*, 55); Downs MSS., Aylesbury, 100/24; *Town and Country Magazine*, Mar. 1769; Horace Walpole, *Journals of Visits to Country Seats, Walpole Society*, 16 (1928): 50; John Wilkes, *New Foundling Hospital for Wit* (1784), 3: 104–7; J. Almon, *Letters of John Wilkes* (1774–1796), 3: 60–63.

13. *Letters between the Duke of Grafton . . . and John Wilkes*, ed. A. H. FitzRoy, third duke of Grafton (1769), 1: 48.

14. Fuller, *Hell-Fire Francis*, 144; Walpole, *Journals of Visits*, 16: 50–51.

15. Fuller, *Hell-Fire Francis;* McCormick, *Hell-Fire Club.*

16. See Paulson, *The Fictions of Satire* (Baltimore, 1967), 153–54.

17. *Public Advertiser*, 2 June 1763.

18. Johnstone, *Chrysal*, 3: 233–35.

19. Ibid., 3: 240–41.

20. Cited, McCormick, *Hell-Fire Club*, 80–81.

21. He gives a satiric description of the Medmenham rituals in *The Candidate* (1764).

22. McCormick's references are to Fuller, *Hell-Fire Francis*, 93 (Hogarth

"was said to have attended one or two meetings of the Club"), who gives no reference.

23. Sterne, *The Life and Opinions of Tristram Shandy, Esq.*, ed. James Work (New York, 1940), 1.5; 8. By volumes 3 and 4 curiosity has become the universal need to understand Slawkenbergius's nose—a specifically sexual motive. In the final volume (9, published in 1767), in chapter 1, it takes Tristram's mother's "curiosity" to "get fairly to my uncle Toby's amours," the objective first stated in volume 1: the motive force of Hogarth's "Intricacy," Quantity is then invoked in chapter 2, and the "Line of Liberty" made by the flourish of Trim's stick in chapter 4 (which refers to liberty outside wedlock).

24. See 1.14; 36, 1.20; 56, and 1.25; 79. See also William Holtz, "The Journey and the Picture: The Art of Sterne and Hogarth," *Bulletin of the New York Public Library*, 71 (1967), 25–38.

25. More specifically he recalls the ranks of windows with their prostitutes, who will reappear in the Abbess of Andoillet's story. She and Margarita "entered the calesh; and nuns in the same uniform, sweet emblem of innocence, each occupied a window, and as the abbess and Margarita look'd up—each . . . stream'd out the end of her veil in the air———then kiss'd the lilly hand which let it go: the good abbess and Margarita laid their hands slant-wise upon their breasts———look'd up to heaven———then to them———and look'd 'God bless you, dear sisters,'" and so depart (7.12; 505).

26. See 2.14.

27. Wilbur L. Cross, *The Life and Times of Laurence Sterne* (New Haven, 1925), 116; and Arthur Cash, *Laurence Sterne: The Early & Middle Years* (London, 1975), 209–10.

28. For Berenger (1720–1782), see *York Courant*, 2 Dec. 1760; Gilbert West (his uncle) in *Elizabeth Montagu*, ed. E. J. Climenson (London, 1906), 2: 24; John Taylor, *Records of My Life* (London, 1832), 1: 325–26; Murphy, *Garrick*, 1: 340–41; letter from John Hoadly to an unnamed correspondent (probably Dodsley), Nov. 1757, in the Hyde Collection, Somerville, N.J.

29. *Letters of Laurence Sterne*, ed. L. P. Curtis (Oxford, 1935), 99, 101. Wilbur Cross (*Sterne*, 215) says that "Hogarth sent back free of charge" the illustration, but does not name his source. I am not sure whether he refers to this when he says later that Hogarth came to call at Sterne's lodgings—making it sound as if this were immediately after Sterne's arrival (544, again with no source or explanation; cf. Curtis, ed., *Letters*, 99–100). See also *London Evening Post*, 19–22 Apr.; 20–22 May 1760.

30. *London Evening Post*, 1–3 Apr. 1760.

31. Although this subscription began at the first of March, it seems certain that Hogarth subscribed *after* he was approached by Berenger. The

Sermons were published on 22 May (*London Evening Post,* 19–22 Apr.; 20–22 May 1760).

32. For the thesis "that Garrick's 'revolution' in acting brought a new authority to the actor's art of nonverbal expression," see Michael S. Wilson, "Garrick, Iconic Acting, and the Ideologies of Theatrical Portraiture," *Word & Image,* 20 (1990): 368–94.

33. Noted by William Holtz, "Sterne, Reynolds, and Hogarth: Biographical Inferences from a Borrowing," *Art Bulletin,* 48 (1966): 82–84.

34. Though, as his positive reference to Reynolds may suggest, he also laughs at Hogarth's "principle" and system, possibly the way Reynolds's *Idler* essay did, I cannot say, as Arthur Cash does, "that Reynolds supplanted Hogarth as an influence upon Sterne's aesthetic theory" (Cash, *Laurence Sterne,* 31).

35. Sentences like the following are obviously poking fun at the affected precision of Hogarth's *Analysis:* "The necessity of this precise angle of 85 degrees and a half to a mathematical exactness,——does it not shew us, by the way,——how the arts and sciences mutually befriend each other?" (122). This could in fact be a reference to the dedication of *The March to Finchley* to Frederick the Great, the patron "of Arts and Sciences."

11. PORTRAITS AND LIKENESSES

1. John Hoadly to Joseph Warton, 21 Apr. 1757, *Gen. Works,* 1: 212. For Hay, see below, 295.

2. This account relates to the story of the trouble Hogarth had taking Garrick's impersonation of Fielding for the frontispiece of Arthur Murphy's edition of Fielding's works (1762): *London Chronicle,* 9–12 Nov. 1786. The same anecdote was later applied to Gainsborough; or perhaps Garrick tended to repeat his little joke (Gainsborough's obituary, *Morning Chronicle,* 5 Aug. 1788).

3. *Gen. Works,* 1: 21.

4. *Garrick Letters,* 1: 369–70. George Kahrl dated this letter, inscribed "early Saturday the 8 January," 1763, admitting that the year was conjectural. The only other possibility where 8 January falls on a Saturday is 1757. The references to ill health and managerial difficulties recommended 1763. I discussed the date with Professor Kahrl, who agreed that it is hard to believe that Garrick would have written to Hogarth in this vein in 1763: the *North Briton* attack came at the end of September 1762, and Hogarth was apparently desperately ill the rest of the autumn. Garrick surely would not have written about his own "indifferent State of health" at such a time without mentioning Hogarth's, or chid him with complaining that he had not seen Garrick in a long time.

5. See Oliver Millar, "'Garrick and His Wife' by William Hogarth," *Burlington Magazine,* 104 (1962): 347–48; *Tudor, Stuart, and Early Georgian Pictures in the Collection of Her Majesty the Queen,* ed. Oliver Millar (London, 1963), 1: 560.

6. *Gen. Works,* 1: 21.

7. AN, BL Add. MS. 27991, f. 28b. (omitted by Burke, 215).

8. Lance Bertelsen makes this point in "Garrick and English Painting," *ECS,* 11 (1978): 312–13.

9. Antal, 70. The painting is now lost but survives in a mezzotint of 1758 by Edward Fisher. Richard Wendorf reads her action as guiding, not stealing, the pen; i.e., as Cibber's muse (*The Elements of Life: Biography and Portrait-Painting in Stuart and Georgian England* [Oxford, 1990], 185).

10. George Winchester Stone, Jr., and George M. Kahrl, *David Garrick: A Critical Biography* (Carbondale, 1979), 48; *Thirty Different Likenesses: David Garrick in Portrait and Performance* (exhibition catalogue, Buxton Museum and Art Gallery, 1981), no. 11.1.

11. Wendorf, *Elements,* 187. He also notes the way Hogarth suggests "the affection Garrick and his wife share for each other: as the sprig pinned to his breast balances the flowers woven into her hair, and she, in turn, wears a miniature portrait on her left wrist, the blue of its dress mirroring the colour of his coat."

12. Wilson's autobiographical notes, in Randolph, *Life of General Sir Robert Wilson,* 1: 17, 15; *Gen. Works,* 1: 193–94; citing S. Ireland, 1: 155. The only portrait of Welch recorded was bought by Samuel Ireland from Jane Hogarth in 1780 and engraved by him in reverse with bust added, published in *Graphic Illustrations* in 1788.

13. Fielding, *Journal of a Voyage to Lisbon,* 26 Jan. 1754; Laetitia-Matilda Hawkins, *Memoirs, Anecdotes, Facts, and Opinions* (1824), 1: 46–47; Welch, *Proposal,* 16–19, 25–30; Trumbach, "Sex, Gender, and Sexual Identity," 100–101; H. F. B. Compston, *The Magdalen Hospital, 1758 to 1958* (London, 1958); Stanley Nash, "Prostitution and Charity: The Magdalen Hospital, a Case Study," *Journal of Social History,* 17 (1984): 617–28. For Lock, see Anthony Highmore, *Pietas Londinensis* (1810), 143. The portrait of Lock is now in the collection of David B. Goodstein. Dingley's daughter Susanna married Dr. Walter Chapman, at whose Bath house (or that of her brother-in-law) Hogarth is supposed to have stayed while planning the Bristol altar-piece. Dingley was a rich London merchant trading with Russia and Persia, an amateur architect and artist, collector, and member of the Dilettanti (Vertue, 3: 161; 4: 80; Collins Baker, *Chandos,* 155).

14. *Lady Mary Cholmondeley* is in Lord Leaconfield's collection.

15. The Rembrandt imitation was pursued by Reynolds as well, most obviously in his self-portraits, but also in his employment of a wide range

of known styles for expressive effects. This was a strategy Hogarth had employed only modestly in his "French" engravings of *Marriage A-la-mode* and the style of his "popular" prints.

16. To Huggins, 9 Nov. 1758, in the Hyde Collection, Somerville, N.J., where may also be found the two portraits of Huggins and his father.

17. See above, 245, and note.

18. Hyde Collection.

19. Hyde Collection.

20. See *HGW,* no. 204.

21. His will, dated May 1761: P.R.O. Prob. 11.876. f. 252.

22. Lord Hardwicke to the duke of Newcastle, 9 Oct. 1761, BL Add. MSS. 32929, ff. 143–45.

23. John Butler to Lord Onslow, 17 May 1778, Onslow MSS. at Clandon House; quoted, *Commons, 1754–1790,* 2: 600; see also 599.

24. Undated note, Hyde Collection (formerly R. B. Adam Collection, 3: 186): "Dear George / Lambert and I believe forrest dine with me to day, 3 o'clock if you can favour us with your company you will very much oblige / yours most sincerely / Wm Hogarth / Sunday morn 10 o'clock."

25. Collection, Benchers of Lincoln's Inn.

26. *Garrick Letters,* 1: 172. I am not sure whether this is the same Dr. Hay mentioned by Garrick in the 1770s as an adulterer (*Garrick Letters,* 605 n and 653).

27. Letter of 21 April 1757, *Gen. Works,* 1: 212–13. Unfortunately this portrait cannot at present be traced (Beckett, 52).

28. Martin to his father, 24 June 1761, BL Add. MS. 41347, f. 83b. For his supplying Bute with treasury papers, see Lewis Namier, *England in the Age of the American Revolution* (London, 1930), 313, 316–17, 415.

29. *Commons, 1754–1790,* 3: 117.

30. *Commons, 1754–1790,* 2: 462; for Fox's private ledgers (1758–1773), containing among other things accounts relating to his private transactions with the payroll, in the Bunbury Papers in the Bury St. Edmunds and West Suffolk Record Office, see Lucy S. Sutherland and J. Binney, "Henry Fox as Paymaster-General of the Forces," *English Historical Review,* 70 (1955); rpt. in *Essays in Eighteenth-Century History,* ed. R. Mitchison (London, 1966), 231–59. The version of the portrait reproduced (fig. 77) was, according to Beckett, originally bought by Samuel Ireland from Mrs. Hogarth; it was unfinished, and still lacks the final touches of buttons and the like. With Ireland in 1781–1782, it was supposedly acquired by the Fox family only in the mid-nineteenth century. Since exhibitions began only in 1867 (National Portraits, No. 330), it is possible that this is not the same portrait owned by Ireland. But its unfinished condition certainly resembles the etching by Haynes that Ireland published in 1782. It therefore seems possible that the

£20 portrait of 1762 (25 × 21 in.) was not made for Fox himself but for his friend and adherent John Calcraft, M.P. for Rempstone, sometime before their break in April 1763, and that Hogarth kept his first, *ad vivum* sketch (23½ × 19 in.) for himself—as he also did portraits of Martin and others. The finished portrait was exhibited in the 1971 Tate Hogarth exhibition (collection, D.C.D. Ryder, Esq. of Emptstone; repro., Paulson, "Hogarth the Painter: The Exhibition at the Tate," *Burlington Magazine,* 114 [1972], fig. 16).

31. Walpole, *George III,* 1: 296.

32. *George III,* 1: 313.

33. For the Thornhills, see Beckett, nos. 39, 98, and 99; for his mother, see above, vol. 2, fig. 29; for Mary and Anne, vol. 2, figs. 73, 74; and for Jane, vol. 1, fig. 69, and vol. 2, fig. 89.

34. The story about Mary Lewis is inscribed on the back of the canvas, as also the date 1755 [or 59]. This and a small full-length portrait of her father, David Lewis, playing his harp, are in a private collection, on loan to the Aberdeen Gallery. David Lewis is not traceable in the Royal Archives. In 1807 Mary Lewis was getting on toward seventy, according to Farington (*Diary,* 4: 79–80), which means that she was born around 1735, and so was in her twenties at this time.

35. *The Diary of John Baker,* ed. Philip C. Yorke (London, 1931), 120. John Bannister was a wealthy West Indies magnate, Martin was a close friend of Hogarth's (see below), and Mr. Sloper may have been the Colonel Sloper who was later a witness against Lord George Sackville.

36. *Diary of John Courtney (1734–1806),* 1: 114–15, in East Riding Archives Office, Beverley, Yorkshire. The 4 July 1759 visit is described, 1: 30–31.

37. See, e.g., the Pond MSS., BL Add. MS. 23724; John Trusler, *The Way to be Rich and Respectable* (London, 1777), 18–19; J. Jean Hecht, *The Domestic Servant Class in Eighteenth-Century England* (London, 1956), 7–8. For the servants' names, see S. Ireland, 1: 169; Edward Draper, "Memorials of Hogarth," *Pictorial World,* 26 Sept. 1784.

38. Gowing, *Hogarth,* no. 197.

39. See Fried, *Absorption and Theatricality* (Berkeley and Los Angeles, 1980).

12. THE ART EXHIBITIONS

1. Reprinted, *Gen. Works,* 3: 292–94; for the list of artists attending, see John Brownlow, *Memoranda; or, Chronicles of the Foundling Hospital* (London, 1847), 17–20. The dinners were still being carried on in November 1763 (*St. James's Chronicle,* 5 Nov.).

2. Minutes of the General Court of Governors, 8 July 1752, 4 June 1755, 24 May 1756. It is mentioned as early as the meeting of 25 February 1746/47 that the charity boxes, filled by fashionable visitors, were opened and found to contain £14 8*s* in one and £8 12*s* in the other.

3. *Conduct of the Royal Academicians* (1771), 8. The Dilettanti proposal for an academy had included "a yearly exhibition of pictures, statues, and models, and designs in architecture," but of course to be regulated by the Dilettanti (Cust, *Dilettanti*, 52–55).

4. Wood, *Royal Society*, 226–27; see Crow, *Painters and Public Life*, chap. 1.

5. *Collected Works of Oliver Goldsmith*, ed. Arthur Friedman (Oxford, 1966), 1: 318.

6. R. H. Wilenski, *French Painting* (London, 1949 ed.), 133–34.

7. Minutes of the General Court of Governors.

8. Pyne states that Hogarth became "seriously ill of an inflammatory disorder, caught at one of the windows of the Old Golden Cross, where he stood too long exposed to a current of air, making sketches of the heralds, and the sergeant trumpeters' band, and the yeoman guard, in their splendid liveries, who rendezvous'd at Charing Cross. He purposed to paint a picture of the ceremony of proclaiming the new King"—which would place this in 1760 (*Wine and Walnuts* 1 [1823]: 162–63). This is followed by a jumble of plausible but insignificant and probably invented incidents. The reader can select his or her own nugget of truth from the passage.

9. Quoted, Wood, *Royal Society*, 35.

10. The documentation of the artists' movements appears in the *Minutes of the General Meetings of the Artists and of the Committee for Managing the Public Exhibition*, beginning 12 November 1759, now in the Royal Academy Library; published with some inexcusable abridgments in the *Walpole Society*, 6 (1917–1918), 116ff. See also *Royal Magazine*, 1 (Dec. 1759), and Whitley, 1: 165.

11. Waterhouse, *Three Decades*, 47.

12. Jones, *Memoirs*, 13.

13. Two meetings of the governing committee took place (on 1 and 22 Dec.) before it was resolved to make application to the noblemen and gentlemen of the Society of Arts to obtain their room for the exhibition: this "Great Room" was 10 by 40 feet and suitable for a relatively large exhibition. Reynolds attended neither of these meetings, but the letter that was drafted to the society was written by his good friend Samuel Johnson. This letter, dated 26 February 1760, was received at the Society of Arts' meeting of the 27th, read, and referred to "a large and important Committee," which included Ramsay, Chambers, and Stuart. The committee reported on 5 March, approving the proposal "under such Regulations and Restrictions as the Society shall hereafter prescribe" (Wood, *Royal Society*, 228;

Royal Academy, *Minutes of the General Meeting, Walpole Society,* 6: 118; Society of Arts minutes books, vol. 4, 27 Feb. 1760).

14. In their original proposals the artists wished to charge both the visitors a shilling for admission and the artists half a crown for exhibiting. There is no record of their having received either. The accounts list only the catalogues as a source of income.

15. Waterhouse, *Three Decades,* 51–52.

16. Pye, 96.

17. Pye, 97.

18. *Apology for Painters,* 95.

19. The address also appeared in the *Daily Advertiser,* 12 Jan. 1761, and was pointed up by anonymous complimentary verses in the *London Evening Post,* 10–13 Jan. and the *Public Advertiser* 14 Jan.

20. AN, 223–25.

21. Kitson (*Apology for Painters,* 62) assumes that Charlemont was intended (though Nichols thought it Bute, *Gen. Works,* 1: 293). Charlemont would have had no influence, and this is not a conventional address to a nobleman, as Ireland's version would have it. The letter is actually asking for an interview in order to broach practical matters. Besides, Hogarth would not have needed Martin as a go-between with Charlemont.

22. If one accepts this date (ca. 1760), and the thirty years he says the academy has been in operation, it seems improbable that he would talk this way about an academy with which he had severed connections. That interpretation (see Kitson) would stand up only if these notes were dated in the mid-1750s.

23. Retold by Cunningham; Alastair Smart, *The Life and Art of Allan Ramsay* (London, 1952), 99–100; revised ed., *Allan Ramsay: Painter, Essayist, and Man of the Enlightenment* (New Haven, 1992). In the latter, Smart's statement (69, 80) that from the end of 1747 Ramsay's portrait of Dr. Mead hung as a pendant to Hogarth's of Captain Coram in the Secretary's office of the Foundling—and thus the two portraits were compared—is based on a misreading of the General Committee minutes (16 Dec. 1747): Hogarth's *Coram* was moved to the Secretary's office and Ramsay's *Mead* was "hung up in its room," i.e., where Hogarth's portrait had previously hung.

24. The letter to a nobleman is presumably misplaced in the MSS., but one may find perplexing the resemblance between the account of Ramsay on the back of f. 48 and the one on ff. 33–34 in the notebook that can be dated 1763. Hogarth must have kept these papers together, never having completed and sent the letter, and added this note on Ramsay to follow his remarks on the other side of the sheet.

25. *Apology for Painters,* 79. Hogarth's MS. notes (described in vol. 1, xix–xx) consist of (1) rejected drafts for *The Analysis of Beauty,* (2) notes toward an explanation of his prints which included an autobiography, and

(3) materials on the academy controversy including notes toward an "Apology for Painters." These have been edited by Burke (*Analysis*, AN) and Kitson (*Apology for Painters*). The basic MSS. are in the British Library; but besides these, there are scattered pages in other collections. One explanation for Hogarth's erratic punctuation (it should be noted) is that he tends to let the end of lines serve as full stops.

26. Houghton Library, Harvard (transcribed, below, n. 35).

27. Kitson, intro., *Apology for Painters*, 55.

28. Algernon Graves, *The Society of Artists of Great Britain* (London, 1907), 303–6; "The Papers of the Society of Artists of Great Britain," *Walpole Society*, 6 (Oxford, 1918): 113–30; Derek Hudson and Kenneth W. Luckhurst, *The Royal Society of Arts, 1754–1954* (London, 1954), 36–39.

29. "Papers of the Society of Artists," 122. There is confirmatory evidence in Thomas Jones's *Memoirs* of the hanging of pictures as the main reason for disagreement (8).

30. See above, 304: he was not at the meeting of the artists on 7 December 1760.

31. According to Louise Lippincott, Arthur Pond may have introduced the practice of darkening modern paintings to London (117–18).

32. Burke, *Philosophical Enquiry*, 82; Gilpin, *Two Essays* (1804), 140.

33. See Hogarth's own note on Poussin, landscape, and dark tints, in his MS. notes (*Apology for Painters*, 54); both Richardson and Burke argued that such landscapes are better dark than light (Richardson, *Essay on the Theory of Painting*, 144; Burke, *Philosophical Enquiry*, sec. 16).

34. *Works of Samuel Foote* (London, 1830), 80.

35. Hogarth's prescription for varnish appears on a page now in the Houghton Library: "In the course of thirty years as I have continually been amongst painters, the Business of preserving Pictures by varnishes or otherwise has often come upon the Table [?]. a great number of receipts both printed and written I have seen which have been used and recommended some by one some by another all of which I found disused and disapproved [disproved?] at different times. that which after all has according to my own experience proved the best is what follows. but which if not used with proper caution may be very mischevious as [I] have found to my cost.

"In short it is nothing more than a white of an Egg beat up to a froth. which froth must be laid on the Picture equally but not very Thick only sufficient to give it gloss. The great caution I have to give is that a fresh painted Picture be spoil by laying it in the sun so as to render it faint and weak in all its darker part, and thereby make the Picture appear faded in less than a years time. to prevent this you have only to let your Colours be perfectly Dry and hard before you [apply] it for should you put your Egg on whilst they are yet moist the Egg will somehow incorporate with the

paint and as it drieth and hardens into a white substance every darkish part will partake of it and be made faint, nay more it will be Eat into . . . in an honey-comb manner especially where it lieth pretty thick, as a proof of this . . ." (the MS. breaks off at this point). See also E. H. Gombrich, "Dark Varnishes: Variations on a Theme from Pliny," *Burlington Magazine,* 104 (1962): 51–55; and, in the same issue, Otto Kurz, "Varnishes, Tinted Varnishes, and Patinas."

36. See Gowing, *Hogarth* (London, Tate Exh., 1971), 59. The Greek motto on the picture frame is from Crates, the Greek comic dramatist, translated by J. Ireland as "Time has bent me double; and Time, though I confess he is a great artist, weakens all he touches" (1: xcvi); see *HGW,* no. 208. An example of the graphic representation of Time-the-devourer, though not anticipating Hogarth's composition, shows Time gnawing at the torso of the Apollo Belvedere (*Eigentlyke Afbeeldinge, van Hondert der Aldervermaerdste Statuen, of Antique-Beelden* . . . [Amsterdam, 1702]).

37. I am indebted to Marc Gotlieb for these insights.

38. *Daily Advertiser,* 28 May 1751; *Analysis,* 131 n.

39. The last paragraph was inexplicably omitted from the Walpole Society transcription.

40. Hogarth must have seen one of Chardin's *singeries,* his *Monkey-antiquary* (see above, 211).

41. Present at the meeting were Hayman, Collins, Gwynn, Hone, McArdell, Moser, Newton, Reynolds, Rooker, Seaton, Wale, Wilson, Wilton, and Yeo.

42. For Gardelle, see Tom Taylor, *Leicester Square* (London, 1874), 493–95; *London Evening Post,* 28 Feb.–3 Mar. 1761, also 8–10 Mar. and 7–9 Apr.; *Public Advertiser,* 6 Apr. Years later Richards gave the sketch to Samuel Ireland, who tells the story (S. Ireland, 1: 172; Ireland etched a copy, published 1 Apr. 1786 [Oppé, cat. no. 111]). John Inigo Richards, in the early nineteenth century secretary to the Royal Academy, claimed that Hogarth was his godfather. He was son of a scene painter, probably the same Richards who helped Hogarth with the scrollwork and other decorative borders on the St. Bartholomew's paintings (*Gen. Works,* 2: 263). Richards was a landscapist; in the 1761 exhibition he displayed a *View of Covent Garden.*

43. Hogarth to Charlemont, 30 Apr. 1761, Pierpont Morgan Library.

44. Walpole, MS. notes in his copy of the *Catalogue,* Lewis Walpole Collection, Yale; the list is printed in the *Public Ledger,* 11 May 1761.

45. Pears, *The Discovery of Painting: The Growth of Interest in the Arts in England, 1680–1768* (New Haven, 1988), 125–26.

46. 16 Feb. 1761, *Lloyd's Evening Post, Daily Advertiser,* etc.; *Public Advertiser,* 2 Mar. 1761.

47. *Public Advertiser,* 7 Mar. 1761; also in the *London Evening Post,* 5–7 Mar. Kirby published a defense of *Sigismunda* in the *Monthly Register of Literature,* 2 (1761; see J. Ireland, 3: 207 ff.). There are also some MS. comments in Hogarth's hand alongside unidentified printed verses on *Sigismunda* in Mellon, Yale.

48. BL Add. MS. 22394, k.1, fols. 29 ff.

49. Lewis Walpole Collection, Yale. See Hugh Gatty, ed., "Notes by Horace Walpole, Fourth Earl of Orford, on the Exhibition of the Society of Artists and the Free Society of Artists, 1760–1761," *Walpole Society,* 7: 55–88.

50. Birch to Lord Royston, later second Lord Hardwicke, 15 June 1763 (BL Add. MS. 35400, f. 75); *St. James's Chronicle,* 8–10 April 1790, part of a letter signed M.M. Cf. Alberti's advice in *Della pittura* to painters re planting an observer, and his story of Apelles's hiding behind a painting to freely overhear the comments of viewers.

51. *Gen. Works,* 1: 317 and n.; cf. the praise by Kirby in the *Monthly Register of Literature,* 2 (1761): 35; *Tate,* 143 (cat. no. 116). *The Lady's Last Stake* also received some attention. "Picquet, or Virtue in danger, Occasioned by seeing a Picture of Mr. Hogarth's, (so called) at the Exhibition of the Artists of Great Britain," was sixty lines of couplets explaining the meaning of the picture, dated 23 May 1761 and signed S. Hosmer, published in the *Public Advertiser,* 30 May.

52. See R. W. Ketton-Cremer, *Horace Walpole* (London, 1940), 203. The fourth volume, which includes Hogarth, was completed and printed in 1771, but was not published until 1780 "'from motives of tenderness' towards the surviving relatives of artists whom he could not wholeheartedly praise" (Ketton-Cremer, 314).

53. Walpole to George Montagu, 5 May 1761; in *Corr.,* 9: 364–66.

54. Cf. Walpole's similar account, *Anecdotes,* 4: 142–43; *Biog. Anecd.,* 1781, 43, quotes this passage, states that the fingers were not bloodied, and adds in a note that Walpole's memory must have failed him. In Walpole's copy of *Biog. Anecd.* (Lewis Collection), he wrote: "It was so represented at first: Hogarth might correct or alter it, on its being so much censured as it was before his death, as appears from this very note." Walpole refers to page 46, where it appears from a note that Hogarth did alter it, and adds at bottom of that page: "Here is a proof that it *was* altered, and probably after Mr W. saw it." *Biog. Anecd.,* 1785 ed., adds that the hands were originally bloodstained.

55. Le Blanc's *Letters of the English and French Nations* (1747); see above, 9–10.

56. For Walpole's eventual account of Thornhill, see *Anecdotes,* 4: 31–38.

57. BL Add. MS. 27993, f. 3v; *Apology for Painters,* 78.

58. See above, 491 n69.

59. Hogarth to Rev. Herbert Mayo, reproduced in an unsigned item in *The Living Age,* 2 Dec. 1923, 578–80; H. F. Fullenwider, "The Rhetoric of Variety: Observations on a Rediscovered Hogarth Letter," *Burlington Magazine,* 131 (1989), 769–70.

60. It is an excerpt from an anonymous critical essay on Watelet included as a supplement to the Amsterdam edition, entitled "Lettre à M***. Contenant quelques Observations sur le Poème de L'Art de peindre." The MS., which among other things demonstrates Hogarth's good knowledge of French, is in the University of Illinois Library: see John Dussinger, "William Hogarth's Translation of Watelet on 'Grace,'" *Burlington Magazine,* 126 (1984), 691–94; rpt. *William Hogarth's Translation of Watelet on Grace* (Urbana, 1983), unpaginated. Dussinger points out that "the new religion of Nature" offered up by Watelet, "extolling the virtue of the primitive and the child over the civilized adult, is utterly at odds with the mechanical physiology deriving from Descartes and Le Brun, and incorporated into the *Analysis.*"

61. *Analysis,* 193; and some notes, 194.

62. Oppé, cat. no. 94, pl. 85; *HGW,* no. 235.

63. BL Add. MS. 29672, f. 87; *Apology for Painters,* 49n.

64. J. Ireland, 3: 100; Hudson and Luckhurst, *Royal Society of Arts,* 37.

65. Gwynn, *London and Westminster Improv'd, illustrated by Plans, to which is prefix'd, a discourse on Public Magnificence, with Observations on the State of the Arts and Artists in this Kingdom* (1766), 24.

66. Introduction to the 1762 catalogue, quoted, Edwards, *Anecdotes,* intro., xxvii–xxviii, and n; Pears, *Discovery of Painting,* 127.

67. Edwards, *Anecdotes,* intro., xxvi.

68. At least parts of the "Oakly" letters were by Garrick, but Bonnell Thornton's hand is detectable here (Nathaniel Thomas, the titular editor, communicated in a note to Bowyer the printer, and quoted in A. Chalmers, *The British Essayists,* 25 [London, 1823]: xix–xx). See Chap. 13.

69. *Apology for Painters,* 109.

70. Letter to Baretti, 10 June 1761, *Letters of Samuel Johnson,* ed. R. W. Chapman (Oxford, 1952), 1: 134.

13. THE SIGN PAINTERS' EXHIBITION

1. As Lance Bertelsen points out, the minute books of the joint-stock company that published the *St. James's Chronicle* show that "Thornton was one of a consortium of ten (then almost immediately twelve) investors— among them Garrick, Colman, Thomas Davies, Ralph Griffiths, and the printer and prime mover, Henry Baldwin—who backed the paper. Of the

twenty available shares, Thornton held two himself and two in trust for an unknown third party; Colman and Garrick held one each" (*The Nonsense Club* [Oxford, 1986]), 137). Bertelsen is our main source on the Nonsense Club; on Thornton in particular, see also Bertelsen, "Have at You All: or, Bonnell Thornton's Journalism," *Huntington Library Quarterly,* 44 (1981): 263–82.

2. Eugene R. Page, *George Colman the Elder* (New York, 1935), 47.

3. In the spring and summer of 1761 Arthur Murphy published the *Ode to the Naiads of Fleet-Ditch,* followed by counterattacks in the *Epistle to Churchill* and *The Murphyad;* further responses came in *The Churchilliad, The Triumvirate,* and *The Examiner, or the Expostulation.*

4. Bertelsen, *Nonsense Club,* 71; see also Colman, "Cobler of Cripplegate's Letter to Robert Lloyd, A.M.," in the *St. James's Magazine,* May 1763, which gives sketches of each member of the group.

5. Lamb, letter to William Wordsworth, 16 Apr. 1815, *The Letters of Charles and Mary Anne Lamb,* ed. Edwin W. Marrs, Jr. (Ithaca, 1978), No. 291, 3: 140.

6. Hogarth may also have known the headmaster John Nicoll, an educational innovator who played down dead languages and turned much of the disciplinary system over to the students themselves. See John Carleton, *Westminster School* (London, 1965), and Richard Cumberland, *The Memoirs of Richard Cumberland* (1806), 31–32.

7. The others were born in 1732 and 1733.

8. In December 1751, following Thornton's "Ode," Smart had opened his "Old Woman's Oratory," with this sort of plebeian British music burlesquing Italian music.

9. *Fielding: The Critical Heritage,* ed. Ronald Paulson and Thomas F. Lockwood (London, 1969), 319.

10. It is probably also significant that Roxana Termagent is Thornton's chosen figure to preside over his parody of the Fielding brothers' Public Registry Office, which functioned in London as an employment agency for young women from the country seeking domestic service (the place where Fanny Hill was hired by a bawd).

11. Bertelsen notes that Thornton uses her as a subculture type "related to the 'unruly' woman of the popular culture: the female (or disguised male) who challenges conventional authority, treats men rudely, and puts 'woman on top'" (Bertelsen, *Nonsense Club,* 44).

12. *The Connoisseur,* in Chalmers's *British Essayists* (London, 1819), 3: 218–19; 28: 201. For the more usual view on the "knowing and judicious" versus ignorant and vulgar spectator of pictures, see Charles Lamotte, *An Essay upon Poetry and Painting, with Relation to the Sacred and Prophane His-*

tory (1730), 19, 31; cited, Stephen Copley, "The Fine Arts in Eighteenth-Century Polite Culture," in *Painting and the Politics of Culture,* ed. John Barrell (Oxford, 1992), 31–32, and on the whole issue, 29–34.

13. *City Latin,* 2d ed. (1761), 24–26; cited and discussed, Bertelsen, *Nonsense Club,* 133–35.

14. See Page, *Colman,* 39.

15. The *Chronicle* continued its defense of Hogarth into the summer of 1761. Lloyd published in the issue of 4–7 July a fulsome poem called "Genius, Envy, and Time. Addressed to William Hogarth, Esq." which echoes the Hogarthian line on connoisseurs. Stealing lines and rhymes from Pope, Lloyd adapts "Time" and "Prince Posterity" (presumably with no awareness of their original use) from Swift's *Tale of a Tub,* though also recalling Hogarth's *Time Smoking a Picture.* "Genius" (Hogarth), according to the fable, is pursued and calumniated by "Envy" until he turns to "Prince Posterity," whose chief minister "Time" replies that in time he will be hailed by all (rpt., *LM,* 30 [1761]: 382; *Annual Register,* 5 [1762]: 204–6; and Lloyd's *Poems* [London, 1762], 199–205).

16. Dryden, *The Medal,* "Epistle to the Whigs," *Works* (Berkeley and Los Angeles, 1972), 2: 38; Fielding, "An Essay on Conversation," in *Miscellanies,* ed. H. K. Miller (Middletown, 1972), 136. This account of the Sign Painters' Exhibition draws on *HLAT,* 2: 334–53; Paulson 1979, 31–48; Bertelsen adds a few details, *Nonsense Club,* 238–45.

17. *Covent-Garden Journal,* ed. Bertrand Goldgar (Middletown, 1988), 288.

18. Cf. Warburton's account of the development of writing, which could apply to the signboard (*Divine Legation,* 4.4; 2: 71 ff.).

19. As early as one of the *Student* essays, Thornton had exclaimed, "How sublime are the signs of our shopkeepers: the *angel,* the *cross,* the *mitre,* the *maidenhead* with many others, are too well known to need mentioning."

20. See above, 55. He is supposed to have painted a "Man Loaded with Mischief" signboard; but the description is a pastiche of *South Sea Scheme, Gin Lane,* and *March to Finchley.* This was at 414 Oxford Street, an alehouse. (See Jacob Larwood [pseud. for H.D.J. van Scherichaven] and John Camden Hooten, *The History of Signboards* [London, 1866], 39, 456).

21. *History of Signboards,* 3, 5, and 473.

22. *Gen. Works,* 1: 416–19. Walpole, in his copy of the catalogue of the 1761 exhibition, identifies Dawes as a pupil of Hogarth's. He contributed figures to John Inigo Richards's *View of Covent Garden,* exhibited there (Lewis Walpole Collection, Yale). Edwards mentions Dawes as Hogarth's pupil (*Anecdotes,* 9); Redgrave's *Dictionary* is probably closer to the truth, listing him as natural son of a city merchant, apprenticed to Henry Mor-

land, and then working ca. 1760 under Hogarth as an engraver. He was most likely not a pupil but somebody who worked for Hogarth and imitated him.

23. It was on 29 Sept. 1759 that Kirby published a farewell and thank-you to Ipswich, announcing his resettling in Surrey (*Ipswich Journal*). According to Gandon, "He was applied to by Lord Bute, to teach the Prince of Wales (afterward King George III) perspective" (*Life of James Gandon*, 210).

24. The entry for 28 November says the money for Widow Weldon was not yet "apply'd for," which suggests that Hogarth recommended her as a worthy object but had not yet delivered the money.

25. Allen, *Hayman*, 6; *Conduct of the Royal Academicians* (1771), 12, 13 (anon.).

26. Taylor was probably Dr. John, the "oculist" Oakly referred to in the issue of 14–16 May 1761 (see above, 333). Another Taylor associated with "shows" would have been George, the pugilist (whose death may have been in 1757; for Hogarth's design for a monument, see Oppé, cat. no. 79).

27. *St. James's Chronicle*, 5–8, 12–15 Sept. 1761.

28. See *Daily Advertiser*, 23 Sept. 1761; and also Goldsmith's essay in the *Public Ledger*, 24 Sept.

29. Cf. Pyne's story (above, Chap. 12, n. 8) about Hogarth's illness resulting from observing a ceremony preliminary to the coronation.

30. *Public Advertiser*, 6 Nov. 1761.

31. The archaeological tract, *The Antiquities of Athens Measured and Delineated*, by Stuart and Nicholas Revett, had been announced as soon to be published, but (as Hogarth's inscription predicts: "*In about* Seventeen Years") the first volume did not in fact appear until 1762 (the second in 1789 or 1790). For details, see *HGW*, no. 209.

32. Following *The Five Orders of Periwigs*, the *St. James's Chronicle* also satirized the breakdown of social distinctions implied by wig styles (25–27 May 1762; 10–12, 17–19 Aug.).

33. For a list of the ladies-in-waiting, see Kielmansegge, *Diary of a Journey to England*, 30–36; cf. J. Ireland, 2: 366.

34. They were identified as Lord Melcombe (Bubb Dodington) and Bishops Warburton, Mawson, and Squire according to "A Dissertation on Mr. Hogarth's Print of the Order of Periwigs, viz. the Episcopal, Aldermanic, and Lexonic," in *The Beauties of All the Magazines* (1761), 52; also Nichols, *Biog. Anecd.*, 1782, 299. Matthias Mawson seems to be someone's wild guess since there is no face to compare. He had been translated to the bishopric of Chichester in 1740 and to Ely in 1754 and does not seem newsworthy in 1761.

35. For Warburton's response, see below, 366. Hogarth also made a full-

length profile drawing of Melcombe around this time (Oppé, cat. no. 32). Squire's reputation was similarly opportunist; rewarded for deserting Newcastle for Bute, he was satirized in a print called *The Pluralist* for his multiple livings.

36. For the general background on the exhibition of 1762, see *London Register*, Apr. 1762, 345–52; *History of Signboards*, 512–26; and Thornton's letter to Henry Baldwin, the printer of the *St. James's Chronicle*, 3 June 1762 (MS. in Yale University Library).

37. The publication line gives 15 March 1762; the first advertisement I have seen is in the *St. James's Chronicle* and *London Chronicle* of 29 April–1 May. His old friend John Rich having died the year before, Hogarth was probably at the auction of Rich's effects on 2 April 1762, when Horace Walpole bought his earliest *Beggar's Opera* painting for 5 guineas and the duke of Leeds bought the elaborate final version for £35 14s—prices that cannot have overly pleased him (Walpole, MS. note in his *Description of Strawberry Hill* [1774], in the Lewis Walpole Collection, Yale University).

38. *History of Signboards*, 512.

39. Signs were often altered to suit the times (Bertelsen, *Nonsense Club*, 143). But see also *Spectator* No. 122, where a Knight's Head is "altered with a very few Touches" into a Saracen's Head.

40. See Robert Southey, ed., *Works of Cowper* (1836–1837), 1: 37. There was no sign of a "paviour" in the exhibition. Hogarth may have painted the *Pavior's Sign* (Yale Center for British Art), and it could be from the time of the exhibition. Bryant Lillywhite lists a "Paviour's Arms," a tavern sign (*London Signs: A Reference Book of Signs from Earliest Times to about the Mid-Eighteenth Century* [London, 1972], 402, nos. 11236–41), surmising that it arose in the eighteenth century with the paving of London. St. Martin's Lane, near where Hogarth lived, was one of the first experiments in 1742, and the 1762 act included the paving of all the main streets.

41. For other examples, No. 30, "The Dancing Bears," seems built upon Hogarth's image in *The Analysis of Beauty* Pl. 1 of the Grand Tour tutor with his bear cub tutee; No. 40, "Welcome Cuckolds to Horn Fair," sounds like a development of *The South Sea Scheme* and *Times of the Day: Evening*, with a strong element of the *Skimmington*. No. 64, "View of the Road to Paddington, with a Presentation of the Deadly-Never-Green, That Bears Fruit All the Year Round," may be related to the view of Tyburn in *Industry and Idleness* 11; and No. 67, "Death and the Doctor," probably alludes to the scene in *Harlot's Progress* 5, with the two doctors quarreling over their dying patient.

42. The "Harlot Blubbering over a Bullock's Heart," which according to a later story was displayed and offended Hogarth by its ridicule of *Sigismunda* ("although the hint of that burlesque assemblage was derived from

him"), does not appear in the catalogue, and, I suspect, is only a memory of the anti-Hogarth caricature *A Brush for the Sign-Painters* (*BM Sat.* 3841, fig. 87). See *European Magazine,* 51 (1807): 43n.

43. *History of Signboards,* 457.

44. Lillywhite, *London Signs,* 459. There was still a Three Loggerheads at 57 Virginia Road, London, E2, in 1966, built in the 1820s; and a drawing of one in Shoreditch by Walton, No. 52 of his series of shop signs, is in the Museum of London.

45. Hazlitt's remark is about "a phantasmagoria . . . with as little attention to keeping of perspective, as in Hogarth's famous print for reversing the laws of vision." (Said of *Childe Harold's Pilgrimage,* canto 4, in *Complete Works of William Hazlitt,* ed. P. P. Howe [London, 1933], 19: 36.) See also 17: 33: "like the objects in Hogarth's Rules of Perspective, where every thing is turned upside down, or thrust out of its well-known place."

46. *St. James's Chronicle,* 29 Apr.–1 May 1762; *London Register,* Apr. 1762, 345–52.

47. *St. James's Chronicle,* 22–24 Apr. F. G. Stephens in *BM Sat.* thinks "Plebeian" is a pseudonym for Hogarth. Again, though Hogarth's ideas are expressed, the author was probably Thornton. The name "Plebeian" crops up again, e.g., 16–19 Oct., discussing the noblemen who serve two kinds of wine after dinner.

48. See *BM Sat.* 3841. Bertelsen has noted that Thornton's shape refers to No. 8 in the exhibition, *The Vicar of Bray* ("a Ass in a Feather-topped Grizzle, Band, and Pudding Sleeves") and the bat exclaiming "OH HA HA—HE HE HE" (bespattering his head) refers to Nos. 49 and 50, which were covered by blue curtains in the manner of "indecent" pictures (as in *Marriage A-la-mode* 2). When the curious viewer lifted the curtain he was confronted with two signs that read "HA! HA! HA!" and "HE! HE! HE!" (*Nonsense Club,* 146).

49. After the Royal Academy was founded, dissident artists picked up the format of the Sign Painters' Exhibition for their counterexhibitions, described as the work of sign painters. These were also usually political in theme (see, e.g., the *Middlesex Journal's* description of Wilkite signs, 24–26 May 1770).

14. *THE TIMES, PLATE 1*

1. *Seasonable Hints from an Honest Man on the Present Important Crisis of a New Reign and a New Parliament* (1761), 40.

2. Walpole, *George III,* 1: 95. See also his comments in his letters to Montagu, *Corr.,* 6–7, 282.

3. Wesley, *Journals,* quoted by Douglas Grant, *The Cock Lane Ghost* (London, 1965), 23.

4. *Collected Works of Oliver Goldsmith,* 4: 417, 438. James I's *Demonology* comes up in a similar connection in *Tom Jones,* 8.10, and Hogarth may also have remembered other allusions in that novel: to the ghosts of Villiers and Mrs. Veal (8.1) and Whitefield's sister trying to respond to the spirit (8.8).

5. Churchill characteristically claimed in *The Ghost* that Johnson had been superstitiously credulous; but, as characteristically, he touched a nerve by drawing attention to the appearance of malfeasance in Johnson's tardy Shakespeare edition: all in response to Johnson's pension from Bute.

6. See *Critical Review,* 13 (Mar. 1762): 227.

7. Middleton, *Free Inquiry,* 96.

8. *Philosophical Works* (London, 1874–1875), 4: 105.

9. Two offending passages had been pointed out by the reviewers in the first volume of his *History of England* (1755) and removed from the second edition (1759): one charging Catholics with "superstition," the other charging Presbyterians with "enthusiasm." See William Rose, *Monthly Review,* Mar. 1755; Rev. Daniel MacQueen, *Letters on Mr. Hume's History of Great Britain* (Edinburgh, 1756).

10. Walpole, *George III,* 1: 95.

11. Walpole, *Anecdotes,* 4: 145; *George III,* 1: 97; *Letters of John Keats,* ed. Hyder Rollins (Cambridge, 1958), 2: 260.

12. *Pope's Literary Legacy: The Book-Trade Correspondence of William Warburton and John Knapton,* ed. Donald W. Nichol (Oxford, 1992), 148.

13. Murphy's praise of Hogarth runs throughout his writings, exceeding that showered on his mentor Fielding. For example, in the *Gray's Inn Journal* No. 31, 27 Apr. 1754 (in collected ed., 182), in a version of Parnassus, the Graces walk about each holding a copy of *The Analysis of Beauty.* Murphy praised Hogarth in five issues of the *Gray's Inn Journal* in 1756; in one *London Chronicle* "Theatre"; in his review of Burke's *Philosophical Enquiry* in the *Literary Magazine* (15 Apr.–15 May 1757), 1: 189; in a note to the *Hilliad;* in the *Auditor* for 14 Oct. 1762; in a review of Smollett's *Reprisal* in the *Literary Magazine* (1757), 36–38; etc. For a recorded social gathering attended by both Hogarth and Murphy, see Murphy's *Life of David Garrick,* 1: 340–41.

14. *London Chronicle,* 7–9 Nov. 1786; adapted from La Place's *Pièces intéressantes et peu connues pour servir à l'histoire* (1785), 3: 98–108. In the latter La Place relates that when Garrick was in Paris with his wife in the 1760s, La Place, who was one of his friends, presented him with a set of his translation of *Tom Jones,* which had a copy of the portrait of Fielding as frontispiece. Garrick burst out laughing and told him the story, which had appeared, much abbreviated, in the *St. James's Chronicle,* 4–6 Jan. 1781, and was repeated in the *Morning Herald,* 9–10 Nov. A more convincing account was published in a reply (*London Chronicle,* 9–11 Nov. 1786), to the effect that Garrick and Hogarth, "sitting together at a tavern, mutually lamented

the want of a picture of Fielding. 'I think,' said Garrick, 'I could make his Face,' which he did accordingly. 'For Heaven's sake hold, David,' said Hogarth; 'remain as you are for a few minutes.' Garrick did so while Hogarth sketched the outlines, which were afterwards finished from their mutual recollection."

15. Murphy, intro., *Works of Henry Fielding* (1762), 1: 47–48.

16. J. T. Smith, 1: 223 (on the word of his father).

17. *Farington Diary,* 7 Mar. 1802, 1: 341. John Galt's account of West's story is somewhat different, and may be a conflation of the story Farington recorded and accounts of Hogarth's 1751 auction, when only Lane appeared (*The Life and Studies of Benjamin West, Esq.* [London, 1816–1820], 2: 17).

18. *The Private Correspondence of David Garrick,* ed. James Boaden (1831–1832), 1: 145; Martha W. England, *Garrick's Jubilee* (Columbus, Ohio, 1964), 11; S. Ireland, 2: 147. The chair is now in the exhibition hallway of the Folger Shakespeare Library, Washington.

19. *Diary of John Baker,* 164; Burke, *Enquiry,* 47. The malefactor has not been identified. Executions were sometimes held, as an example to others, at the place where the crime was committed or before the criminal's house.

20. For an account of the journals and their arguments during these years, see Robert D. Spector, *English Literary Periodicals and the Climate of Opinion during the Seven Years' War* (The Hague, 1966).

21. BL Add. MS. 27993, f. 29: P.R.O., Patent Rolls, George III, 1–18, 87; the document itself, c. 66/36882. See also Privy Seal, Index/6765 and Woburn MS. no. 226.

22. Randolph, *Life of General Sir Robert Wilson,* 1: 30–32. George III's own large collection of Hogarth prints, not to be confused with the great Hogarth collection built by his son, later George IV, now hangs in the Index Room of the Royal Archives, Windsor Castle. For other instances of George III's admiration for Hogarth, see *HMC,* 15th Report, app., pt. 7 (1898): 270, 272; and Harcourt Papers, 4 (5 Feb. 1789): 224.

23. See Walpole, *George III,* 1: 22–23.

24. See above, 310.

25. Steevens, in *Gen. Works,* 1: 371. In *The Hungry Mob of Scriblers and Etchers* of 1762, Hogarth appears, along with Johnson, Smollett, and others, receiving handouts from Bute. It might have seemed a coincidence that only a few months after Hogarth's patent was renewed, in July 1762, Johnson was awarded his pension—which, to Hogarth, would have appeared another sign that the new reign was supporting English writers and artists. Johnson's position on the Seven Years' War must have appealed to both Hogarth and the Bute ministry. But Johnson in fact wrote nothing for Bute; he was included with Hogarth in the attacks on Bute simply because he had accepted the pension—in effect had given his moral sanction by accept-

ing—and *might* have written and *had* earlier written against Pitt's policies.

26. I am indebted to Leonie Gibbs for pointing out to me that John Fraser of Lancaster, assumed younger brother of Simon Fraser, Lord Lovat, married Margaret Hoggart of Haverbuech in the parish of Beethum, Westmoreland. The record of their marriage is in the Kendal Record Office: "12th Feb 1739. / John Frasier of Lancaster & Margaret Hoggart of Beethum Parish." While it is not proved that John was Simon's brother (the family records were destroyed), it seems likely that at however remote a level the Hogarth and Fraser families were, as of the time when Hogarth and Lovat encountered and Hogarth drew the latter's portrait, related. (See vol. 2, 275–76.) In short, as the contemporary sources suggest, the two men may have known each other (or *of* each other in some personal way); and Hogarth's relationship to the Scots, indeed to the Jacobites, calls for further research.

27. Reported, H. Digby to Lord Ilchester, 1 Mar. 1757; MS. 51341, f. 42, quoted, Clark, *Dynamics of Change,* 328.

28. James Lee McKelney, *George III and Lord Bute* (Durham, 1973), x–xi.

29. Wilkes, *English Liberty: Being a Collection of Interesting Tracts, from the Year 1762 to 1769. Containing the Private Correspondence, Public Letters, Speeches, and Addresses, of John Wilkes, Esq.* (London [1769]), 366–67 n.

30. For Wilkes, see John Brewer, "The Wilkites and the Law, 1763–74: A Study of Radical Notions of Governance," in *An Ungovernable People? The English and Their Law in the Seventeenth and Eighteenth Centuries,* ed. Brewer and John Styles (London, 1980), 196; also Trumbach, "Sex, Gender, and Sexual Identity," 91; and in particular, G. S. Rousseau, "'In the House of Madam vander Tasse, on the Long Bridge': A Homosexual University Club in Early Modern Europe," *Journal of Homosexuality,* 11 (1989): 311–47; also, "The Pursuit of Homosexuality in the Eighteenth Century: 'Utterly Confused Category' and/or Rich Repository," in *'Tis Nature's Fault: Unauthorized Sexuality during the Enlightenment,* ed. Robert P. Maccubbin (Cambridge, 1985), 132–68. Hogarth's idolized friend, the young Lord Charlemont, while in Rome, had patronized Thomas Patch, who was the fulcrum of a homoerotic enclave of young British aristocrats (and was later expelled by the Pope for his sodomitical practices). Hogarth had painted with knowing flourishes a flagrantly homoerotic circle in *Lord Hervey and His Friends* (ill., vol. 2). Such close personal ties might be another explanation for the strange conjunction of dedicatees of the *Election* prints: three if not four of them were either homosexual or participated in homoerotic networks. Sir Edward Walpole was blackmailed for alleged homosexual practices; in his youth Henry Fox was part of Lord Hervey's circle (appearing in Hogarth's painting); Hanbury Williams was one of Horace Walpole's closest friends, and Walpole also claimed a close attachment to Hogarth;

and, although we know less about him, the bachelor George Hay fits the profile (as does Hogarth's other political friend, Samuel Martin). It is also the case that Mark Akenside, who is associated with Hogarth in *Peregrine Pickle,* was a known homosexual (although Smollett makes no reference to this fact). None of this is to suggest that Hogarth himself was bisexual, only that his was an intensely homosocial society whose groupings shaded off, sometimes indeterminately, into overt homoeroticism. Further research will perhaps resolve some of the questions and speculations raised here.

31. George Nobbe, *The North Briton: A Study in Political Propaganda* (New York, 1939), 13–14; Bertelsen, *Nonsense Club,* 166–67.

32. Charles Knight, *London* (1843), 5: 136. Knight places this in the Beefsteak Club.

33. Walpole, *George III,* 1: 113.

34. Wilkes, *English Liberty,* 367.

35. *Monthly Review,* 41 (1769): 382.

36. For the position and place of Wilkes I am indebted to the work of John Brewer, in *Party Ideology and Popular Politics at the Accession of George III* (Cambridge, 1976); "Wilkites and the Law," 128–71; and "English Radicalism in the Age of George III," In J.G.A. Pocock, ed., *Three British Revolutions, 1641, 1688, 1776* (Princeton, 1980), 323–67.

37. Walpole, *George III,* 1: 113.

38. Wraxall, *Historical Memoirs of His Own Time* (London, 1836), 3: 48. Cf. Edward Gibbon's comment, based on his meeting with Wilkes in the summer of 1762, just as he was engaging upon his quarrel (*Gibbon's Journal to January 28th, 1763,* ed. D. M. Low [New York, 1929], 145–46).

39. Burke to Rockingham, 7 Nov. 1773; James Harris, 15 May 1777, Malmesbury MSS.; *Commons, 1754–1790,* 3: 640.

40. *Public Advertiser,* 8 Sept.; *St. James's Chronicle,* 7–9 Sept.; an explanation was published in the *LM,* Sept. 1762, 463.

41. *John Bull's House* was advertised in the *Public Advertiser,* 6 Sept. 1762; *BM Sat.* 3890.

42. J. Ireland, 3: 344. There are prints that could have suggested the motif to Hogarth: e.g., "Demonstration of the New Fire Hoses" from *Description of the Newly Discovered and Patented Hose Fire Engine and her Way of Putting out Fires* (1691) by Jan ver der Heyden.

43. See above, 163. Smollett's *Briton* expressed a low opinion of the crowd: "the dregs of the people," "the base, unthinking rabble," "forlorn Grubs and Garretteers, desperate gamblers, tradesmen thrice bankrupt, prentices to journey-men, understrappers to porters, hungry pettifoggers, bailiff-followers, discarded draymen, hostlers out of place, and felons returned from transportation. These are the people who proclaim themselves free born Englishmen, and transported by a laudable spirit of patriotism,

insist upon having a spoke in the wheel of government" (quoted, Bertelsen, *Nonsense Club,* n 33).

44. Quoted, Peters, *Pitt and Popularity,* 211; see also 174–76. See above, 177.

45. See above, 169.

46. *Commons, 1754–1790,* 3: 551.

47. Cf. *Analysis,* 55.

48. Letter of 9 Sept., *The Correspondence of John Wilkes and Charles Churchill,* ed. Edward H. Weatherly (New York, 1954), 15–16.

49. BL Add. MSS. 35.3999, ff. 349 and 4478c. Birch records other visits to Hogarth's studio in July 1740 and, accompanied by Philip Yorke (later 2d earl of Hardwicke) and later by the duchess of Kent, in 1744. Birch also had Deist and Latitudinarian connections (with Hoadly, Tyndal, Middleton, and Hume).

50. *Royal Magazine,* 7 (Sept. 1762): 152:

> Hogarth's engraver on one tablet tells,
> What, told in writing, into volumes swells;
> All Europe's business in portraits is seen;
> The farce of nature, and the state machine.
> His mimick genius triumphs o'er the pen;
> One Hogarth's worth an hundred scribling men.
> North Briton, Briton, Auditor, each class,
> Of weekly writers, to H. Howard's ass.

Henry Howard, alluded to again in Sandby's anti-Hogarth print *The Fire of Faction* (see fig. 95), was a scurrilous printseller, engraver, and poetaster who had attacked the queen in August in *The Queen's Ass* (*BM Sat.* 3870); this performance led to a number of attacks in which he was labeled as "the real ass" (*BM Sat.* 3871, 3872, 3875). The point of Sandby's association of Hogarth and Howard is that Hogarth has joined the worst representatives of faction in *both* parties.

51. *Universal Magazine,* 31 (Sept. 1762): 155.

52. J. Ireland, 1: xcii; he states, however, that *North Briton* No. 17 was out on the 17th too (it did not appear until the 25th).

53. My statement about Hogarth, Wilkes, and the Beefsteaks, *HLAT* 2: 372, was unsubstantiated.

54. *BM Sat.* 3971; dated 23 Sept.; announced the same day, *Public Advertiser.*

55. The allusion is to *Burlington Gate* (1732), which Sandby evidently considered to have been Hogarth's work: "with what judgement y^e judge y^e shall be judged. Matt. Chap. 7.2." As Hogarth showed Alexander Pope whitewashing Burlington Gate and spattering the duke of Chandos, now

he is himself whitewashing Bute and spattering Pitt and company. (Whether Hogarth was actually the author of that print is doubtful; see *HGW* 1965, 2: 299–300.)

56. *BM Sat.* 3973. One poetic attack, "To the Author of *The Times*," Hogarth copied down and kept (BL Add. MS. 1795, f. 3; J. Ireland, 3: 210–11).

57. Raymond Postgate, *That Devil Wilkes* (London, 1930), 29.

58. The only date is "Saturday night," but presumably between 7 and 25 September (Hyde Collection).

59. J. T. Smith, 3: 274: "Stacey, the famous jockey, who kept the Bedford Arms in Covent-garden, informed me that it was at his house that Hogarth and Churchill quarreled, and that it was over a rubber of shilling whist." John Timbs (perhaps having no other source than Smith), repeated the story (*Club Life of London* [London, 1866], 2: 80).

60. Undated, but sometime between 7 and 25 Sept., *Garrick Letters*, 1: 366.

61. Wilkes writes that Hogarth's royal office was little more than that of a "*house*-painter; for he is not suffered to *caricature* the royal family. The post of portrait painter is given to a *Scotsman*, one *Ramsay*. Mr. *Hogarth* is only to paint the wainscot of the rooms, or, in the phrase of the art, may be called their *pannel-painter.*"

62. Birch to Hardwicke, 25 Sept. 1762, BL Add. MS. 35399, f. 362.

63. *Public Advertiser,* 25 Nov. 1762; *BM Sat.* 3916.

64. *BM Sat.* 3983, advertised in the *Public Advertiser* of 16 Dec.

65. Tinker Collection, Yale University Library; *Tinker Catalogue,* no. 1707.

66. See Smart, *Ramsay,* rev. ed., 161–64, 172.

67. *The Grenville Papers,* ed. W. J. Smith (London, 1852), 2: 5.

68. *Correspondence of Wilkes and Churchill,* 37.

69. See above, 368. He was also painting—or at least finishing—a portrait of Captain Sir Alexander Schomberg (dated 1763; National Maritime Museum, Greenwich). Schomberg (1720–1804) was the younger brother of Hogarth's physician-friend Isaac Schomberg. From 1761 to the peace in 1763 Schomberg was commanding the *Essex;* in August 1763 he married Arabella Susanna Chalmers. The date 1763 could be Hogarth's sign of completion of a portrait he had begun earlier; perhaps completed for the marriage.

15. *THE TIMES, PLATE 2*

1. Wilkes was unaware that there was a *Times, Plate 2:* "The public beheld the first feeble efforts [*Times, Plate 1*] with execration, and it is said that the *caricaturist* was too much hurt by the general opinion of mankind,

to possess himself afterwards sufficiently for the execution of such a work" (*English Liberty*, 367n).

2. John Brooke, *King George III* (New York, 1972), 97–98.

3. Walpole, *George III*, 1: 147.

4. Ibid., 1: 174.

5. *2 George III*, cap. 21; see *Journal of the House of Commons*, 29: 349.

6. *History of Signboards*, 28–29.

7. He has, of course, reversed them (not taking reversal into consideration in his engraving).

8. The reference may be to Chambers's *Plans, Elevations, Sections, and Perspective Views of the Gardens and Buildings at Kew*, published at the king's expense, in 1763, which included the pagoda (his *Designs for Chinese Buildings* had appeared in 1757). He enjoyed strong royal and Bute patronage by the 1760s. Richard Wilson had exhibited two views of Kew—the pagoda and the ruined gate with the Society of Artists in 1762. These were plainly celebrations of the court, the new king, and his advisers. (J. G. Cooper, in *Letters on Taste* [3d ed., 1757], had linked Hogarth and Wilson as the only artists of "use.") What significance there was in the fact that Kirby was clerk of the works at Kew is not clear.

9. Walpole, *George III*, 1: 23. On the dedication of *Enthusiasm Delineated* to Secker, see above, 261.

10. J. Ireland, MS. quoted in *Gen. Works*, 2: 306–7n. He adds that "The figured markings on a board rising a few inches above the surface of the ground, were used in playing the game of the *Mall*, and have not many years been removed."

11. On Bute's fear of assassination by the London crowd, see Brooks, *King George III*, 100.

12. Wilkes, *English Liberty*, 367n.

13. Quoted, Nobbe, *North Briton*, 230–31; emphasis added. I am again indebted to John Brewer (see above, 520n36).

14. Ibid., rpt. in the *Political Controversy*, 4 (1763): 434–35, 438.

15. On Wilkes and the crowd ritual, see Brewer, *Party Ideology*, chap. 9; and Paulson 1979, 28–30.

16. For the story of his throwing it into the fire where "it would have been instantly destroyed had not Mrs. Lewis, who resided in the house, eagerly rescued it from the flames," see S. Ireland, 1: 176. Another version taken from Mary Lewis applies the story to the memory sketch of Fielding (J. Ireland, 2: 471n).

17. For the graphic tradition of the figure of Britannia, see Herbert M. Atherton, *Political Prints in the Age of Hogarth* (Oxford, 1974), 91–96. Wilkes's opinion of the likeness was recorded a few years later: "It must be allowed to be an excellent compound caricatura, or caricatura of what na-

ture had already caricatured" (*English Liberty*, 367–68n). The vignette of Rousseau's *Contrat social* (1762) shows Justice with a spear and cap of liberty in one hand and her scales in the other. Hogarth may have had this revolutionary document in mind when he portrayed Wilkes.

18. The print was frequently copied and reprinted, as in the *Scots Magazine*, 25 (May 1763): opp. 272.

19. On a worn copy of this print, Samuel Ireland wrote: "This paper was given to me by Mrs. Hogarth, Aug. 1782, and is the identical North Briton purchased by Hogarth, and carried in his pocket many days to show his friends" (1: 177). Has Ireland forgotten that this issue appeared six months after the original one? Verses published in the *London Evening Post* (26–28 May) described the bulbous-nosed caricature:

> If, Ho—d! we are to suppose
> Thou hast such a confounded Nose,
> A Nose, that's not unlike an Hog's,
> Not half so handsome as a Dog's,
> It must be a matter of surprize,
> How thou could'st sneer at W—ke's eyes.

Another poem "On Mr. Ho—rth's Nose" was published in the same paper of 2–4 June:

> Since thy nose, H—th, is a true Hog's snout,
> We may suppose, without all kind of doubt,
> Thy name was taken from that hoggish part,
> And is not surely Hoo-th, but Hog-art.

20. Also published in *Universal Magazine*, 32 (June 1763): 323; and *Annual Register*, 6 (1763): 236. For graphic replies, see *An Answer to the Print of John Wilkes Esqʳ.* (fig. 103, *BM Sat.* 4051), and *Tit for Tat* (fig. 104, *BM. Sat.* 4054, which was published 9 June (*St. James's Chronicle*, 7–9 June).

21. Bertelsen, *Nonsense Club*, 16.

22. *The Author*, l. 250; *The Ghost*, 2.653–54; 3.793–98.

23. *Correspondence of Wilkes and Churchill*, 48, and 54–55. Churchill wrote to Wilkes: "I have laid in a great stock of gall, and I do not intend to spare it on this occasion—he [Hogarth] shall be welcome to every drop of it, Tho' I thought, which I can scarce think, *that it would never be schew'd*" (*Correspondence*, 48; emphasis added). Bertelsen (*Nonsense Club*, 169) interprets this to mean that Churchill had harbored a dislike of Hogarth; but it could merely refer to his having obeyed Garrick's plea for restraint; and its tone should be read in the context of the following sentence, which describes his current bout with gonorrhea. Weatherly tentatively dates this

letter 16 March, while Douglas Grant dates it following the publication of Hogarth's *Wilkes* (*Poetical Works of Charles Churchill,* ed. Douglas Grant [Oxford, 1956], 518). Bertelsen's interpretation of Churchill's *Epistle* is illuminating (201–4).

24. BL Add. MS. 35,400, f. 75.

25. *Gen. Works,* 1: 367; AN, 221.

26. Walpole, *Anecdotes,* 4: 145.

27. Morris Golden, "Sterility and Eminence in the Poetry of Charles Churchill," *Journal of English and Germanic Philology,* 66 (1966): 333–46.

28. On 19 July there was one "to Mr. C. Churchill on The Motto of his Epistle to Hogarth—Ut Pictura Poesis":

> Churchill, your Motto surely is untrue,
> Not as the Picture have we Verse from you:
> Just to the Measures of the scottish clan,
> To abuse and falsify, was Hogarth's Plan;
> Your honest Lines at Truth's Command are writ,
> And Judgement owns the Triumph of your Wit.

Just before or after publication of the *Epistle,* a print called *The Boot & the Block-Head* was published (*BM Sat.* 3977): while on one side the "Auditor" and his allies bow to the idol Bute, a wig block on a pole anchored in a single large boot (crowned with a Scotch bonnet with a long serpentine queue labeled "Tail of Beauty"), on the other "Church—," "North Briton" in hand, chastises a shaken and elderly Hogarth: "Il spare none of you from the top of the bonnet to the sole of the Boot." Hogarth replies, "Dam it Charles what have you done to me you'l make me run mad." On the 26th came a reply ("To the Rev. Mr. Churchill, Non ut Pictura Poesis"), an attack on Churchill and Wilkes, which says of Hogarth:

> His Fancy has already hit on,
> A Frontispiece for the North Briton;
> Where in full View, the virtuous Pair,
> Shall their united Merits share.

29. Reviews of Churchill's *Epistle:* John Langhorne, *Monthly Review,* 29 (Aug. 1763): 134–38, was saddened by all this rancour; he briefly relates the squabble and says that the *Epistle* "is merely a paraphrase of the North Briton, N° 17." *Critical Review,* 16 (1763): 63–67: "Never did Hogarth scourge vice and folly more severely than the tremendous drawcansir, Churchill, hath in this epistle scourged the unfortunate Hogarth: all that the bitterness of resentment could dictate, or the malevolence of keenest satire inspire, is poured forth on the devoted victim. Whether the portrait, which

the poet hath drawn in such lively colours, doth in every feature resemble the person for whom it is designed, the world must determine; for our own parts, we are inclined to think it is rather, like Mr. Hogarth's Wilkes, a Caricature: and that the excellent artist is by no means so contemptible a character as he is here represented." This article, which ends by complimenting Churchill as a fertile but undisciplined genius, sounds like Smollett, who had departed for the Continent at the end of June about the time the *Epistle* appeared. See also the issue of November 1763, 395 (for a reference to Hogarth's "madness" in Churchill's *Epistle* at the end of a review of Christopher Smart, who was then mad). The magazines were in general neutral: e.g., *LM,* 32 (July 1763): 386–87; (Aug. 1763), 440; (Nov. 1763), 614–15, and *Royal Magazine,* 9 (July 1763): 47; (Dec. 1763), 321–22. The *Universal Magazine* was pro-Pitt and so sided with Churchill against Hogarth (33 [Nov. 1763]: 262–65; [Dec. 1763], 323–24, and supplement 1763, 374–76, 279–80). The *British Magazine* criticized Churchill's subject matter but praised his poetry (2 [Mar. 1761]: 16; 4 [Feb. 1763]: 98, 4 [Aug. 1763]: 433–34).

30. *St. James's Chronicle,* 12–14, 24–26 July. The MS. is BL Add. MSS. 27995, ff. 19–20: partly reprinted in J. Ireland, 3: 214–16, but with large omissions.

31. *Garrick Letters,* 1: 378.

32. *St. James's Chronicle,* 5–7 July; see George Colman's *Prose on Several Occasions* (1787), 1: 237–38.

33. This pamphlet was attributed to Paul Whitehead by an Oxford correspondent in the *London Chronicle,* 12–14 July 1763, who says Hogarth designed the frontispiece. However, already Churchill's resemblance to a bear had been noticed by Samuel Foote in a new version of *Taste,* performed in April 1761, as a reply to the attack on him in *The Rosciad:* there, with George Townly (Colman) and Fustian the poet (Thornton), Charles Manly (Churchill) was described by Townly as being "rugged and shaggy as a Beast of thy own breeding after a hard winter."

34. *Daily Advertiser,* 1, 4 Aug. 1763; *St. James's Chronicle,* 4–6 Aug.

35. Cf. Hogarth to Huggins, 24 June 1760; see above, 293.

36. *Correspondence of Wilkes and Churchill,* 59–60.

37. Ibid., 64.

38. J. T. Smith, *A Book for a Rainy Day, or Recollections of the Events of the Last Sixty-Six Years,* 2d ed. (London, 1845), 301–2.

39. BL Add. MS. 35.400, ff. 99*v* 100.

40. Walpole, *Anecdotes,* 4: 145.

41. See *Scots Magazine,* 25 (1763): 498: "After this print was published, Mr. Hogarth was said to be in his dotage when he produced it: which, it seems, provoked him to make the following additions, in order to give a further specimen of his still existing genius." See also the obituary of Ho-

garth in the *Public Advertiser,* 8 Dec. 1764: "Hogarth's picture of Churchill was but little esteemed, and Churchill's letter to Hogarth has died with the subject"; and in the "dialogue" between Hogarth and Churchill in the *Public Advertiser,* 30 Jan. 1765, Hogarth refers to "the ill Reception my Answer to it [the Epistle] met with from the Public." See also J. Ireland, 2: 260.

42. Announced, *St. James's Chronicle,* 1–4 Oct. 1763. *The Bruiser Triumphant. A Farce,* an emblematic anti-Hogarth print, sums up the attack at this point (repro., Bertelsen, fig. 8). An ass ("Hog-ass") wearing his palette (marked with the Line of Beauty) around his neck is finishing *The Bruiser.* (He has not yet added the "PETIT PIECE" on the palette, which would date the print between August and the beginning of October 1763.) He wears a boot with the usual anti-Bute inscriptions and his pug is at his feet. His easel and stool rest on a dais whose steps are labeled "SELF SUF-FICIENCY," "JEALOUSY," "SCORN," "MALICE," "VENALITY," "ENVY," "ARROGANCE," "WANT OF CHARITY," "AVARICE," and "DETRACTION." On the step marked "AVARICE" his paintpot, again doubling as a chamber pot, is spilling its contents on a document inscribed "Patriotism."

The "Hog-ass" is accompanied by idealized representations of Wilkes and Churchill, the first holding up cuckold's horns behind the ass's head and the second (obviously continuing his "Epistle") writing "The Life and Opinions of Willm HogAss the Pannell Painter and his last dying Speech and Conf[ession]."

In the background a satyr mounts a board on the wall: "Ha! Ha! Ha! said Old Will. Now you shall see yᵉ boasted Works of all the Ancient & Modern Painters, Your Raphael, Rubens, Carrach OUTDONE! I'll show you a Picture done by MYSELF! A Picture indeed! Ho! Ho! Ho! Ho!" Below the satyr's arm, which divides the board, can be read his own comment: "What the Devil had he to do with the more Sublime Branch of Painting or with Politics whose Talent consisted in low HUMOUR?"

Also on the wall is a veil inscribed "THIS CURTAIN HANGS HERE to preserve from Vulgar Eyes the beauty of that inestimable PICTURE, representing a HARLOT blubbering over a BULLOCK'S HEART [adapted from the catalogue of the Sign Painters' Exhibition, referring to *Sigismunda*], Painted by WILLᴹ HOGASS at the Golden Blockhead, in LIE[chest]ER FIELDS."

43. AN, 222, 215 (f. 286, not transcribed by Burke).

44. See, e.g., the one written him by a Quaker named Ephraim Knox on 20 August (BL Add. MS. 27995, f. 21; reproduced, J. Ireland, 3: 212–13).

45. See Walpole, *George III,* 1: 252–53; Postgate, *That Devil Wilkes,* 78; *Correspondence of the Late John Wilkes,* ed. J. Almon (1805), 2: 12–14.

46. Wilkes, while M.P. for Aylesbury, had been appointed the treasurer

of that branch of the Foundling Hospital. "When he left the Kingdom in 1764, some ugly disclosure connected with the Accounts took place, by no means creditable to 'honest John'" (Brownlow, *Foundling Hospital,* 48n).

47. *St. James's Chronicle,* 18 Jan. 1763.

48. Brown, *Churchill,* 38.

49. Richard B. Peake, *Memoirs of the Colman Family* (London, 1841), 1: 129–30.

50. *Mrs. Montague, 'Queen of the Blues,' Her Letters and Friendships from 1762–1800,* ed. R. Blunt (New York, 1924), 1: 79. The relationship between this girl, Elizabeth Carr, and Sir Henry Cheere has by no means been definitely established—whether she was his daughter, stepdaughter, daughter-in-law, or whatever. For discussion and references, see Brown, *Churchill,* 177–79.

16. "FINIS"

1. The two most recent to die were Roubiliac and Ralph in 1762. For Roubiliac, see the *St. James's Chronicle,* 14–16 Jan. 1762; for Ralph, the *Daily Advertiser,* 25 Jan. 1762. Ralph's death coincided with his launching a project for the defense of Bute; it is possible that his death in these circumstances may have contributed to Hogarth's decision to make *The Times, Plate 1* in the following months.

2. See Boswell, *London Journal* (New York, 1950), 24 May 1763. Some sort of a break between Wilkes and Thornton is alluded to by Colman in a letter to Wilkes of 21 June 1765 (BL Add. MS. 30877, ff. 41–42).

3. MS. in Dr. James Browne's collection.

4. AN, 228–29. Charlemont had also asked for a commentary (above, 327).

5. According to Dodsley's record books, Clubbe's *Physiognomy* was published on 21 Dec.; it was not advertised, however, until 26–28 Jan. 1764 (*London Chronicle;* R. Straus, *Robert Dodsley* [London, 1910], 381). See *HGW,* no. 242. The lines from Horace are his *Ars poetica,* 180–81, which must always have been significant for Hogarth.

6. *Gen. Works,* 1: 382.

7. [Edward Draper], "Memorials of Hogarth," *Pictorial World,* 26 Sept. 1874, 135.

8. *Lloyd's Evening Post,* 1–4 July 1763. After Hogarth's death, Smollett eulogized him in *Humphry Clinker* (1771); his spokesman, Matthew Bramble, in his letter of 12 June, points to a pair of faces that "would be no bad subject for a pencil like that of the incomparable Hogarth, if any such should ever appear again in these times of dulness and degeneracy." In *The Present State of All Nations* (1768, 1: 230) he expressed his opinion of English art and of Hogarth (not different from the one he expressed in *Peregrine*

Pickle): "England affords a great variety of geniuses in all the liberal arts, except in the sublime parts of painting. . . . In the comic scenes of painting, Hogarth is an inimitable original with respect to invention, humour, and expression." See also "Recapitulation of the Principal Events of George II's Reign," in his *Continuation [of the Complete History]*, 4: 131.

9. This was the final view taken of Hogarth by others as well. Arthur Murphy had written in 1754 of Hogarth who, "like a true genius, has formed a new school of painting for himself," that this was by sustaining the "unity of character," and the *Harlot's Progress* and *Marriage A-la-mode* were as "well drawn as anything in Molière." And Reynolds referred in *Discourse* 14 to Hogarth's "new species of dramatick painting" (Murphy, *Gray's Inn Journal*, 9 Mar. 1754; Reynolds, *Discourses*, ed. Robert Wark [New Haven, 1975], 254).

10. Pointed out by Joseph Burke, *Encyclopedia of World Art*, 7: 581. Hogarth is also playing variations on the word "piece": Frontis*piece*, petit *piece*, Tail*piece*, and finally—by way of the dog pissing in *The Bruiser*— "Frontis-*piss*" (1763). The last (made for a satire on John Hutchinson's anti-Newtonian philosophy of "glory [i.e., revelation] over gravity") submits a witch's "thin circulating fluid" (a flow of urine) to the law of gravity. Though unpublished, it was Hogarth's final satire on "credulity, superstition, and fanaticism" (*HGW*, no. 243).

11. Pliny, *Natural History*, 35.85, in *The Elder Pliny's Chapters on the History of Art*, ed. K. Jex-Blake and E. Sellers (Chicago, 1982), 125; cf. above, 122. I am indebted to Barry Wind, "The Last of *The Tail Piece*: Hogarth and Apelles," *Source: Notes in the History of Art*, 3 (1984): 12–15.

12. Wind, "Last of *The Tail Piece*," 14. For Apelles's reputation, see Pliny, 35.79, 89.

13. *St. James's Chronicle*, 27–29 Mar., 3–5 Apr. 1764. The issue of 5–7 April noted that during the height of the eclipse the temperature dropped nine degrees Fahrenheit.

14. *Philosophical Enquiry* (ed. Boulton), 62.

15. A sketch by Hogarth for Catton to work from was engraved by Richard Livesay in April 1782: a scrollwork design enclosing the word "Cyprus" and surmounted by the Cyprian cone; underneath is the word "Variety." From a note in one of Hogarth's notebooks (MS. Nichols Collection, Fitzwilliam Museum), it appears that Hogarth kept his equipage in stables at the Old Nag's Head in Orange Street, Leicester Fields. A watercolor of this building is in the Crace Collection, BM, reproduced in *English Illustrated Magazine*, Aug. 1886; a sketch by Philip Norman is in the Bethnal Green Museum (*Annotated Catalogue of Drawings of Old London*, 1900, 37 [No. 72]).

16. *St. James's Chronicle*, 19–22 Mar. 1764. Churchill's verses were first printed in *The Muses Mirrour* (1778), 1: 8; included in *Poetical Works of*

Charles Churchill, 453. For verification, see *Gen. Works*, 3: 312. Other verses on Hogarth, by George Thompson, appeared in the *Public Ledger*, 10 May and 11 May 1764 (reproduced in *Gen. Works*, 3: 312–13). Verses "To Mr. Hogarth on his Print of Mr. Churchill in the Character of a Russian Hercules" (attacking Hogarth) appeared belatedly in the *St. James's Chronicle*, 7–9 June 1764.

17. Probably a dubious anecdote, given its source: Peter Pindar (John Wolcot), letter to *GM*, 55, pt. 1 (1785): 344; shortened and reprinted in Thomas Faulkner, *History of Brentford, Ealing and Chiswick* (London, 1845), 447–48.

18. BL Add. MS. 22394.

19. Edwards, a typical artist with a typical career for this time, had begun as an apprentice to an upholsterer, left him to study drawing from casts at the duke of Richmond's gallery in 1759, and in 1760 opened an evening school to teach young men who wanted to become artists or cabinet or ornamental furniture markers. In 1761 he was admitted to the St. Martin's Lane Academy, where he could draw from the human figure. He was then encouraged to enter a drawing for a Society of Arts premium, and won. In 1763 he was hired by Boydell to make drawings from Old Master paintings to be engraved by others, and in early 1764 Hogarth employed him in the same way for *Sigismunda*. It is a pity that Edwards, who is best remembered now for his *Anecdotes of Painters*, written as a sequel to Walpole's anecdotes, did not leave any record of his brief association with Hogarth.

20. BL Add. MSS. 22394, f. 32; noted dated 12 June 1764, formerly in the collection of William Upcott, reproduced in *Historical and Literary Curiosities, consisting of Facsimiles of Original Documents . . .*, ed. Charles John Smith (1840), pl. 45; letter to Hay, in the library of the Historical Society of Pennsylvania.

21. *Gen. Works*, 3: 311.

22. Ibid., 1: 321 n. For the unfinished etching, see *HGW*, pl. 289.

23. *Biog. Anecd.* (1782 ed.), 436.

24. BL Add. MSS. 22394, f. 37.

25. Recorded in George Steevens's copy of Jane Hogarth's sale catalogue (BM Print Room). For Boydell, whose patronage schemes parallel some of Hogarth's solutions to the same problems, see Thomas Bolston, "John Boydell, Publisher: 'The Commercial Maecenas,'" *Signature*, 8 (1948), and Lawrence Thompson, "The Boydell Shakespeare: An English Monument to Graphic Arts," *Princeton University Library Chronicle*, 1 (1940).

26. For the abortive engraving of *The Lady's Last Stake*, see Charlemont to Edmond Malone, 20 June 1781; *HMC*, 12th Report, pt. 10 (1891), 385; cf. *Biog. Anecd.*, 1781, 16; *HGW*, 32.

27. Lindsay, *Hogarth*, 66.

28. Danto, "Andrea Mantegna," *The Nation*, 29 June 1992, 905–6.

29. Told by Barry to J. T. Smith's father (J. T. Smith, 2: 270).

30. *Diary of John Courtney,* 2: 31. His other two visits were on 6 and 14 August 1766 (2: 110, 120: East Riding Archives Office, Beverley). Jane Hogarth's letter to Dr. Coningsby is in volume 5 of Nichols's Hogarth collection in the Fitzwilliam Museum, Cambridge.

31. Leslie and Taylor, *Reynolds,* 1: 224.

32. See Jack Lindsay, *1764, The Hurlyburly of Daily Life Exemplified in One Year of the Eighteenth Century* (London, 1959), which draws largely on the *London Chronicle.*

33. David Hall (an associate of Strahan and partner of Franklin in his printing business in Philadelphia), letter to William Strahan, 25 June 1764; Strahan, letter to Hall, 19 Sept. 1764; American Philosophical Society Library. The prints were not secured until February 1768 when they were acquired from Jane Hogarth (Franklin to Hopkinson, 9 May 1766, in the Historical Society of Pennsylvania; the payment to Jane Hogarth of £14 11*s* on 5 February 1768 is in Franklin's accounts and was charged to the Library Company account [*Franklin Papers,* ed. Leonard W. Labaree (New Haven, 1969), vol. 8]).

34. In the P.R.O., P.C.C. Simpson, 427. The whole document is reproduced in Appendix J of *HLAT.*

35. Hogarth's physician during his illness would appear to have been Dr. Schomberg, whom he had known for years (see above, 171) and remembered with a ring in his will. Another physician, one Richard Loveday, a witness to his will who eventually inherited the Chiswick house, may have attended him while in the country. For Schomberg's checkered career, with its interesting parallels to Hogarth's, see Sir George Clark, *A History of the Royal College of Physicians of London,* 2 (London, 1966): 547–51; also *Minutes of the Proceedings of the Royal College of Physicians, relating to Dr. Isaac Schomberg, from February the 6th, 1746, to December the 22d, 1753* (1754); *GM,* 29 (1754): 50–51, and the many contemporary pamphlets that described Schomberg's long battle with the College of Physicians over the rights of the individual physician.

According to John Kobler (*The Reluctant Surgeon: A Biography of John Hunter* [New York, 1960], 127), Hogarth was at one time a patient of William Hunter, who also collected his prints (see *HGW* 1965, 1: 74).

36. P.R.O., Letter Books, Works 1/4. There is a separate payment to Samuel Cobb, painter, instead of Hogarth, on 14 September, £30, and 26 October, £30. Payments in the account books are still to Hogarth. Cobb also appeared in the monthly payments (Works 5/63) from time to time in respect to work done on Kensington Palace: the earliest reference I have found is for September 1762. For the final accountings to Jane Hogarth, see Royal Archives 16811–15.

37. *Gen. Works,* 1: 385, 388. The newspaper accounts of the time add

nothing: they all reported that "On Friday night died suddenly, after being very chearful at supper . . . ," etc. The only exception was the *London Evening Post* (28–30 Oct.), which had it that he "died at his house in Leicester-square after a tedious illness." The *Scots Magazine* elaborated, producing a different version from Nichols's: "He eat supper with his usual chearfulness, and had no complaints of any kind; but about half an hour after, he fell back in his chair, and instantly expired" (26 [Oct. 1764]: 576). (The other accounts: *St. James's Chronicle,* 25–27 Oct.; *Lloyd's Evening Post,* 26–29 Oct.; *Gazetteer,* 29 Oct.; *Public Advertiser,* 29 October; *Annual Register,* 7 [1764]: 108; *LM,* 32 [1764]: 541; *Universal Museum* [1764], 549.)

The cause of death was first given by Horace Walpole in his *Anecdotes,* 4: 80, in 1770 (not pub. until 1780) as "a dropsy of his breast," and this was picked up in the earliest editions (1780–1781) of Nichols's *Biographical Anecdotes,* with the parenthetical addition, "the same that killed Mr. Pope" (undated 1780 ed., 37; 1781 ed., 57). "Dropsy in the breast" usually applied in those days to a cardiac condition. Nichols, on the information of one of his correspondents (presumably not Dr. Schomberg, who had died in 1780), changed this in later editions to "an aneurism."

38. The cast was sold in Jane Hogarth's sale at her death (no. 58) and is now lost; see *HLAT,* Appendix I; the burial is recorded in the Burial Register of St. Nicolas's Church.

39. See Garrick's *Poetical Works,* 2: 483: also *Poems of Samuel Johnson,* 181–82, for Johnson's revisions; also *Letters of Samuel Johnson,* 2: 778, 781, 782. Variants are in the Folger Library, the Berg Collection (New York Public Library), and the Hyde Collection.

40. Jane Hogarth died on 14 November 1789 in her house in Leicester Fields and was buried on the 21st. The *Morning Herald* of that date noted that when the vault was opened "the body of her celebrated husband was not to be seen. This at first, excited some alarm and some conjectures, but it has since been recollected that the body was deposited in a grave only, and the vault built over it afterwards." This may explain the story, current in 1853 when the tomb was repaired, that Hogarth's body had been stolen from the grave and his skull offered for sale to the British Museum (F. G. Stephens, "Hammersmith and Chiswick," *Art Journal* [1885], 277–78).

41. Garrick, letter to Colman, 11 Apr. 1764, *Garrick Letters,* 1: 412; 10 Nov. 1764, *Letters,* 2: 429.

42. Walpole, letter to earl of Hertford, 1 November 1764, Corr., 38. 459.

43. *Gazetteer,* 26 Oct.; 31 Oct.; James Harris to Grenville, 2 Nov. 1764, *The Grenville Papers,* ed. W. J. Smith (London, 1852), 2: 457.

44. Letter to Mann, 15 Nov. 1764, Walpole, Corr., 22: 261.

45. Griffiths, in the *Monthly Review,* 41 (1769): 382, still claims that the *North Briton* "accelerated" Hogarth's death.

46. BL Add. MS. 30877, f. 42. On 19 November the *Public Ledger* published a long epitaph written by Hogarth's old friend James Townley, now headmaster of the Merchant Taylors's School; on 8 December the *Public Advertiser* published a long biographical obituary, apparently by someone (probably Morell) who was familiar with Hogarth; it was reprinted in the *Whitehall Evening Post* for 11 December, the *Annual Register* (7: 62–64), and *Scots Magazine* (26: 648–49).

47. *London Chronicle,* 31 Jan.–2 Feb., and again 2–5 Mar. 1765. Already, however, copyists were beginning to emerge; *The Sleeping Congregation* had been pirated by Carington Bowles, son of Hogarth's old enemy, and Jane continues her advertisement with a warning against copies. The copyright had run out on the engravings of the 1730s and 40s, and she was in competition with the now legal copies. She had her own cheap copies made of the prints. When the revised Engravers' Act (7 *George III,* cap. 38) was passed in June 1767, a special clause was inserted that secured the copyright to her personally for twenty more years. This extended copyright expired in 1787, and she must have found her income dwindling dangerously in spite of various expedients (such as Richard Livesay's copies of Hogarth's drawings and Thomas Cheesman's engravings), for she petitioned the Royal Academy— her husband's old bête noire—and was granted a pension of £40 a year.

48. *Public Advertiser,* 5 Aug. 1766.

49. Undated clipping in the Forster Collection (V & A, F. 10.E.3, no. 174). One other final glimpse of Jane Hogarth appears in her answer on 28 June 1765 to Mr. Collingwood of the Foundling, who had decided that the chilc' en who remained with her after Hogarth's death should be sent back to a branch of the Foundling: "imagining that if the Children which are under my inspection was Brought to the House when the Year was expired which is but a few months to come; it would be but a triffling Expence to the House; but perhaps a Material Difference to the Children as they would enjoy the benefit of a run in the Country for the Summer Season, which in all probability would quite establish their Healths." There is also a story that she "regularly invited the children of the village every summer to eat the mulberries; a custom established by her husband" (an elderly person who remembered Jane Hogarth, to C. R. Leslie or Tom Taylor, *Reynolds,* 1: 235).

50. See Paulson, *E and E,* Chaps. 9–12; *Rowlandson: A New Interpretation* (London, 1972); *Literary Landscape: Turner and Constable* (New Haven, 1982).

General Index

academy: English, in Rome, 190, 259; Imperial, of Augsburg, possible hoax concerning, 216–18

academy, state: agitation and search for, 9–10, 15, 217, 309, 332; associated with exhibitions, 303–4, 308; controversy over, 254–55, 267, 283; projects for, xi, 10–11, 132–33, 158, 186–87, 273–74; Reynolds and, 192; WH's opposition to, 13–15, 133, 137, 195, 254, 265, 282. *See also* French Academy; Hogarth, William, life and career; Royal Academy

Addison, Joseph, 250, 262, 279, 317, 347, 466n18, 473n37; on "Pleasures of the Imagination," 36, 68–71, 82, 240, 241–42, 365; theory of the Beautiful, Great, or Novel, xiv, 68–70, 90, 125, 244; *The Drummer,* 365

Aeschylus, 81, 85

aesthetics, English: contemporary conflicts concerning, 33–34; as new philosophy, xii, xiii; the Picturesque, xiv, 95–98; the Sublime, 240–44, 249, 257; treatises on, xii, 70, 71. *See also* Addison, Joseph; Burke, Edmund; Hutcheson, Francis; Shaftesbury, Anthony Ashley Cooper, 3d earl of

Akenside, Mark, 469n38; in *Peregrine Pickle,* 1, 2, 520n30

—*Odes,* 82

—*Pleasures of Imagination, The,* 1, 64, 82, 83, 84, 487n19

Alberti, Leon Battista, xii, 71, 510n50

Aldridge, A. O., 459

Alfred, king of England, 475n10

Allen, Brian, 348

Allen, Ralph, 469n40

Anderson, James: *Constitutions,* 131; *Defense of Masonry,* 127–28

Andrews, Malcolm, 462–63n76

Angerstein, John Julius, 453n63

Anguish, Mrs., 201

Answer to the Print of John Wilkes Esqr, An (fig. 103), 398; verses on, 524n19

Antal, Frederick, *Hogarth,* xv, 225, 448n14

Anti-Line of Beauty, The, 144

Apelles, 34, 122, 124, 421–22

Arne, Thomas, 302

Atkinson, Thomas, *Conference between a Painter and Engraver,* 9

Augusta, Princess Dowager of Wales, 173, 198; and Bute, 374, 387, 392, 394; as regent, 175

Ayton, William, 392

Baker, John, 298, 368, 388

Baldwin, Henry, 330

Baldwin, Richard, 54

543

tions for *Pamela,* 220; *A Critical Examination,* 186, 195
Hill, Dr. John, 451n34
Hoadley, Benjamin, bishop, 260, 297, 521n49
Hoadley, Dr. Benjamin (son of the bishop), 59, 63, 297; and the *Analysis,* 63, 64; portrait of, 321; in Sandby's caricatures, 137, 138
Hoadley, John, 252, 253, 285, 292, 321, 323, 364
Hoare, Henry, 105, 186, 230, 231, 454n66
Hoby, Sir Philip, 271
Hockney, David, 356, 431
Hogarth, Anne Gibbons (mother), 92, 93
Hogarth, Anne (sister): portrait of, 292, 298; and WH's will, 433, 434
Hogarth, Jane (wife), 292, 429; elopement and marriage, 91, 93, 326; and Garrick, 286, 287; inheritance, 433–34; later life and death, 418, 532n40, 533n49; letters from, 234–35; as model for WH, 4, 227–28, 231, 385; portraits of, 298, 301; promotion of WH's works and reputation, 433, 434–35, 438; and sale of WH's works, 150, 435, 484n41, 503n12, 504n30, 531n33, 531n47
Hogarth, Mary (sister), portrait of, 292, 298
Hogarth, Richard (father), 18, 59, 92, 93
Hogarth, William, life and career
—and the academies, xi, 11–15, 133, 255, 320–21; French Academy, 13–14, 171, 178–79, 194, 259, 304; ideas for, 12, 187, 192, 263, 309, 310, 312, 371, 459n41. *See also* academy, state; St. Martin's Lane Academy

—and aesthetics: as erotic and hedonist, 69, 77, 94, 97–98, 220–21, 269, 276, 279, 284, 461n66; idea of copying, 102–3, 195, 256, 482n29; nature over art, 94, 212, 256, 299; as remystification, 131; and role of spectator, 67, 81, 99, 101, 221, 419. *See also Analysis of Beauty, The,* in INDEX OF HOGARTH'S WORKS
—career stages and changes: as engraver, 31, 33, 42, 44, 46, 427–28, 429; plans for, 118, 210, 219–20, 224, 285; as portrait painter, 265; as public, 3; sources of income, 214, 215, 219, 485n6; as winding down, 292–93, 305, 322. *See also, infra,* Serjeant Paintership; as writer
—character and personal traits: collection of self-justifying documents, 150–51, 230, 234, 369, 375, 410, 429; cynicism and disillusionment, 182, 215–16; as observer and instructor, 57, 147; paranoid strain and need for self-justification, xi, xvi, 58, 146–47, 150–51, 232, 252–54, 283–84, 367, 415; possibly aristocratic yearnings, 370, 372; as pretentious, 2, 191; self-perceptions, 151, 201, 211, 232, 403; as self-publicist, 3; as simple and straightforward, 192; touchiness, pugnaciousness, belligerence, 286, 373, 380, 406–7
—commission(s), 29, 126, 207; for conversation pictures, 218, 220, 223, 229–30, 270, 293, 429; special, 269–70, 272; for sublime history painting, largest, 204; unbusinesslike manner in fulfilling, 270

Index of Hogarth's Works

1. PAINTINGS, ENGRAVINGS, DRAWINGS (GENERAL)

graphic sources and models (*cont.*) 245; Masonic writings, 127–29, 137; new poetics, 81–85; the stage, 221, 258, 317, 318, 419, 476n16. *See also* Milton, John; Shakespeare, William, *in* GENERAL INDEX
—WH's own work, 151, 155, 211, 236, 244, 328, 341, 405, 422, 424, 426, 448n13

history painting(s), 4, 46, 240, 242; burlesque of, 39–41; criticism of, 242–43, 251–52, 255–57; largest, commission for, 204; as model, 46; and popular prints, 34–35; sources for, 41–44

Latin inscriptions, 269, 271, 277, 338, 423

"modern moral subjects," xiii, xv, 7, 93–94, 270, 299, 361; *Analysis* plates as continuation of, 100, 107; Fielding and, 276–77; satire in, 209; theme of identity in, 345

oil sketches, 301, 431

paintings, 263, 430; vs. engravings, 157, 429–32; and signboards, 342, 343, 345, 346; style and tone, 227, 243, 246, 475n5; use of color, 99, 155–56, 157, 243, 270, 464n84, 475n5, 486n13; varnish for, prescription, 508–9n35. *See also* history paintings
portraits and portrait painting: commissions for, 269–72, 522n68; in exhibition, 321; of family and friends, 18, 30–31, 298–99; late examples of, 290, 291, 292, 297; of political figures, 294–97; pro-

posed partnership with Wilson for, 289–90; Reynolds, comparison with, 192; and sitters, 290; sketches kept by WH, 505n30; WH's return to, announced, 118, 210, 285. *See also* self-portraits
puns, 162, 247, 259, 318, 350, 379, 392, 402, 407, 421, 424; in signboards, 346, 354, 361, 380–81

self-portraits, 2, 45, 57, 58, 84, 210, 212, 291, 317–318, 409, 487n17; caricatures and reproductions of, by others, 55, 137, 140, 346, 358, 359, 387, 398; depiction of self in, 210, 211, 318, 350, 417, 418; self-effacing trend in, 151, 318, 405–6, 424, 426, 427; updating of, 427
stylistic features: autobiographical trend in, 45–46, 151; baroque, 407; change to simplicity and generalization, 44–45, 227, 229, 271, 287, 361, 475n5; fairy-tale mode, 407; form and shape in, 299–301; variety, 73, 157, 300, 376, 430
subject matter
—Choice of Hercules, 159–60, 220, 289
—comedy of incongruity, 115–16, 119, 156–57
—family: the child, 92–94, 461n68; the father, 461n68, 461n69
—friends and contemporaries, 18, 29, 30–31, 106, 111, 112, 161, 181, 237, 247, 258, 351, 366, 373, 378–79, 389; homoerotic circle, 270–71, 519n30
—marriage, 93, 119–20, 175
—political and current events and allusions: battle of Culloden, 136, 174, 178, 274, 391; City interests,

II. PAINTINGS, ENGRAVINGS, DRAWINGS (INDIVIDUAL WORKS)

III. WRITINGS